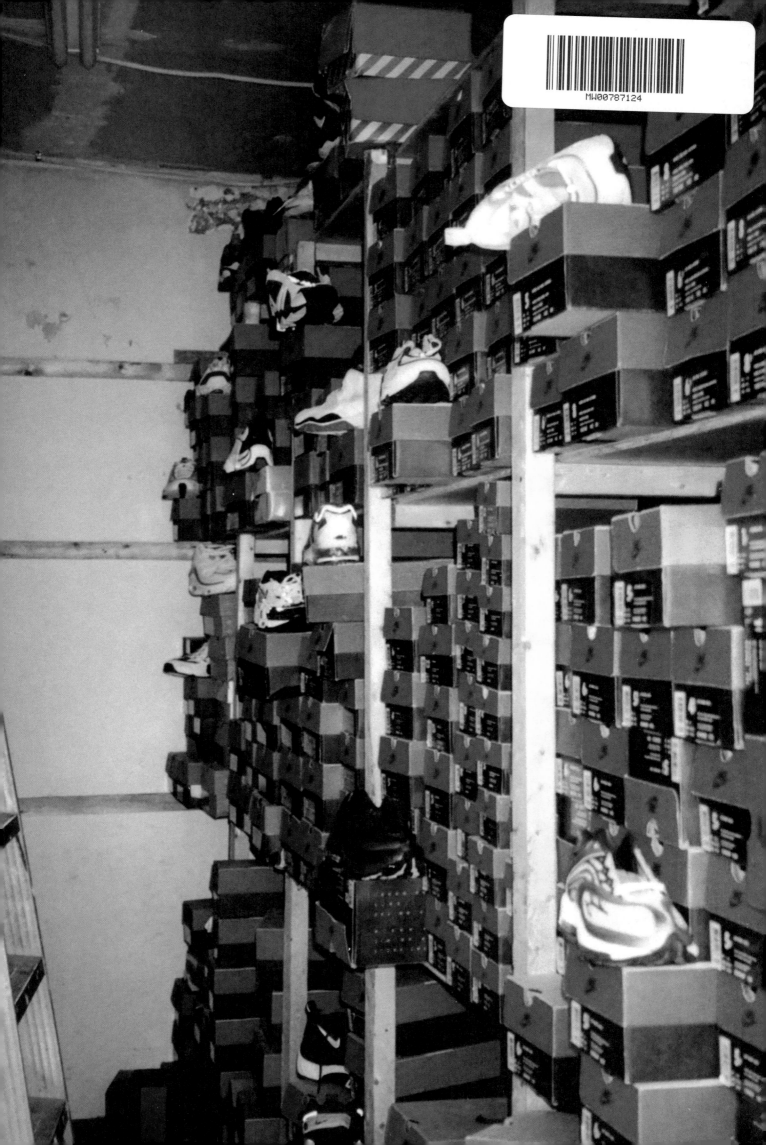

This book was written,
designed and edited by
Sneaker Freaker International
hello@sneakerfreaker.com
WEB sneakerfreaker.com
IG @sneakerfreakermag

Front cover:

2005: Diamond Supply Co.
x Nike SB Dunk Low 'Tiffany',
photo by Ella Haines

Back cover:

Photo by Ella Haines

End Papers:

Nike vintage sneaker racks (NYC),
photos by Tommy Rebel

**EACH AND EVERY TASCHEN BOOK
PLANTS A SEED!**

TASCHEN is a carbon neutral publisher.
Each year, we offset our annual carbon
emissions with carbon credits at the
Instituto Terra, a reforestation program in
Minas Gerais, Brazil, founded by Lélia and
Sebastião Salgado. To find out more about
this ecological partnership, please check:
www.taschen.com/zerocarbon.
Inspiration: unlimited.
Carbon footprint: zero.

To stay informed about TASCHEN and
our upcoming titles, please subscribe
to our free magazine at w*ww.taschen.com/
magazine*, follow us on Instagram and
Facebook, or e-mail your questions to
contact@taschen.com.

© 2023 TASCHEN GmbH
Hohenzollernring 53, D-50672 Köln
www.taschen.com

Printed in China
ISBN 978-3-8365-9629-9

SNEAKER
FREAKER

World's Greatest Sneaker Collectors

TASCHEN

SNEAKER FREAKER — ISSUE 48
RARE
THE GREATEST JORDAN COLLECTION EVER
AIR!
1984 – AIR JORDAN 1 'BLACK TOE'

SNEAKER FREAKER — ISSUE 47
Alley cats
SNEAKER FREAKER x ATMOS

SNEAKER FREAKER — ISSUE 46
Patta
AIR MAX!

SNEAKER FREAKER — ISSUE 45
FRESH
JOE FRESHGOODS
OUTSIDE CLOTHES
made for U.S.
GOODS!

SNEAKER FREAKER — ISSUE 44
INTER VIRGIL VIEW

SNEAKER FREAKER — ISSUE 43
AIR
DIOR
UNOBTAINIUM

SNEAKER FREAKER — ISSUE 42
1-800-AIR-ZOOM-SPIRIDON

SNEAKER FREAKER — ISSUE 41
LOONEY TUNED!

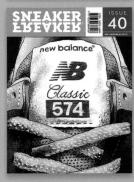

SNEAKER FREAKER — ISSUE 40
new balance
Classic 574

SNEAKER FREAKER — ISSUE 39
VANS
CHECKERBOARD

SNEAKER FREAKER — ISSUE 38
OVER 200 PAGES!
RIDUNKULOUS
NIKE SB
RETROSPECTIVE!

SNEAKER FREAKER — ISSUE 37
E.A.R.L
GENIUS OR GIMMICK?
HYPERADAPT

SNEAKER FREAKER — ISSUE 36
OG COLLECTOR FEATURE
NIKE AIR NIKE AIR
CRACKED & ROTTEN
VINTAGE JORDANS!
HIP HOP KICKS • SUPREME • NIKE COLAB HISTORY • ADIDAS NMD RETROSPECTIVE

SNEAKER FREAKER — Reebok ISSUE 35
ALIEN STOMPER
BACK ON THE BIG SCREEN

SNEAKER FREAKER — ISSUE 34
OVER 200 PAGES
PUMA DISC BLAZE
BAPE

SNEAKER FREAKER — ISSUE 33
FUTTOSUKEPU
DARE TO BE DIFFERENT

SNEAKER FREAKER — ISSUE 32
ADIDAS ORIGINALS
SUPERSTAR
LOVE LETTER TO A MASTERPIECE

SNEAKER FREAKER — ISSUE 31
SNEAKERFREAKER
MELVIN
SON OF ALVIN

SNEAKER FREAKER — ISSUE 30
MORE 184 PAGE ISSUE
BLACK & GOLD
JORDANS
$20k TREASURE FOUND FOR $10

SNEAKER FREAKER — ISSUE 29
MORE 180 PAGE ISSUE
20 YEAR ANNIVERSARY SPECIAL
PUMP FURY!

SNEAKER FREAKER — ISSUE 28
AIR MAX
OUT NOW!
THE COMPLETE*
RETROSPECTIVE

SNEAKER FREAKER — 27 ISSUE GLOBAL SNEAKER GUIDE
AIR MAX ATTACKS!

SNEAKER FREAKER — 26 ISSUE GLOBAL SNEAKER GUIDE
VINTAGE NB572 DAPPER DAN
HARLEM'S ORIGINAL HIP HOP TAILOR IS BACK!
READ OUR EXCLUSIVE INTERVIEW
DAPPER DAN

SNEAKER FREAKER — 25 ISSUE GLOBAL SNEAKER GUIDE
THE ADMIRAL RETURNS
THE 90s REVIVAL
USE THE FORCE!
DAVID ROBINSON'S AIR FORCE 180 IS BACK
WE COMPARE THE RETRO TO THE ORIGINAL

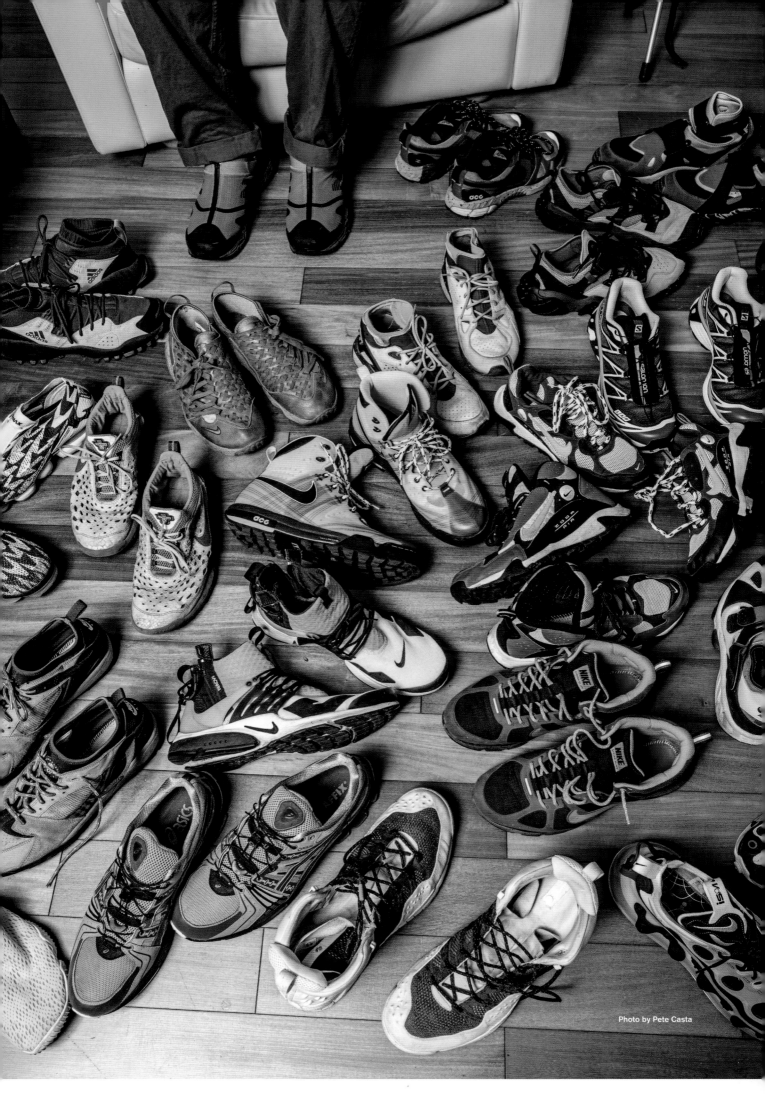

Photo by Pete Casta

Text: Woody

The Art of Sneaker Collecting

As Editor-in-Chief of *Sneaker Freaker* magazine, analysing the art of sneaker collecting has been a pre-requisite of my day job for the past 20 years. Over that time, I have quizzed dozens of devotees to illuminate the forces that have shaped their obsession. Schoolyard rivalries, 90s TV shows, hip hop videos, hoop dreams and lady luck all conspire to play their part in this pop cultural bonanza. This is not just about putting big numbers on the boards, though accumulating hundreds – and sometimes thousands – of pairs is the natural progression.

The *World's Greatest Sneaker Collectors* are motivated by a completist mentality that separates them from mere fans. They are *always* fiending, scheming and dreaming of 'the one' shoe they don't yet own. They are also prepared to make untold personal sacrifices, can survive without food for days if necessary, spend hours deciphering lazy eBay listings, travel the world in search of mythical sports stores, stay up all night watching Yahoo Japan auctions and turn themselves into nervous caffeine-addled wrecks in the process. When you care this much, the stress is real. And like Indiana Jones, they are never satisfied until the holiest of Holy Grails is in their possession.

I've often been asked how to start collecting sneakers, almost as if there's a secret password or magic invitation required. The simple answer is – obviously! – that you buy one pair, then another. Over and over again. But the reality isn't as simple as that. Collecting anything takes many forms, evolves over time, and where you start out isn't always where you end up. Like all good things, it takes a moment to find yourself. You need to establish your knowledge base and figure out who you are and what you're into. Then, and only then, should you make it your 'thing' and start investing your hard-earned money. Once that happens, you'll have all sorts of personal dilemmas, catch-22s, high-stakes dramas and subjective sacrifices to endlessly work through. Sounds highly melodramatic, but in my experience, that's all part of the fun.

As you'll read in the following interviews, sneaker collecting is laced with quirky personalities and multiple dimensions. The similarities and common causes that link them all are endless, but there are no hard and fast rules. Some focus exclusively on a single shoe. Others covet chunky 90s skate models or silky mesh-and-nylon runners from the early 70s. A select few wax lyrical over weird-ass designs that barely cause a ripple in hype circles (looking at you, Nike Footscape!). Some refuse to pay top dollar, while others spend a small fortune curating their collection to perfection.

A high percentage make life much harder for themselves by only buying shoes in their own size. Ultra-connoisseurs are perched at the top echelon of this footwear family tree. For these apex predators, only the most obscure, impossible to find, batshit crazy, super-rare shoes will suffice. 1-of-1s, cancelled releases, never-seen-before samples, handmade prototypes, Player Exclusives, game-worn Jordans, athlete SMUs – the minutiae can be mind melting. Then there are the sneakers, several of which feature in this book, that are so rare and potentially controversial or litigious, brands don't even officially admit they sexist.

The secrets of how and where shoes of this type are acquired will go to the graves with their current owners. At this rarified altitude, as Lindy Darrell notes [p 560], collectors often face the ultimate paradox of giving up a prized shoe to gain another pair they rank higher in the food chain. 'I will always be willing to trade. What I seem to get myself into is that one of these crazy shoes will surface and I need quick cash. I don't like to do this, but you gotta do what you gotta do! I've made some good trade-offs, but I wish I could get some of them back.'

Berlin's Julia Schoierer [p 380] is known worldwide for her love of adidas hightops. In her view, the obsessive nature required is a double-edged sword. 'Collecting sneakers is a constant tug-of-war between insanity, passion and reality. On the one hand, you can have a very strong passion that you think about all day, every day. On the other, how much time and money can you rationalise allocating for the passion?' Storage space is another nightmare with IRL repercussions that can often affect interpersonal relationships. Her apartment looks like a real-life Tetris game. 'I don't know when I last had people over for dinner because I don't have a table to sit down and eat. Then, when I go to bed, I'm not praying for better health – I'm praying that I won't be buried underneath a collapsing shoe rack next to my bed!'

Bianca Derousse

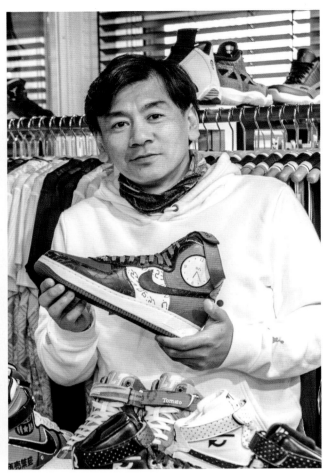

Tadahiro Hakamata

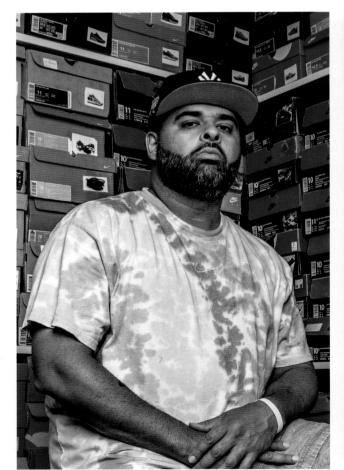

Chris Rosario

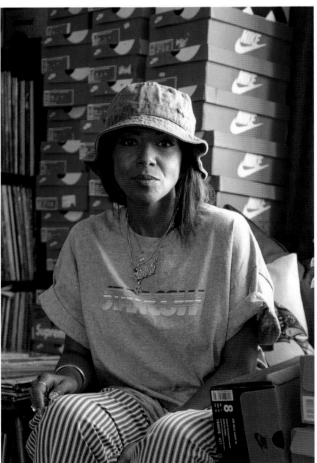

Super Lalla

'I'm not at liberty to reveal the entire story of how these shoes were unearthed but suffice to say I'm very pleased they ended up exactly where they should be, which is safe in the Nike vault. I've never been involved in anything like it, and I never will again.'

Lindy Darrell

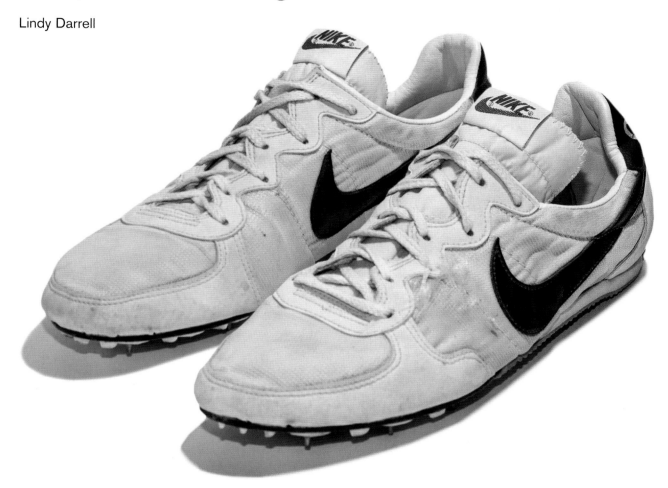

1980: The first Nike sneakers to win Olympic gold were worn by UK runner Steve Ovett

Holy Grails

The term 'Holy Grail' pops up in almost every feature. We've defined a Grail as 'The ultimate sneaker you've been chasing forever, usually exorbitantly expensive, ultra-rare and never for sale anywhere.' The reality is that Holy Grails, by their very nature, are not just ephemeral – they have universally ascended to 'meta-mythological' status. Grails are a construct of the (im)perfect world inside every collector's head where time, money and status have no rationality. It's a perverse occupational hazard that all collectors innately appreciate, even if it drives them nuts. If a shoe is all too easily acquired, it will not qualify as a Grail. If, by some crazy series of happenstances, you do manage to secure your most wanted, then it, too, is no longer a Grail. That's just how it is. Tommy Rebel [p102] has a top three in his head but knows he'll never cash in. 'I would never pay the price people are asking for my first choice. I don't think the second was for sale. And I could never find my size in the third shoe!'

In Paris, Super Lalla [p510] is a veteran sneakerhead with a penchant for OG hoops sneakers, trail runners and Nike ACG hiking boots. 'I am into shoes for one and only reason – the love of it! The passion, the obsession, the search for the perfect shape, materials, colours and technology behind every shoe… Some people collect stamps and rocks. I collect sneakers.'

Chris Rosario [p488] admits that one-upmanship and competitive instincts motivated his mentality as a teenager. 'You couldn't come to

school with the same shoes the next man got on – that was a big "you played yourself" moment. I always viewed collecting sneakers as not only a hobby but a sport, and this shit is a competition to me still.'

In the UK, Ben Weaver [p302] picked up a childhood memory once he had the cash to pursue head-to-toe Troop tracksuits and Cobra trainers on his feet. Growing up in Spain, Luis Miguel [p404] didn't even know Nike existed, but he channelled his love of the Swoosh by watching Mr T kick ass on *The A-Team*. Richie Roxas [p572] loves New Balance so much he set out to rock a different pair every day on IG for a year under #365daysofNB.

Some of our subjects have taken their private passion to a professional conclusion. A proud New Yorker, Dave Goldberg was a huge Knicks and Patrick Ewing fan through the 80s and 90s. Like Victor Kiam, he loved Ewing's eponymous sneaker brand so much he bought the company. Gary Aspden [p190] turned his love of terrace fashion and the Three Stripes into a corporate career that netted him a ringside seat at the birth of the original BAPE x adidas colabs and his own Spezial sub-label.

Bringing things into a modern perspective are the Chicks With Kicks [p172]. These three American sisters may have inherited a 6000-strong collection of exotic shoes from their parents, but their determination to document and safeguard the familial stockpile is mightily impressive. Don't underestimate the Chicks – like Nike EKINs, they know their sneakers backwards.

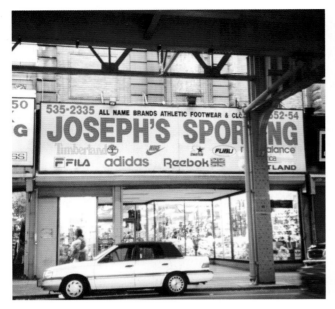

Joseph's store in Philadelphia (Tommy Rebel)

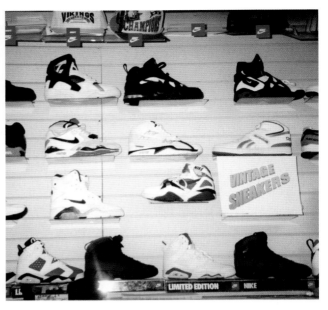

Sneaker Barn, Upstate New York (Tommy Rebel)

Sneaker hunting in Argentina (Gary Aspden)

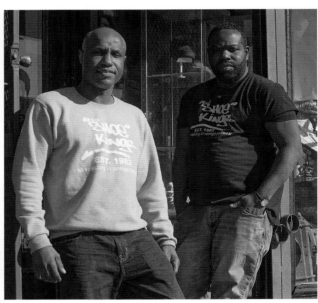

Bryon and Darien Gans, Shoe Kings, Philadelphia

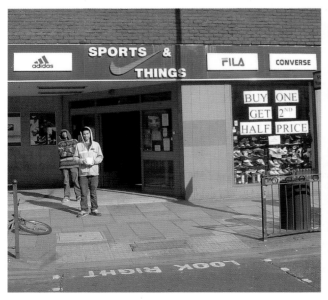

Sports & Things, South London

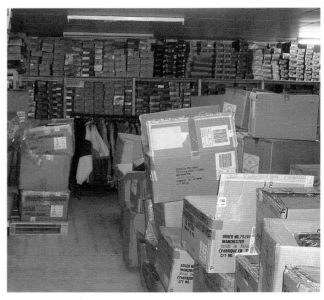

Sports & Things subterranean stockroom

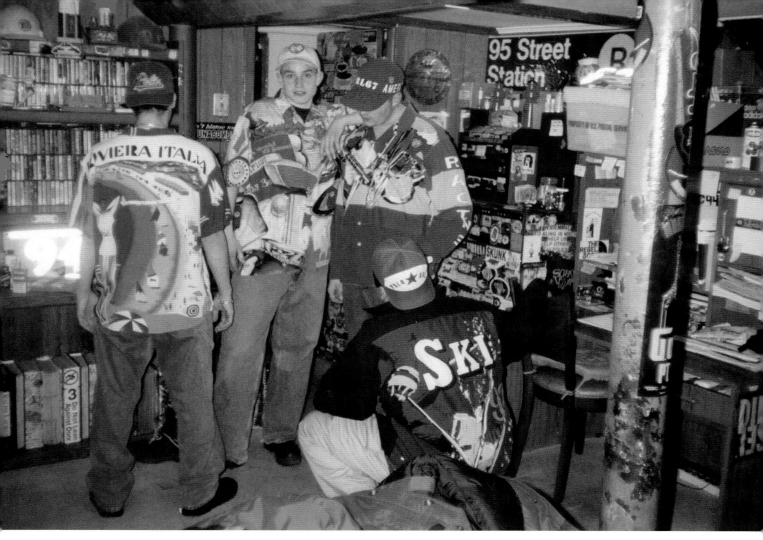

1999: Tommy Rebel's basement

Thirst for Knowledge

Regardless of demographics, finances or geographical location, what all these collectors have in common is not just a love of the finest footwear – it's the prodigious thirst for knowledge. Matt Kyte [p 648] was so obsessed with the New Balance 997, he spent a decade creating an archive that detailed every single release. That information is not freely available – even from NB – forcing Kyte to turn to sneaker forums, catalogue snippets, Google dead ends, tiny images from Japanese blogs and indecipherable Yahoo Japan listings. As he says, 'The lack of info was excruciating. It's hard to know what New Balance produced because these shoes were truly handmade, which means strange variances are common. Vintage pairs are still one of the hardest New Balances to track down.'

For Lindy Darrell, overseeing the return of Steve Ovett's gold medal-winning Nike track shoes from a private collector to the official brand archive is an all-time highlight. 'I'm not at liberty to reveal the entire story of how these shoes were unearthed but suffice to say I'm very pleased they ended up exactly where they should be, which is safe in the Nike vault. I've never been involved in anything like it, and I never will again.' While the full story behind these priceless artefacts and how they stayed undiscovered for years will never be revealed, the price tag would easily be counted in the multi-multi-millions if they went to public auction today. Try finding another pair!

Sneaker Hunters

As far back as the early 90s – just a few years after the first Air Jordan debuted and long before brands had any idea that 'retro' shoes would be big business – a small group of aficionados were already trading shoes all over the world. At that time, the athletics industry was far from the globalised multinational beast it is today, which opened up supply-and-demand situations soon identified by natural-born hustlers as a fun and fast way to make a buck.

As Neal Heard brilliantly chronicles in Deadstock Hunters [p 214], the eloquent chaps behind the Duffer of St George store in London regularly travelled the world to repatriate specific shoes unavailable in UK stores. With their astute eye for trends and style, the lads soon had long-lost adidas Superstars, Baskets and Gazelles back on Duffer shelves. On American and Canadian digging missions, they scoured sports stores for unwanted 'Wally Waffle' Nikes and other gems.

The Duffers and their maverick ilk weren't just ahead of their time. Their understanding of what their customers wanted and how to obtain these shoes outside regular supply channels would fundamentally change the sneaker game, not that they were aware of it. As Fraser Moss recounts, 'After those digging days, a whole part of the footwear industry was born out of what we were doing. It changed the way people looked at sneakers for good.'

Scram's interview with long-time friend Tommy Rebel is one of my personal favourites. Not only because Rebel has entertaining stories for days – and a supernatural infatuation with 3M reflective – but also because he documented his hunting missions with a point-and-shoot camera. He later told me he worked in a photo lab and had the resources to develop (literally) his nocturnal travels, including these rare NYC sneaker shopfronts. Cruising the Five Boroughs in all conditions, yearning for Terra Humaras, Air Max 97s and Air Structures, Rebel soon branched out and started hitting up fabled spots all over the eastern seaboard. There are many quotable quotes, but this nugget stands out: 'My thing was always if you really like something, one is NEVER enough! I still have that mentality to this day. If you find something you love, you buy as much as you can because they're going to discontinue it, and then you're never going to see it again.' Now that's the true collector mentality.

Back in London, Craig Leckie takes us back in millennial time to Sports & Things [p 118], a legendary sneaker vault hidden below an old supermarket in Streatham. Thousands upon thousands of vintage shoes of all persuasions were entombed there for years, until attrition, larceny and exposure to the elements intervened. It's unlikely we'll ever see a mother lode of this scale ever again, but hopefully, there's one last undiscovered vintage sneaker trove still out there somewhere.

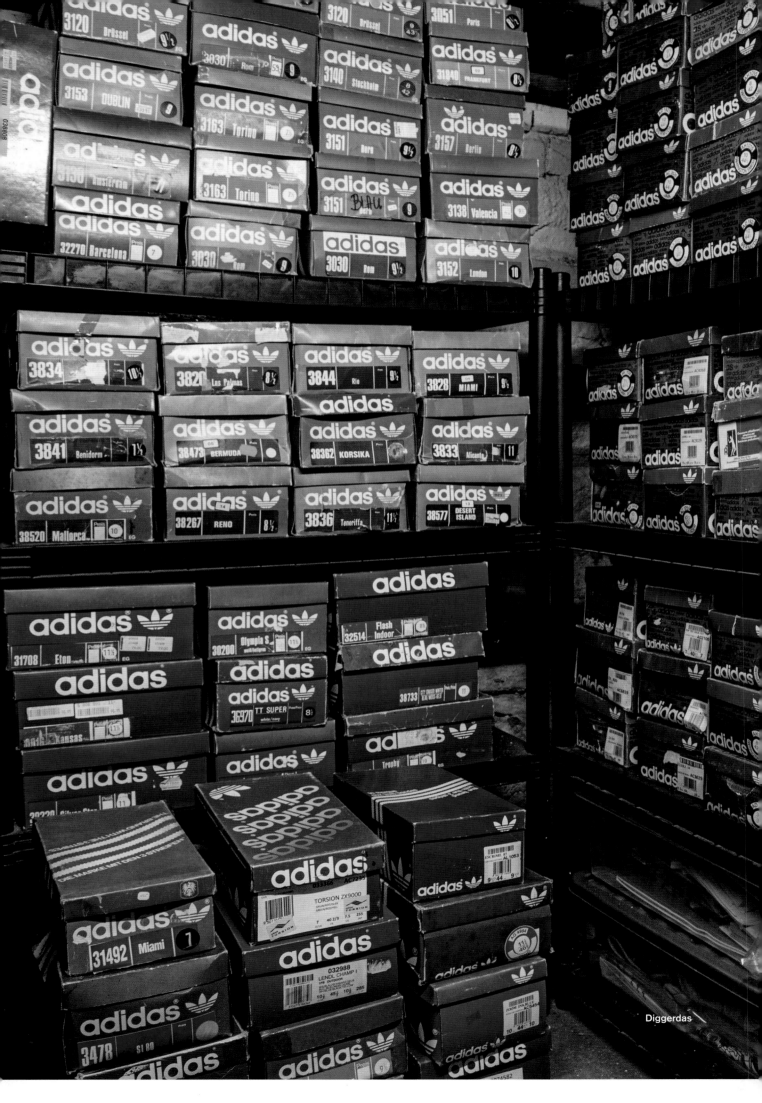

Diggerdas

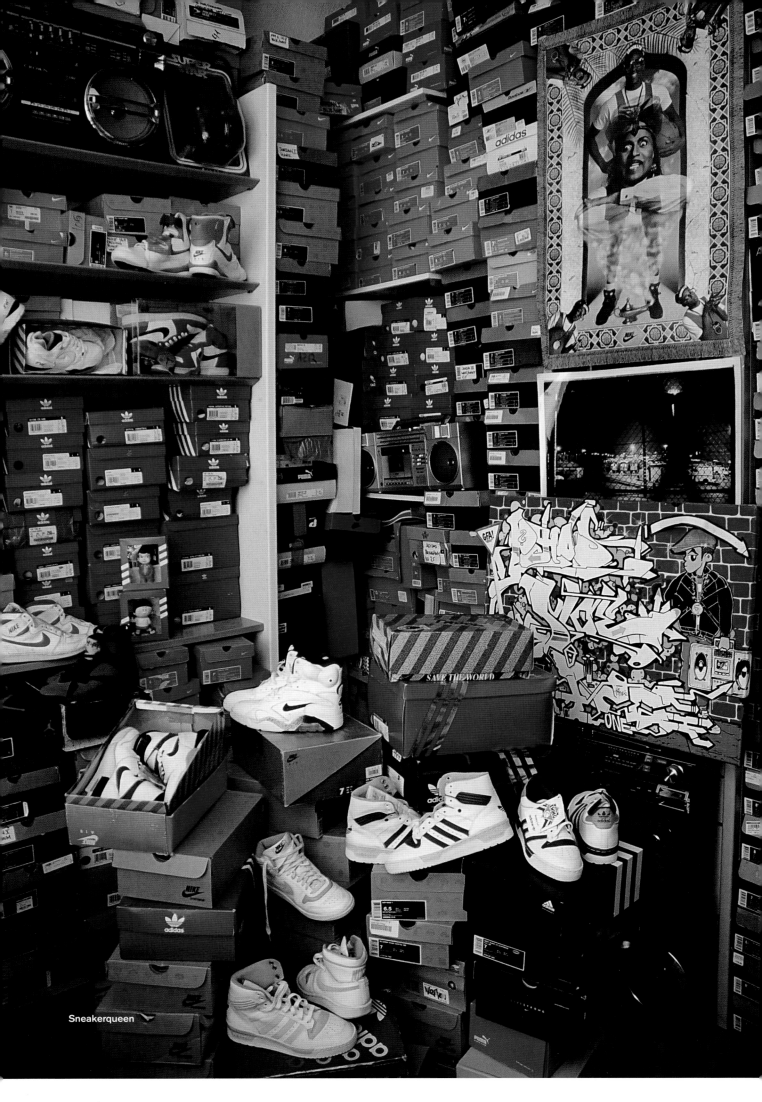

Sneakerqueen

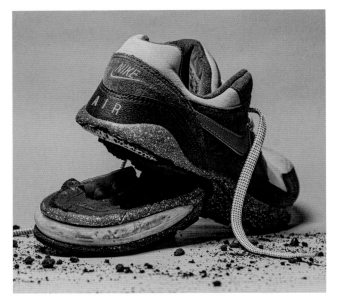

2002: Nike Air Max Burst 'Storm'

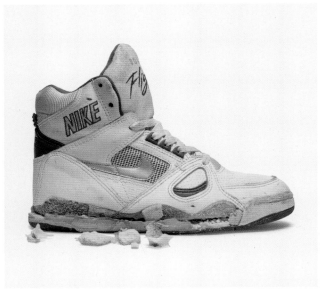

1989: Nike Air Solo Flight '89 (Julia Schoierer)

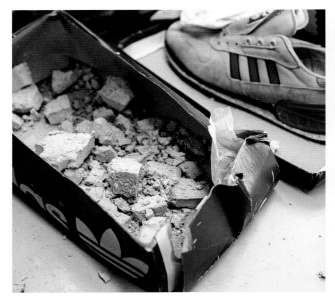

adidas Silverwind (Gary Aspden)

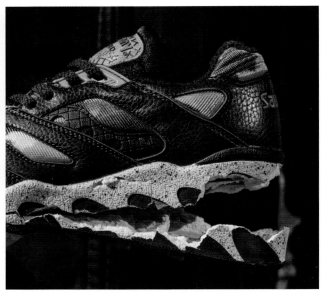

1992: Saucony GRID Eclipse (Sergey Vetrov)

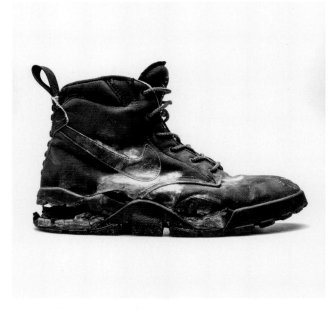

1994: Nike Air Vulgarian Mid

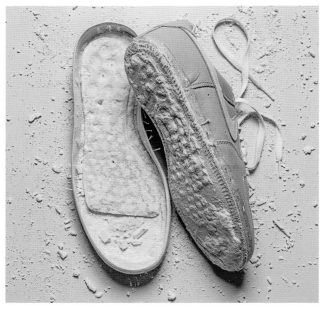

2001: Nike Air Force 1 'Linen'

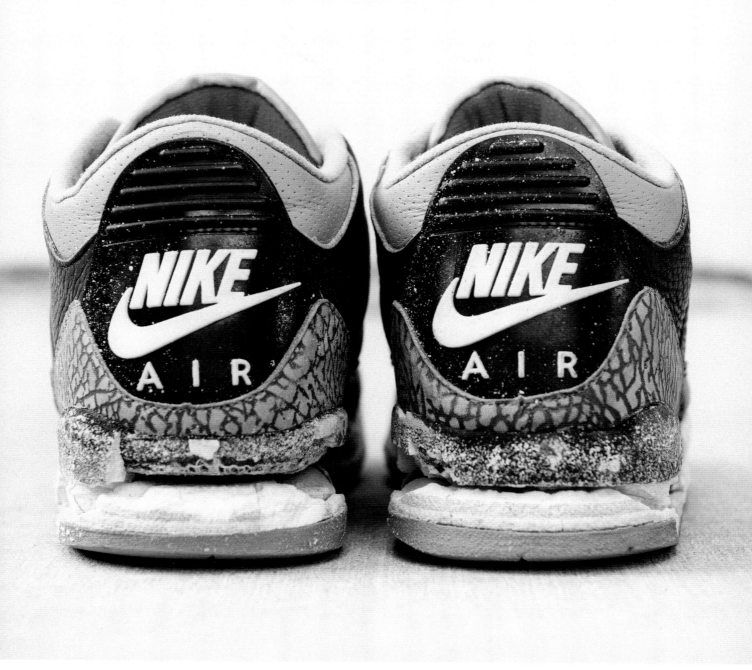

1988: Air Jordan 3 (Rolo Tanedo Jr)

A Life Well Lived

A different breed of collectors focus solely on vintage pairs, which we've taken the liberty to define as sneakers that are more than 20 years old. Rolo Tanedo Jr [p 426] has pursued every OG vintage Jordan with single-minded determination. In his eyes, 'These shoes are a piece of history you can hold in your hands. That's why I always try to find them in their original condition, even if it means the midsole is falling apart.'

Byron and Darien Gans [p 144] have lovingly assembled a cornucopia of vintage delights housed at their Shoe Kings store in Philly. Their one true love is game-worn shoes from the likes of Clyde Drexler, Magic Johnson, Moses Malone and Larry Bird, but it's their understanding of the intricacies behind NBA history, expressed through basketball and hip hop, that makes this such a riveting read. The brothers' vintage collection redefines eclectic, with Saucony, PRO-Keds, Gucci, Lotto and Diadora all featuring heavily in their rotation. Thanks to Adam Leaventon, the knowledge runs deep in this 5000-word interview.

Glue drips, yellowed foam compounds, cracked components and delaminating outer soles are just some of the imperfections embraced by collectors. Patina can be a charming sign of a life well lived, but when you crack open a shoe box and a pile of midsole crumbs spill out, the heartbreak is no joke. Sadly, hydrolysis (or *kasui-bunkai* in Japanese) is a natural and unavoidable process accelerated by exposure to oxygen, humidity and daylight. Check our guides to storage [p 56] and cleaning [p 54] for tips on how to postpone the onset of dreaded sneaker decay.

Elliot Tebele [p 68] has curated an incomparable collection of game-worn Jordan sneakers with multi-million-dollar price tags over the last decade. Faced with the dilemma of unwearable shoes with crumbling foams underfoot, Tebele commissioned exacting sole swaps, where a modern reproduction is sandwiched between the original leather uppers and rubber outsoles. When done right, his Jays not only look OG, they can be confidently worn with gusto. It's a neat compromise that will become increasingly common as more and more vintage shoes reach their natural expiration date.

As Tebele reflects in the opening 'Game-Worn' feature, 'It's no longer totally original, but at least it looks good, and you can hold and enjoy them without pieces of polyurethane flying all over the place. Side by side, you're looking at a crumbled pair with a sole you can't touch, or you can restore them and 95 per cent of the shoe is still original.'

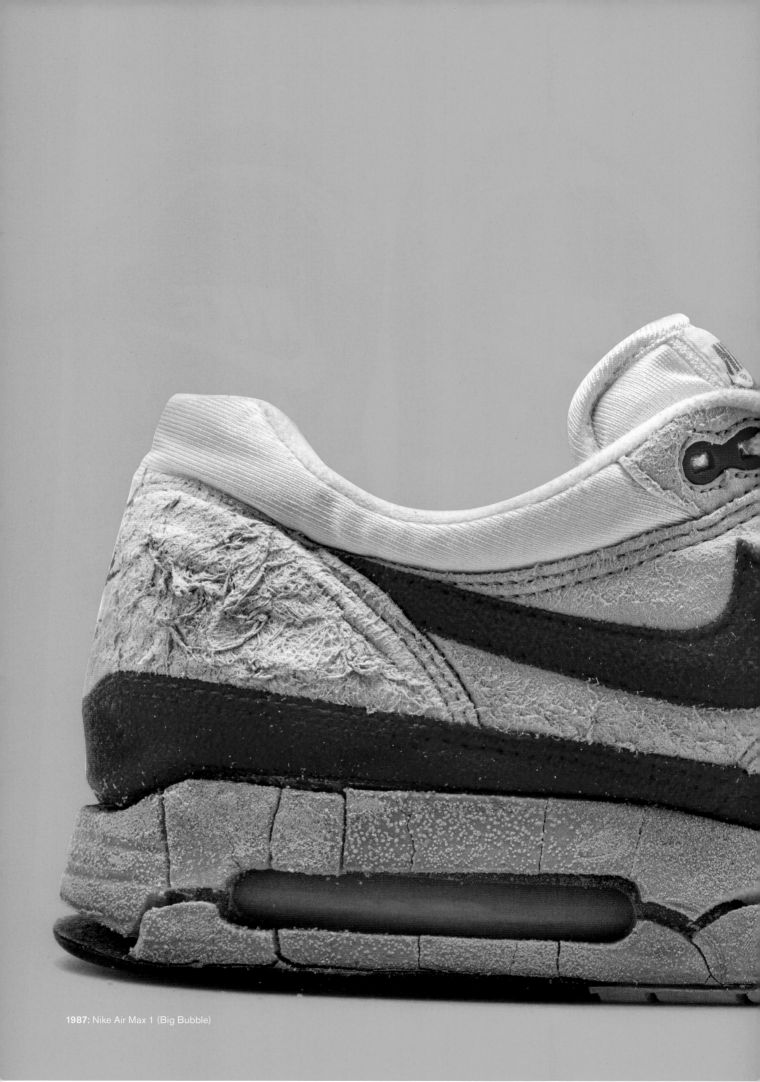

1987: Nike Air Max 1 (Big Bubble)

'Glue drips, yellowed foam compounds, cracked components and delaminating outer soles are just some of the imperfections embraced by collectors. Patina can be a charming sign of a life well lived, but when you crack open a shoe box and a pile of midsole crumbs spill out, the heartbreak is no joke.'

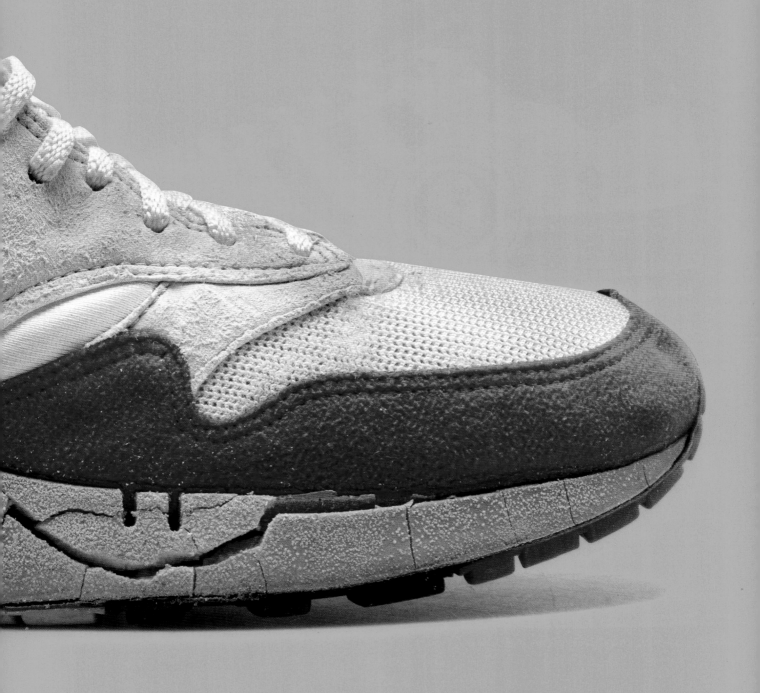

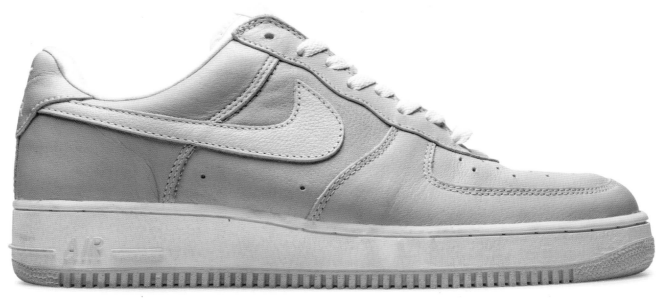

2001: Nike Air Force 1 'Linen'

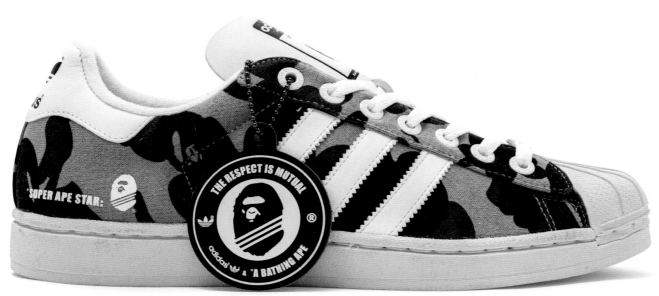

2003: A Bathing Ape x adidas Super Ape Star (Gary Aspden)

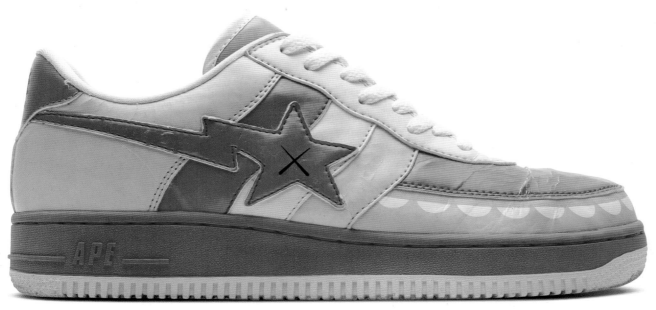

2006: KAWS x BAPE STA 'Chompers' (Patrick Pan)

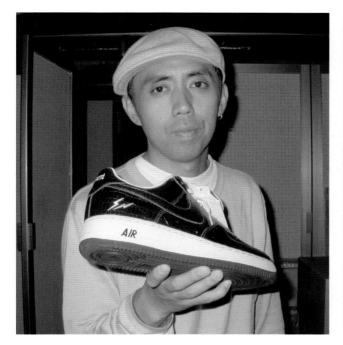

Hiroshi Fujiwara

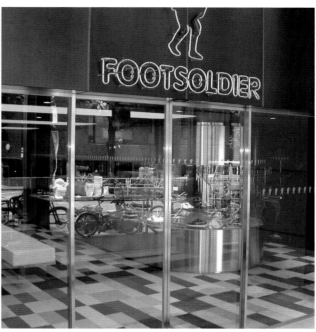

Footsoldier, Daikanyama

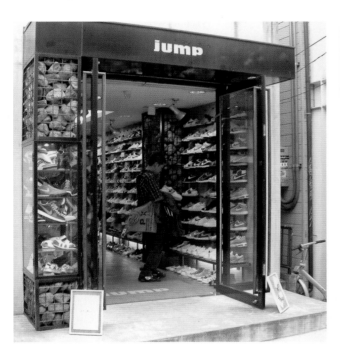

Jump, Harajuku

2003: atmos, Harajuku

Big in Japan

Tokyo was a powerhouse of exotic sneaker retail experiences in the early 2000s that attracted early adopters from all four corners. From parallel importing to obscure Japan-only collaborations and plastic-clad Nikes galore on the streets of Harajuku, many unique factors make this period highly influential decades later. Limited-edition products, artist connections, retailer SMUs, Hiroshi Fujiwara, the cult of BAPE… the list goes on.

This was, of course, an era that was still virtually pre-internet. As a result, Japan was, in many ways, culturally and commercially cocooned from the sneaker game in North America and Europe. Local sneaker-selling websites were impenetrable. Yahoo Japan offered obscure auction gems galore, but without an interpreter and access to local freight forwarding, this, too, was mission impossible.

It sounds quaint in hindsight, but the only way to play was to get on a plane and see for yourself. Even then, Western mobile phones didn't work in Japan (until a major system update), which made day-to-day communications difficult. Without Google Maps as a guide, streetwear tourists wandered the city with eyes glued to

the brilliant Superfuture.com maps – hastily printed in hotels on paper – that detailed the location of every cool store in Tokyo.

The highest-profile local boutique, atmos, launched in the year 2000 and would go on to produce a series of game-changing Nike Air Max colabs. Known for their co-branded projects with ASICS and New Balance, mita sneakers were based at a low-key market stall in Ueno, a short train ride from Shibuya. With its mind-boggling 'sushi train' that sent BAPE STAs rumbling around in a continuous loop, BAPE's Footsoldier concept store was always worth a trip to Daikanyama.

That leaves Harajuku as Tokyo's unchallenged sneaker epicentre. As my photos from 2003 reveal, Harajuku was a buzzing hive that lured cashed-up buyers to the ultimate sneaker honeypot. Entering from Omotesando or Meiji Dori, an oasis of unfathomable cool awaited, as interconnected laneways opened up to reveal dozens of compact stores stuffed with cascading displays of shrink-wrapped sneaks. The sense of imminent discovery was beyond intoxicating. There were many missions where the abundance of choice was overwhelming, even if my size 11 feet slashed my odds considerably.

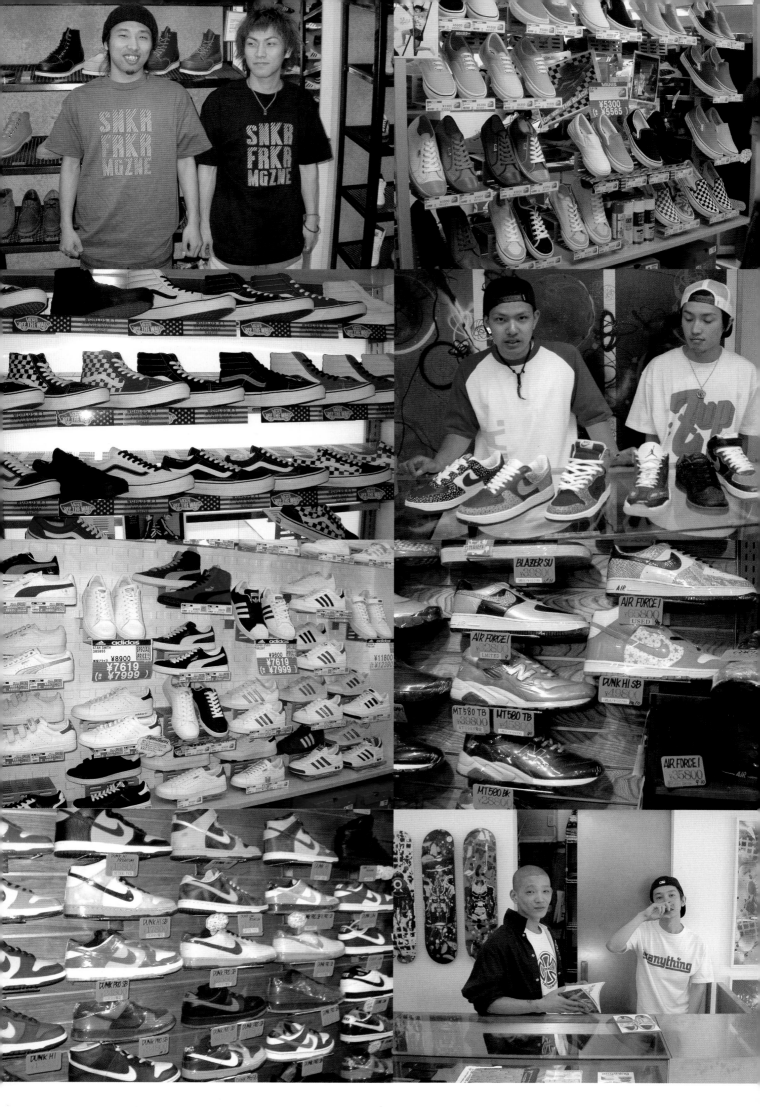

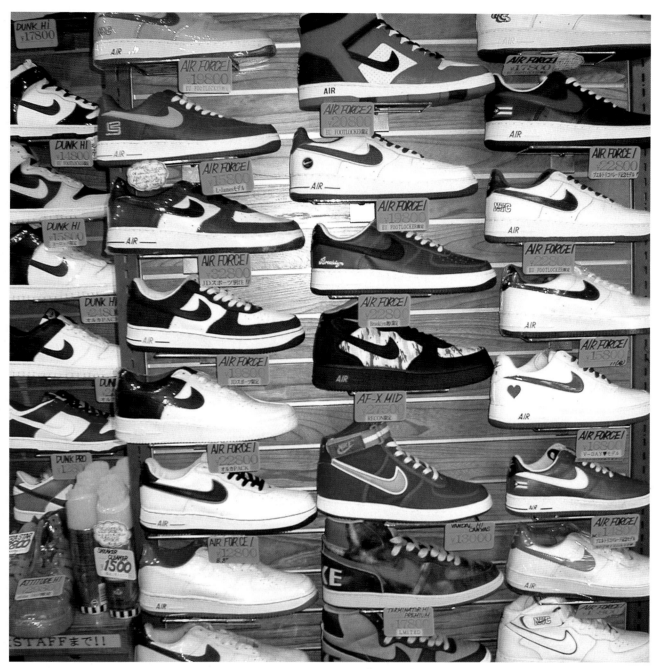

2003: Hunting Nike Air Force 1s in Harajuku

The concept of 'reselling' had not been officially promulgated at that time, but these mysterious micro-retailers, many of which seemed to be owned and operated by knowledgeable young'uns, established a business model that would dramatically influence the industry in years to come. Nestled among the proto-resellers were legit retail operations with Nike accounts, like Jump and Chapter (the latter an early off-shoot of atmos). Both stores were highly skilled at sourcing and importing 'grey-market' shoes from the US and Europe that were not available in the Japanese market. The mix of curated imports, alongside domestic JP product, was a unique situation that has never been contractually allowed in any other region by Nike.

Another unique facet of Japanese retail is the fact that Converse, Saucony and Vans (among other brands) signed domestic licencing deals. That explains the quirky products rarely seen outside Japan, many of which looked like straight-up bootlegs or lookalikes. Collaborative obscurities, such as the FUTURA x Saucony Jazz Trail from 2004 and the legendary Real Mad Hectic x New Balance MT580 from 2000, added further layers of regional exclusivity.

The LVMH-backed CELUX club on Omotesando offered members-only NikeiD x Air Force 1s – serving as a spiritual ancestor to the Louis Vuitton collaboration 15 years later. If you knew, you knew.

If you didn't, at least you have this book. Nike, in particular, studied Tokyo's trends and fashion happenings with obsessive *otaku* detail. Some of that knowledge was reconstituted into 'Concept Japan'. Now commonly referred to as CO.JP, in honour of Nike's Japanese URL, the program produced legendary releases such as the 'Linen', 'Sakura' and 'Cocoa Snake' Air Force 1s, alongside Far East delicacies like the Air Zoom Haven and Zoom Seismic. The entire Air Woven range, and the Air Rift, are other prominent examples of Japan's otherworldly obsession with future-forward footwear design. AD21, Nike's experimental retail exhibition space in Harajuku, released a highly sought-after Air Huarache Burst in 2004 that would become the bread and butter of Aussie expat sneaker plug Gustodaninja for the next decade.

CO.JP was unceremoniously retired sometime in the early 2010s, but the pervading sense of ultra-cool sneaker weirdness reinforced Tokyo's all-time-greatest claim to the throne. Today, the world is a very different place, and Tokyo, while still a highly creative mega-metropolis, is no longer the driver of global footwear trends it once was. But from the mid to late 90s to the tail end of the 2000s, Tokyo ruled them all and established a blueprint that would turn the underground sneaker craze into a global phenom.

2005: Diamond Supply Co. x Nike SB Dunk Low 'Tiffany' (Nate Wallace)

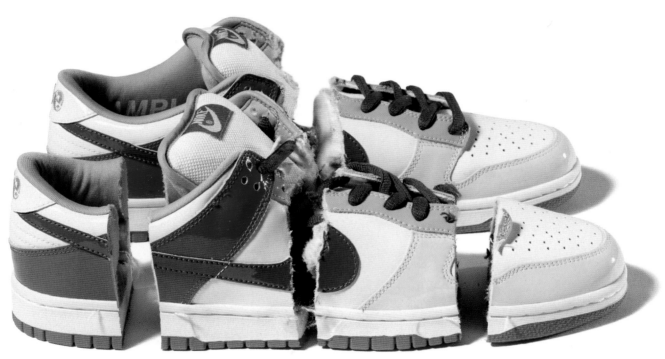

2003: Nike SB Dunk Low 'eBay'

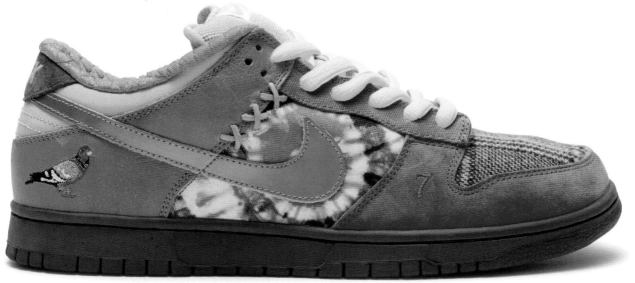

2007: Nike SB Dunk Low 'What The Dunk' (Nate Wallace)

2003: Nike SB Dunk Low 'Paris' (Andre Ljustina)

Skate or Die

When Nike SB launched in 2002, a nondescript basketball shoe from 1985 was suddenly repackaged as a skate model – complete with oversize puffy tongues – amid a striking array of collaborations, crazy packaging options and themed releases sold via skate stores. The hype was contagious and intrinsic to the birth of what would become known later as 'sneaker culture'. Freshly minted blogs such as Crooked Tongues, Nice Kicks, Hypebeast and Highsnobiety covered the daily goings-on with reverential glee.

Nate Wallace [p 716] and Chris Robinson [p 734] both throw down their impressive SB collections, acquired over years of meticulous planning. From Jeff Staple's 'Pigeon' release to the technicolour 'What The Dunk' and the 'Tiffany' edition released in conjunction with Diamond Supply Co., the folklore behind many early Nike SB releases put the hype well and truly into hyperbole.

The 'eBay' Dunk SB was auctioned off for charity in 2003, with a winning bid of $26k. The anonymous winner received a pair in their preferred size, while the original sample was destroyed with choice cuts from a chainsaw. Good luck trying to locate that pair. If they did surface, the asking price would easily exceed six figures today.

LA-based Andre Ljustina [p 126] has the wildest Dunk tale of them all. A keen student of FOMO, Ljustina was watching closely as hype around the 'Paris' Dunk bubbled away in 2003.

Based purely on a hunch, using his parents' credit cards as bank, he gobbled up 33 pairs, sat mute on the pressure cooker and sweated for days. The genius selling strategy he devised to offload his precious cargo – one escalatingly priced shoe at a time – changed how collectible sneakers were valued. Attaching a four-figure price to a $65 Dunk was suddenly situation normal, and things would never be the same again.

As Nike SB supremo Sandy Bodecker (RIP) revealed in *Sneaker Freaker* Issue 38, the Dunk's cultural gravitas was already apparent in those early days. 'We can take some credit for being part of the generation where the lid came off the Pandora's box of sneaker collecting. The role that Nike SB played was really around elevating sneakers – in this case, the Dunk – as a canvas for creative storytelling. We were able to make things more personal and more deeply connected, first to the skate community and then to the broader sneaker community. I think we helped introduce the idea of sneakers as "currency" both culturally and financially.'

2003: Reese Forbes Nike SB
vinyl figure by Medicom Toy

'While original Nike SB releases still fetch insane collector prices, the days of week-long campouts and fashionable shoe riots are long gone, replaced by an army of sneaker-bots and faux raffles on Instagram. We can't help but lionise those thrilling "Orange Box" days when everything Nike SB touched turned to gold. Far from wrecking the skate industry, Sandy Bodecker simply reimagined its creative potential. Nike SB is the OG – the sneaker Don Dada – that brought storytelling through product design to life and perfected the collaboration model.'

The Ultimate Sneaker Book
Sneaker Freaker

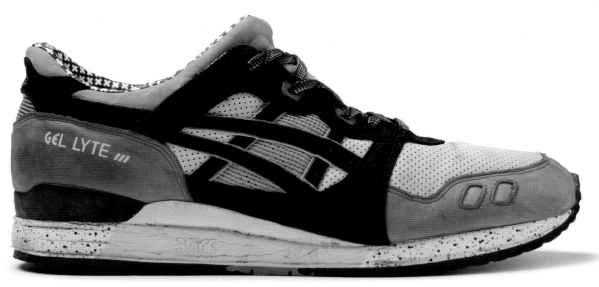

2007: Patta x ASICS GEL-Lyte III (Lee Deville)

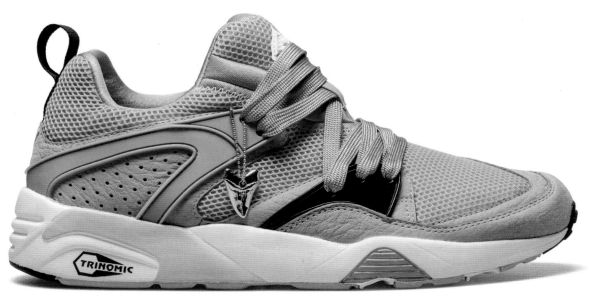

2013: Sneaker Freaker x PUMA Blaze of Glory 'Sharkbait'

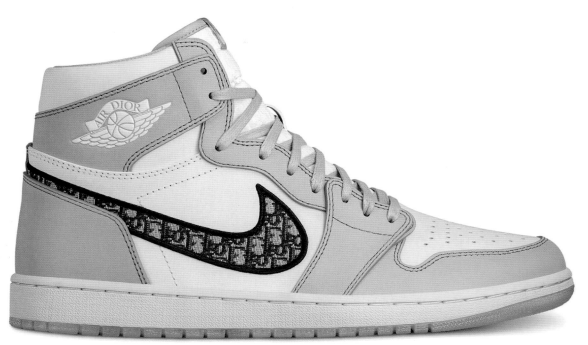

2020: Dior x Air Jordan 1 High

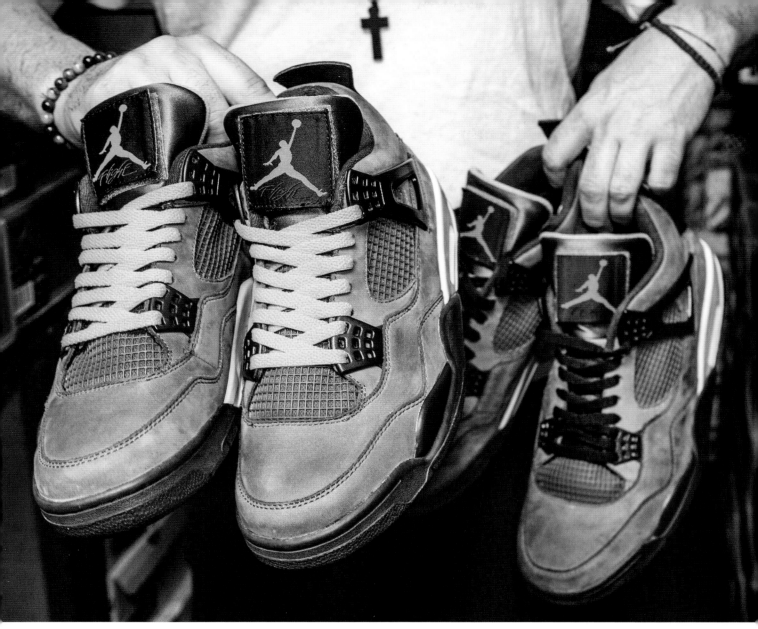

2005: UNDEFEATED x Air Jordan 4 (Andre Ljustina)

Collaborations

As detailed in our twin Dunk SB collector features, collaborations and products deliberately released as 'limited editions' were both well-established concepts by the early 2000s. While all shoes are created equal (in theory), some colabs are absolutely more equal than others. A lot of that magical alchemy is related to hype and nostalgia, but rarity is the key driver. Brands are constantly finessing production numbers to slightly under-satisfy the collector market. Making too few is a pointless sin, but too many can wreck the delicate equilibrium that elevates product through FOMO.

Aside from Dunk SBs, several seminal colab releases deserve an extra call-out. The original BAPE x adidas collaboration in 2003 was a proper creative meeting of the minds. BAPE was arguably at peak prowess and applied their signature camouflage print to the classic adidas Shelltoe. As detailed in *The Ultimate Sneaker Book*, Gary Warnett (RIP) was lavish in praise. 'Sold via select stockists worldwide, the shoes ignited overnight queues and a dreaded resell rate for those who weren't willing to sleep rough or set their alarms. With the project slogan, "The respect is mutual", the release remains pure in its organic creation, meticulous in execution and an expression of genuine fandom from both parties. This was less a business model and more a love letter to a masterpiece.'

Based in Perth, on the western fringe of Australia, Lee Deville's passion inspired him to collect every colab ever produced by ASICS [p 622]. At that point in time, the total was already 183 pairs, with over 50 released in 2015 alone, which would have tested Deville's synapses and finances in equal measure. Having survived freak motorcycle incidents, torrential 'Melburn' rain and even the curse of

the Concepts GEL-Lyte V 'Phoenix', Deville reached his intended target with ease and relates many of his shoes with emotional life moments. 'I see shoes in a similar fashion to rings on a tree, with each pair representing significant memories of my life. I can tell you the pair I was wearing when I proposed to my wife, got married in Vegas, when my children were born and when they came home from the hospital.'

One of Deville's prized possessions is Patta's GEL-Lyte III from 2007. This release from the Dutch brand, carved from vivid green and red nubuck, featured localised storytelling that appeared as a revelation. Speckled midsoles and a pattern of Xs nodded to the three St Andrew's Crosses on Amsterdam's flag. Released in tight numbers, the shoe garnered hype that established ASICS' credentials as a contender. There's no doubt this partnership unlocked the destiny of both brands, establishing a powerful new formula for designing colab sneakers.

The olive green UNDEFEATED x Air Jordan 4 from 2005 is the first official Jordan Brand colab and is referenced many times in these pages. Tommy Rebel still harbours a major jones for what he calls 'The BEST colourway the Jordan 4 has ever been graced with'. That might be so, but nothing compares to the mathematical madness unleashed in the form of the 'Air Dior' Jordan 1s. As was widely reported back in 2020, over 5,000,000* people entered the raffle, with only 8000 limited-edition pairs available. A further 5000 units were sold to Dior's top clients. This was an absolutely insane release, though our asterisk denotes a certain scepticism based on the sheer number of bots and automated email entries that undoubtedly pushed the unfiltered numbers into ludicrous territory.

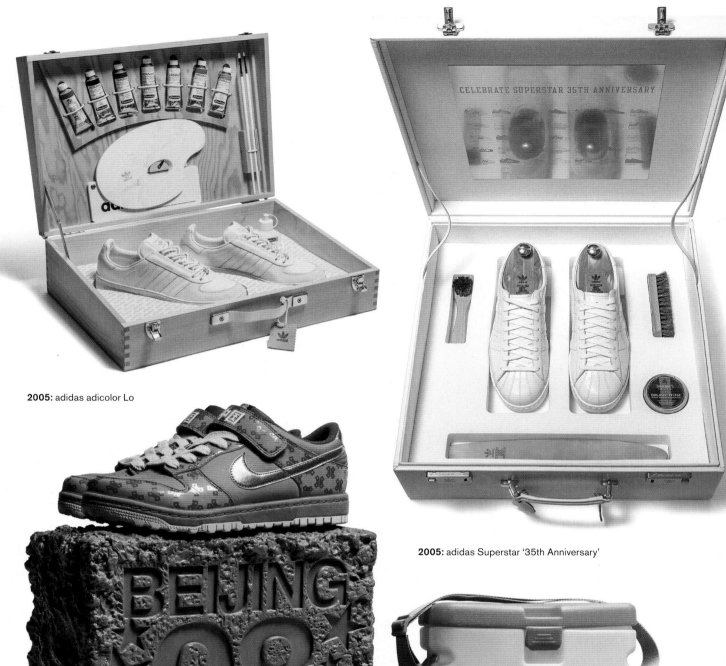

2005: adidas adicolor Lo

2005: adidas Superstar '35th Anniversary'

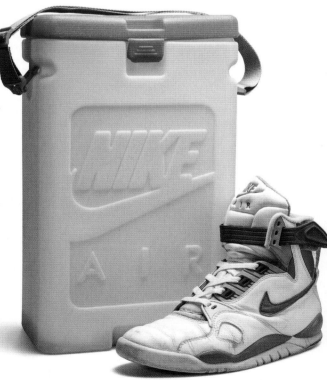

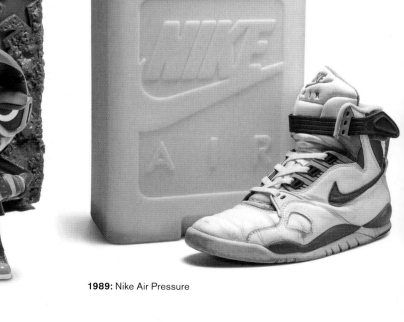

2008: Michael Lau x Nike 'China BMX'

1989: Nike Air Pressure

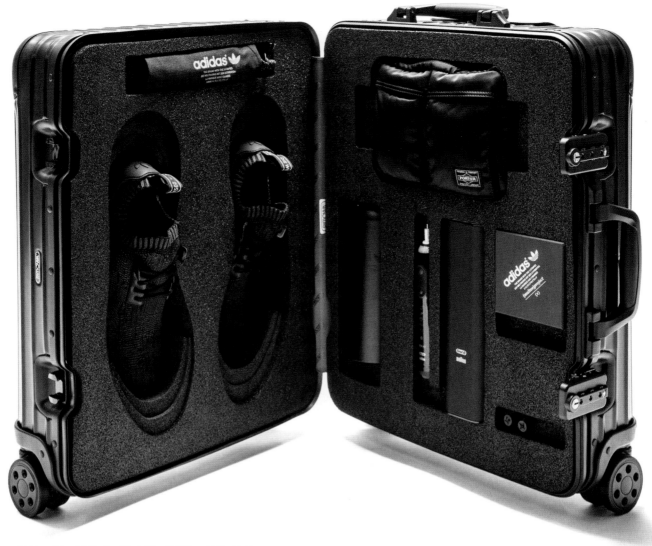

2016: adidas NMD_R1 'Pitch Black' (Urban Utility Unit)

Thinking Outside the Box

Upping the ante with insanely premium packaging is another ball game altogether for collectors. The earliest example arrived in 1989 when Nike released the Air Pressure, a belated riposte to Reebok's inflatable Pump gimmick. While the Swoosh never came close to puncturing Pump, they had one thing over its equivalent – a towering red-top sneaker box. Rocking up to the blacktop with 'Tupperware' casually slung over your shoulder made you a king. Three decades later, OG Air Pressures have all succumbed to sneaker rot, though the boxes have survived and are still freely available on eBay. At the start of 2016, out of nowhere, the Air Pressure finally received a retro release – plastic packaging included – and its adjusted-for-inflation price tag of $300 once again left it out of reach for all but the most diehard heads. Still, this is an interesting moment in Nike history and the first example of packaging used to sell shoes to the masses.

Nike SB have produced dozens of killer concepts over the years, including polystyrene ice boxes for the 'Lobster' Dunk SBs, a giant milk carton for the 'Fly Milk' SB Blazer and a Ben & Jerry's ice cream tub for the 'Chunky Dunky' Dunk SBs. Hong Kong designer Michael Lau dialled in one of his classic cutesie figurines, complete with Team China colours, inside a huge 'mud-cake' vinyl box alongside a BMX-ready Dunk Gyrizo. Looking more like a gigantic oblong turd, only 100 units were reportedly made. Today, they are rarely sighted for sale.

Global media went into overdrive in 2011 when Nike dropped news of Marty McFly's *Back To The Future* footwear and auctioned the shoes through eBay. By the time the dust had settled, the highest price paid was $9959. Each pair was sealed within a blinding yellow, magnet-sealed cardboard box labelled with 'Anti-Gravity' tags. Also included were a pamphlet featuring Tinker Hatfield's illustrated instructions, a metal licence plate featuring a unique serial code for online registration and a DVD with a product announcement video. A further 10 pairs were sold at live events. The ultimate prize for

BTTF film buffs, these 10 pairs were nestled inside a yellow road case styled after the plutonium containment chamber in the original film. Auctioned off at the Montálban Theater in Hollywood, the first pair was bought by British rapper Tinie Tempah, who walked away victorious after forking out a cool $37,500. More than just a fluffy feel-good exercise in marketing hoopla, the McFly campaign was a hyper-viral pop-culture phenomenon. Thanks to Nike, research into Parkinson's was advanced in a tangible way, and the world saw a positive example of what's achievable with immense goodwill and imagination. A subsequent Air Mag release in 2016 featured Nike's self-lacing tech and raised another $6.75 million for charity, with the final pair reportedly sold for $200,000.

Over at adidas, blockbuster campaigns delivered lavish packaging productions. In 2005, the adicolor pine box arrived packed with paints, palettes and brushes to reinforce the custom concept first seen in the 70s. The same year, the all-white 35th-anniversary Superstar box reset the bar. Reportedly made in Switzerland, the briefcase featured a gold SS35 plaque engraved with the full line-up. Brushes, leather polish, a shoe horn and handmade wooden shoe trees completed the minimalist masterpiece. Notably, this was one of the rare occasions when collectors were given a decent crack at taking home the goods. Treasure hunts held in Berlin, London, New York, Los Angeles and Hong Kong encouraged fans to make like Sherlock and hunt the shoes down.

That moment was only topped by adidas in 2016, with a limited-edition 'Urban Utility' version of the 'Pitch Black' NMD_R1. Housed inside Rimowa's aluminium Topas Multiwheel 45L suitcase, each murdered-out NMD was shipped with an Oral-B electric toothbrush, Porter Travel Pouch, SIGG Traveler water bottle and a Type-2L carabiner. A set of earplugs were thrown in, presumably to drown out the wailing of envious sneakerheads. This was the new standard by which all packaging was now judged, though not for long.

Air Jordan 13S '1998 NBA Finals Game' sold at Sotheby's April 11, 2023

$2,200,000

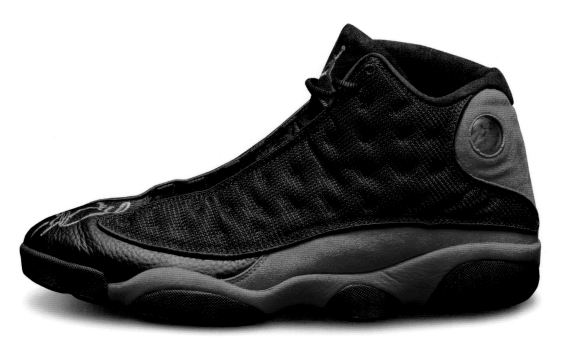

Nike Air Ship sold at Sotheby's October 25, 2022

$1,472,000

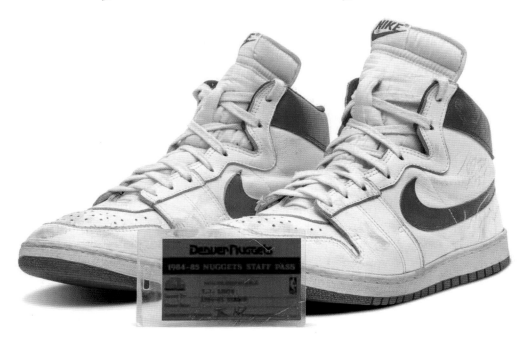

Nike Air Yeezy 1 Prototype 'Grammy Awards' sold at Sotheby's April 26, 2021

$1,800,000

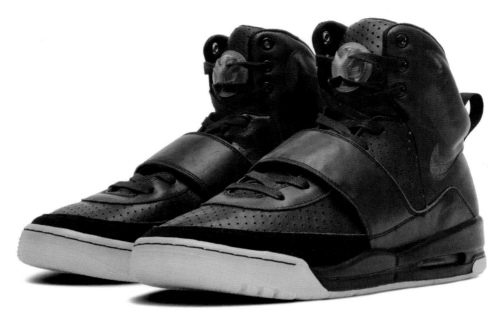

Note: Was offered and withdrawn from Christie's in 2022

Air Jordan 1 'The One' sold at Sotheby's May 17, 2020

$560,000

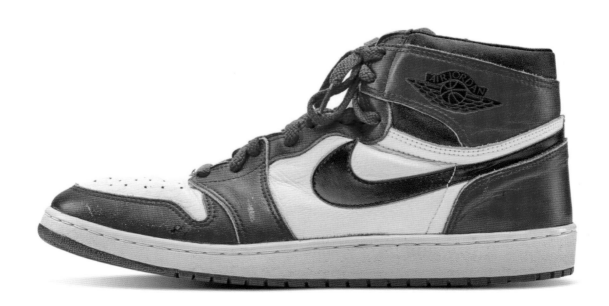

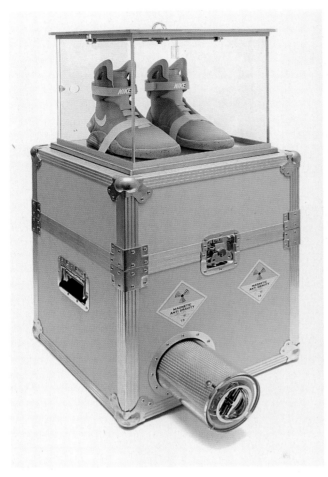

2011: Nike Mag 'Plutonium Case'

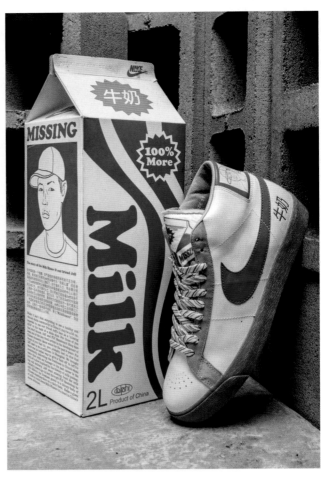

2007: Nike SB Blazer 'Fly Milk'

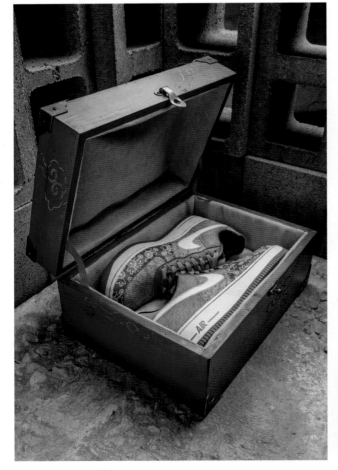

2005: Nike Air Force 1 Low 'Year of the Dog'

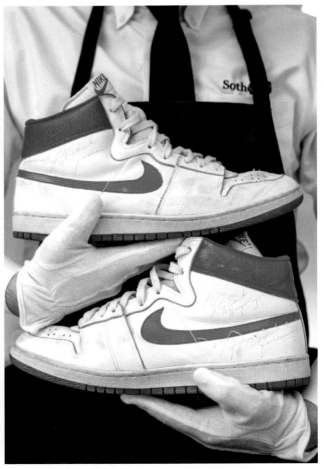

1984: Nike Air Ship (Signed by Michael Jordan)

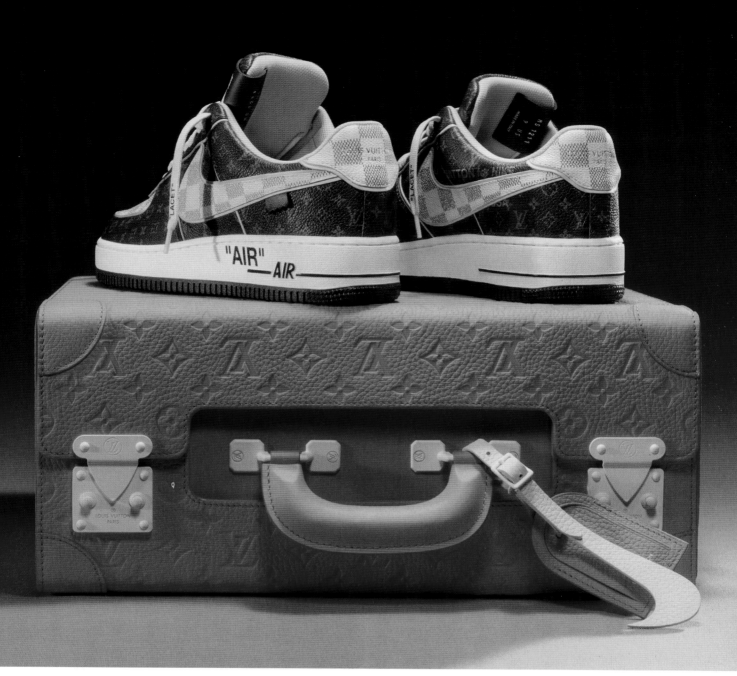

2022: Louis Vuitton x Nike Air Force 1 by Virgil Abloh

While Ye's defection to adidas led him to proclaim 'Yeezy Yeezy Yeezy just jumped over Jumpman' in 2016, his OG Nike Air Yeezy prototype sold through Sotheby's for a record $1.8 million in 2021. The pair supposedly surfaced the next year at Christie's before being withdrawn from sale in light of 'TAFKA' Kanye West's problematic sentiments. Given he rapped 'It won't feel right till I feel like Phil Knight' in 2018, the auction market for Veblen-category sneakers can be as fickle as Ye's Brobdingnagian ego.

In 2022, Nike, Virgil Abloh and Louis Vuitton triple-teamed to produce 200 pairs of Air Force 1s. Abloh's signature quotation marks were all in place, along with the LV Damier pattern, but the addition of the orange LV pilot case is what sent collectors into click-frenzy beast mode. The auction bids started at $2000, and prices eventually topped out at $352,000 for the size 5, which was the only 1-of-1. All 200 pairs eventually sold for a staggering total of $25.3 million, a percentage of which helped support Abloh's scholarship fund for Black students.

Loco prices like these are not just a high-water mark for collectors, they also represent an influx of moneyed investors looking at sneakers as blue-chip investments. Legitimised by their trade through esteemed fine-art auction houses, the numbers are undeniably nuts. The first sale of this type was held by Sotheby's in July 2019. A pair of 1985 Air Jordans sold for $560,000, more than three times the highest estimate.

The following year, Christie's sold Michael Jordan's famous 'Shattered Backboard' shoes for $615,000. Today, both prices (perversely) look like bargains – if you can stomach the idea of old sports shoes worth as much as a house. In September 2022, Jordan's jersey from the opening game of the 1998 NBA finals sold for $10.1 million, making it the most expensive sports memorabilia sale of all time. Hypothetically speaking… should His Airness be ejected from the game of life tomorrow, prices for his merch would instantly explode in value.

These auctions have been so successful that Sotheby's now accepts consignments and will happily value your entire collection. They also offer a private sales service designed 'for the discreet brokerage of a high-value transaction between seller and buyer'. Over at their arch-rival Christie's, corny blogs with titles like 'How to elevate your sneakers from basic to collectible' advise buyers and sellers alike on how to maximise returns on potential footwear investments.

Richie Roxas

Hanna Helsø

Ariana Peters from Chicks With Kicks

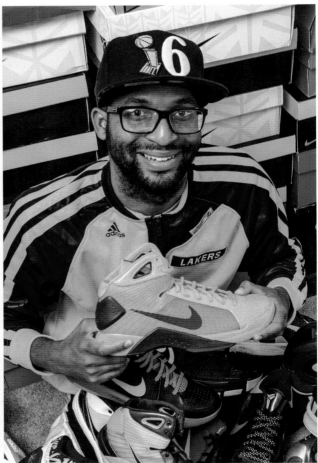

Darryl Glover

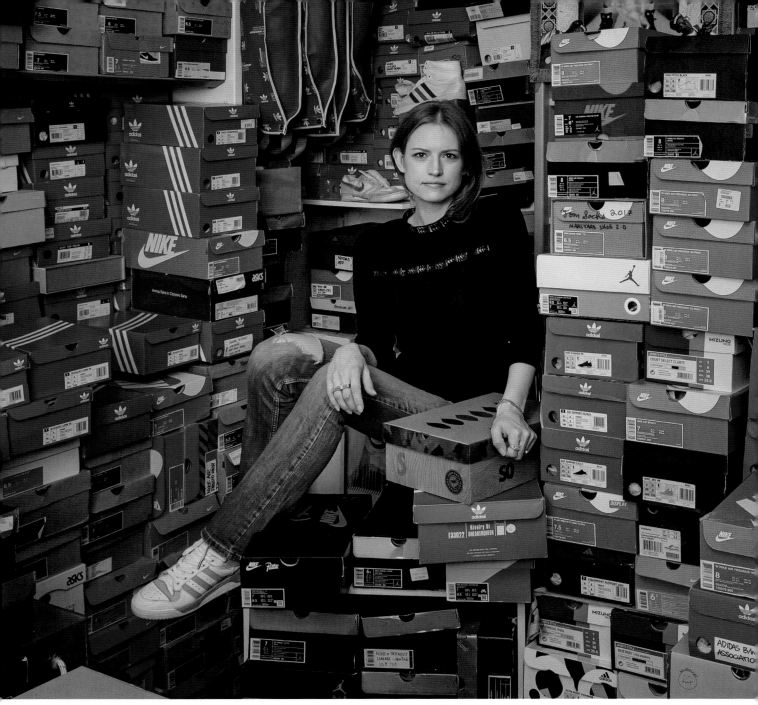

Julia Schoierer

Yeezy Come, Yeezy Go!

Having spent the last 20 years covering the pop-cultural colossus that is the sneakergame™, I'll never cease to be amazed at the competitive creativity that defines this unique industry. Brands fly up the sales charts with squishy cushioning concepts, then collapse under their own crippling inertia. Hyped shoes explode into popular consciousness, then float into faded obscurity just as quickly. Prices wildly fluctuate as sneakerheads hone their hunting instincts and selectively add more (and more) shoes to their rotation. The tension and shoenanigans make for riveting viewing.

Enjoy the next 719 pages ahead as we examine in excruciating detail the innermost thoughts of the *World's Greatest Sneaker Collectors*. From Tokyo to New York, Leeds and Melbourne via London, Philadelphia and Shanghai, we've left no crumbled sneaker midsole unturned as we seek out the fundamentals of what it means, and takes, to define yourself as a 'true collector'. The expertise in every one of these interviews is priceless. The stories will keep you entertained for days. The healthy camaraderie of this global community is apparent on every page. Thanks to all our subjects for their time, energy and willingness to share their unique stories. I also have to thank Benedikt and Marlene Taschen for allowing Sneaker Freaker to produce another of our ridunkulous anthologies.

Since we all have to start somewhere, we've included a definitive 'How-to' guide that will help juniors and newbies navigate the scene's niche complexities. From photography skills to storage and cleaning tips, insurance advice, notes on avoiding fakes and even a dip-dye tutorial, the next chapter is a solid knowledge foundation. We've also included an A–Z of Sneakers [p 44], with over 100 acronyms, colloquialisms and linguistic nuances, all documented for future generations. Memorise this and you'll be bantering like a proper G in no time.

Keep your laces loose!

Woody

Sneaker Freaker
Editor-in-Chief

'People with money are not collectors to me because they can get it easy. The people who skip a meal and don't pay rent for a month are the real collectors. That's the story I want to hear. I don't want to hear about a guy that has money and a personal shopper and gets sent free shit from brands.'

Tommy Rebel

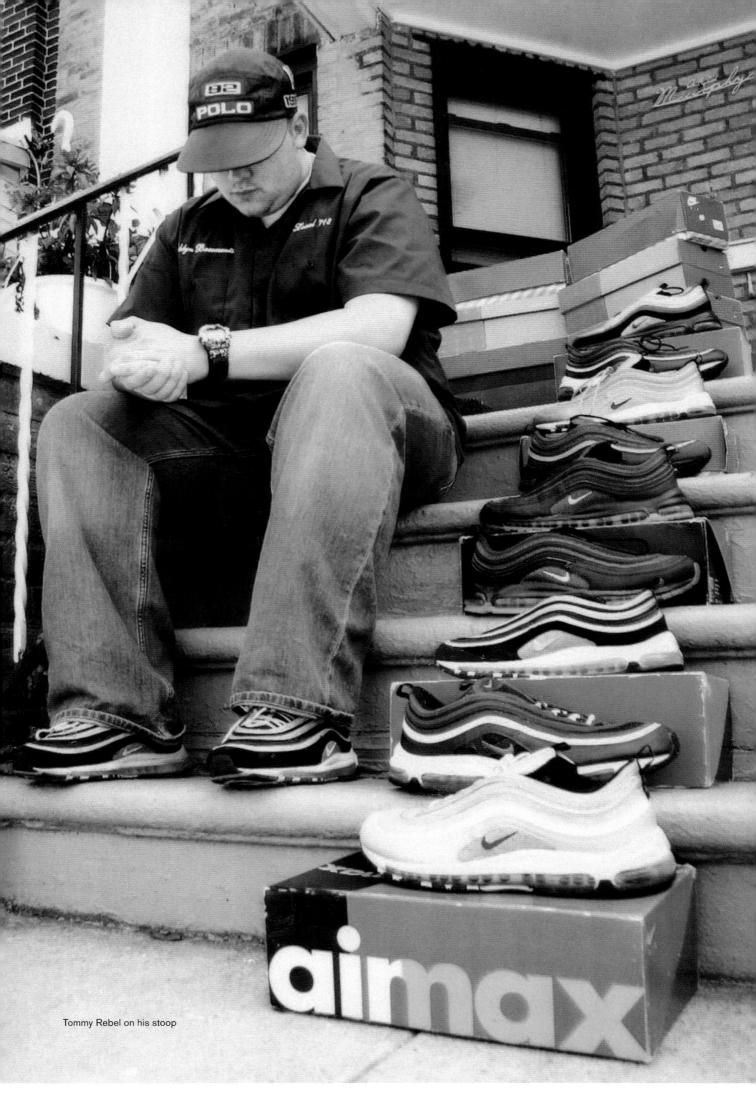

Tommy Rebel on his stoop

Collectors

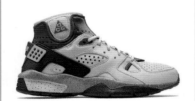

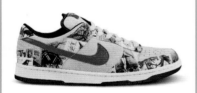

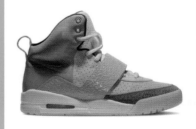

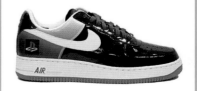

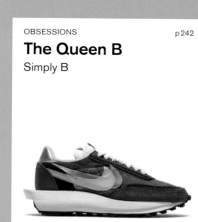
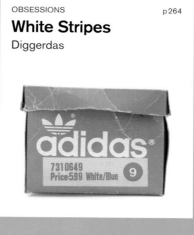
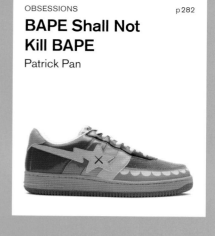
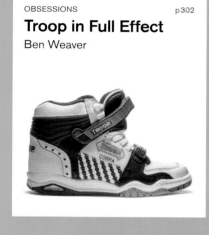
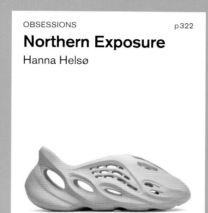
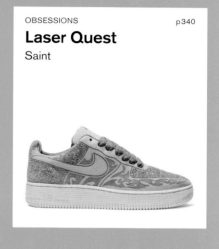
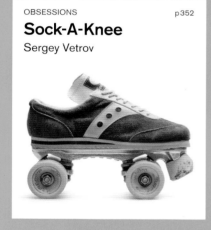
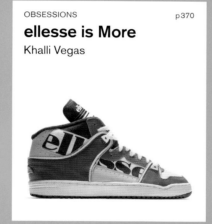
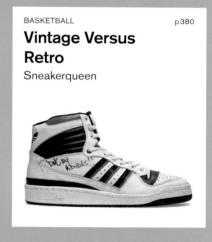
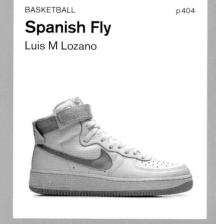
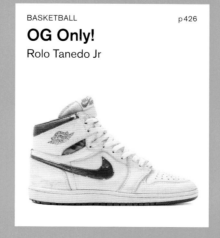
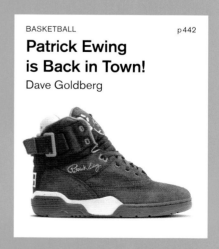

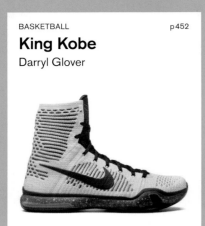
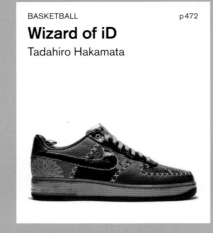
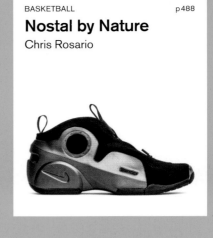
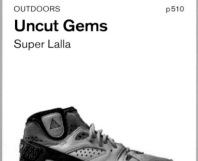
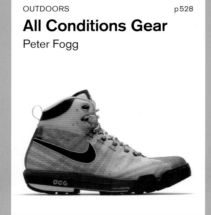
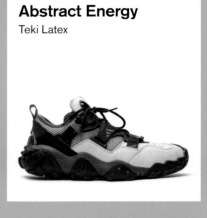
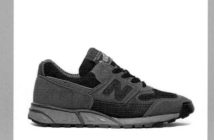
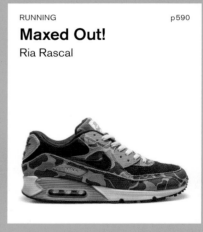
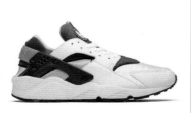
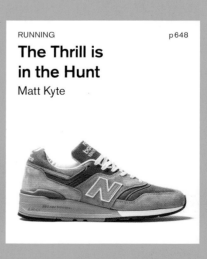

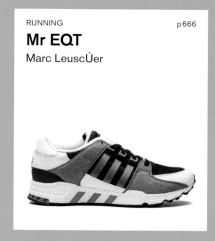
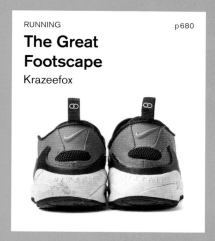
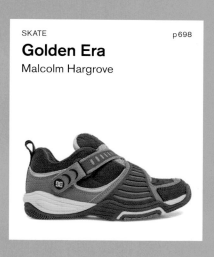
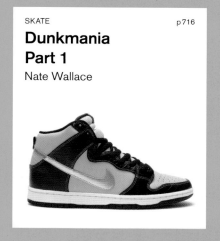
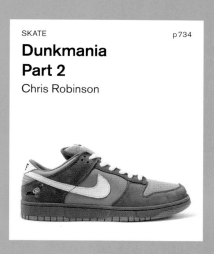

Credits

Sneaker Freaker

Editor-in-Chief
Woody

Managing Editor
Audrey Bugeja

Design
Tim Daws

Senior Editor
Will MacFarlane

Fact Checking/Research
Minh Vuong

WEB sneakerfreaker.com
IG @sneakerfreakermag
TW @snkrfrkrmag

Interns

Claude Wood
Marlowe Wood
Sonny Wood
Ginger

Inside Cover Image

Tommy Rebel

Writers

Lucas Blackman
Audrey Bugeja
Sebastian Bugeja-Drinkell
Amber De Luca-Tao
Gabe Filippa
Oliver Georgiou
Paul Kampfmann
Adam 'Air Rev' Leaventon
Craig Leckie
Ella Maximillon
Nick Santora
Scram
Minh Vuong
Mike Ward
Marlowe Wood

Thanks

Brian Austin
Bill Bowerman
Adolf Dassler
Horst Dassler
Rudolf Dassler
Jim Davis
Chris Davis
Chris Fifer
Paul Fireman
Tinker Hatfield
David Kennedy
Phil Knight
Mike Lapilusa
Kihachiro Onitsuka
Steven Smith
Sarah Tucker
M Frank Rudy
Dan Wieden

Interviewees

AllDay
Gary Aspden
Lindy Darrell
Bianca Derousse
Lee Deville
Diggerdas
Peter Fogg
Byron Gans
Darien Gans
Darryl Glover
Dave Goldberg
Tadahiro Hakamata
Malcolm Hargrove
Neal Heard
Hanna Helsø
Krazeefox
Matt Kyte
Super Lalla
Teki Latex
Marc LeuscÜer
Andre Ljustina
Luis M Lozano
Patrick Pan
Ariana Peters
Dakota Peters
Dresden Peters
Ria Rascal
Tommy Rebel
Chris Robinson
Chris Rosario
Richie Roxas
Saint
Julia Schoierer
Rolo Tanedo Jr
Elliot Tebele
Khalli Vegas
Sergey Vetrov
Nate Wallace
Ben Weaver
Gooey Wooey

Photography

Louie Arson
Neil Bedford
Lucas Blackman
Brandon
Pete Casta
Stan Chan
Nathan Damour
Tim Daws
Lee Deville
Manuel Dominguez Jr
Daniel Edwards
Canicio Fotografia
Austin Fountaine
Maria Garibian
Ella Maximillion
Phillip Himburg
Darren Hirose
Lucie Hugary
Amund Janssen
Jeremy Kelly
Dom Moore
Stephanie Morales
Denley Murat
Nikita Moskalenko
Peter Rad
Tommy Rebel
Beau Ridge
Runnerwally
Kentaro Sawaguchi
Julia Schoierer
Timmy Smalls
Jed Steele
Rolo Tanedo Jr
Ant Tran
Gary Watson
Alan Weaver
Wang Chen Wei
Todd Westphal
Roman Wong

SUBSCRIBE

How to...

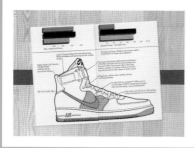

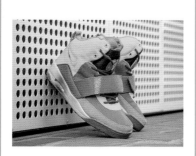

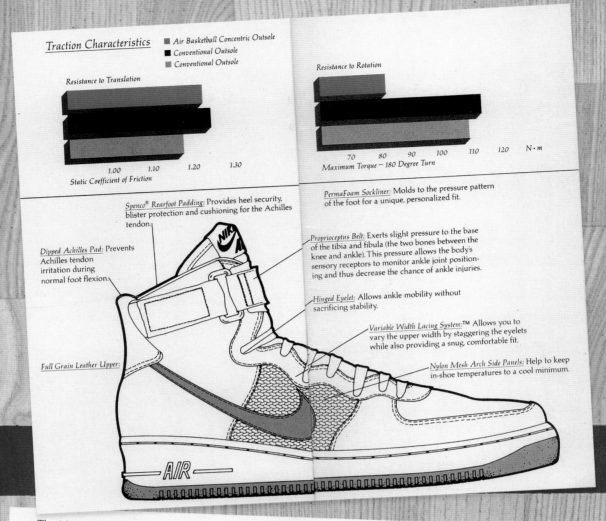

Traction Characteristics

- Air Basketball Concentric Outsole
- Conventional Outsole
- Conventional Outsole

Resistance to Translation

Static Coefficient of Friction
1.00 1.10 1.20 1.30

Resistance to Rotation

Maximum Torque – 180 Degree Turn
70 80 90 100 110 120 N·m

Spenco® Rearfoot Padding: Provides heel security, blister protection and cushioning for the Achilles tendon.

Dipped Achilles Pad: Prevents Achilles tendon irritation during normal foot flexion.

Full Grain Leather Upper:

PermaFoam Sockliner: Molds to the pressure pattern of the foot for a unique, personalized fit.

Proprioceptus Belt: Exerts slight pressure to the base of the tibia and fibula (the two bones between the knee and ankle). This pressure allows the body's sensory receptors to monitor ankle joint positioning and thus decrease the chance of ankle injuries.

Hinged Eyelet: Allows ankle mobility without sacrificing stability.

Variable Width Lacing System:™ Allows you to vary the upper width by staggering the eyelets while also providing a snug, comfortable fit.

Nylon Mesh Arch Side Panels: Help to keep in-shoe temperatures to a cool minimum.

The Advantages of "Air":

Studies show that the larger the player, the more cushioning is needed since the increase in force generated against the bottom of the foot during play exceeds the increase in the sole area that is absorbing the impact. Scientists have shown that the Air-Sole® provides up to 30% more cushioning than conventional basketball shoes.

In addition to providing superior cushioning, the flow of gas throughout the Air-Sole® unit during foot contact creates a conforming foot bed, providing stability for side-to-side maneuvers.

Moreover, studies show the Air Force I to be 20% more resilient than conventional basketball shoes. A "resilient" material is one which returns energy that is put into it. The resiliency of the Air-Sole,® with its return of energy to the player, reduces fatigue and makes possible those important fourth quarter rallies. And, unlike conventional midsoles, the Air-Sole® will not lose its cushioning, resiliency or stabilizing capability with use. The Air-Sole® contained in the Air

Force I is with you every step of the way.

Strap yourself in and take to the sky. The Air Force I...it's earned its wings.

FEATURES

Concentric Circle Outsole:

The concentric circle outsole pattern is designed for two purposes: To provide optimal traction during side-to-side and front-to-back maneuvers, and to provide minimal resistance to pivoting movements that apply large and potentially injurious pressures to the ankle, knee and hip joint.

In tests done in the NIKE Sports Research Laboratory, the Air Force I was compared with conventional European shell outsole patterns. Results show that while having similar resistance to side-to-side and front-to-back movements, the NIKE concentric circle outsole demonstrated a lower maximum torque, or lower resistance to twisting movements. This study indicates that while performing as well, the concentric circle design may be safer than conventional outsole patterns.

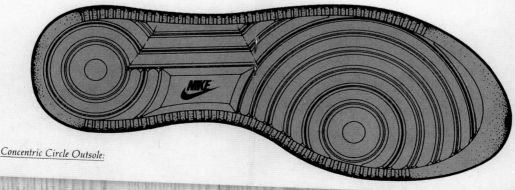

Concentric Circle Outsole:

Text: Sebastian Bugeja-Drinkell

How to… Speaker Sneakers

From NDC to EQT, the sneaker game can be a tricky realm to navigate if you're unfamiliar with the acronyms, colloquialisms and arcane terminology developed over the last 20 years. If talk of Hyperstrikes, Quickstrikes and CO.JP releases makes your head spin, Sneaker Freaker's comprehensive A–Z guide to the nuances of contemporary sneaker culture will have you walking the walk and, way more importantly, talking the talk – just like a proper OG!

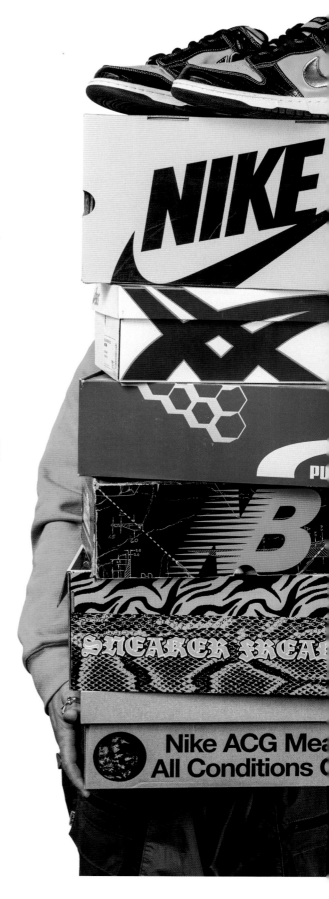

A–Z of Sneakers

Term	Definition
1-of-1	One-of-a-kind sneaker, often a Sample or Player Exclusive (see also, 'Unicorn')
Adi Dassler	German cobbler who founded adidas in 1949. Younger brother of Rudolph, founder of PUMA
AF-1	Abbreviation of Air Force 1, the classic Bruce Kilgore-designed Nike basketball shoe from 1982
Aglet	Tip of a shoelace, often coated in plastic
All Conditions Gear (ACG)	Nike sub-brand that produces sneakers and apparel for the outdoors
Alvin Purple	Legendary Sneaker Freaker x ASICS GEL-Lyte III colab. Named after an Australian softcore porn film from the 70s
Backdooring	When stores sell sneakers at the inflated street price rather than the RRP. *'Holy Shit! Did you see MJ's son backdooring those Jays?'*
Beaters	Trashed or 'beaten-up' sneakers, often worn solely for laborious tasks. *'Dude! Can't believe you let your 990s become beaters!'*
Beaverton	Location of Nike World Headquarters on the outskirts of Portland, Oregon
Bespoke	Defunct Nike customisation service that allowed fans to produce a 1-of-1 using high-end materials for $800 (RIP)
Bill Bowerman	Legendary American track and field coach and co-founder of Nike
Blue Ribbon Sports (BRS)	Founded by Phil Knight in 1964 to import Onitsuka Tiger sneakers from Japan
BOT	Automated software used by resellers that can purchase shoes online faster than humans
Bred	Abbreviation of 'black and red', the classic OG Air Jordan 1 colourway from 1985
Brick	A sneaker that takes forever to sell and has zero resale value. *'Damn! These sacai Blazer Lows are total bricks!'*
Bringback	The process of a brand 'bringing back' a vintage sneaker design to sneakerheads' acclaim
BW	The 1991 Air Max BW. BW is short for 'Big Window', a reference to the size of the air bubble
Casuals	Influential 1980s UK-youth movement that saw soccer fans adopt brands like FILA, Tacchini and Diadora to show off on the terraces
Chicago	Iconic 'Chicago' black, red and white colourway seen on the OG Air Jordan 1
CO.JP	Abbreviation of Concept Japan. Name was originally based on Nike Japan's URL and now refers to all JP-exclusive editions
Cook Group	A community of resellers that help each other buy shoes for resale and communicate on Discord (see also BOT)
Cool Grey	Iconic Nike colourway synonymous with the Air Jordan 11
Cop	The act of buying a pair of sneakers. *'Yo homie, I'm 'bout to cop these new 'Alley Cats' ASICS!'*
Crackle	See 'Elephant'
Crep	UK slang for sneaker. *'Awright, Guvnor? Check out me natty new creps!'*
Cross Trainer	Category of sneakers designed to support multiple sports and movements
Crumble	When midsoles break down and 'crumble' due to hydrolysis – a chemical reaction that occurs between polyurethane and water vapour
Custom	Sneakers handmade by a customiser – often painted and sometimes rebuilt using exotic materials
Deadstock	Shoes that have never been worn, touched the ground and, sometimes, even removed from the box
Doernbecher	Children's hospital in Portland, Oregon, that collaborates with Nike to generate funds
Dubrae	Small ornamental metal or plastic tab looped through laces, especially the AF-1 (also, Deubré)
Elephant	Distinctive 'Elephant' leather pattern used by Nike and first seen on the Air Jordan 3
EQT	Abbreviation of Equipment – an adidas range of high-performance products released in 1991
Factory Lacing	Default lacing pattern used by sneaker manufacturers (usually way too tight and totally lame!)
Flip	Selling sneakers, usually for a small profit (although not always, especially if it's a brick!)
Friends & Family (F&F)	Super-limited sneakers reserved for the closest 'friends' of the store, brand or collaborator
Full-Size Run (FSR)	Sneakers that are available in every size upon release, which often means it's a GR or a brick
Game-worn	Sneakers worn by an athlete in a professional game
General Release (GR)	Sneakers that are widely available at all levels of retail
GORE-TEX	Waterproof membrane that stops liquid from entering shoes and apparel
Grade School (GS)	Nike-specific shoe sizing for school-aged kids
Heat	Awesome or rare sneakers. *'Ooooooh, those Tassie Tigers are pure heat!'*
Herzogenaurach	The German city in which both the adidas and PUMA headquarters are based
Hiroshi Fujiwara	Japanese musician and designer known as the 'godfather' of Ura-Harajuku fashion for his work at Nike, Good Enough and Fragment
Holy Grail	The ultimate sneaker you've been chasing forever, usually exorbitantly expensive, ultra-rare and never for sale anywhere!
HTM	Short for 'Hiroshi, Tinker and Mark' (Fujiwara, Hatfield, Parker), who joined forces to create a series of classic Nike releases
Hyperstrike	High-end Nike sneaker often given to celebrities or individuals close to the Swoosh
Icy	Semi-translucent outsoles that resemble frozen water. Commonly found on the Air Jordan 11
Infrared	Iconic Nike colourway synonymous with the original Air Max 90
Jumpman	Jordan Brand symbol that debuted on the Air Jordan 3 showing MJ soaring through the sky in the 'Jumpman' pose
Just Do It (JDI)	Nike tagline created in 1988 by Wieden+Kennedy – arguably the greatest advertising slogan of all time

Term	Definition
Midsole	The foamy part of a shoe's sole that provides cushioning and stability
MJ	Abbreviation of Michael Jordan (also, His Airness)
Mudguard	Panel above the midsole that provides protection from moisture
NDC	Abbreviation of Nike Dot Com
Neighborhood	Highest-level Nike account that stocks the most exclusive sneakers
Newbie	Colloquialism meaning a New Balance sneaker
Nike SB	Nike Skateboarding division
NikeLab	Nike sub-brand producing elevated but minimally branded footwear, apparel and inventive concept stores
NikeTalk	Online forum created in 1999 for sneakerheads to discuss all things Nike
NOS (New Old Stock)	Deadstock sneakers, usually found in a mom-and-pop sports store
NSW	Abbreviation of Nike Sportswear
OG	Highly regarded person, or sneaker, considered an original or originator. *'My man! Bobbito Garcia is proper OG!'*
On-Ice	Sneakers put away for years to be worn at exactly the right moment. *'Yo! My "What the Dunks" have been on-ice since 2007!'*
Phil Knight	Co-founder of Nike and arguably the most influential identity in the athletics goods industry
Player Exclusive (PE)	Highly collectible Nike sneakers created for athletes or celebrities, usually for special occasions
Polyurethane (PU)	Thermoplastic polymer used in sneaker midsoles to provide cushioning and shock absorption
PRM	Abbreviation of 'premium', used for Nike product made with high-quality materials
Quickstrike (QS)	Nike product tier signifying a sneaker will be sold in limited quantities at select boutiques
Replica	An exact copy of an original sneaker, usually made by a counterfeit factory
Reseller	Someone who purchases sneakers with the sole purpose of selling them for a profit
Retro	A rerelease of a vintage sneaker. *'WTF! Nike is seriously gonna retro the Air Shizznit next year?'*
Rudolph Dassler	Founded PUMA in 1948. Adi Dassler's older brother
Sample	Sneaker prototype made for testing or promotional purposes, usually in very limited numbers
Shoe Dog	Memoir written by Phil Knight chronicling the history of Nike from its founding as Blue Ribbon Sports
Sitting	When a sneaker isn't selling as quickly as expected, usually because it's a 'brick'
SKU (Stock Keeping Unit)	System of letters and numbers used for inventory management (also, Style Code)
Sneakerhead	Footwear obsessive with a vast knowledge of history and likely to spend all their money on fresh sneakers
Sneaker Freaker	Legendary footwear magazine founded in 2002 in Melbourne, Australia
Special Make-Up (SMU)	Unique sneaker created for high-profile individuals, usually athletes
Spezial	Sub-brand at adidas that produces modern interpretations of archive shoes and apparel
Steven Smith	Maverick designer responsible for the Reebok Instapump Fury and New Balance 550 and 997
Strangled	When shoes are laced so tight you can barely see the tongue (see also, Factory Lacing)
Swoosh	Nike's iconic 'tick' logo designed by Carolyn Davidson, who was paid just $35
Tier Zero (TZ)	Top-level Nike retailers that receive coveted releases (also, Nike product made in small numbers from premium materials)
Tinker Hatfield	Nike designer responsible for innovative sneakers like the Air Max 1, Air Trainer 1, Huarache, Air Jordans 3–15 and more
Toe Box	Front area of a shoe (typically made from mesh and suede). *'OMG, the toe box on these 1500s is so ganky!'*
Torsion	Technology used at adidas to provide a bridge between the front and rear of the foot, usually in distinctive yellow plastic
Trainer	Common UK slang for 'sneaker'
Trefoil	Iconic adidas branding created in 1971
Triple Black	Entirely black sneakers. *'Those Triple Black 95s are murdered-out!'*
Un-Deadstock (UN-DS)	To remove shoes from a box and wear them. *'Yo! Time to bust out these 'Wu-Tang' Dunks and UN-DS 'em!'*
Unicorn	One-of-a-kind sneaker, often a Sample or Player Exclusive (see also, 1-of-1)
Uptowns	New York slang for the Air Force 1. Derived from when sneakerheads travelled 'Uptown' in search of fresh pairs
Vintage	Sneakers that are more than 20 years old
Volt	Shoe colour introduced by Nike in 2008 to highlight the futuristic inspiration behind the Lunar performance range
Waffle	Iconic Nike sole design based on Bill Bowerman's waffle iron, which he filled with rubber
White-on-White	Slang for all-white Air Force 1s, one of the bestselling shoes of all time
Wieden+Kennedy (W+K)	US advertising agency, founded by Dan Wieden and David Kennedy, responsible for Nike's 'Just Do It' and 'Bo Knows' ad campaigns
Y-3	Collaboration between adidas and Japanese designer Yohji Yamamoto

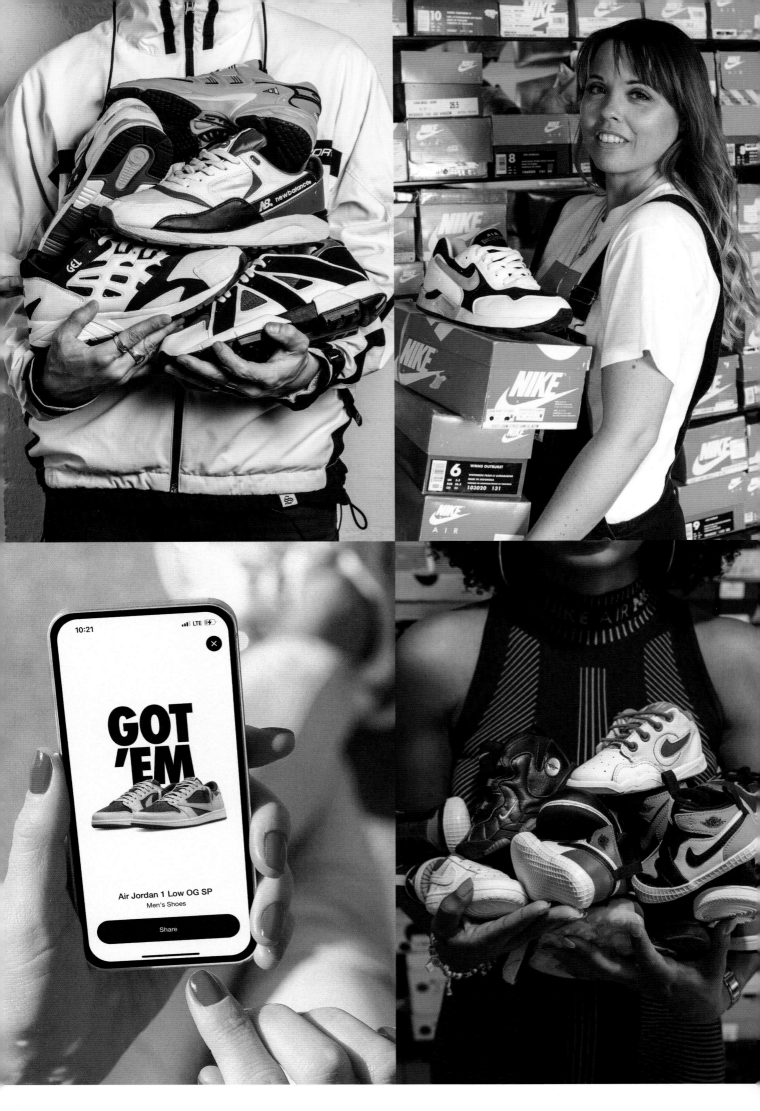

Photo Top Right: Reyes Yllera. Photo Bottom Right: Bianca Derousse

Text: Amber De Luca-Tao

How to... Buy Online

The days of overnight sneaker campouts are long gone, replaced by myriad raffles, mysterious restocks, first-come-first-served hype sales and BOT-induced mayhem. While braving the elements 24/7 is no longer required, plenty of booby traps and pitfalls can have you copping endless Ls or acquiring piles of unwanted shoes that don't even fit. Read up and say RIP to your bank account as we go deep into the dark art of buying sneakers online.

Rule Out Uncertainty

Buying online is riddled with uncertainty. So, before adding to cart, identify whether you really – and we mean deep down – want to spend your hard-earned on that new pair of Jordans. Don't fritter your cash away on shoes you only half love.

Research is the first step, especially for a brand or model you're unfamiliar with. There's loads of info available via the blogs at SneakerFreaker.com. Trawl social media for reviews to gauge the quality of materials and assess general feedback. A well-informed opinion is always a good one.

TOP TIP: We always advocate supporting your local independent store, but if you have to source shoes via secondary accounts like eBay or GOAT, check out our guide to avoiding fakes [p 60].

Grey Areas

Online images aren't always realistic, and shoes can look very different IRL. They may appear lighter, darker, brighter or even made from totally different materials. Compare images from multiple sources. If you've purchased from a retailer before, you'll know how accurate their product shots are. Boutiques like atmos, Kith, Up There and END. are bankable reference points.

TOP TIP: Hook up your iCal, send out reminders and set alarms – do whatever it takes or you'll be paying reseller prices!

True to Size?

Chasing a new silhouette can result in sizing mishaps, so pay attention to our sizing feature [p 62] for specific advice. Retailers often note whether a shoe runs big or small, so make contact via email or slide into their DMs. Don't be shy to ask if the shoe runs true to size (TTS).

TOP TIP: If there's a (W) next to the shoe name, it's a women's release, so order accordingly.

Art of the Raffle

If you're after the latest Patta or Salehe Bembury colab, mastering the various online raffle systems is essential to your strategy. First off, rationalise how badly you want the shoes. Targeting a bunch of raffles is like putting all your chips on the table – the odds of winning might be high, but the return doesn't always justify the means. If you enter five raffles, you might end up winning multiples. The chances of that aren't crazy high, but can you pay the rent if $1500 is automatically deducted from your bank account overnight?

Raffles accept varying payment methods – some exclusively take credit cards, while others allow PayPal, so be born ready. Most automatically charge payment without notice, so make sure your bank balance can handle that or you'll take a heartbreaking L instead of that W.

TOP TIP: Make sure your address and credit card details are auto-saved in your phone for swift data entry, especially if you get a pre-sale email and have to pounce.

Nike SNKRS App

To increase the chances of copping from Nike SNKRS, ask friends and family to download the app and enter draws on your behalf. Keep track of release dates, and your next score could be just around the corner. Persistence pays off!

Know Thy Shop

Our general advice is always to support your local independent store, but if that's not possible, you'll have to look internationally. There are hundreds of retail options to choose from, but many have restrictions on selling particular products outside their region. Some stores provide free global shipping, while others offer member discounts, particularly later in the week. Some of the bigger chains have codes and loyalty cards. Any saving is worth hustling for.

TOP TIP: We're aware of retailers in obscure regions with generous allocations (in certain brands and styles) and less demand, increasing the odds dramatically in your favour. Sorry, but you'll have to crack that code yourself!

Critical Conditions

If all else fails, make sure you check the fine print in the returns policy. Conditions vary greatly from store to store, meaning some only offer credit notes in exchange. You may also have to pay to ship the shoes back. Keep this information front of mind before making your all-in move.

Finally, don't let the fear of striking out stop you from playing the game. Just because the hype seems nuts doesn't mean you have zero chance. There's always more than meets the eye when buying online, but with these insider tips up your sleeve, consider yourself well equipped. Remember... don't shop hard – shop smart!

★

Text and Photos: Ella Maximillion

How to...
Shoot Sneakers

If you're hungry for sneaker hearts on Instagram, these tried-and-tested sneakography tips will help you hit the creative spot every single time. There's no reason to enrol in an expensive course (though that can be useful) or have expensive gear to capture amazing images – all you need is a love of footwear, a discerning eye and a solid understanding of light and technique. And if all else fails, take a picture of this guide and save it on your phone.

Camera

This guide applies to shooting with a DSLR, but it works equally for the iPhone. The only difference is that the depth of field is manually created within your DSLR settings while you select portrait mode on the iPhone. Regardless of your equipment choice, taking photos should be fun, and once you've mastered the basics, you'll progress quickly.

DSLR Settings

Aperture	4.5 F-Stop
Shutter Speed	≥160FFS
ISO	Ideally <1000
Lens	50mm f/1.8
iPhone	Portrait mode
Light Source	Ideally 45 degrees above the subject
Time of Day	9:00 am to 11:00 am is ideal, or before the sun gets too bright
Weather	Slightly overcast is perfect

Light Source

Whether you're shooting in a studio or out on the street, the rules of great lighting stay the same. The light source should generally be positioned directly above or at around 45 degrees in relation to the subject. You can, of course, make things more complex by using multiple light sources, but we're firmly in favour of keeping it simple. A single light source – either the sun or a flash unit – is all you need to capture the sweet lines of your favourite shoes.

TOP TIP: Never direct the light source at shoes front-on, as this will flatten the image and blow out the texture. Healthy shadows are key to defining contours and making texture pop.

TOP TIP: A silver reflective bounce (available in camera stores), or even an A3 piece of white plastic, is ideal for 'bouncing' light where you want it.

Speedlight

The same rules apply if you're shooting outside at night with a Speedlight set-up. Get your flash off the top of the camera and mount it to a tripod, or better yet, hold it in your hand (or use an assistant) to produce shadows that induce dramatic effects. Place the light above the shoes pointing directly downwards for moody 'midnight' vibes.

TOP TIP: An extra hit of light will breathe life into any dull daytime situation, so always take your Speedlight on potentially murky missions.

Aperture and Shutter

A razor-sharp sneaker in front of a luxuriously soft backdrop is a killer combo. Shoot with a lens that lets you get the whole shoe in focus, usually 50mm, then use f/1.8 to make the background melt away. The aim is always to make the shoe the hero – you definitely don't want anything distracting in the periphery.

TOP TIP: A shutter speed of 160 or higher guarantees a fast shot and will eliminate motion blur in handheld situations.

Time of Day

'Sunrise' is a great name for a Nike colourway, but it's a bad time to shoot because the shoe's natural colours will be distorted by golden light. Early morning is generally ideal as the tone is neutral, and your images will be relatively correct. Mild cloud cover is perfect as it's a natural light diffuser. Avoid super-bright situations because the sun will blow out sneakers and create shadows that are way too heavy.

TOP TIP: If you absolutely have to shoot in hot sunlight, look for urban environments where light bounces off buildings or walls to create areas with soft, reflected light.

TOP TIP: Set up your white balance correctly, or the colours will look completely wrong. This will save loads of time colour-correcting later on.

Creative Direction

Determining the overall mood you want to create is essential. This can be drawn from the theme behind the shoes, the materials or the general vibe. Choose colours, contrasting textures and a location that will amplify the impact of every image.

When scouting for locations, look for compact areas with personality, such as reflective surfaces, gritty metal, polished concrete, distressed timber, organic matter, industrial staircases and tiled surfaces. The aim here is to complement the shoe, not overwhelm it, so find a spot with a decent depth of field behind it. The background should seem insignificant compared to the greatness of the sneaker.

TOP TIP: Sweep away any distracting detritus, such as dust, cigarette butts and litter.

TOP TIP: Bring a bottle of water to splash around – the reflections look cool!

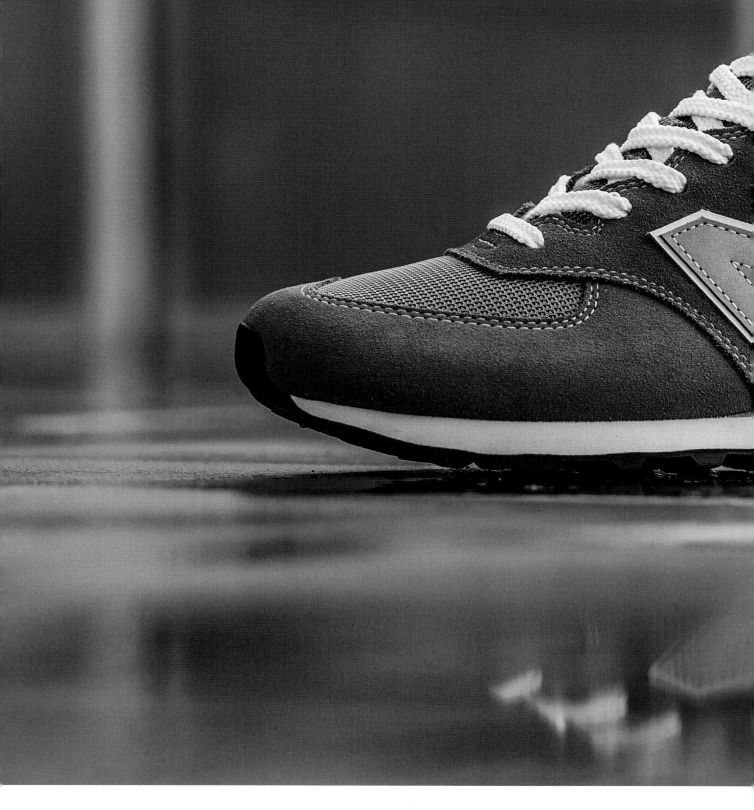

'A simple yet stylish backdrop lets the shoe shine and won't overpower the image. This symphony of navy and grey, with just a hint of reflection from the concrete below, is the perfect complement to the New Balance 574.'

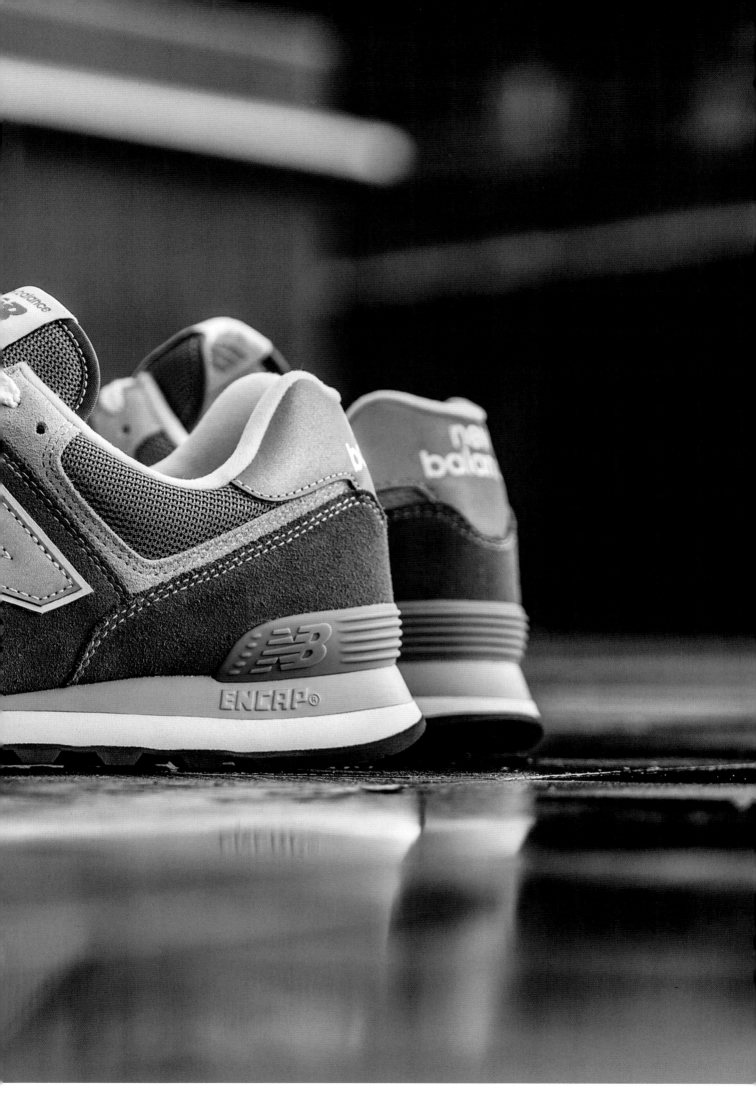

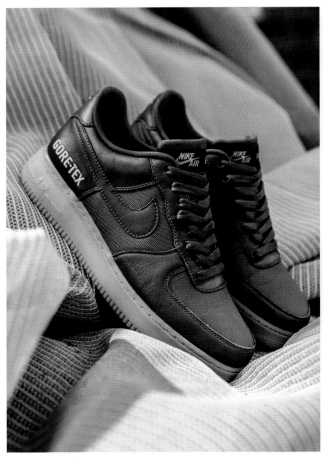

Random props found on the street can make great backgrounds

Action shots can help build the narrative

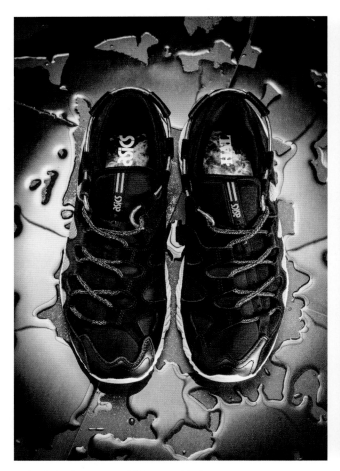

A splash of water can add drama and intrigue

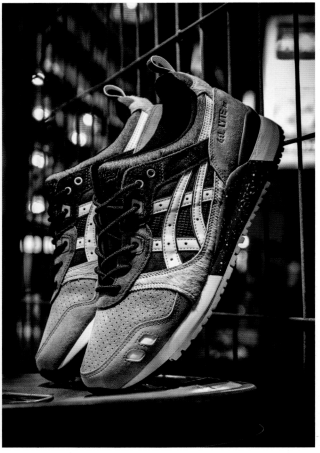

Shoot at night with a flash for a totally different look

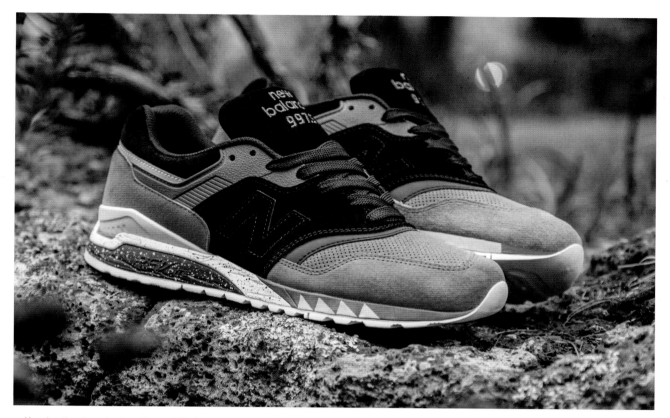

Keeping the shoes in sharp focus while the background stays soft always looks good

Ridin' Solo
No model or crew is required if you tripod your DSLR and use your camera's iPhone app to trigger your selfie wirelessly. If you're shooting with a Speedlight, just hold the light, trigger the camera and flash!

Still Life
Bring sneakers to life through a pose and stance that projects personality. The subject should look confident, well behaved and relatively natural if you're out on the street. If shooting the profile, make sure the shoe is perfectly side-on and not wonky. Standing the shoe 'nose-down' is a classic *Sneaker Freaker* magazine trick we use to fill a single page, but you'll likely be more focused on the one-to-one format.

TOP TIP: To make sneakers look 'epic', drop the camera to the floor and shoot upwards.

Styling and Loose Lacing
It's surprising how many photographers fail this elementary part of the process. Firstly, every aspect of the shoe should be inspected for blemishes. Trim off unwanted threads, wipe away any dirty marks, tease out any wrinkles and make sure the soles are clean if you plan on shooting them. This will not only look good, but it'll also save you hours of retouching time.

The next step is to stuff the shoes with tissue paper (or socks) to create a deliciously plump shape. Shoes that have collapsed because they don't have padding look dreadful! The tongue should also sit nice and upright and press firmly against the laces. No gaps!

Quality styling is the mark of a true sneakerhead. Original factory lacing is bad 'Feng Shoei' so take the time to re-lace shoes consciously, then conceal the aglets neatly inside the collar. Neat and natural is the perfect package. Do not strangle the shoe.

TOP TIP: Take an intimate moment when inspecting the shoe and appreciate the design intricacies worth highlighting in your images.

Model Behaviour
The number-one rule for working with a human model is to make them feel comfortable. Include them in the conversation by offering clear verbal feedback and regularly showing them your shots. Collaboration is the key to a happy relationship.

TOP TIP: The colour, texture and style of pants can make or break an on-foot shot.

TOP TIP: Never mix brands! For example, Air Max should never be seen with adidas trackpants.

Processing
Adobe Lightroom or Camera Raw in Photoshop is a must for image processing and retouching. The lighting should look correct in the first instance, but image manipulation can easily turn Charmander into Charizard.

Here's a rough guide to processing standard images, though things can get much more complex depending on the outcome required. Import the image into Lightroom, ascertain the colour temperature, adjust the exposure and contrast, and then add clarity and shadows until the image sings and everything is in harmony. Once the basics are complete, you may need to mask the shoe, or sometimes the background, to enhance those areas specifically. The final step is to analyse the image closely for dust, dirt or factory errors using the 'Patch Tool' or 'Clone Stamp' to remove anything untoward.

TOP TIP: Always shoot in RAW format to retain direct image data from the camera sensors so you can edit photos without losing quality.

TOP TIP: Desaturating the background often makes the sneaker pop hard.

Grand Finale
Hopefully, this multitude of tips should have you popping shots like Annie Leibovitz. Work on the fundamentals, build on the basics and experiment with lighting and composition. Your skills will grow in no time, and you might even graduate to a paid position in the industry. Most importantly, there's no substitute for getting out there and just doing it!
★

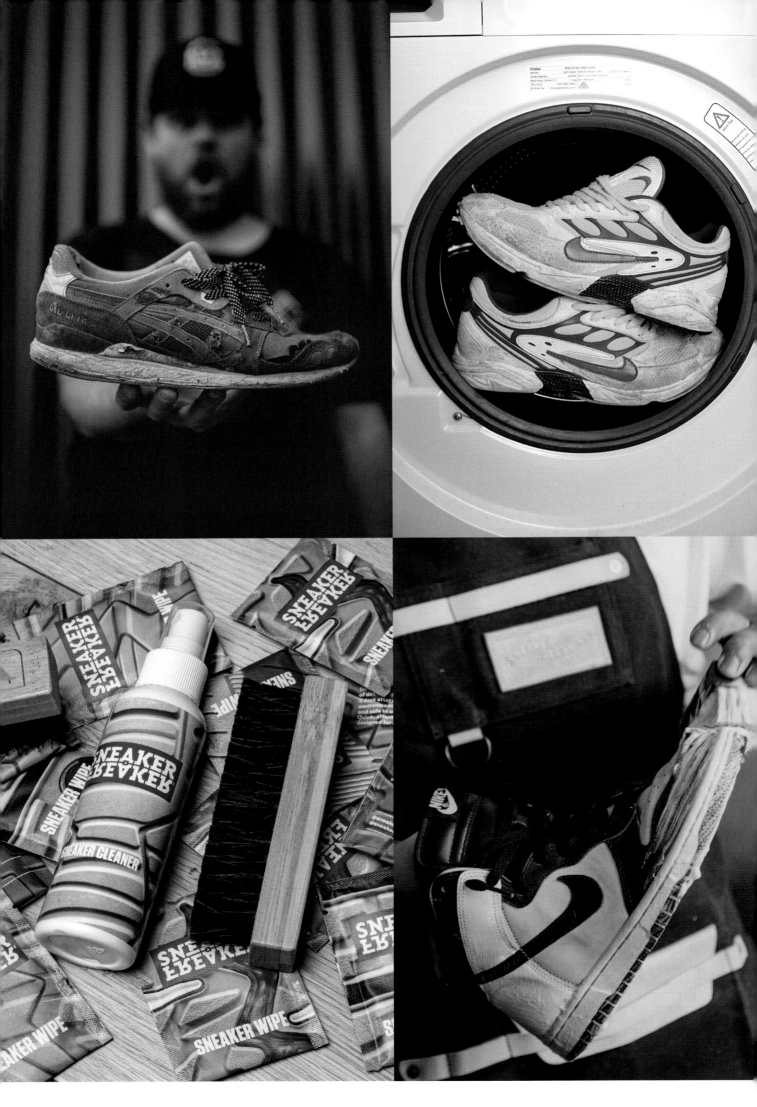

Text: Minh Vuong

How to… Clean Sneakers

Keeping your sneaks squeaky clean ain't all that complicated. A little bit of water, a dash of soap, an old toothbrush and some mild elbow grease will take care of just about any grimy situation. But since we all get a bit lax from time to time, some more vigorous methods may be required. From buffing suede to dealing with 'yellowed' soles, here's the Sneaker Freaker guide to common cleaning issues.

Essential Toolkit
- Soft-bristle brush
- Dish soap
- Sneaker cleaner
- Water bowl
- Cotton rags
- Paper towel

Easy Peasy
Let's start with some basics. Rubber soles and midsoles can take a proper scrubbing, while leather, nubuck and microfibres are best finessed with a damp cloth. Soaps that foam up are ideal, and many commercial sneaker cleaners do a really good job – but check the fine print for harsh chemicals that damage delicate materials. Unscented and alcohol-free baby wipes also work surprisingly well.

The first step is to remove the laces and insoles. After applying the soap and lightly scrubbing, wipe off any liquid with a clean cloth. Stuff the shoes with paper to soak up any internal moisture, then simply let them air dry. Don't put them directly on a heater or in harsh sunlight. Slow and steady works best.

Protective sprays work by creating a hydrophobic film that stops water and dirt from sticking to the shoe, but you'll need to reapply these regularly. Silicone-based sprays offer superior weatherproofing, but they also trap moisture and stanky smells. They may also cause some materials to yellow after prolonged use.

Saving Suede
When it comes to suede and nubuck, always opt for the dry method before using liquids. A good rub with a clean brush can surprisingly shift a fair bit of dirt. Failing that, a specific suede cleaning block – designed to crumble as it cleans – lifts off almost anything that sticks to suede.

If that ain't enough, grab some suede cleaner and a bristled brush. (Denture brushes are great!) Always test on a small, discreet area to ensure the suede dye doesn't run and taint the rest of the shoe. Scrub gently and work up a lather before immediately wiping with a clean cloth. Suede can stain if left damp, especially if there's excess cleaning solution, so make sure to dab that off before letting the shoes dry naturally.

TOP TIP: Suede tends to sit flat and stiffen after a wash. When almost dry, buff the area to restore the nap. Don't skip this step! ★

Spin Cycle
If all else fails, the washing machine can be an express route from filthy to fresh, though it is a controversial move. For obvious reasons, canvas, nylon and synthetics are best suited for this process, while throwing leather and suede into the tub is not without risk.

Firstly, take a moment to assess the general condition. Chipped foams and flapping soles will only deteriorate further, so always clean those by hand. Stick the machine-safe kicks (and the laces separately) in with some heavy towels. If the insoles are removable, wash them by hand. A laundry bag can also help stop the shoes from bumping around inside the machine. In our experience, front-loaders are kinder to shoes.

Use a small dab of detergent, add the softener and run the smoothest cycle with an extra rinse and slow spin cycle, then take the shoes out immediately to air dry. They'll be completely saturated, so stuff them with paper to retain the shape. Suede and microfibre will need a good brushing to restore the fuzz.

TOP TIP: Don't put your sneakers in the tumble dryer, as the heat can cause premature sole separation and even melt plastic components in extreme cases.

Sympathetic Restoration
Mitigating natural patina such as scuffs, tears and creases requires a more prudent approach and a bit of DIY. Scuffs can be buffed out using a Magic Eraser, but be careful with painted surfaces as you can rub too deep. Angelus paint, or even a Sharpie pen, can be used to fill in areas that require colour repair.

When exposed to UV light, photo-oxidation causes rubbers and plastics to yellow and become brittle – a perennial issue with vintage shoes. Developed to clean boats, Sea Glow (available from a chandlery) will remove the yellow, but be careful as it's a toxic brew. Retrobrite is another product that promises crystal-clear results. Whatever you pick, remember to wear gloves and keep the goo away from leather and suede.

Turning a belated beater into a box-fresh masterpiece is not a realistic aim, but undoing years of abuse and refreshing tired shoes for another few years of life is a worthy cause worth fighting for. Throwing down some fresh laces will also work wonders. Now, get out there and start scrubbing – it's time your old faithfuls were back in the game!

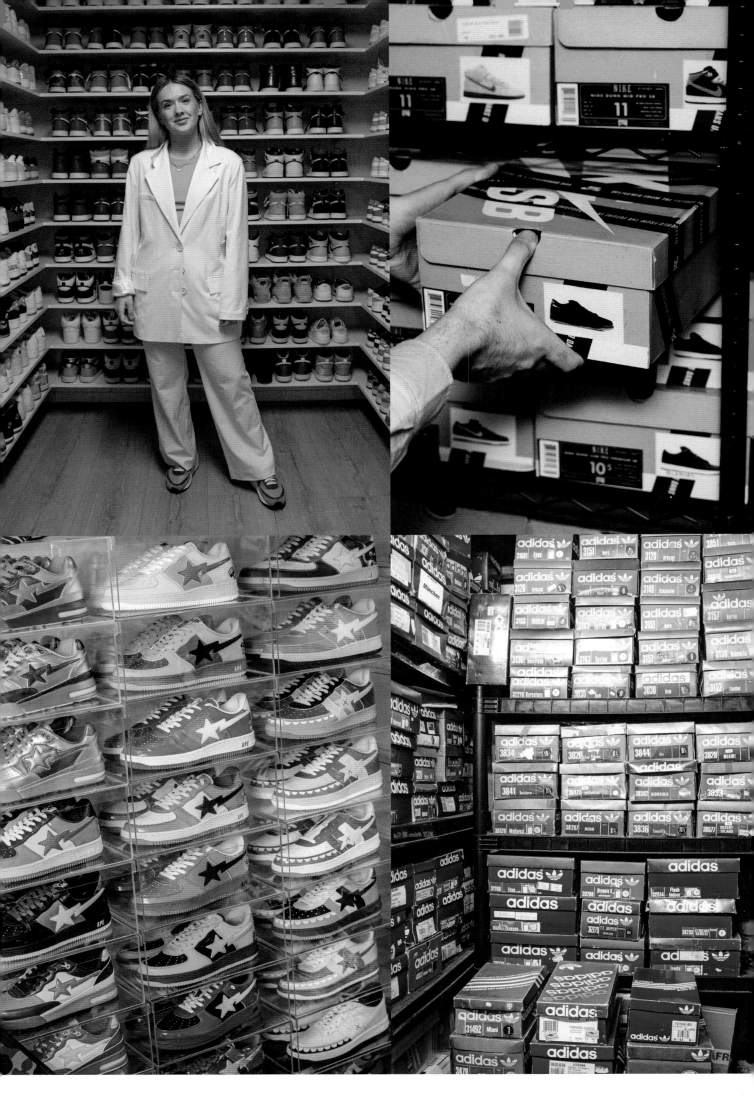

Text: Minh Vuong

How to… Manage the Chaos

If you're packing over 100 pairs in your collection and things get tight in your crib – which they inevitably will – effective sneaker storage is no joke. Beyond managing the day-to-day chaos, how and where you park them is also vital to ensuring their long-term survival prospects. Here are a few tips that cover all sizes and levels of storage options.

The Basics

Rule #1 is to keep the original sneaker boxes. Whatever happens, do not remove them from their natural cardboard habitat! It should go without saying, but a pair of shoes with the box and trimmings intact will always be worth more. At the very least, you can fold the OG cardboard box flat and put it away for assembly later. The boxes look pretty cool too.

Keep your rotation neatly arranged on racks, wardrobes or shelves. Keep all stacks to fewer than five shoes, as columns that are too high and heavy will crush the lower boxes and make reaching for those pairs a total pain in the ass.

Storing your collection indoors is a given, but if your shoes are in a garage, near a window or even up in a loft, take note of any potential moisture sources and avoid areas exposed to wild temperature fluctuations. Adequate ventilation and minimal exposure to light are essential to ensure your shoes don't end up covered in mould and denuded of shine. Humidity is a silent killer, so avoid storing your goods in areas with heated air. We suggest taking shoes out of the box now and again to let them breathe, and this is also a good time to double-check your shoes for any issues.

Lastly, do not allow your shoes to be exposed to direct sunlight. Not only will certain materials and colours fade fast, but the entire shoe can warp and lose its shape. They will literally deteriorate in front of your eyes!

Intermediate

When a collection hits triple digits and up, orange box after orange box can really start to look the same, making it hard to identify specific pairs (ask us how we know!). Label each pair with a Post-it note, or like Nate Wallace's SB Dunk collection [p 716], take Polaroids and stick them on the box for easy reference.

Those plastic display cases you've seen on the internet are stackable and look pretty good, but as above, we still advise that you keep the OG packaging. Translucent storage tubs also work well. When using these airtight options, add silica gel packets to absorb moisture. More importantly, crack the lids open now and again and take the shoes out for a breather.

Shrink-wrapping has matured from a curiosity reserved for Harajuku sneaker boutiques to commonplace practice. It makes sense in a retail setting as high-value items are vulnerable to dust and greasy fingerprints. But the jury is still out on personal use, as long-term degradation from the shoes drying from the inside out is an ongoing issue. Leather uppers can turn rock hard, and foam collars get crusty if kept in stagnant shrink-wrap. Encasing vintage pairs in Glad Wrap likewise holds everything together, but it effectively confines the shoes to a plastic coffin. We're not convinced it's a good idea in the long run.

Organised chaos will make your life easy. You don't need Dewey Decimal levels of arrangement, but it makes sense to group brands, models or even genres together (basketball hightops in one section, runners in another, skate shoes in a separate room, etc.). Sorting shoes by colour is a right-brain move, but if it works for you, it works.

Advanced

If you're spending big money on shoes, it's worth investing in storage. At this stage, it's all about physically preserving pairs that might not see much airtime. If you're lucky and have the space, integrating the stash in a dedicated shoe room, like Hanna Helsø's [p 322], is a worthy long-term goal. Adding security features and taking out specific insurance [p 56] are both good for your peace of mind.

Off-site storage is another option when things get big on you. It may seem like an out-of-sight, out-of-mind solution, but shit happens. We've heard horror stories of break-ins, entire collections gutted, vermin infestations and natural disasters, so assess the site carefully, check the feedback and test the security. The same principles regarding temperature and moisture management still apply, so keep your eyes wide open.

Hardcore

Truly irreplaceable shoes justify a bespoke storage solution. Fort Knox-level security, climate control, CCTV, key codes, biometric access and fireproof ratings are standard features in high-end underground facilities. One unnamed collector reportedly stores their most valuable pairs in a gigantic 700kg (1500lb) safe hidden inside their house. You won't even need this guide if your storage methods require this level of protection, but for everyone else, stay safe and look after your precious possessions.
★

Text: Marlowe Wood

How to... Insure Your Collection

Whether you need to insure your sneaker collection or not is based on all kinds of assessments. Your age and income versus how much the shoes are worth – not to mention the price of the yearly premium – are all things to weigh up. Theft should be the top of every sneakerhead's fear factor, but storm damage, floods and fire are other calamities that can wipe out years of hard work in an instant. Sneaker insurance is hopefully something you'll never need, but if you do, here are a few things to consider.

If you own a dozen pairs of basic sneakers, they'd generally be covered under a standard household contents policy. But if there's a high-value item – commonly defined as anything over $1000 – they will need to be individually covered by an agreement with your insurer. If this item isn't documented and approved, you're likely not covered if a crisis occurs. Your policy might also stipulate a professional valuation supplied by an external source.

Here's another scenario familiar to experienced sneakerheads. Let's say you begin as a teenager and put away a few pairs. You start work in your early 20s, the hustle takes over and the collection grows. Some of the shoes appreciate in value astronomically... One day you wake up and realise $150k is sitting in cardboard boxes in the family garage. In this case, you'll need a policy that covers the entire collection at what's called 'actual value'. If you regularly attend events to buy and sell shoes, you might also consider adding coverage for when you're outside your home.

But before you even start thinking about getting an insurance quote, the first step is to document every sneaker in a spreadsheet that lists the name, the price you paid, the condition and the actual value. The more detail, the better, and it goes without saying you should have a backup file stored in the cloud just in case you lose your laptop. If you're regularly adding shoes to the rotation, make sure you update the insurance company. Photographs, including the packaging, will also be useful.

What you paid for the shoe is only a starting point in assessing your collection, as appreciation means the actual value is often many times the original investment. Keep receipts for all purchases (photos are fine), but you should also use trusted sources like eBay and GOAT to keep track of completed auctions and prices. Just remember that valuing your shoes too high means you'll pay too much for your insurance. Undervalue them and you won't be fully covered.

Once you have a detailed spreadsheet prepared, you're ready to start looking for an insurance company. Get as many quotes as possible, and be 100 per cent honest with all the information you supply. Specialist firms offering bespoke insurance for collectors of records, toys, vintage cars and memorabilia often have a better understanding of the sub-cultural obsession. Online reviews can also help determine your final decision.

Most importantly, follow all the policy requirements, especially when it comes to security, like fitting deadlocks and alarms. After all, there's not much point in paying the premium if you don't qualify for a payout if disaster strikes. Read all the boring fine print carefully, and if there's any doubt, get someone you know and trust to help explain the details. And remember, the cheapest policy might not be the best!

★

2015: Concepts x ASICS GEL-Respector 'Coca'

2009: This fake AF Nike Air Yeezy is one of the craziest counterfeits of all time

Text: Gabe Filippa **Photo:** Lucas Blackman

How to... Avoid Fakes

With the black market for high-ticket sneakers booming and the quality of knockoffs at an all-time high, not to mention the sheer number of fakes in circulation, it has never been harder to avoid being catfished by counterfeiters. The simplest way to protect yourself is to ONLY BUY FROM LEGITIMATE RETAILERS! But if you need to shop around on the grey market for whatever reason, here are a few ways to protect ya neck and avoid being flamed by a fugazi. Chances are, if it's too good to be true, it almost certainly is!

Authenticity Guaranteed

Most online marketplaces offer some form of authenticity guarantee, so make sure you do your research and read their policies. That doesn't mean fakes can't slip through. In 2022, Nike sued StockX for selling counterfeit sneakers, so buyer beware at all times.

When it comes to eBay, a seller's online reputation should be rock solid, but they don't necessarily require 100 per cent positive feedback to be considered legit. Suss the comments section to gauge the overall temperature. The quality of images is often a giveaway, and consistency is key. If the gallery craters in quality from Canon DSLR to potato pics, you're in trouble. Similarly, if the seller uses stock shots or only has one image – leg it. When in doubt, contact the seller and ask for more info and more photos from different angles. No response? Ghost 'em like Casper!

The Price Is Right

Hyped sneakers in small quantities command big price tags on the secondary market. So, if you find your $700 Holy Grail available in every size for $69.99 on a website using templates from the year 2000, it's not an authentic product. Steer clear unless you want to spin the sneaker wheel of fortune.

50 Shades of Fake

Counterfeit sneakers often sport never-before-seen colourways that may be fresh (in a weird way) but are most certainly fufu. They're not 'samples', variants, Friends & Family pairs or factory seconds. Seen those SpongeBob x Jordan Dub Zeros? Fake AF! These unofficial and unauthorised combos are most often found on those sites selling every colour and every size for one price, so avoid them like the plague.

Beware of Drop-Shippers

Drop-shipping is often a tipoff that fakes are on the way, but not always. This occurs when the seller doesn't hold stock but drop-ships directly from another region, usually China. A tell-tale sign is if they're locally situated but give you an ETA of four to six weeks. ALARM BELLS be ringing!

Check the Box

If the state of the packaging is as unsettling as Kevin Spacey's box in *Se7en*, you'll break down like Brad Pitt once it's cracked open. Frequently, in our experience, it's actually easier to spot a fake box than identify the fake sneakers sitting inside. First, cross-check your SKU codes with Dr Google, as they often don't match the shoe.

Then, move on to the size, colour and overall box design. Closely inspect the typography. Are the sneakers buried in fancy, official-looking tissue paper? If not, you're sure to be wiping away tears later. Knockoff boxes also tend to be flimsy, but you can't tell that over the internet.

Loco Logos

This may seem obvious, but it's crucial. From 'McJumpmans' aerially grounded by one too many Big Macs to scrawny Swooshes, we've seen many bastardised (hilarious) logos over the years. Other times, it's much more subtle. Always, always check your labels and tongue tags – fraudsters frequently trip themselves up by using generic tags that don't match the shoe.

Give It a Big Sniff

Believe it or not, smelling your sneakers is one of the easiest ways to determine a fake. If you know the real-deal Nike aroma – take a big whiff! – fakes usually smell different due to the foams and compounds used in the counterfeit factories.

All Is Not What It Seams

Paying close attention to the stitching is a great way of diagnosing rip-offs. Check the spacing and quality of the seams. Counterfeiters often have trouble imitating the authenticity and consistency of the original because they don't have the same machinery. They also make shoes faster and with less care, so cutting corners is common. Still, even high-quality originals have inconsistencies, so it's best to combine this step with the others here to make your final determination.

Authentication Apps

While they're not infallible, authentication apps can be helpful tools. Some use artificial intelligence, while others rely on humanoids. You can download apps that will take you through a step-by-step guide for the model you're buying. Just remember – what you're looking at might not be the same shoes you're actually sent. And once you have them in your hands, it's too late!

Last but not Least: Go with Your Gut

If you're trapped in an MC Escher-style sneaker paradox, you have one last option – trust the hundreds of bacteria fluttering delicately in your stomach. If the deal feels shady, then it most likely is. Don't be left with your head in your hands because you didn't trust your gut!

★

Text: Minh Vuong

Photos clockwise from top left: Ivan 'Iori' Lui & Little. By YOHO, Lucas Blackman, Louie Arson

How to… Keep Your Laces Loose!

Determining your correct shoe size is often way more complicated than it needs to be. Across countless models, genres and brands, it's beyond frustrating that shoes in any given size usually fit entirely differently – and that's not including all the quirky variations in UK, US, EU and JP sizing systems. Here's a basic rundown and a few simple ways to avoid hurling your Huaraches out the window when the wrong size arrives in the mail.

Try Before You Buy

Even with abundant online advice, there's no substitute for trying shoes on IRL. Hit up your local shoe shop to dial in the fit, talk to the experts and use tried-and-tested tools like a Brannock Device to determine the length of your feet. New Balance are one of the few brands that still offer different widths, though generally not in lifestyle releases.

Lost in Translation

While a universal sizing system for men and women remains a distant pipe dream, it's still possible to Babel fish your way through the conversion snafu. Frustrations abound! Japan makes sense with their cm increments, but even that's not perfect. Why does Europe have their own continental size chart with weird fractions? (Looking at you, adidas!)

Adult unisex shoe sizing is based on men's sizes, so let's work with that. UK sizes equate to one size bigger than US sizes, meaning a UK11 is the same as a US10. In Japan, one size bigger or smaller means there'll be a one-centimetre difference either way, and their half-sizes are simply half a centimetre bigger or smaller. These are the most commonly used systems in the industry, but it's rarely that straightforward.

Annoyingly, Nike's European size conversions don't follow a linear path. US9 is the same as EU42.5, US9.5 equals EU43, and US10 is EU44. It's even messier with adidas because there's only half a centimetre difference between their UK and US sizes, making US9 the same as UK8.5. And don't start with their EU conversions – their scale shifts in two-third increments, meaning US9 is EU42 2/3, US9.5 is EU43 1/3, and US10 is EU44. WTF? The best advice here is to consider all numbers as approximations. One brand's 42.5 will likely be in the ballpark of another's 42 2/3. Check the charts and refer to our IRL commentary if you're still unsure.

Another essential point to remember is the difference in men's and women's sizes. To buy a women's shoe in an equivalent men's size, add 1.5 to the US size. For example, US9 men's equates to US10.5 women's. Some brands (like Converse) advise going up two sizes when converting men's and women's shoes. But again – try before you buy, or there will be tears.

Sneaky Suggestions

Here are some general rules devised after decades of personal experience. For any given size, you can likely comfortably wear a half-size bigger or smaller than your usual (although a full size can work for some models). Shoes that feature sock-like booties – Huaraches, for example – tend to run small, so it's best to size up by at least half. Chuck Taylors fit a little wide, so go down half a size. Air Force 1s fit slightly larger in all dimensions, so you'll also want to go down by half with those. Interestingly, Air Max TNs seem to have shrunk recently, so we suggest ordering half a size up. And for Timberland boots or Clarks, go down by a half to a full size.

The shape of the last – a 3D approximation of the foot that all shoes are modelled on – is another consideration. Nike Air Max 90s err on the chunky side and are made with a plump last to suit 'fat feet', while classic adidas Shelltoes and Stan Smiths use a European-style last that favours longer, skinnier feet. If you have wide feet and are after some Shelltoes, we recommend ordering a size up from your usual, or they'll feel way too tight across the midfoot.

Fit Happens

Beyond laces and unique closure systems like the BOA, Reebok Pump and PUMA Disc, there are some extra tricks to squeezing into – or padding out – shoes that don't fit quite right. As leading proponents of keeping your laces loose, doing exactly that can help make a tight-fitting pair of shoes feel more comfortable (plus, they look much sweeter on-foot!). For more extreme cases, removing insoles can help open up the shoe by at least half a size, though it does diminish comfort. Shoe-stretching devices can also help you pick up an extra half-size and sometimes more. Trimming toenails and thinner socks are other last resorts.

At the other end of the spectrum, ordering slightly too big shoes is sensible, even if it does look a tad clownish. Adding thin, cut-to-fit insoles can help fill any void, while a pair of thick socks (or two) will help make sure fit happens. Ultimately, the number on the tag is just that. If the shoe fits, wear it with pride! ★

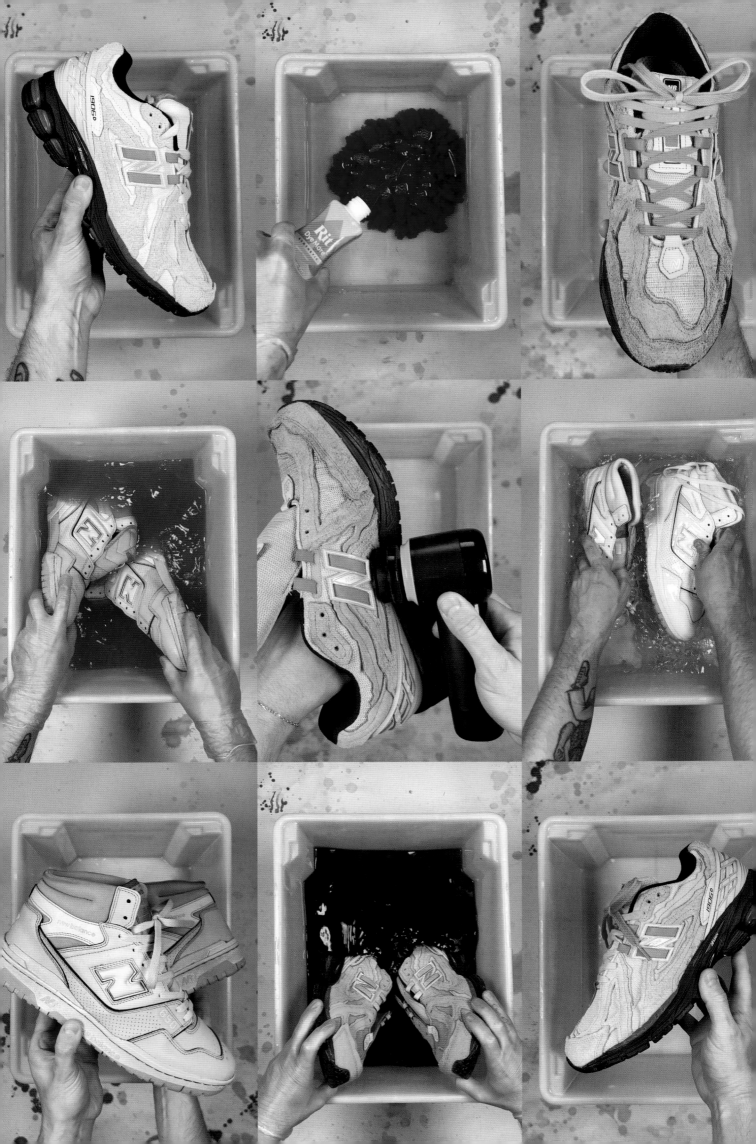

Text and Photos: Lucas Blackman

How to...
Dip-Dye Sneaks

Thinking about ditching your not-so-pearly-white Air Force 1s or adding a rainbow spritz to your tired Chucks? Wanna upgrade those pastel yellow Yeezys you copped yesteryear but haven't worn because you can't find the right fit? The solution is cheap, effective and loads of fun – just grab some dye and start dipping for a classic win-win situation. Loosen your laces, strap on some rubber gloves and caress your creativity with this guide to the subtle art of dip-dyeing.

What You'll Need
- Light-coloured sneakers
- All-purpose dye for canvas, cotton and leather
- Synthetic dye for mesh, nylon, rubber and plastic
- Fixative to lock in colour, especially for synthetics
- Bucket or sink big enough for sneakers
- Hot water (not boiling)
- Dishwashing detergent
- Rubber gloves
- Something to stir the bucket
- Towels to mop up any spillage
- Salt or vinegar to aid the dyeing process
- Vinyl tape
- Kitchen apron

TOP TIP: The pros use Rit dye, so we suggest you do the same.

Prepare Your Station
Assemble the essential items above and place them at arm's length from where you'll be working. The dye process is inherently messy, so make sure you're not wearing Holy Grails and your freshest pants – or you'll pay the ultimate price.

The second step is to tape up any components you don't want dyed, such as rubber midsoles or plastic logos. Colour leakage is common so keep that in mind as you add the tape. The garage is a great spot to start your dip-dye project, but make sure you have access to a stainless steel sink or somewhere you can drain water easily. Grab a friend if you need help carrying the buckets.

TOP TIP: Kitchen aprons are always welcome for obvious reasons.

Time to Dye
1. Fill the bucket with enough hot water to cover the shoes. The heat will help open up the materials and let the dye soak in.
2. Before adding the dye, soak the shoes in water to help the colour absorb evenly. Remove shoes from the water after about 10 minutes.
3. Squirt a small amount of detergent into the bucket, then add salt or vinegar to help the dye bind to the materials.
4. The amount of dye you use will depend on your desired colour scheme. If you want a pastel ensemble, pour in a quarter of the Rit and dip-dye for no more than 20 minutes. If you want a rich and vibrant vibe, use the whole bottle and submerge the shoes for 60 minutes.

5. If you're after a rainbow fade, you'll need two or more Rit colours. Submerge parts of each shoe in stages, then repeat the process using different colours. Flip the shoes around and submerge the remaining parts with a bit of overlap to produce a desirable fade.
6. Once you've achieved the intended colour, run the shoes under water to remove excess dye.
7. Remove any tape you applied earlier.
8. Scrub the shoes with detergent and warm water, then rinse again.
9. Leave shoes to dry naturally, away from harsh sunlight, to avoid bleaching.
10. Stuff the shoes with tissue paper to dry them out quickly while maintaining their shape.

TOP TIP: Don't forget to throw the laces into the dye as well. To achieve a tie-dye look, try adding a few knots to the laces.

Time to Flex
After all these steps are done, it's showtime! Lace your snazzy dip-dyed sneaks and gaze upon your colourful creations. As detailed in our guide to cleaning shoes [p54], use a brush to gently restore the suede fuzz – just massage the material in circular motions until you notice it soften and spring back to life. Pair with dark double-knee pants or Maharishi cargos to make the dip-dye pop, or match with tie-dye joggers for the complete DIY aesthetic. Snap your on-foots [see our photo guide on p48] and share your masterpiece with the world!
★

Sneaker Hunters

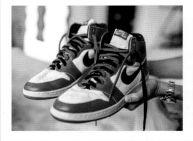
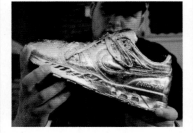
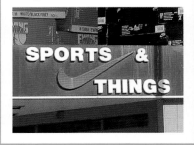

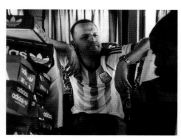
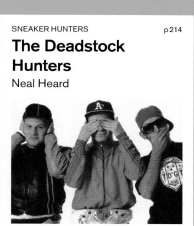
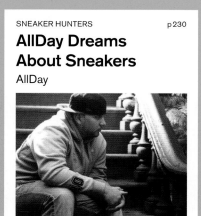

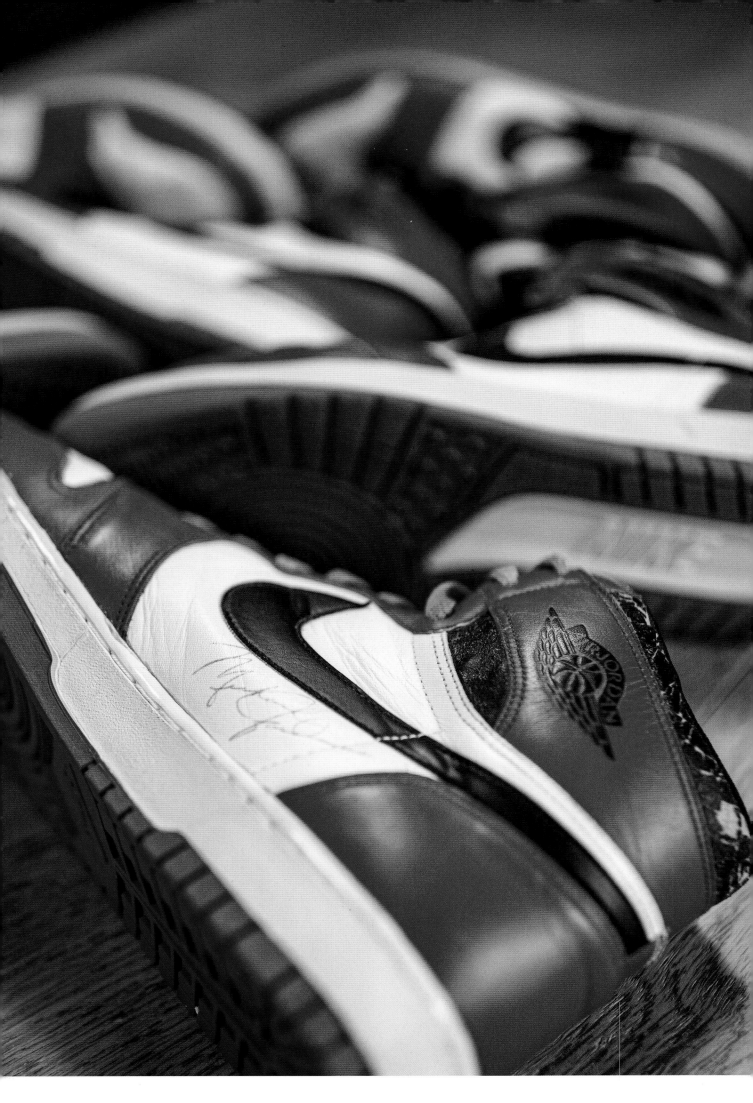

GAME

LEGIT CHEQUE

We've featured some insane collections over the years, but nothing —
and we mean *nothing*! — compares to the sheer scale and quality
of Player Exclusives assembled by the enigmatic @collector10012.
From the OG Air Ship to the 'broken-foot' AJ1s with custom strapping and
an AJ7 photo-matched from the Dream Team's gold-medal game in Barcelona,
every pair has been authenticated as game-worn and signed by
Michael Jordan. This is a Smithsonian-quality, wallet-shredding,
WTF standing ovation that will melt your face! The owner has been content
to stay in the shadows and let his sparse Instagram feed do the talking,
but in this exclusive *Sneaker Freaker* feature, we finally reveal
the identity behind The Greatest Jordan Collection Ever.
Time to cash over 60 legit cheques!

Interview

WOODY

Images

STEPHANIE MORALES

Research

MINH VUONG

WORN

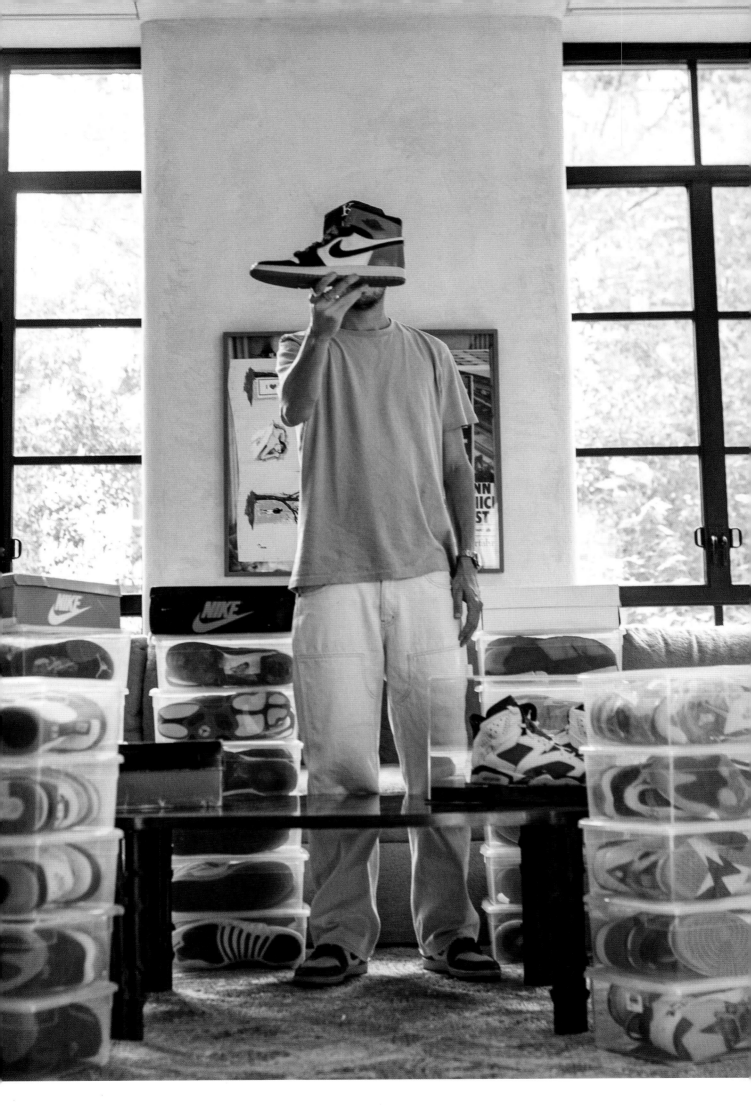

This story starts with the mysterious @collector10012 Instagram account. Just a handful of vintage Jordans posted over 18 months is no biggie – except that every single pair was a golden 1-of-1 Grail signed by His Airness himself. The chatter among aficionados was united in admiration at the game-worn gravitas. On any level, this was uniquely rare air.

A YouTube video produced by *Complex* added further historical dimensions but did not divulge anything about the owner, or their motivations. In the online world where everything must be known, the mystery was maddening. Who? What? How? Why? I'm sure I'm not alone, but in my head, I imagined @collector10012 as a Gen-XXXL boomer with a Bulls fixation, loud Hawaiian shirts and unlimited access to generational wealth.

Assumptions often bite you on the ass, and this was the case when @collector10012 stepped forward and agreed to reveal their identity in *Sneaker Freaker.* As you'll read, Elliot Tebele is a 30-ish social media whizkid from NYC. Too young to remember Jordan playing ball, he nevertheless quietly assembled his prized stash over the last decade. Buying wisely, trading up and swapping shoes where needed, he spotted the true value of these legendary artefacts long before *The Last Dance* sent MJ memorabilia prices into orbit.

I know what you're thinking, and TBH, I had all the same $$$ thoughts as well. In my defence, it just seems uncouth to grill any collector about finances, but since it's human to speculate, let's just say the value has to be calculated with eight figures in mind, and possibly comfortably so. That alone ensures this is a significant moment, but the method behind the madness is what makes the real story even more intriguing.

Equal parts Columbo and MacGyver, Elliot sourced many of his 60+ pairs directly from the recipients of Jordan's post-game footwear largesse. How he tracked down the equipment manager at UNC, where a young MJ studied in the early 1980s, or Gerard Gallego, the Spanish teenager gifted the gold medal-winning Jordan 7s from the Barcelona Olympics, will remain off the record, but that's where the smart moves were made. As Elliot says, 'hard work and hustling, you can't beat it!'

Enjoy the next 30 pages as we take it deep into game-worn overtime, where a verified photo-match to a big game shoe signed by MJ adds so many zeros the price resembles a phone number. Over 20 years of interviewing the hardest of hardcore collectors all over the world, I've never seen anything like this monumental display of sneaker unicorns, many of which are tied to immortal Michael Jordan moments. On behalf of everyone at *Sneaker Freaker,* bravo Elliot Tebele!

Keep your double-laces loose.

Woody

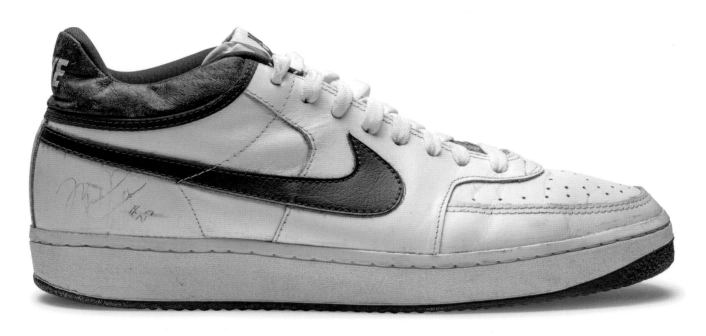

1982: Nike Sky Force

'The story, as I was told, is that the shoes were given to Jordan in 1983 during his sophomore year. Jordan was already an up-and-coming star, so Nike started sending him shoes as a recruitment tool. MJ ended up wearing them during practice. Mid-session, he went back to the equipment manager and said something along the lines of "I don't want these anymore. Give me back my Converse!" These Sky Forces feature beautiful early-style MJ signatures, and they've been in the equipment manager's collection ever since. It's a very cool story from Jordan's pre-Nike era and one of the first – if not the first – pair of Swoosh ever worn by Michael.'

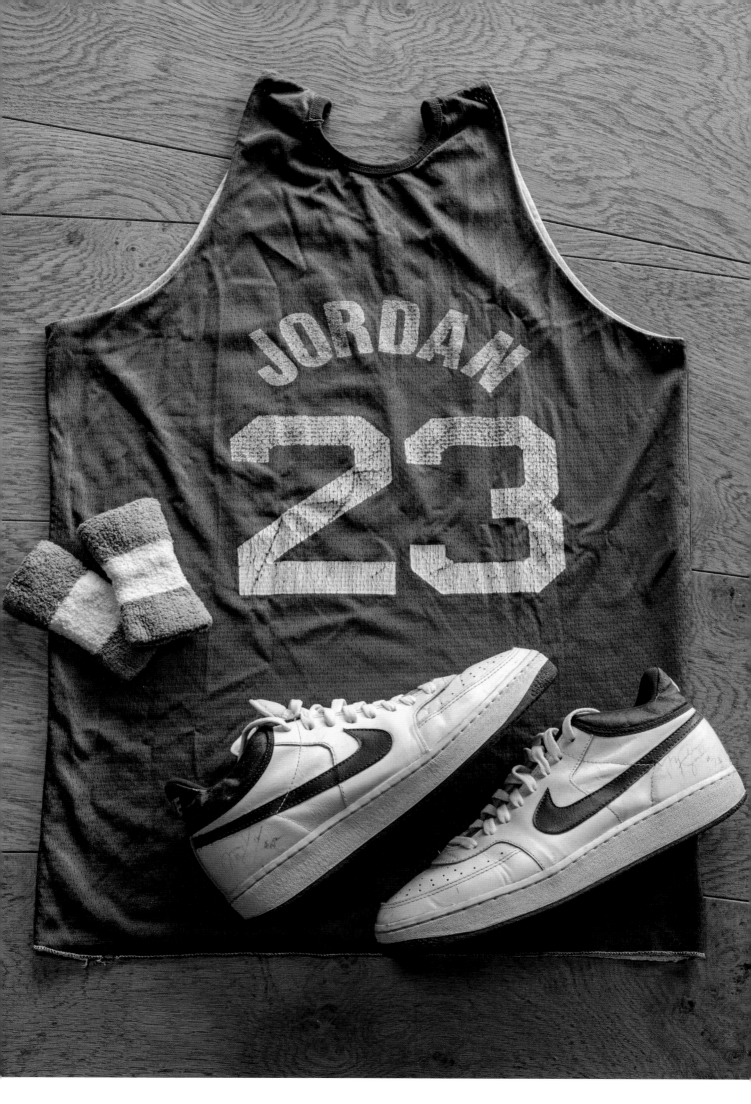

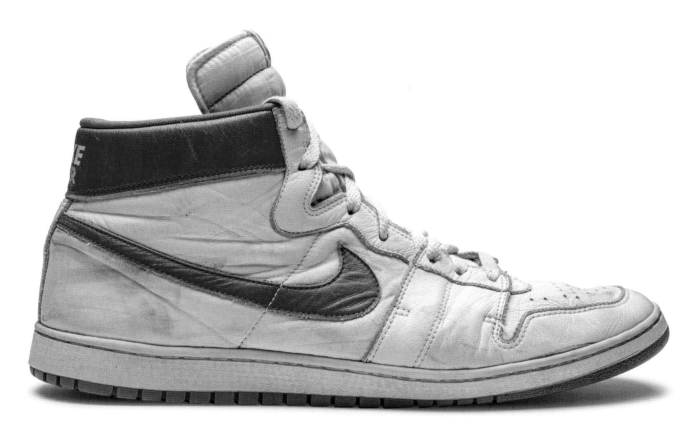

1984: Nike Air Ship

'Michael kicked off his NBA career wearing the Air Ship while Nike was finishing production of the Air Jordan 1. They are a modified version of a production model that suited Michael's preferred specifications. They feature a mid-cut with a shorter outsole as Jordan liked playing lower to the ground. Only a few pairs exist, and I am so grateful to have these unicorns from MJ's earliest moments in the NBA. They're an important piece of history.'

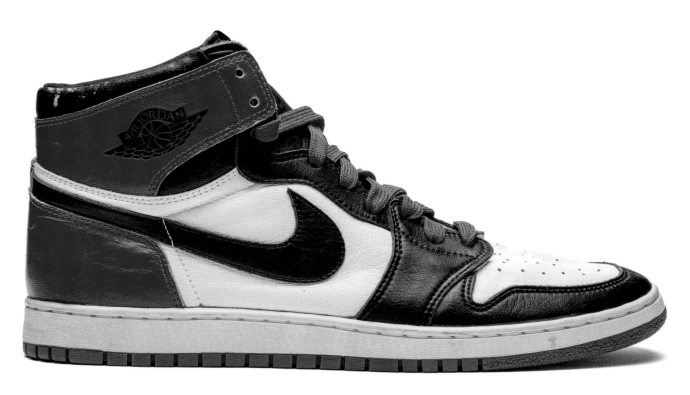

1984: Air Jordan 1 'Black Toe'

'The "Black Toe" is my personal Holy Grail, and the most iconic pair in my collection without a doubt. They were the first Jordan 1 ever produced and are supposed to be the version that Jordan wore in his rookie season, but the story is there was something MJ didn't like about the black and he told Nike he'd prefer an all-red version which led to the "Chicago" colourway. This pair is one of only two that have ever surfaced. I got them from MJ's old college roommate at UNC. The beautiful inscription and signature makes them even sweeter!'

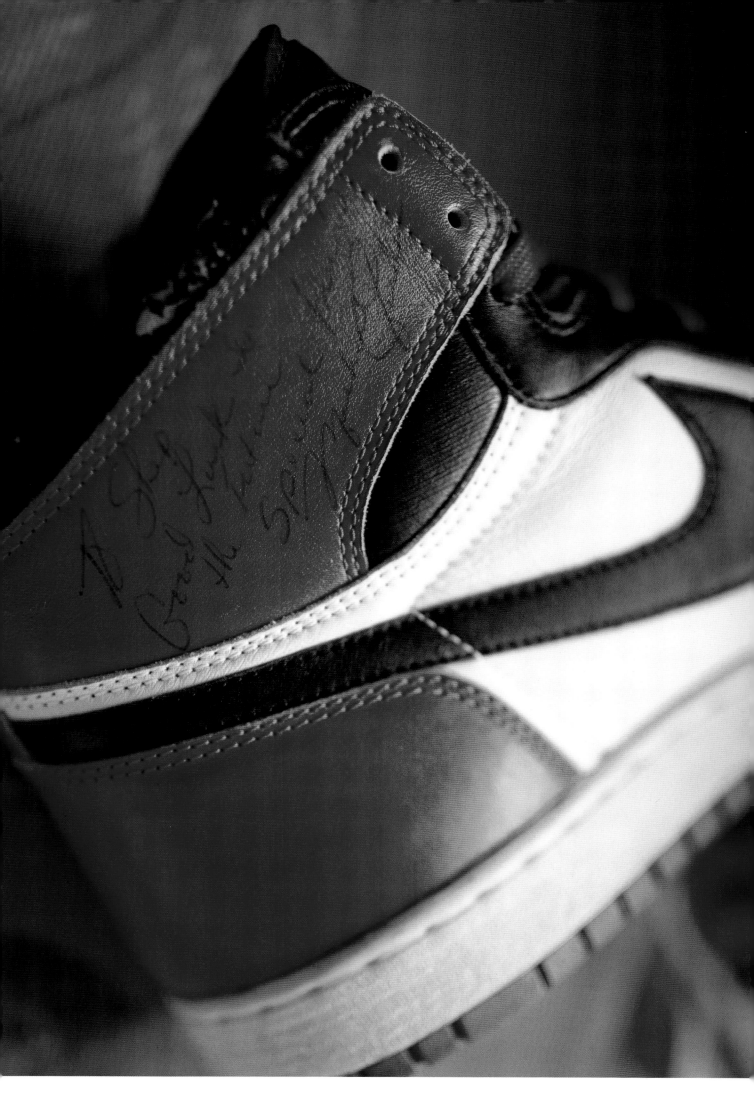

1986: Air Jordan 1 'Strap'

'Anything worn by Jordan is cool, but this pair is on a whole other pedestal! It's also an absolute anomaly because Nike literally had someone cut through his normal PE 1 and add the strap. A couple of other pairs have surfaced, but none show wear like this pair. They were clearly worn in a handful of games, the last being at Madison Square Garden on March 29, 1986. After the game, MJ gave the shoes to a friend of the referee. They were stored away until I was able to acquire them.'

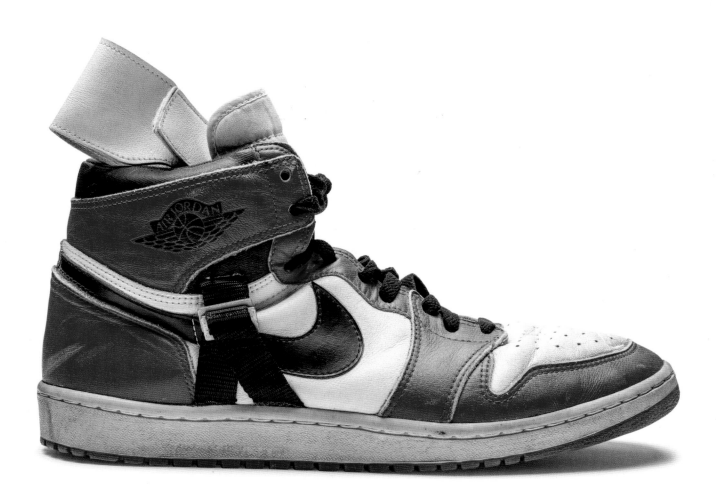

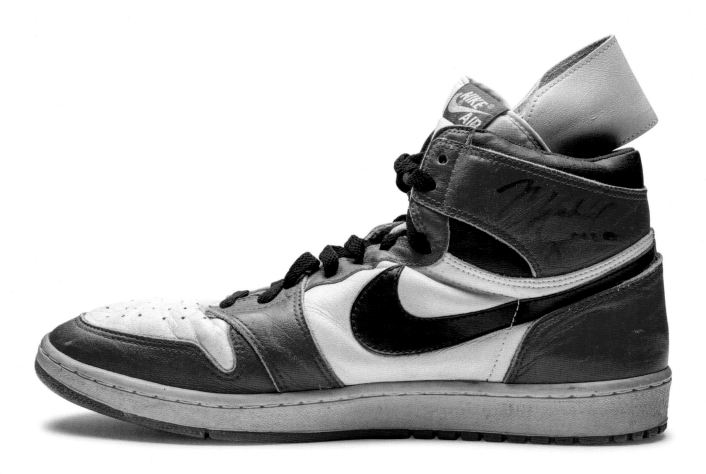

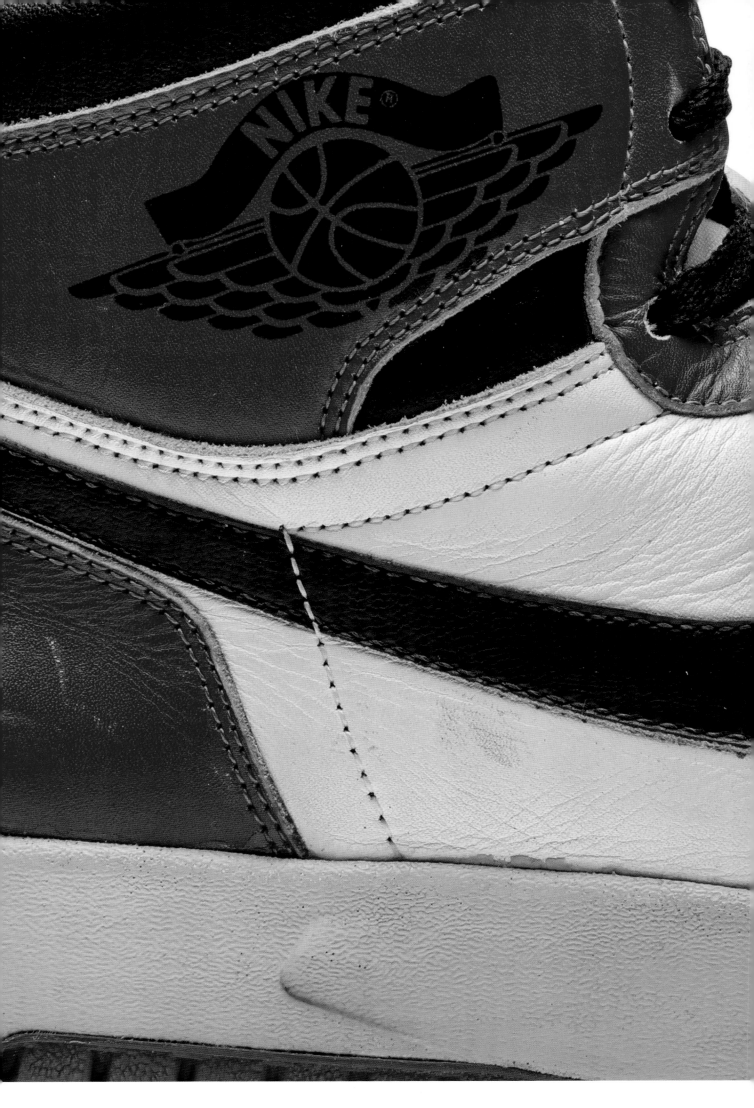

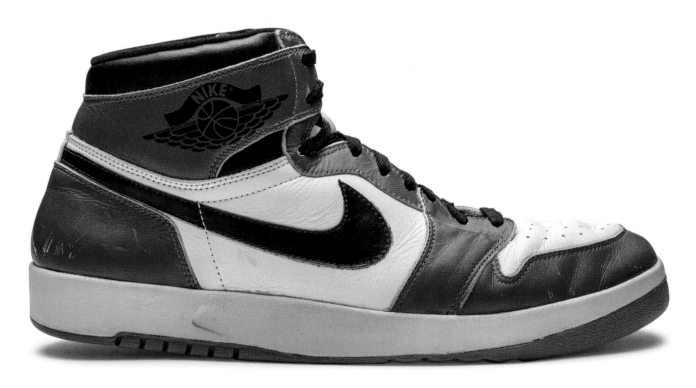

1986: Air Jordan 1.5

'This pair is super mysterious. MJ wore them in 1986 when he came back from a broken foot – the first of three modified Air Jordan 1s that he wore post-injury. The soles reportedly provided more cushioning for his feet. It's unclear if this shoe is an early AJ1 prototype pulled from the archive or if it was an early version of the AJ2. My guess is that it's an early AJ1, considering the logo says "Nike" and not "Air Jordan". A couple of deadstock pairs have popped up in their original sample box, and they have the year 1984 on it.'

'You can't just buy a collection like this. It takes an incredible number of hours researching and learning the nuances of each pair and how that impacts value. I was also very lucky to get into it when I did. As I said, it was a small group of folks collecting game-worn and signed MJ shoes, and I was fortunate to be there when the market was undervalued. This game is not easy. Collecting these 60 pairs has taken me over 10 years, and I worked hard to dig them out. It's all about the hunt. I bought most of them directly from the owners. That's the secret to my success. Hard work and hustling, you can't beat it! Without the passion to keep me going, I wouldn't have made it this far.'

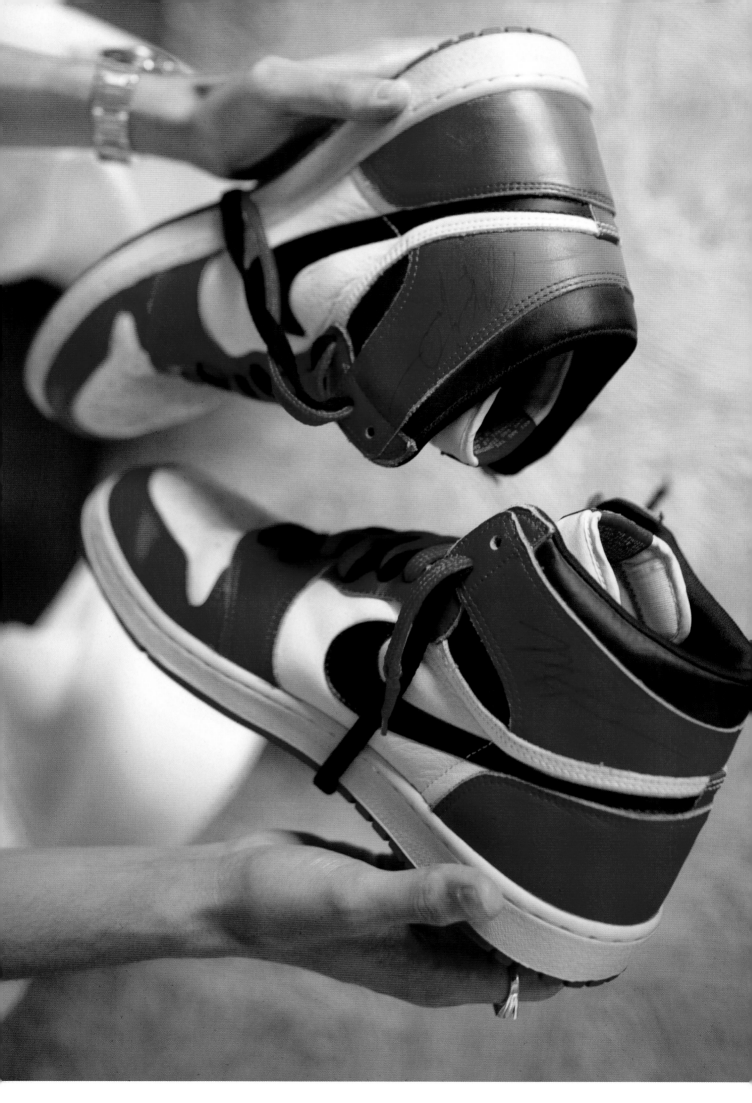

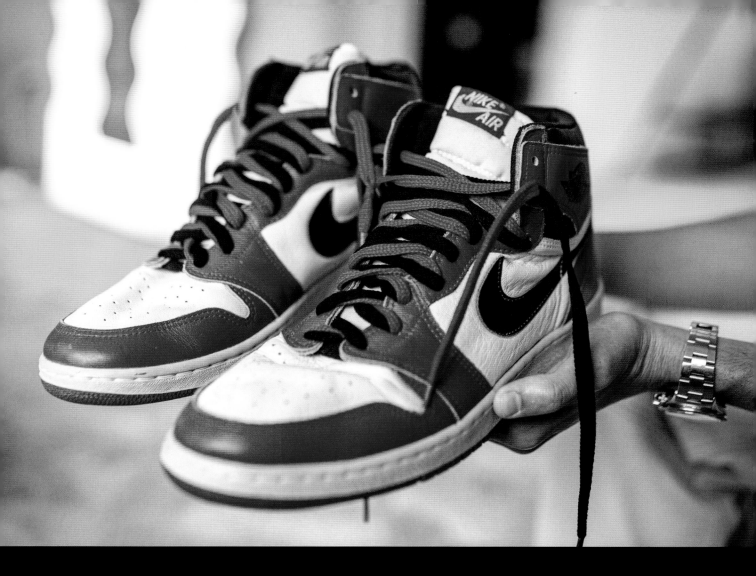

1985: Air Jordan 1 'Double-Laced'

'The Bulls vs Detroit Pistons game on October 26, 1986, kicked off the beef between the teams. MJ was taking it to the hole and Lambier gave him a really dirty hit which inspired a bench-clearing brawl with multiple ejections. MJ went off for 33 points and the Bulls got the W. But what makes the story even cooler is that Jordan was fouled with one second left. The Pistons walked off court and MJ shot his free throw left-handed – and sank it! This was an extremely meaningful game in MJ's young career.'

TWO BLACK CENSOR PATCHES POP
ON OVER THE SHOES.

SFX: METAL SOUND ALA DRAGNET.

ANNCR(VO): Fortunately, the

NBA can't stop you from wearing

them.

1985: 'Banned' TVC Storyboard

'After Jordan debuted the Air Ship in 1984, the NBA fined him $5000 because the colours broke uniform rules. Nike spun it into one of the greatest marketing campaigns ever, responding with the first Air Jordan, now nicknamed "Banned!" Nike projected they'd sell 100,000 units, but the TV commercial changed everything and sales reached $3–4 million! MJ gave this original storyboard to one of his UNC professors, Dr John Bittner, who passed away in 2002. It's one of my favourite pick-ups.'

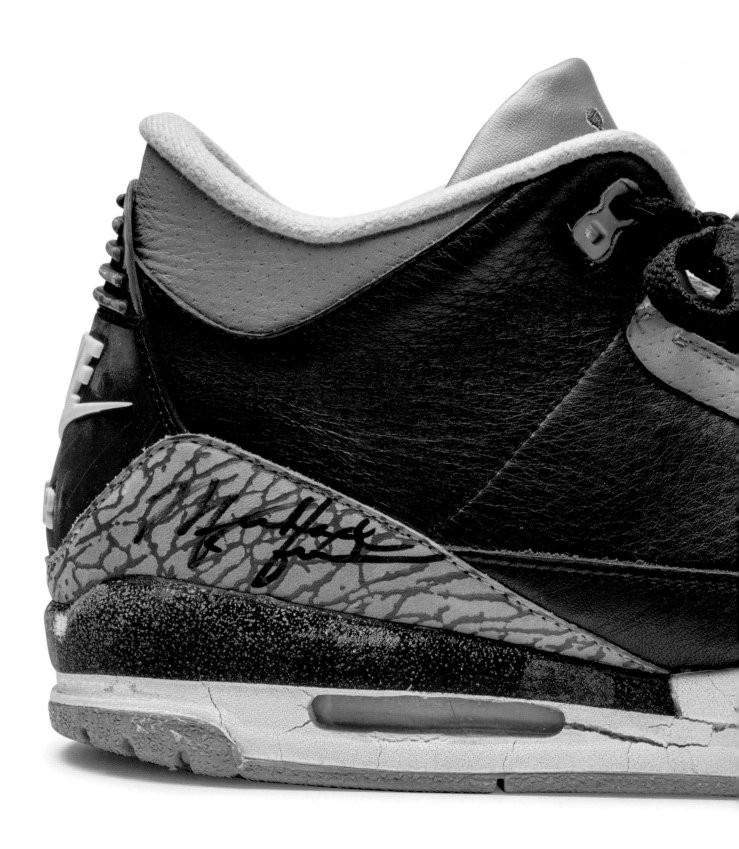

1988: Air Jordan 3 'All-Star'

'The 1988 All-Star game in Chicago was a homecoming, and MJ wanted to put on a show. He went on to score 40 points, had eight rebounds, four steals and four blocks, and took home the MVP. What makes them even more special is that he unveiled the Jordan 3 for the first time that weekend. Fortunately, with the amount of media at the event, there are some great images that photo-match this pair. The elephant print is unique from one shoe to another, so that was the key!'

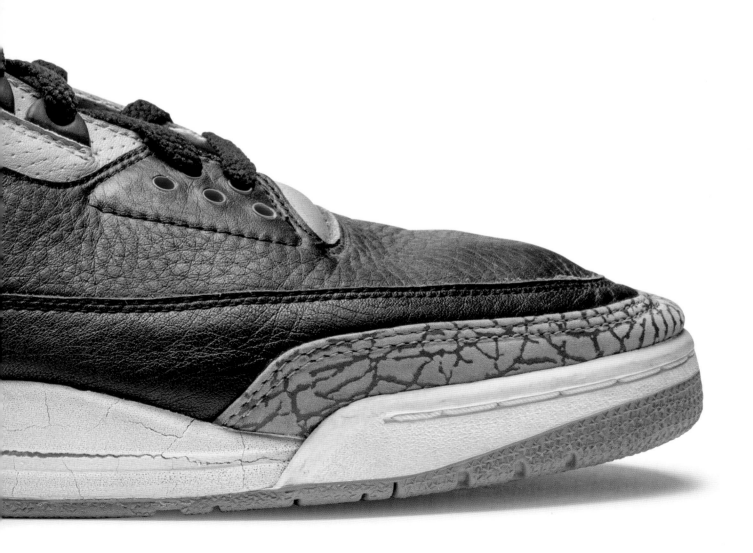

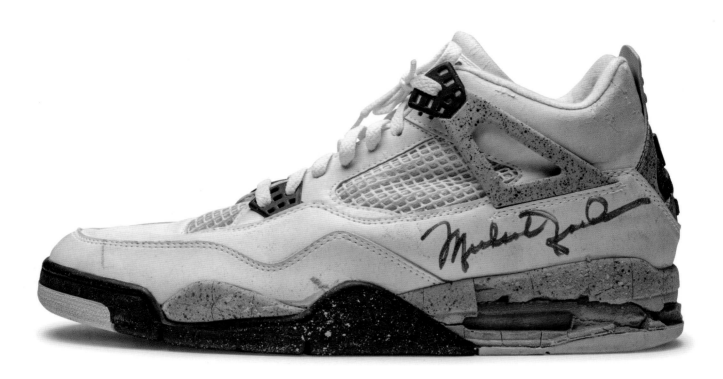

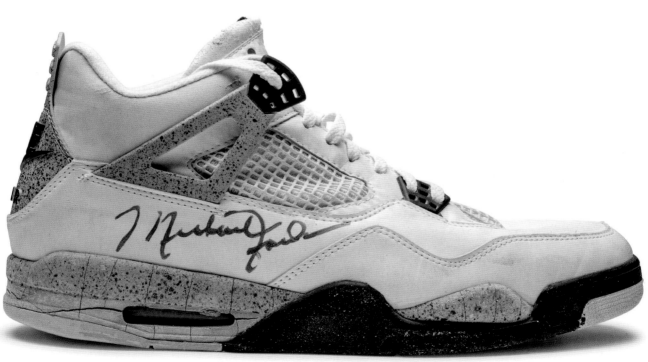

1989: Air Jordan 4 White/Black ('White Cement')

Let's talk about provenance. We all know there are a lot of fake shoes out there, but is there an issue with fake PE models? What experiences have you had verifying authenticity?

When you do it for so long, you learn to spot things right away. It's a very tricky space to navigate, but fortunately, it's hard to fake a game-worn Jordan because each pair was specially coded and has unique characteristics.

Many PE shoes have Feng Tay Player Sample (FTPS) tags, which denote the factory where the shoes were made. Most 'gamers' were signed, so that further cements the fact that the shoes were once in MJ's hands. A signature can be faked, but it's relatively easy to spot.

Besides, a shoe has to have the right documentation, as supplied by the James Spence Authentication or the Professional Sports Authenticator, who are the authorities on signatures. The other aspect of provenance is whether the shoe was used in a game or only used off court or in practice. Given MJ wore a pair every day, there are a lot of different levels. These details are super vital when it comes to pricing the shoes.

Jordan was by far the most famous and watched athlete of his era, so there are a million images out there to work with. Is photo-matching a relatively recent thing?

Photo-matching has been around for a bit, but the importance is a relatively new thing for sure, and it's fast becoming the gold standard and is sometimes required by big collectors. Sneakers are tougher to photo-match than a jersey. The creasing, the markings – there aren't that many obvious scuffs where you can definitively say, 'This is that pair!' Jerseys have mesh holes and patches that are all unique.

How much research is required to play at this level?

I do a ton of research. Many collectors try to match photos to add value right away, although you can use a third party like MeiGray. You send the item to their office and they do all the groundwork. Some collectors will only purchase if it's photo-matched by their service.

It's definitely a hot topic right now. A lot of folks say you need to have a 100 per cent definitive photo match, but I believe there's a middle ground – it's just that the community hasn't figured out what these 'in-between' shoes should be called. Oftentimes there is visual evidence from multiple points, but the resolution isn't totally crystal clear. In those cases, I think a positive determination is still possible.

And how does photo-matching influence value? Are we talking multiples of 5x or 10x the value?

Dramatically, especially jerseys! There's an abundance of jerseys that hit auctions that are advertised as 'game-worn', but without a genuine photo-match, they are automatically treated as an 'issued jersey' by collectors. A signed top would probably fetch anywhere from $10–30k, but if it's photo-matched, the value can instantly skyrocket to $1 million plus!

Jerseys from Jordan's era are rare, as the players only wore a few each season, whereas he broke out a new pair of shoes every game. If a sneaker is advertised as 'game-worn' and checks all the boxes but isn't matched, the value is still pretty strong. The real value increase comes when you can match a pair to a big moment like playoffs or finals. When that happens, the prices can increase by several multiples.

Let's talk storage. We all know that Jordan 1s are indestructible, but pretty much every Jordan 2 and 3 will be crumbling by now. It's heartbreaking, but it's part of vintage shoe collecting. What steps have you taken to prolong their life?

I keep them in a climate-controlled storage vault, though I have a few pairs at home on display. It sucks to have to put your shoes in a vault, but that's more from a security standpoint. I'm personally less concerned about crumbling because I'm a fan of resoling and restoring shoes. Each collector has their own perspective when it comes to restoration, and I completely appreciate the fact that some collectors want to keep them in their original form.

Your Jordan 3s must be just hanging on – the midsoles could shatter at any point. Very few from that era would still be totally intact.

My pair from the All-Star game in 1988 is a unique case because there's barely any cracks. I've never seen that with a Jordan 3, 4 or 5 from that era, so maybe it was the way they were stored, or maybe the

climate they were in was perfect? As a result, I try not to touch them as I enjoy seeing them in their original condition.

But yeah, this might sound crazy, but sometimes I almost want them to crumble so that I can restore them! [Laughs.] To do that, we use the original leather upper and the OG rubber sole and just swap the midsole. It's no longer totally original, but at least it looks good, and you can hold and enjoy them without pieces of polyurethane flying all over the place. Shoutout to @ammoskunk and @a1restorations, who are the masters of reconditioning midsoles.

Is that viewpoint becoming more widely accepted in the collector market?

Yeah. I think this is going to become more and more accepted and preferred by most collectors. Side by side, you're looking at a crumbled pair with a sole you can't touch and doesn't display well, or you can restore them, and 95 per cent of the shoe is still original. I think all game-worn collectors will eventually make this decision.

What was your first big-time signed pair?

The Jordan 11 'Space Jam' was actually the first game-worn pair I ever had. It was the pair Michael wore in the Eastern Conference Finals when he came back from baseball and caught the tail end of the 1995 season. That was the year Orlando eliminated the Bulls. This pair has the number 45 stitched on the back, so it's an extremely rare pair that he only wore a couple of times.

A memorabilia shop in a mall listed them on eBay and had no idea what they were selling. They were displayed in a framed box so you couldn't even see the heel with the 45 on the back! But they were super cheap, and my gut instinct told me it was the '45' game-worn shoe, so I pulled the trigger.

As a young kid, I had landed the absolute gem of gems! When I posted on NikeTalk, I started getting bombarded. Long story, but I got caught up in the moment, and unfortunately, I let them go. Ever since then, I've kicked myself because I love the shoe, the movie, the colours, everything about them. They were the only Jordan 11 pair with the 45 that's ever come to market. And I sold them! I kept collecting, and ever since then, I've tried to track down the owner and buy them back. Unfortunately, they wouldn't let them go. And I was like, 'The only other thing I can do now to fill this void is to find another pair of Space Jams.' Then I thought it would be way cooler to own the pair he wore in the movie!

I got in touch with a couple of collectors whom I knew had a pair, but no luck. On Twitter one day, I saw a comment about Michael Jordan, and a guy responded in the comments, 'Jordan is the nicest. I even helped him on the set of *Space Jam*, and he gave me his shoes.' I messaged him right away. He responds a couple of months later, and I'm like, 'Any chance you still have those *Space Jam* shoes?' Apparently, Jordan wore a few different pairs on the set, including the Concords, which are not visible in the movie.

The odds that he actually had the black *Space Jam* pair were pretty slim. I asked to see pics, and he finally sent them a couple of days later – it's the *Space Jam* shoes! Holy shit!

This guy is now 70. He's a relatively famous actor, I won't say his name, but he was hired to help MJ with a few scenes. We're going back and forth, and he's telling me about hanging with MJ and watching him play on the court Warner Brothers built so he can stay in shape during filming. We started talking prices and I told him about myself and my collection and how important this pair was to me.

We went back and forth for two months and then he just goes dark. I'm like, 'Holy shit, I cannot believe I miraculously found an old dude on Twitter with MJ's Space Jams, and I dropped the ball.' A month later and he pops back up and is ready to sell. We agreed on a price, and the deal was done. I look at that pair differently from the rest of the collection for sure.

I can see why! What's the story behind the film props?

Warner Brothers made them to promote the release of *Space Jam*. They designed a ceramic-style pair of the Air Jordan 7 'Hare' to feature in select WB stores. Very few exist today as they were meant to be destroyed.

Your pair of Sky Force has a really interesting origin story that dates back to Jordan's college years. How did you find them?

A very cool pair and one of my most recent acquisitions. I obtained these shoes directly from the UNC equipment manager. The story, as I was told, is that the shoes were given to Jordan in 1983 during

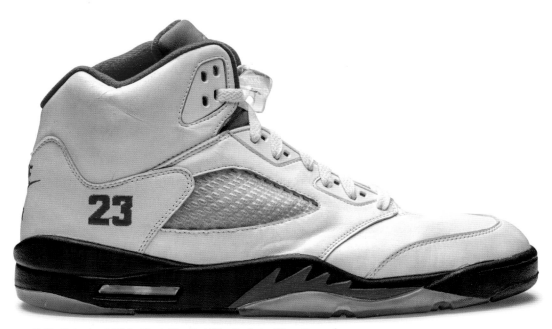

1990: Air Jordan 5 White/Black/Fire Red ('Fire Red' aka 'Silver Tongue')

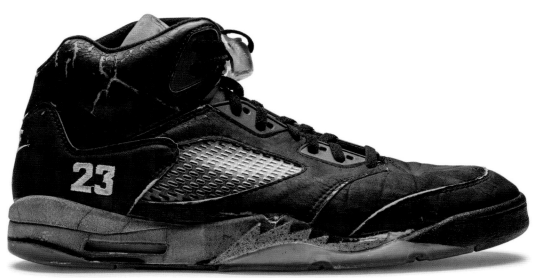

1990: Air Jordan 5 Black/Black/Metallic Silver ('Black Metallic')

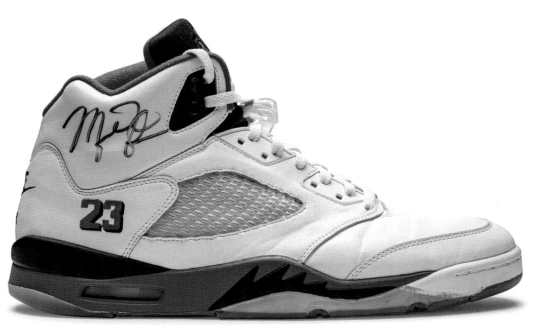

1990: Air Jordan 5 White/Fire Red/Black ('Black Tongue' aka 'Fire Red')

his sophomore year. Jordan was already an up-and-coming star, so Nike started sending him shoes as a recruitment tool. MJ ended up wearing them during practice. Mid-session, he went back to the equipment manager and said something along the lines of 'I don't want these anymore. Give me back my Converse!'.

These Sky Forces feature beautiful early-style MJ signatures, and they've been in the equipment manager's collection ever since. It's a very cool story from Jordan's pre-Nike era and one of the first – if not the first – pair of Swoosh ever worn by Michael.

The Air Ship is another serious find. From what I can see, the leather looks incredible. What a score!

Oh yeah, the Air Ship features really soft, super-nice leather. MJ kicked off his NBA career wearing the Air Ship while Nike was finishing production of the Air Jordan 1. They are a modified version of a production model that suited Michael's preferred specifications. They feature a mid-cut with a shorter outsole as Jordan liked playing lower to the ground. Only a few pairs exist, and I am so grateful to have these unicorns from MJ's earliest moments in the NBA. They're an important piece of history.

The double-lacing pair of Jordan 1s is an interesting anomaly. What have you learned about them?

What's cool about this pair is that MJ only double-laced his shoes once! The Bulls vs Detroit Pistons game on October 26, 1986, kicked off the beef between the teams. MJ was taking it to the hole and Lambier gave him a really dirty hit which inspired a bench-clearing brawl with multiple ejections.

MJ went off for 33 points and the Bulls got the W. But what makes the story even cooler is that Jordan was fouled with one second left. The Pistons walked off court and MJ shot his free throw left-handed – and sank it! This was an extremely meaningful game in MJ's young career.

The Jordan 1.5 is another interesting shoe, which is, of course, a Jordan 1 upper with a Jordan 2 sole. A lot of conjecture around this one.

This pair is super mysterious. MJ wore them in 1986 when he came back from a broken foot – the first of three modified Air Jordan 1s that he wore post-injury. The soles reportedly provided more cushioning for his feet. It's unclear if this shoe is an early AJ1 prototype pulled from the archive or if it was an early version of the AJ2. My guess is that it's an early AJ1, considering the logo says 'Nike' and not 'Air Jordan'. A couple of deadstock pairs have popped up in their original sample box, and they have the year 1984 on it.

How many of the Jordan 1 'Straps' do you think exist, and where do they rank for you? It'll be interesting to see if Jordan Brand gets around to retroing those.

A lot of people are requesting a retro and I'm definitely interested to see Jordan Brand do that. The shoe ranks top three in my collection. It's a unique piece with such a cool story, and to me, it feels like a museum-worthy item. Anything worn by Jordan is cool, but this pair is on a whole other pedestal! It's also an absolute anomaly because Nike literally had someone cut through his normal PE 1 and add the strap.

A couple of other pairs have surfaced, but none show wear like this pair. They were clearly worn in a handful of games, the last being at Madison Square Garden on March 29, 1986. After the game, MJ gave the shoes to a friend of the referee. They were stored away until I was able to acquire them.

Is that where the Jordan 1 x Dunk hybrid comes in?

This is probably my favourite pair in the collection. They're the third and final modified AJ1 that MJ wore post-injury. The 1.5 and the 'Strap' held him over until these were produced. They feature a Jordan 1 upper (high- vs midtop) and a Dunk sole.

He famously wore this shoe in his first career playoff series against the Celtics in 1986, where he dropped 63 points and Larry Bird was quoted saying, 'It's just God disguised as Michael Jordan.' I was able to get them from a ball boy for the Atlanta Hawks.

The Jordan 2 has always been an outlier. How many do you have in your collection? They're probably the most fragile of all Jordans due to their construction.

Yeah, I only have one pair and I personally never loved the Jordan 2,

though I've learned to appreciate them over the years. I kick myself now because they're an important shoe – I especially love the all-white 'Made in Italy' pair. It's a good shoe, but it just hasn't been high up for me.

Now we come to what must be one of your all-time pairs, the game-worn 'Black Cement' Jordan 3s. What an absolute unicorn.

Not many pairs can top these 3s – they're a true unicorn that was worn in one of MJ's greatest career moments. The 1988 All-Star game in Chicago was a homecoming, and MJ wanted to put on a show. He went on to score 40 points, had eight rebounds, four steals and four blocks, and took home the MVP.

What makes them even more special is that he unveiled the Jordan 3 for the first time that weekend. While the 'Black Cement' scheme is widely considered the greatest Jordan ever, he actually only wore them one time in his career, and that was in this game.

Fortunately, with the amount of media at the event, there are some great images that photo-match this pair. The elephant print is unique from one shoe to another, so that was the key!

Yeah, I agree with you there.

Typically in the playoffs, Jordan would switch to a black pair, but for whatever reason, in 1988, he was wearing the 'White Cement' Jordan 3s. In the playoffs, he wore the 'Fire Red' edition. So just, obviously, a one-of-a-kind pair with two beautiful signatures and the killer elephant print. And as I mentioned, the condition is astonishing.

I'm guessing you might have had to dig the deepest to buy that pair. Is that fair?

It's definitely up there. [Laughs.]

Your 'Olympic' pair has a unique story as well. The fact it was worn in a gold-medal game is pretty hard to top. Then there's the controversy around the Nike x Reebok branding, the amazing photo of the players in Dream Team suits with MJ holding the shoes. What a story.

Oh yeah. That's the greatest team to ever play any sport, right? He was wearing that pair when the gold medal was put around his neck, so it's hard to beat that. It has some cool design nuances as well, including custom insoles that you don't really see with any other Dream Team pairs that have surfaced. It's one of the only pairs that actually shows true wear. In my opinion, Michael probably wore them during the last three or four Olympic games, making them even more significant.

How did they turn up?

A teenager named Gerard Gallego worked at the Ambassador hotel where the Dream Team stayed. After the tournament, Jordan was checking out, and as a token of appreciation, he gave the shoes to the kid. I also have Gallego's 'USA Team Employee' security card, which just further solidifies the incredible provenance. They are a really amazing pair from Barcelona!

When it comes to photo-matching the Jordan 7 'Olympics', the sole colouring from one pair to another was unique due to production defects. It's hard to explain. But basically, there's colour bleeding that veers from blue to white and red. There's a crisp, beautiful image of MJ dunking in that game, and you can see the undersole clearly, so I could match them exactly, which was such a big moment. That's when the real value and significance comes in.

Let's say, hypothetically, that pair sells at Sotheby's. Would they command the highest price out of all the shoes you own?

It's hard to say, but it's up there. It's such an iconic team moment, but if you look at the 'Strap' shoe and how unique that story is, then who knows? Then if you look at the 'Black Cements', their significance makes them top three as well. The Jordan 1 'Black Toe' is probably up there too.

Do you ever bug out at the thought of owning the great man's shoes? Michael Jordan's sweat is in these shoes, and the cleats have soil on the soles from when he played baseball. Do you ever get a little shiver that you have these items of historical significance?

When I picked up that first pair, I got a crazy rush and that's honestly why I still collect a decade later. It's like a renewed thrill every time I track down a new pair and open the box. The feeling is addictive, and it *never* gets old.

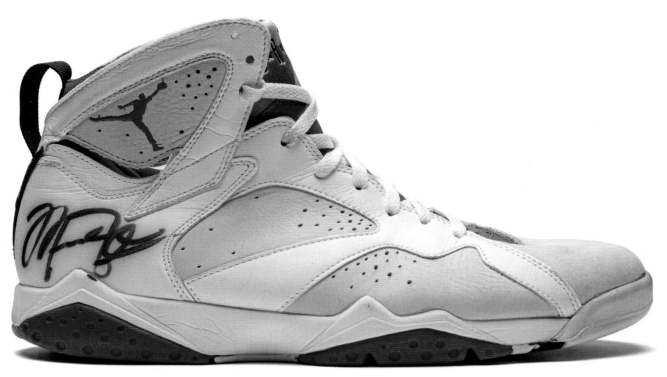

1992: Air Jordan 7 White/Light Silver/True Red ('Hare')
This pair is photo-matched to the night MJ had a 46-point game against the Cavaliers on his 29th birthday

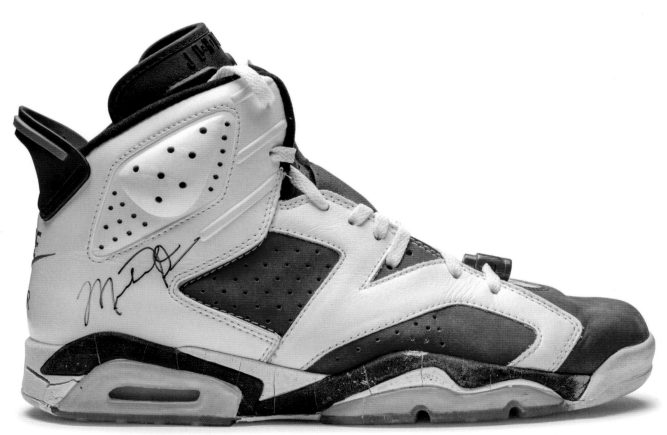

1991: Air Jordan 6 White/Carmine/Black ('Carmine')

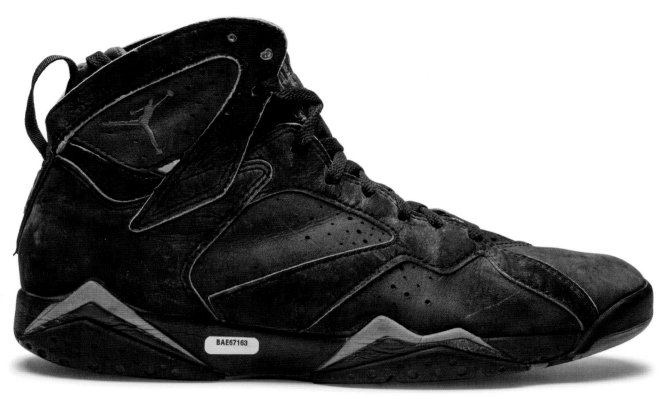

1992: Air Jordan 7 Black/Dark Charcoal/True Red ('Charcoal')

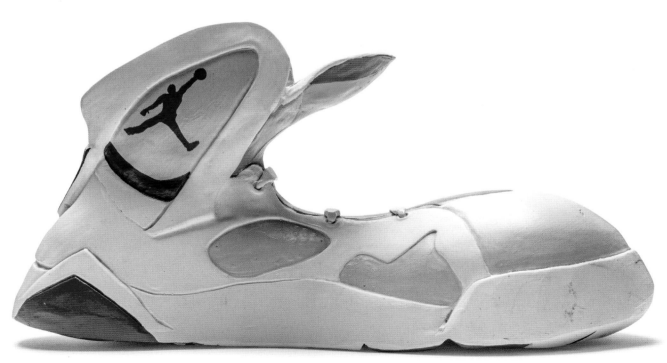

1996: Air Jordan 7 'Hare' (*Space Jam* promo prop made by Warner Bros)

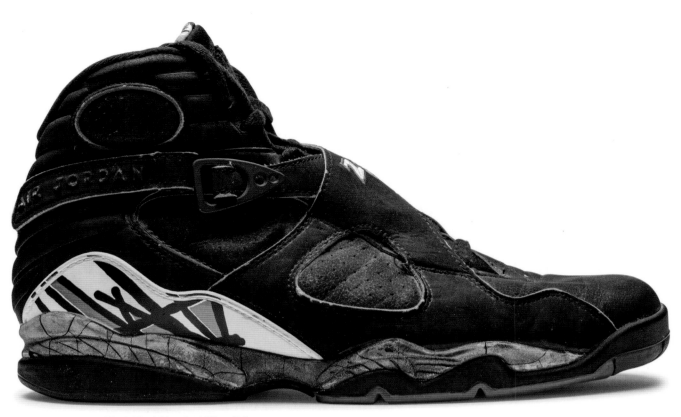

1993: Air Jordan 8 Black/Black/True Red ('Playoffs')

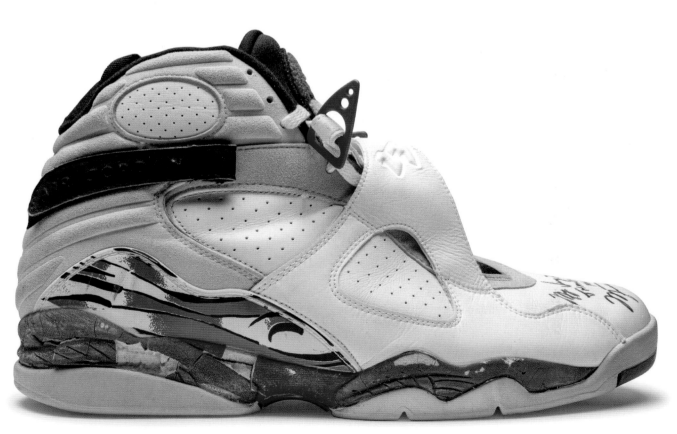

1993: Air Jordan 8 White/Black/True Red ('Bugs Bunny')

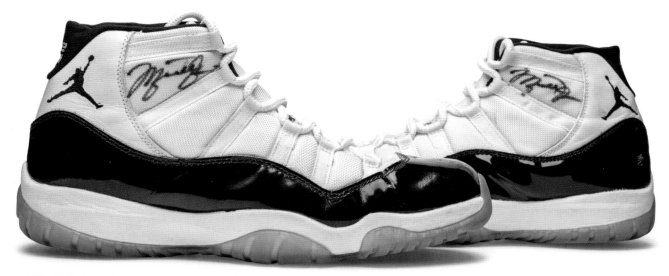

1995: Air Jordan 11 White/Black/Dark Concord ('Concord')

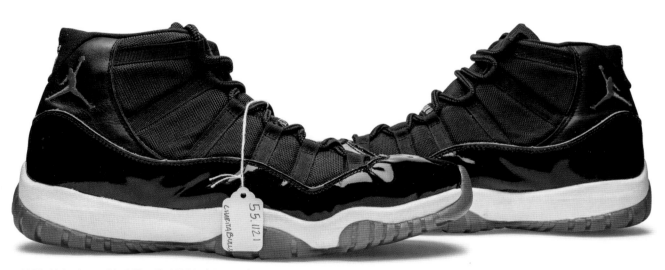

1996: Air Jordan 11 Black/True Red/White ('Playoffs')

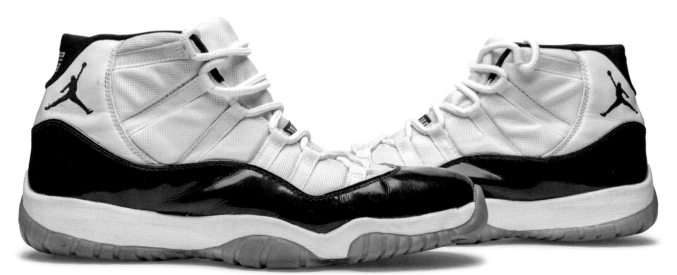

1995: Air Jordan 11 White/Black/Dark Concord ('Concord')

1996: Air Jordan 11 'Space Jam'

'On Twitter one day, I saw a comment about Michael Jordan, and a guy responded in the comments, "Jordan is the nicest. I even helped him on the set of *Space Jam*, and he gave me his shoes." I messaged him right away. He responds a couple of months later, and I'm like, "Any chance you still have those *Space Jam* shoes?" Apparently, Jordan wore a few different pairs on the set, including the Concords, which are not visible in the movie. The odds that he actually had the black *Space Jam* pair were pretty slim. I asked to see pics, and he finally sent them a couple of days later – it's the *Space Jam* shoes. Holy shit!'

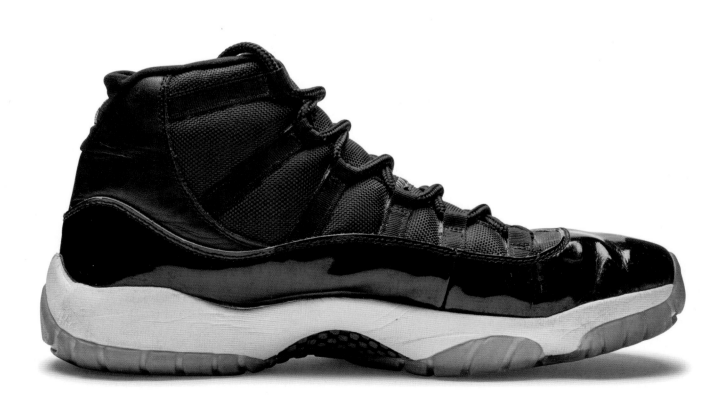

1994: Air Jordan 9 Baseball Cleat (#00 PE)

1994: Air Jordan 9 Baseball Cleat (#45 PE)

1995: Air Jordan 10 Baseball Cleat

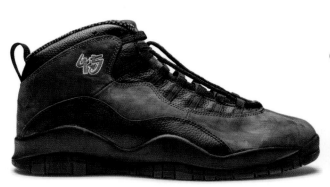

1994: Air Jordan 10 Black/Dark Shadow/True Red (#45 PE)

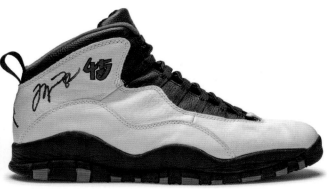

1995: Air Jordan 10 White/Black/True Red (#45 PE)

1996: Air Jordan 11 Low ('Playoffs')

1997: Air Jordan 12 Black/Varsity Red/White/Met Silver ('Playoffs')

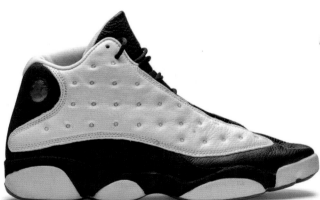

1997: Air Jordan 13 White/True Red/Black

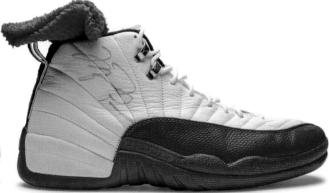

1997: Air Jordan 12 White/Varsity Red/Black ('Cherry')

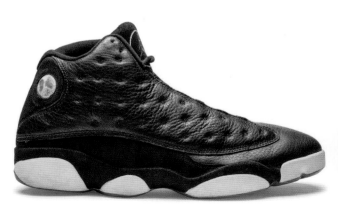

1998: Air Jordan 13 Black/True Red/White ('Playoffs')

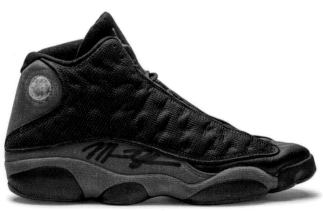

1998: Air Jordan 13 Black/True Red

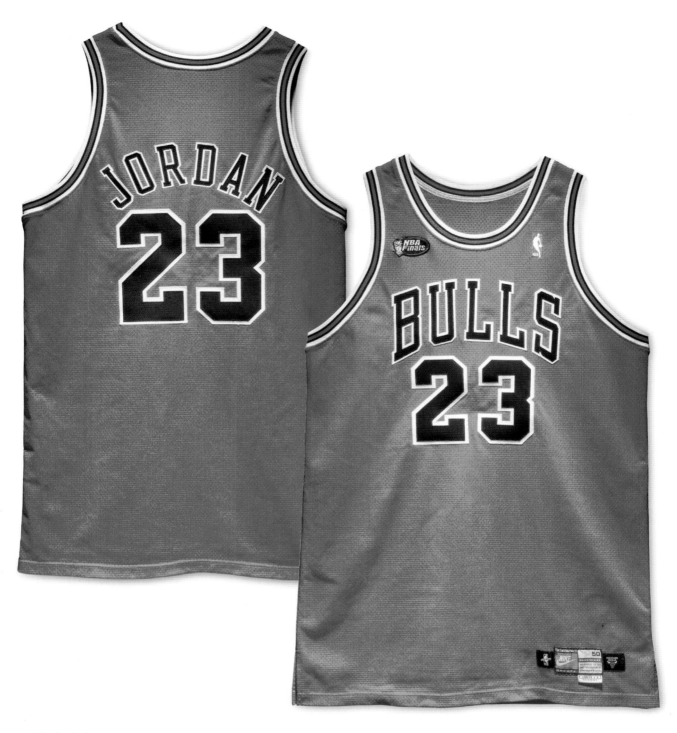

1998: Jordan's jersey from the opening game of the 1998 NBA finals was sold by Sotheby's for $10.1 million in September 2022, making it the most expensive game-worn sports memorabilia of all time

One last question. It's a curly one, so I hope you don't mind. You posted nine anonymous images to IG and blew everyone's mind. When the *Complex* YouTube video went live with your collection – but with zero visibility from you personally – the comments lit up with universal praise and respect. Given all that, I know our audience will want to know how the mysterious @collector10012 had the means to acquire a collection of this magnitude. So yeah, I have to ask… You're only 31, but how the f&%k have you been able to pull this off?

I think really just from my passion. The thing is, you can't just buy a collection like this. It takes an incredible number of hours researching and learning the nuances of each pair and how that impacts value. It takes even more time to track down shoes from across the world. Most were purchased direct from the original owner, and each transaction has its own unique story.

I was also very lucky to get into it when I did. As I said, it was a small group of folks collecting game-worn and signed MJ shoes, and I was fortunate to be there when the market was undervalued.

I started with Dunk SBs. I bought some, then flipped them. I went to sneaker conventions, hustling, looking for opportunities on eBay all day, every day. Everything was done by myself, and it really just started with one pair, then two pairs. Sell that third pair! Sometimes I had doubles, so I sold one, which paid for the next four. That's how I slowly scaled up. Obviously, I never want to sell anything, but if I buy at a reasonable price and then sell at a multiple, I'll use that money to buy more pairs.

This game is not easy. Collecting 60 pairs has taken me 10 years, and I worked hard to dig them out. It's all about the hunt. I bought most of them directly from the owners. That's the secret to my success. Hard work and hustling, you can't beat it! Without the passion, I wouldn't have made it this far.

★

@collector10012

TOMMY
REBEL
GOLD
PLATED

Terra Humara, Humara SE, Silver Bullet 97s, Air Stab, Mowabb, Lava Dome and Son of Lava Dome... do we need to go on?

Interview: **Scram** Photos: **Tommy Rebel**

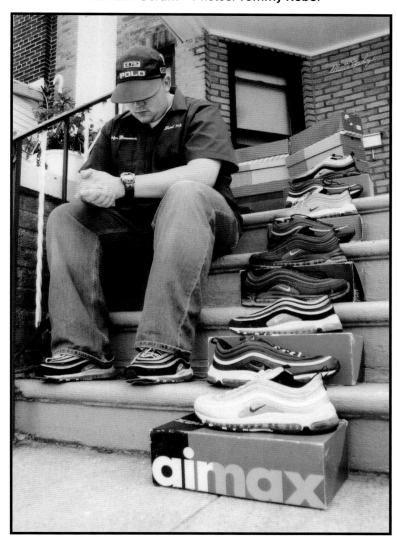

From head-to-toe Polo to Nike ACG and Air Max 'Silver Bullets',
Tommy Rebel loves sneakers the way some people love breathing air.
We asked his old friend Scram to go *mano a mano* with Tommy,
covering everything from his spot in the *Just for Kicks* film to how he
ended up with the only pair of gold-plated Air Stabs in the world.
Tommy has also graciously allowed *Sneaker Freaker* to publish
his personal collection of sneaker shots from the 90s. This is a rare
treat from one of the 'real people' in the sneaker game.

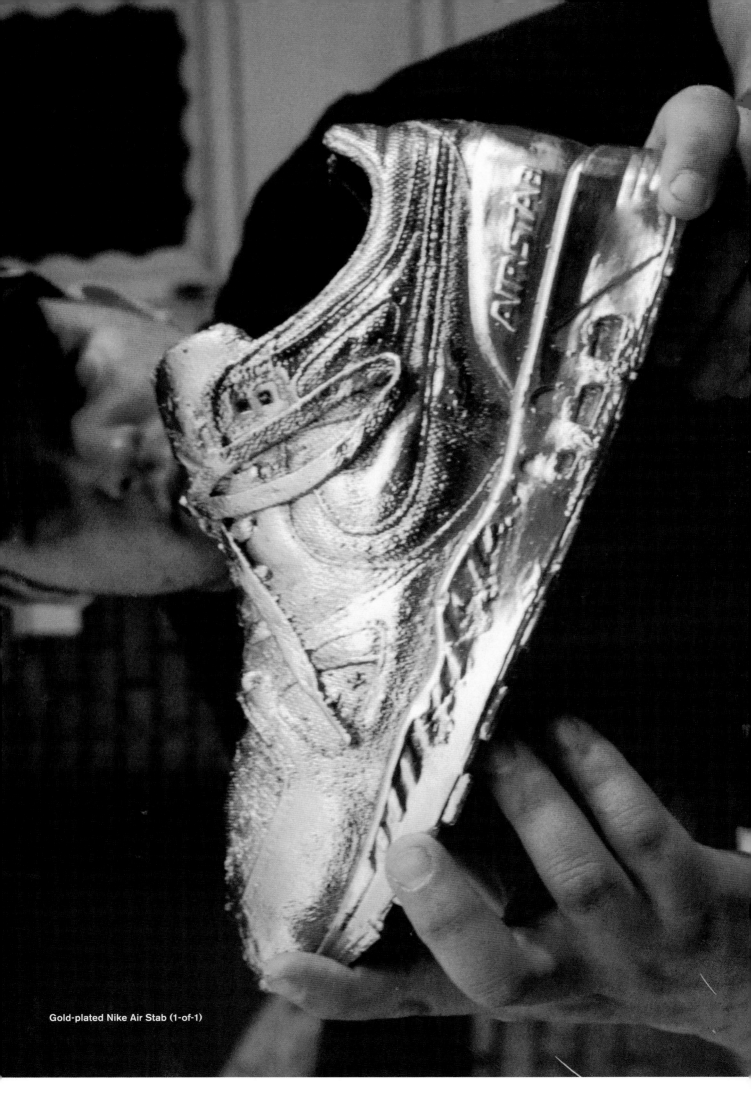

Gold-plated Nike Air Stab (1-of-1)

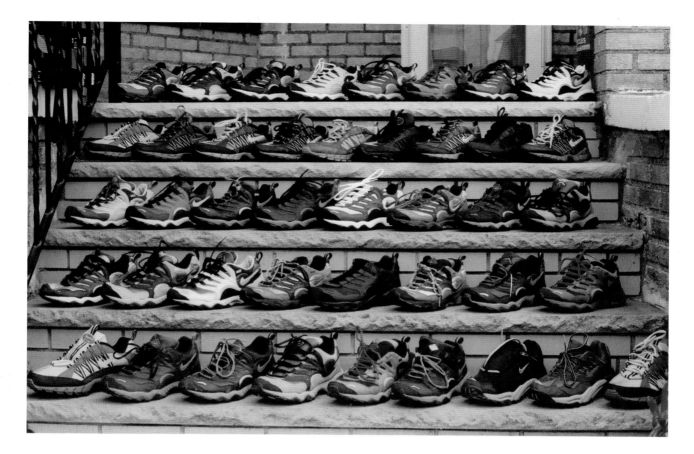

At long last, here we are, Tommy.
Welcome to the Honeycomb Hideout.

Give us a little introduction.
Just a regular guy from the neighbourhood who appreciates history and collects items that evoke emotion.

How did you fall in love?
The first time was back in 1989. My cousin Edward was visiting from California. He was a runner and had a pair of Air Stabs, and I vividly remember, when he wasn't looking, I wore them to the store. I could not stop looking at my feet! Around that time, I remember asking my mother to buy me a pair of Delta Force hightops. After begging and pleading, she finally agreed if I paid half, so I started running errands for people on the block until I had the cash. I was psyched, and then she looked down at me and said, 'What about sales tax?' She laughed, and off we went!

Once you get a taste of keeping stuff clean and fresh, that's where the addiction starts. For me, it was always the colours and materials. You match your shoes with your hat or shirt, and then you put your outfit together. You could wear the same shoe every day if you had to, but you couldn't wear the same shirt. You couldn't wear the same underwear every day, but you could wear the same shoe. So that was your statement piece!

What was the Tommy Rebel uniform?
The uniform varied depending on the activity. If it was school or just hanging out, I was dipped head to toe in Polo, North Face, Nike, Vasque boots and other brands. If it came to missions or graffiti, it was always utilitarian gear like Carhartt, Nike ACG and GORE-TEX.

Fast-forward. How did you come up with the idea of travelling around to buy sneakers?
The idea came from meeting friends in different cities who all shared an appreciation for footwear. During the 90s, if you were into graffiti, you were probably into similar music and fashion, so when visiting different places, you always checked the local spots for old paint in hardware stores, sneakers in sports stores and records. Once someone told you about a spot in a neighbourhood, we were like hawks! Nothing stopped us. We were always on a mission!

We really started digging in the early 90s when we found a spot in the neighbourhood called Circle Army Navy Work and Western Wear. They used to have original adidas Campus and Superstars that were

made in France and came in blue boxes. They were $20, and we bought so many pairs in natural/white, we started dyeing the stripes different colours. The owner let us in the back, where we found original PUMA Clydes made in Yugoslavia with the size punched into the tongue and the cat on the back with the eye. There was NO stopping us by this time. We found so much stuff in the Five Boroughs, and eventually, we had to branch out!

To Philly?
There was a place in Philly called Bill Batty. The guy in the back was Jay. He ran the floor, and we always bothered him to go into their basement, but he never let us in. Every time I went down there, we would bother him and bother him and bother him and bother him. One day we flashed him a wad of cash, and he's like, 'Okay, I'll let you in!' And it was game on. We stuffed the car with so many boxes we could hardly fit 'em all in.

What did you find?
You name it, and it was in the backroom on the second floor. In the basement, hundreds of Nike 'Stripe' boxes, Air Max, ACG, Huaraches, basically everything from the late 80s to around 2000, which is when I was there. A pair of original Delta Forces from 1988 was on the display rack, so we knew they had stuff! Whenever I went on a mission, I knew what all my friends liked and what sizes they wore, so I shopped for everyone. We found limited-edition Nike 'Escape' series and various rare ACGs in the Wilmington spot. In Camden, we found tons of 'Orange' and 'Black' Nike boxes, original Humaras, Air Max, random adidas Torsions and some old boxes of Balances.

Was Jay giving deals?
At first he was kinda annoyed that we went rogue, but once he saw how many pairs we were buying, his attitude changed. Most of the time, these people were happy to get rid of dead inventory but you always had to have a poker face and never let them know how excited you were. It was a game of chess.

There was a store called Joseph's in Philly owned by this Korean couple who had old inventory on the shelves and never gave deals. I haggled with Mrs Parks for hours every time I went in there. One time I found original teal green Air Max BWs from 1991 in my size on the wall. She went out back but never returned with the other sneaker. This went on for years until one day she found it! But she never let us in the back, no matter how much money we had.

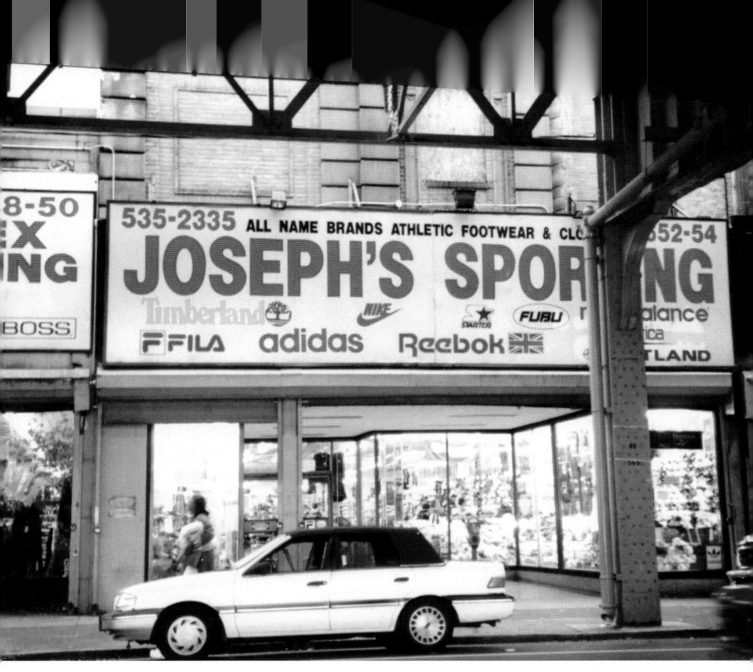

Joseph's store in Philadelphia

The first time we rolled into Wilmington, Delaware, we found a store that had a lot of old stuff. One time my buddy knew about a spot that was always closed, but one day it was open, and I ended up buying Nike mirrors and benches from 1988. I'm searching every crevice in the store and see this mess under the register and pull out an adidas catalogue from 1989. The lady wouldn't sell it no matter what, so I stuffed a shopping bag full of them and just bounced!

Another time I was in Philly and found an Air Stab in the first colourway, but they could never find the matching shoe. The store was a wreck, so down the leg it went. So many crazy stories!

Let's hear about the infamous car crash.
It was a blizzard snowstorm, but nothing would stop us. Some car rear-ended us, and I slammed into the windshield but wasn't hurt. After all was said and done, I was like, 'The Jeep ain't too fucked up, so let's keep it moving!' As a result, the mission that day got cut short. I had tunnel vision because I heard one of the stores we were going to hit had a pair of Stabs. Turns out they only had one half, and that was the one that went down the leg.

You still have that Stab don't you?
I kept it for years. I was so mad because it was only the right shoe! But later on, I ended up catching an original pair in turquoise for $10. They were a little dusty from sitting all that time, so I wiped them down, but when the water accidentally hit the midsole, it crumbled to dust.

I was so mad I punched a hole in my wall! One half looked like a karate shoe with no sole, so I just threw it on my radiator and the other one I just put back in the box.

Years later, we were at this spot in the Bronx called James'. I was paying for some old Mowabbs when I noticed a bronze baby shoe on the counter. So I took the business card and eventually called the company. The guy came by the house with all these baby shoe samples in bronze and pewter, then he pulled out this gold version, and I was like, 'Whoa!' I showed the Air Stab to him and he bugged out. I formed the laces as I wanted them to sit and gave him a deposit.

A few weeks later, I had 24kt gold Air Stabs in my collection. After selling off almost my entire collection, they're the one sneaker I never got rid of, and they're still on display in my house. The price of gold always fluctuates, but at the time it was $720.

How did your parents feel about you bringing all these shoes to the house?
I always lived in the basement, and they really never came down there too much, though one time it was like a big open closet of sneaker boxes, piles of Polo, North Face and paint cans. I guess they had to think I was a little crazy, but I was always a collector, which is something I got from my mom. I guess there are worse things I could have been doing, right? I remember when I was filming *Just For Kicks* – she was here the whole time. I just wish I would have had her on camera saying something. It would have been hysterical.

Mrs Parks at Joseph's, Philadelphia

How did you end up in the film?
To be quite honest, being in that film was a total coincidence. It just so happened I passed by my buddy Kaves' tattoo shop. Ill Bill and Danny Boy from La Coka Nostra were there and they were doing some filming. Danny told Thibaut De Longeville, the director, that they had to go to my house. I asked Thibaut what the one sneaker was that he had always heard about but never held in his hand. His answer was the grey-and-black Bo Jackson cross trainers with the number 34 on the back and the orange tab! Before I let the crew enter the basement, I ran in real quick and grabbed a pair in my size and a baby pair deadstock in the box and handed it to him! He fucking lost his mind!

I don't remember seeing Bill in the documentary.
Yeah. Kaves didn't make the cut either. A lot of my interview never made it in. Kaves had one of the greatest quotes, 'Rich people collect cars, and poor people collect sneakers!' I would love to see that footage nowadays. When I asked Thibaut who was in the movie he told me Missy Elliott and Dame Dash. I was like, 'Any real people in the movie?' He started laughing. I asked him again. 'Who are the real people in the movie?'

People with money are not collectors to me because they can get it easy. The people who skip a meal and don't pay rent for a month are the real collectors. That's the story I want to hear. I don't want to hear about a guy that has money and a personal shopper and gets sent free shit from brands.

You're known for being very anal when it comes to shoes. You can't just buy one pair, for example.
My thing was always if you really like something, one is NEVER enough! I still have that mentality to this day. If you find something you love, you buy as much as you can because they're going to discontinue it, and then you're never going to see it again. So if you buy 10 pairs, you have them until they break. Several years ago, I found a pair of adidas Terrex in GORE-TEX. I've been wearing that model for six or seven years! Now they're totally discontinued. I have one pair left that is brand new in the box. After it's gone, they're gone forever. So now what do I have to do? I got to find the next shoe that I love and repeat the process all over again.

What's another shoe you went HAM for?
Once the Humara SC dropped, I had to have every colourway. Then I followed up with the Terra Humara, Air Stabs and Air Max 97. When the 97 first came out, there was a huge billboard modelled after the Japanese bullet train on Neptune Ave in Coney Island. That blew my mind! Michael Johnson also wore them in the Olympics. I loved that shoe. Super comfortable, and it has one of my favourite things – 3M reflective. I had every single pair Nike ever made in men's sizes. Every pair! At one time, I had seven pairs just of the Silvers in different variations. I also love Nike ACG models like Mowabbs, Lava Domes and Son of Lava Domes. Anytime I found those shoes, I bought them. If it was my size, I bought it. If I had the same colour, I would buy it again.

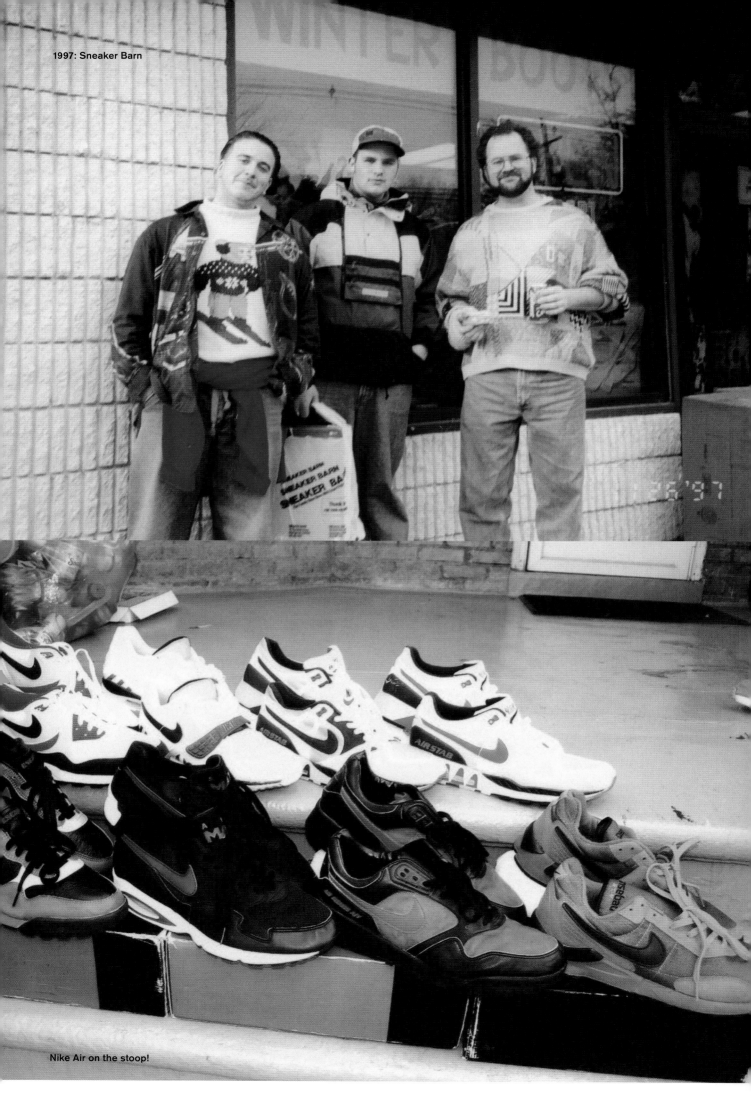

1997: Sneaker Barn

Nike Air on the stoop!

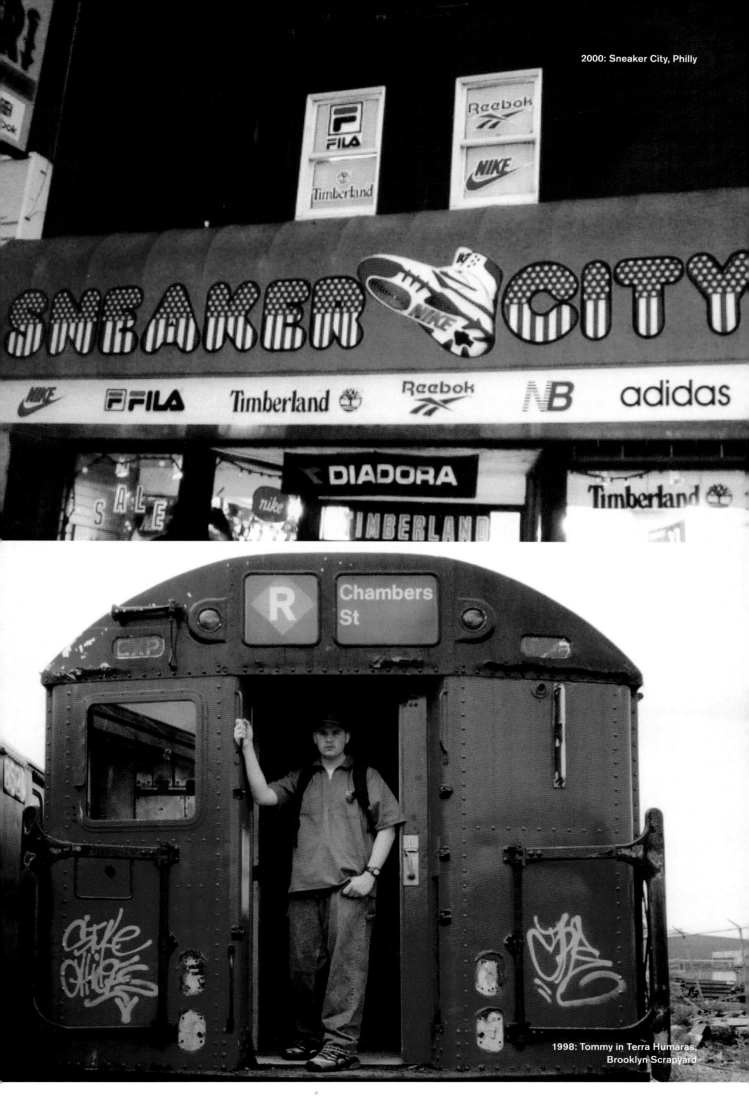

2000: Sneaker City, Philly

1998: Tommy in Terra Humaras, Brooklyn Scrapyard

1997: Scram in Polo

Nike Air Structure

What's with the 3M obsession?

That's a good question. You know what it is? Things happen organically – things that you never really put much thought into. I would say it all goes back to the Jordan 5. When that first came out, my cousin had them in California. When I went out there, they were sitting in the garage, and when we pulled in with the car, the shoe was shining! I was like, 'Oh my God!' Brands started using it more and more, and then it becomes your thing.

I made a jacket in 2006 that I called 'Paparazzi Proof' as it was all 3M reflective. I even made a hat to match and found reflective laces that I used in my 97s. I never ended up putting that into production due to a few issues, and now in 2020, I see all these reflective jackets made by brands.

You never know who or where your influence might come from.

Right! We would go down to Fulton Street and look at what the Black girls were wearing because they always had the shit before anybody else. I don't know why that was. I remember the first time I saw the lime green Terra Humaras on a girl walking down Fulton. Those shoes blew my mind, and I'd never seen that colourway. When I found the women's pair in turquoise, silver and black, I was like, 'Oh my God!' all over again.

Fulton Street had so many spots. Two of them would always get stuff early, and they had sample sizes of future releases, so when buying your mixtapes, you could get a sneak peek at what was dropping. If you wore a size 9 or 13, you might be in luck. Fulton was always a spot that had flavour. Everybody left a little

influence on me, from the old man with his adidas Rod Lavers to the guy with New Balances on the corner.

What about the Air Max 95?

I had a bunch of 95s, but I always felt the toe box was a little narrow. I remember being in the Village and meeting my friend Ramsey. He was talking about this store on 6th Avenue that had the new Air Max 95 display in the window, so we trooped it over there and bugged out.

He was like, 'Yo! It's grey sweatpants and white tees all summer with those on your feet! That's when they first dropped and had the psi markings on the Air bubbles. We LOVED that original colourway, but they never got as much rotation as the 97s. Once I found the Asia release of the 97 in black and silver and neon green, I needed nothing else.

If you could go back in time and get one shoe, what would it be?

That might be a few, but I'll tell you two because we could be here all day. Okay. Let's say top three. I would never pay the price people are asking for my first choice. I don't think the second was for sale. And I could never find my size in the third shoe.

Which is?

The UNDEFEATED Jordan 4 in green, orange and black is, in my humble opinion, the BEST colourway the Jordan 4 has ever been graced with. That's number one. Number two would be the 2004 Nike Zoom Talaria by Stash/Nort in two-tone grey. The last one would be the Air Force 1 Low 'Wheat' from 2001 with the gum sole.

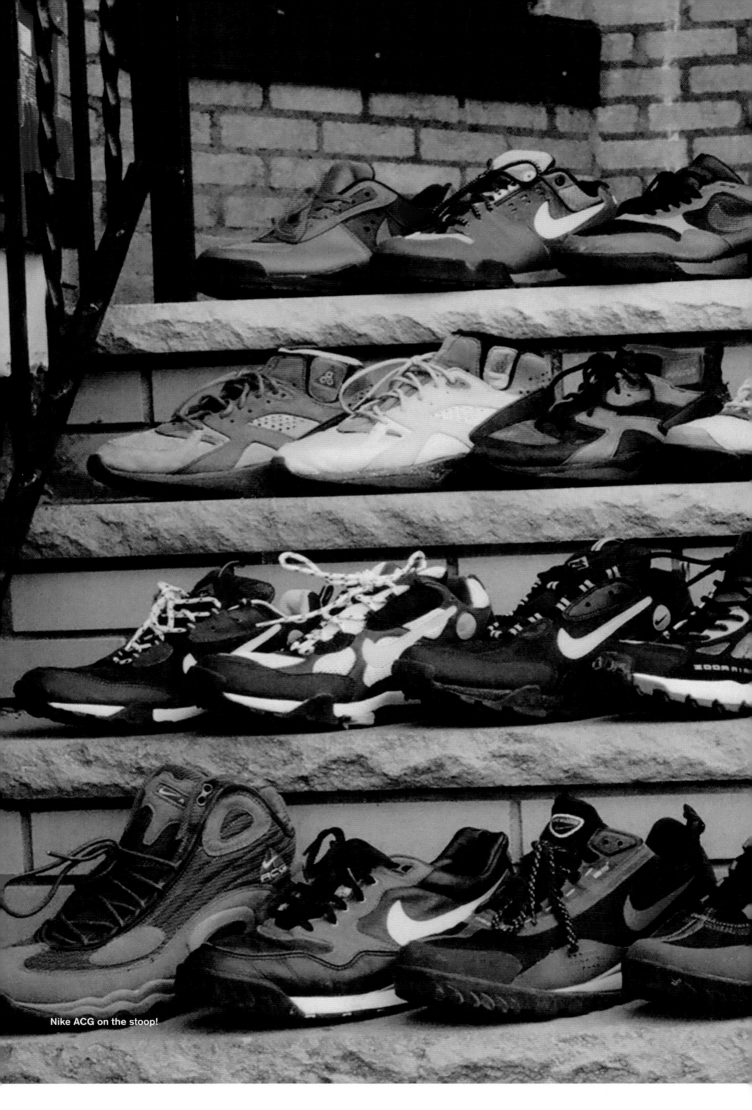

Nike ACG on the stoop!

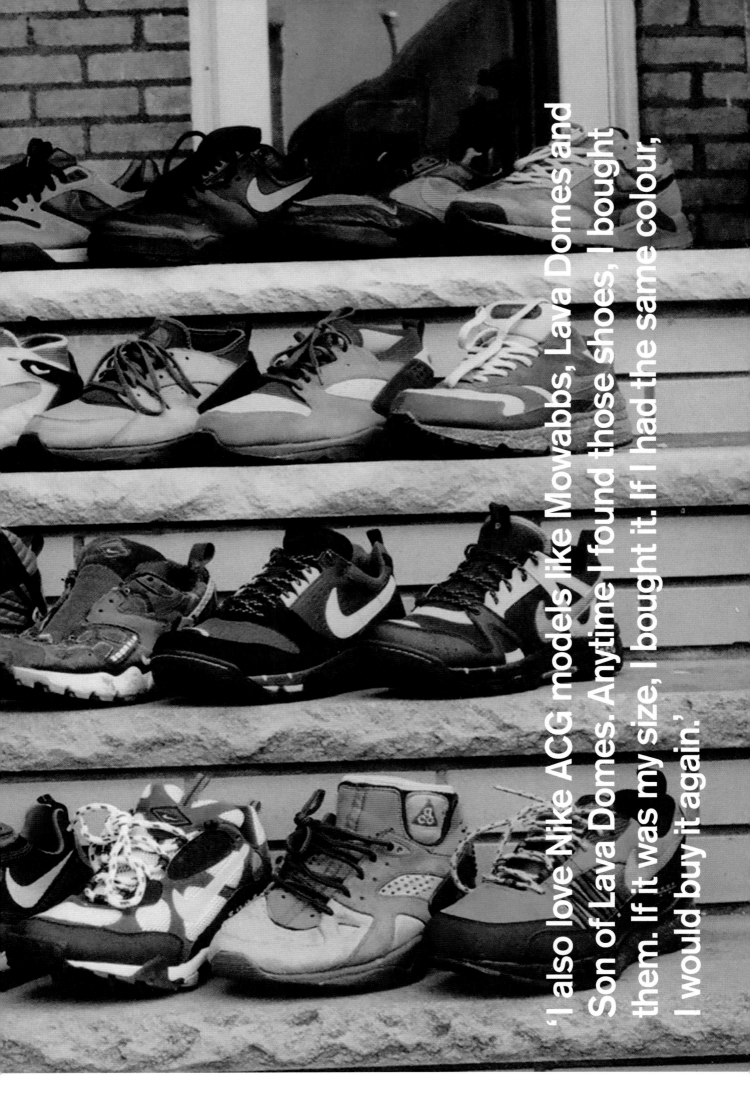

'I also love Nike ACG models like Mowabbs, Lava Domes and Son of Lava Domes. Anytime I found those shoes, I bought them. If it was my size, I bought it. If I had the same colour, I would buy it again.'

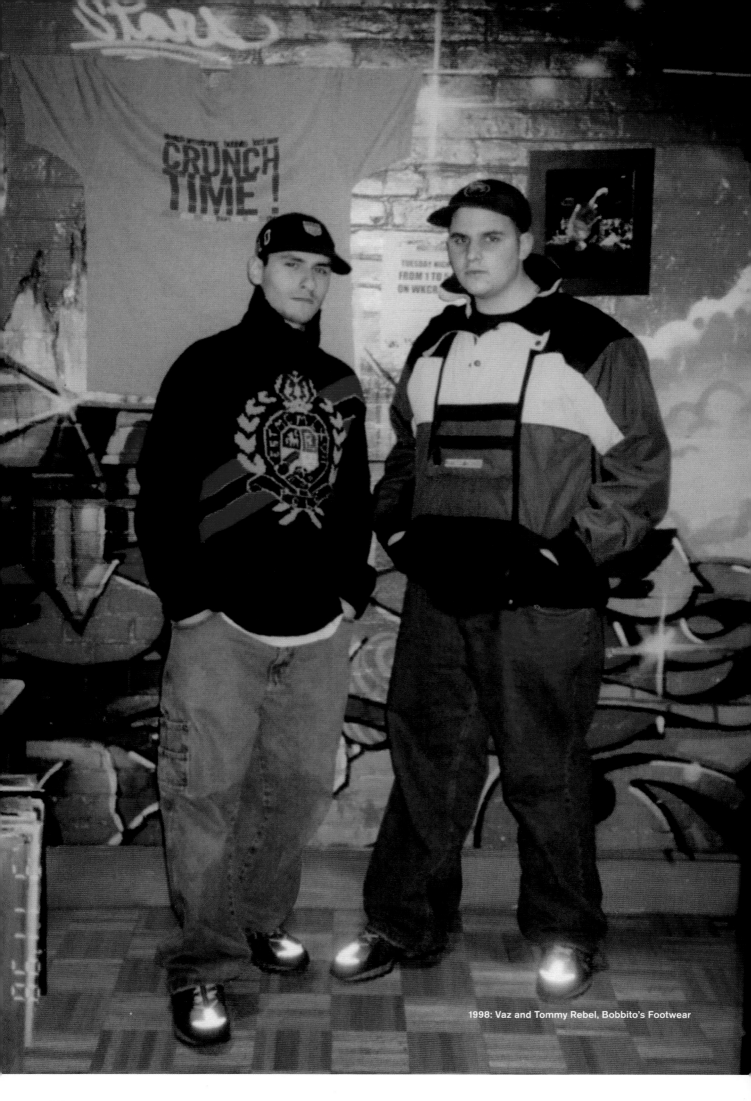

1998: Vaz and Tommy Rebel, Bobbito's Footwear

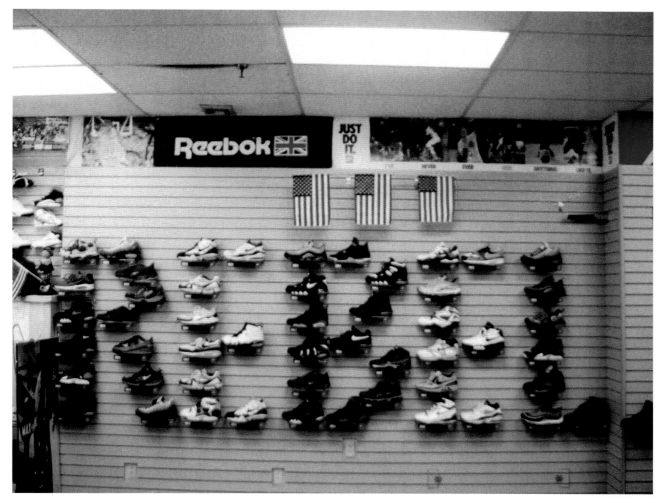

2000: Rebel shoe installation, Sneaker Barn

They're dropping soon.
Which one?

Wheats.
With the gum sole?

Yeah.
I need that. If it's GORE-TEX, I'll need a few of them. For some reason I could never get a 12 ever. Clark Kent got it. He ain't giving it up, though! It was so simple but really good-looking. It was clean.

So it wouldn't be the Jordan 3 in 'Cement'?
I have one downstairs. The 'Cements' are a shoe that you could wear every day for the rest of your life.

Why?
Because it's black, it cleans up well and has good style. But it's got to have 'Nike Air' on the back. And I don't want the leather to be all shiny and plasticky – the elephant print has to be real leather. When they had NikeiD at 255 Elizabeth St (NYC), I told them they should make Jordans with high-end leather and get rid of all this other nonsense.

How do you feel about the sneaker game right now?
The game has totally changed. You can no longer just walk into a store and buy something you really want. Now you gotta go online and race against a bot or enter a raffle. It's more than jumping through hoops – it's an Olympic event just to buy a pair of shoes, which sucks! Why do I have to enter a raffle for a shoe? It's ridiculous. They made it into a mockery.

Brands are still creating great stuff. I just hate it when one brand makes something, and every other brand copies it. I really like what Sean Wotherspoon and Virgil Abloh have done. Frank the Butcher and Bodega always curate beautiful projects. WTAPS, Supreme, Patta and Maharishi are quality. A lot of people who work at brands just collect a paycheque, whereas, for us, it's passion. We want to see stuff done the best way it can be done, and we're not going to cut corners to get there. I look at a shoe and say, 'What's the best way this could be done?'

The first time I bought a pair of New Balance 2040s, I'd heard about the shoe but never seen it. The way they displayed it in-store, it was the most prominent thing on the floor. The lady came over and explained the entire process of making the sneaker, the fact it's hand-stitched, made in the US, and had the history on the sole. I was sold immediately! Now I have six or seven different pairs. The way she explained that product, you know that there's pride there. Too many companies mindlessly pump stuff out and follow trends.

Is that what made you fall out of love?
I wouldn't say I fell out of love. As you get older, it's just not practical to have 500 pairs when you only have two feet. You have so much stuff you've never worn, so it comes down to sticking with something that represents you, something comfortable and practical that you can wear all the time.

Knowing how these sneakers we loved so much were made in foreign countries under 'slave labour' also bugged me. Everyone kinda knew it at the time, but Jim Keady's Team Sweat video called *Behind the Swoosh*, where he explored the factories, and you see the conditions of how they live and work, really opens your eyes to the world of sweatshops. I highly suggest people watch it.

The other thing that made me step away was – after all the years of digging and hoarding – when you finally go to break shoes out, and they end up crumbling, or the bubble blows out. After that happens more than a few times, you come to a realisation that some things aren't meant to last forever. I always wanted to wear my shoes, which is why I never bought or kept anything that wasn't my size. The thing is… everything becomes old eventually!
★

@mrtommyholiday

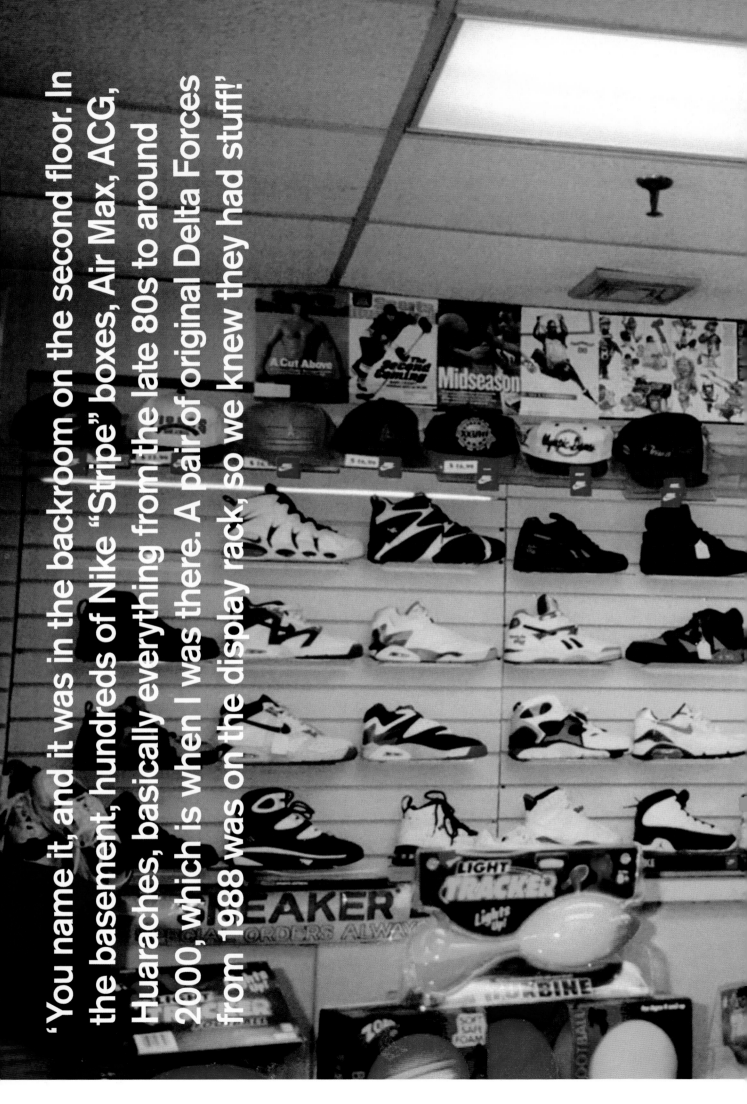

'You name it, and it was in the backroom on the second floor. In the basement, hundreds of Nike "Stripe" boxes, Air Max, ACG, Huaraches, basically everything from the late 80s to around 2000, which is when I was there. A pair of original Delta Forces from 1988 was on the display rack, so we knew they had stuff!'

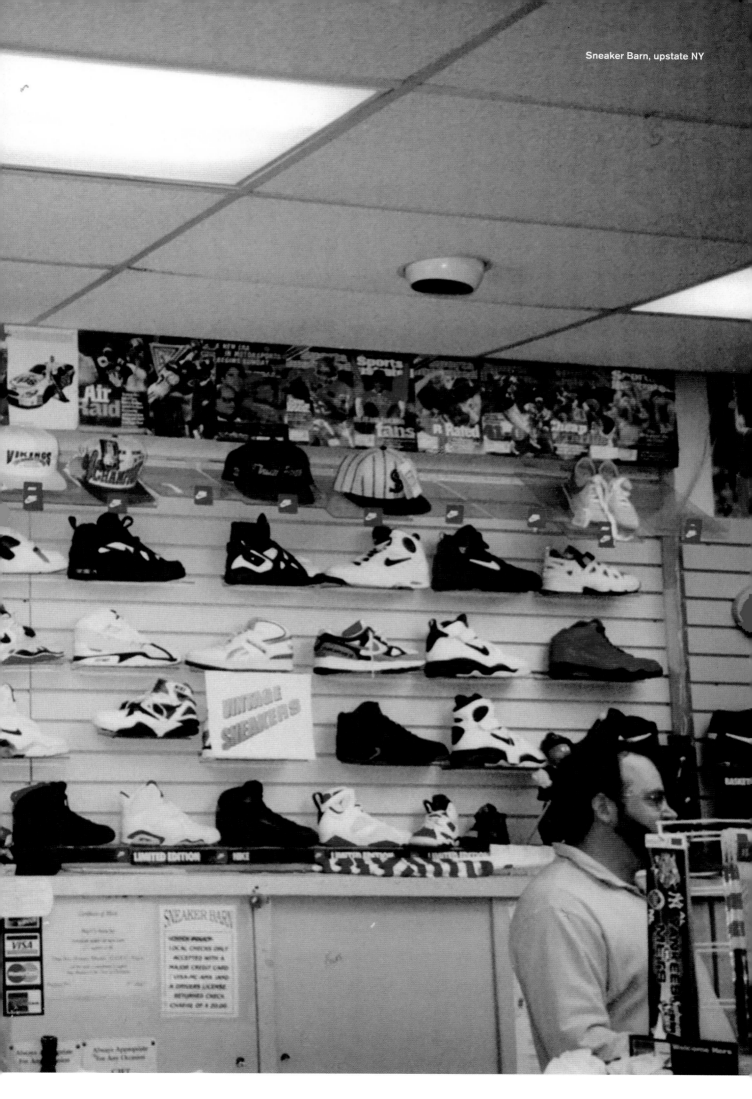

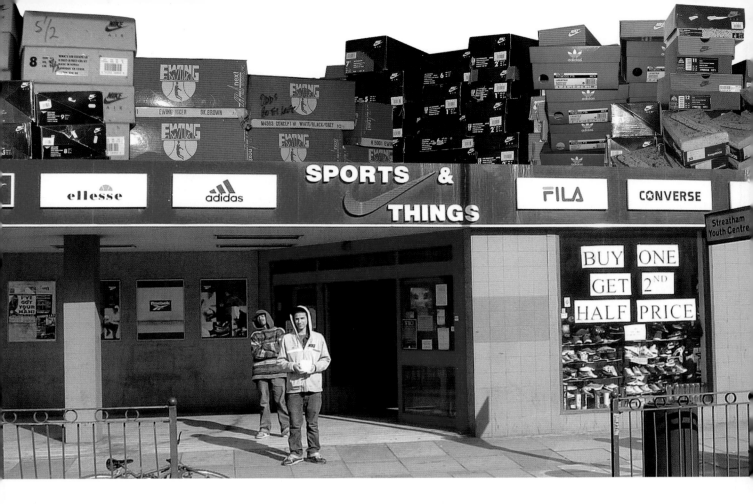

Text and Photos: **Craig Leckie**

DEADSTOCK HEAVEN IN SOUTH LONDON
SPORTS &
THINGS

Deadstock Heaven caused a sensation when it appeared in *Sneaker Freaker* magazine back in 2005. How was it even possible that an entire warehouse rammed with thousands of highly coveted vintage trainers was secretly stashed away below a former supermarket in South London?

As Craig Leckie revealed in this brilliant feature, the truth is that loads of locals did know, but in that (almost) pre-internet era, the news stayed surprisingly tight. Finding the store was relatively easy once you were in the know, but being granted admittance to the basement by the mercurial ownership team required the right attitude and some fast talking. Wads of cash and a firm idea of what things were worth were essential negotiating tools.

Following publication, heads flew in from the US, Europe, Japan and even Brazil to raid the jackpot of jackpots. By the time I finally made it to Sports & Things, the primo stock had well and truly been rinsed, and several burglaries had further compromised the wow factor. Even then, the basement was still a mind-boggling bonanza. Confoundingly, the pallets overflowing with busted boxes were so tightly packed together it was impossible to meaningfully photograph and replicate the experience of being there IRL.

As it turned out, the owners wanted to flip the entire mother lode in one transaction and even offered it to me for a cheap-cheap rate of £1,000,000! In the decades since, I've heard various reports of abandoned sports stores and mythical long-lost collections, but nothing has ever come close to the gritty grandeur of Sports & Things. Are there vintage sneaker treasure chests out there in the wild still undiscovered? Let's hope so!

Woody

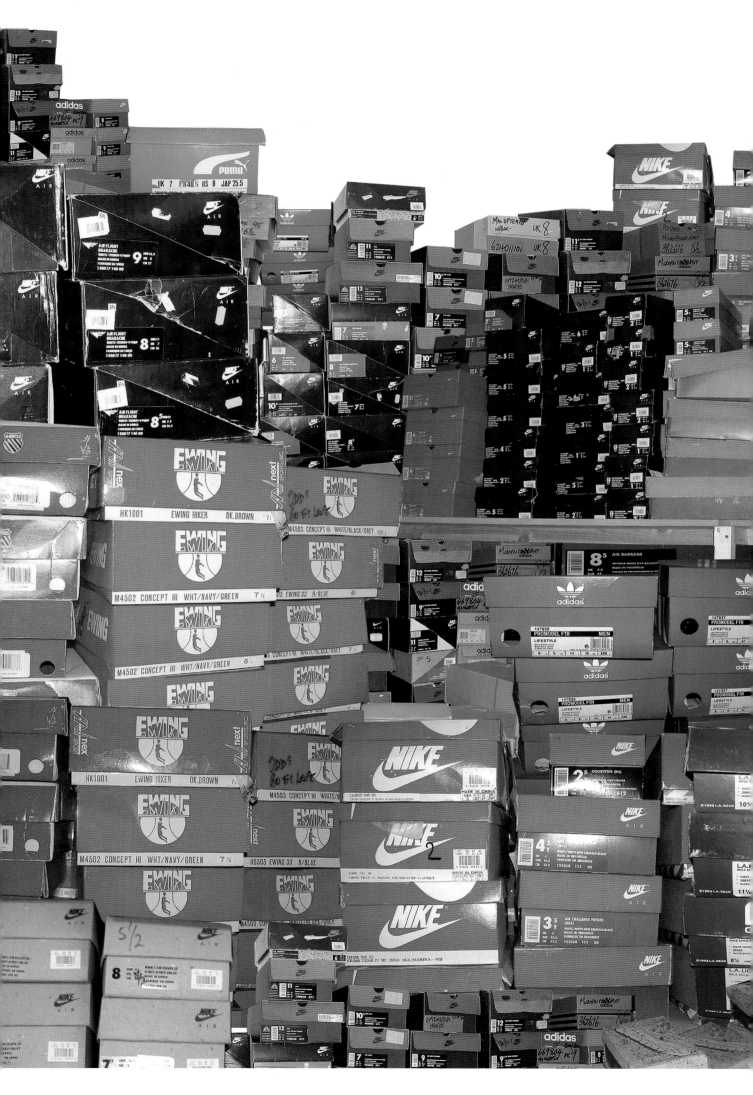

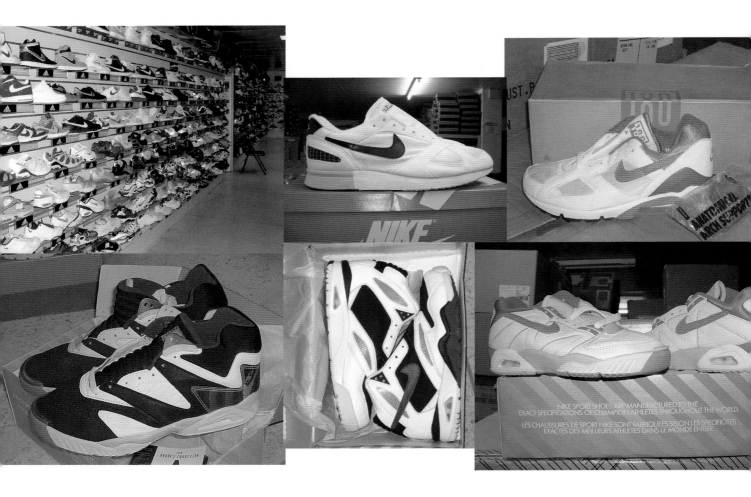

Back in October 1999, I was fortunate enough to experience something that will turn all crate diggers green with envy. While on holiday in New York City, I was granted access to one of the most prolific record emporiums in the world, the fabled Sound Library, situated on Avenue A in Manhattan. [*Note: the store is now long closed.*] If you have a passion for collecting vinyl, then you'll know the shop well. My buddy and I had been hanging out with a friend who knew one of the owners, and he generously offered to give us a tour before the shop opened.

The memories of trawling through the racks that day are still clear in my mind, as is the aroma of fresh paint as the last few licks were applied all around us. The excitement when thinking back to the redolent air in that basement as we hot-stepped down the stairs is still vivid. The vinyl was racked sky-high. Bulk quantities of rarities that, to this day, I still haven't seen elsewhere were fastidiously propped against walls. Flicking through the overflowing crates of classics screaming to be bought was almost too much to withstand. The experience was a humbling one, and these were the very same emotions that came back to me when I experienced a sneaker find of similar magnitude in London.

If you've seen the Doug Pray documentary *Scratch*, you may recall DJ Shadow at the Records store in Sacramento [*Note: sadly also now long closed.*], where the iconic images used on the cover of *Endtroducing* were photographed. One of the most magical sequences focuses on the notoriously camera-shy DJ surrounded by mountains of vinyl relics. Shadow had been a regular customer, just as I had been at the Sports & Things store in Streatham, South London. As was customary for the record store clerks, they used to taunt the world-famous music producer and inform him of the gems they had tucked away. The Sports & Things owners likewise referred to a mysterious vintage hoard they'd been selling off at irregular intervals over the years.

During the summer of 2001, I finally cracked the code and was allowed into the stockrooms. Yep, that's plural! At that time, one small storage area had nothing but a desk, a redundant old computer and hundreds and hundreds of original Stan Smiths strewn all over the floor and piled to the ceiling. This room is now FULL of 'Neon Yellow' and 'Cool Grey' OG Air Max 95s, some even in leather! We had a brief, excitable, yet fanatical look around the other two huge stockrooms. One is full of stuff that's actually for sale. Another basement floor that wasn't particularly easy to access was entirely dedicated to deadstock sneakers of all kinds.

After a long hiatus and discovering that the owners – Boss and his son, Junior Boss – are now actively seeking a buyer for the business, I knew that this Holy Grail had to be documented and shared with the world via *Sneaker Freaker*.

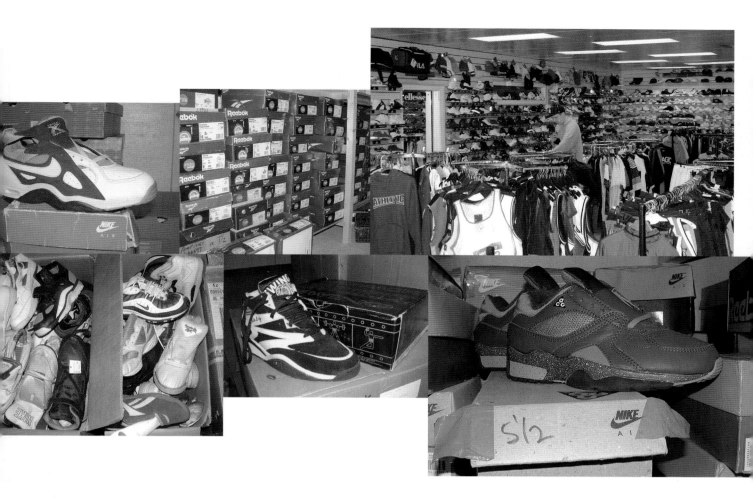

The first time I stepped into the basement, I felt like I was being ordained into a secret priesthood. It was an intimate experience that, to be honest, set my soul on edge. The main basement floor is an old storage room with a biting chill. The ceilings are high, and the boxes are loftily stacked on wooden shelving, one on top of the other, sometimes three deep. There's very little order to the layout, although a random pick will more than likely expose a jewel. A few brands hold court in their own nooks and crannies. PUMA, adidas and quite a few Reebok (Omni Zone 4 in black and mulberry being a highlight) struggle for space. 'Jackie Chan' Instapump Furys take up a whole section. There's even a shoe rack full of women's pastel colours, aerobics inlay cards and cute shoes in the smallest sizes.

A second room is full of neglected brands like Avia, Brooks, LA Gear, KangaROOS and British Knights. Ewing Concept His, 33s and Guards are just sitting around waiting to be scooped up. All the Ewing boxes still contain the plastic lace guards, stickers, product info tags and the famous basketball keyring. Some K-Swiss Classics in white and burgundy and odd pairs of Saucony for the running connoisseur are also to be found.

As a collector, the scale of this haul is difficult to comprehend. In a passionate yet predatory fashion, I find myself grabbing at boxes to expose not only the shoes inside but original monogrammed tissue paper, promotional product info cards (Jordan Flight Club membership, anyone?) and more anatomical arch supports than you could shake a shoe horn at.

After inviting a carefully chosen number of trainer nuts to the store, I firmly believe there isn't another cache of this size in the UK, and maybe even Europe. Who knows, this could be a complete one-off worldwide!

As I brush the dust off a box with Air Trainer 3 SCs in 'Clockwork Orange' inside, there's a cry from across the 'Bay of Broken Dreams' (aka the Air Max section). Behind the shelves, I hear my mate Rixx yelping in elation, 'Holy fuck, look at these Jordans!' It seems he's uncovered original Air Jordan 10s with MVP details on the sole. Then he shows me a box of kids' Jordan 1s. Then another whoop and more expletives as he discovers OG Jordan 3s in white and black. 'Jeeesus, there's even more Jordans over here!'

I return to where I'd been dusting off a stack of Huarache Internationals, and some PUMA boxes catch my peripheral vision. Sadly, I find few styles of note, but then it hits me, a box that says 'Basket Leather'. As an owner of Baskets, Super Baskets and Clydes in several colours, I almost soil myself as I lift the lid. At first, it's the grid-pattern gum sole, but then my eyes light up as I discover the white-on-white Puma Baskets in leather with a perforated flash. Utter perfection!

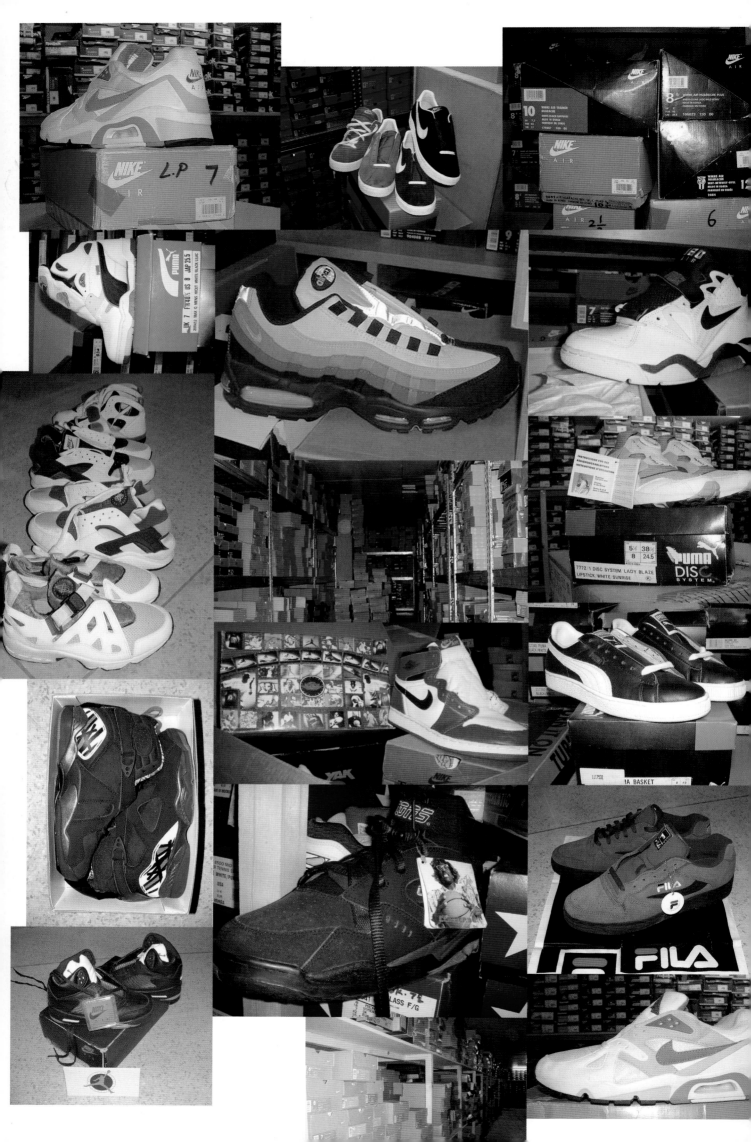

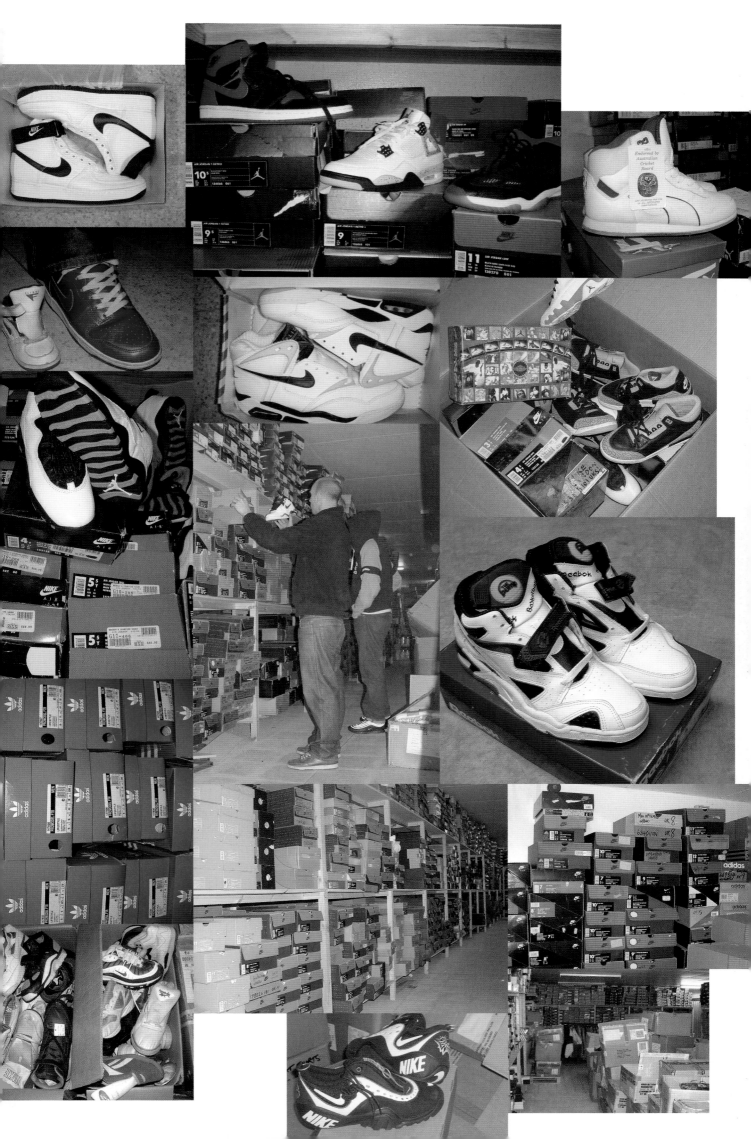

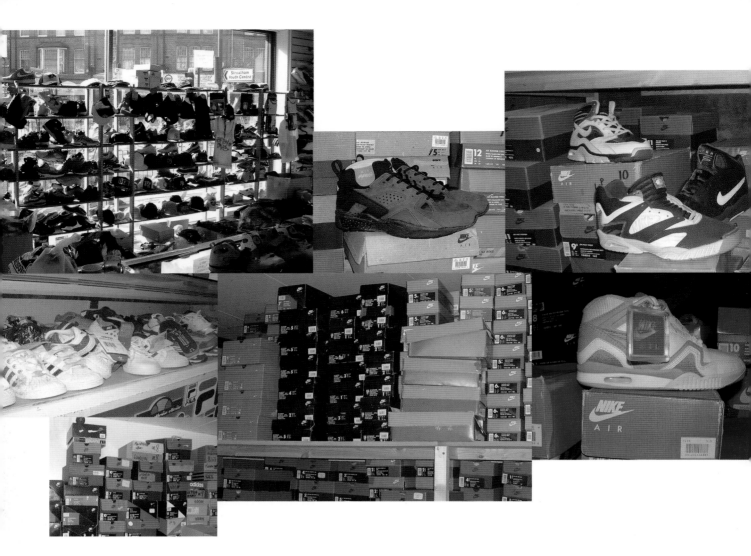

At one stage, I think to myself, 'Wait a minute, I haven't spotted any Uptowns'. Within seconds I peek behind a bank of Nike ACG Mowabbs in their recycled boxes, and there they are – a pristine pair of Nike Air Force 1s in white canvas with black trim. This truly is deadstock heaven.

A wall of really old Chuck Taylors is located nearby, but sadly, these have seen better days. Remember, kids – sneakers are perishable goods, and glue doesn't stick forever! There's something of note at virtually every turn, like Nike Air Max Accelerators in purple and black – an exquisite shoe for balling, as I remember.

A selection of FILA FX-100, as well as several Nike Air Bounds, appear. Black-and-orange Air Max BWs, Pegasus and Air Mad Max with purple trim hold our collective attention span for just long enough until another unearthing occurs, this time some OG Air Raids. 'The straps!' Rixx hollers again. 'This is too much!'

I stumble upon some Air Flight Mids in Lakers colours from 1991 (worn originally by Cedric Ceballos), and then I find the same design in navy and red. There's a small stash of 'Big Window' Air Max designs from the early 90s. I uncover a pile of unblemished white-and-fluoro Duellist PRs, several Infrastructure Plus and Air Huaraches, as well as one solitary OG pair of Air 180s. Air Magnum Force, Air Escape in black and green leather, Andre Agassi's Tech Challenge line, Air Uptempo, Nike Baby Sport and literally hundreds more designs have been in this basement since they were purchased not long after the store opened in 1991. According to the owners, many other pairs were picked up at bankruptcy auctions across the US during the mid to late 80s. All the stock came from reputable sources – no variants or counterfeits have ever sat on these shelves!

The staff are some of the most obliging and knowledgeable in the game. If there's a shoe they don't know, they'll dig hard for it. That might take a while, as there are thousands of boxes here, but they'll check. As they admit themselves, they still use paper files with dog-eared pages for inventory, but every single pair is listed, so the hope is kept alive. If they do unearth one of the gems you have in mind, it's a guarantee you'll pay a fair price. Most have been on ice here for some years, remember.

This remarkable family-run shop is located in a gritty area of South London. It's a sleepy and highly parochial neighbourhood at times but a far cry from the pretentious reissue-wearing wannabes often found in Soho. There may be a tad bit of mean-muggin' going on, but that's to be expected around these parts. The majority of kids that shop here are from Brixton and Streatham – both areas of social and economic deprivation – with some travelling from

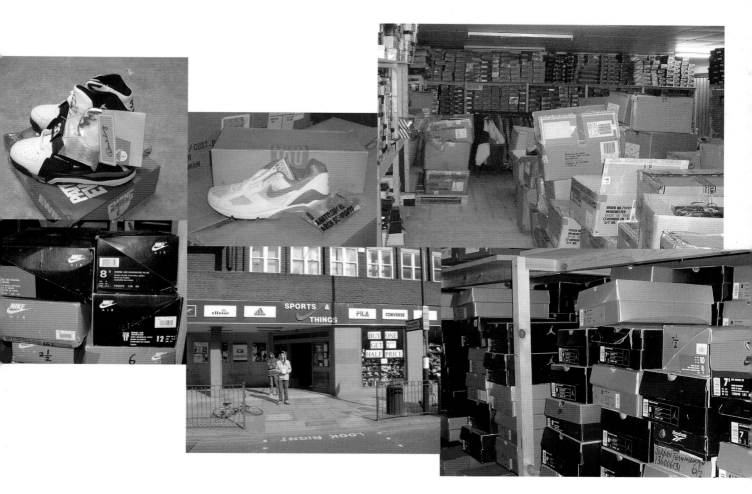

further afield for this truly original retail experience. The staff say they used to get Japanese kids coming in every few months, but lately, they've found something else to spend their money on. The number of times people have queued at this store overnight for a Quickstrike release, you could count with no fingers!

At Sports & Things, they work at their own pace, and they rush for no man. Junior is bright, friendly, sharp and savvy. Despite his tender years, the store owner's 'progressive youngster' son could school more than most on his specialised subject. Between my pals and Junior, I didn't know whether I was in the basement of a sports store, courtside at a Knicks game or a fly on the wall at a Nike marketing meeting in Oregon circa 1990.

Boss is an erudite old boy. He's a mindful sneaker magnate, a reserved yet quick-witted gentleman that doesn't need to move too fast. He has other people do that for him, namely his comedic younger brother, who's also on staff. As well as being aware of trends, Boss still makes regular trips abroad. As an elder statesman of sneaks, that's quite an accomplishment.

Far too often, independent sneaker boutique owners are unaware of the vintage/deadstock game as they're more concerned about where their next overpriced rent check payment is coming from. Sports & Things is no more interested in eBay shenanigans, launch parties, Quickstrike releases and fancy finger food than you are in chewing on your own feet.

If you do have an enquiry, don't expect a reply within five minutes or even five days – they like to take their time and do things the old-fashioned way. There's no preset price structure, so you need to know your shit. The lease is up for review in 2011, so that's how long you have to save up and get yer asses down there. Alternatively, get your negotiation hat on and make Junior a serious offer he can't refuse.

★

@randomrapradio

Thanks to Boss, Junior, Brad Farrant, Rixx Firth and Mr Rek-Shop (aka The Raiders of the Lost Ark), without whom none of this would have been possible!

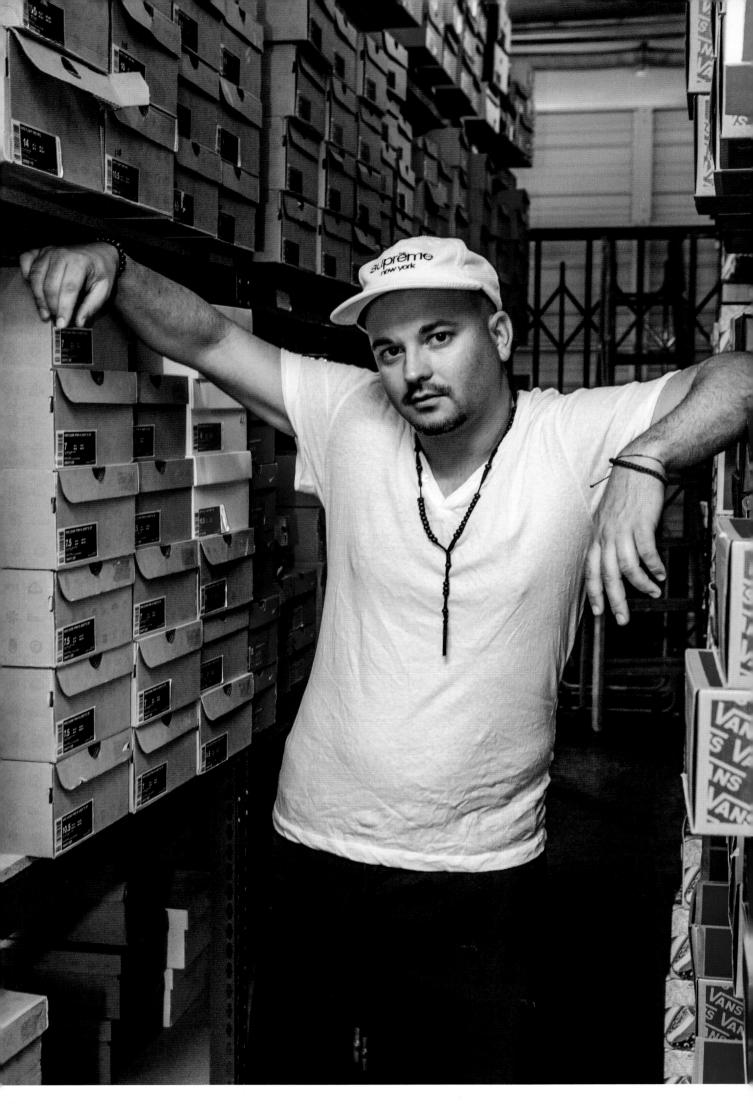

33 PAIRS OF PARIS DUNKS

CROATIAN STYLE

It's the year 2002. A nascent sneaker scene is rapidly escalating into a global frenzy. Nike SB collaborations with Supreme, Zoo York and Chocolate Skateboards are giving the new sub-brand an appeal that transcends the skate world. As part of a looming *White Dunk* exhibition, an uber-exclusive 'City Collection' is tantalisingly teased. The first release is slated for Paris, where artist Bernard Buffet's design is about to drop to relatively minimal fanfare. Watching closely from California is Andre Ljustina. Stealthily snapping up every pair he can find, Ljustina bides his time until the moment is right. BANG! Out of nowhere, a post appears on NikeTalk showing an astonishing 30 pairs of 'Paris' Dunks, rocking the fledgling sneaker world and establishing a new benchmark for hype. By the time the 'Pigeon' Dunk is released a few months later at Reed Space in New York, the scene has undeniably changed. Camp-outs, riots and four-figure mark-ups make the Pigeon front-page tabloid news. Two decades after that seminal moment, Ljustina has elevated the art of collectible sneaker retail with his business Project Blitz. Name a dope shoe, and he knows how to get it, but you'll have to pay the price!

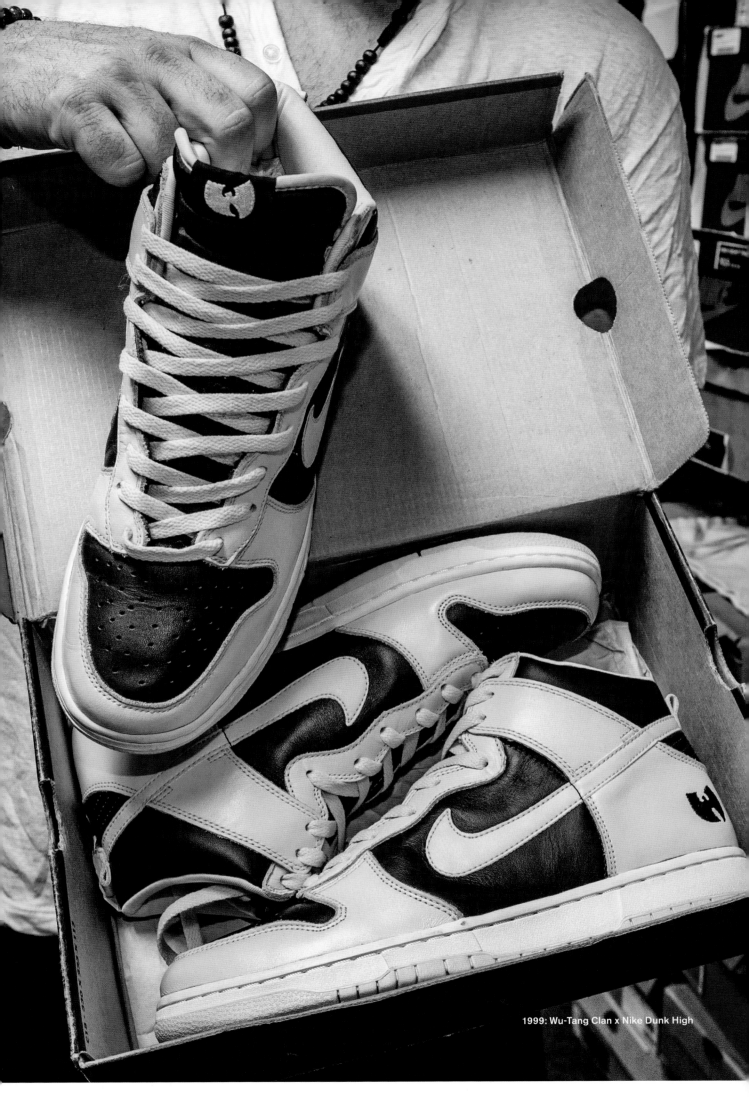

1999: Wu-Tang Clan x Nike Dunk High

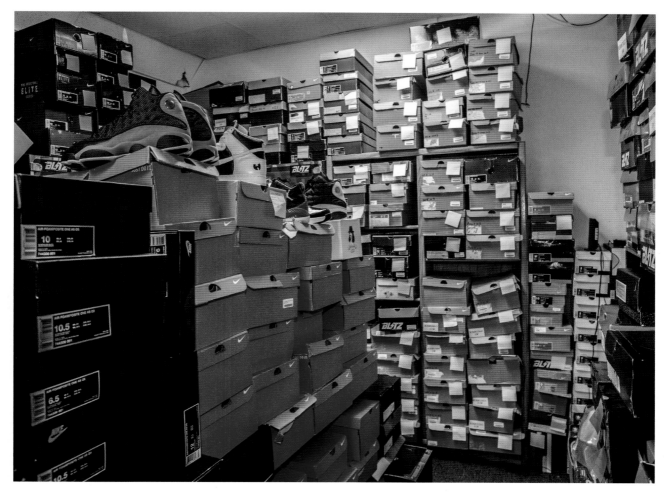

The Project Blitz backroom looks a lot like the Sneaker Freaker office, only neater

What do you say when people ask you what you do?
Well, if it's a hot chick, I usually tell them I walk dogs.

Does that work?
Yeah, it does. [Laughs.]

Man, I wish I knew that 20 years ago. I was curious because 'reseller' has a bad vibe these days. You're clearly on another level to a casual flipper, but how do you feel about that word and the stigma attached to it?
I've never called myself a reseller. I've always been an enthusiast and a collector first and foremost. I'm not going to tell people I walk dogs, obviously, I'm going to tell them I own a company with a website and a VIP shopping warehouse with 15,000 sneakers. I source product. I curate the collection globally and offer it to my clients, who are collectors. I've never looked at myself as a reseller because I'm not sitting there trying to flip a few pairs before the week is over. If you own a store that's buying product from Nike at wholesale and selling it, you're a reseller. If they're not called resellers, then I wouldn't call myself one either.

Fair point. I guess you're a bit like a pirate, you're outside the industry and all the controlling tactics that Nike use. Ultimately, you have freedom, at a cost.
Yeah, it's definitely a double-edged sword for sure. There's always a pro and a con with either route. This is not a consignment store like the ones popping up all over the country with people bringing stuff in and the stores act like it's their own sourced supply. I'm trying to develop a different model here with Blitz. This is more of a gallery and showroom. It's not a cookie-cutter, brick-and-mortar store with T-shirts on one side and shoes on the other. We actually own our entire stock outright. We offer things that are under $100 up to tens of thousands. I'm not all about the hype shit only. We do have celebrity clients, but my whole thing was to always have size runs for people from all sorts of backgrounds.

How did you start selling shoes?
I grew up in Hawthorne, California, between the beach and Compton. Everyone here was always conscious about what they wore, but if your shoes were shit, you were nothing. You could wear swimming trunks and a tank top, but if you had Bo Jacksons on, you were the man. We were ditching class to go wait in line and be the first ones at school wearing Jordans. That was the best feeling. I remember when the Jordan 1, 2 and 3 were retroed, but nobody cared because everyone wanted the new shoes. At some point I just kind of drifted off. I went to Europe and my friend Jae was telling me that Jordan 5s are coming out again. That's the one shoe that I regretted never having! I also missed the 4s, I wanted the white ones, he loved the black ones, and we went on a mission trying to track them down. We went everywhere, no luck, so I started looking on the internet. This is like 56K dial-up time. If you went to eBay and searched 'Nike Air Jordan', there were maybe three pages of shoes, that's it. I remember I finally saw those 5s in my size. I saw the price and realised the eBay seller wanted $20 on top of retail. I asked him why he wanted $20 and he was like, 'You can't get it anywhere else. That's why you're trying to buy it from me!' Right there at that moment, I knew that there was something to this and everything just started from there.

I presume it started as a hobby rather a business?
I was never into Air Force 1s or Dunks growing up, they meant something in New York but not on the West Coast. Here, it was all about the flashy stuff. On NikeTalk, people were talking about Japanese magazines like *Boon* and *Street Jack* and I started converting the money they wanted for Dunks in the mags and realised that it was triple or even quadruple US prices. Then I noticed Japanese collectors had been buying all my Foot Action Dunks. One guy from Japan asked me about bulk shipments and that was the turning point. I started branching out by getting 'Puerto Rico' and 'LA' Air Force 1s for him and they were sending the Japanese stuff to me. One thing led to another and I was basically controlling most of that market in Southern California. Being around those old-school styles gave me an appreciation for them, and that's when the SB craze hit.

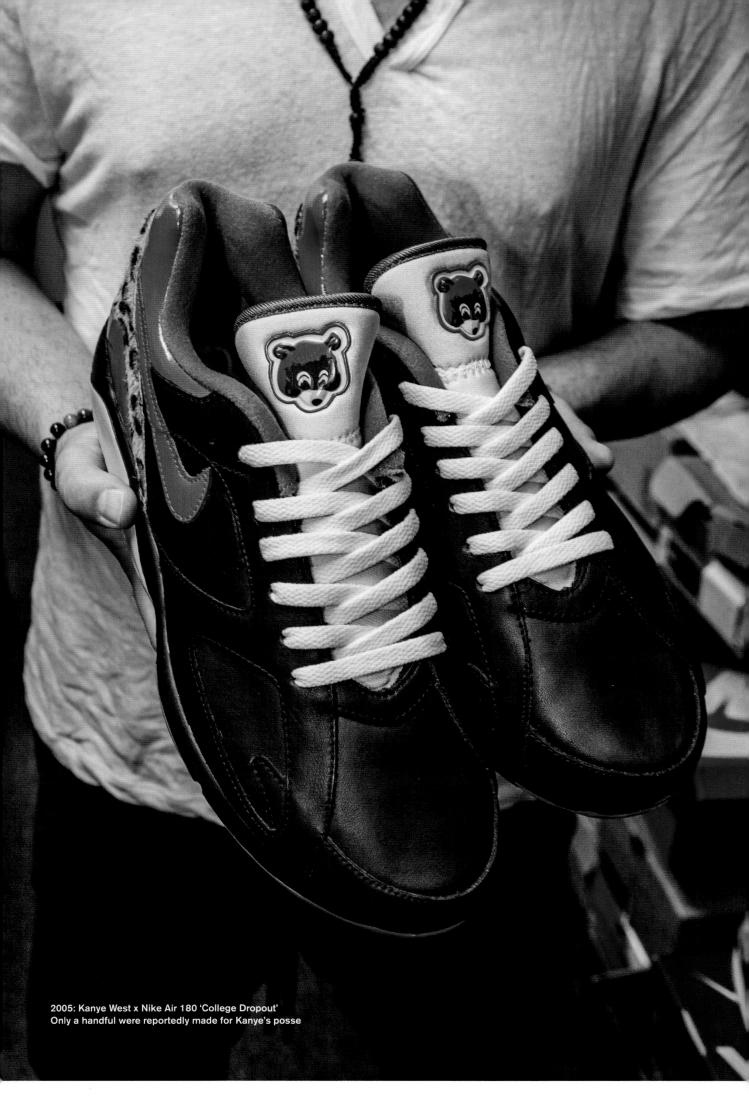

2005: Kanye West x Nike Air 180 'College Dropout'
Only a handful were reportedly made for Kanye's posse

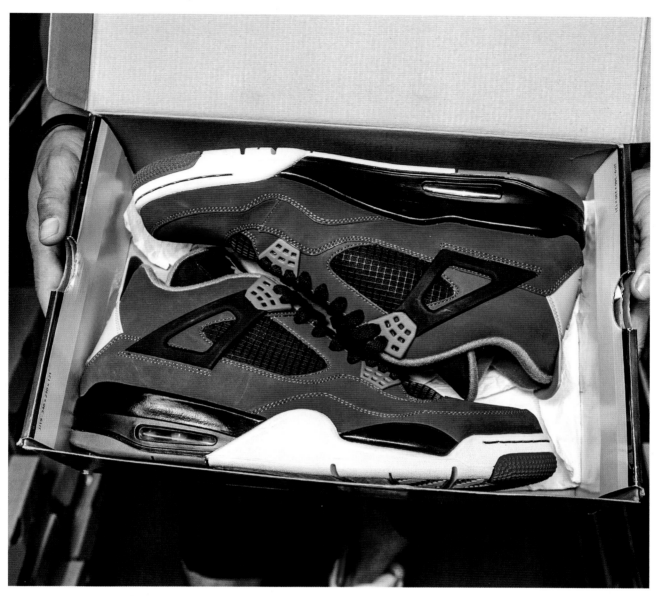

2013: Air Jordan 4 'Nitro' (Chris Paul PE)

How pivotal was that SB moment? The hype was mental.
I don't know if we'll ever see it again quite like that. It was crazy. The Dunk was doing very well at Foot Action, but when the 'Stüssy' Dunk came out with that two-tone brown and also the snakeskin Dunk High, that was a major deal. Dealing with Stüssy brought me to the Union store, which was right next door. They were also importing sneakers from Japan. I thought I was the only one doing it at that time! When the SB hype came, I bought hundreds of each pair. Basically at least two-thirds, if not more, of the entire Southern California stock.

Really?
I'll just say at least two-thirds. It just catapulted everything. Now I had people from all over the world trying to get SBs off me. It was just insane. I was buying the shoes for $65 – and getting bulk discounts! No one knew what was going on. The first three that came out – the 'Danny Supa', the 'Richard Mulder' and the 'Gino Iannucci' – it was incredible. I traded those Dunks for original Jordans and made a killing. It was unreal. I had a whole house full of sneakers, and I said to myself, now I'm gonna go completely HAM!

Speaking of which, I have to ask you about the 'Paris' Dunk story. It all started with that photo on NikeTalk. I don't know whether people loved or hated you for that.
Okay. I'll start by saying that the most iconic SB of all time is the 'Diamond' Dunk. The Tiffany colour with the black croc skin – that's the one that brought loads of people into the sneaker game. There were Dunks that were a lot more limited, like the 'White Dunk' pairs, where they created sculptures out of them. As part of that event, they

created Dunks for Paris, Tokyo, London and, finally, New York. There was nothing said about the 'Paris' Dunk beforehand. Nike gave away pairs, and all these drunk French kids that were artists or just rich or whatever threw them over power lines. When I saw that shoe, I knew they were amazing. I didn't know Bernard Buffet, the famous painter, but I looked at the shoe and thought, 'Wow, it looks like a Picasso!' So I told my friend I needed to get as many 'Paris' Dunks as possible! This was a huge risk because I was buying them for $750 a pair, and no SB had ever gone up to that price. There were a couple of key players in the game at that point, and they all knew that it was gonna change everything. My parents allowed me to use their credit cards, so I pooled them all together and was able to acquire 33 pairs.

That's nuts. I can't help but wonder how you got them.
I can't really say. But any pair on eBay – I bought every single one. I was doing everything on the quiet. I waited until it was calm, and no more pairs popped up. I planned to visit Japan and stick them in consignment shops, but someone hit Tokyo with six pairs, and I almost shit in my pants. I just totally lost it. [Laughs.]

The guy was selling them for $850, and I had been paying $750. And they were sitting there, not selling. I was like, 'Shit, the Japanese market doesn't get it!' One of my friends – he'll know who he is when he reads this and laughs about it – likes things that are worth something. We were talking about value, and he looked at them and said, 'I love the "Paris" Dunk. It's amazing, but I don't know if I can spend that much on a shoe.' By this time, I was nuts. I'm totally fucked. I'm 23 years old. I racked up $30k in debt. My parents are gonna kill me. What the hell am I gonna do?

'I put them on eBay at $1200 and said, "Every time one pair is sold, all the prices go up after that." Everyone was like, "No one's gonna pay that amount. That's crazy for a Dunk!" Sure enough, the first one sells within an hour. So I re-listed and added all the prices so people could see the old listing and the new one at an even higher price. The next guy is like, "Hey man, come on dude, can I just get one at the other price?" And I was like, "That's just how it is. If you buy this one, the next sale is gonna go up. It's your choice." Boom, the next one sold!'

Andre Ljustina

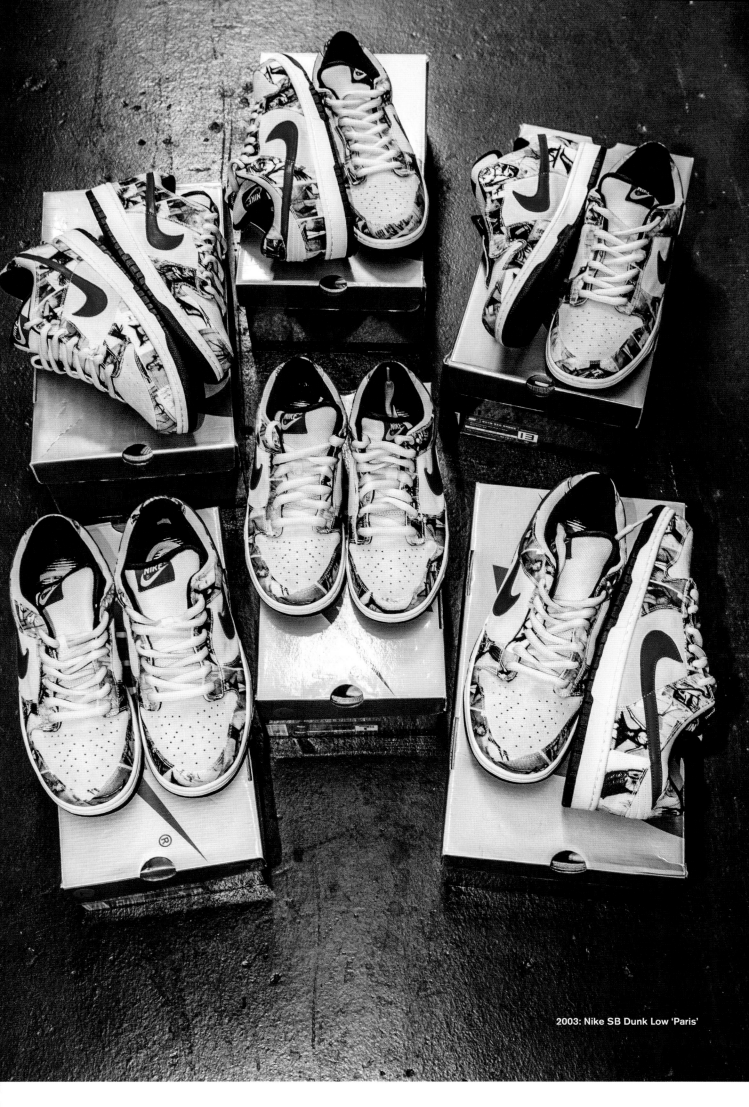

2003: Nike SB Dunk Low 'Paris'

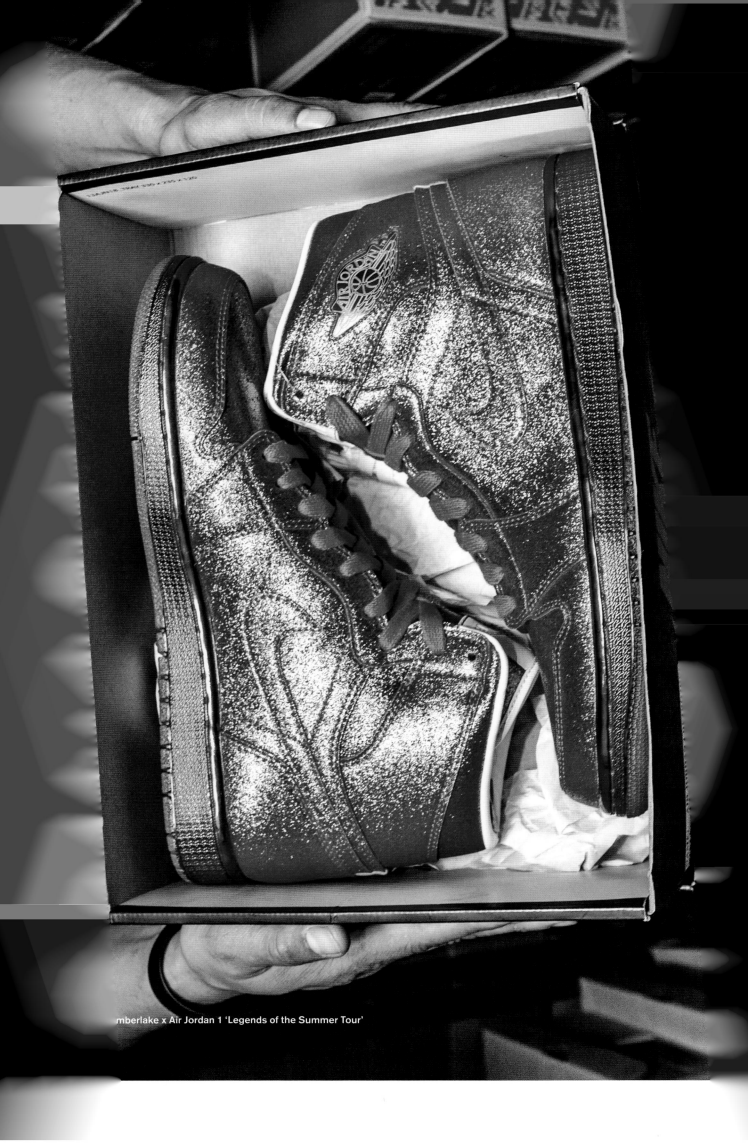

mberlake x Air Jordan 1 'Legends of the Summer Tour'

Is that how the NikeTalk pic came about?

Yeah. I was known for doing 'stock pics' at the time, showing how many pairs I had picked up. A simple point-and-shoot, nothing crazy. It wasn't like a 'whose dick is bigger?' type of attitude. People just appreciated it. So I looked at the Paris Dunks, lined them all up and took some shots. I unleashed them on NikeTalk, and it was immediate insanity. My Instant Messenger was just blowing up – ding, ding, ding, ding!

So I put them on eBay at $1200 and said, 'Every time one pair is sold, all the prices go up after that.' Everyone was like, 'No one's gonna pay that amount. That's crazy for a Dunk!' Sure enough, the first one sells within an hour. So I re-listed and added all the prices so people could see the old listing and the new one at an even higher price. The next guy is like, 'Hey man, come on dude, can I just get one at the other price?' And I was like, 'That's just how it is. If you buy this one, the next sale is gonna go up. It's your choice.' Boom, the next one sold! So we did it again.

That same friend of mine saw the auction and was like, 'Wow, you're selling for $1300 now? Do you still have my size in those?' And that's when I realised that if something all of a sudden becomes 'good value', people are gonna buy it.

I kept running the whole game like that until it trickled off. That's when I went to Japan and bought all the pairs that were sitting there.

Genius!

Then it was at a stage where the way people looked at SBs in monetary terms had changed altogether. Yeah, they were a thing of beauty, but whoa, these shoes are over $1000 now? That's insane. Thankfully, the first one out of the series was the fanciest because when the 'Tokyo' Dunk came out, there were tons of people trying to get them. When the 'London' Dunk came out, there was no way to do what I did with the 'Paris' Dunk and accumulate that many pairs. When the New York 'Pigeon' Dunk was set to release, people scrambled from everywhere trying to get the shoe and sell it for a quick $1000 profit.

What does that 'Paris' Dunk experiment tell you about human behaviour? It's supply and demand at its ultimate, I understand that, but the psychology is absurd.

Well, yeah, there's always the thing of wanting what you don't have, but let's look at what's really driving it. It's the sense of value. What brings out the masses is the value of what it's worth versus what they're gonna pay for it. Let's just say you buy a Honda Civic for $15k brand new. If you want an E-class Mercedes, that's $50k. But if someone told you that you could have that brand new E-class at a discount rate of $20k, you're gonna do that deal because you know you can drive it around and sell it in a year or two and still get more than what you paid for it. That's the mentality.

In sneaker terms, isn't it more that you can buy four Honda Civics and then sell them in six weeks for double what you paid, then go buy an S-class?

Well, yeah, if you wanna put it like that.

So, if you look at this scenario in purely economic terms, compared to the stock market, is it a Ponzi scheme, a bubble or something else entirely? Is it sustainable?

I mean, there's risk in everything. The stock market is pure gambling. People manipulate the stock market all the time, just like what I did with the 'Paris' Dunk. It's high-risk, high-reward. When you're 23, and you don't have a cent to your name and your parents don't have much, but you pool all their credit cards together and buy $30k of shoes and don't know what the hell is

The OG 'Paris' Dunk photo that started it all

gonna happen – that's the biggest risk I ever took in my life. It was a game-changer. It was a pivotal point. Not everything is a 'Paris' Dunk. Those deals are few and far between.

You mentioned the 'Pigeon' Dunk before and the whole mini-riot that happened. Do you think that might have been different if you hadn't made that big call on the 'Paris' Dunks?

The truth, to be totally accurate, is that people wanted that 'Pigeon' Dunk no matter what it was or what it looked like. Everyone saw what the Paris was going for, and they wanted the Pigeons for monetary reasons. This is the middle of New York, and the whole hood was out. All five boroughs were in front of Reed Space trying to get the Dunks because they knew they could exchange their $100 bill and turn that into 15 of them instantly! Without the Paris, would people have been out there? Absolutely. Not as many. No way.

The hood would not have come out because there was no reason to. Nowadays, you got people camping out to make $20, which is crazy. I can't believe what these people are doing to make a few bucks. It's insane. But when you're talking about $1000, that's what makes people go wild. Honestly, the 'Paris' Dunk was the perfect alignment. You have the best-looking Dunk of the four, the most colourful one, and it was unattainable by anyone in the US, the biggest market for sneakers. The Paris now goes for $12k. The Pigeon goes for between $3k and $5k, which is still a lot, but it hasn't really made that major jump like the Paris did.

Did Jeff Staple give you any credit for buying up all those 'Paris' Dunks?

Uh, no, I didn't really expect any! [Laughs.] There were a few more factors involved in the whole thing that I can't really disclose, but I've never really talked about this on the record. It is what it is. I didn't create the shoe – I just created the market behind it. But I knew about market behaviour and the mindset of these people. Just like my friend when he first saw the shoe, he loved it but didn't want to pay $800, but as soon as he saw that I was selling them for $1300, he immediately wanted it. That's the formula right there.

What is it about Nike that makes people love their shoes more than any other brand?

Well, I was never just always a 'Swoosh-only' person. I was a 'Swoosh-mostly' person. I have pictures of me in third grade with checkered slip-on Vans in black and white. That's 1988. The thing is, Nike had all the best athletes back in the 80s and 90s. People looked at Nike's commercials and saw their favourite player wearing the new shoe. And they had all these different models! Air Jordans were different every year. The other brands never had the big star athletes. Nike commands over 90 per cent of the basketball sneaker market, so that's why the Blitz warehouse is about 90 per cent Nike.

Do you think Nike appreciate your role in the industry?

I know quite a few people that have worked for Nike for years, and they appreciate what I've been doing. But all the recent people in middle management don't have a clue. They don't really understand how we actually help the entire scheme of things, create the market and boost their overall revenues. There's a reason the boutique retail level and Nike Energy doors exist – to create this whole scene. It was a big money push for them.

2003: Air Jordan 8 'Lakers' (Kobe Byrant PE)

The role resellers play in the sneaker industry, alongside stores and brands and even eBay – the way it all slots together – is it actually a perfect commercial ecosystem where everyone has their role to play? Is it a reasonably healthy model?

No, I don't think so. Actually, there are a lot of problems. People need to understand, especially companies, that not everyone is buying because they want the product. They want it because of the value associated with it. That doesn't mean they'll sell it later, but the fact they know that they're buying something for, say, $170 – that is suddenly now worth $350 – they feel like they got a good deal. That's the concept. It's different from buying a car because it's already lost half its value when you take a car off the lot.

Brands think that 400 people camping out or entering a raffle is a big deal when it's not. Out of those 400 people, maybe 40 really shop at that store, and the other 360 people will never return.

The problem for me is that those 40 people who shop at the store can't get pairs. Those are the people that should be taken care of. Unfortunately, these days, the influx of people trying to jump in on the action has taken that camaraderie away.

You can't stop progress. Or can you?

There is a way to weed them out. The sharks swim away as soon as you stop throwing chum into the water. Dude, if all these stores had raffles with only the customers who really shopped at their stores, this problem wouldn't be happening. It would be fairer, people would be less jaded, and those leaving the game would still be part of it.

It's hard for me to separate what you're saying – which I agree with – from what you do for a living. Aren't you in a position to profit from this as much as anyone?

I'm not here taking pairs away from people – I'm just bringing them back when people passed on them or missed them and want them later. That's how I started doing my thing. The flippers making 10 to 20 bucks take pairs away from people.

I'm not sure I totally understand that distinction. We might come back to that. Whatever method is used, kids that are smarter and hustle harder always seem to end up with the shoes, one way or the other.

Let's just say you're a store dealing with an 18-pair allocation. You have 100 great customers, and 30 of them are VIPs, total family. You have five employees that also want the shoes and a whole swarm

of the public as well. You're the only store in the city with them, and you only get 18 pairs! That is a total sham in itself because this is not 2001, when 18 pairs per store for a limited release was enough to satisfy demand. There's 10,000 times the number of people into this compared to 15 years ago. Think about it. Let the retailers decide who their best customers are. It would even work at Foot Locker.

That's how things used to be done, and people still got pissed off. I guess kids, especially newbies, need to understand that you can't buy everything.
Right. I love the fact there's limited-edition product. As an enthusiast, you don't want something that's everywhere. A lot of these problems are driven by social media. People are anointing certain models, and the sheep go jump all over it.

Give me an example.
Let's talk about the 'Shattered Backboard' Jordan 1. Before it came out, pairs leaked, and people were asking $800. Beautiful shoe – I love the materials and the colours. I would love them even if they were not hyped, no matter how many they made. Most shops didn't get many pairs. But still, everyone thought they were going to be the next $1500 shoe – the next 'Fragment' Jordan in terms of market value. Everyone put pairs up for sale at the exact same time, and what did that do? Some people right away said, 'Oh yeah, I don't like that shoe. It's wack!' Then it became a $300 shoe a week later. That's all driven because there are more people out there trying to jump on it for profit than there are picking it up for themselves.

True. But that's not really Nike's fault or problem. Would you say that the Backboards were overproduced? Is it merely a problem of perception?
Honestly, I think they should produce more and put more of them in-store and sell less online. Drip-feed online restocking keeps feeding the same flippers over and over again.

Isn't it a contradiction to produce more?
The shoe does not need to sell out in two minutes to make it a success! How nice would it be to walk into a store and have good pairs on the wall? If you wanna get rid of the resellers, make more of what everyone wants and allow the market price to remain barely over retail. Raising the retail price does not help because it turns off the regular consumer, and retailers have a hard time selling. It's actually destroying that relationship.

Brands love the idea of their shoes selling out instantly, even though they don't see any financial benefit. It's not like they get a 10 per cent royalty when it's sold again. The day the Yeezy 750 came out, adidas sent out a press release mentioning the secondary price as validation of the shoe's success.
Absolutely. The funny thing is companies love to see how much it goes for at the end, but they don't see how the process happens. It's not the brand or the product. It's the consumer and the pivotal people in the secondary market that create the value. Let's say the Yeezy 750 sold out, but it was only going for $400 on the Bay. Was it a success? Of course it was.

No doubt.
It doesn't really matter that it's going for $1000, but for a company that puts that information out there like that, I guess it's important to them. To me, it really doesn't make any sense for adidas to embrace the Yeezy market value like that but hate on the people who created the market.

How much did adidas have to do with that shoe being worth $1000? How much is it to do with Kanye and the hype created around whatever he puts his name on? Does it even matter what the shoe looks like anymore?
Good question. Not always. I'm actually wearing the 350 right now, the first colour. The sole really got me going. I don't care whose name is attached – I'd wear it anyway. I don't care. When I grew up, we didn't care what rappers and celebrities wore.

I think you're underplaying the endorsement effect.
Maybe. I remember back in the day with Fat Joe, everyone was on NikeTalk, 'Wow, this fool, he just got on sneakers a couple of years ago, and now he's talking like he's the biggest collector ever!'

A year before, he was all over Timberlands, and you never saw him in Jordans. But I can't recall him ever saying that he was a long-time sneaker dude. It's cool. I can embrace that because there was no fronting.

Did Jordan see something in Fat Joe that they wanted to exploit, or did Fat Joe see Jordan as a way of marketing his own brand?
Both. There are definitely a lot of people that jump on hype to build themselves up. Celebrities, even regular rich dudes, are buying up to make a name for themselves with sneakers. When I was a kid, it was all about athletes like Jordan, Bo Jackson and Andre Agassi. Signature shoes were a big deal. Now, it's what a celebrity is wearing.

I do think, though – I'm talking pre-social media days – that music videos have always been pivotal. The difference now is that Kanye can put up five Instagrams a day, whereas he might put out five videos a year. That's how much product is being made and how many different ways there are to consume it as news.
I definitely see that, but that's the scale of the consumer base now. I've seen a lot of kids out here in LA, young kids in their early 20s, that are trying to be trendsetters and create their own style, which is a good thing. Maybe they'll be able to influence other people to make their own decisions on what to wear and not just be sheep.

Over the last 10 years, what percentage of Nikes have never been out of the box? Do you ever think about how crazy that is?
Oh yeah, absolutely. When I was a kid, we bought GI Joes and Transformers and played with them until their arms fell off. The thing is, who would have ever thought to keep those toys in the packaging so you could sell them later for a fortune? Nobody! If you were a kid, you were ripping that box open to play with what was inside. But there are always a few people hoarding that stuff! I honestly think that most sneakers are being worn. More than half of all the shoes that have come out are being worn, except for promo models and special things like that. Those go directly to people paying pretty high-dollar for them, and unless you're a millionaire who wears shoes worth $20k, how else can you justify wearing them? Collectors don't wear that stuff. I'd say at least probably two-thirds are being worn for sure.

That still leaves a third locked away. It's always sad to see a beautiful Ferrari, perfectly restored but never driven.
That's just the nature of the beast when things get too valuable. I know. I've had a bunch of those 'Ferrari' sneakers in my closet, and then when I go to take the Ferrari out, I see all the tiny scratches and the tyres are flat. So, that just shows you can't keep stuff tucked away in a closet for too long.

There's a tension between being a collector and running a business that trades shoes. How do you cope?
Truthfully, if I still had every pair I put aside for myself, it would probably be something the world has never seen before! [Laughs.] Unfortunately, I couldn't keep it all. I didn't grow up rich or have wealthy parents. My father worked. My mom had a lot of health issues. I started this business with a $500 credit card.
There's only so much I was able to keep because I had to keep building the business. I had to sell off a ton of original Jordans. Sometimes you have to pass on a deal. Sometimes you have to sell some stuff to get a pair that rarely comes around, and you need to get the funds to do it or make a trade. It still goes on now. I have to budget for a certain amount every month, and it's opportunity versus cost. You go bigger on this and bigger on that, but you have to give up a little bit.

Is there stuff you regret selling for emotional reasons or because it became more valuable later on?
Both. [Looks sad.]

You don't want to talk about it?
I remember 'Eminem' Jordan 4s. A couple of years after they came out, I sold them for $4000, which was a lot at the time. I was getting them for $2000. The last pair I sold for $6000. All of a sudden, two years later, they were going for double that, and now they're going for double that again. They've quadrupled in price in four years!

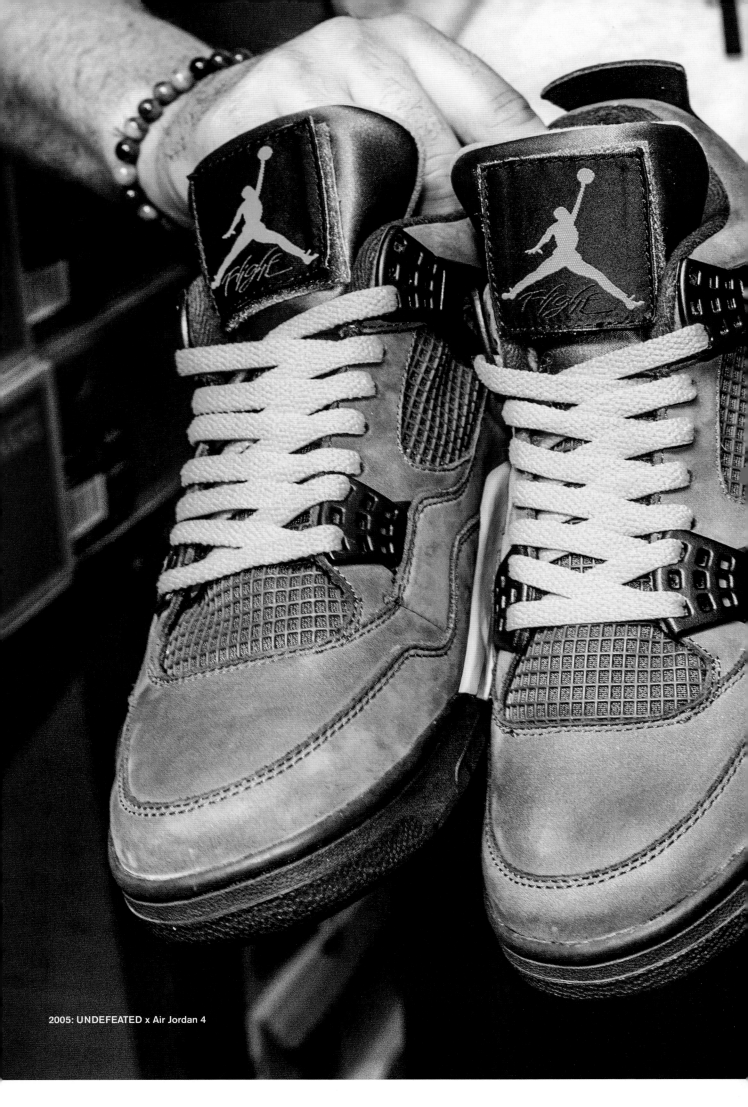

2005: UNDEFEATED x Air Jordan 4

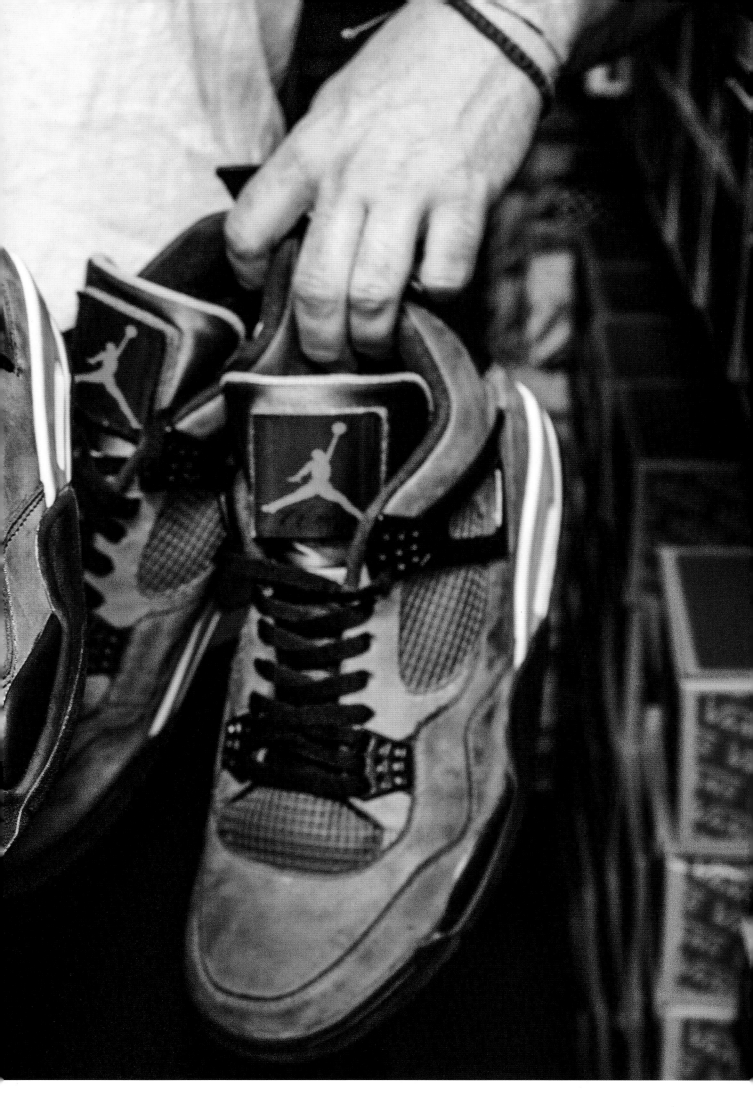

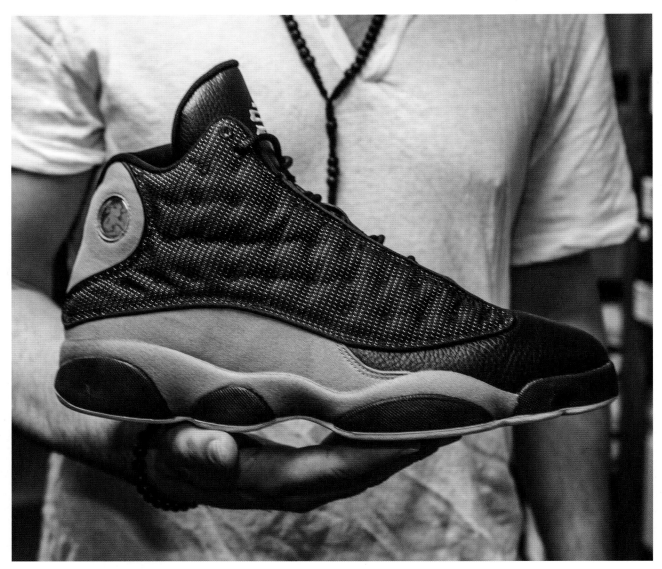

Chris Paul x Air Jordan 13 (PE)

Who are these people paying $24k for Jordans?
It's insane! All these guys that are new to it are just paying whatever.
I wish I had all those Eminems right now because I'd be killing it.
With the 'Paris' Dunks, when I had those 33 pairs, I was selling them
for $1500 to $2500. Fast-forward, and they're worth over $10k.
In 10 years' time, they might double up again – or they could
be worthless. At that point, you're going to regret not selling.
Unless you have a crystal ball, you're never going to be able to tell.

**Eminem could die tomorrow. Does that mean his shoes
become more valuable? Do you just go on gut instinct?**
I mean, yeah, if you attach a big name to it like that, of course
they're worth more. There's a consumer for that side of the market.
But as far as what determines what something is worth, I mean,
before all the social media nonsense, it was really just what
people were into. Between 2003 and 2005, when everything
went multi-colour rainbow, totally wild sneakers were the play.
Just a few years before that, everything was basic – so it just
depends on the trend. Something that wasn't hot a while back is
now worth more because no one can find it, and everyone wants
it all of a sudden.

There are a lot of different reasons something can go up, but
it's basically all based on hype. People make certain shoes a merit
badge, like the Eminem 4s, and they put them on their Instagram
so everyone knows they have them. That's why things have been
driven up that high. Would I ever pay that much for a shoe for
myself? No, but it depends. Paying $500 for sneakers was unheard
of back in the early 2000s. I paid a couple of thousand dollars for a
'Wu-Tang' Dunk, which was just crazy. These days, that's nothing.
There are 17-year-old kids buying shoes for $5k out there.

**I don't understand the availability of money at that young age.
Let me just go back to the Eminems. How do you know what
they're worth, given that so few exist and even fewer change
hands? Is there a lot of internet gossip about prices?**
Well, again, this is the snowball effect happening on Twitter and
Instagram. Let's say someone had the shoe and sold it for $10k.
Anyone who has a pair now knows they can probably get a little
more. So then they put it on the market for $11k, and it sells.
That's usually how it occurs until it hits a ceiling where no one will
pay that much. There have been many times I've sold stuff to people
way above the market, and they're happy because they don't want
the uncertainty of dealing with anyone else, and they know I'm legit.
As far as determining price, it is what it is. If you have to go and look
at other places and always be cheaper, then you're always in second
place. When Blitz has prices higher than elsewhere, that's because
we're selling out fast. If it slows up and nobody wants it, the price
goes down. Simple.

**If you had those Eminems now, would you try to flip them in
18 months or hold on to them for five years and cash in later?**
Years ago, I was holding a certain amount of product and then
just unleashing it three or four years later. I used to do that with all
the good SBs back in the day, but it's a different market now. It's
more saturated. There's a sneaker spot on every corner, all selling
the same stuff, and if you try to hold this stuff for three years,
it's not gonna work. That doesn't relate to the Eminem x Jordan
situation, though.

What was the worst deal you ever made?
Oh God, there were a couple of bad deals. Right off the top of

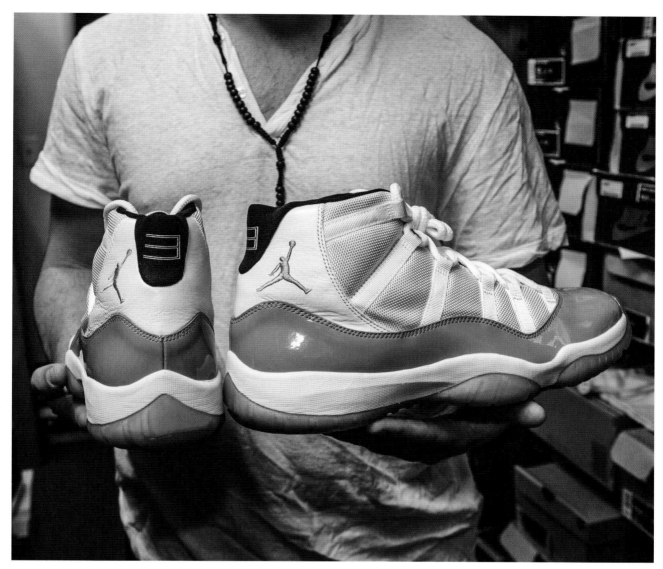

Chris Paul x Air Jordan 11 (PE)

my head, the 'Playing Card' Air Force 1s. I bought a lot of them, and I still have some to this day. The 'LeBron' Air Force 1 just fucking completely died. I couldn't even recoup retail price. The funny thing is, 'Fire Red' Jordan 3s never do anything on the open market. I remember I held almost 100 pairs of the reissue, along with 100 pairs of the 'Military' Jordan 4s, and I'm still waiting for them to do anything. Thankfully, the retail price back then was only $125. I still have maybe 10 pairs left. That goes to show that not everything is worth holding on to because I've had them for close to a decade now.

Where do you honestly think this whole sneaker thing is heading?
Yeah, I've been on all sides, and I am a little bit jaded. When pairs are continually retroed, and some aren't, along with all the politics, the scammers, the fakes and the weirdo people trying to befriend you – sometimes I look at it, and I'm like, 'Dude, I'm in the wrong game because this is for unsocial people that should just stay in their bedrooms and never come out.'

On the sneaker side, it's the corny aspect that has been ruining it for me and other people too. All these people are jumping in, claiming they're super collectors with recent high-dollar shoes, but they've only been around for the past couple of years. Kids doing weird positions with their feet on Instagram and stuff like that. I hate on-feet pics – the stupid positioning and ballerina stuff, the stomping on water. The whole corny aspect is just overbearing.

Go on YouTube and check out the 'food-stomping' vids.
To me, it's bastardising the whole thing. Truthfully, dude, it's corny. Everyone's trying to use shoes to make themselves cool, whereas before, we were just trying to make the shoes cool. Hopefully, it'll go back to the way it used to be.

But ultimately, that will hurt your bottom line, won't it? Some of these people you dislike – they're probably your best customers.
Absolutely not. I don't bank my business on selling super high-end pairs. That just comes with it. I have a clientele that just wanna buy regular stuff. That's the nature of the sneaker business, whether I'm considered a reseller or not.

Maybe we older dudes need to get out of the way and hand over the baton at some point.
I'll be honest with you. I can't talk about shoes all day long – it drives me crazy. I don't give a shit about social media and making friends with people I've never met. If you're cool, I'm cool with you. Social media doesn't run my life. That's pseudo-marketing right there. It doesn't mean shit. It's just a bunch of misinformed sheep following smoke and mirrors. I'd rather be a lion than a sheep, if you know what I'm saying.
★

@croatianstyle

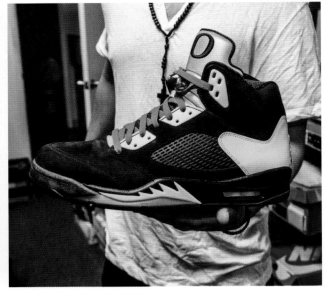

2013: Oregon Ducks x Air Jordan 5

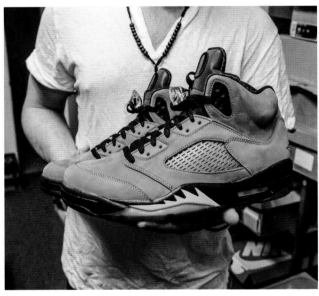

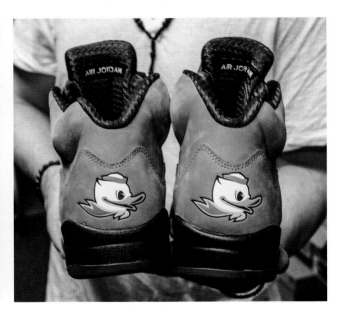

2013: Oregon Ducks x Air Jordan 5

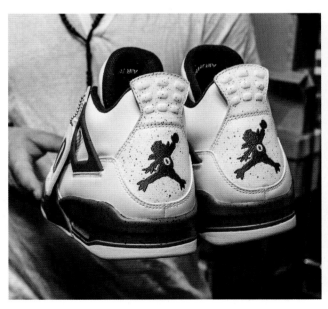

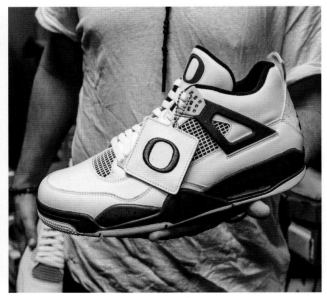

2013: Oregon Ducks x Air Jordan 4

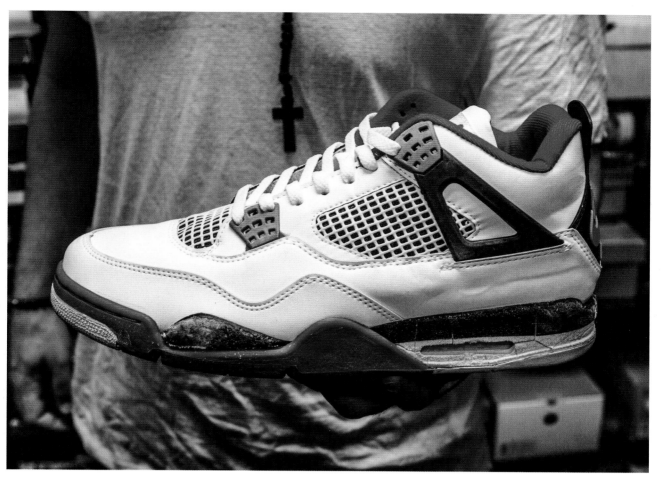

OG Jordans are crumbling!

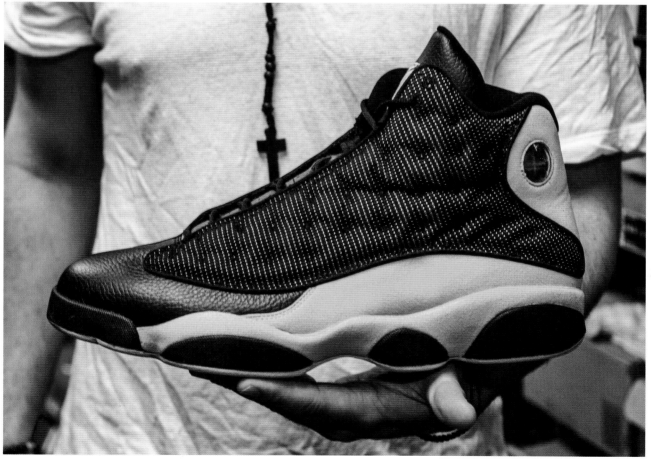

2005: Air Jordan 13 (Carmelo Anthony PE)

THE EIGHTH WONDER OF THE WORLD

SHOE KINGS

Interview **ADAM 'AIR REV' LEAVENTON**
Photos **MANUEL DOMINGUEZ JR**

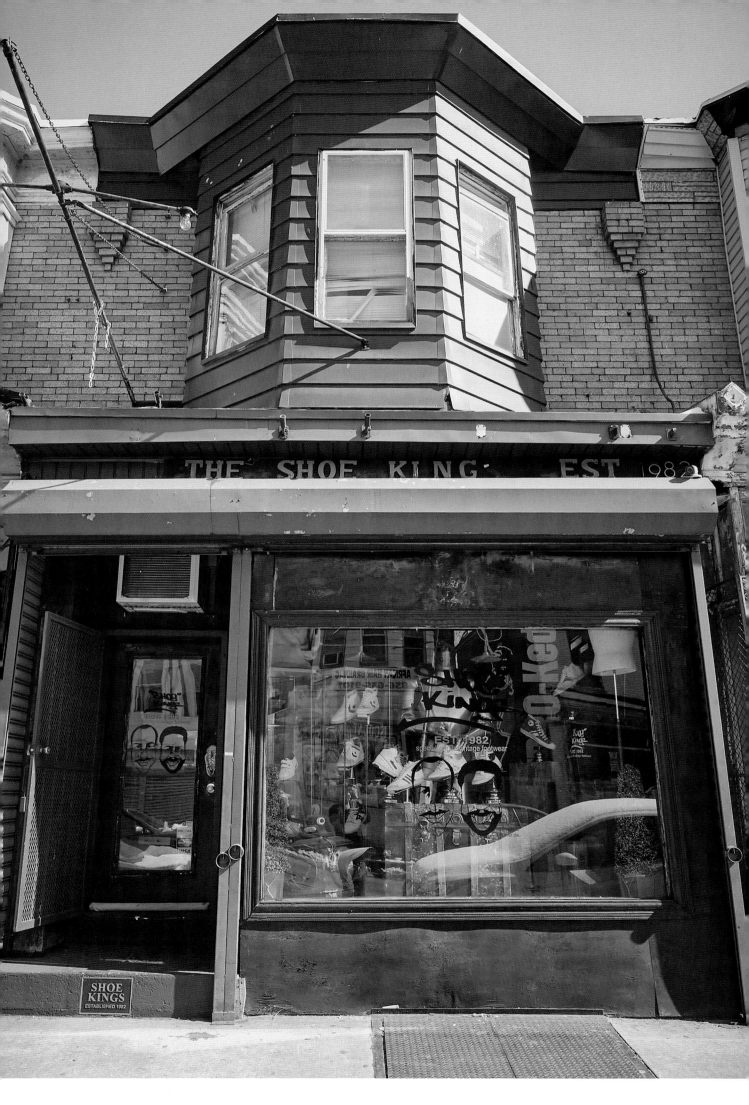

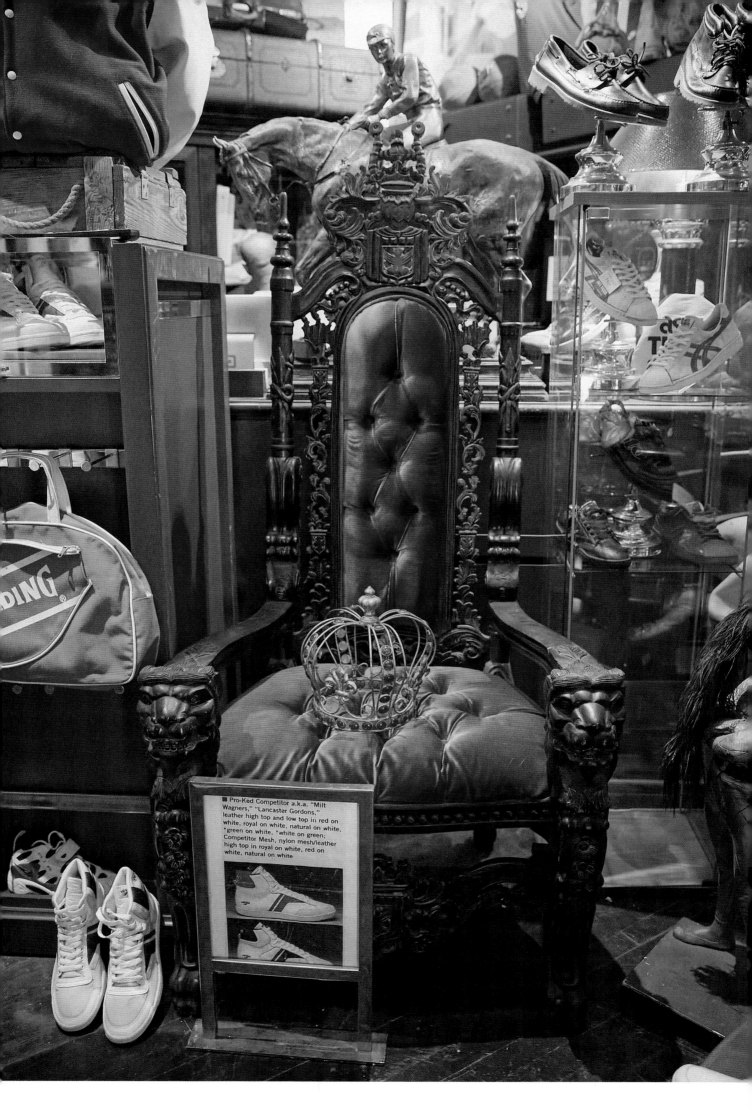

■ Pro-Ked Competitor a.k.a. "Milt Wagners," "Lancaster Gordons," leather high top and low top in red on white, royal on white, natural on white, *green on white, *white on green; Competitor Mesh, nylon mesh/leather high top in royal on white, red on white, natural on white

West Philly-born and Camden-bred Byron and Darien Gans have been living the sneaker dream all their lives. As far back as the 1980s, these two b-boy brothers from the same mother have been quietly going about their footwear business – trading, cajoling, scheming, raiding store after store until their basement overflowed with dusty boxes and precious ephemera. Ever watched the Eddie Murphy classic *Trading Places*? In the first 30 seconds, a shop called Giant Shoes (the largest in West Philly!) flashes across the screen. Quick as a wink, Darien shuts down the VCR and ingratiates himself into the store's basement, hauling out piles of 'old stuff and futuristic 90s Nikes'. They both have stories for days.

After a few false starts and an early incarnation in a barber shop, they opened Shoe Kings in Camden, New Jersey. Step inside the mysterious shopfront – friends, family and sneaker Illuminati only – and an Aladdin's cave chockablock with vintage heat awaits. Wall to wall, floor to ceiling, front door to backroom, this compact cornucopia of memorabilia will melt your face. Everywhere you look, there are a million question marks. And as you're about to find out, every single item they've acquired has a priceless origin story. The knowledge runs deep.

A selection of Nike player posters wraps the roofline, including the all-time classics Iceman, The Supreme Court, Chocolate Thunder and Dr Dunkenstein. On the shoe tip, 'eclectic' barely does justice to this lovingly curated collection. Who knew *Playboy* magazine ripped off the Reebok Freestyle or that Bruce Jenner had his own runner? Beyond these delightfully obscure discoveries, basketball is numero uno at Shoe Kings. Charles Barkley's Air Force 2 (5/8 cut only for Charles!), warm-up suits owned by Darryl Dawkins, Moses Malone's signed Air Force 1s – loyalty to the 76ers was never in doubt. Insanely rare pro models from the likes of Magic Johnson, Larry Bird, Clyde Drexler, Dr J, Danny Ainge and Elvin Hayes are all signed by the players. As promised, they have stories for weeks.

Considering anything remotely 'cool' is rinsed these days by the interwebs, the fact that Shoe Kings has maintained an invisible digital profile all these years is scarcely believable. As you'll read in Air Rev's brilliant 5000-word interview, Byron and Darien's super low-key approach is humbling and reassuring. Unlike many Johnny-come-latelies, the brothers are in it for the long haul and for all the right reasons. Sneaker brands should take note – there are many lessons to be learned at Shoe Kings. Once word gets out, we suspect sneakerheads will come from all over the world to pay their respects and be personally schooled by these two humble greybeards. I can't wait!

Time to kick out the toe jams and revel in the glorious fact that a spot like Shoe Kings still exists in these modern times. You can call it a store, a shrine, a sporting museum, an emporium of shizzle or maybe even 'the mom-and-pop that time forgot', but we prefer to think of Shoe Kings as the Eighth Wonder of the World. Be prepared to lose your marbles!

Woody

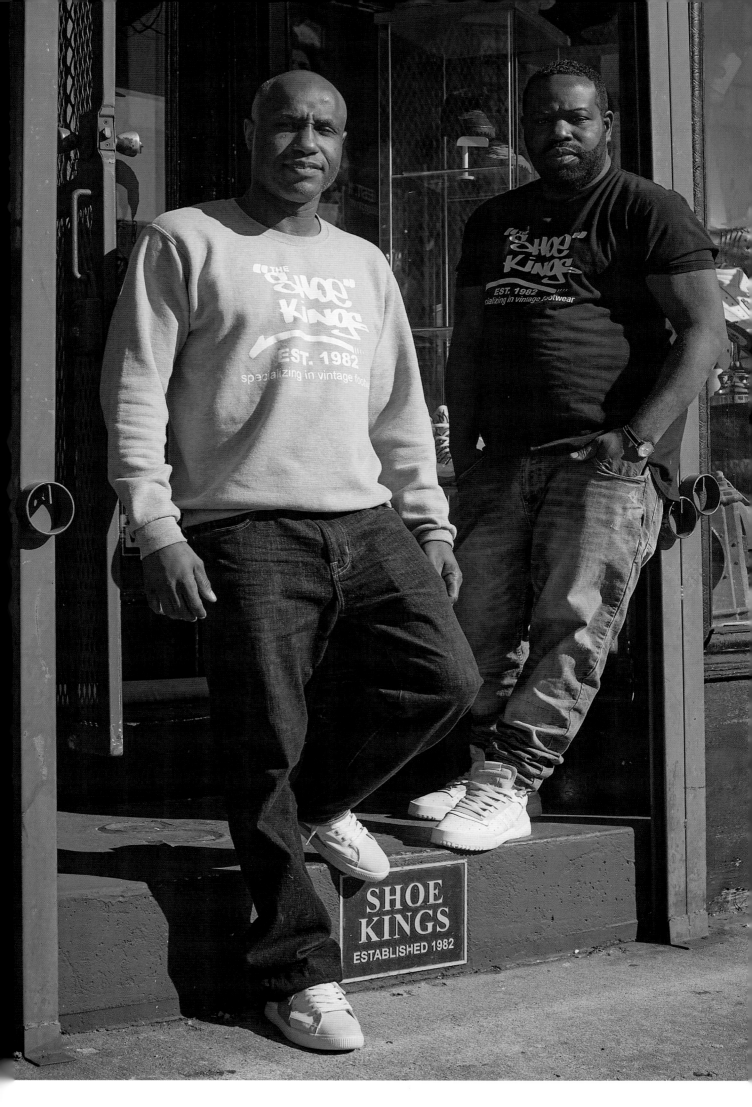

ellesse (Maurice Cheeks) and adidas (Kareem Abdul Jabbar)

Tell me where you're from.
BYRON: We both hail from Philadelphia, Pennsylvania. West Philly, to be exact.
DARIEN: We left Philly in the mid-1970s and came to Camden, New Jersey. That's really where it started, the whole PRO-Keds influence. Then we graduated to leather sneaks, which was a big thing in the 70s and 80s. Real heads know, if you got a real pair of Shelltops, after a while, the leather smells like fish.

And your first shoes?
D: The first shoes I remember were suede PUMAs. My dad took me to the store and said, 'Do you want a pair of shoes?' I can remember it like it was yesterday. Everybody looked at me, and I pointed at the PUMAs. Gold with a black stripe, my first pair.
B: For me, it was 1983, fishnet and leather mid-cut Nike basketball shoes. My uncle bought them for me. Wore them and wore them, but they started getting wear and tear. So one day, I painted them and stretched their life. I made them into Oakland Raiders colours.

What was the retail scene like in your area?
B: Pro Shoes was in Cherry Hill, across the street from the mall. A lot of hype around that because one of the guys from that area was in All-American Camp with Jordan, who was hanging in Cherry Hill going to Pro Shoe. So now it's bubbling away. They carried patent leathers, $100 adidas x Run-DMC sweatsuits and all of that. Then you had your obscure little mom-and-pop spots, 52nd and Market, Front Street.

When you first realised that sneakers made you feel a certain way, what were the really serious shoes?
D: Suede PUMAs, Baskets, Shelltop adidas. At that time, it was a lot of different brands. Everybody wasn't just wearing one thing. He used to wear Tretorns and Skippies. I was like, 'Why are you trying to be different?' For me, at that time, I was into basketball, so I had Spot-bilts and Jordans before they were Flight. That's what I do all day. Sports stuff.
B: Fast-forward the DVD a couple of years. I've copped every brand. Turntecs, Prince, Le Coq Sportif, FootJoy. Now you're talking Camden, Philadelphia, and the hip hop influence. I was at a party, and the guys had sneakers with a ribbon on the back. He says, 'You got to go to Atlantic City and get the Gucci sneaks'. At the time, they were $110 after taxes. This was right around the time Jordans dropped, but I wasn't interested. It was all Gucci. The hightops were $225.

That's when the Benetton stuff was out. It got complex. All of these things sharpened the skills of what we were to become and do in the future.

Any cats in your neighbourhood where you looked down at their feet and couldn't take your eyes away?
D: The greatest shoe king of all time was Raheem Washington. He come out with patent leathers on. Suede Shelltops. He had everything. It was like you had to watch him to know what to wear.
B: He was the first one I saw with the silver and metallic blue adidas Top Tens. Le Tigre shirts. Garanimal shirts. Trendsetter.

Tennis was huge back then.
B: The game was huge! FILA sweatsuits, Sergio Tacchini, we could go on and on. This translated into hip hop wear. Badminton sneaks and squash… the shoes looked good, even brands like Asahi. You just took the sweatsuits, the tennis shorts with the pique tennis shirts. You wanted to match up. That was a Philly thing. Nautica jackets with adidas Ivan Lendls. It played a big part in fashion.

How did you know if something was acceptable back then?
B: When you saw people wearing it but rocking it different ways. It's not like how it is now. I might wear a pair of Tech Challenges with a Nautica spring jacket. I might wear some Lacoste sport tees with a Sixers starter. The tennis wear, the sweatsuits, everybody had their own formula. You knew it wasn't working when you didn't see it. To wear something somebody else had – there was no fun in that. In fact, it was frowned upon. If a guy came in with a pair of Shells on, we see that. If you came in with Guccis or Tretorn or Prince, something sporty – that had to go with your clothes. Girls liked you then.

Is there anything to the fact that this stuff was European?
B: It definitely had a different feel to it. One guy had a white satin Sixers jacket with those Asahis. I was like, 'What the fuck are those?' The shoe was tapered up front and satin in the back. It was different. I could never get them. Today we have multiple pairs. They did feel a little bit expensive, but this was sporty. It was made for rocking. It looked nice, and it felt good. Then you got into the aerobics era. I remember the first time I saw a pair of Reeboks in eggshell, the off-white colour. I was like, 'What the fuck is this?' So to answer the question, tennis gear did feel a little ritzy and expensive.

Old-
Sneakers
never die

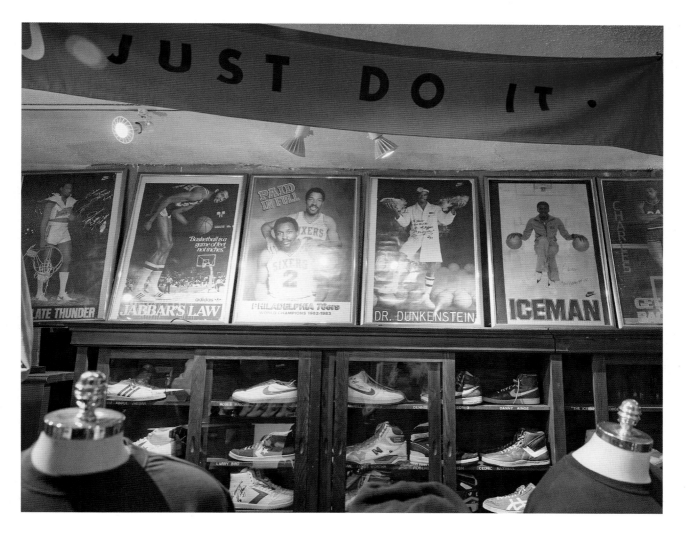

Any details on shoes that caused something to pop in your brains?
B: Every shoe is different. Every brand's different. The Top Ten adidas, fresh out the box, that rubber with the suede on the tip, the weight of the shoe, the funny wax-filled laces, the way they lay on jeans… What was another pair? Oh, man. Tennis Guccis! They had terrycloth on the insole.
D: I used to save all my money. I was taking the trash out for $5, saved $110 and took the train to Atlantic City, but the pair I wanted went up $10. He had just enough to get hightops, but I was $10 short, and I was scarred ever since. I never got to buy mine. That's when I started getting a bunch of Guccis. The first guy I saw with them was Steady B. He was hanging in my neighbourhood in Camden, going over to some girl's house. I knew it was him because he had his hat cocked to the side with a pair of Neil Stein glasses. I was like, 'Yo, I know you!' About two weeks later, *Bring the Beat Back* is on the radio. He's doing shows. He had a green bomber on with the neat neck and an all-white pair of Guccis with the Gs in the back.

How did music influence sneakers in Philly?
B: You can't get away from hip hop because these guys were taking cues from the record cover art and live shows, running into them randomly. You saw it. I used to see Cash Money all the time. I ran into him at Strawbridge & Clothier behind the Polo denim set. He was rocking the jacket and the pants. So it played a real big part. Again, they were trendsetters. Everybody had their own feel. Fresh Fest at the Spectrum was the first hip hop show I remember going to.
D: We were b-boys, so we used to break. It was part of our lifestyle, so sneakers was a given, but we was b-boys. Remember you go down the street in the summer, it'd be like 1000 degrees, you go into every record and sneaker store, and you'd hear the same song because they'd all be playing Power 99.

Who were the notorious block captains in Camden?
B: The Krown Rulers, in my opinion, were the first guys to have a full LP on the radio. It was done well. It was quality. And it put Camden on the map. That's in front of Our Lady of Lourdes Hospital. That's where that's at. I think it's knocked down now. But they were the ones that really perpetuated that. You couldn't wear nothing but Nikes around their area. If you didn't have on Nikes, they was throwing your sneaks up on the telephone pole.

They'd take them off your feet?
B: In some places, yeah, but that was the era. In Camden, those were the guys.

When did you realise you could go on missions to dig shoes?
D: One day, we went to this store on Front Street, and the guy locked the door and said, 'Let me take you downstairs.' He was going out of business, so there was stacks of shoes everywhere. We aired that out. It got so bad we was buying sneaks for $10. We bought it all. That was around 2001.
B: One time, this guy in our neighbourhood was a notorious liar. I don't know why – he just lying to make conversation. One week he says, 'We got this spot in Delaware.' I'm telling you, man. We were all in. He didn't let us know what street. We just went. We used our instincts. You develop a knack for these things after a while. Downtown Wilmington. Let's go find it. What do you know?
D: Black-on-black Top Tens. I still have those sneaks.
B: Reebok boots. Suedes. Gary Paytons with the glove. It was heat.
D: Like 20 pairs. Get them all! I remember I drove, got off work, 20 minutes to Delaware. I don't even know how I did it. I was just grabbing shit back and forth. That was amazing. He was a lying ass, but that day I said, 'He finally came through.' I got another story for you. We were watching the Eddie Murphy film *Trading Places*. In the beginning, you see a guy go into a sneaker store called Giant Shoes, and it was called 'The Largest Shoe Store in West Philly'. The joint was filled with PRO-Keds and all old shit. So I called the store right up, and we went in there, and he had the newspaper clipping where they did that scene in the film. They had a lot of old stuff, cross trainer Nikes, real futuristic 90s stuff. They had a lot of vintage. That guy liked us!

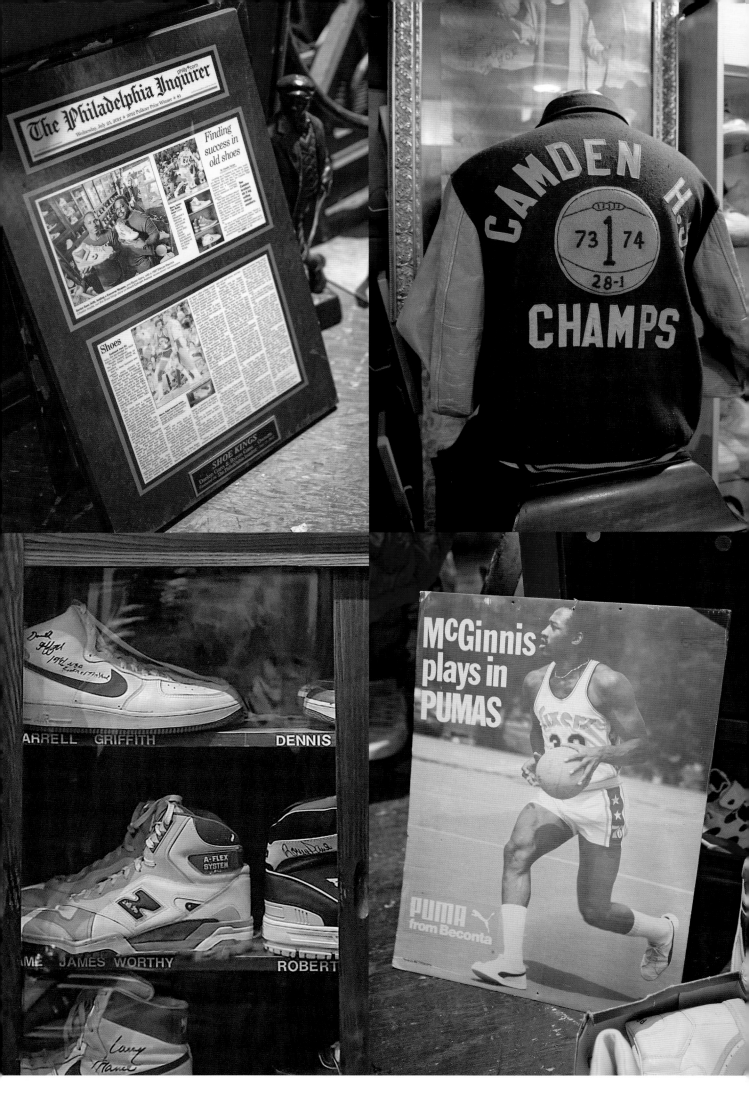

1980: Playboy Pro-Model

What makes a shoe worthy of being in your collection?

B: It has to have a story behind it. It has to be done well. The shoe has to do all the talking. You see a pair of patent leather Nikes in navy and burgundy – there's nothing to discuss. Look at your shoes. They're well made. The wearability, you're not just getting that. And the quality, it's a mixture of things.

D: For me, it's all grandfathered in. If it's old, I'm getting it. It could be anything. It could be a pair of Jordache. Everything's worthy to me.

The quintessential question. One pair to take with you.

D: Probably the patent leather adidas Concords. That's my favourite shoe. Over PUMA, I hate to say.

The red, white and blue?

D: Yeah. That's the one. It's classy. It's from the time period. It's the one everybody wanted. And that's why I haven't worn them yet. I bought them on eBay. This guy had Air Force 1s in patent leather, and I was trying to get the Concords. I said to myself, I'm paying $500 for those, and if I don't buy these now, I'm never going to see them in that condition again.

Byron?

B: My favourite shoe is those hightop Guccis. All four colourways – white, black, green and red. A very rare shoe that was made exceptionally well. Very hard to come by. You can still wear them today. It's the ultimate.

What's a Holy Grail that you just haven't been able to get?

D: Most of the shoes that I always wanted, I have them. Or I got two. Darryl Dawkins did a Nike. I'm sure it was a Blazer, and it said 'Sir Slam' on the back. I'd love to get my hands on them. I only have

pictures of it from a memorabilia site. After that, I think I'd be good for a minute. Of course, I would need the Maurice Cheeks. I know it's in the family, so we're good. It belongs here.

Any regrets?

D: Yeah. I have a couple. It was a game shoe – Gerald Henderson's Nikes. I think it was a Dynasty and had his name on the back. I fumbled on that deal, but hopefully, I'll come across it again. I've conquered Gucci because I was scarred when I couldn't get them, and my brother was able to buy them. We were younger, but I've overcome that now. I'm good.

B: I want to tell you mine. Cherry Hill mall, 1988. Cranberry hightop patent leather adidas Concords. I had the money and didn't buy them. I've never seen that colourway again, and I should have bought them.

The adidas Forum is an amazing shoe. The Decade was a great shoe. What makes the Concord so special?

D: My brother says it reminds him of a baby shoe. The sole, the rarity of them, the time when it came out. It just looks very comfortable and soft on your foot, and the patent is shiny. Oh man, it's the ultimate shoe! I really wish they remade them just like that.

The Forum was a block captain shoe. In high school, I was the starting power forward. We went to a Quaker school in Philly and played public league, so the one thing we did have was the best music. Our team wore black and white Forums, so we won the shoe game but always lost the actual game. My friends had a rap group called High and Mighty. Milo is a big collector. They were in Barcelona one time, and he was like, 'Yo! We found duck sauce-and-mustard Forums.' Milo would lose his mind.

B: I remember their album cover. First time I saw it was on *Just For Kicks*. They got heat.

1988: Gucci Hightop Tennis

I was in the group once. I was MC Phase from Back In The Days. I was such a bad rapper and would spit on the microphone, so I got kicked out. [Laughs.] Fast-forward, there's a gap between loving this when you were young and turning it into a business. What happened?

D: The basement just got filled with shoes. It took a few years to get a building because my brother was a barber at the time. We were still collecting, but now we are in expansion mode. This is the beginning of that little era, so it just awoke our thirst, but like it or not, the more we moved forward, the more we got a crash course in business retail. That's a whole other can of worms.

And the Shoe Kings name?

D: Back in maybe 1999, before we even had the idea of making a store, our basement was filled with shoes. I'm looking at Audio Two's album cover, and you know everybody used to get their sweatshirts done at Shirt Kings? I was like, 'Yo! We're going to call ourselves the Shoe Kings.' I just figured it's a nice catchy name.

B: It happened organically. We collected shoes, clothes, Polo, this and that. Guys were painting sneaks. These are things we always did. We looked at the album cover and was like, 'All right, let's put a little monarchy on it.' It all went hand-in-hand with hip hop culture. A lot of the stuff was Nike vintage, so we geared our antennas towards that. Original double highs, patent leathers, Diadora, ASICS GEL-Lytes, whatever you could get your hands on. We knew we could talk sneaks with fellow sneakerheads, so we considered ourselves an authority and still do.

What was the vision for the store?

B: We didn't have no idea.

D: Well, I'm going to cut you off on that. He was a barber like I said, so we started with a glass case in his shop. We was just painting stuff, putting shoes in there. Then he moved to a building next door, so now we got more space. I never stopped buying sneaks. I never stopped hunting. So all of this is like, 'Let's turn this into something.' We had our Shoe Kings logo by this point.

You guys in here all the time?

D: Yeah, we open every day.

What do kids think when they come in?

B: The young guys come up with their own new language, and that's great. If you want to be a doctor, you have to go to medical school.

You want to be a lawyer, you have to pass the bar. You want to be in this game, you got to know the history. I mean, it's cool to know about Michael Jordan and Jumpman, but you want to get in it, you got to go back to the beginning. And if we're not careful, people are coming up with their own stories, and things just didn't happen that way.

Let me ask you about the Nike Supreme Court poster you have framed in antique timber.

B: This particular poster is actually cardboard. It's thick. This was in the lobby of Nike. The week that Dennis Johnson passed, it was already in the mail, and he called me and said, 'You're a lucky guy!' because it was on the news and everything. And I said, 'Okay. What's the tracking?' It's got all the signatures on it. The guy lived in Oregon.

Wow!

B: I was lucky. I only paid $100, so that's special. It's funny – when I first started on eBay, I had a meltdown because I lost a bid for the poster. My brother, he'll tell you. I didn't know nothing about eBay then.

D: This Nike rep gave me a box of all of them. They're all rolled up, and I have nowhere to put them.

Player Exclusives are another Shoe Kings specialty. Tell me why they're so important.

D: For me, it's a small piece of history. It's the feeling the guy had when he played in them. It's actually game-worn, so it's part of how he felt that day when he dropped 25, 50 points, or a triple-double. It's history. Just the way they specialise the name on them, that's what does it for me. It's like a piece of them. I think the shoes are more important than the jersey.

B: With Player Exclusives, you find a lot of intimate details on the shoe that are not always privy to the public. I didn't know that until we started acquiring them, like these Converse Pro Leathers. You see the arrows in the front? Those are Magic's shoes!

What's the most incredible Player Exclusive pair you have?

D: Magic Johnson's. It was hard to get that shoe in such good condition. Whenever you watch that clip against Boston where he's doing the skyhook, that's the essence of Magic. So to get them game-worn is a huge deal. It's not the Weapon either – it's a Pro Leather. 'Magic' is stamped on the shoe. That's how you know the Player Exclusives. They're all stamped. Converse did theirs on the side, and Nike basically put the names on the back.

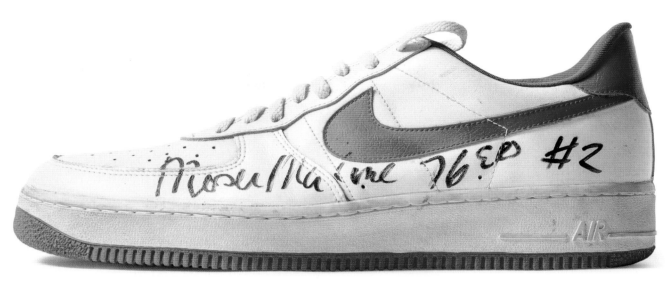

1982: Moses Malone x Nike Air Force 1 (Game-worn and Signed)

Talk to me about Celtics Exclusives.
D: All of them are special. The leather, like my brother said, there's just something about the way it's made. And because you know it's an exclusive, it's hard to get. All the different shades of Boston green are cool. I'm a 76ers fan, but that Boston green does something for me. It's exclusive. Hard to get.

Do you ever talk to the players about how they feel about it? Do they care as much as we do?
D: We met Danny Ainge one night, but we just wasn't talking about shoes. I've met Doc Rivers several times, of course. I don't think the players think of it like we do, but they are often surprised that we have their shoes. One time I was at a speaking engagement. I just waited my turn, and then I finally got a chance to give Doc a pair of Converse Pro Leathers from the 1980s in a box. It was a good feeling. I got a picture with him. Doc was cool. Paid for that signature, though, but it was worth it!

I got Ainge's shoes from a guy in New Orleans. I didn't want to mail that kind of money, so I flew down there, met him at the airport and paid. The price wasn't too bad. You could spend $500, you can spend $1000, you may luck up and spend a couple of hundred, but people know what they have. Some of these shoes go for 10 grand if they're signed. Rarity is key.

Were you going on vacation?
D: That was the vacation! I stayed an extra day. I got to see all the antique stores. Mardi Gras was over, so I didn't experience that. I ate some catfish and grits and came back home. I should have done some digging because I had money, but I didn't have a tour guide. I didn't plan that, but I had the Weapons. I didn't even want to part with them. You are taking chances every time you do this type of deal, but the guy met me, and we did our transaction. You don't get lucky, lightning doesn't strike twice all the time, but I've seen shoes that I missed out on come back around again. I've grabbed some of them.

Your Sixers collection is pretty impressive.
D: Yeah. I appreciate that. I have Charles Barkley's shoes. I bought them off a collector and might've paid between three to four hundred. You know how important that shoe was if you see the Barkley poster where he has them on. I've been fortunate. I met Darryl Dawkins a few times. I have his warmup from 1977. Caldwell Jones's warm-up. I got Andrew Toney's warm-up pants. Just being in the tri-state as a 76ers fan, that stuff is on my list, and if I see it, I'm going to get it just to preserve that history.

I don't have Andrew Toney's shoe, and I had a chance to get it. It was a Converse Startech. The guy wanted me to trade my Doc shoes, and I couldn't do it. This guy was probably in his seventies. He told me a story that he spent the night in the stadium one time so he could steal the seats, so he was hardcore! He comes over, and he's got the Andrew Toney Converses. I had more than one pair of Docs, but I can't do that deal. I don't have the Maurice Cheeks Nike Blazers, either.

Those seem pretty important.
D: Well, yeah, that's a rare piece.

I feel the pain.
D: I'm definitely glad we have that 76ers collection, though. We was able to be a part of the Moses Malone jersey retirement with Wells Fargo. We went and displayed all the 76ers stuff, which felt like it made all these years of collecting worthwhile.

So the 76ers actually borrowed your collection and displayed the whole thing?
B: Yeah. It was a good night – 20,000 fans, everybody appreciating the stories.

So why don't more people know about Shoe Kings? This story is a real eye-opener for a lot of people. How have you flown under the radar?
B: I think it's just by design, and maybe now's the time we're starting to surface. I always thought about when we acquired all this stuff, 'Man, we got to stay off the radar until I get it all!' I think it's evolution. This was a learning process and still is. Now that we've gotten the logistics down on a business level, we can present it in a way where it can be worldwide.

On the other hand, you just got some people that catch the wave late, and that's on them. But our job is to perpetuate our brand and what we're about so people know who we are. It's a standard that we have now. We don't let just anybody come through. You got to have a little knowledge about what Shoe Kings is. This isn't a chain store. It's the Shoe Kings, but we call it K-Town, like NikeTown, and you need to know what's going on when you come to K-Town.

'We were watching the Eddie Murphy film *Trading Places*. In the beginning, you see a guy go into a sneaker store called Giant Shoes, and it was called "The Largest Shoe Store in West Philly". The joint was filled with PRO-Keds and all old shit. So I called the store right up, and we went in there, and he had the newspaper clipping where they did that scene in the film. They had a lot of old stuff, cross trainer Nikes, real futuristic 90s stuff. They had a lot of vintage. That guy liked us!'

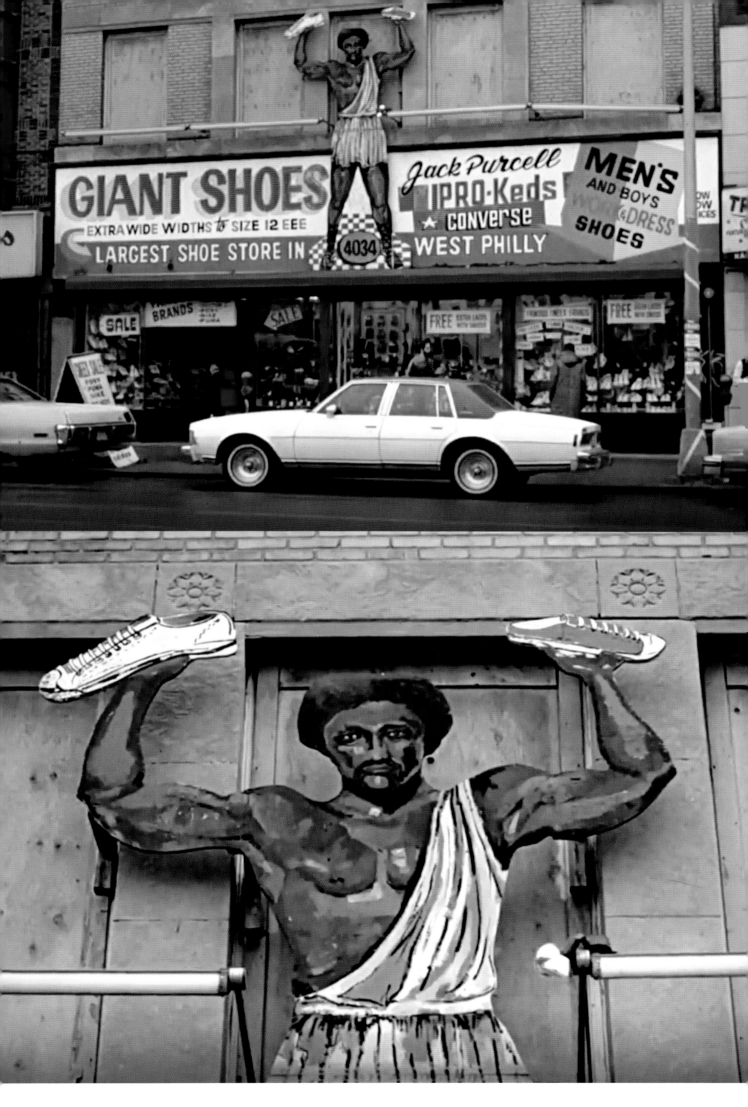

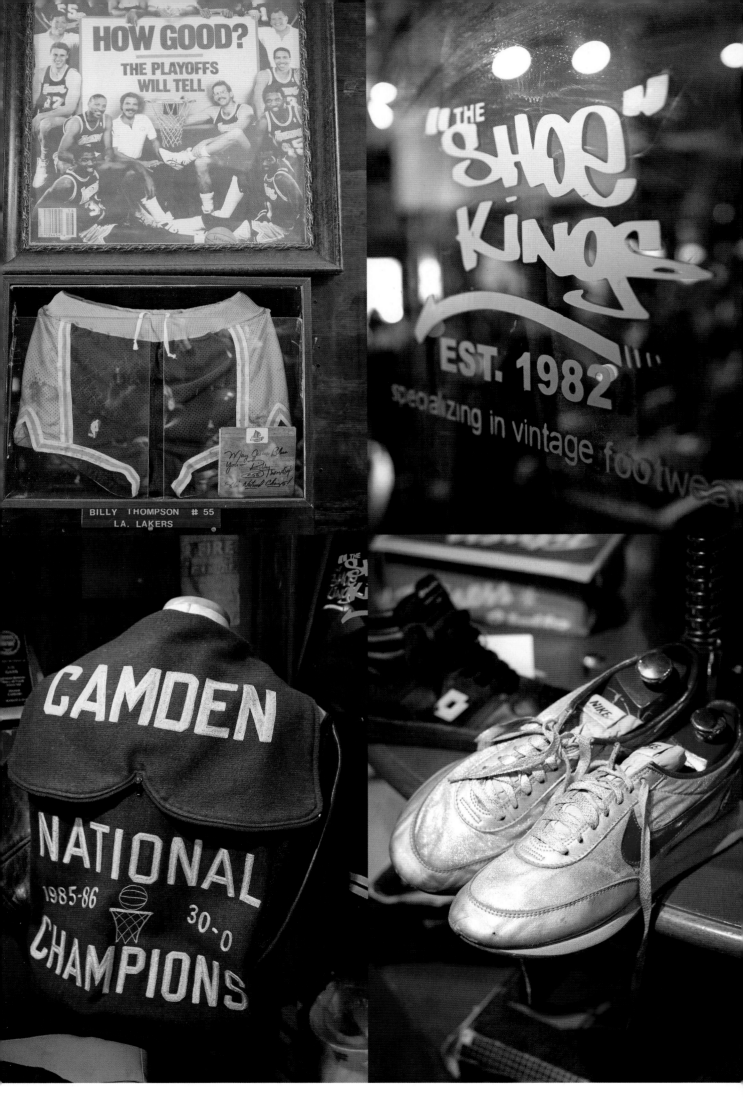

Mid-70s: Bob Lanier x Converse Oxford Canvas (Game-worn)

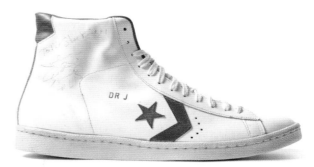

Early 80s: Dr J. x Converse Pro Leather (Game-worn and Signed)

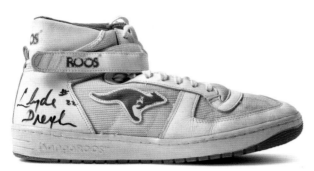

1984/85: Clyde Drexler x ROOS Slam Dunk (Game-worn)

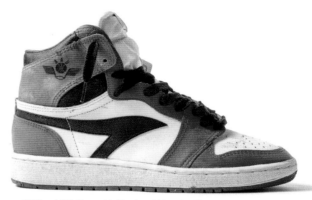

1980s: AAU Court-Air (Jordan 1 Knock-off)

1985: Lotto Tennis

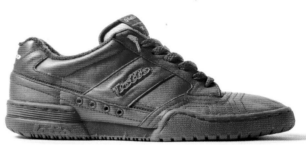

1985: Lotto 'Gucci'

1986: Lotto Basketball

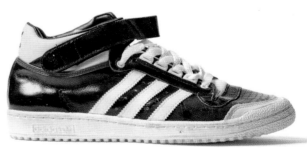

1983/84: adidas Concord

1987: Diadora Slam (Detachable Tongue)

1986/87: Xavier McDaniel x Spot-bilt X-Press
(Game-worn and Signed)

1986/87: Gucci Tennis Lowtop (All-leather)

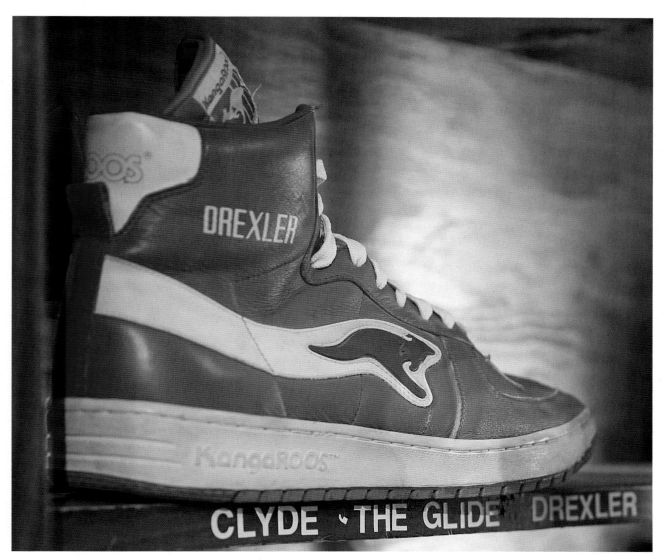

1986: Clyde Drexler x KangaROOS (Game-worn and Signed)

Nobody judges anybody here.
B: No. But I will say that, lately, things have been shaping up via some friendships with artists we admire. The names are moving around a lot. Things are going well. I never knew I'd be sitting up talking to Masta Ace or Grand Puba.

You mean the second Grand Puba?
B: The second, but nobody knows that.

D: Biz Markie been here. I like Biz because he is a collector. We had a good time. We shared stories, and he schooled us on a lot. It was fun hearing it from a guy that's been doing it for a long time, pulling up to stores with a U-Haul. Airing it out. That's how it was done. I mean, you got to get it, and he's a hunter, you know? So yeah, it was a good time with him.

B: We had a guy called Gemini come through. You might've heard of him. He had a song out in the 90s. He's friends with a lot of guys like Danger Mouse and Smif-N-Wessun. We hooked up with Rah Digga, Cam'ron. Everybody's been clapping at this because they're intrigued by what we have. It's crazy.

Your store is like a different world. What would you say to the big sneaker brands?
D: What I would say is… give us a chance. We have a formula. I think if they just gave us a shot and let us sell their products, I know we could do some big things. I want to say more, but you know how it is. Every day we go out on the showroom floor, and we are reminded of the history and great moments in sports and sneaker culture. When we look out our front window, we are reminded of the state of our community and clients. We feel that we are the best qualified to bridge the gap of influence from past to present in sneaker culture. We are connected to its pulse. Given the financial climate the world is currently faced with, this would be a great time for the companies to give back to local businesses that respect the history and future of sneaker culture.

Well said. What's going to happen to all this stuff?
D: Good question. I think about that. I don't have an heir to leave it to yet. I always say if something happens to me, my brother's going to have all the posters. I already know what he's going to do. Do what you got to do. He's got to get it out of here. But I don't care. Just keep the Docs if you want. I always picture a young kid coming in when we're old, and he says, 'You want to sell those posters?' And then I tell him, 'Look, whatever you can carry, you can have it!' And that'll make his day because somebody helped me out like that once. So you got to pass it on.

That young kid might be me. [Laughs.]
D: At some point, you got to pass it on, man. I just hope somebody appreciates it. Because I can't take it with me. Hopefully they'll start a store of their own.

So what's next?
B: What's next for us is to be more interactive, to create a more intimate, bespoke and artisan relationship with the customer through pop-up situations, classes and one-on-ones with different artists – different people in different genres. Innovate and push things going forward.

D: But still nostalgic.

B: Oh yeah. Most definitely, it always is.

★

@theshoekings1982

"THE ICEMAN GEORGE GERVIN

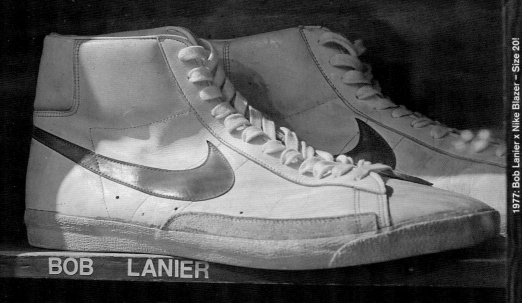

BOB LANIER

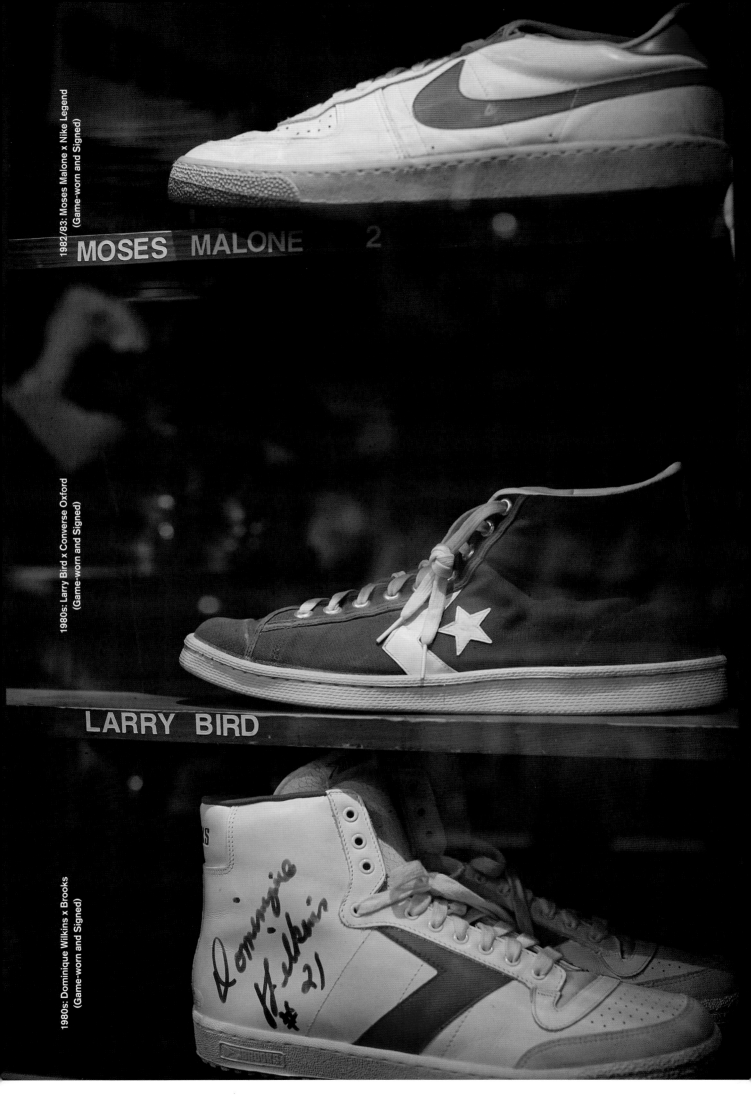

1982/83: Moses Malone x Nike Legend
(Game-worn and Signed)

MOSES MALONE 2

1980s: Larry Bird x Converse Oxford
(Game-worn and Signed)

LARRY BIRD

1980s: Dominique Wilkins x Brooks
(Game-worn and Signed)

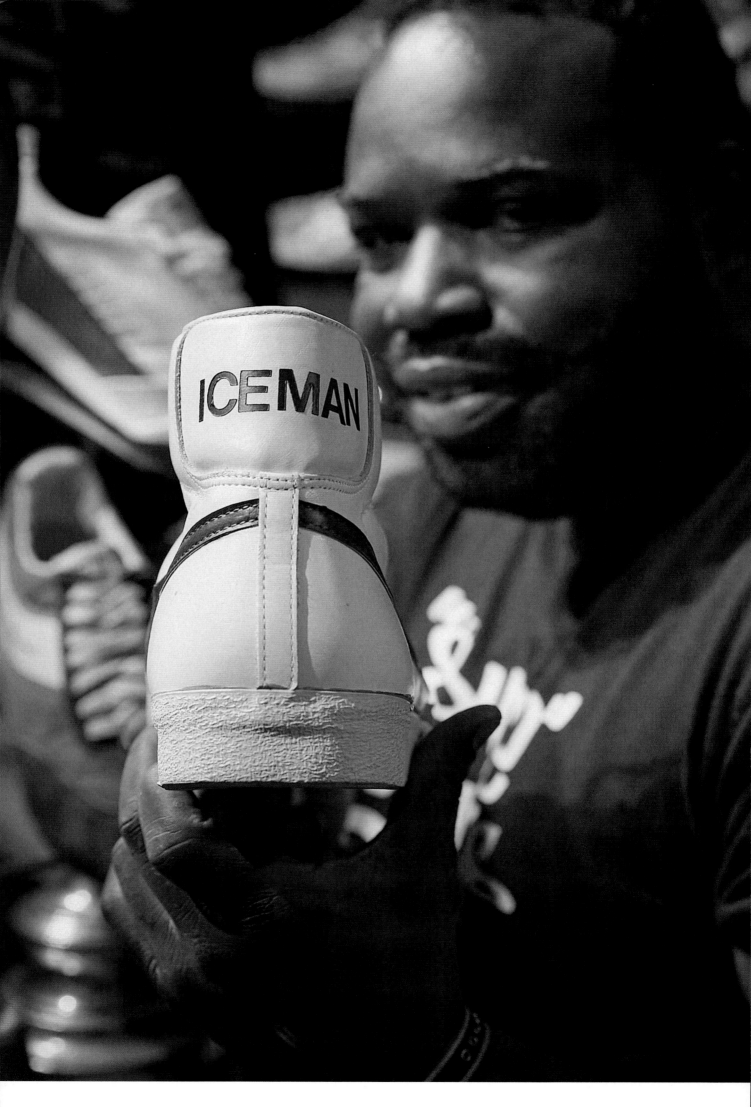

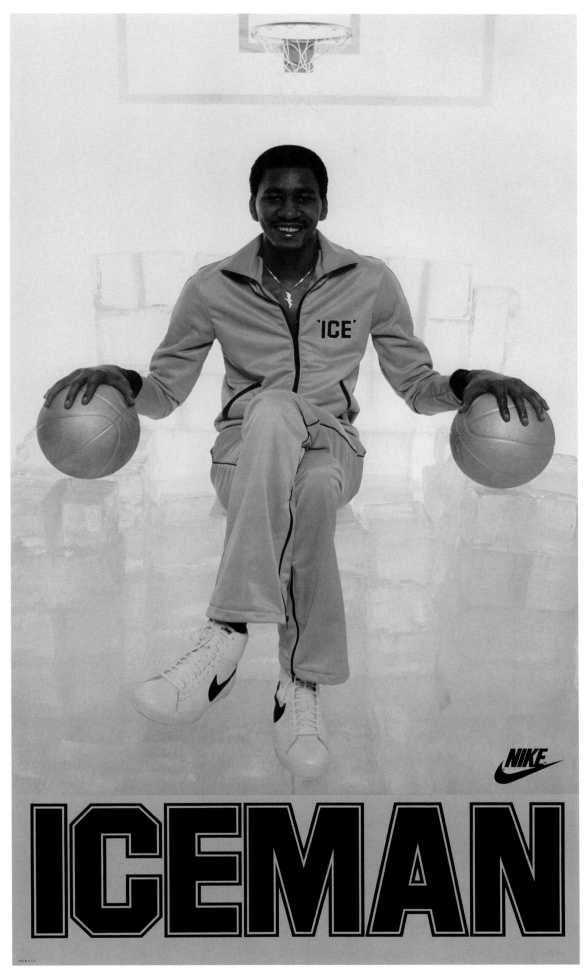

'Iceman' George Gervin

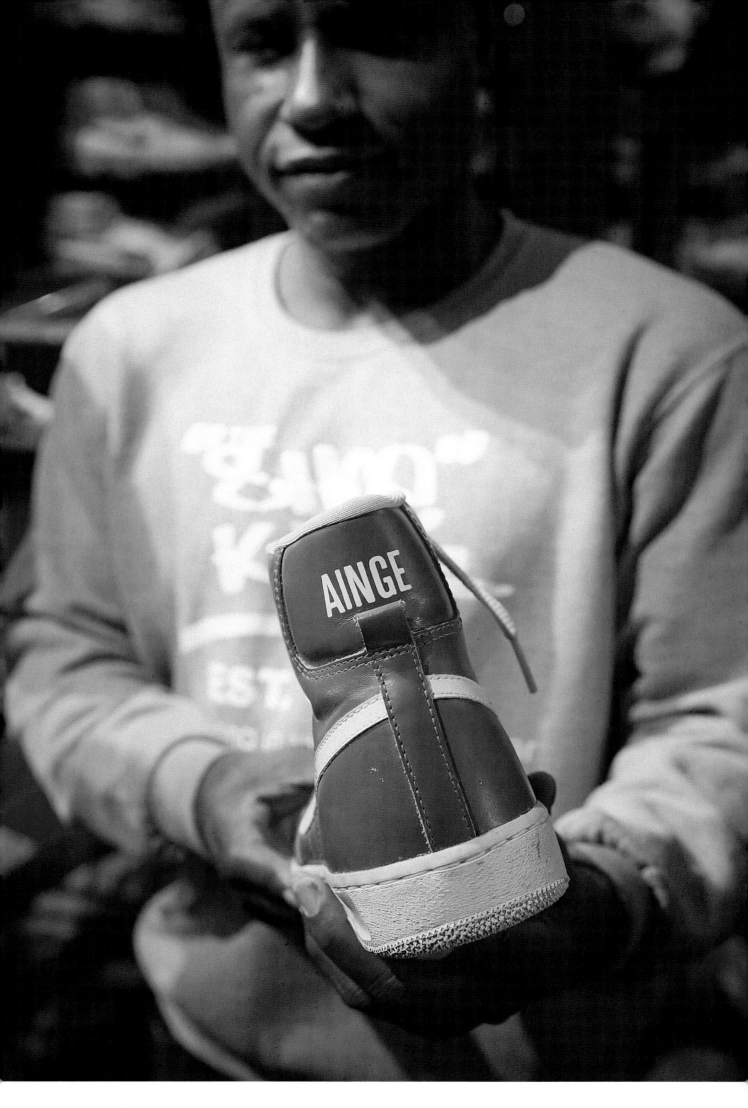

'I got Ainge's shoes from a guy in New Orleans. I didn't want to mail that kind of money, so I flew down there, met him at the airport and paid. The price wasn't too bad. You could spend $500, you can spend $1000, you may luck up and spend a couple of hundred, but people know what they have. Some of these shoes go for 10 grand if they're signed. Rarity is key.'

1970s: Arthur Ashe x AMF Head 1554

1980s: ASICS Tiger (Shelltoe Knockoff)

1970s: David Thompson x DTs Super Pro (Game-worn and Signed)

1977: World B Free x Nike Blazer (Game-worn and Signed)

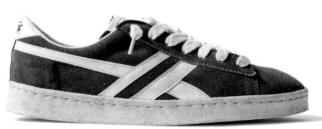

1980s: Thom McAn

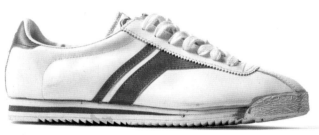

1979/80: PRO-Keds

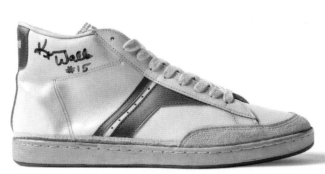

1986: Kevin Walls x PRO-Keds Shotmaker (NCAA Louisville)

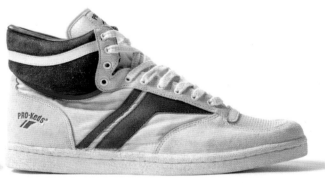

1981: PRO-Keds Hi Scorer

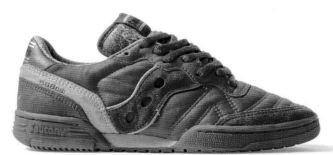

1987: Saucony 588CSI

1988/89: Dainese Scrambler (Marc Sadler)

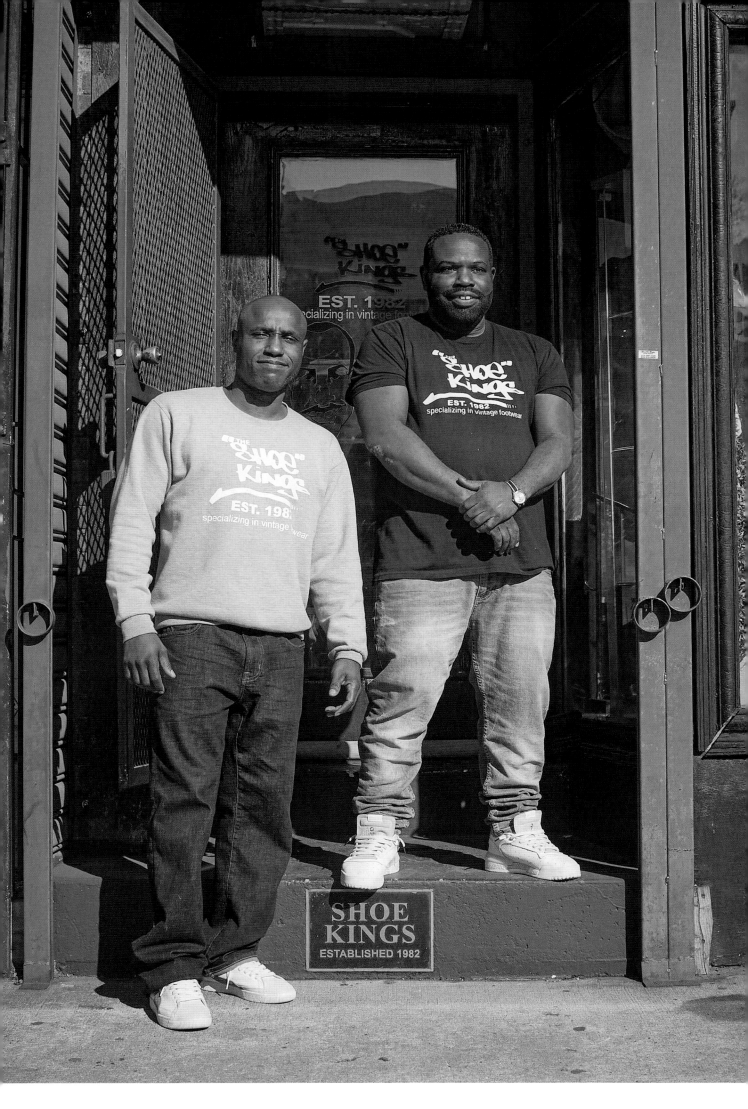

OVER
CHICKS
6000
WITH
RARE
KICKS
PAIRS

For most of our readers, sneakers are an enjoyable hobby or sometimes even a lucrative side hustle. For Ariana, Dakota and Dresden Peters, however, it's all part of the family business. Known online as 'The Chicks With Kicks', the three sisters lifted the lid on their colossal collection back in 2017. And, girl, do we mean co-co-colossal! With over 6000 pairs of dynamite heat, the Chicks' nest is lined with never-seen-before prototypes, unreleased samples, 1-of-1 unicorns and historically significant Player Exclusives. There are even a few pairs that don't technically exist… and that's according to Nike!

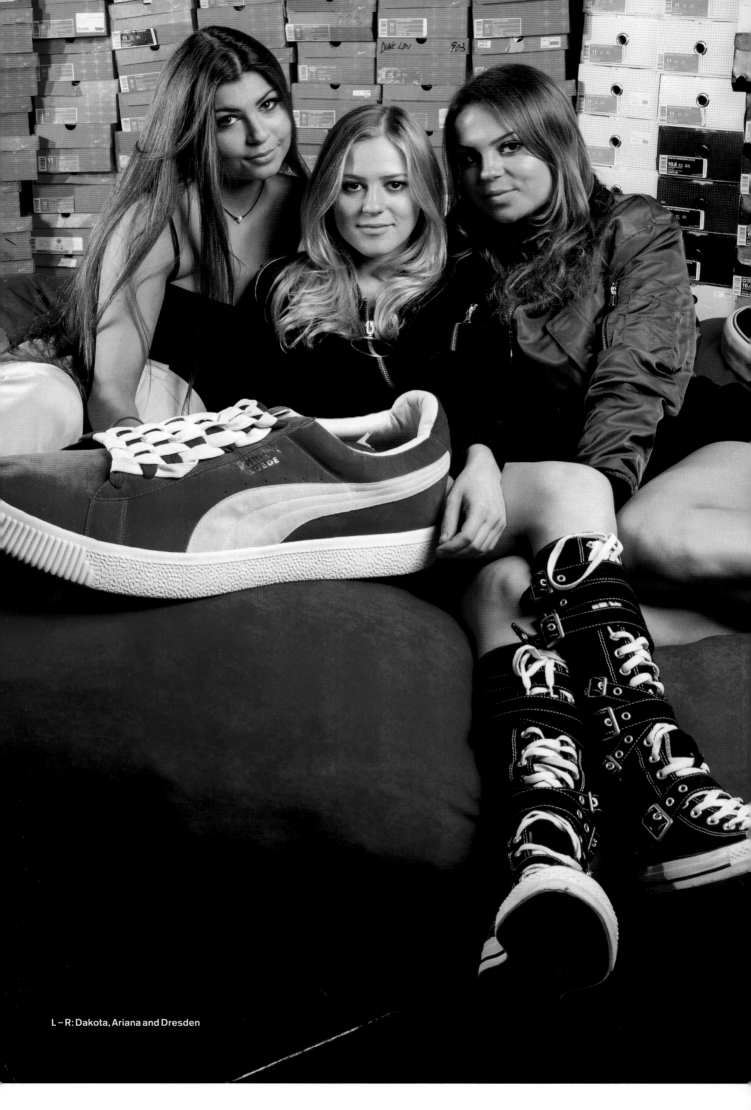

L – R: Dakota, Ariana and Dresden

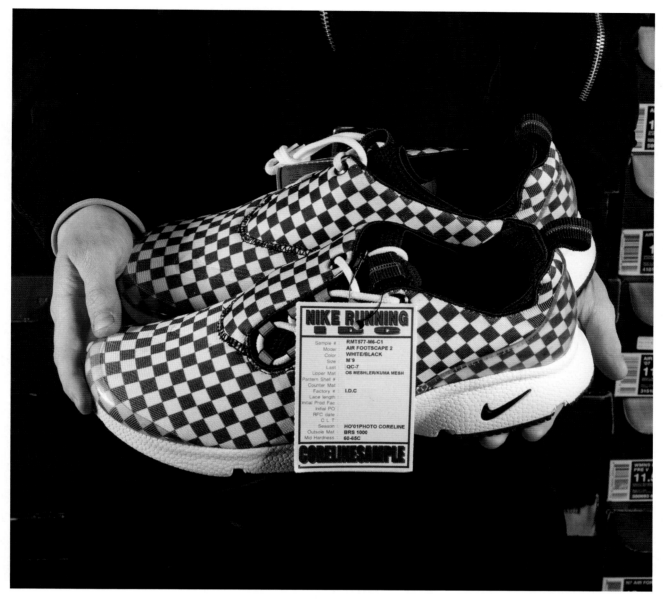

2001: Cheap Trick x Nike Air Footscape 2 (Sample)

*'This is a 1-of-1 sample designed by Steven Smith, who now works on the adidas Yeezy line.
They were made together with Rick Nielsen, the lead guitarist for Cheap Trick. They ended
up running with a checker-board Presto instead, and only ever made a handful of pairs.'*

We hear you've got a pretty big collection.
That is most definitely true! [Laughs.] At last count, there were
6000 pairs, but the collection has expanded a whole lot since then.
We're actually in the process of applying for the Guinness World
Record. We're still waiting to do the official count, though we have
no doubt that we own not only the largest but also the highest-
quality collection in the world.

Where do you even store that many pairs?
To say they took over our home would be an understatement. It got
to the point where we had to build an extension just to house them
all. We now have a commercial building with full climate control
to keep everything safe. It holds the entire collection, except for
the Air Force 1s.

Why aren't the Forces stored there?
Our parents began the collection over 25 years ago, and it all
started with AF-1s. Our mother was an avid runner, and our father
was a basketball player, so it naturally sparked their interest in
sneakers. It didn't take long before the purchases veered away
from necessity, and it became a fully fledged obsession. As the
collection grew, the Air Force 1s always remained in our father's
closet. He expanded the space until the closet was footwear

from floor to ceiling. It looks pretty cool, though, so we decided
to leave them there.

Sadly, our mother passed away many years ago, but our father
continued to add to the collection. While friends of his were
spending their time and money on clubbing, cars and women,
he spent his cash on sneakers. It was his way of gearing down.

About five years ago, he decided it was time to retire and
passed down both the shoe collection and our family's commercial
development company. Although the collection is based on passion,
it entails a lot of work. Between upkeep and sourcing new additions,
maintaining the collection is a time-consuming process, so it made
sense for our father to let it go and enjoy his retirement in full.

Has the focus of the collection changed since you took over?
We have always had a deep appreciation for prototypes, samples
and vintage sneakers, so there's a strong focus on those areas.
We're the largest cash buyers of those types of sneakers in the
world, although the vetting process is extreme.

Our father appreciated sneakers as an art form, so we grew up
infused with that same love. Whenever he purchased a new pair,
we were always involved. Back in elementary and middle school,
our father would dress us in Air Force 1s. We wanted to wear ballet
slippers and sandals, but he insisted we rock the latest Nikes!

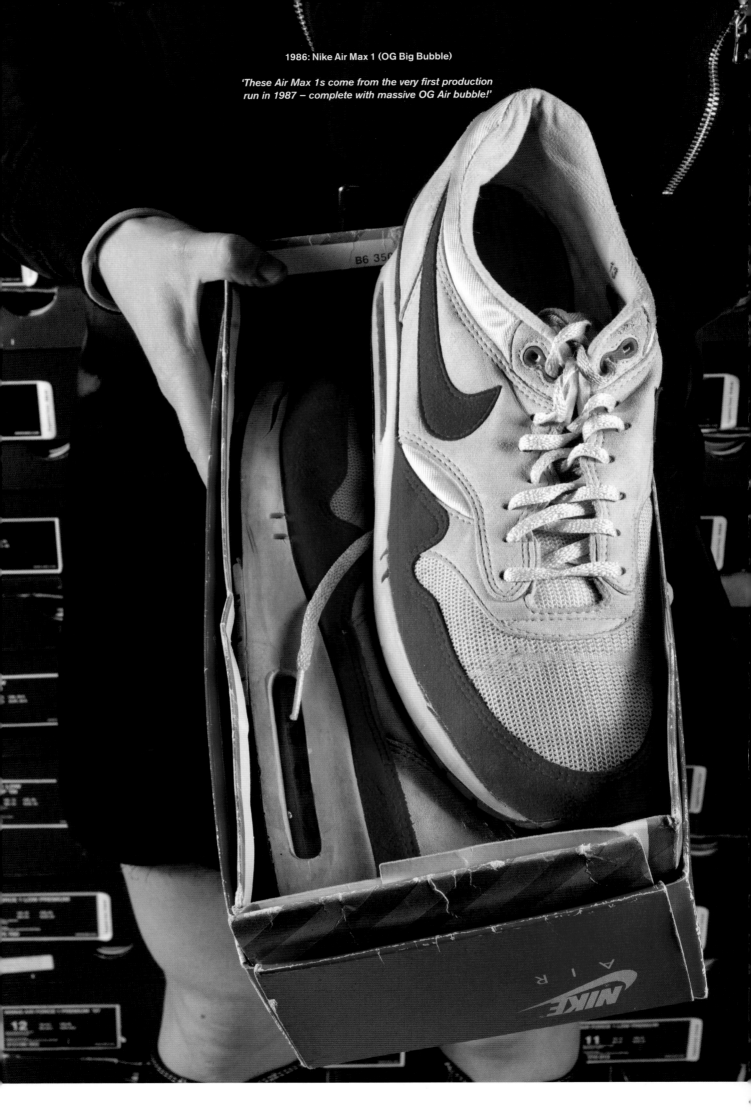

1986: Nike Air Max 1 (OG Big Bubble)

'These Air Max 1s come from the very first production run in 1987 – complete with massive OG Air bubble!'

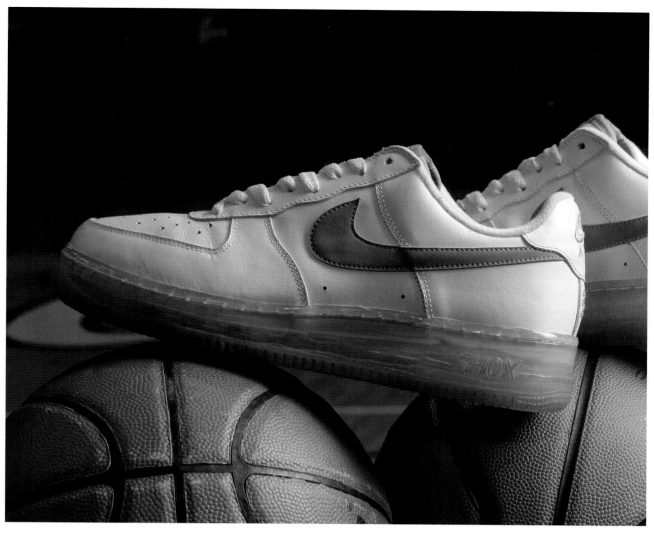

2009: Nike Air Force 1 x Shox (Prototype)

*'These may look like a stock-standard Air Force 1 at first glance, but look again.
This AF-1 switches out the model's traditional Air bag for Shox cushioning from toe to heel.
Not only is the support system visible through the translucent midsole, but Nike even went so far
as to replace the signature "AIR" lettering with "SHOX". Guess this makes them a Shox Force 1?'*

Can't say I'd be complaining about that. Doesn't look like there's much in the collection that you can wear, though.
We have almost every brand and every size imaginable in the collection. We even have a six-foot-long PUMA Suede. That said, any pair considered part of the collection is strictly off-limits for wearing. We each have our own personal collections that we do wear.

When our father started the collection, he was buying up two or three pairs of a sneaker he really liked so he'd have one to wear as well as a spare. As the years wore on, though, some pairs just became so rare and valuable that he couldn't do that anymore. Some of the pairs, like the prototypes, are irreplaceable. It changed his perspective on sneakers, and he began to see them less as items of clothing and more as pieces of art.

How do you keep track of it all?
Our father would write down everything in a little black notebook. He was very meticulous and operated it like a business, except with stuff coming in, not going out. He would keep notes on where the sneaker was purchased, the price he paid and any rare features. When we took over the collection, we began to transfer all that information into a database. It took us a year to convert the bulk of it.

With so many unreleased samples and Player Exclusives, I don't think you're going to find that info out any other way. Can you tell us how he acquired so many insanely rare pairs?
If we told you, we'd have to kill you! [Laughs.] The Nike archives contacted us wanting to know where we got some of the stuff.

They've been trying to piece together how some of these prototypes left Nike headquarters, and they can't figure it out. Even some of the designers themselves have contacted us through Instagram because they know some of this stuff is one of a kind and made for specific people.

One pair was made for Sandy Bodecker, who was the original boss of Nike SB. Nike were completely puzzled as to how they got out. They're missing the insoles, so it looks like they were intended to be destroyed. Sandy contacted us and was like, 'Applause to you guys.' He hadn't seen that pair in years – even he didn't know where they went! [*Note: Sandy, a much-loved friend of* Sneaker Freaker, *sadly passed away in 2018.*]

You did a pretty good job of keeping things under wraps. What made you decide the time was right to reveal your collection to the world?
Our parents were very private people, but my father understands that the world has changed. We weren't intentionally keeping the collection under wraps, but we also didn't purposefully expose it either. In an attempt to reorganise, we began taking pictures of the sneakers. On a whim, we decided to post some on Instagram. Up until that point, most collectors would show off their prized pairs, so you instantly had all these people asking, 'Whoa, who are these people? Where did they come from?' They couldn't believe it. The response was incredible, so we continued to reveal more, and the rest is history.

2000: adidas The Kobe (Development Sample)

2005: Nike Air Force 1 'Croc'

'These Uptowns feature genuine croc leather and are way pricier than the uber-exey Italian-made LUX AF-1 from 2007. Just 48 pairs were made, with all but one gifted to A-list celebrities. The remaining charity pair was auctioned off for $5000!'

I can imagine you're hit up with pretty serious offers.
To this day, we've refused to sell any pairs. We've been contacted by the who's who of the sneaker game wanting to purchase pairs. Every time we post up a Jordan, we get loads of offers, but we haven't taken any of them yet. Recently, we bought 300 pairs of deadstock PUMAs from the mid-70s, and we asked the seller if he had approached anyone else, and he responded that there's simply no one else looking to buy vintage in bulk.

What about modern hype releases like Yeezys?
Yeezys don't have the same depth of history that, say, an original pair of 1985 Air Jordan 1s has – and they can be had for pretty similar money. You also have all the counterfeits, which just work to degrade the brand and dilute the market. You can barely even tell the counterfeits apart from the real Yeezys nowadays.

Also, they're not really art in the same way as the stuff we collect. Anyone can find a pair on eBay, just look at the price and accept that's what they're trading for. It doesn't take knowledge. When you start talking vintage and prototypes, you can't just jump on Google or check Flight Club to find out what it's worth. We probably have about 700 prototypes all up. You have to learn the market with that kind of stuff. It takes expertise.

True. It's been terrific to see such female-driven growth in the market over the last few years.
It's no secret that men largely dominate the sneaker industry, but we're thrilled to be at the forefront of women's involvement. Today, it's important that women showcase their passions regardless of whether they're deemed appropriate or traditional. We love sneakers just as much as men do!

We're often asked how it feels to be women so involved with sneakers, and our answer always seems to be the same – we don't think about it like that. We love sneakers, we collect sneakers, and we're very knowledgeable on the subject. The fact that we're three young women doesn't matter, but we're excited to set an example and to make women feel comfortable sharing their unique passions, collections and interests.
★

@thechickswitŠicks

Nike Air Force 1 'Feng Tay' (Unreleased Sample)

*'This unreleased Nike Air Force 1 sample is signed by Chou-hsiong Wang, the CEO
of Feng Tay Group – the company that creates all of Nike's high-end samples.'*

2004: Nike Air Force 1 x Nike Dunk SB 'Rayguns'

*'These are the pairs that have probably stirred up the most curiosity in our collection.
They feature the uppers from the "Rayguns" Dunk SBs fused with Air Force 1 sole units.
We were offered $9000 for the set and still turned it down!'*

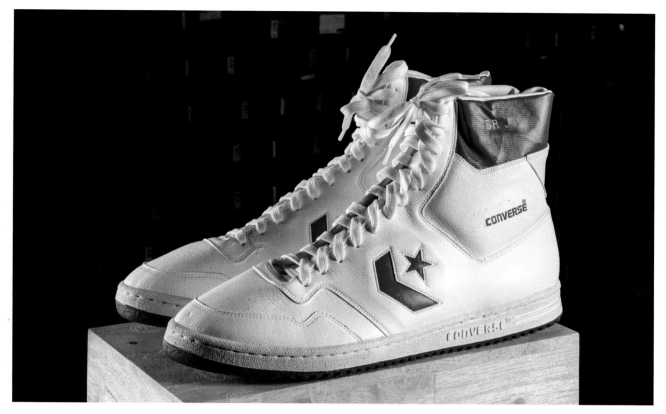

Converse x Julius Irving

*'This pair of Cons was made for Dr J (Julius Erving) himself back in the 80s.
They look like they were made only yesterday, that's how good the quality is.'*

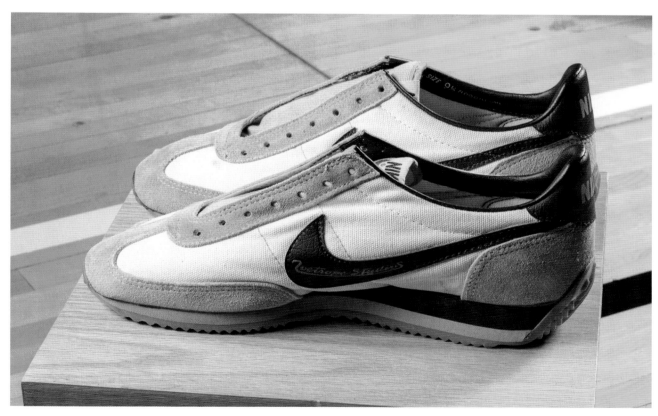

1980: Nike Roadrunner 'Zoetrope Studios'

*'Notice the inscription on the Swoosh – Zoetrope Studios. That's the studio founded
by Francis Ford Coppola and George Lucas. These were specially made for them
to give to the crew that was working at the studio at the time. These were obtained
from a camera operator who worked on Coppola's film* One From the Heart. *
They have never been worn and are believed to be the lone survivor.'*

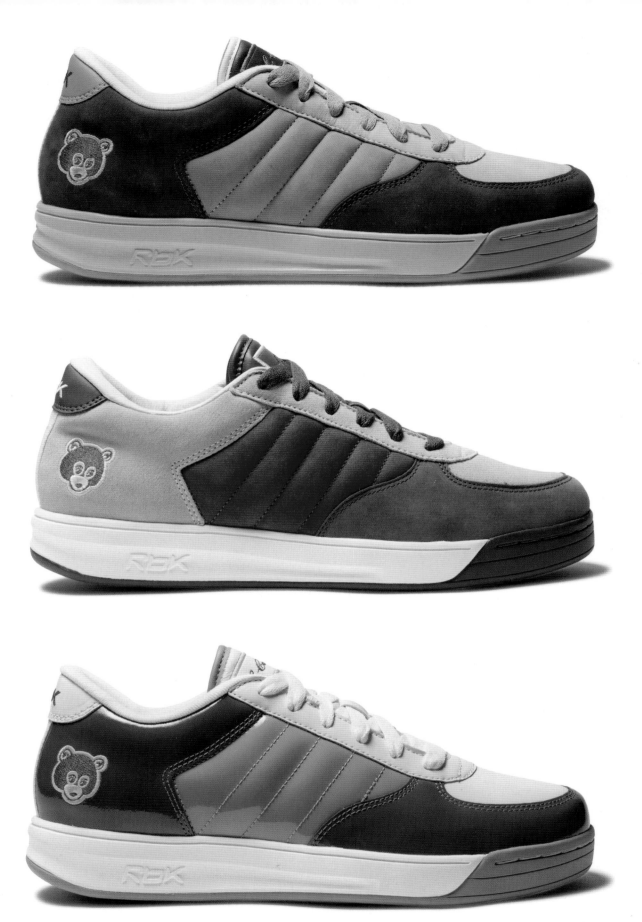

2008: Kanye West x Reebok S.Carter Classic Low (Promo Samples)

*'This set brings together two of hip hop's biggest names: Jay-Z and Kanye West.
We have four different colourways, each accented with the bear from Kanye's debut album,
The College Dropout. On each pair's OG box, the label reads "CUSTOM MADE FOR:
KANYE WEST". These are very different from his newer stuff with adidas – they don't
resemble anything in the marketplace right now. We actually have two sample sets;
it would have been interesting to see the response if they were released.'*

'Back in elementary and middle school, our father would dress us in Air Force 1s. We wanted to wear ballet slippers and sandals, but he insisted we rock the latest Nikes!'

DAKOTA

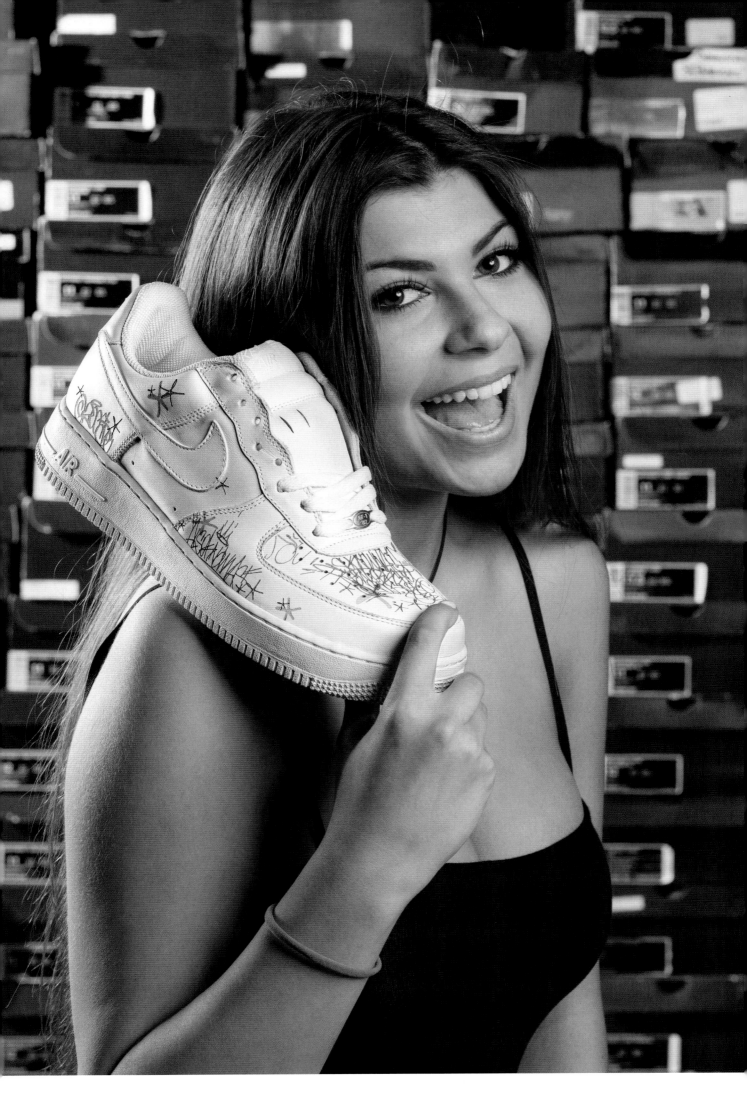

2007: Lebron James x Nike Air Force 1 PE 'SNL'

'These Air Force 1s were specially made for LeBron when he appeared on Saturday Night Live *back in 2007. They are in his size and still unworn. They also made a matching promo pair of SNL-branded Air Force 25s. An all-black AF-1 was given out to all the cast and crew of the show that night.'*

2002: Nike Air Presto 'Sex and the City' (Sample)

'This is the original prototype sample for a Nike Air Presto that was specially made for the cast and crew of Sex and the City. *Only a handful of pairs were ever produced.'*

2012: Jeremy Scott x adidas JS Roundhouse Mid 'Handcuff'

'When the design for this sneaker was previewed on adidas' Facebook page prior to release, controversy arose, with people claiming they resembled shackles and glorified slavery. Shortly after, adidas defended Jeremy Scott's eccentric design, but decided to destroy the entire inventory and not move forward with the release. While you can find pictures on the net, we have never come across another pair in real life.'

2015: Jordan CP3.VII AE 'Entourage'

'This Jordan CP3.VII AE make-up was made exclusively for the cast and crew of 2015's Entourage *movie. The tongue of the left shoe features a silhouette of* Entourage's *key cast members embroidered in gold.'*

2010: Air Jordan 1 (Sample)

'With its one-piece rubber upper, blinding colourway and ventilation throughout, was this Jordan Brand's attempt to cash in on Crocs?'

2002: Bad Boy Entertainment x Nike Air Revolution

'In 2002, Sean Combs reached a deal to buy back the 50 per cent stake in Bad Boy Entertainment held by Arista, making him the sole owner of the label. It is said that these Air Revolutions were made to commemorate the occasion, complete with Bad Boy branding at the toe.'

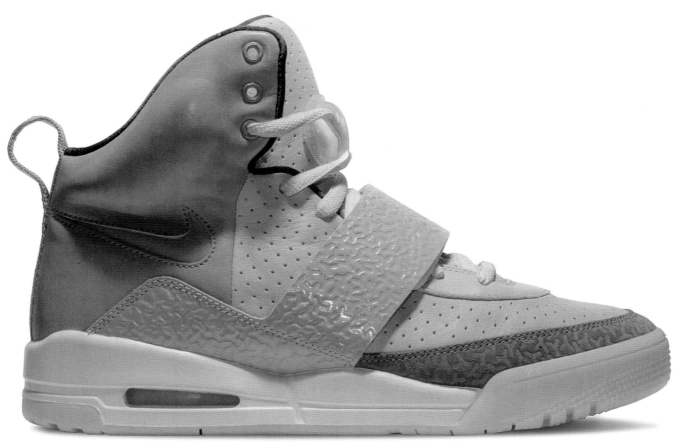

2008: Nike Air Yeezy (Sample)

'This is a sample of Kanye West's very first collaboration with Nike, made by the Feng Tay Group in China. Unlike the released version, this sample features a blue inner lining. We've never seen another like it!'

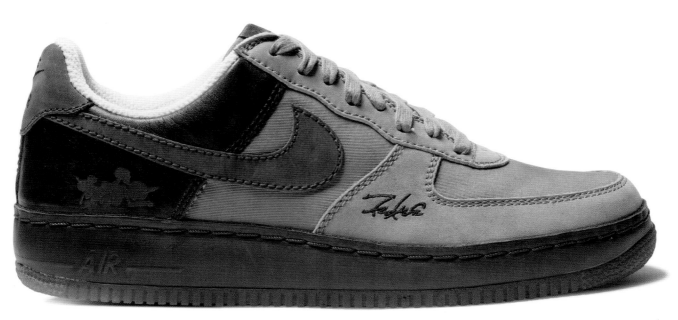

2006: STASH x FUTURA x Nike Air Force 1 Low (Friends & Family)

'These "Friends & Family" Air Force 1 Lows feature laser-engraving at the heel and FUTURA's signature embroidered at the toe. Some people say there were only 10 pairs of this special version released, some people say 25. We have come across two other pairs, but never another deadstock pair.'

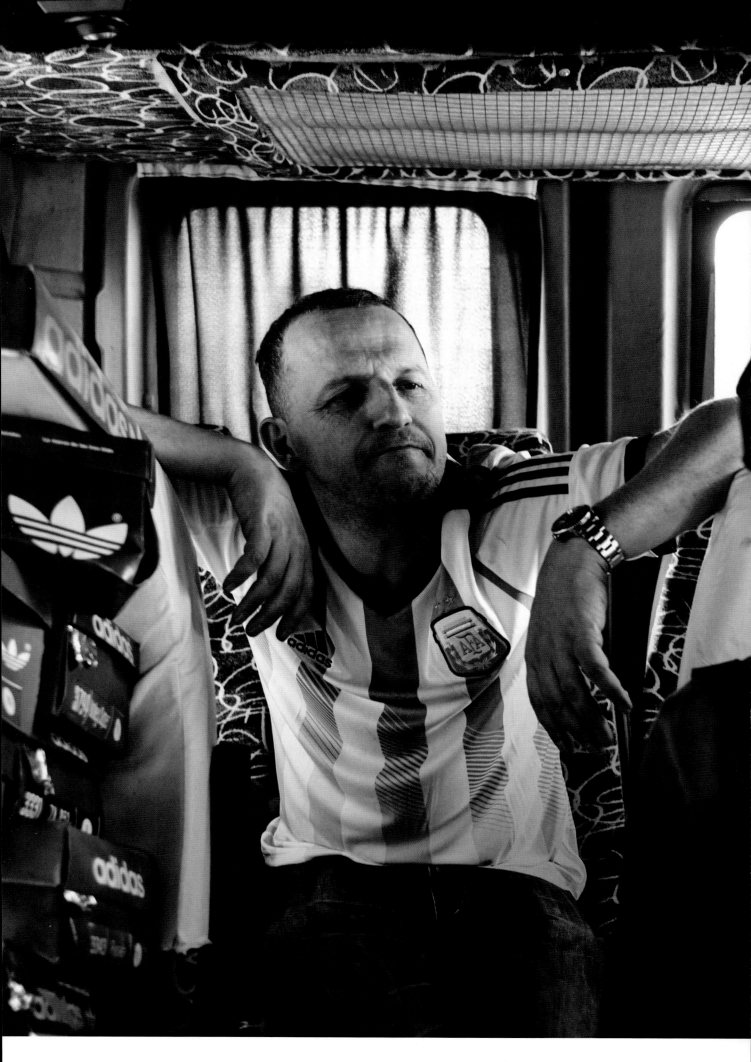

Interview: **Woody**
Argentina Photos: **Neil Bedford** Spezial Photos: **Gary Watson / Nathan Damour**
Additional Collector Photos: **Jeremy Kelly**

gary aspden

adidas Spezial

Inspired by a love of football and b-boying, Gary Aspden embraced the Three Stripes lifestyle as a youngster. His lifelong passions eventually piloted him into a position at adidas, where he worked on the original BAPE collaboration in 2003. Along the way, Gary stockpiled rarities and deadstock heat – around 3000 pairs by his own reckoning. Following a hot tip, Gary and his like-minded posse made a mad dash to Argentina, where a sports store had reportedly remained untouched since the 1980s. With piles of dusty adidas boxes and crusty trainers galore, it was likely one of the last brand-specific treasure troves like it left in the world. Today, Gary curates the adidas Spezial collection, fusing classic sports style with contemporary leisure wear.

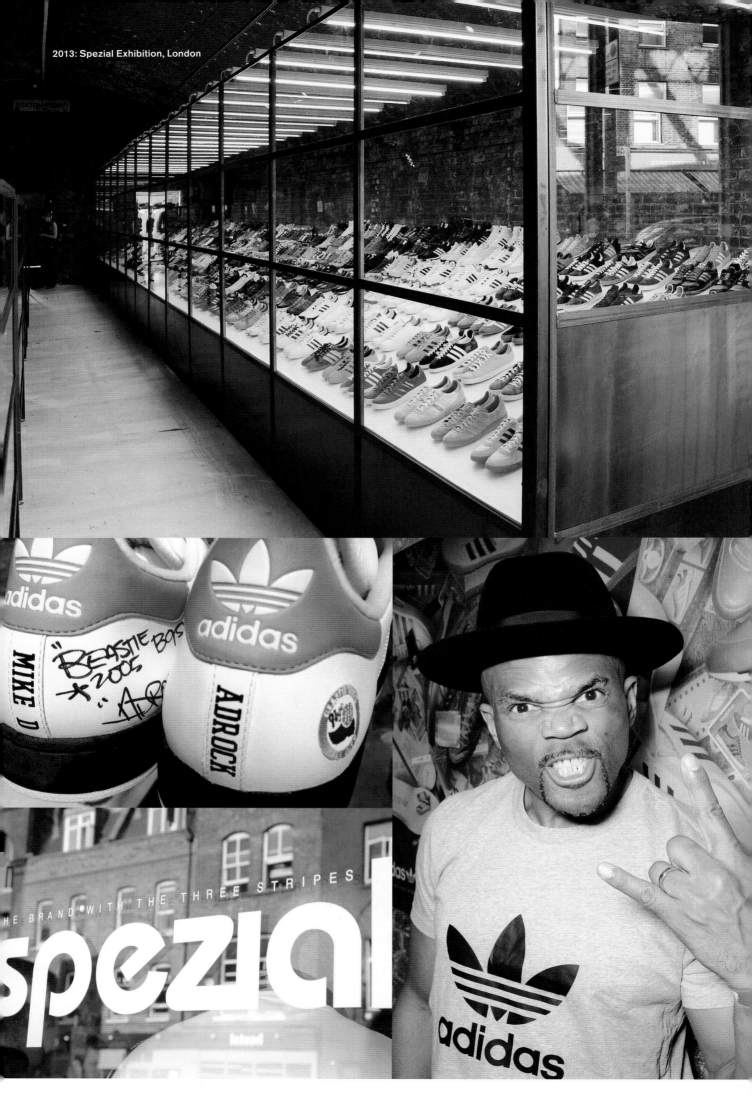

2013: Spezial Exhibition, London

Gary Aspden
adidas Spezial
Manchester

I grew up in a town called Darwen in the North West of England. I have a brother who is four years older, and playing football was pretty much all we did. If you were into football, you were into adidas. In the early 80s, I remember a group of older kids breakdancing on cardboard outside the park near my house. They were listening to a *Street Sounds Electro* compilation that blew my mind.

They were wearing European sportswear brands like Sergio Tacchini, ellesse, FILA and adidas. I got into the whole b-boy thing until it well and truly died off in 1986, and rap began to take off. Times were very different, and the social landscape of that era is difficult to imagine these days. No social media, no eBay, no sneaker boutiques, no mobile phones, no DVDs, home computers with 1K of memory and the TV – with only three channels – shut down at midnight.

Life was pretty boring, which meant that clothes, football, music and clubs were everything. England's north had a rough time during the recession of the 80s, and my dad didn't know if he'd have a job from one week to the next, so there wasn't much money going spare. Those tracksuits and trainers that we wore back then were VERY expensive. Don't ask how we got the money, but everything we got our hands on was worn rather than collected.

I interviewed Ken Swift from the original Rock Steady Crew in 1999, and I asked him why the early b-boys and graffiti writers were drawn to adidas and PUMA. He said it was because European brands seemed exotic and sophisticated to kids like him in the South Bronx. I realised that was also a big part of the appeal of those brands for us in the UK, but we were coming at style from a different angle from the Americans.

Shoes like Superstars that we saw American b-boys wearing in videos were not available in the UK at that time, so we had to appropriate the look with what was available locally. The biggest shoe in the mid-80s here in the UK was probably the adidas Gazelle. Prior to that, Sambas had been huge too, but they were purely a football lad's shoe. The adidas Century with homemade fat laces was the closest thing to the look of a Superstar available in the UK, although they were really heavy on foot and impractical for dancing. We also wore other flat, suede trainers like adidas Monaco, Madeira and Samoa, as they had a similar classic 'Three Stripe' look like Gazelles but were cheaper and came in more muted colourways.

Manchester

I looked up to some of the older youths from my hometown who regularly travelled to Manchester to watch United. I suppose it was working-class kids dressing up to assert some sense of identity, and you really had to be on it to keep up with it. We didn't read fashion magazines, and there was no internet, so you'd take your lead from seeing what older kids wore in youth clubs, discos, all-dayers and at football matches. There were also a number of older lads travelling to Austria, Switzerland and Germany specifically to pick up clothes and trainers, which is when the black market for rare adidas styles began to develop.

There were only two branches of JD Sports in the UK at this point (both in Greater Manchester), and the main stockist for rare adidas footwear back then was Oasis. It sat above the Underground Market and was not a sports shop in the traditional sense, as they carried cords, knitwear, shoes and leather jackets alongside sportswear and trainers. It was owned and run by a group of Mancunian football fans. That shop helped define and set the foundations for much of the Manchester street fashion that exists to this day. They were regularly going over to mainland Europe and bringing back gear that no one else had. Often the shoes didn't have boxes, so it was a pretty rough approach, but nobody minded as their offering was like nowhere else. They were respected and had their ear to the ground, so everything they sold at that store was popular.

I didn't spend much time in Liverpool growing up, but the city undeniably played a crucial role in the history of adidas and the Casuals culture in the UK. The look and the pursuit of rare adidas trainers spread to places like Birmingham, Stoke, Leeds, Blackburn, Cardiff and Aberdeen, but most people agree that the roots of modern Casual culture were born out of Liverpool and Manchester, although some Londoners might dispute that! The look continues to remain relevant, and there's a whole new generation of youths here who are really into it, particularly outside of London, where the whole hype/streetwear thing is still niche and has never really taken hold.

I draw on my experiences as a youth as a source of inspiration for adidas Spezial, although I would say the primary influence for the range is the brand itself. In my opinion, there is no brand with a better design archive to draw on. My job is one of a curator as much as designer – finding elements from the past that can be translated into something contemporary, be that through new footwear hybrids or updates on classic apparel pieces. That's the essence of what adidas Spezial is about. It's not futuristic or retro – it's modern.

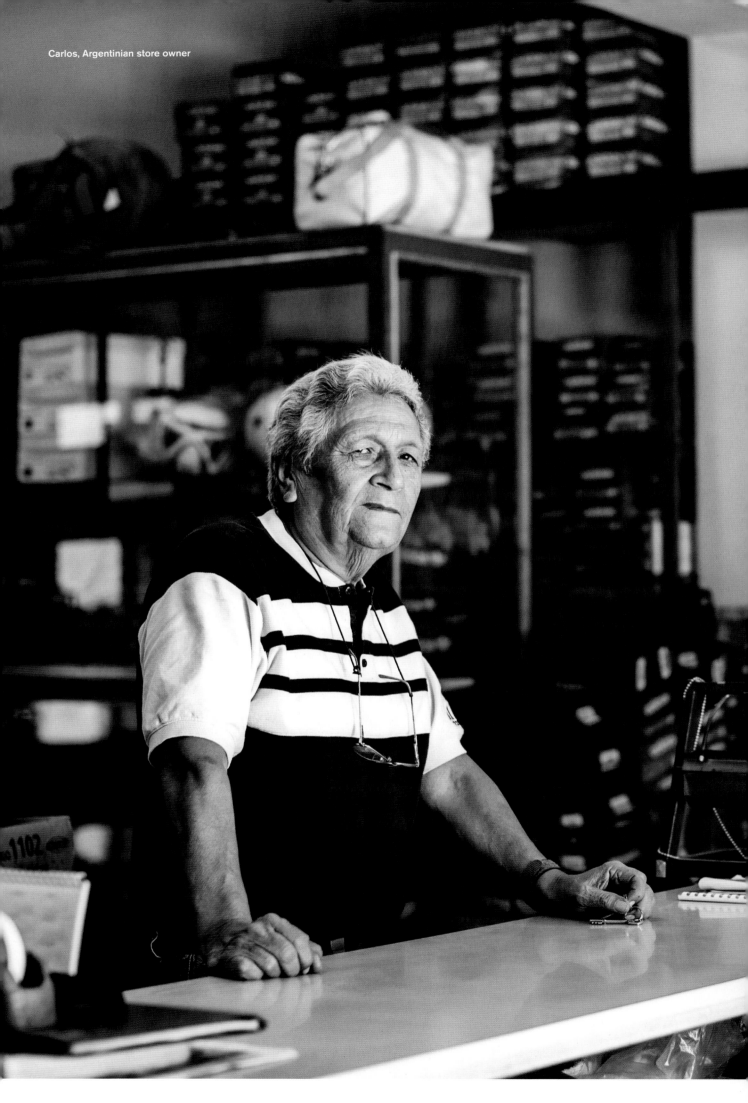

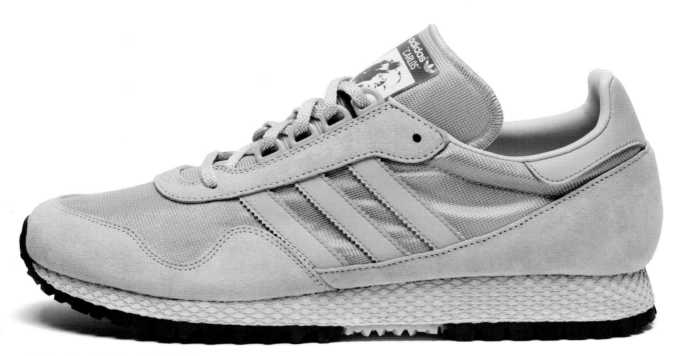

2019: adidas SPZL New York 'Carlos'

The Mother Lode

I spent much of the 90s seeking out deadstock trainers, so I have some experience in this area, but the trip to Argentina was an unbelievable experience. It was really good to document everything at a time when the value of vintage products was no longer a well-kept secret. Sources of deadstock have long dried up.

A colleague of mine sent me photos of Carlos' shop, and I immediately knew we had to get over there, assuming it hadn't been cleared out already. The people from adidas Argentina verified that the shop was still there. They said they weren't aware of the store as the owner didn't currently have an account with them – even though the store has been there since the late 70s!

The story behind the store is interesting. Carlos, the owner, had an accident and had to stop working. When he was away from his shop, the Argentinian economy collapsed, leading to adidas buying back the licence. Since adidas wanted to clean up local distribution, all the stockists had to reapply to get an account. He wasn't willing to fill out the forms, and as a result, he was no longer supplied by adidas.

Carlos then went out and bought up all the South American-made stock to fill his shop. It's an odd set-up because he would still open every day with no desire to sell. Decades later, he's still very reluctant. You could call him a hoarder, I guess. He doesn't need the money, so I can only imagine the shop gives him a sense of purpose and that he goes in purely to meet people.

Once Carlos met us and understood that our motives were not reselling, he was much more accommodating. I think he was quietly flattered that we had travelled so far, although we were warned not to take buying anything for granted. We heard that someone had tried to hire his store (for a significant fee) to use as a film set, and he rejected their offer, as he didn't like how they approached him. We took him some adidas gifts as a peace offering, and when we showed him footage of the first Spezial footwear exhibition in London at the Hoxton Gallery, he understood that we were passionate fans and not a group of mercenary resellers.

The climate in Argentina doesn't suit the preservation of polyurethane, so many of the shoes had disintegrated midsoles but perfect uppers. We grabbed a few pairs and later had them repaired by our colleagues at adidas' Athlete Services in Herzogenaurach. We found some good vintage runners, like the ZX390, that nobody had ever seen before. The Infinity was another shoe that was new to us – they had a similar silhouette to the New York but with a half-web midsole. I would have loved a pair in my size. Noel Gallagher from Oasis bagged one of our pairs.

Noted UK adidas collector Robert Brooks picked up the most substantial haul. Ian Brown (Stone Roses) is not a fan of shopping, but has a huge collection of adidas shoes and loves travelling, so he came purely for the experience. I think the only time we had an issue was when Robert and I had to flip a coin over a single pair of adidas Candy. Robert won!

To repay the goodwill Carlos showed us, we created a Spezial shoe for him – an adidas New York in Argentina blue with his face on the tongue. The same team returned to Buenos Aires a year or so later to hand-deliver his shoes.

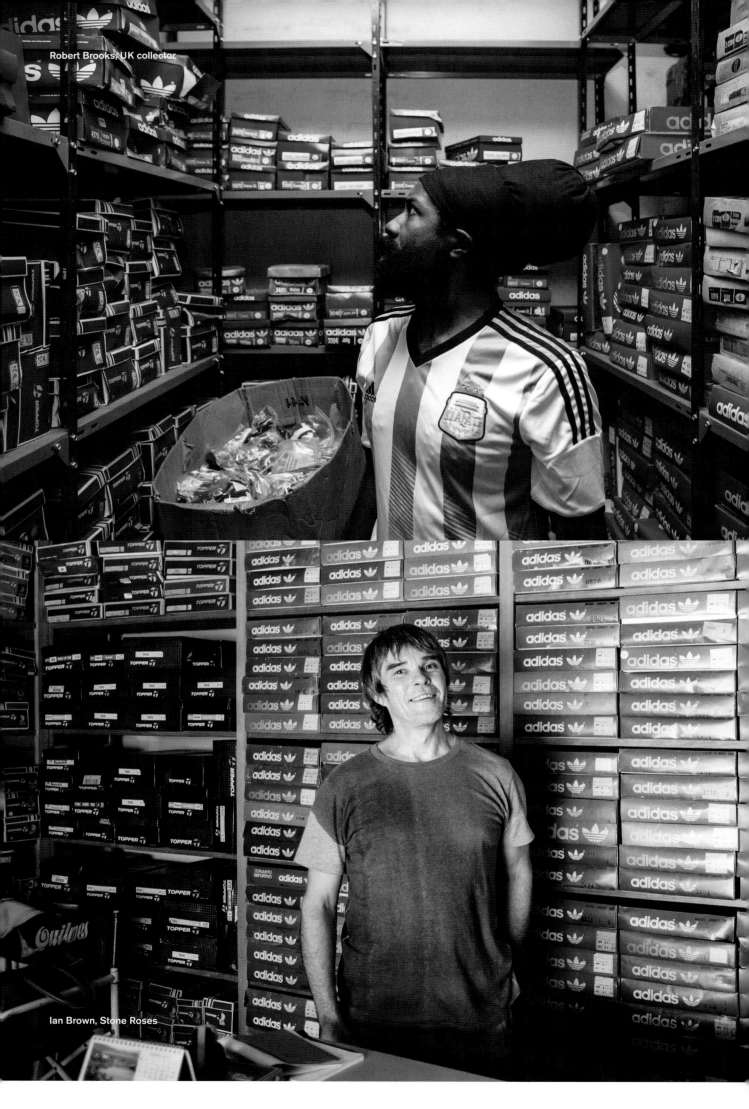

Robert Brooks, UK collector

Ian Brown, Stone Roses

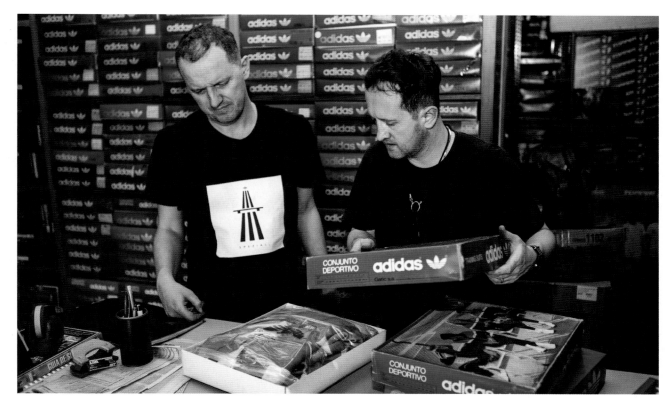

Gary Aspden and Mike Chetcuti checking out the vintage tracksuits

adidas Spezial

The Spezial range came from a proposal I put to adidas in 2013 to create a capsule collection of premium leisurewear. I wanted it to be modern and relevant to adidas purists without being solely reliant on 1-to-1 reissues for their attention. From the beginning, we were determined to create a range with a strong adidas identity. I thought a lot about how our birthplace and roots shape our individual identities and applied that idea to adidas. I wanted Spezial to feel almost 'Super European' in that sense.

Another strand of inspiration comes from my experiences growing up in the North West and 'Interrailing' around the continent as a teenager. We look for those details in the product outside of the brand marks that make it identifiably adidas and try to mix that with new materials, ideas and concepts. The range has continued to develop and has picked up a cult following in the UK and Northern Europe. If I see people wearing it at the football, that's the ultimate compliment. The value in that goes way beyond monetary value – it's the very essence of what got me into trainers in the first place.

The Shoes

We put the first Spezial footwear exhibition on in London in July 2013. It spoke directly to adidas fans and built equity into the name prior to the release of the product range. It also gave me an excuse to catalogue my personal collection, which was stored in several locations back then.

I used to head up adidas' Entertainment Marketing team globally. Times were very different, and our only currency was relationships and product. I would hunt down vintage shoes to gift alongside new releases for some of the artists I worked with. If I had a good find, I would inevitably keep a few pairs back for myself. I probably amassed about 800 pairs over a decade or so. I contacted other collectors like Robert Brooks and Noel Gallagher to see if they wanted to exhibit a few of their shoes alongside mine, and they both agreed. For the exhibition opening, Ian Brown and Bobby Gillespie (Primal Scream) came down, and DMC also flew in, which was a huge honour. The exhibition was extremely popular. It was amazing to finally see all those shoes on display under one roof and see kids come into a gallery who perhaps wouldn't ordinarily set foot in those environments. The sense of adidas history and progression through design was really powerful. With the depth of the adidas archive, there are so many different concepts and tecÚologies, and we wanted to showcase that and educate new generations. For example, in the 1980s running ranges alone, we have the Marathon TR to TRX to L.A. Trainer to Waterproof to Rising Star to Micropacer to Boston Super, and then both of the ZX series. adidas aesthetics have always been very diverse.

We followed the London show up with a bigger Manchester event in 2014 to celebrate the global launch of the Spezial range. The response was off the scale, as the northwest of the UK is such an adidas heartland. We then took it to Paris and Moscow in 2015, then resurrected the idea in Blackburn with the biggest Spezial show to date. The recent Spezial FC exhibition in Manchester was timed to coincide with the World Cup.

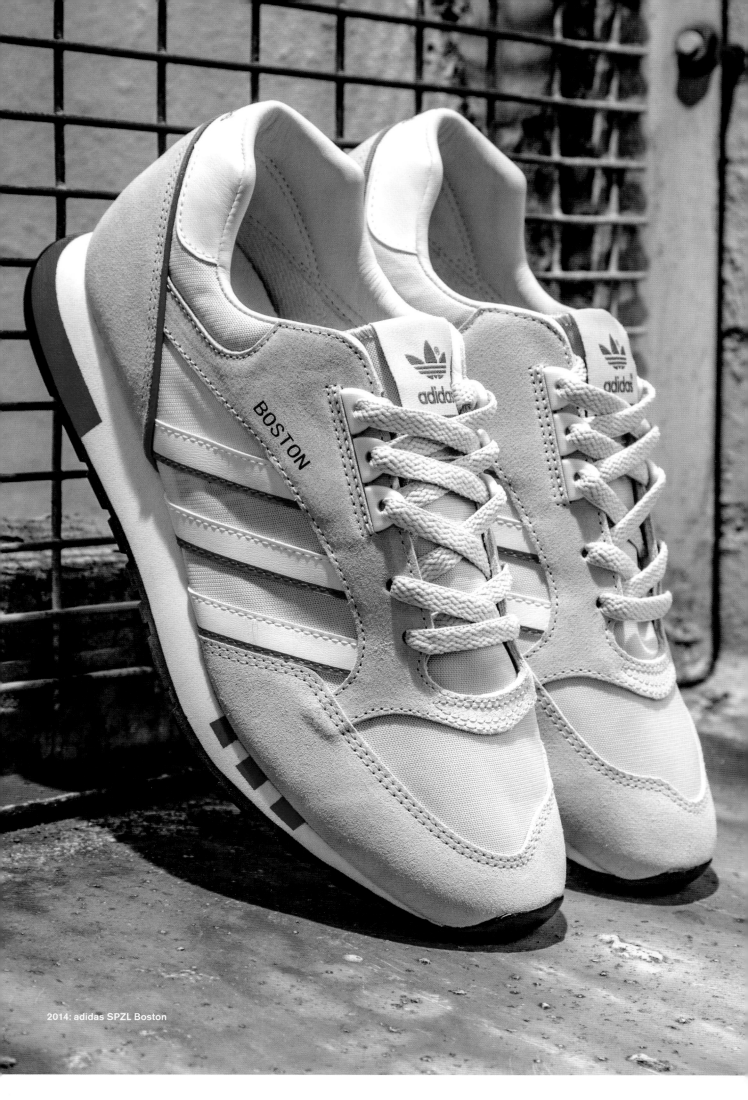

2014: adidas SPZL Boston

2022: adidas SPZL Exhibition

Freizeit Leisure Range

One of the quirkier chapters of adidas footwear – and one that dramatically divides opinion – is the Freizeit Leisure range. When I first started at adidas in the late 90s, the Leisure shoes were all I talked about to product managers, but the costs of producing new moulds were prohibitive. Some of the styles are incredible, but others haven't aged well. The Leisure shoes were never top sellers because they weren't easy to get hold of. In the adidas Spezial range, we've created new hybrids like the McCarten SPZL and the Punstock SPZL that pay homage to this iconic range. Noel Gallagher lent us his adidas Brisbane, which we redesigned as a low-cut and named the Garwen SPZL. We made him a signature pair in navy and then collaborated with Chris Gibbs in Union.

Vintage handball and indoor shoes are another phenomenon popularised in the UK, and these shoes still have a cult following. Low-profile, brown suede trainers, many of which were originally conceived and produced in France, is another area of adidas footwear that has a dedicated fan base. For me, they conjure images of Californian hippies and 70s roots reggae artists.

ZX runners are a significant part of adidas history. The second ZX range used colours that were really bright and over the top, and their release coincided with the birth of rave culture. It was not a premeditated move, but that palette worked so well with what was happening in fashion and culture at the time. The second ZX range, especially the ZX8000 and ZX9000, became known as the 'adidas Torsions', and that name has stuck to this day. Accessorised with Burlington socks and jogging pants, they were huge in London and the North. I have memories of wearing the ZX5020 to acid house parties in 1989. They were a women's edition in a silvery grey with pink stripes and a blue midsole, and while mates of mine had ZX8000s, I liked the unusual colour combinations.

The Torsion tecÚology of the later ZX releases continued right through into the Equipment range in the early 90s and beyond. Unlike a lot of the more visible, so-called tecÚologies that other brands were launching in the late 80s, Torsion was all about legitimate performance. Today, adidas has Boost tecÚology, which anyone can understand and, performance-wise, is head and shoulders above anything else I'm aware of.

I make no secret of the fact that I really didn't like the EQT range when it originally came out in the early 90s, but when I discovered some deadstock EQT pairs about 18 years ago, I had to concede that they looked great. I can now see that many of these designs were way ahead of their time. They may not have the simplicity and timelessness of an SL72 or a Stan Smith, but a lot of 90s stuff is highly experimental and deserves acknowledgment. Feet You Wear was another adidas era where design was really bold and innovative. I particularly take an interest in some of the outdoor shoes they created.

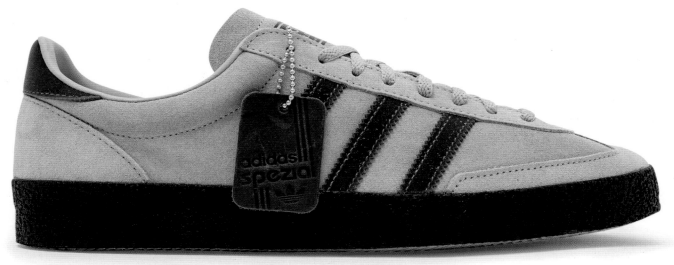

2020: adidas SPZL Lotherton

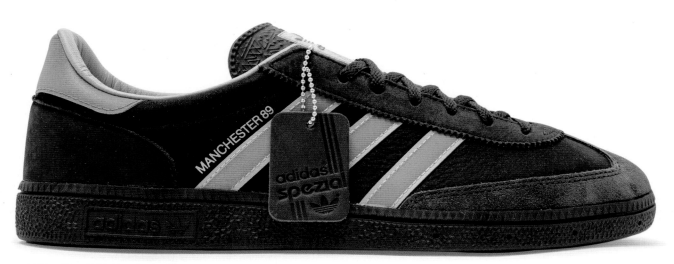

2020: adidas SPZL Manchester 89

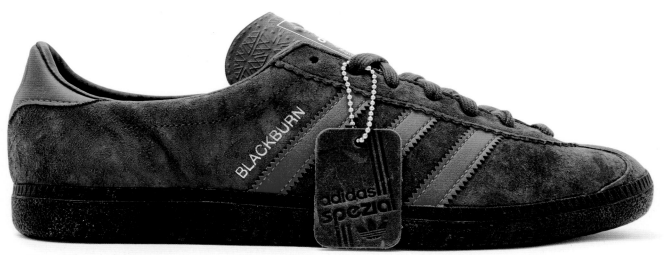

2019: adidas SPZL Blackburn

2023: adidas SPZL Hiaven

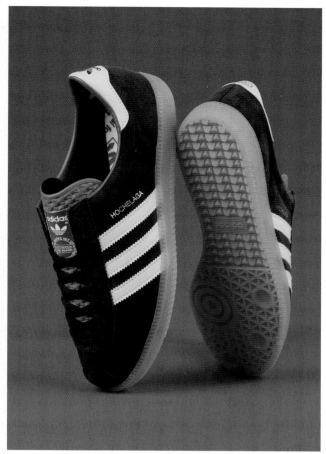

2023: adidas SPZL Hochelaga

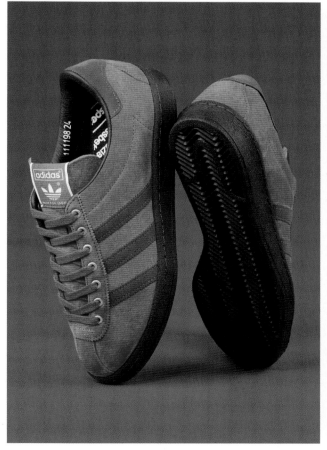

2023: adidas SPZL Arkesden

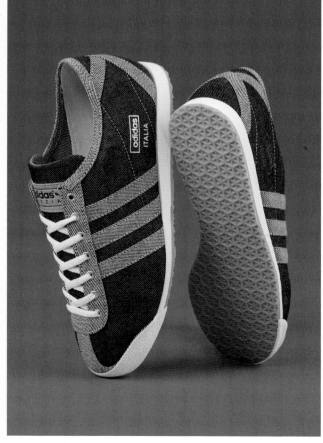

2023: adidas SPZL Italia Denim

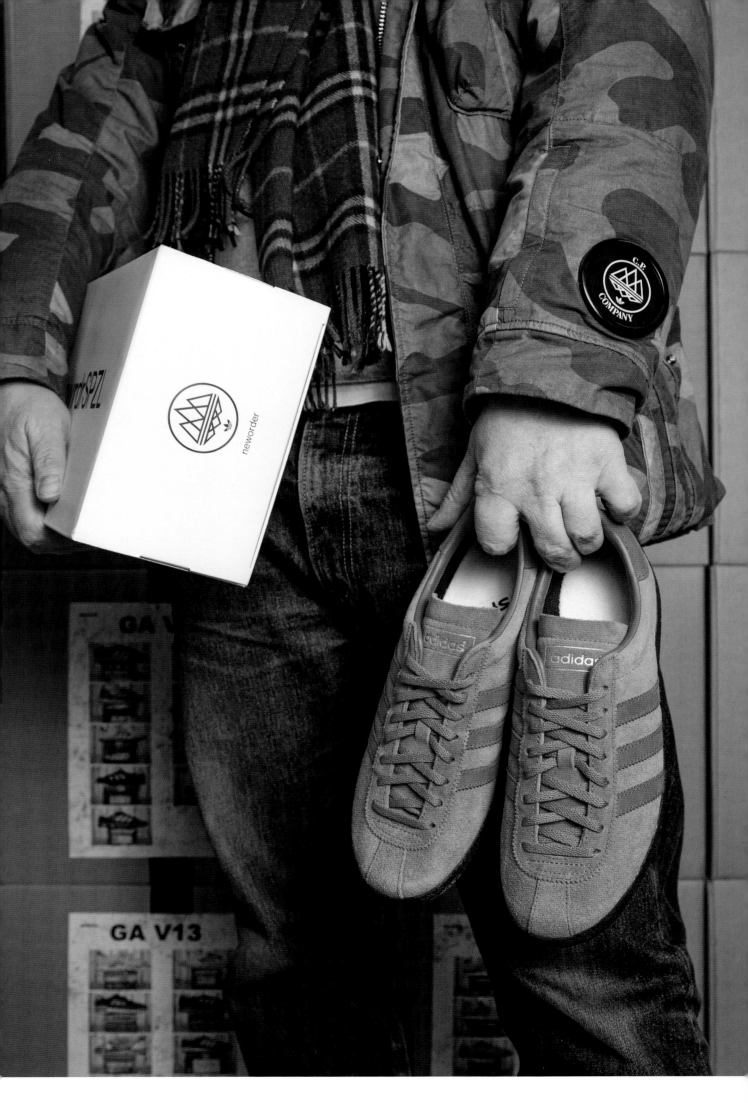

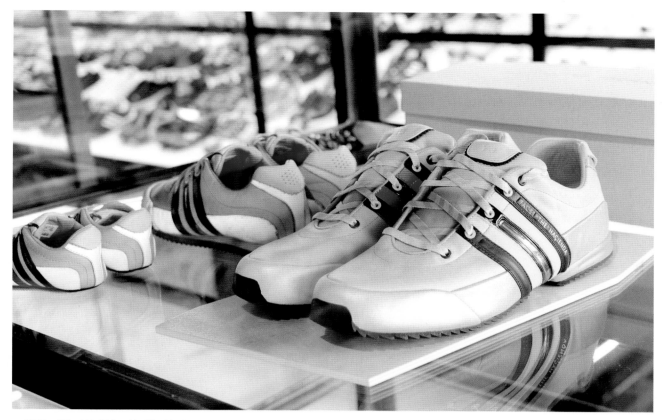

2007: adidas Y-3 FAC51-Y3 'The Hacienda 25th Anniversary'

Personal Favourites

The FAC51-Y3 Hacienda crib shoes are one of my all-time favourite pairs. The birth of my son Wilson was imminent, and we were in the midst of facilitating that project when he arrived six weeks early. It was a pretty full-on time, and the circumstances around his birth were completely unexpected. When I got back from paternity leave, the crib shoes and a kids' pair (that he ended up wearing for his fifth birthday party) were delivered to my office for 'services above and beyond the call of duty'. It was a nice touch from adidas, and I appreciated the acknowledgment. They are the only pairs in existence and my son's first pair of adidas, so they are definitely sentimental.

Throughout my career, I worked on a number of adidas collaborations, some of which are now seen as milestones. I was instrumental in the first BAPE x adidas collaboration from 2003, and for me, that project was everything a colab should be. It was born out of a genuine relationship and respect between the people that worked for the two brands. Ian Brown introduced me to Kazuki Kuraishi, a designer at BAPE, around 2001 when he was playing gigs out in Tokyo. I began supplying kits for the Bathing Ape football team, and we became good friends. BAPE were producing the Skulltoes, a homage to the Superstar, so we had a number of conversations about collaborating.

Everything was done right. Complete attention was paid to every detail, and no corners were cut with the shoe boxes, point of sale, PR and marketing. Most importantly, the shoes themselves were beautifully executed. We worked closely with Michael Kopelman to launch them at the London Busy Workshop store. The whole project had a really good vibe and raised the bar for the entire industry. It was the first time I saw people queue overnight for an adidas product. It also created a formula that is now industry standard. Personally, I don't think it will ever be bettered.

Through the benefit of hindsight, we can now see how visionary that project was. It laid the foundations for the NEIGHBORHOOD collaboration that kicked off the 35th anniversary of the Superstar in 2005. When we did that first colab with BAPE, one of the guys from adidas football had some one-off boots and Astroturf shoes made for Kazuki. He asked me if I would like some, too, as I was instrumental in bringing the whole thing together. They're yet to kick a ball!

I often meet people who tell me about an adidas shoe they would like to see reissued. With such a vast archive and so many cultural touchpoints, there are lots of different perspectives. The new generation of young football Casuals is fascinated by the style of the 80s in the same way we'd been fascinated by the Mod culture of the 60s. The core audience for the adidas Spezial range is rooted in that sub-culture. Spezial is just one small piece of a much bigger adidas jigsaw, albeit a significant piece that I am very proud to work on.

★

@gary.aspden

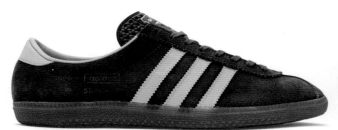

1976: adidas Stockholm

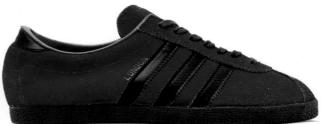

1976: adidas London

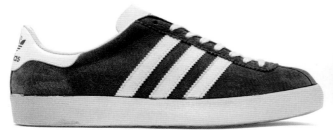

1977: adidas Chamois

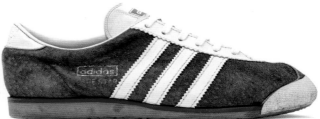

1977: adidas Blue Star

1977: adidas J Barrinton Pro

1979: adidas RunnerSuper

1983: adidas LA Trainer

1987: adidas Hallenhandballtorwart

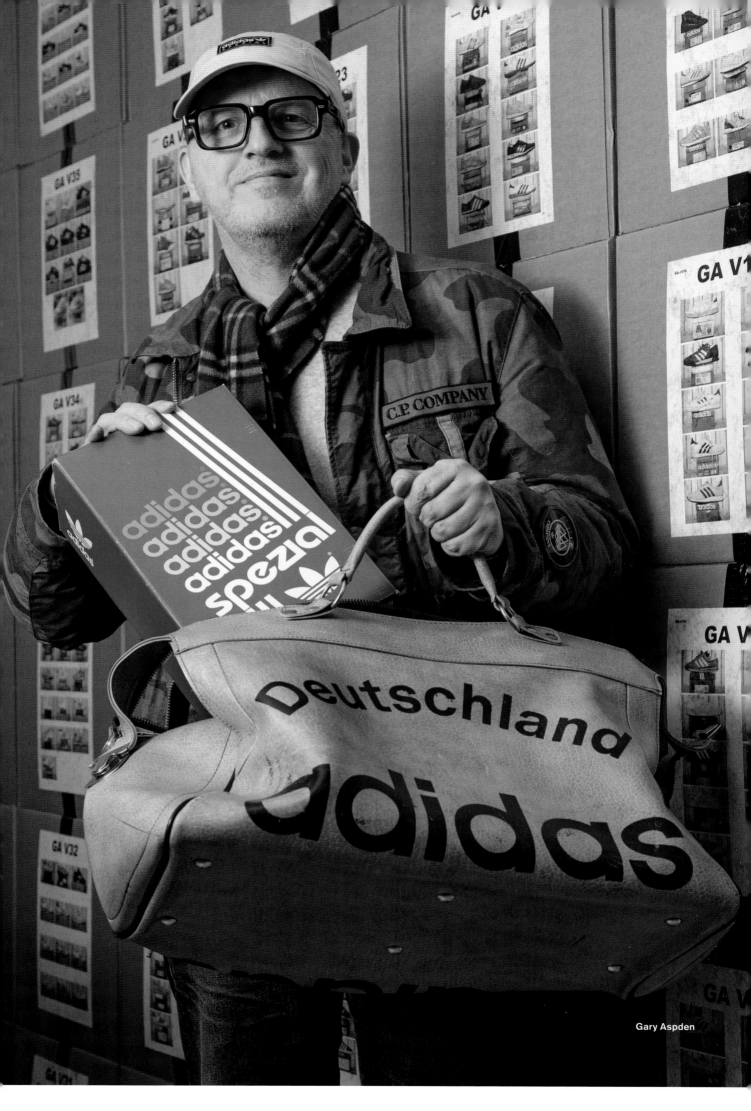

Gary Aspden

1986: adidas Marathon Comp

1985: adidas MicroPacer NL

1985: adidas Highway

1980: adidas SL80

1981: adidas Samba

1983: adidas Zelda

1983: adidas Dallas

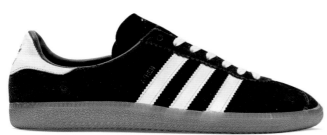

1984: adidas Athen

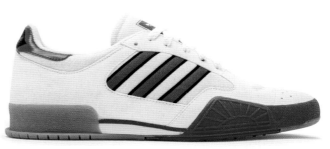

1987: adidas Volley Ball

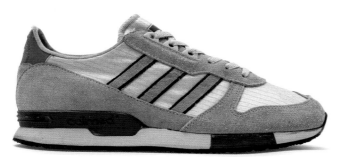

1987: adidas Adipromed

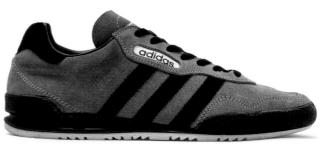

1987: adidas Jeans Super

1988: adidas ZX220

1994: adidas Price II

2006: adidas ZX600

2008: Footpatrol x adidas ZX800 'aZX'

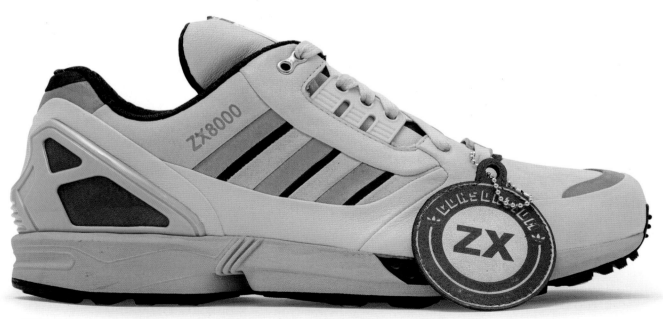

2008: adidas Consortium ZX8000 'aZX' (Friends & Family)

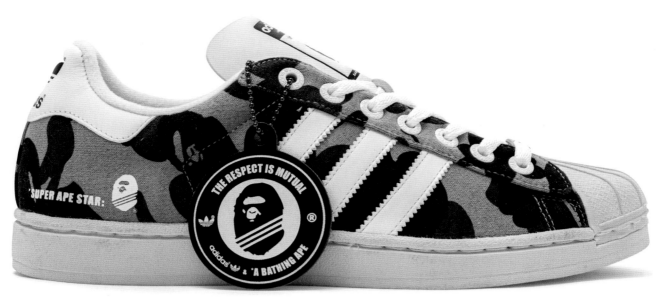

2003: A Bathing Ape x adidas Super Ape Star

2009: Stone Island x adidas Five-Two 3 Samba

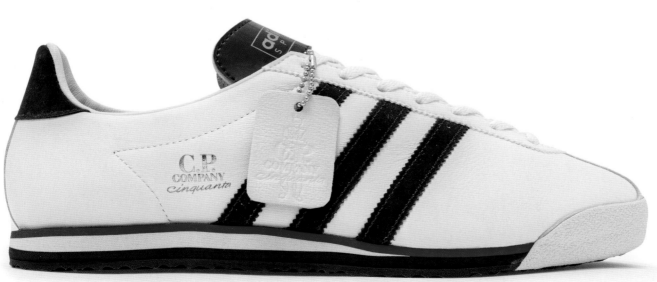

2021: C.P. Company x adidas SPZL

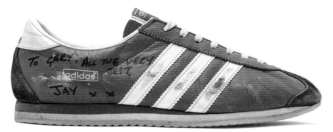

1994: adidas Berlin (Signed by Jay Kay from Jamiroquai)

2005: NEIGHBORHOOD x adidas Superstar '35th Anniversary'

2011: Noel Gallagher x adidas Training 72NG (Signed)

2017: Noel Gallagher x adidas SPZL NG Garwen (Signed)

2018: Union x adidas SPZL Garwen

2019: Liam Gallagher x adidas SPZL LG (Signed)

2020: adidas SPZL Winterhill

2022: Peter Saville x adidas SPZL 'Pulsebeat' (Signed)

2022: Liam Gallagher x adidas SPZL LG2 (Signed)

2022: adidas SPZL Moscrop

THE DEAD STOCK HUNTERS

Just imagine. No Air Force 1. No Air Jordan 1. No Air Max in any guise. Nada, nothing, zilch. (You get the picture.)

c'est la qualité

Aqua SOCK Too²

Text: **Neal Heard**

Back in the late 1980s, long before the interwebs superhighway connected everything, everywhere, all at once, the idea of a 'sneaker scene' would have been laughable. But there were a few pockets around the globe where a deep appreciation of footwear was starting to coalesce. A handful of chaps even had the bright idea of hunting down unloved vintage footwear and selling it for a tidy profit in the UK and Japan. This is their story!

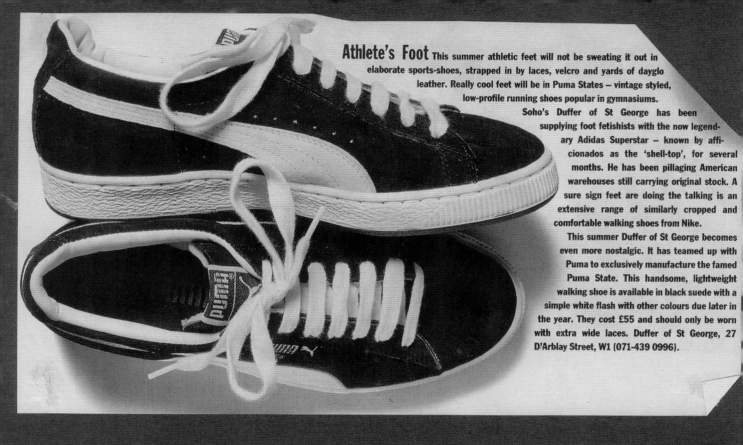

Athlete's Foot This summer athletic feet will not be sweating it out in elaborate sports-shoes, strapped in by laces, velcro and yards of dayglo leather. Really cool feet will be in Puma States — vintage styled, low-profile running shoes popular in gymnasiums.

Soho's Duffer of St George has been supplying foot fetishists with the now legendary Adidas Superstar — known by afficionados as the 'shell-top', for several months. He has been pillaging American warehouses still carrying original stock. A sure sign feet are doing the talking is an extensive range of similarly cropped and comfortable walking shoes from Nike.

This summer Duffer of St George becomes even more nostalgic. It has teamed up with Puma to exclusively manufacture the famed Puma State. This handsome, lightweight walking shoe is available in black suede with a simple white flash with other colours due later in the year. They cost £55 and should only be worn with extra wide laces. Duffer of St George, 27 D'Arblay Street, W1 (071-439 0996).

Photography Joelle Depont

1989: *The Face* magazine

THE FACE 89

216

1989: *The Face* magazine **1990:** *The Face* magazine

Neal Heard
Deadstock Sneaker Hunter
Wales

In the United States, the twin pillars of hip hop and basketball have been culturally intertwined with an appreciation of sporting footwear for decades. In the United Kingdom – a historically often overlooked source of footwear fascination – it was the 'Casuals' youth movement, born on football terraces in the early 1980s, which first embraced trainers and the now ubiquitous sportswear, especially high-end European labels. Though stylistically very different, the US and UK movements were both based on a common denominator. Long before mass advertising and the modern hype apparatus were invented, working-class kids appropriated the 'sneakers' worn purely on sporting fields, courts or running tracks in order to express themselves and create a distinctive visual identity.

In order to fully appreciate the story I'm about to tell you, it's best to breathe deeply, slow things right down and imagine a faraway time when sneakers were only sold at sports stores. Once a new running shoe or basketball model had survived a season or two, it was removed from store shelves and replaced with the updated version. Even hall-of-fame perennials like Chuck Taylors and Stan Smiths were not always available year-round. Once a shoe was gone, it was gone! And once that happened, except for finding the odd deadstock pair in a sports shop, you could not buy your favourite shoe anywhere.

Just imagine.
No Air Force 1.
No Air Jordan 1.
No Air Max in any guise.
Nada, nothing, zilch.
(You get the picture.)

Now, hold that thought for a minute as we continue to set the stage in the late 1980s. This is where our four major players come into the picture. Marco Cairns, Eddie Prendergast, Fraser Moss and Idris Kaid can all rightly claim to be pioneers of the deadstock sneaker hunt. Admittedly, there were others moseying around old sports shops at the same time, such as yours truly and the lads who set up a market stall in Manchester. Japanese collectors had, in their usual methodical way, also started to collect vintage shoes, but it was the main characters in this story that took it to a totally different level. You might even say they made sneaker hunting look almost professional!

After interviewing each of our protagonists separately, it's interesting how often the memories overlap. As Cairns (co-founder of The Duffer of St George) remembers, 'We were doing it for the passion really. We didn't really have a plan. It all came and went fast – we wanted to have a laugh, and we wanted to create!' Fraser Moss (co-founder of You Must Create) sounds like a twin separated at birth. 'We did it for the buzz. It was exciting finding stuff, and it was exciting on the one-upmanship front. It was adrenaline-fuelled, almost like a rush, getting the stuff first before anyone else!'

STRIPE HORIZONTAL ▬▬▬ T SHIRT

NUMBERS ON HIP & CHEST.

GOLEY QUILTED SWEAT SHIRTS

NEXT TO FRED BARE ~~~~~~ TRAINERS

CHEQUERS. BRICK LANE. FRANKS — BRIXTON

YELLOW PAGES. ROMFORD AREA. CLAPTON SPORTS — GAZELLE

WHOLESALERS WARREN ST STOCKWELL RD

NIKE ALL COURT

PLIMSOLE.

ADIDAS GYM
ADIDAS. UNIVERSA
PUMA EUROPE
PUMA DALLAS
ADIDAS — COUNTRY USA ROM

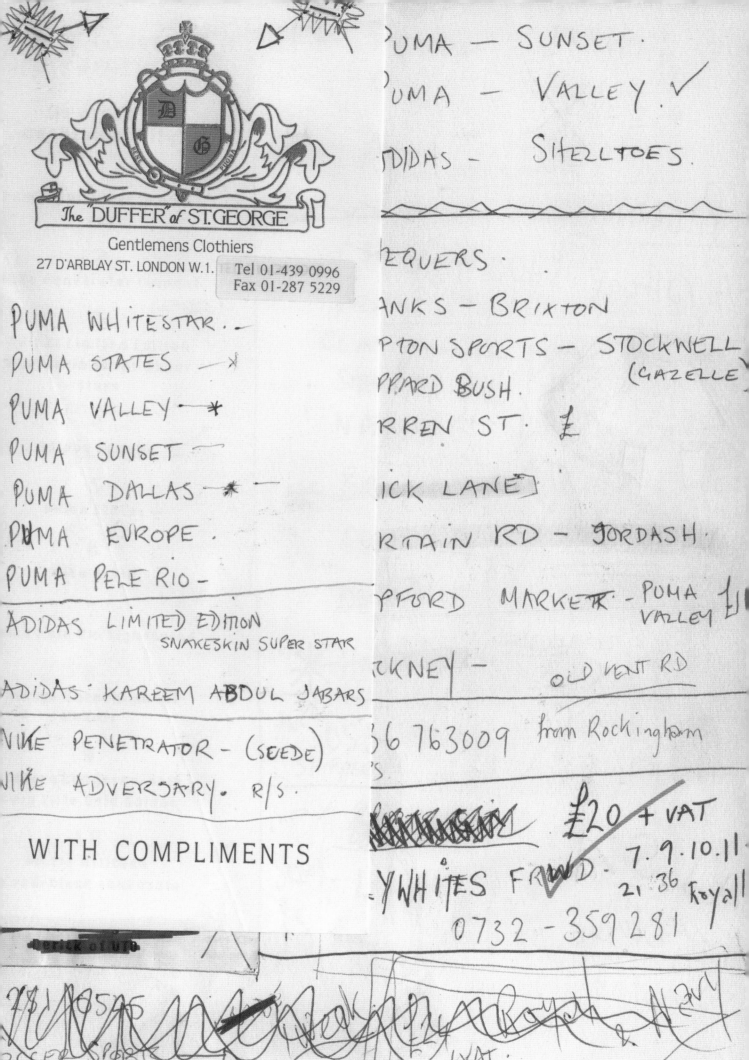

The "DUFFER" of ST. GEORGE

Gentlemens Clothiers

27 D'ARBLAY ST. LONDON W.1. Tel 01-439 0996
Fax 01-287 5229

PUMA WHITESTAR ._

PUMA STATES _—*

PUMA VALLEY —*

PUMA SUNSET —

PUMA DALLAS —*—

PUMA EUROPE .

PUMA PELE RIO —

ADIDAS (LIMITED) EDITION
 SNAKESKIN SUPER STAR

ADIDAS. KAREEM ABDUL JABARS

NIKE PENETRATOR — (SUEDE)
NIKE ADVERSARY. R/S.

WITH COMPLIMENTS

PUMA — SUNSET.

PUMA — VALLEY. ✓

ADIDAS — SHELLTOES.

CHEQUERS.

BANKS — BRIXTON

...PTON SPORTS — STOCKWELL
 (GAZELLE)
...PPARD BUSH.

...RREN ST. £

...ICK LANE

...RTAIN RD — JORDASH.

...PFORD MARKET — PUMA £1
 VALLEY

...CKNEY — OLD KENT RD

...56 763009 from Rockingham

£20 + VAT

...Y WHITES FRWD. 7.9.10.11
 21 36 Royall
 0732 - 359 281

+ VAT.

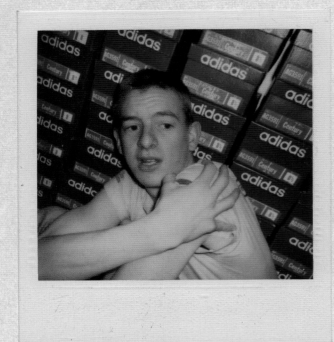

1989: Danny Moss at Duffer

The Duffer of St George, Soho

1990s: adidas Shelltoes

1995: The diggers in Boston at the end of a two-week road trip

Meet the Hunters

The Duffer of St George
Eddie Prendergast and Marco Cairns are two larger-than-life Londoners who co-founded the legendary 'The Duffer of St George' fashion label in the late 1980s. The Duffer stores in Soho and Covent Garden offered a unique mix of British and European 'terrace' classics alongside retro sneakers personally sourced by the lads from all over the globe. Eddie now consults with various labels, while Marco still works with Duffer Japan.

Idris Kaid
An all-around ducker and diver, Idris Kaid hails from Newport, Wales. In the late 1980s, he co-founded the now-defunct Professor Head stall at London's Camden Market, pioneering the deadstock sneaker cult. He now runs ic3uk.com.

Fraser Moss
A noted vinyl collector and fellow Newportonian, Fraser Moss co-founded the respected British menswear label You Must Create (YMC) in the mid-1990s. Prior to that, along with Idris Kaid, he was a co-founder of Professor Head, making him one of the UK's earliest diggers of vintage trainers.

The DUFFER *of* St.GEORGE

Professor Head

The early 90s was a generational cross-over period for creativity, style and music. As Moss recollects, 'Most of the football Casuals had gone to the rave scene in the late 80s where there was less focus on shoes. It was a very creative time, and I began to notice this subset of clued-up kids coming into Vivienne Westwood's shop, where I was working, rocking what we would now call 'Old Skool' shoes. Kids from Bracknell and other parts of Kent were mixing the original b-boy look of adidas Shelltoes and goosedown jackets with vintage Vivienne Westwood and sports apparel. It was a very specific new look that was ahead of its time. One of the first people who started it was Trevor Norris, who had a shop selling deadstock Shelltoes mostly to Japanese collectors. I remember meeting Robert Plant from Led Zeppelin there while he was buying a pair for his daughter. I thought there was potential to make a bit of money, and this led me and fellow Newport pals Idris Kaid and Chris Towers to start what became known as Professor Head at Camden Market.'

'The other stallholders hated us!' reminisces Kaid. 'We also sold some of our stock to clued-up shops, including one called Interstate, which Fraser Cook (now a senior Nike employee) used to work in.' Moss concurred. 'Back in those days, you could just rock up early to wait in a queue to get a stall at Camden. I remember us pissing all the other stallholders off as we would set up at 7 am, and by 9:30 am, we would be sold out, mainly to Japanese clients who turned up early once word got around!'

The Duffers

The Duffer of St George was a fashionable store located on D'Arblay Street in London's Soho district. Prendergast makes a strong case regarding the way trends changed over time. 'There was no internet back then, so you couldn't get clued up on a new trend in a matter of minutes. It took about a year for new styles to spread and catch on across the globe. Working in D'Arblay Street, which we saw as the centre of the world, we could see the trends coming, with less technical shoes and a return to basics.'

The two English entrepreneurs took a punt and flew to New York in 1989. The Canal Street area on the Lower East Side was a bit like London's Petticoat Lane, where you could buy fashion leftovers on the cheap. Prendergast had noticed the same transitional change. 'At this time in New York, the original b-boys had moved on from classics like adidas Shelltoes and PUMA Suedes, which they had rocked to death. They simply no longer wanted "retro" trainers, which is what we had come over to buy.'

Following an extensive local search, Prendergast and Cairns chanced upon an old store in the vicinity of Orchard Street. As Cairns recounts, 'Out of the corner of my eye, behind yellow washed-out window blinds, I spotted a single faded adidas box. The store was closed, but we rang the bell and persuaded the owner we were looking for old stock to help kit out poor kids in a youth centre football team. We went downstairs to the damp basement, and we were dumbstruck! Piles and piles of adidas boxes, around 150 pairs of Shelltoes issued by the US Institute of Mental Health, as well as snakeskin adidas Baskets. We bought the lot and pissed the hotel right off when we filled our room with dusty boxes. That was the start of everything. When we got home, the press featured our story, and we knew we were really on to something big!'

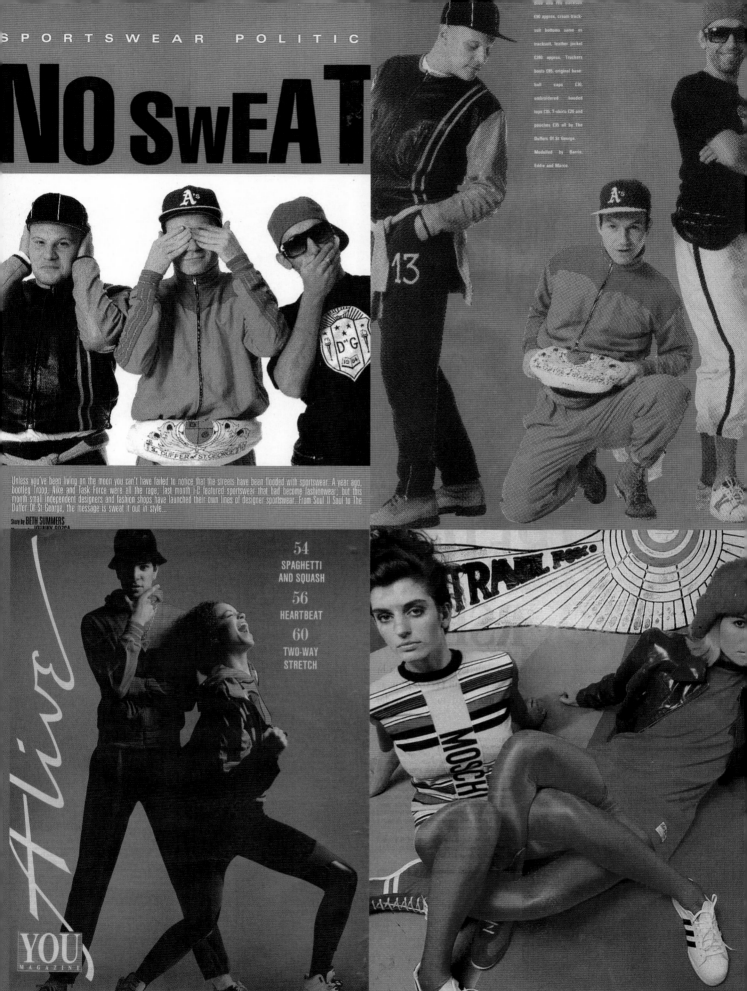

NO SwEAT

Unless you've been living on the moon you can't have failed to notice that the streets have been flooded with sportswear. A year ago, bootleg Troop, Nike and Task Force were all the rage; last month i-D featured sportswear that had become fashionwear; but this month small independent designers and fashion shops have launched their own lines of designer sportswear. From Soul II Soul to The Duffer Of St George, the message is sweat it out in style...

Story by BETH SUMMERS

Blue and 760 buckson £90 approx, cream track-suit bottoms same as tracksuits, leather jacket £280 approx, Truckers boots £85, original base-ball caps £30, embroidered hooded tops £35, T-shirts £20 and pouches £35 all by The Duffer Of St George. Modelled by Barrie, Eddie and Marco

54
SPAGHETTI
AND SQUASH

56
HEARTBEAT

60
TWO-WAY
STRETCH

Alive

YOU
MAGAZINE

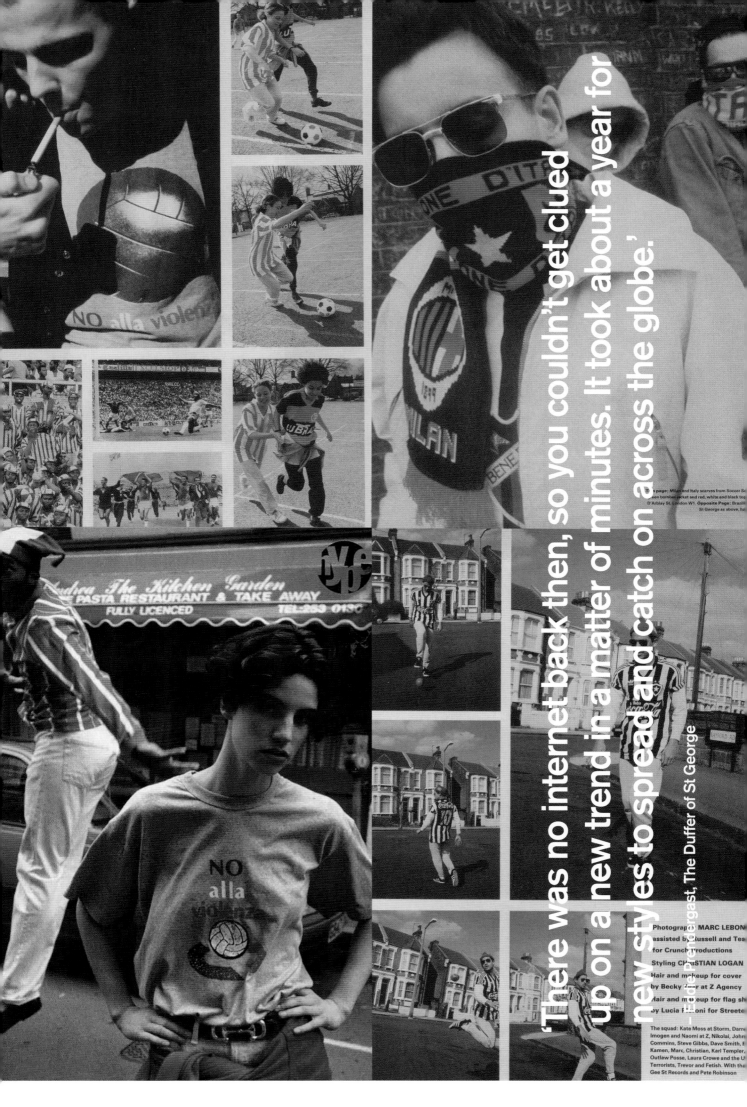

'There was no internet back then, so you couldn't get clued up on a new trend in a matter of minutes. It took about a year for new styles to spread and catch on across the globe.'
— Eddie Prendergast, The Duffer of St George

This page: Milan and Italy scarves from Soccer Se... green bomber jacket and red, white and black top D'Arblay St, London W1. Opposite Page: Brazil... St George as above, ha...

Photography MARC LEBON assisted by Russell and Tes... for Crunch Productions Styling CHRISTIAN LOGAN Hair and makeup for cover by Becky ... er at Z Agency Hair and makeup for flag sh... by Lucia P...oni for Streete...

The squad: Kate Moss at Storm, Darre... Imogen and Naomi at Z, Nikolai, John... Commins, Steve Gibbs, Dave Smith, ... Kamen, Marc, Christian, Karl Templer, ... Outlaw Posse, Laura Crowe and the U... Terrorists, Trevor and Fetish. With tha... Gee St Records and Pete Robinson

"It was 1989. You have to remember that, at the time, there was no back catalogue. The brands, especially Nike, were pretending they still only sold their shoes to sportspeople. They wanted their shoes technical and had no interest in the past. Boy, has that changed!"

— Eddie Prendergast, The Duffer of St George

Nike Air
Jordan III

Nike Air
Force Hi.

Adidas
"Metro Attitude"

Adidas
"Forum"

Adidas
"Mutant Hi"

Adidas
"Mutant Hi"

Running order: from the low-cut Puma Clyde of the early Seventies to the hi-tech, high-top Nike Air Jordan III of the late Eighties; now Puma is reissuing the Clyde, and Adidas the Stan Smith and Gazelle

A step-by-step guide to trainers

W hile Nike and Reebok continue pumping hype and gimmicks into their trainers, the sneakers most in demand are free of tricks. The "Old School" variety has taken over from the hi-tech trainers. And Old School they are: these are the trainers of the football-crazy schoolkids of the mid- to late-Seventies, of the flared-trouser school uniforms, plastic Adidas sports bags (another rediscovery and selling fast) and matching Stan Smith striped trainers. Today, a pair of vintage gold-stamped Stan Smiths will change hands for £100 at VKS (Vintage King Sneakers) in sneaker-mad Japan.

Shoes first made around 1970 — Adidas Gazelle, Campus, Superstars (nicknamed "shell toes" because of

Adidas has, unwittingly, contributed to its own success. It destroys some styles every four years, and is now having to reproduce defunct models to keep up with demand. Simon Lilley, sports manager at Adidas, is surprised at the rapid resurgence of interest, although it started in the US last year. "Only a few brands have the history to bring out authentic vintage shoes," he said.

Adidas was founded in Germany in the Twenties by Adi Dassler, a cobbler who loved sports and saw a gap in the market for sports shoes. When Jessie Owens won four gold medals in the 1936 Olympics, he was wearing Adidas track spikes. The new issues of vintage shoes at Adidas (Stan Smiths and Gazelles) are all from the Seventies. "If they

want, they were superseded long ago. "Skate-boarders have always worn Pumas," says Kenneth Mackenzie at Duffer of St George. "They are popular now because they're easy to wear – a modern classic."

The Puma Clyde was named after a basketball player, Walt "Clyde" Frazier, superstar of the New York Knicks, who tested his Puma Suedes for quality before endorsing them. When his nickname was put on the sneakers, it was the start of the boom, when kids on the street could buy into a piece of sports mythology. That was in 1974. Puma Clyde sales peaked in 1985, when more than 2 million pairs were sold in the US. Now their time has come again.

The difference between Clyde

back through the archives unearths such treasures as the Ir J, endorsed by basketball star Dr Julius Irving; and the Jack Purcell, t tennis shoe first introduced more than 50 years ago.

In the US, the race is still on to be the owner of the latest, most hi-tech sneaker. L A Gear's L A Lights must have the all-time useless gimmick — battery-operated lights that come on when pressure is applied to the heels. But in this country it is mainly teenagers who are buying "new school" trainers.

"The Old School sneakers are more subtle and grown up," says Mr Siggins. The simpler styles are also in tune with the relaxed mood of today. The Supermodel Kate Moss never travels without her Gazelles. "I've got five diffi ir," she

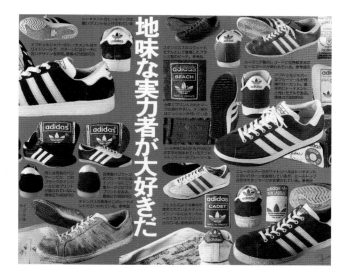

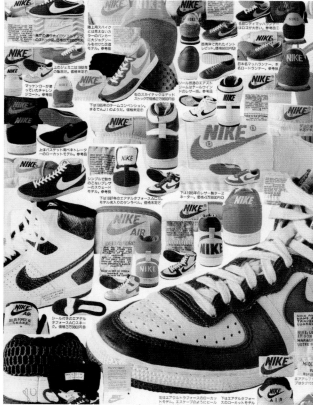

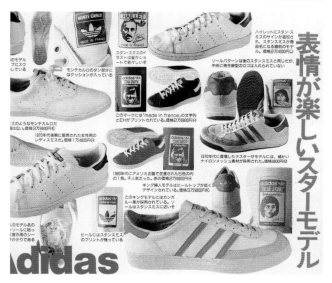

1997: *Boon* magazine

This Sporting Life

The triumphant crew headed home to Wales, going back to their roots by knocking on the doors of small independent sports stores. Ron Lewis' store in Maesteg was a treasure trove. Ron was an ex-rugby referee and one of the first to import Nike into Wales. Apparently, he was trying to get them involved with the Welsh national team, so he had a lot of rare gear, including Jordan jackets with the original basket logo, not the Jumpman! Others include Shoe Warehouse in Bradford, Salopian Sports in Shrewsbury and Bolwells in Blackwood, which was beloved by local Casuals as it often had unique adidas samples. City Road Sports in Cardiff was also great, but the owners were difficult, so access was scarce. Trips to Scotland and Ireland were so productive, the lads were soon using a vintage Citroen DS to transport stock liberated from dusty storerooms into a bright new world insatiable for once-it's-gone-they're-gone trainers.

A race across London soon developed as the friendly rivals made manic attempts to track down sports shops before their pals could rinse the premises. As attested by the amazing notepad kept by Cairns, the shopping list itself was a thing of wonder. Meteor Sports, Franks in Brixton (with Nike Omega Flames in the window!), the small shop at the bottom of Kingsland Road in Shoreditch, Warren Street, Shepherd's Bush and Stockwell… the list of potential spots to plunder was seemingly endless.

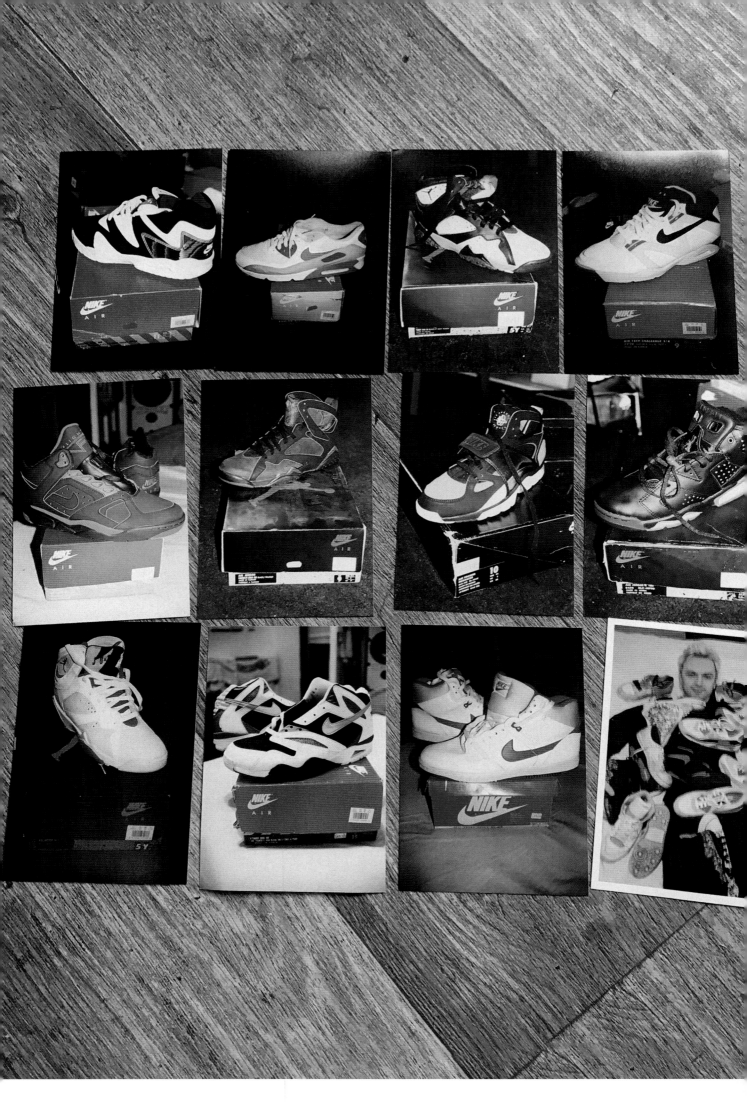

PHOTOGRAPHY BY
MATT JONES
STYLING BY WILLIAM
BAKER AT PATRICIA
MCMAHON
ASSISTED BY
STEPHEN DASILVA
MODELS: DAN AT
TAKE 2, GILES AT
MODELS 1 AND MATT
THANKS TO DHARANI
AND EVERYONE AT
BHAKTIVEDANTA
MANOR, HILLFIELD
LANE, ALDENHAM
FOR THEIR HELP AND
HOSPITALITY

**i-D MAGAZINE No 163
APRIL 1997**

Matt wears Nike Air Rift trainers from The Duffer Of St George, 15 Shorts Gardens, London WC2; bag by Copperwheat Blundell from Liberty, Regent Street, London W1 and Hervia, Royal Exchange Arcade, Manchester; shirt by Helmut Lang, as before; watch by Fila, as before; Krishna robes from the Temple Shop, as before.

i-D THE OUTLOOK ISSUE 111

1997: *i-D Magazine* No. 163

Two particular destinations ranked as Holy Grails. Hales in South Wimbledon and Four Seasons Sports in Tonypandy, a tiny village in Wales, would gridlock social media if even one of them was discovered today. Kaid remembers the moment he first laid eyes on the latter. 'Four Seasons was run by this lovely old ex-rugby player from the 1990s. Byron had a sports shop and a toy shop in the same space. We knew we were onto something as soon as we saw the windows crammed with old toys and original sports gear, including adidas and PUMA. It was totally surreal to find boxed Air Jordan 1s literally sitting behind the counter! It sounds over the top now, but it was like a dream. The storeroom was packed full of old football shirts, tracksuits and cool toys. We took two carloads out of there. He also had original Muhammad Ali and Ken Norton toys in their boxes, but he wouldn't sell them!'

Moss chimed in with his own Grail recollection. 'Hales in South Wimbledon was run by this brother and sister who were ex-javelin athletes, and they were sat on the best stock in London!' Kaid picks up the baton. 'We found a lot of adidas Trimm Trabs and Forest Hills. The brother used to go upstairs, as he had a flat above the shop, and he would only bring us down 10 pairs at a time. But we struck gold one time when he was out, and his sister gave us access, and we nearly cleared them out!'

The score was so good that the Japanese streetwear magazine *Boon* somehow heard about the exploits and ran an interview. 'We made the mistake of believing our own hype and giving away some of our contacts', remembers Kaid, a regrettable admission that was also endorsed by Moss. 'Sometime later, loads of Japanese tourists had found a few of the shops we'd been to, and there was suddenly very little left!'

Cyprus III

The Professor Head boys weren't operating alone. As Cairns recounts, 'The mother lode was a tipoff we managed to find in Cyprus of all places.' Prendergast (aka Mr Memory) takes up this particular story. 'We were getting our stock from a friendly competitor, Phil, who was another early digger and ran a shop called Acupuncture. You NEVER give away your sources, but just one time, Phil left a swingtag on one of the bits we bought off him. On close inspection, the tag was from Sodeas Sports in Cyprus. This was well before the internet, so the only way we could locate the shop was by going to the Cypriot Embassy and going through their version of the Yellow Pages. Bingo, there it was! We knew Phil was heading out to Greece, so the race was on. I remember asking the airline staff if his name was on the passenger list. In Athens, they told us he wasn't on the next two flights but that there was an early morning flight. We rocked up to the store at 8:30 am only to find Phil had got there earlier! It turned out that the owner of the shop was an adidas distributor. The owner took Phil up each floor of his five-storey building, while the disgruntled store manager allowed us second choice of the good stock after Phil. Our bad luck soon turned good. The store manager sent a fax to both Phil and us with the details of a bonded warehouse full of adidas stock. It turned out later that Phil couldn't read his fax as it was blurred. With that small piece of luck, we ended up getting there first. Athens was a freeport, so this warehouse had loads of seized goods like cigarettes, but it also had 15,000 pairs of boxed, deadstock adidas shoes!'

As Cairns gleefully recalls, 'We managed to get them for $8 a pair, but there was no way we could take them all in one go, so we persuaded them to let us take batches of 500. It took a few trips, but we cleared the lot. Some went to Japan, and the rest went to our shop, as the press had picked up on the whole scene by then, and it all went ballistic.'

The Stuff of Dreams

The Cyprus haul inspired Moss, who had a brainwave that America was the next destination for their sneaker-hunting expeditions. As he saw it, 'Middle-class America was paydirt! All the rich stores serving rich people… we were learning from experience that these types of stores had the best stock. So we approached the Duffer pals to come with us and split the takings. It turned out to be the trip of a lifetime!'

Before they left, both groups visited the British Library, where American copies of the Yellow Pages were stored. After scouring the books and calling bemused sports shop owners with all sorts of questions about 'old sneakers', our brave adventurers flew Stateside, with Kaid infamously turning up with just a toothbrush in his luggage. The Massachusetts area was deliberately chosen as it was full of old Ivy League towns like Cambridge, Worcester, Springfield and Brimfield. They even visited a town just outside of Boston (whose name they now forget) to witness the grave of Marquis Mills Converse, who founded Converse in 1908.

Kaid remembers finding loads of rare Nikes, some of them with tags marking them as '1-of-200'. He contacted the brand in Oregon to say they should exhibit the shoes in their museum. The response wasn't as positive as Kaid had imagined. 'Who are you to tell us what to buy? I couldn't believe it! It's worth noting that we also found lots of Nike models marked as "Made in Japan", which I didn't think too much of at the time, but we later learned that this was the very early days of Nike when they were using factories Phil Knight had worked with in his Blue Ribbon Sports days when he repped Onitsuka Tiger. One of my favourite-ever finds was about 100 pairs of Nike Lava Dome we found in an amazing store called Hollybuck & Coughlin, which was somewhere near Boston and supplied Ivy League universities with sporting goods. You can imagine how good the stock was, all boxed up in grey with purple, green and the even rarer orange Swoosh!'

Beantown Bandits

All three interviewees wax lyrical about one find that shocked this bunch of hardened hustlers. It's here that our narrators revert to hushed tones, even though the moment passed more than two decades ago. Located just outside of Boston, 20th Century Sports is a place so legendary they still can't believe it was real.

Moss remembers the moment like it was yesterday. 'The funny thing was, for once, we knew that this was an amazing deal at the time, that it could never be beaten. Full-size breaks of Jordans, Dunks, Wally Waffles, Cortez, salesman samples and swing-tagged shoes. The list went on and on.'

The moment was equally seared into the brain of Cairns. 'I remember walking down into the basement, and when the old guy switched on the light, my eyes were swivelling out of their sockets. This huge pyramid of shoes was stacked haphazardly. He told us to help ourselves, but we had to pair them up. It literally took an entire day, but it was worth it!'

'It shows you the mood of the time', remembers Prendergast. 'When we went in and asked about old classics, the store kids were laughing at us, as they were all wearing tech shoes. They thought we were crazy "Limeys" behind the times for buying old-fashioned shoes. The even better bit was finding a wall full of the old red boxes. Three hundred pairs of Nikes for $8 to $10 a pop!'

The standout find of all their trips was in this warehouse. The memory of finding handwritten salesman-tagged samples of 'Wally Waffle' Nikes still chills. They were resold for what seemed great money at the time, but the value today would be 100 times plus what they reached back then. Which, of course, is to say that they were all exported to Japan.

1994: *i-D* 'Essential Guide to Trainers'

Kaid remembers the ecstatic nature of that deal. 'The guy we were dealing with was called Billy Fox. He knew we were on to something, but because we had come all that way, paid cash and had the gift of the gab, he let us have every pair for $5. It seems mad now, but you have to remember at the time that this was just old stock catching dust. We bought over 500 pairs and sold the whole lot to a company called Goodwill of Tokyo. *Boon* magazine featured the whole thing again. I remember the article, but it was in Japanese, of course.'

Sometime later, I was lucky enough to go on another deadstock-hunting trip with Moss and Kaid. We landed in Toronto and drove a Mustang convertible from Buffalo to Detroit, then on to Worcester to visit Charlie's Sports. All I have now from that trip are photos of us smoking cigars and meeting Canadian Mounties. A local newspaper, *The National Post*, heard about our expedition and covered the crazy story with the headline 'Searching for the Mother Lode'.

Then and Now

Explaining the differences between this innocent time and now is an impossible task. Some 30 years later, it's obvious how much new ground was broken by these entrepreneurial British style addicts. Though they didn't know it at the time, the 'retro' footwear revival they helped seed in the early 90s would turn out to be incredibly influential on modern-day menswear and street style. Reissues and back catalogue digging by brands would go on to become the norm at Nike, adidas, New Balance and Reebok et al., but it definitely wasn't the case in those days.

The hugely important role played by The Duffer of St George and YMC may have been overlooked in the official history books, but their appreciation of classic sneaker style created an oft-copied identikit that is now ubiquitous around the globe. It's not ludicrous to suggest that the athletic sneaker industry might look very different today without their 'deadstock-hunting' contribution.

My deliberately vague 'Is there anything else?' final question hit a raw nerve with Prendergast, who summed up his yearning to set the story straight and put the facts on record in the pages of *Sneaker Freaker*. 'There are a lot of revisionists around nowadays. The fact is… we actually did do it. It was all of us! We more than helped invent the whole sneaker thing, and that's the truth!' Fraser Moss also eloquently summed up the whole experience. 'We didn't quite realise it at the time, but after those digging days, a whole part of the footwear industry was born out of what we were doing. It changed footwear fashion worldwide and the way people looked at sneakers for good.'

★

@nealheard

Photos:
Peter Rad

Interview:
Woody

ALLDAY DREAMS ABOUT SNEAKERS

Meet our man AllDay, an utterly humble Brooklyn-bred sneakerhead who has been hustling hard for years, buying and selling so many Nikes he had to move house just to free up space. At one point, he owned 19 of the total 150 pairs of 'PlayStation' Air Force 1s. Remember those impossible-to-buy AF-1s in elephant print made for the Nike SB team riders back in 2002? Yeah, he has both colours – and a whole lot more! Listen up as AllDay explains how he built up a gobsmacking 3000-deep collection, including every Jordan released since 1999.

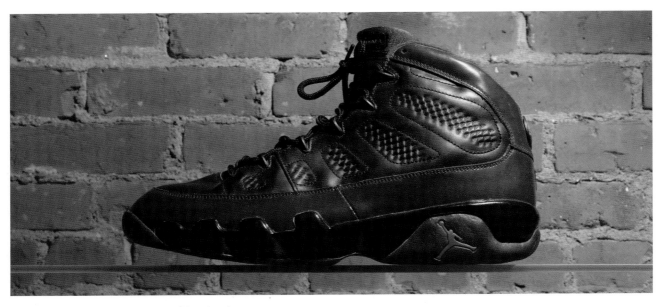

2003: Air Jordan 9 PE 'Eddie Jones' (Heat Away)

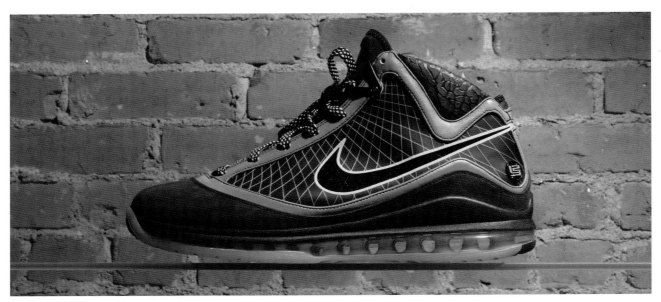

2009: DJ Clark Kent x Nike LeBron 7 '112'

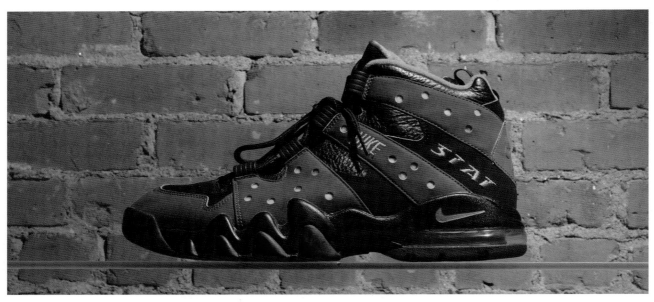

2010: Nike Air Max 2 CB 94 PE 'Amare Stoudemire' ('STAT' Away)

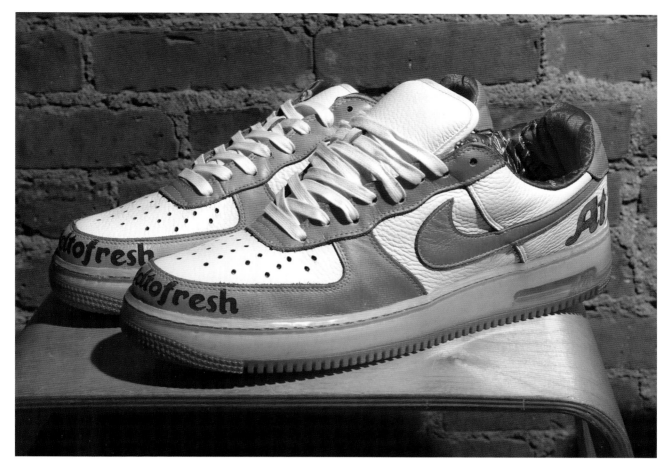

Nike Air Force 1 Low ATF 'Addicted to Fresh!' (1-of-1)

How did you get into sneakers?

Growing up in Brooklyn, I always saw people who had money – hustlers mostly – and they always had the latest sneakers on their feet. New Balances, Nike, ASICS and adidas Shelltoes. I also remember Etonic, AVIA, FILA and British Knights with the elephant print. So now, when they bring back retros, you have all these memories and it's like, 'I remember that. I want them again!'

My first pair of Jordans was the 12 in white and black. I got the Pennys that year as well. From my first year in high school until my last, I bought over 100 pairs with my own money. Then I started driving around everywhere to get shoes, from the Bronx to Manhattan, Queens, Jersey and Philly.

People started asking if I could get them a pair or two. The first shoe I remember like that was the 'Black Cement' Jordan 3s, and I scooped up at least 20 or 30 pairs. I realised that places in the city were selling them for $200, even though I paid $99. So I went from doing favours to making money by going to NikeTown to buy 50 or 60 pairs that everybody wanted. I even had to get my own place after high school because the sneakers were piling up out of my room and into the hallway. Right now, I have about 3000 pairs tucked away in various places. At one point, I had between 4000 and 5000 pairs.

What was the first shoe where it went beyond flipping them for an extra $50?

Probably the 'Black Album' and 'Video Music Box' Air Forces from 2003. That rolled into the 'Pigeon' Dunk SBs and UNDEFEATED Jordan 4s. At one point, I had 19 of the total 150 pairs of the 'PlayStation' AF-1s.

How is that even possible?

I knew a guy who told me he can get a pair. I told him I need three, so I traded him six or seven sneakers. After that, I offered to pay. It didn't even occur to me to sell any – I just really wanted them because they were rare. On top of that, growing up in the hood like I did, it was hard enough getting a PlayStation console. So when you see Nike collaborate with PlayStation, it's instant euphoria. That shoe blew my mind! I got on the phone, made a deal, and before I knew it, I ended up with 19 pairs. That was a big investment at the time.

No doubt. You're well known as a collector, but then you're also prepared to sell. How does that tension work?

I never considered myself a collector until one day, I looked around and saw shoes everywhere. That's when I realised! I don't buy stuff just to have it – I buy it because I like it. Then you've got all these people hitting you up with emails, phone calls and making generous offers, so that's basically how it all happens.

In New York, product flies around from place to place all the time. I used to keep track, but I'm not really into it like that anymore. One time with the white-on-white Air Force 1s with gum bottoms, somebody wanted 50 pairs in the Bronx, so I found them. That 'Patta' Air Max in burgundy went up to $1000. So if you got lucky with two or three pairs, you just made a few grand to spend on something you really want. That's all it is – buying, trading, selling – it just depends what it's worth to people.

What's the most valuable shoe to you?

That would be my Air Force 1s made for the Addicted to Fresh (ATF) crew. The inside has memory foam, so it basically moulds to the shape of your foot. It's exactly like those pillows that adjust to your spine.

How do you get handmade Nikes? [*Note: this was well before the $800 Bespoke iD service was introduced, so it was a big deal at the time.*]

That's something I can't talk about. [Laughs.]

Tell us about the ATF crew. Seems you're all hardcore Air Force 1 guys.

I wouldn't say that because you never know who's out there getting what they like. I believe there are 10 members, but the five heads would be me plus DJ Clark Kent, Mayor, Bun B and DJ Greg Street. I go back and forth with Clark a lot. We try and take things off each other's hands all the time because we're both size 13. That's just the way it is.

I always wanted those '3M Snake' Air Force 1s.

Mmmm. Those are good. What size are you?

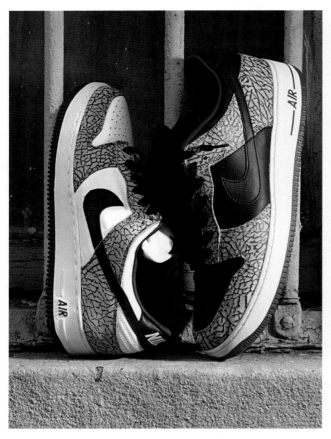

2002: Supreme x Nike SB Dunk/Air Force 1 Hybrid

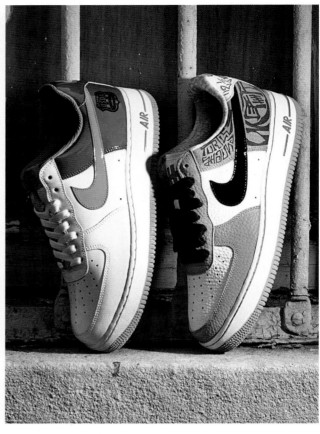

2006: Nike Air Force 1 'USDA'
2006: UNDEFEATED x Nike Air Force 1 'Entourage'

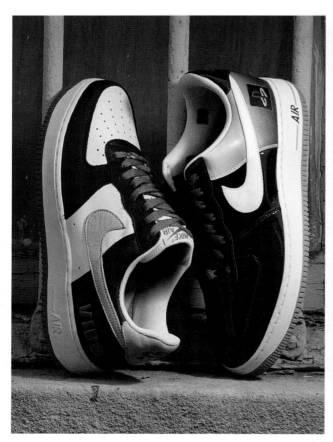

2003: VIBE Magazine x Nike Air Force 1
2006: PlayStation x Nike Air Force 1

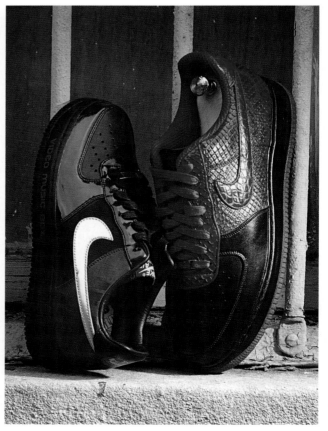

2008: DJ Clark Kent x Nike Air Force 1 'Video Music Box'
2007: Nike Air Force 1 '1 Night Only'

'In the blue scheme that I have, only one pair. Of the gold one, I believe there are anywhere from seven to 13 pairs. Each was given to the main cast of *Entourage*. Mark Smith (Nike designer) has a pair, and some are on display at the HBO building. There's one pair out here in New York. One day they'll be mine!'

First published *Sneaker Freaker* Issue 20 – December 2010

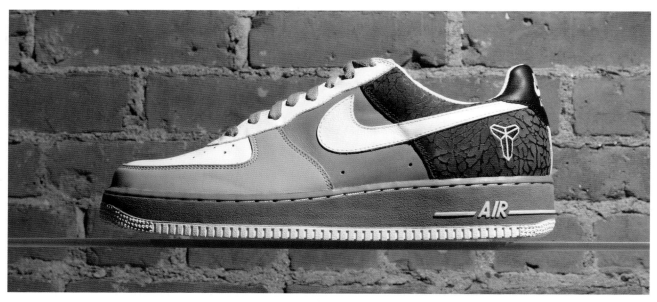

Nike Air Force 1 Low 'Kobe Cement'

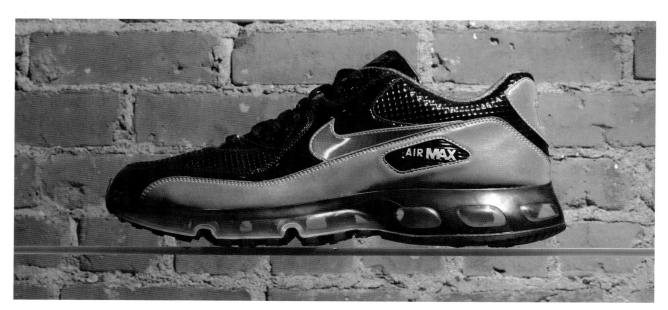

2006: Nike Air Max 90/360 'PlayStation 3'

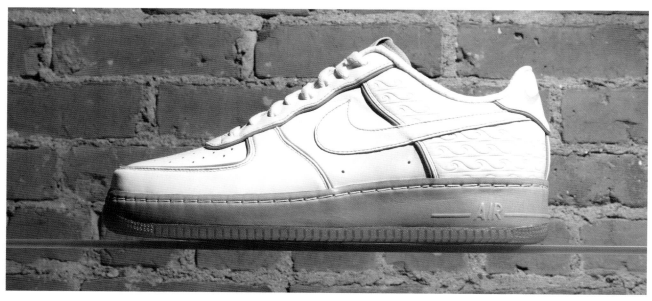

2008: NFL Pro Bowl x Nike Air Force 1 Low

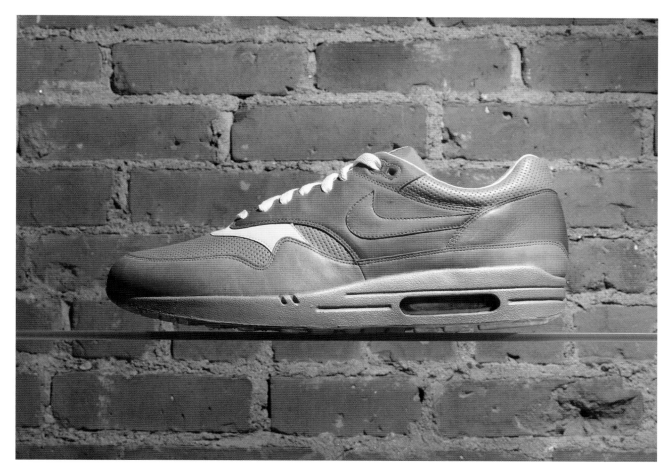

2005: Kidrobot x Nike Air Max 1 (Hyperstrike)

US11.
I have them.

Have you travelled to buy shoes?
I've been to Japan. I was in Florida once for vacation, and they released a 'Miami' Air Force 1. I saw them in the store for $150, and I knew you couldn't get them in New York, so I picked up every pair I could find. It went from a three-day getaway to breaking down 100 pairs just to bring them home. Things are always worth different amounts in different places. In New York, it's all basketball – mostly Air Forces and Dunks – but in Europe, they're more running, so shoes like the Air Stab and Air Max 90 are popular. It's a different atmosphere over there.

What's the one shoe you had to work the hardest to get?
There really haven't been that many pairs I couldn't get. Nine out of 10 times, money talks, and the only time money doesn't talk is when someone has a personal connection with that sneaker.

What's the most you've paid?
I paid $6000 for some Air Forces and Dunk SBs, like the 'For Love Or Money' edition. I have the 'Turtle' AF-1s from *Entourage* and the 'Supreme' Air Forces with the elephant print.

How many Turtles are there?
In the blue scheme that I have, only one pair. Of the gold one, I believe there are anywhere from seven to 13 pairs. Each was given to the main cast of *Entourage*. Mark Smith (Nike designer) has a pair, and some are on display at the HBO building. There's one pair out here in New York. One day they'll be mine!

Tell us about those Supreme x Dunk SB x Air Force hybrids.
Only six pairs were made for the first Nike skateboard team. They were doing a world tour and happened to be near the factory while they were making the 'Supreme' Dunks. They asked if they wanted something special, so they made six pairs with the elephant print. About four years ago, I came across one and jumped on it. They cost me a pretty penny.

How many pennies?
Over 50,000! [Laughs.]

Will you ever get to a point where there's nothing left to fiend over?
Never. There's no way to have everything. And even if Nike stop making shoes, there's always something. I'll always be buying and selling something. More often, I'm not all that concerned with what's coming up because I can get that easy. It's more about the stuff you missed out on. If I see something and have the urge, I'll get it. I have every Jordan released from about 1999. At some point, I bought 34 pairs of each, so I have anywhere from 12 to 18 boxes, each holding 12 pairs of Jordans I never wore. Brand new! Sometimes I'm about to buy something, and then I realise I already have them in storage somewhere.

Do you ever worry about them deteriorating?
Yeah, definitely. I remember having a few newish pairs, and when I opened the box, they were yellow, which was disappointing. Something always goes yellow on sneakers. Even if it doesn't, the black ones often get that ashy look. The only thing you can do is wear them. Everything I've got in my size, I'm wearing, and if I don't get around to it, I will get around to it soon. We're not here forever.

Have you had a moment where you think, 'What the fuck am I doing with all these shoes?'
Yeah, you get what you want, but then you got extra somehow! Sometimes I do have one of those days where I have a headache and can't find a shoe. I know I own the pair, but I can't find it anywhere, and that pisses me off! On those days, I might not even go outside because I'm so mad. Honestly, I think if you've got 100 pairs, you're fine. You don't need more. Anything over that is a headache – unless you've got a mansion or something!
★

@alldayatf

Thanks to Premium Pete for the intro and Clarence at Premium Goods in Brooklyn.

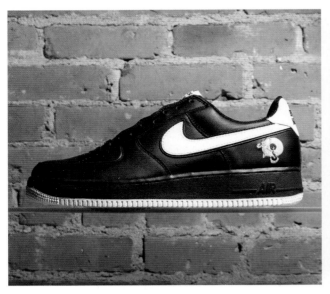

2003: Nike Air Force 1 Low 'The Black Album'

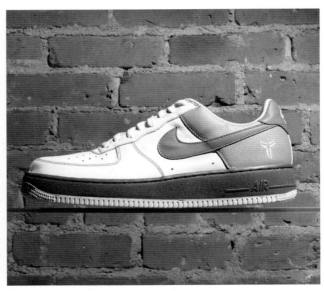

2005: Nike Air Force 1 Low 'Grey 3M Kobe'

Bespoke Nike Air Force 1 Low 'Joker'

2010: Nike Air Trainer SC 'NFL Pro Bowl'

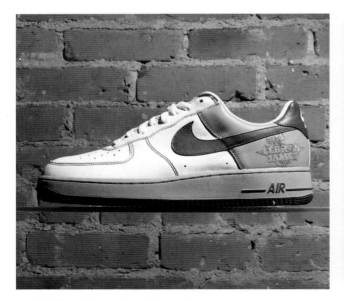

2007: Nike Air Force 1 Low 'Neon LeBron'

2009: NFL x Nike Air Force 1 Low 'Pro Bowl'

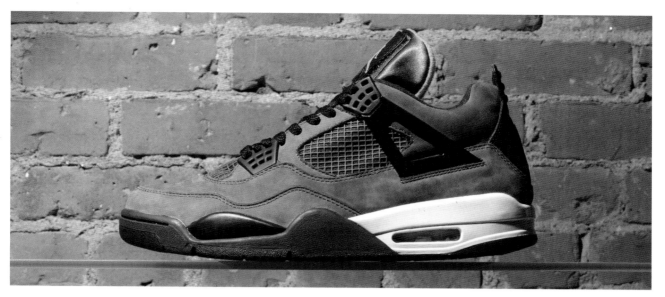

2005: UNDEFEATED x Air Jordan 4

2010: Air Jordan 2 PE 'Fred Jones' (Knicks Away)

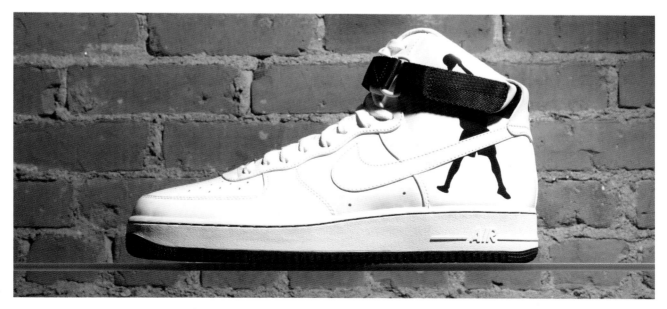

2008: Nike Air Force 1 High 'Rasheed' (Sample)

Sneaker Obsessions

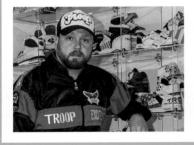
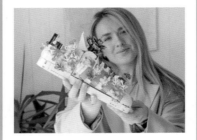
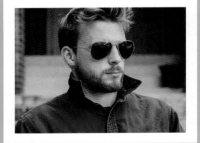
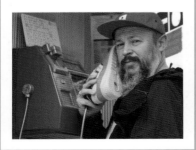

THE QUEEN B

INTERVIEW: AUDREY BUGEJA

PHOTOS: LOUIE ARSON

MIAMI, FLORIDA

Born and raised in Miami, Florida, Bianca Derousse was
blessed from birth with an exacting eye for detail and
a huge heart. Her sneaker taste veers from classics
to vintage gems and hype heat, which means her rack
is stacked with everything from Lil Pennys to Dunks
and Zoom FC SBs, though she freely admits she has
'never been on a board, not once in my life!' Colabs,
Quickstrikes, Tier Zero and GR don't mean a thing —
nothing impresses B unless that sole got soul! And when
the vibe is right, she ain't afraid to throw down in
a pair of Air Monarchs. As you're about to read, B is all
about building the community and making connections,
which indirectly provided the inspiration for her to start
Sneaker Sunday, a forum for women in the footwear
industry to talk shop, raise spirits and elevate the
sisters. All hail the Queen B!

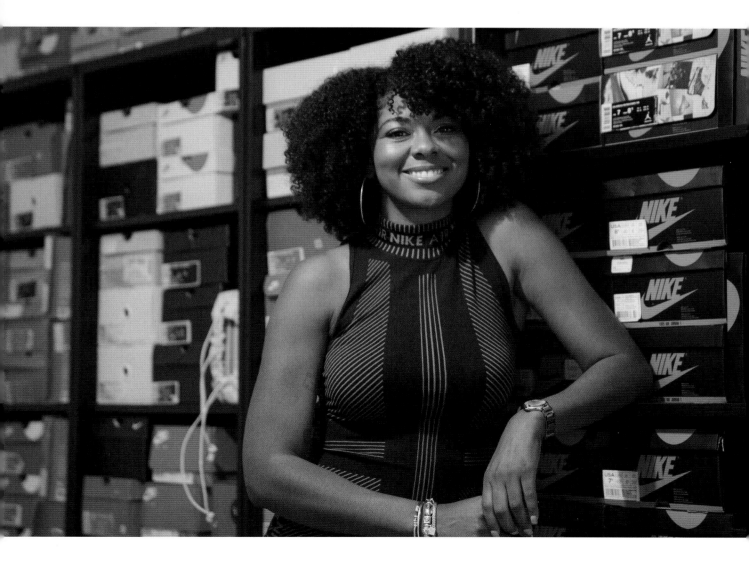

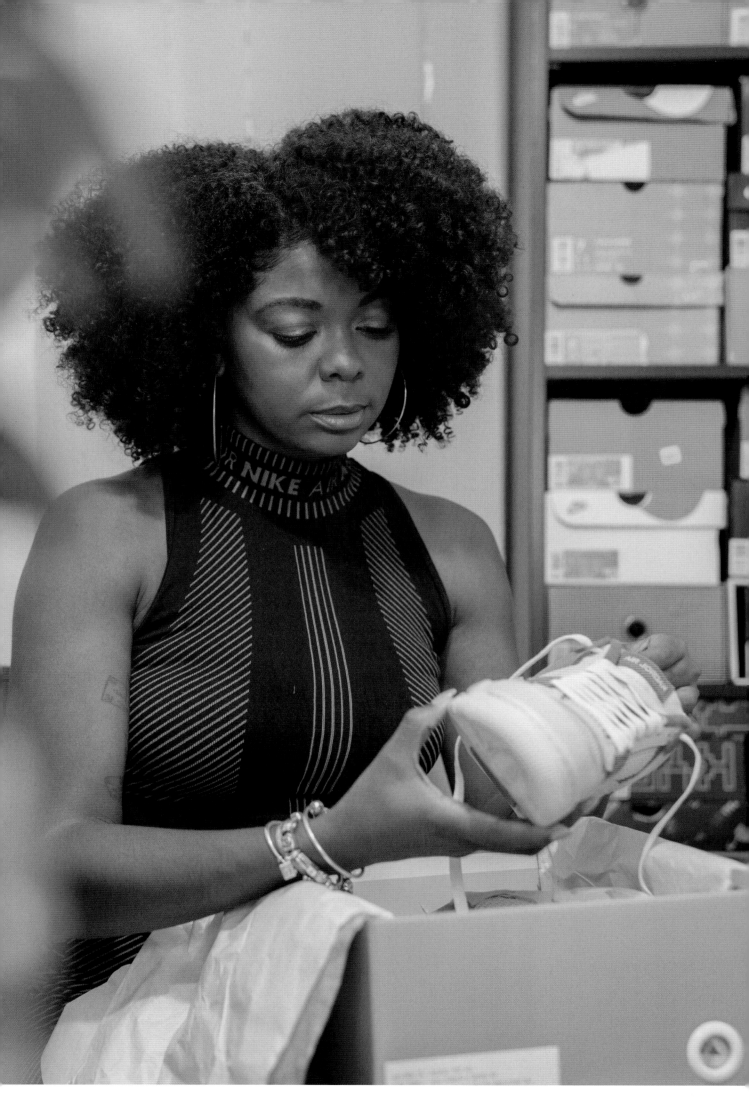

Simply B
Sneaker Sunday
Miami, Florida

I was born and raised in Miami. I'm of Cuban and Jamaican heritage, so family is very important to me, and we're all very close-knit. I used to love watching Penny Hardaway playing basketball on TV with my dad before he passed away. My mom was a single parent, which is kinda why I got into sneakers later in life because she had other priorities and couldn't spend money on them. So yeah, as a kid, I grew up rocking Payless kicks and Keds.

The first pair I recall wanting was the Air Max 'Pennys'. Another shoe that really got me into things was the Gino Iannucci FC. No one cared about that shoe ever, but I fell in love as they're so clean. The suede and perforations are dope. It's funny – I rocked a lot of Nike SBs, so everyone always assumed I could skate. But I've never been on a board, not once in my life, so it's just a visual attraction for me. Knowing the stories behind the designs was also a big part of SB in the early days, like with the Heinekens and Falling Stars.

When I walk down the street in Miami, I see all kinds of people wearing all kinds of sneakers, and that diversity is cool to me. Miami isn't known for sneakers like New York with Air Force 1s and California with the Cortez, but at least we do have the South Beach colourway! The scene here used to be small but what was great is that everyone knew everyone.

Buck15 was a local event with artists and local resellers. MIA Skate Shop had their own SB back in 2013, but they had to close, which really was heartbreaking. Shoe Gallery is the OG local spot. That's authentic Miami. I love that place. They have *cafecito*, the Cuban coffee, which they serve to customers. The vibe is cool, they have good music, and when they do raffles, they make it fun and keep things local. A lot of the time, you have to come and take a picture at the store so they know you're from around here. They're really, really good about women's releases as well. Now we have Kith and a few of the bigger brand stores, but back in the day, when it was just mom-and-pop shops, the scene was pretty tight.

Back then it wasn't like it is now, where every blog and Instagram account shows what sneakers are coming out – you had to do your own research to know. That sense of mystery and the chase is missing now that things have gotten so big. I sometimes feel like everyone's wearing the exact same thing, which I guess is cool because everyone is into sneakers now, but I do miss the sense of originality. That was a thing then! You did not want to walk into a room and see someone else had the same sneakers because it would ruin your day.

It's not always about how rare a shoe is, or the price for that matter. For me now, honestly, comfort is a priority. One of my favourite silhouettes – this is ridiculous, and people always laugh at me – is the Air Monarch! I obviously wear a lot of Air Max and Air Jordan 1s as well, but Monarchs can be made to look cool. You just need to know how to make it work. I literally have every colour, from the regular old 'dad' pairs to the newer M2K Tekno. I was so upset when they became a hype shoe because everyone used to hate them. But I still love Monarchs, and they are definitely one of the most comfortable Nikes of all time.

People look at me like, 'Damn, how are you able to make the Monarch look cool?' and I'm just like, 'Yeah, it's cool that you have the latest Travis Scotts, and you spent $10,000 on the Dior Jordans, but can you rock a pair of $40 Monarchs and make them look good?'

Most people would say I'm crazy because I declined a pair of Travis Scott 1s, but I ended up getting a pair for someone I know who loves that shoe. Friends help friends get sneakers! I'm not the type to have shoes just because they're hype. I buy what I like, and helping a friend out means more to me than reselling. I'd also be a hypocrite. You know what I'm saying? I'd just be adding to what's messed up about the sneaker game.

Don't get me wrong. People resell coins, stamps, cars and everything, so resellers of all kinds have been around forever. I feel like, back in the day, you could buy multiple pairs for good prices on eBay because that's where we found the gems. But now it's a completely different monster because people who aren't actually into sneakers are the ones reselling them. The floodgates opened when all these reseller companies saw dollar signs. Some are even renting out sneakers, which I think is super weird.

The sense of community is such a positive thing. There are pairs in my collection I wouldn't have if it wasn't for an assist from someone I met through a shared love of sneakers. I've definitely helped a lot of people get shoes in the same way. You build those relationships in camp-outs and at sneaker events. I've made friends through Instagram as well. Years ago, I posted that I wanted a pair of Huaraches, and this guy Collins, who lives in London, said he could help me out. It was a risk, but I sent him the money, and he sent me the shoes. He's family to me now! I send his kids sneakers and everything. So that's what I'm saying… through the shared love of sneakers, you can definitely build up that sense of community.

One of the reasons I started Sneaker Sunday was because I could see that brands were finally starting to realise that women are consumers with their own money. I hate to say it that way, but I feel like brands didn't really see us before, and now they do. Since they're paying attention, I want to show them that it's not just five girls who are into it, there are thousands of us out here, and we all have different stories, different collections and different styles. We all got into it for our own reasons, not just because our boyfriend bought shoes for us.

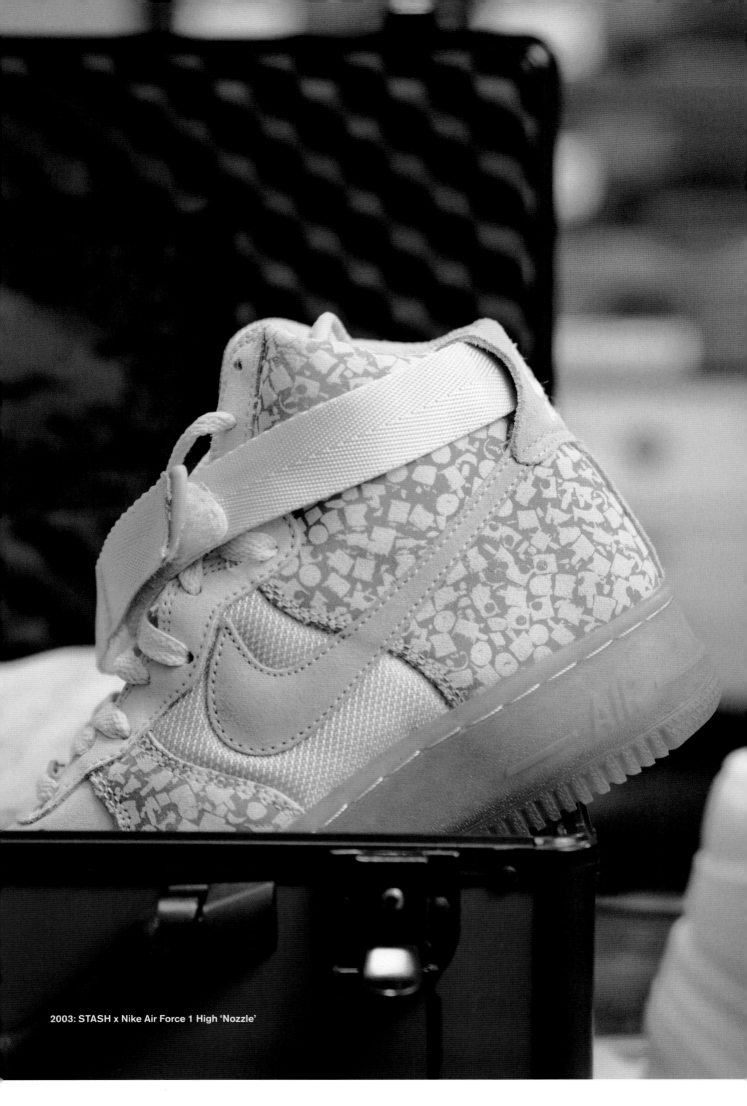

2003: STASH x Nike Air Force 1 High 'Nozzle'

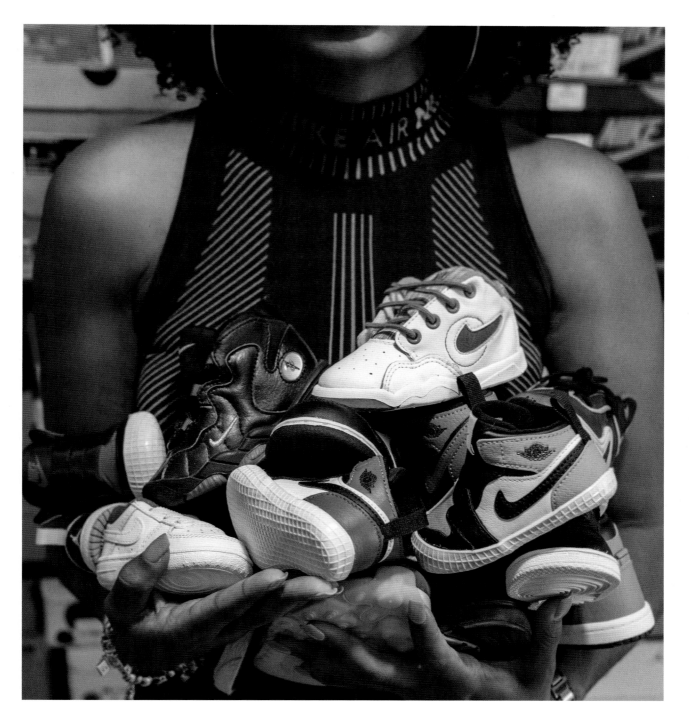

Women designers are killing it right now. We're seeing it with Aleali May and sacai – their shoes are selling out just as fast as any Virgil Abloh shoe. I follow some amazing women who are getting collaborations, like Jazerai Allen-Lord's 'It's A Man's World' campaign. Not only did she get a Reebok deal, but she also brought four other women along with her. When you get to that place, bringing other women with you is inspiring. That's what we, as women, need to do together – just keep bringing other women up with us.

I bought A Ma Maniére's Jordan 3. From the story to the materials, it's such an amazing shoe. Everybody wants them, and they're a women's release! They really tried to get them into the hands of women too. I feel like that's what it'll come to – everyone will want women's releases. Women will be given more opportunities, and they'll be inspired by other women because women are killing it!

I honestly feel like I learn something every week from Sneaker Sunday. I had no idea about bots until Carnella explained it all to me and how much they cost. She broke it all down, and that really put me on. The most heartfelt Sneaker Sunday was with Jane. She shared how important it was to connect with the community during quarantine to maintain her mental health. Doing her creative sneaker posts was her form of expression. When you're trapped in your house for months, any form of creative release has to be a positive. And when you're home alone, communicating with others is even more important. That's when I realised… that's exactly why I started Sneaker Sunday! It's all about connection. I've had the pleasure of speaking to some extraordinary ladies, from major brand vice presidents to women with over 1000 pairs in their collection.

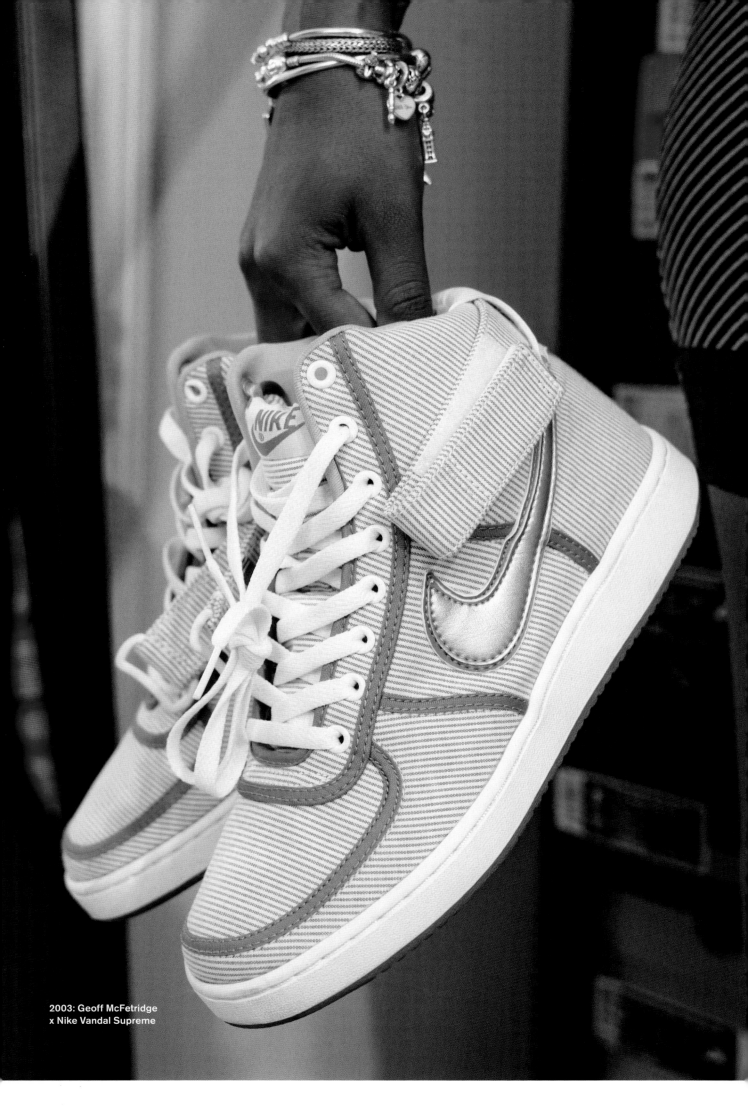

2003: Geoff McFetridge
x Nike Vandal Supreme

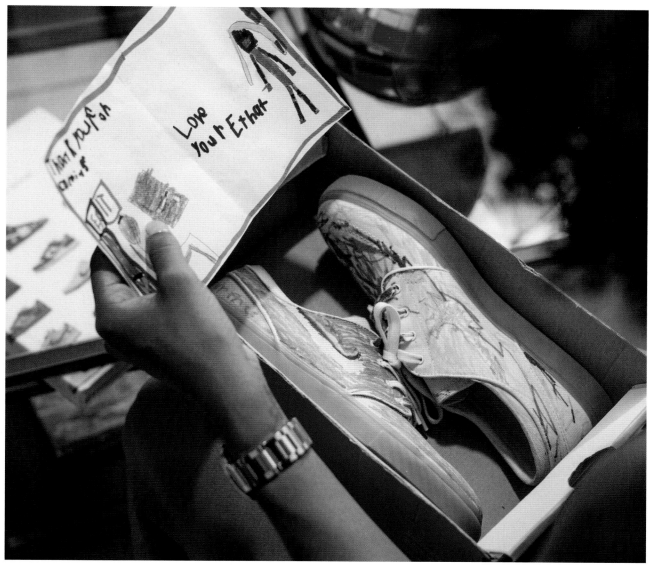
Nike SB Zoom Stefan Janoski customs

Looking to the future, I would love to have Sneaker Sunday on a major platform where I can give women a louder voice. I have a decent following, but I really would love to highlight these women on a bigger stage, which I feel the major blogs and platforms don't do. In the sneaker space, there are a lot of knowledgeable women fighting for us to be taken seriously, but most aren't given the opportunity to speak. Women have had a passion for sneakers for years. I feel like people need to see that.

Hmmm. If I was shipwrecked and had to survive on a desert island, I'd most likely want a pair of Monarchs, but I'd also definitely want the UNDEFEATED 'No Liner' Dunks because I love that shoe. I'd also take my 'Penny Hardaway' Air Force 1s in all white with the blue Swoosh because it's one of my Grails, and it took forever to find that pair. I could not part with them after all this time.

I'd also have to take DJ Clark Kent's 'Got The White' Air Force 1s, mainly because of sentimental value. I'll never forget when he handed them over. He gave me the whole story about how this was for the hustlers. It was a special moment.

I feel like the top three are always easy, and the other two are a little more difficult. Let me think of an SB that I would take. I would select my 'SBTG' Dunks because they're such a nice shoe with lots of intricate details. They're so dope and so beautiful. My friend Louie bought them for me. They weren't a US release, so to have a shoe that rare is really cool. As mentioned, I'd also take a pair of Monarchs but not the OG old-man ones. I would take the 'Volt' pair with me – I love those!

My favourite pair of all time is my Stefan Janoski SBs. I'm sure if anybody else saw them, they'd be like, 'What the hell happened to her shoes?' That's because I gave the shoes to my two nephews, Ethan and Lawrence, and they drew all over them. They're definitely the most prized and personal pair in my collection. They mean the world to me.
★

@imsimplyb

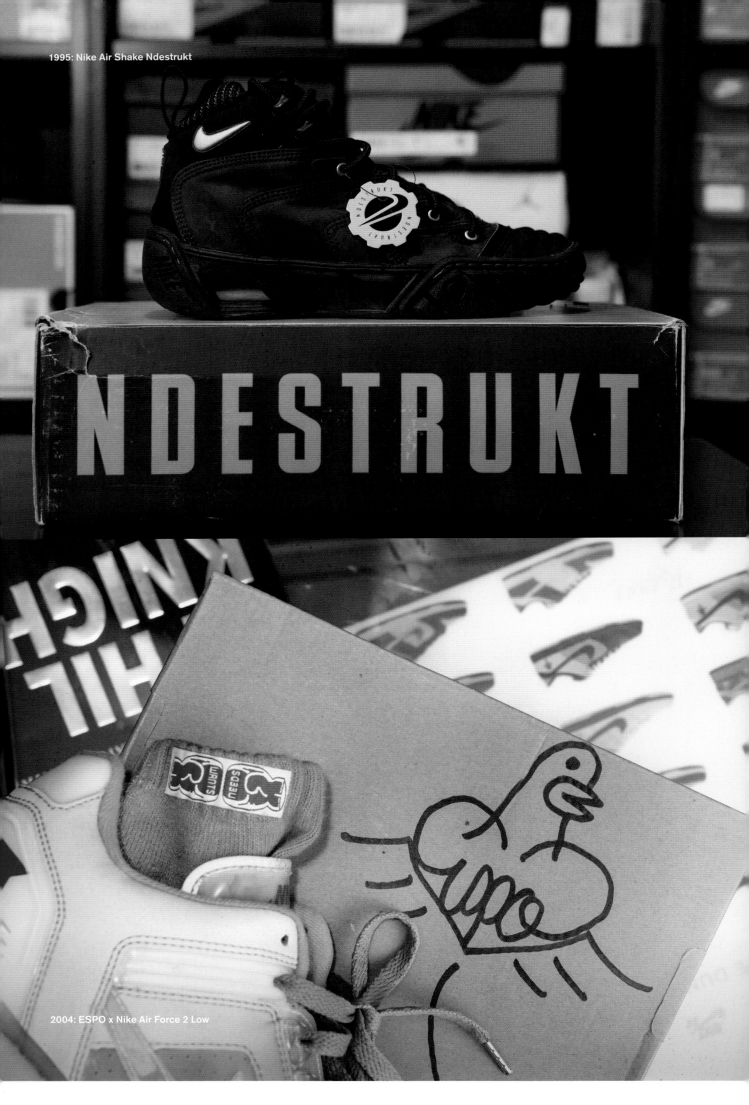

1995: Nike Air Shake Ndestrukt

NDESTRUKT

2004: ESPO x Nike Air Force 2 Low

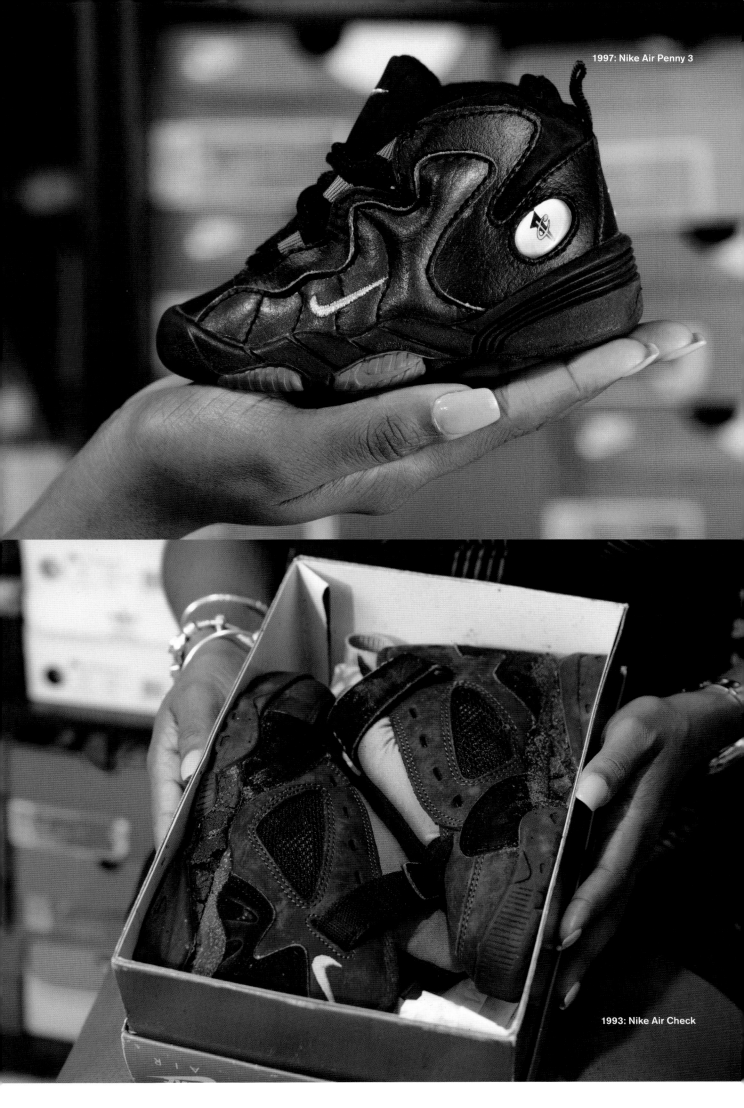

1997: Nike Air Penny 3

1993: Nike Air Check

'Women designers are killing it right now. We're seeing it with Aleali May and sacai – their shoes are selling out just as fast as any Virgil Abloh shoe. I follow some amazing women who are getting collaborations, like Jazerai Allen Lord's "It's A Man's World" campaign. Not only did she get a Reebok deal, but she also brought four other women along with her. When you get to that place, bringing other women with you is inspiring. That's what we, as women, need to do together – just keep bringing other women up with us.'

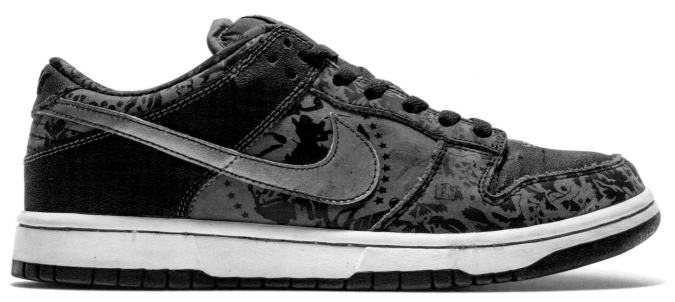

2005: SBTG x Nike SB Dunk Low

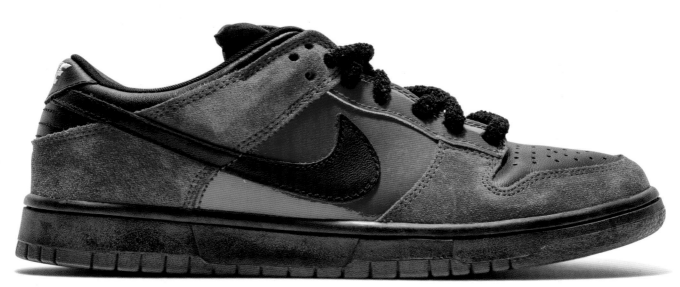

2007: Nike SB Dunk Low 'Milli Vanilli' (Fallen Heroes Pack)

2017: Nike Air Monarch 4

2004: Nike SB Air Zoom FC 'Gino Ianucci'

2019: sacai x Nike LDWaffle 'Blue Multi'

2018: Nike M2K Tekno

2016: Nike HyperAdapt 1.0 'Metallic Silver'

2019: Jazerai Allen-Lord x Reebok Club C 'It's A Man's World'

2017: DJ Clark Kent x Nike Air Force 1 'Got The White'

2013: Nike Air Force 1 Low 'Penny Hardaway'

NBA Barbie and Li'l Penny

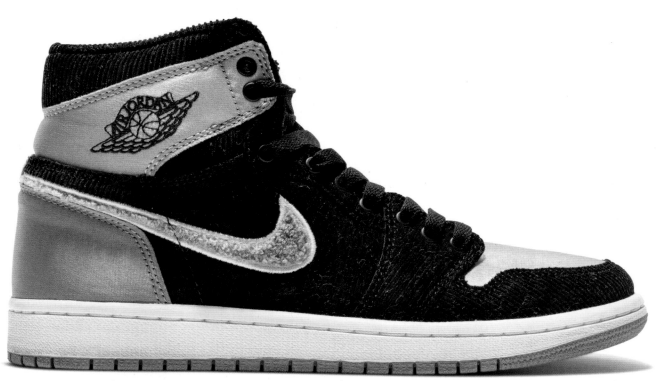

2017: Aleali May x Air Jordan 1 High 'Satin Shadow'

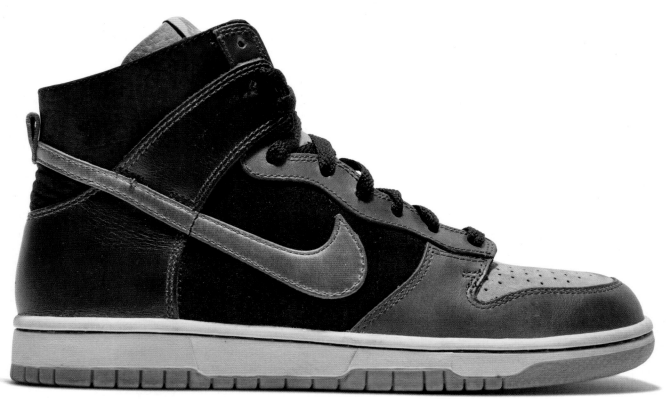

2005: UNDEFEATED x Nike Dunk High NL

262

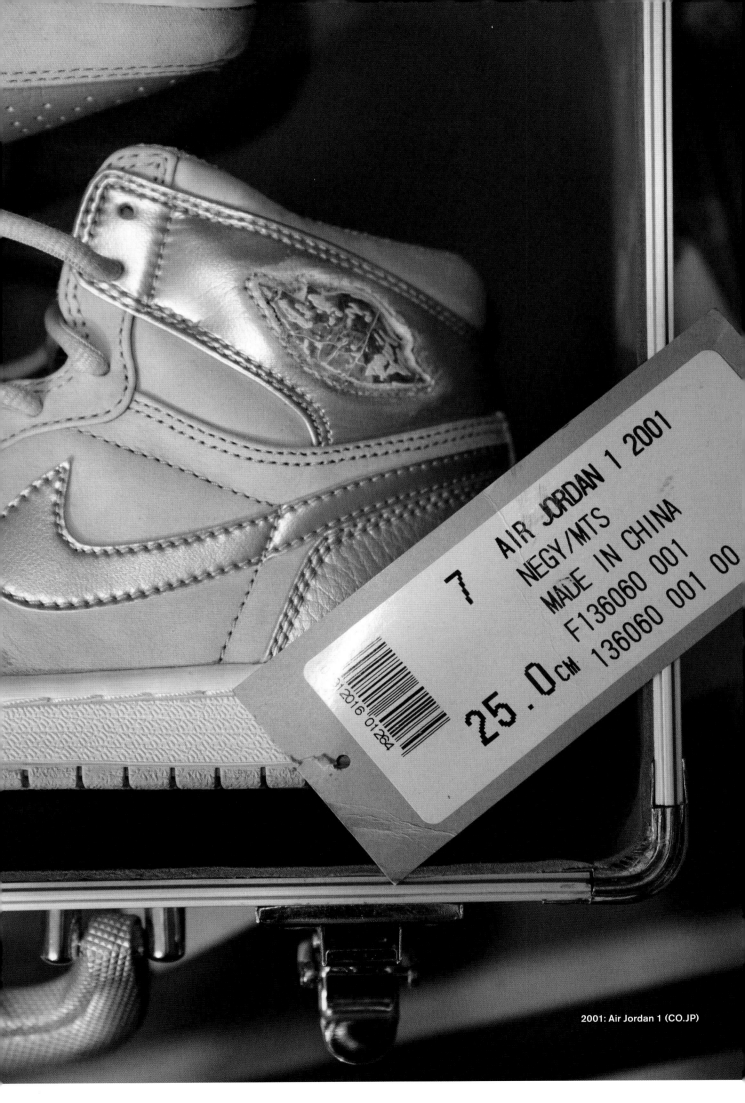

AIR JORDAN 1 2001
7
NEGY/MTS
MADE IN CHINA
F136060 001
25.0 CM 136060 001 00

012016 01284

2001: Air Jordan 1 (CO.JP)

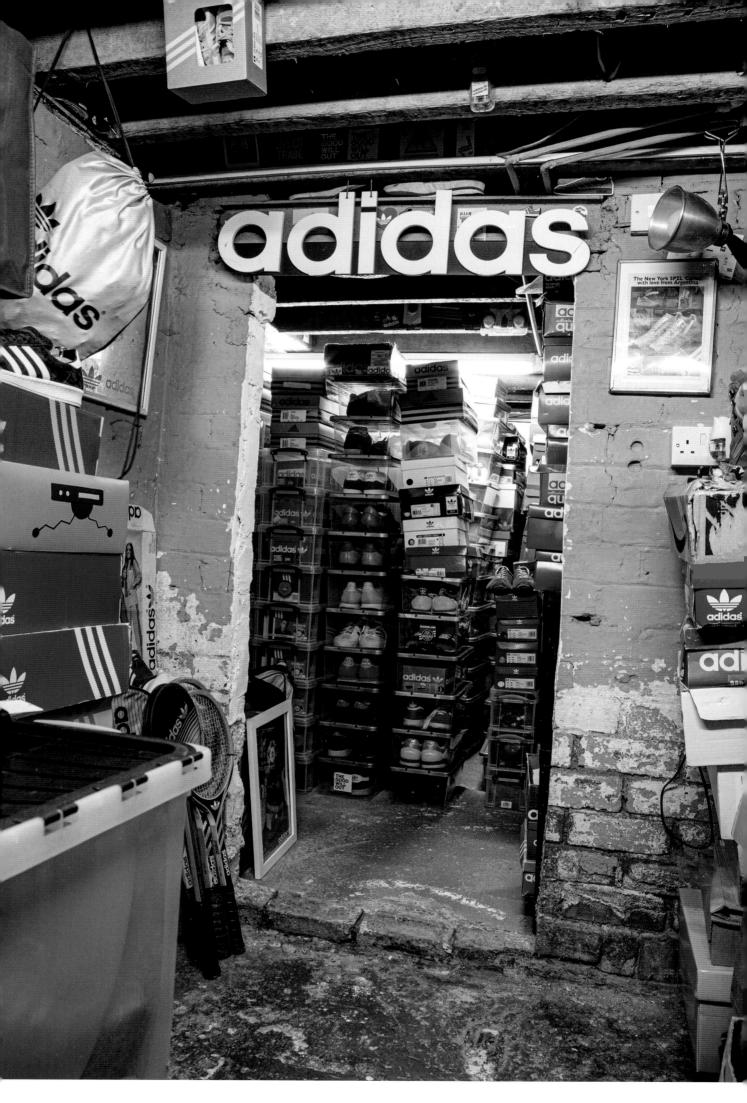

WHITE

DIGGERDAS

With over 2000 pairs housed mostly in 'Blue Bird' boxes, Diggerdas'
underground lair is an adidas aficionado's dream come true. The bulk dates
back to the halcyon days of the 1970s and 80s, but Digger also steps out
with super-rare editions from the late 1940s as well as plenty of
contemporary 'advanced technology' releases. Get ready to excavate
with a UK collector who is deadly serious about deadstock!

Interview
WOODY

Images
JEREMY KELLY

STRIPES

Diggerdas
adidas Obsession
United Kingdom

I grew up in the North East of England in the 1980s, where my connection with adidas started in a typical way, mainly through watching football and the Olympic Games on television. I quickly learned that brands and labels were very important in determining your social class at school. You had to have the right trainers, football boots and tracksuits, as these were the main criteria for choosing friends and being popular. It's ridiculous in many ways, but it was very true then and probably still is today.

As a teenager, I distinctly remember seeing the ZX0000 models appear. The bright colours and yellow Torsion bar blew me away. The price tag was ridiculously high, which gave these shoes real kudos. Me and my mates would talk for hours about the shoes we wanted as we flicked through retail catalogues. At that stage, our parents would only buy us one pair every six months if we were lucky, so it was all talk.

By the early 90s, I finally had disposable income, which meant freedom. Ironically, this wasn't the most prolific period in the history of adidas, but that didn't stop me. The UK range wasn't all that great compared to previous decades. Shoes were still sold in independent sports shops, and you had to travel around looking for gold. This was the 'Brown Box' era at adidas, which many consider a low point for the brand, but I became quite obsessed, and these shoes are a very important part of my collection.

When I started collecting seriously in 1995, the OG Micropacer was only 11 years old, so that gives you some context of the timelines. Around this time, I spent holidays with family in Canada and hit the outlets around Toronto. I even ventured into New York to pick up EQT, Campus, Superstar, Gazelle, Kegler Super, Trimm-Trab, Stan Smith, Ilie Năstase and Marathon TR, to name a few. The locals showed very little interest in these models, and they were cheap.

By the early 2000s, I had over 100 pairs, which was highly unusual. I then started using eBay to source vintage models from Germany, Japan and the US. You had to be brave, take risks, be patient, put effort into translating listings and take care in your communication, but the rewards were obvious.

At that stage, the adidas Originals range was small, and although there were some standouts, they didn't always resemble the shoes I was fiending for online. I bought some vintage catalogues, and my knowledge began to grow, along with my appetite for made-in-Europe shoes like the Kegler Super, Universal, Marathon TR, TRX, Grand Prix and ZX runners. The quality, look and feel were amazing. I was hooked!

I owe a huge debt of gratitude to Gary Watson and Stu Burrows, who both sold me some amazing items. More importantly, they answered lots of questions and shared their knowledge. Gary copied loads of catalogue posters, and they provided me with my main visual inspiration.

I honestly don't know exactly how many pairs I own right now, but it's well over 2000, including spikes and football boots. It's about 50-50 between pre- and post-millennium releases from 1949 to the present day. I think people would be surprised by how many modern shoes I have. If it's a significant new technology, then I'm in. I have the first Climacool, NMD and Boost releases.

Storage is always an issue. I'm lucky I have a dry basement and a loft. I take a very pragmatic view of crumbling soles. It's predictable and not ideal, but it's part of the game. I even buy shoes in poor condition. I've re-soled several crumbling pairs over the years, but I leave the really rare pairs alone. Trainer storage avalanches are a common occurrence – sometimes, I'll get trapped underneath loads of old boxes, and someone will have to dig me out!

I met my wife in 2006. At that point, I was already sitting on around 300 pairs, so she knew what she was getting into. I certainly wouldn't have the collection without her patience. One time we went to Germany, and I hit the jackpot in Munich. We went to a newly opened Originals store, and I asked the lad at the counter if he knew of anywhere that sold vintage adidas. Next thing you know, I'm in the basement of a store that sells graffiti paint. A door opened to reveal a huge treasure trove of vintage gear. I was stunned and bought 10 pairs of super-rare deadstock, including the Munchen and Munchen Hi in the original red/white. The owner had racks full of OG adidas x Run-DMC clothing, including all the leather tracksuits, Patrick Ewing models and Forum hightops, as well as Nike stuff and Air Jordans. I bought quite a bit from him over the next year or two, but the store is no longer there. It was a unique experience and one I will never forget.

My daughter has just turned eight and has grown up surrounded by adidas. I was able to get her first pair of Stan Smiths signed by the man himself. She remains utterly bemused that I allowed someone to write on her shoes with a gold Sharpie and that we now keep them in a Perspex case.

Terrace culture played a big part in my early adidas days, but by the time I became a proper collector, the influence had waned. I really have a wide-ranging love for the brand and love all elements, which is what really differentiates me from many other UK collectors.

There are a lot of presumptions and myths perpetrated on social media. For example, the 'Cities' range of shoes is synonymous with modern-day terrace culture, but in reality, they were rarely seen at UK football games in the

1974: adidas Artic

1977: adidas Reno

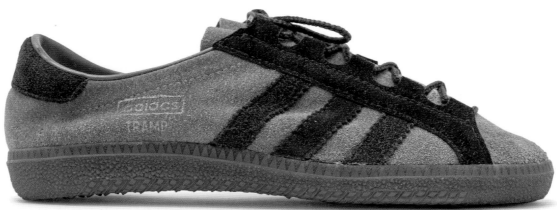

1972: adidas Tramp

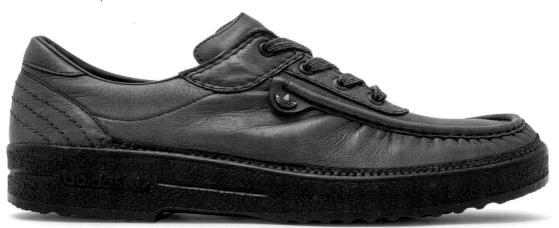

1979: adidas Alicante (Leisure Range)

70s and 80s, with the exception of the Dublin and Rom. The entire Leisure range, Trimm-Trab, Jeans, Munchen, Wimbledon, Samba, Bamba, Lendl, ZX, TRX, Stan Smith and, of course, Forest Hills, were definitely the shoes to have in those days. I'm not sure anyone remembers the Trimm-Star.

Around 12 years ago, I bought a pair of cheap spikes from eBay, mainly for the box. I sent an email begging for the packaging to be protected. By chance, the seller was the son of a famous sports chain retailer from the late 1960s. The stores had long closed, but the family still had loads in storage. Over the next few years, I bought many items, including some very rare promo pieces Adi Dassler handed out in the early 1970s.

One of my most cherished pairs is the Kegler Supers, made from ostrich leather. Back in 2000, adidas produced 100 units to recognise Adi Dassler's 100th birthday. Handmade in Germany, they also featured cedar shoe trees, a gold metal tin and 24 kt stitching on the heel Trefoils! They retailed at £650 in Paris, New York, Berlin and London. I thought my chance had passed until I found a pair in France at a very reasonable price, thus ending a 20-year search. And they're my size! A Consortium retro release a few years later was made from synthetic materials. Nevertheless, it's still a great shoe, and prices have rocketed recently.

Aside from that, I find it hard to pick an all-time favourite. But if I had to, I would say it's gotta be the Gazelle. One of the main reasons is how successful the shoe is to this day. The others in my top three would be the Stan Smith and Superstar. They are timeless classics that have transcended the decades and been adopted by countless sub-cultures around the world.

My oldest pair is the Leichtgummi from 1949. The branding was only used in that specific year, so I know exactly how old they are. Pre-1970 shoes are by far the hardest to find, and anything from the 1940s is virtually impossible. The number of collectors that appreciate this era is small, but there is always stiff competition when a pair comes up. The old shoes are priceless, and the earlier they are, the higher the chances that Adi Dassler himself worked on the production. It's almost certain the Leichtgummi came from the original factory in Herzogenaurach, where Adi was based all those years ago.

I love all the adidas tennis shoes. These shoes are a fundamental component of my collection. The Lendl models are really coveted as they generate great memories that are often shared on my IG posts. My Lendl Competition II are in true deadstock condition, and I have owned them for about 20 years.

The Leisure range is the butt of many negative comments on social media. I've heard all the jokes over the years, but I love these plain 'grandpa' shoes and have quite a comprehensive collection, with the Korsika the only notable absence. The Leisure range was an integral part of the adidas lineup from around 1975–85. On that basis, a true collector can't ignore them.

You can't wear many of the original Leisure editions today, but I do wear the excellent Albrecht, Garwen, Newrad, Hoddlesden and McCarten interpretations from the current adidas Spezial range. In my opinion, the Spezial design team's modern updates of this much-maligned range are the most significant achievement in adidas design over the last 30 years.

Vintage catalogues are unbelievably hard to find. They were generally produced for independent retailers so they could place orders, and many were disposed of when the next season's catalogue arrived. My biggest score was from the previously mentioned eBay connection. Even then, it was only about five catalogues. I'm lucky if I find one or two a year these days.

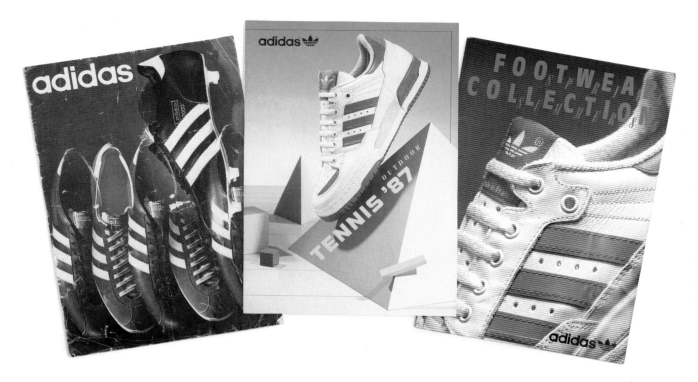

I love all the collectibles and treasure my promo items. But my favourites are the ones Adi Dassler handed out personally, like the briefcase, a history of adidas booklet and a bottle of 'Trefoil Scotch Whisky'. I was assured the whisky was the only surviving bottle, as the English retailers all got hammered on the long train trip home from Herzogenaurach. The bottle I have is reportedly the only souvenir.

Another standout is the 12-inch figure of Franz Beckenbauer in his adidas Bayern Munich tracksuit. This is an original piece from 1975, and it's very rare, although you occasionally see them for sale at astronomical prices. The adidas radio hat is a recent addition. It's fully working and is a brilliant piece that just transmits the 80s!

The rarity of a shoe alone is never my motivation – it's more a byproduct of wanting to own them all! Size and condition also add to the rarity. I have some mint Italia from the early 70s that get a lot of attention. I also have some beautiful Gazelles from that time that were made in New Zealand using the nicest suede imaginable, and I haven't seen another pair come up for sale ever.

I recently loaned a pair of adidas John Newcombe to Gary Aspden, who runs the Spezial team. Gary had a vision to create a contemporary classic and turned it into the stunning Lacombe model, which has since become a huge commercial success. It was a real insight as it took 12–18 months from loaning the shoes to the finished product. The process is much more involved than I thought, with multiple stages, decisions and agreements needed by all the different departments.

I've also loaned other models that have provided varying amounts of inspiration over the years. I'm a huge fan of the Spezial range, and I truly rank some of these releases alongside my original models. Look at the Trainer and Trainer SPZL – the Spezial release is a far superior shoe! Spezial has influenced my approach massively and provided inspiration and validation for my love of all things adidas.

There have been plenty of fails over the years. Missing out is all part of the quest. When it happens, I try not to dwell on the frustration by simply moving on with the hunt. Just so I don't get overwhelmed, I always have an active list of around 30–50 shoes that I want to track down. The green Gazelles made in Austria in the early 80s are top of that list right now. I'm also chasing the original ZX600 from 1985 and the Arthur Ashe tennis shoes from the early 70s. The Korsika is another I'm desperate to hunt down.

In my opinion, the biggest change over the last decade is the volume of new releases and how hard it is to cop these days. I miss out on loads as I have little to no raffle success! Vintage has always been hard, but quality new releases are impossible, particularly colabs like the atmos ZX8000 and the Union Berlin. I understand it's a double-edged sword and that 'exclusive' releases need to be limited, but a little more luck in raffles would be very welcome indeed.

Aside from that, my big dream is to visit the adidas Archive in Herzogenaurach. That would be like an Elvis fan going to Graceland! I don't have any ambition to design a new shoe or even choose my own colourway, but my ultimate dream is to have an adidas shoe named after Diggerdas! Ultimately, the never-ending quest to perfect my collection gives me a huge amount of pleasure. I just hope people appreciate my passion for all things adidas.
★

@diggerdas

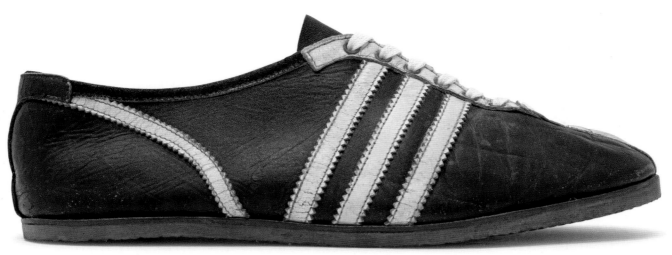

1949: adidas Leichtgummi

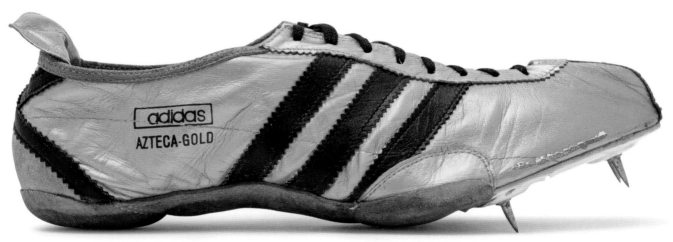

1968: adidas Azteca Gold

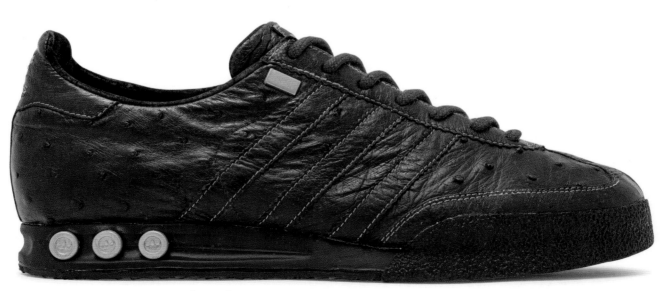

2001: adidas Kegler Super Ostrich Skin (1-of-100)

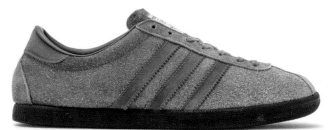

1977: adidas Tahiti

1978: adidas Trimm-Trab

1982: adidas Trans

1987: adidas Villach

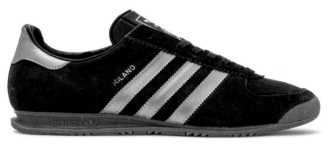

1982: adidas Milano

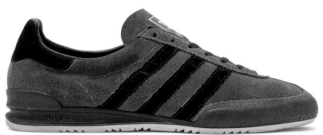

1983: adidas Jean MkII

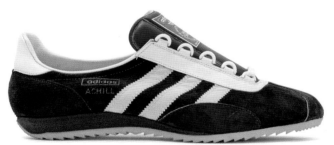

1974: adidas Achill

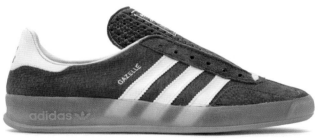

1980: adidas Gazelle Indoor

1970: adidas Riviera

1976: adidas Malmo

1967: adidas Gazelle

1958: adidas Trumpf

adidas
5010 Tokyo **9.**

adidas
078029
SHOT PUT
1GA LEICHTATHLETIK
LILA/GELB
VIOLET/JAUNE
PURPLE/YELLOW
7½ 41⅓ 7½ 260

adidas
Eddy Merckx
AJ1121

adidas
AD 1024
9½ 44
RIVIERA

adidas
Chaussures officiellement adoptées par l'Association des Tennismen professionnels.
Official shoe of the Associations of Tennis Professionals.
AF 1121
9 43½
ATP OUTDOOR

adidas
3460 Achill **8**

adidas
ZX 400
BLAU/WEISS/SILB AC3713
MADE IN FRANCE
7 40⅔ 7
UK FR US

adidas
anti-BAKTERIELLE
Ledertrainingsschuhe
Modell „FAVORIT"
42
Bestell-Nr. **170**
8
DIE MARKE MIT DEN 3 RIEMEN

adidas
1910 BAMBA **9.**

adidas
11050 World Champion
Preis 7½
EG

adidas
112 280 SIERRA **11-46**

adidas
3263 Wimbledon
Preis 7½

adidas
3947 Malmo
Preis DM 7½

adidas
1901 Bamba **8**

adidas
AD 1615
8½ 42½
MONTEREY

adidas
3080 Hobby
10 44⅔

adidas
19007 STADION
Preis 5½

adidas
AC 1700BG
ATHENS
BLUE/GREEN
7½ 26.0cm

Box Fresh!

Diggerdas' remarkable stash is housed in an equally impressive mix of original adidas shoe boxes. The telltale Trefoil logo was introduced in the 1970s, a glorious time that spawned many classics and signature models for sporting luminaries, including Ilie Năstase, Eddy Merckx and Kareem Abdul-Jabbar. The most recent examples in this selection are the staid 'Brown Box' Originals and EQT releases that dominated the 1990s.

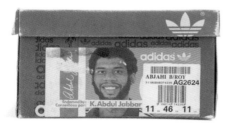

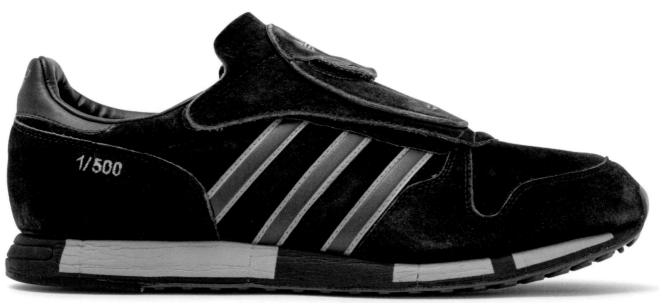

2004: adidas Micropacer 'Buck' (1-of-500)

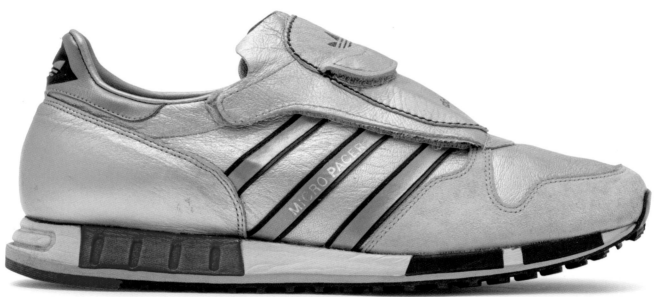

1984: adidas Micropacer (Silver)

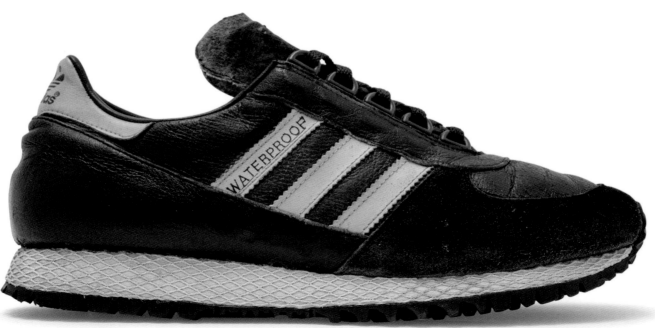

1985: adidas Waterproof

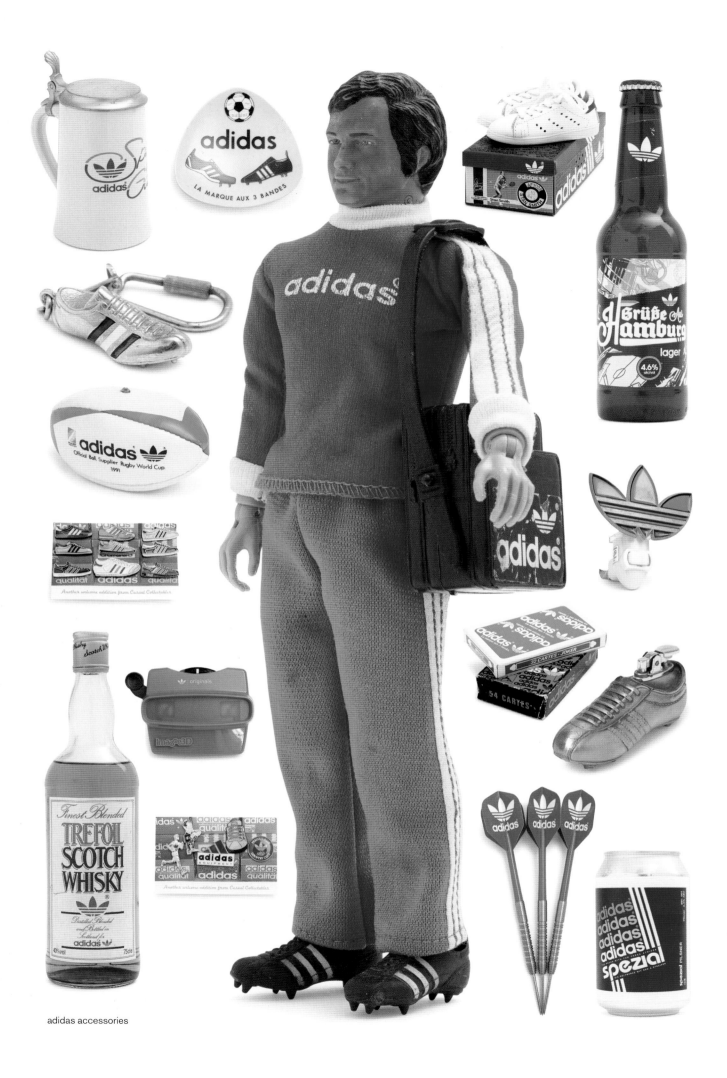

adidas accessories

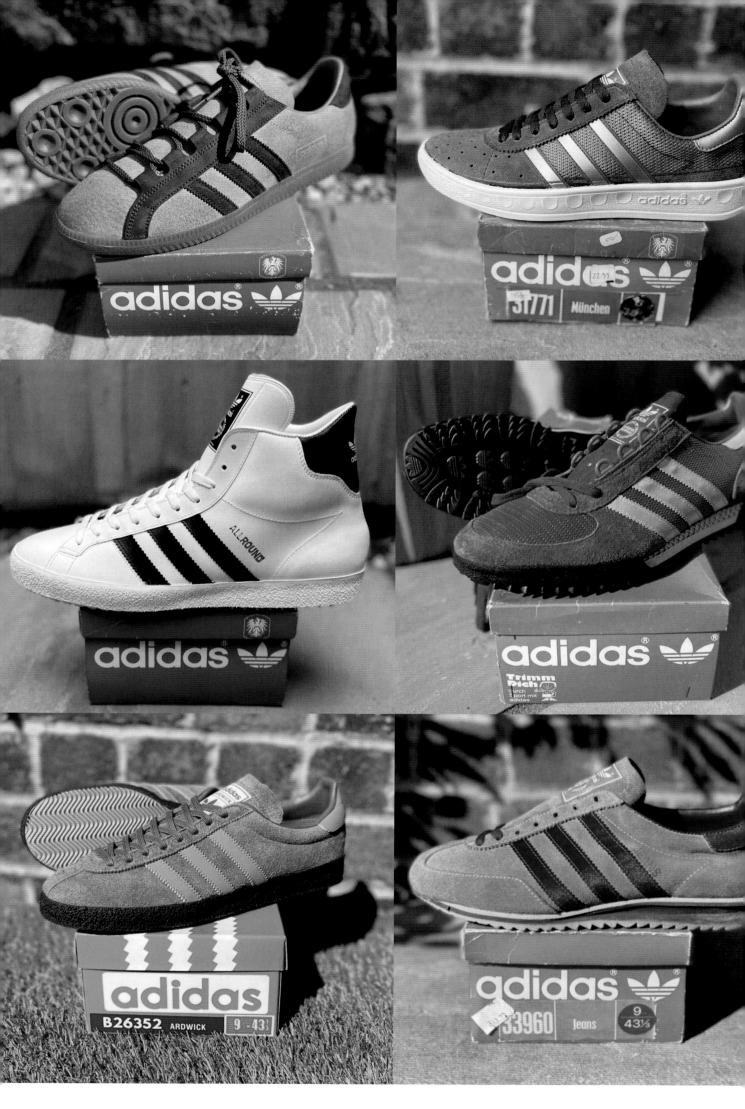

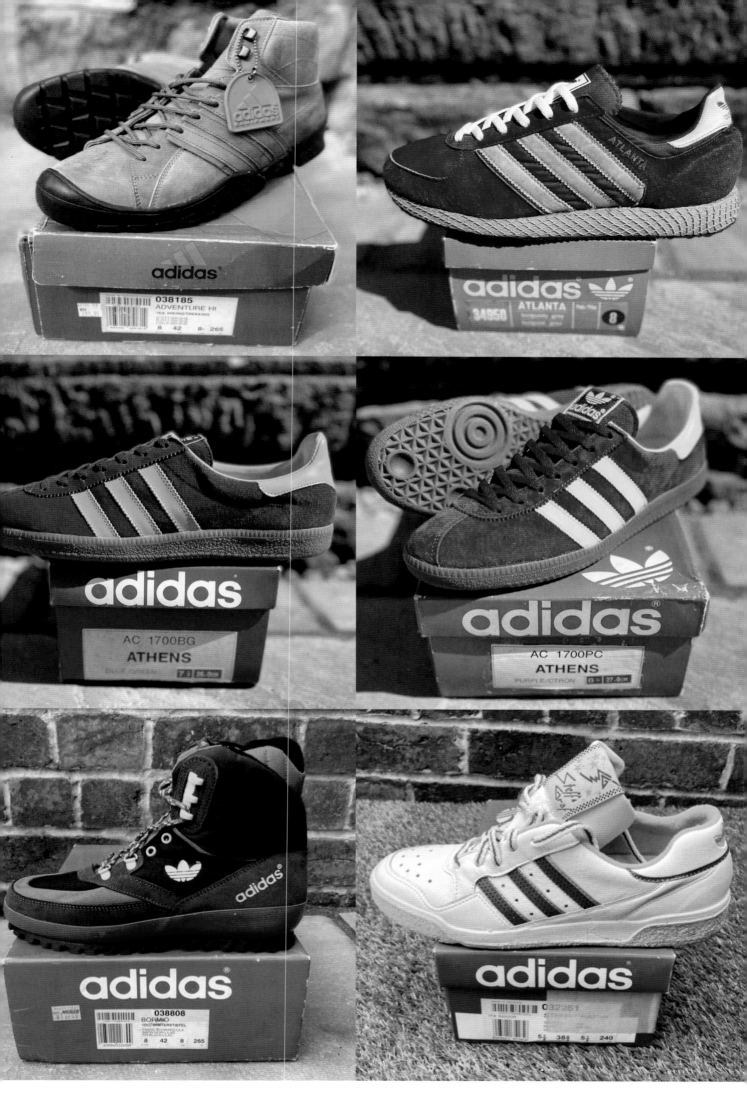

1969: adidas Wimbledon

1971: adidas Robert Haillet

1986: adidas Lendl Competition II

1973: adidas Buda

1968: adidas Diamont

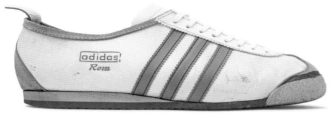

1964: adidas Rom (Made in West Germany)

1980: adidas Fechterschuh

1976: adidas Gut Holz

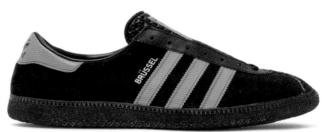

1974: adidas Brüssel

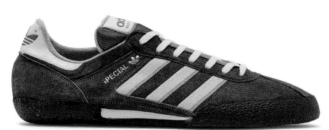

1989: adidas Shot

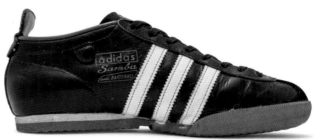

1965: adidas Samba

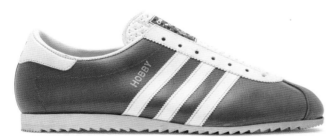

1979: adidas Hobby

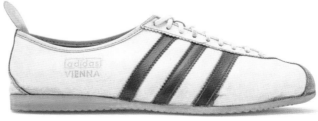

1965: adidas Vienna

1986: adidas Jean MkII

1976: adidas Montreal

BAPE SHALL NOT KILL BAPE

INTERVIEW: WOODY

PHOTOS: WANG CHEN WEI

SHANGHAI, CHINA

If you dialled '2008' into your Tesla time machine and landed in Harajuku or New York, the abundance of shiny BAPEs on cool-kid feet would have dissolved your retinas. That seems a lifetime ago now, but there's no denying Nigo's original Japanese streetwear brand was on fire in the late 2000s, as colabs with Kanye, Daft Punk, Marvel, Pharrell and KAWS made the BAPE STA 1000 per cent cooler than the Air Force 1 on which it is so slavishly based. As Newton's third law of motion implied, 'What goes up must come down hard AF!' And in this case, BAPE's insane altitude was matched with a crushing bummer as the brand flatlined and ended up being sold for pennies. That generational hole explains why so few stalwarts from this era are around these days. Over in Shanghai, Patrick Pan has stayed true to the cause. Not only has he acquired an impressive stash, but he also held on to it long after most of his contemporaries cashed out. Pop the Baby Milo Wayfarers on — it's time to unleash the ultimate technicolour feet beasts as we venture deep into the Planet of the BAPEs!

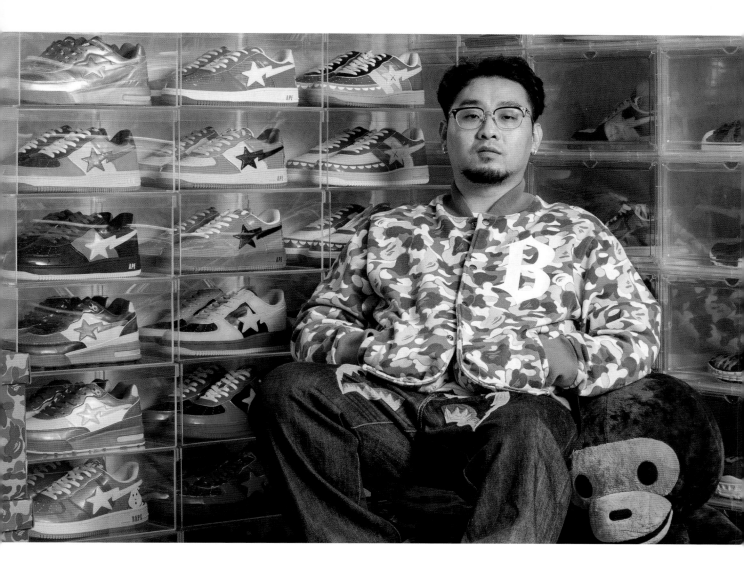

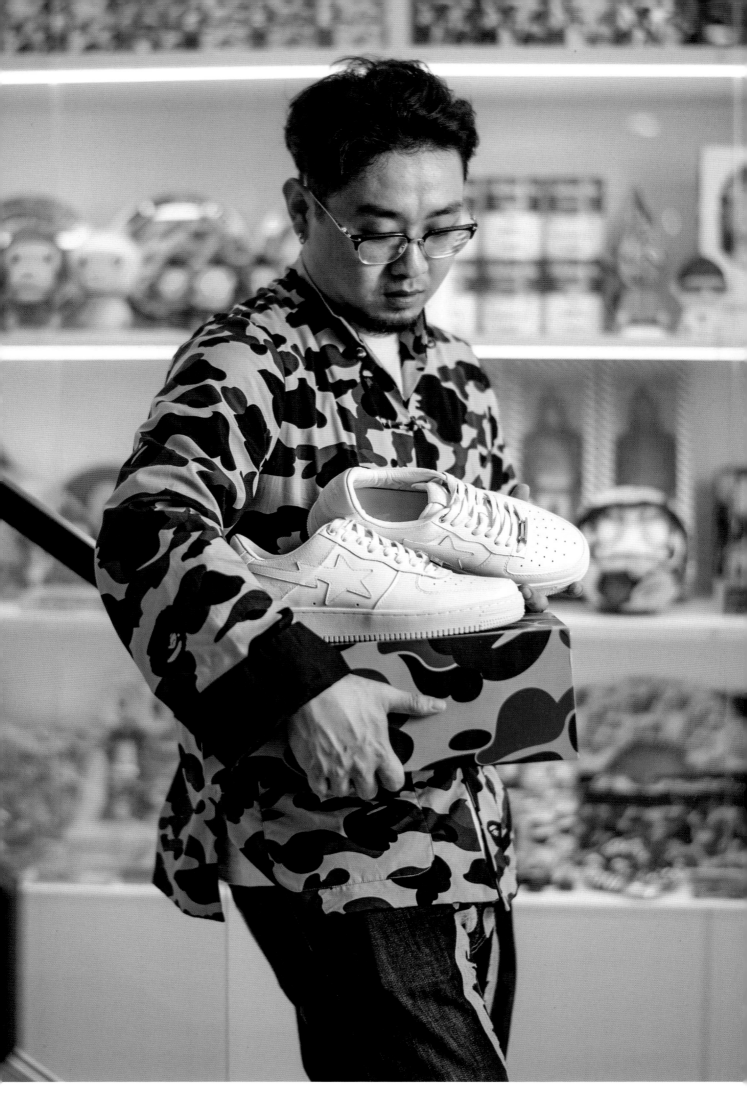

Patrick Pan
BAPE Bonanza
Shanghai, China

I've been collecting BAPE for more than 10 years. My first encounter with the brand was a basic camo tee, and it was so cool it melted my heart at first sight. From that moment on, I started to actively search for anything BAPE. Back then, the internet was not like it is nowadays, so I had to rely on information from Japanese street fashion magazines like *Boon* and *Street Jack*.

My parents worked in Japan for more than 10 years, and they always used to bring me back selections of BAPE stuff when I was a teenager. I used to visit them at least once every year, so that's basically how my obsession developed. At Footsoldier, I would watch the BAPE shoes travel around the shop on conveyor belts, though I never had the money when I was young to buy all the shoes I wanted.

You can say my house is like a shrine to BAPE. Coming home and seeing my collection arranged nicely in the cabinets makes me happy. Some of the original accessories were really cheap, and you can still find some Yahoo auctions with decent prices. I have no idea at all how much money I have spent so far as I try not to think about it like that.

At different times BAPE shoes were really hard to get outside Japan, so most of the shoes came from resellers or Yahoo auctions. I know quite a few older collectors have given up on the brand, and many have sold all their shoes. I'm not gonna say I will stay loyal forever because I did stop buying for a while. But I don't think I will ever sell my collection because BAPE is where everything started, and the brand still means a lot to me.

I love Nike Air Force 1s, but the BAPE STA is the best and most successful clone that was ever made. They are classics! BAPE STAs have always used colours differently. Some of those crazy bright colourways you might not think should work, but they do, at least in my eyes. That's the beauty of the BAPE STA. I think anyone who lived through that 'patent' era in the back half of the 2000s will think the same.

I must admit I don't wear the shoes all that often, so most of them are just going to stay in their display boxes forever. That's not because they are so bright and crazy but because of the ageing process. Most are not that old, but they would crack in two steps if I was to walk down the street. The patent material has a habit of leaving big creases in the toe box as well. Not much you can do about that.

My all-time favourite is the red ROAD STA from the Pharrell collaboration. Aside from that, I think I pretty much have most of the BAPE shoes I ever wanted. KAWS is one of my favourite artists, and I have some vinyl pieces from him too. I got to know KAWS thanks to his connection to BAPE and Nigo. Those OG colabs were crazy nice. They actually released quite a lot of 'Chompers' colours. I'm always looking for fresh models at a good price, but it's really hard to find them in good condition.

The Kanye pair came from an auction. Everyone likes them, not only because of Kanye West but also because the 'College Dropout' design is dope. I don't really remember the price I paid because it was too long ago. But they definitely cost a lot for sure, and I know they are worth way more money nowadays.

Aside from that, I have loads of Medicom toys and other BAPE accessories. I did have to slow down a bit as I was running out of space, but I'll still buy if I'm feeling it. I also have OG clothing pieces, the mastermind Japan (MMJ) colabs and some KAWS bits and pieces. Nothing too crazy. BAPE has obviously collaborated with adidas, New Balance and other footwear brands like Dr Martens and Uggs, but I don't really go for them. I like the shape and style of the BAPE STAs. No matter what happens, you'll never see me wearing the Ape Crepes. They just don't work for me.

Nigo has left a huge impact on a lot of us. After all these years, people are still talking about his work, his mind and his lifestyle. I've collected Human Made for a long time too. I'm not that into BAPE after Nigo left, of course, but I'm really happy they're bringing back the original design of the BAPE STA. That other version was pretty odd looking, and I didn't like it. Perhaps it was due to the legal situation with Nike – I'm not sure.

Life is always a circle. In streetwear and sneaker culture, people like certain kinds of things and styles at certain times, and then they move on to something new, and so it goes around again and again. So you never know what's going to pop next.

★

@pkyesway

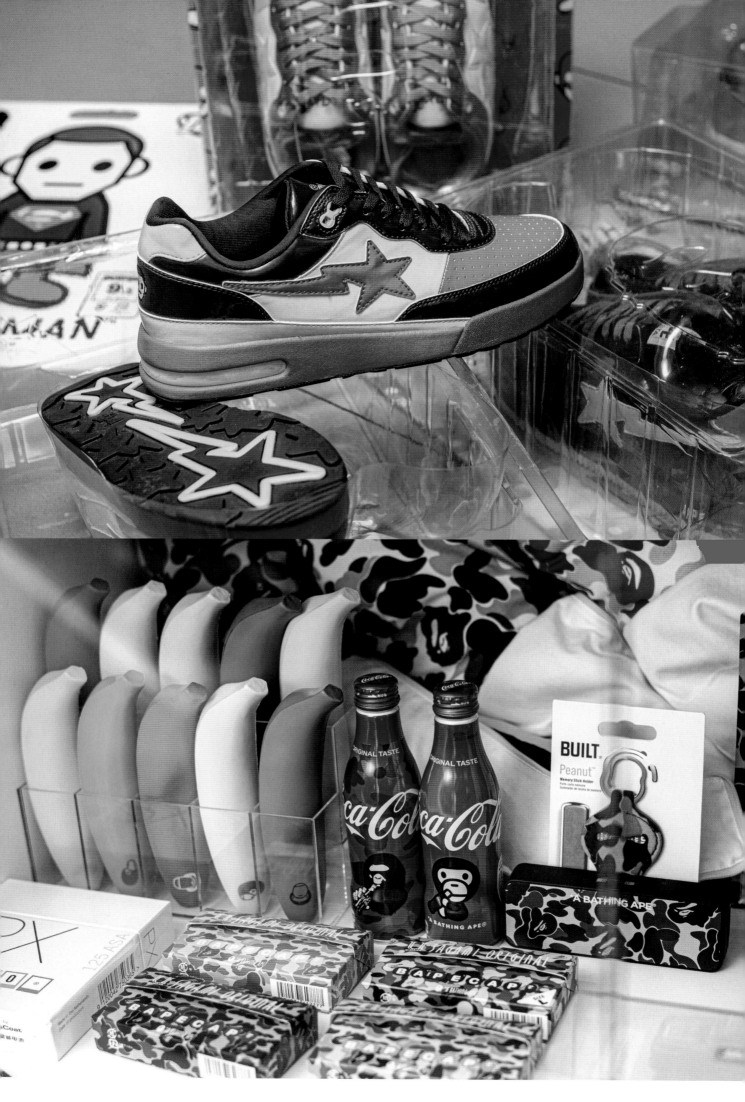

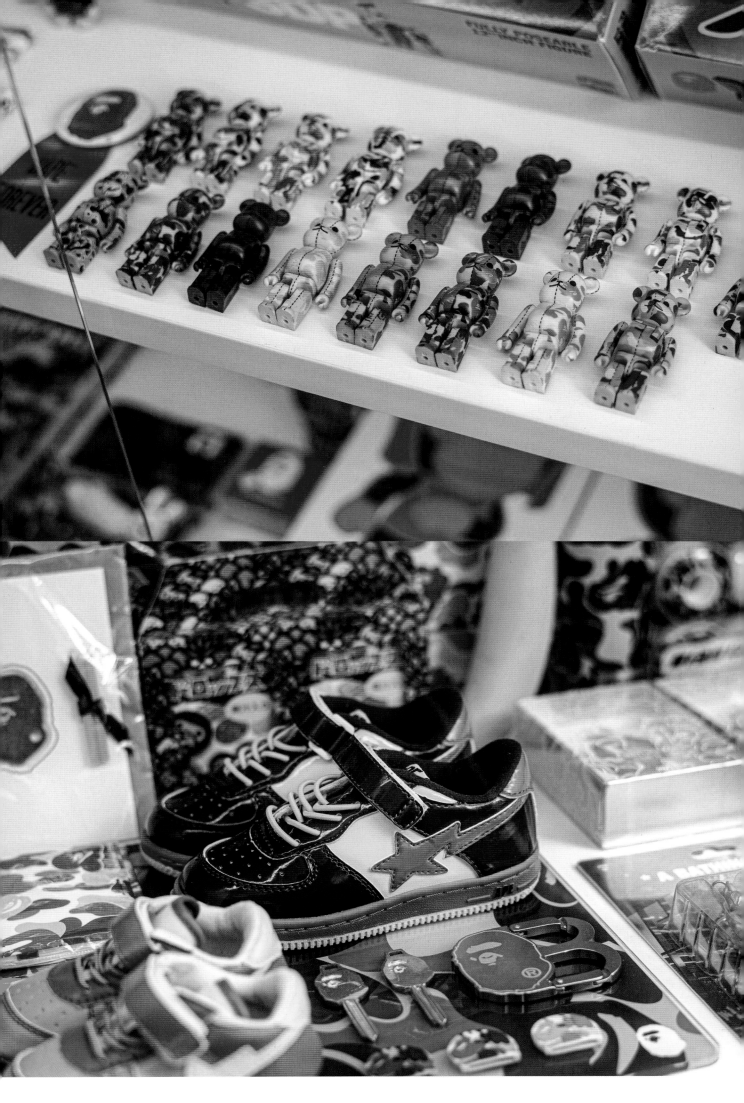

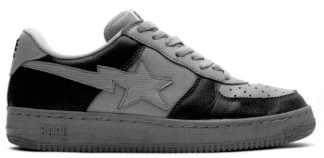

2013: BAPE STA

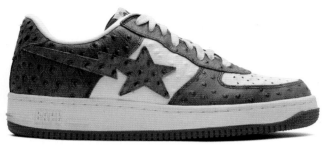

2010: BAPE STA Ostrich Skin

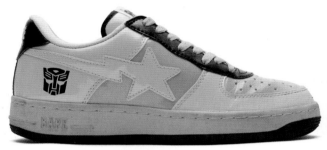

2013: Transformers x BAPE STA

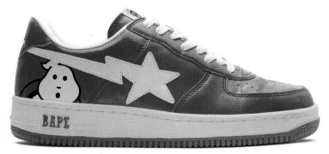

2009: Ghostbusters x BAPE STA

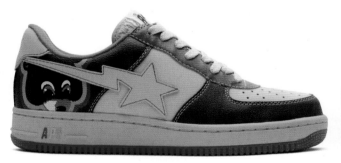

2007: Kanye West x BAPE STA 'College Dropout'

2010: Baby Milo x SKULL STA

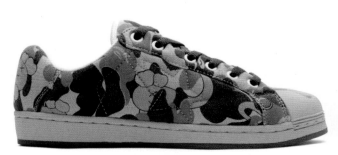

2004: KAWS x SKULL STA

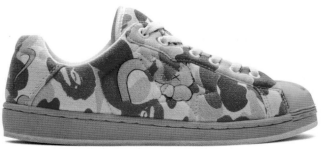

2004: KAWS x SKULL STA

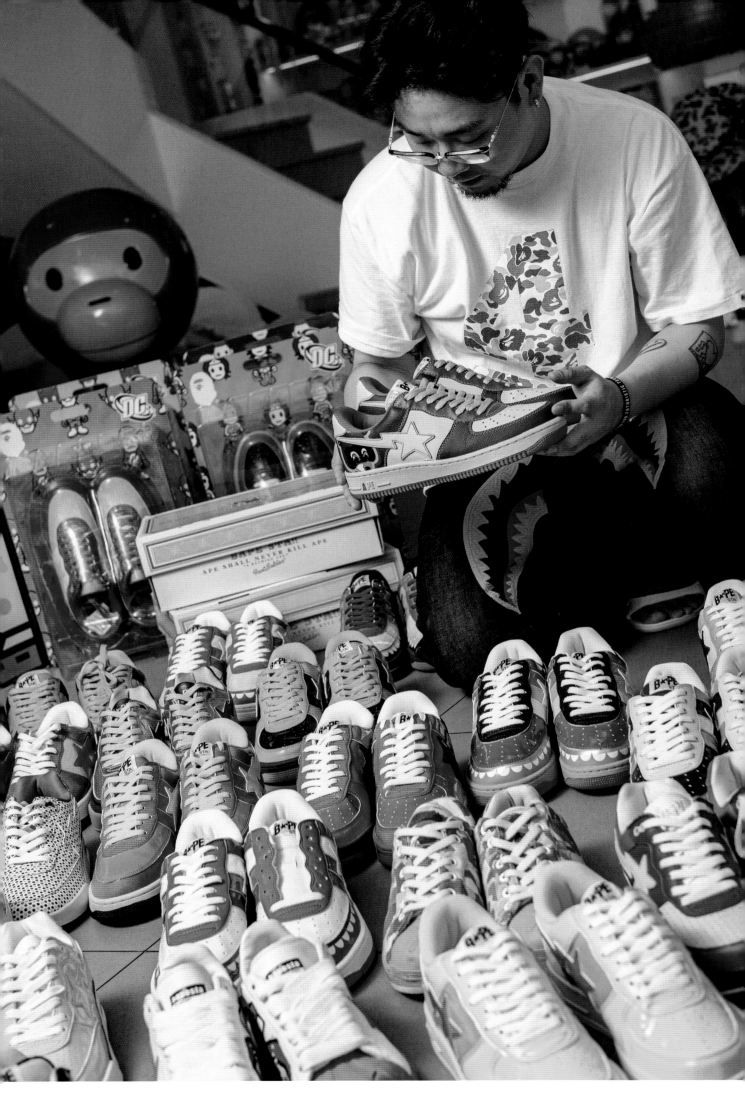

2005: Marvel Comics x BAPE STA 'Human Torch'

2005: Marvel Comics x BAPE STA 'Cyclops'

2005: Marvel Comics x BAPE STA 'Thor'

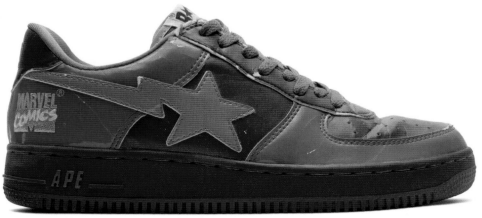

2005: Marvel Comics x BAPE STA 'Silver Surfer'

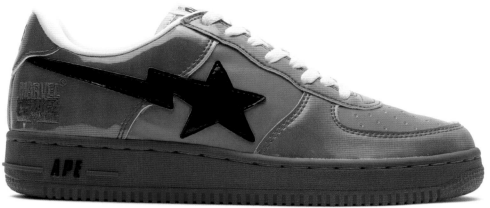

2005: Marvel Comics x BAPE STA 'Spiderman'

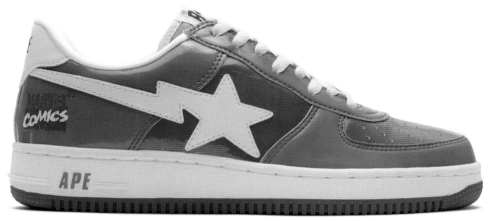

2005: Marvel Comics x BAPE STA 'Captain America'

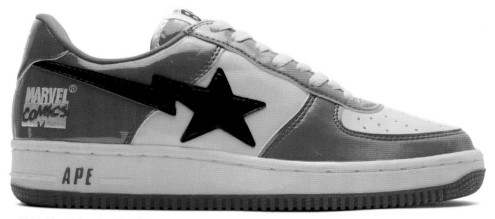

2005: Marvel Comics x BAPE STA 'Iron Man'

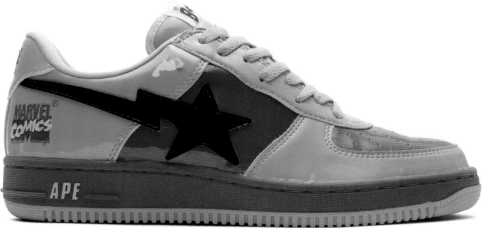

2005: Marvel Comics x BAPE STA 'Hulk'

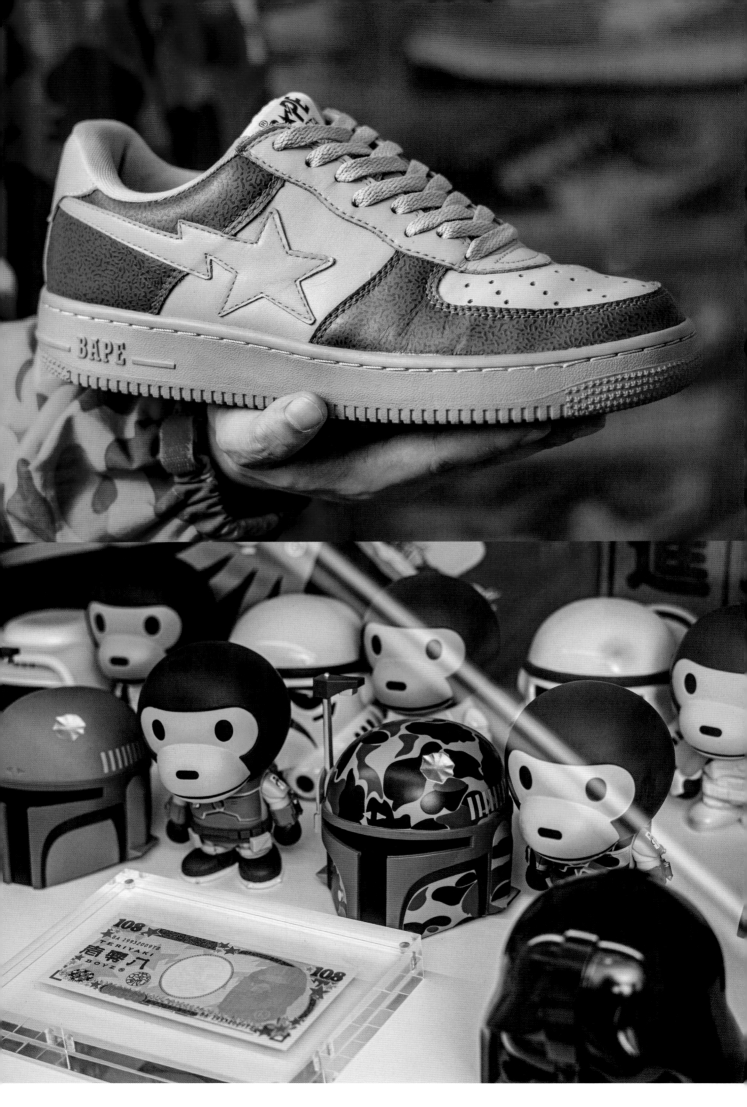

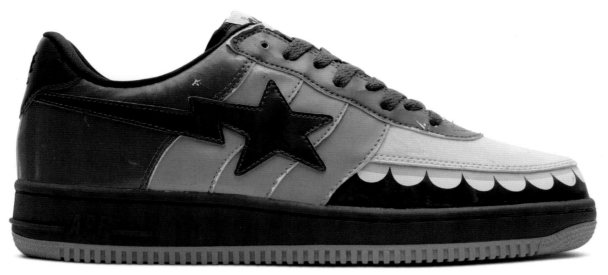

2006: KAWS x BAPE STA 'Chompers'

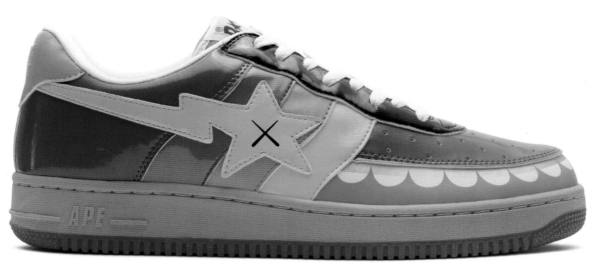

2006: KAWS x BAPE STA 'Chompers'

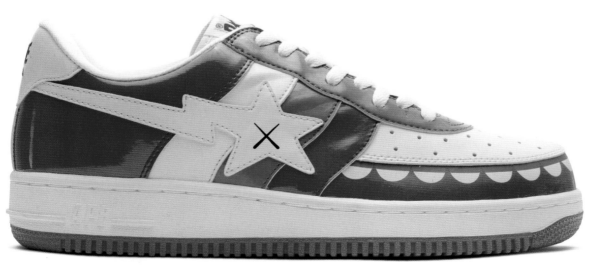

2006: KAWS x BAPE STA 'Chompers'

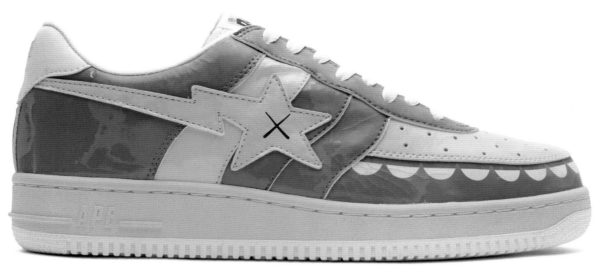

2006: KAWS x BAPE STA 'Chompers'

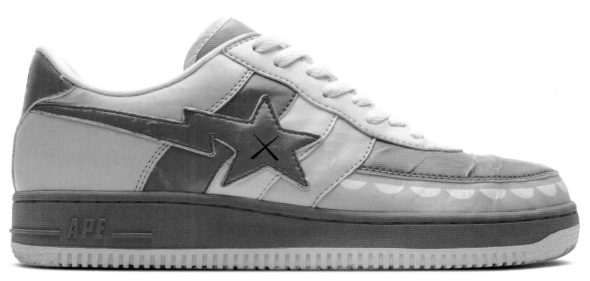

2006: KAWS x BAPE STA 'Chompers'

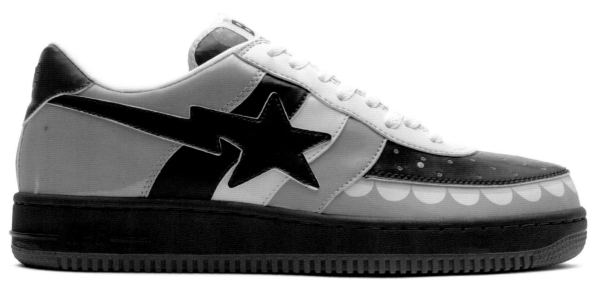

2006: KAWS x BAPE STA 'Chompers'

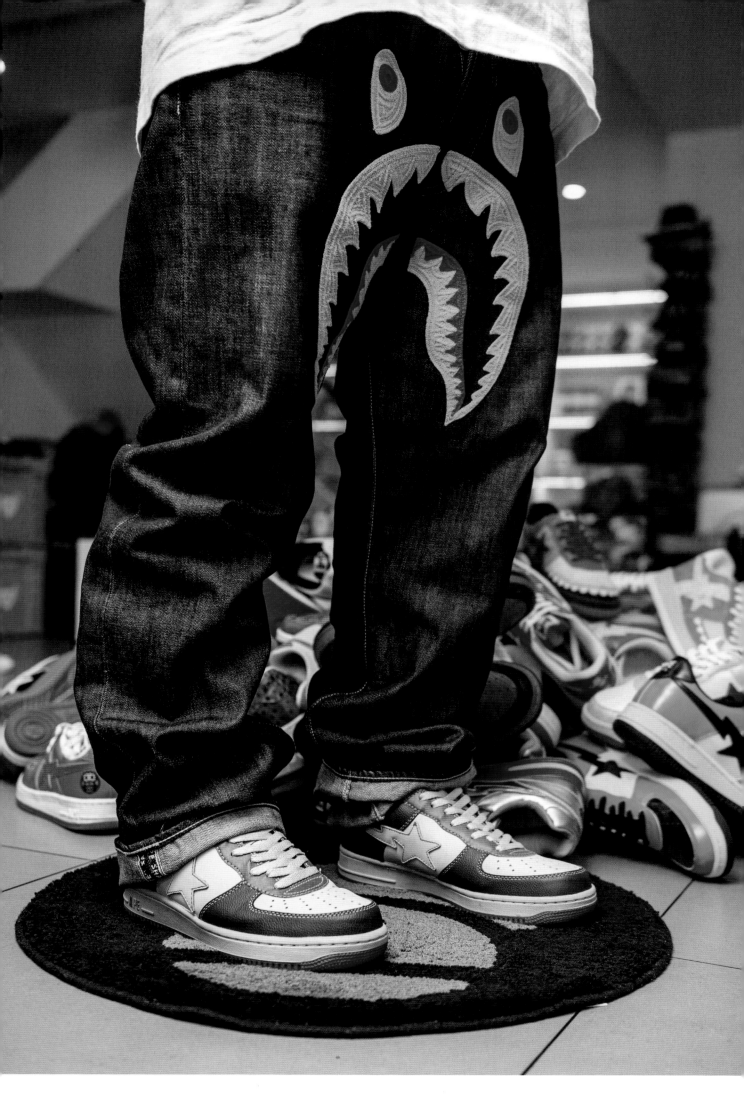

'I love Nike Air Force 1s, but the BAPE STA is the best and most successful clone that was ever made. They are classics! BAPE STAs have always used colours differently. Some of those crazy bright colourways you might not think should work, but they do, at least in my eyes. That's the beauty of the BAPE STA. I think anyone who lived through that "patent" era from the back half of the 2000s will think the same.'

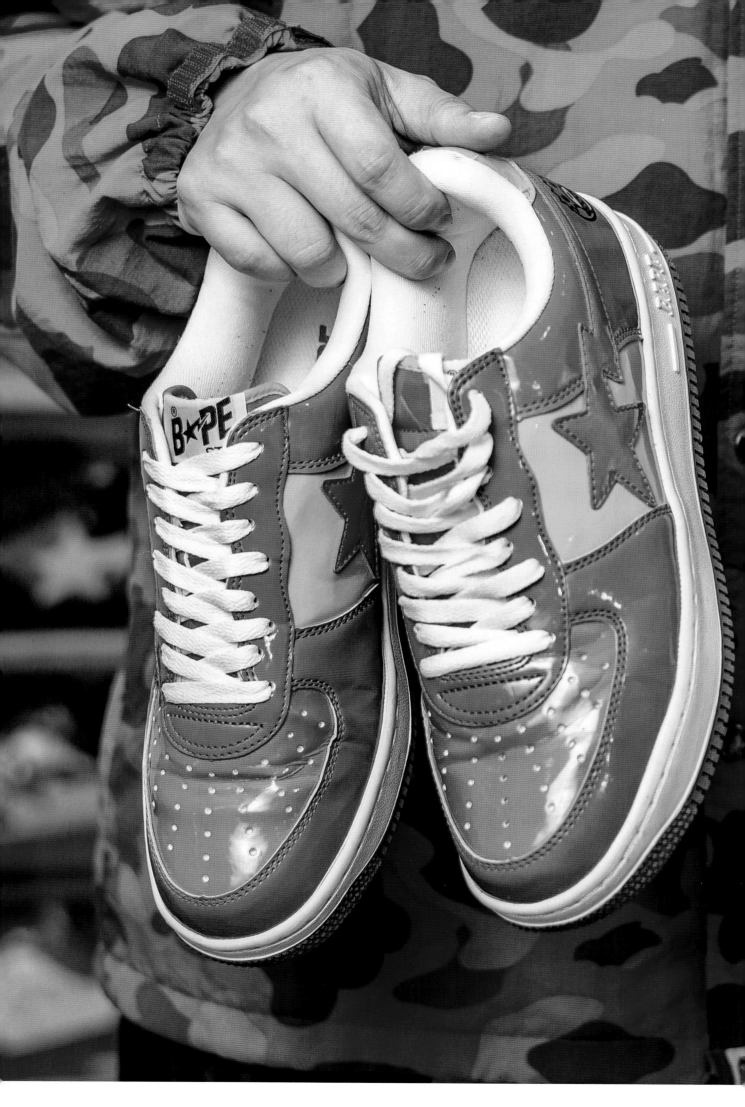

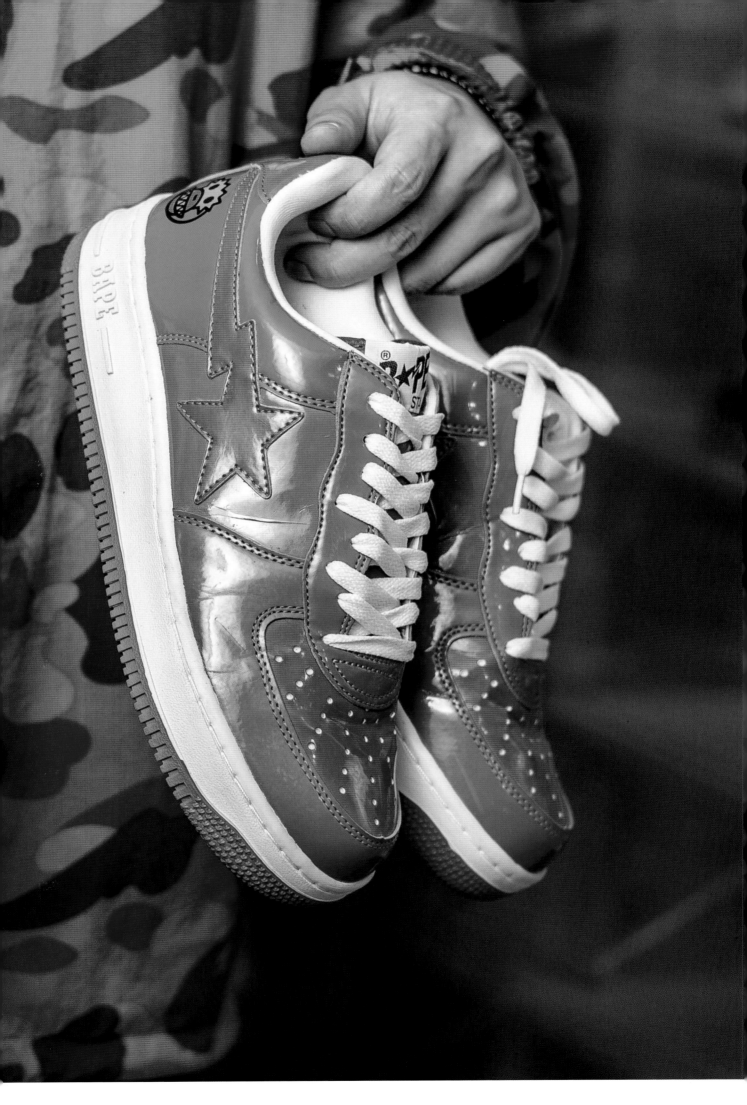

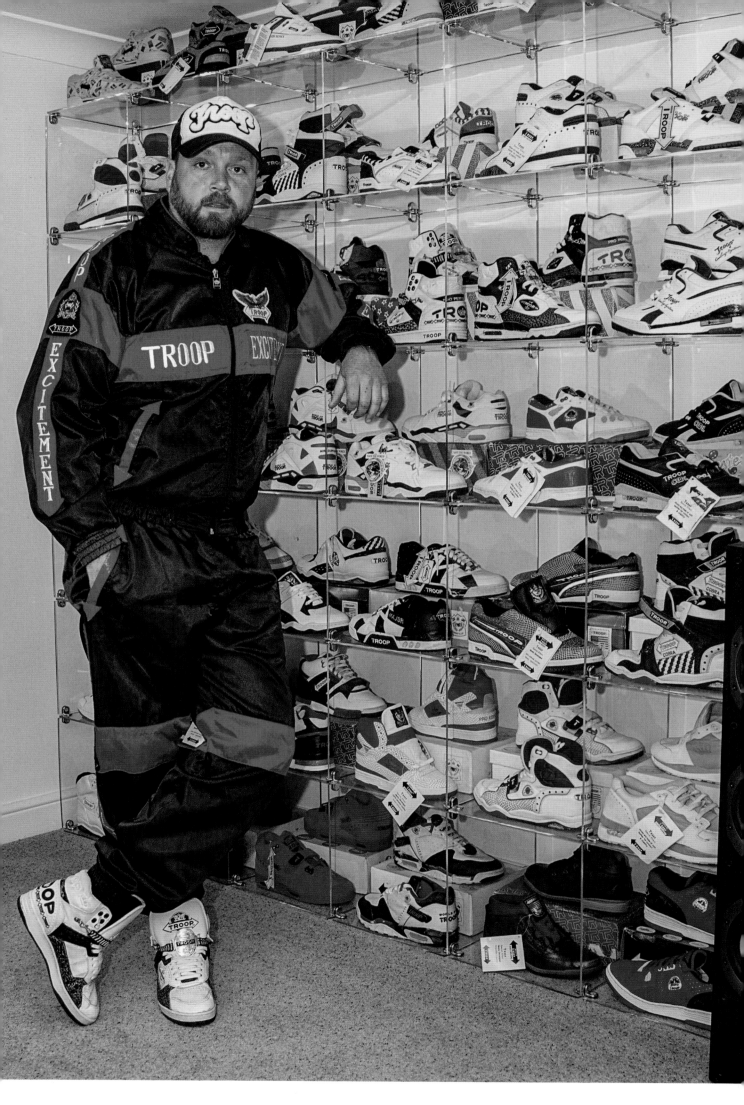

302

INTERVIEW: **WOODY** PHOTOS: **ALAN WEAVER**

BEN WEAVER

TROOP IN FULL EFFECT

The year is 1985. With a young Michael Jordan on fire and Dapper Dan cold-crushing custom clothing in Harlem, Jewish entrepreneur Teddy Held launches Troop, a full-flavour sports brand laced with flashy 'urban' detailing. An instant sensation, Troop was adopted by street hustlers and endorsed by hip hop royalty including LL Cool J and MC Hammer. Expanding at supersonic pace in the US and around the world, Troop imploded spectacularly after malicious – and untrue! – rumours circulated that connected the brand with the KKK. Far from the Bronx, in the United Kingdom, Ben Weaver was a tender 12 years old when he fell in love with Troop. Several decades later, following a dedicated shopping spree, Weaver has assembled dozens of jackets and over 70 pairs of Troop trainers. The best part is that he still rocks Troop with pride in the local boozer on the reg!

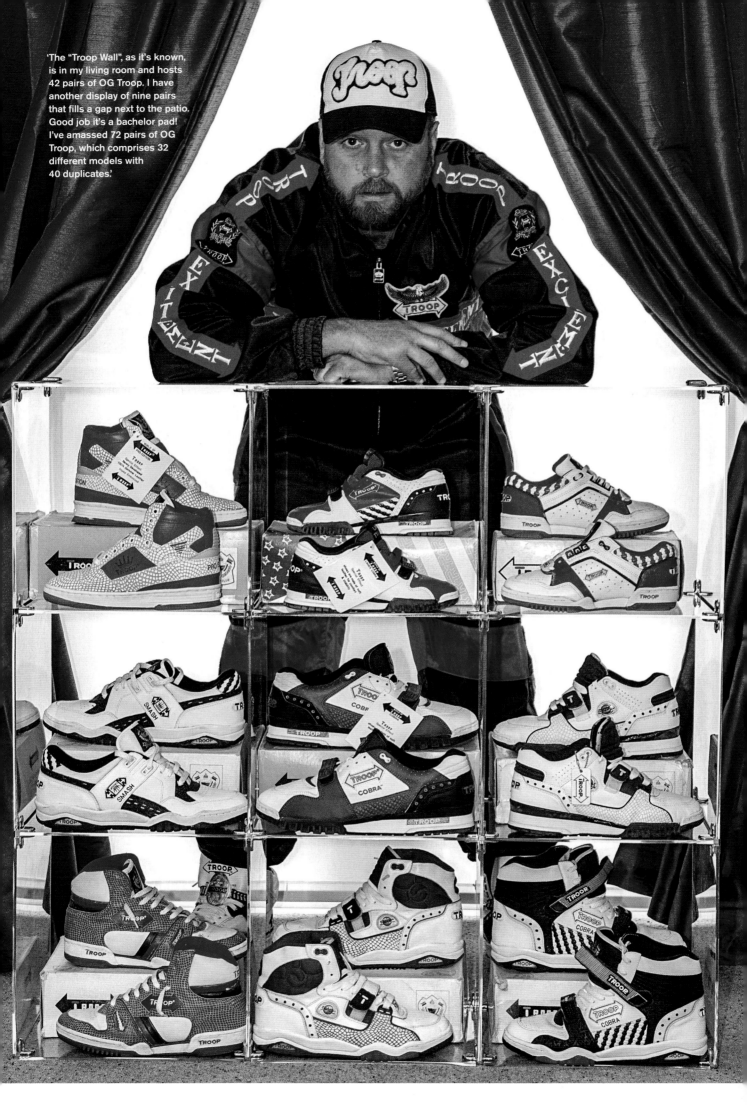

'The "Troop Wall", as it's known, is in my living room and hosts 42 pairs of OG Troop. I have another display of nine pairs that fills a gap next to the patio. Good job it's a bachelor pad! I've amassed 72 pairs of OG Troop, which comprises 32 different models with 40 duplicates.'

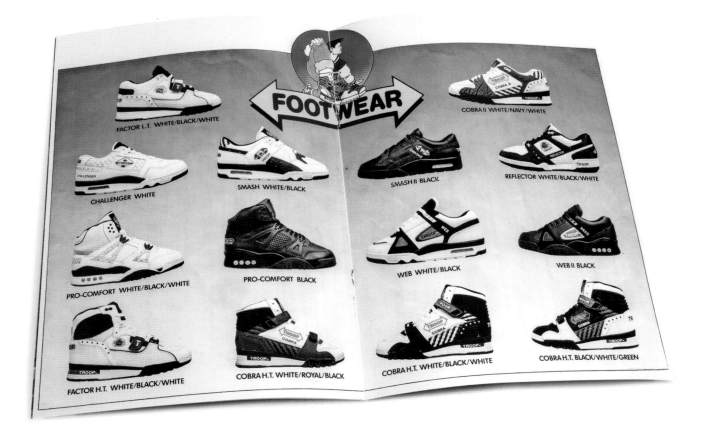

FACTOR L.T. WHITE/BLACK/WHITE

COBRA II WHITE/NAVY/WHITE

CHALLENGER WHITE

SMASH WHITE/BLACK

SMASH II BLACK

REFLECTOR WHITE/BLACK/WHITE

PRO-COMFORT WHITE/BLACK/WHITE

PRO-COMFORT BLACK

WEB WHITE/BLACK

WEB II BLACK

FACTOR H.T. WHITE/BLACK/WHITE

COBRA H.T. WHITE/ROYAL/BLACK

COBRA H.T. WHITE/BLACK/WHITE

COBRA H.T. BLACK/WHITE/GREEN

Original Troop catalogues are super rare

Was there one key moment that sparked the flame?

I've always had a fondness for trainers in general, mainly stuff like Nike Airs, adidas and PUMA, but my Troop story goes all the way back to when I had just started high school. I'd never heard of the brand until this point, but all the older guys I looked up to suddenly wore Troop trainers and tracksuit tops to school. I just wanted to be as cool as they were!

After a lot of pestering, my mum gave in and bought me a pair of Pro Performance and a Troop 'Excitement' suit in black and red. When I turned up at the 1989 school Christmas disco with my Troop in full effect, nobody else was even close. There was the odd pair of FILA kicking about, but that was about it.

A few months afterwards, a market stall in the local shopping centre became notorious for selling Troop on the cheap. My pairs had cost 70 quid, a lot of money at the time, so this sounded too good to be true. My mum took my younger brother and me down there, and it was true, Troops were half the price they were in other shops. Mum bought me a pair of Factor High in white and black, and my brother scored a pair of Troop Web. Without wanting to be seen buying Troop from a market stall, we legged it back to the car before anyone from school spotted us. This period was probably the brand's height of popularity, at least in the UK.

Was there a moment recently that brought all these childhood memories back?

My obsession, as many people call it, started a few years ago. In the past, I've had a quick look on eBay, but because I never came across anything very often, I left Troop as a childhood memory. Back in 2013, I was going to an 80s-themed weekend at Butlin's holiday park in Skegness, which is on the east coast of the UK. Around 10,000 people get dressed up at these events. I was in my local pub, and we were all discussing our outfits. I thought to myself, 'If I could rock up head to toe in Troop gear, I'd be buzzin'!' As luck would have it, a Troop 'Stars & Stripes' shell suit was for sale right at that minute, so I got on it, and nobody else was having it. I won the auction, messaged the seller and asked if he had any other Troop items for sale. He then sold me a jacket, so I was well on the way. Now I just had to try and find some kicks to rock with my shell suit, so I searched for Troop, British Knights, Travel Fox and SPX.

Lo and behold, a pair of Ice Lamb in white came up on the Bay. I didn't remember them from my school days, but I bought them anyway. They were the 2003 re-releases, as it turned out, so I wasn't overly star-struck, but hey, I was fully Troop'd out for the weekend, and this boy was going to rock!

I would have liked to see that. I bet your shell suit could tell some stories from that night. What sort of reaction did you get?

Within minutes of turning up for the main event on Saturday night, everyone was in fancy dress coming up to me saying, 'I loved Troop when I was a kid!' and 'Wow, I had the same shell suit!' Of course, I loved the attention, and my interest in the brand was totally reinvigorated.

I guess you either love or hate the aesthetic. Growing up in the UK is a long way away from the Bronx. How did Troop's hip hop halo translate into your world?

Yeah, the Bronx and Sheffield are definitely worlds apart, style-wise. [Laughs.] I was actually introduced to hip hop by my best mate, who was a couple of years older, and incidentally, he used to rock Troop Challengers. It's hard to overstate things thinking back on it all, except to say that, to me, wearing Troop meant you were about as cool as any 12-year-old could possibly be. It's all about 'newness' at that time in your life. New school, new friends and new clothing to go with it. Life had suddenly become an adventure, and it's one that has left me with fond memories of Troop.

Troop's success was cut short by rumours that the Ku Klux Klan owned the brand. I've since heard that someone at adidas apparently started the racist talk. Another opinion is that the KKK stories derived from the use of 'YKK'-branded zips. Do you remember all of that stuff being talked about in the schoolyard?

I do remember when the rumours started. Kids without Troop used to say they were made by Gola and that when the soles wore out, they had a racist slogan underneath from the KKK. I just thought it was jealousy at the time. Since I've been collecting Troop, I've done quite a bit of research into the history of the brand and came across the stories about a famous sports brand that thought Troop were becoming too big and put the false stories out. It is interesting how a brand so large and popular could be crushed so quickly – it's not something that'd happen nowadays.

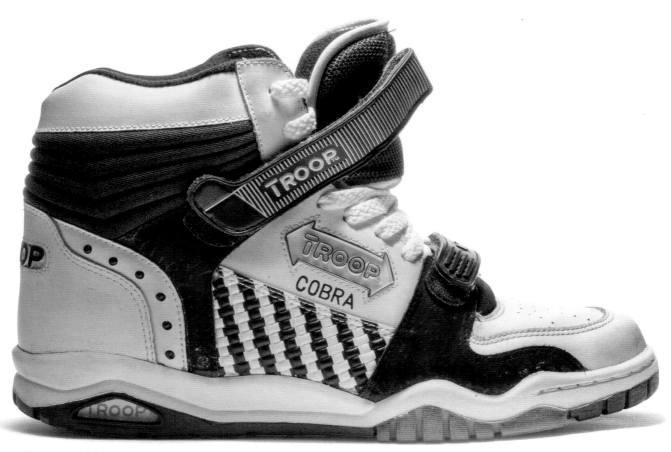

Troop Cobra High

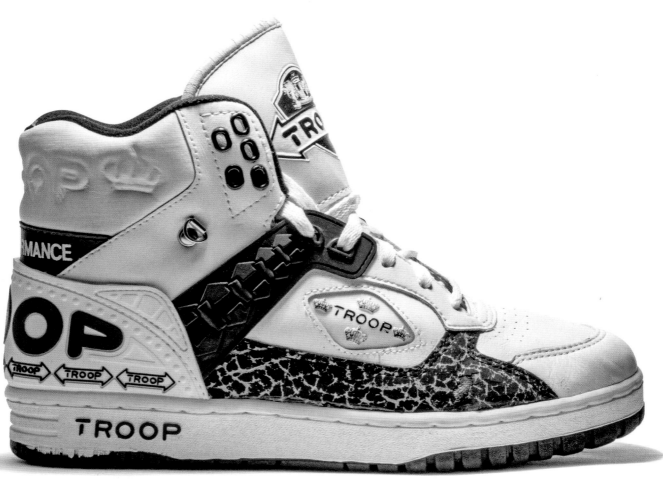

Troop Pro Performance: one of Ben's few pairs that can be worn with confidence

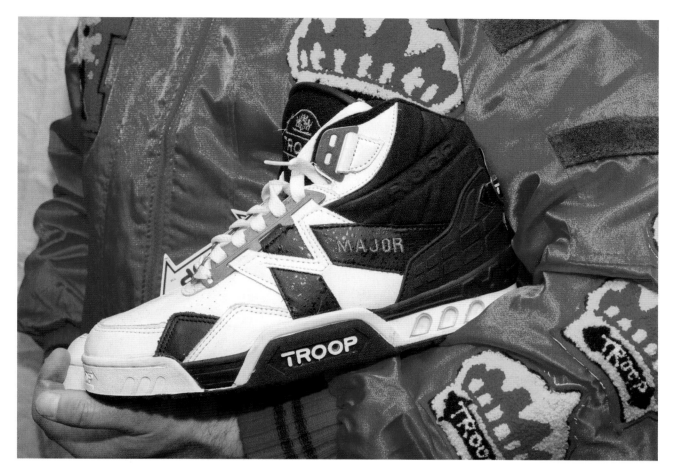

Troop Major High

You mentioned SPX, a UK brand formed to cash in on Troop's success. Did SPX, British Knights and Travel Fox also catch your teenage eye?
Back in the day, I thought those brands were poor relations and had jumped on the bandwagon to cash in. I have a few pairs of BK and SPX, and I have to say it's a shame Troop weren't made at the same quality as Travel Fox because their shoes are proper and still very comfortable. If Troop had been top-notch with their materials and manufacturing, I think plenty of people would still have a survivor pair in the back of their wardrobe.

Let's talk about your collection. Just how deep is it, and how have you got it stored at your crib?
The 'Troop Wall', as it's known, is in my living room and hosts 42 pairs of OG Troop. I have another display of nine pairs that fills a gap next to the patio. Good job it's a bachelor pad! Since I started collecting, I've amassed 72 pairs of OG Troop, which comprises 32 different models with 40 duplicates. I also have a few pairs of the re-releases and three pairs of fakes.

I'm also a member of a Facebook group called Remembering Troop, British Knights and SPX, which has been a massive influence. Dayle Dickson runs the group and does an ace job. His knowledge of the brand is second to none. If I hadn't joined the group, my collection would never have grown so big.

Any big-time scores?
I've had a couple of lucky scores along the way, but out of the blue, I picked up 11 pairs from one guy and another 20 pairs from another source. When I'm offered stuff I've already got, I still pull the trigger because I want to be their go-to buyer. Dayle's knowledge in this regard has been invaluable. Some of the pairs in my collection are unique, and a few were unknown until they resurfaced.

How many are wearable? Troops from this era are pretty delicate, and many are crumbling badly.
I go through stages where I'll rock the odd jacket and tracksuit down the local boozer two or three times a week, and then I'll go through a stage where I don't wear it for a while. I have five pairs of

Cobra High in my collection which I bought with the view of wearing a pair until they drop dead, then I wear another pair and so on. I love 'em to bits. There are three different models I can still wear, including the Cobra Highs I just mentioned, plus a pair of Smash and a pair of Pro Performance with cup soles, which I wear very occasionally as I know there's not much life left in them. The Cobra and Smash share the same solid rubber sole, so they are good to wear. But yes, the quality, on the whole, is shite. I once wore a pair of Troop Driver – brand new, never worn before – and they barely lasted 100 metres before the sole started to give way. I learned a costly lesson that night!

Judging by some of the prices we've seen online recently, you've obviously invested heavily in some of these relics. I hate to talk money, but give us some indication of what you've spent. What's the most you've coughed up for a pair?
Yeah, you're right. I've spent a small fortune on my collection. I would guess it's around the £20,000 figure. The highest bid I've placed on eBay was for £485. Fortunately, they came in for less than that amount, but I'd have to say that's what I was prepared to pay for a special pair. A few times, I bought pairs from different auction sites around the world and paid good money, only for them to arrive and be very disappointed. This happens regularly with Troop clothing.

I feel your pain. Are these gems mostly in Europe or the US?
My two big finds have been in the US, but I've also bought from the UK, Japan, Germany, Holland and Spain. It's a case of searching on a regular basis until they eventually turn up. I've not got any great vintage-hunting stories in old sports stores or anything like that, but I have been lucky to come across some big finds. I believe you create your own luck in life.

You have quite a few colours in the Cobra Low, including some women's pairs, which must be super rare. Is that the pinnacle of your collection?
I'm a big fan of the Cobra Low. I did have a wearable pair of Cobra II in black and red, but they were slightly too small, so I ended up doing a swap with Dayle for the only known pair of Destroyer out there. I do believe I'm the only person to have a pair of Lady Cobra, and I have

Troop Pumps?

The Control Low featured inflatable 'Pump' valve technology that was swiped from Reebok, along with a cosmetic version of adidas 'Torsion' in the sole that was more show than go.

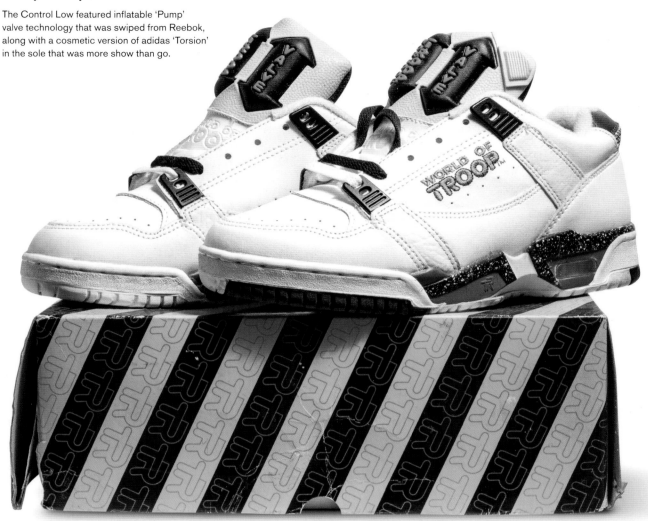

four different pairs in total. Although they sit up there with the best of what Troop produced, the pinnacle for me is the Pro Performance with the gold medallions and the Major High. I'd love to own a pair of Destroyer II, but I know I'm going to have to wait and pay big for this to happen.

The gold cop badge on the tongue is nuts. I always thought that was an odd association to make.
I'm with you on that. They're about as badass as you can get in my eyes, although I've never known them to be called 'cop badges' before. To me, it's always been a medallion with 'professional sport' embossed on it. The Destroyer II also rocks the same gold medallion. In all, I have several sets of the medallions, as there are six pairs of varying Pro Performance in my collection. I also have a 'Magic Force' shell suit with the medallion printed on the back.

The Control Low is amazing. I've never seen Troops with that pump mechanism before. What else do you know about them? Reebok must've been impressed.
I have three different pairs of Troop with the pump mechanism – the Control Low, Driver and Air Support. I don't think Reebok would have been too worried at the thought of Troop pinching their idea, as it was unlikely the pump mechanism ever worked. [Laughs.] Some of these models also have a similar design to the adidas Torsion system in the sole, though I also doubt that had any effect on foot control and stability either.

The Slick definitely has a Jordan 2 kinda vibe.
I'll be honest – I'm not a big fan of the Slick. I found four pairs of these in my first big haul, three in white and one pair in black. In hindsight, I should have kept the black pair on display. I did give a pair each to the guys who helped me put the deal together.

Like Airwalk, which tried to move into brown hikers, Troop started releasing boots like the Strider. Was that the beginning of the end? Are there any Troops you wouldn't collect?
I buy them all just for the collection, but ask me if I'd wear them, and that would be a different kettle of fish. The Strider, Tracker and Street Force II are hideous. I'm not so sure if that was the beginning of the end for Troop, as the good stuff like Pro Performance and Cobras in the UK were still big hits before the rumours started.

What's your take on the Troop renaissance?
Speaking on behalf of a few others from the Facebook group, we were all disappointed that Troop 2.0 were releasing the same models they had in previous comebacks. We will likely buy and wear them, but we were all hoping that the OG Troop we know and love would make a comeback. I feel they'd stand a far better chance if they brought back the Pro Performance and Cobra over the Ice Lambs! I know quite a few lads in their early 20s, and they've all said they'd wear the Pro Performance. I wear my Cobra High all the time, and it's surprising how many people start talking about the Troops they used to have.

How many more Troop Grails do you think are still out there?
There's still plenty out there! The Destroyer II is my big one. Then there's the Platinum, Reactor, Solution, Delta, Defender and Havoc. If any *Sneaker Freaker* readers are in possession and willing to trade or sell, look the other Troop enthusiast and me up on the Facebook page Remembering Troop, British Knights and SPX. Peace out, people!
★

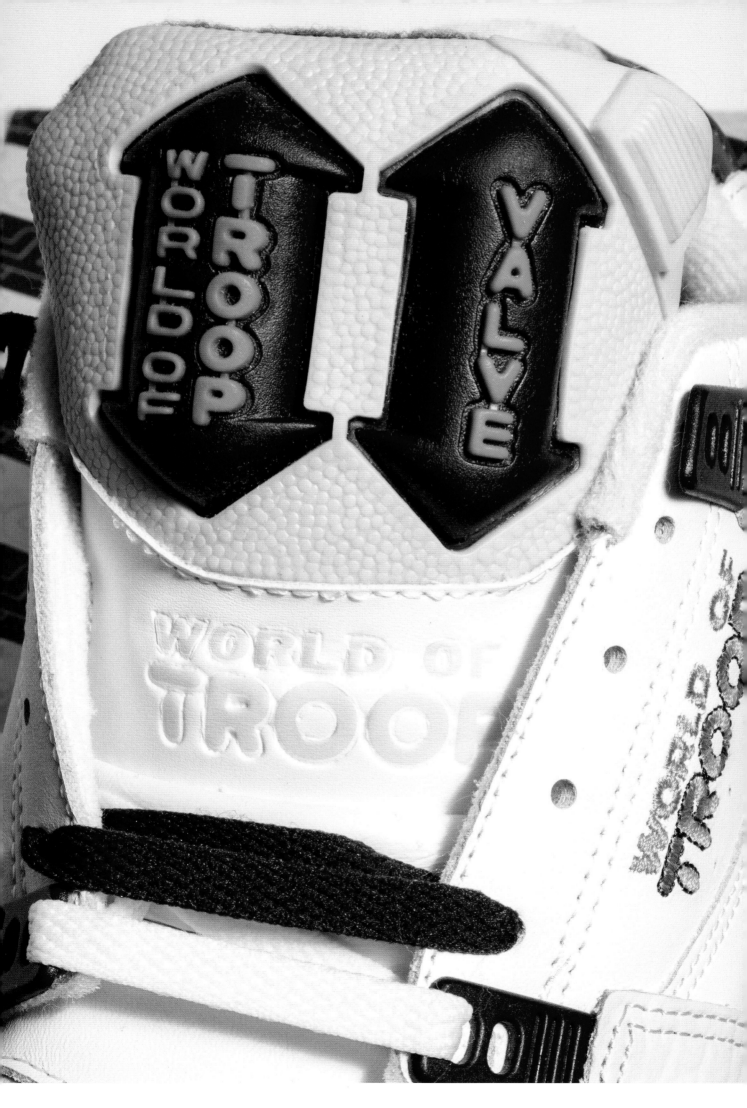

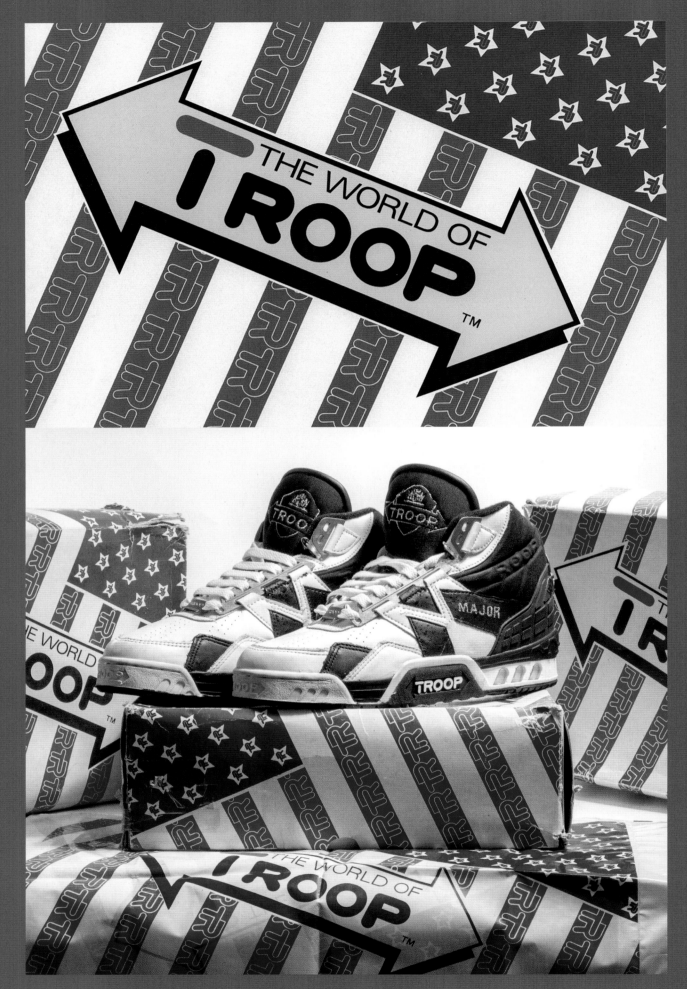

Troop packaging always played heavily on 'Stars & Stripes' iconography

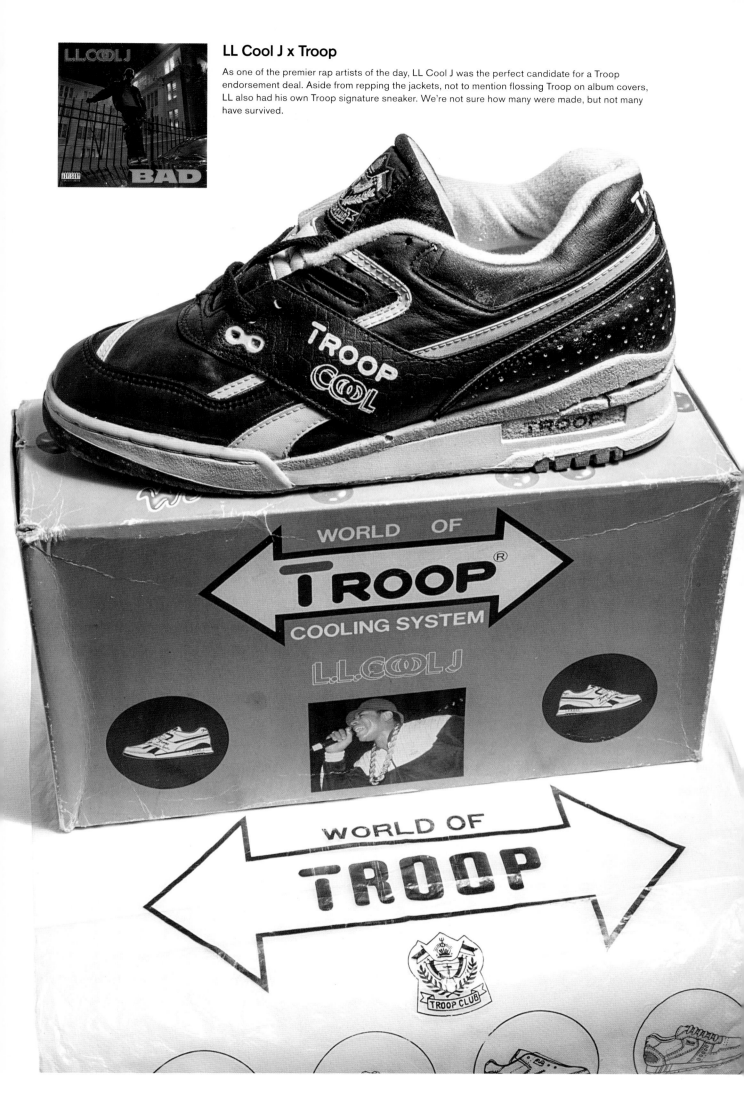

LL Cool J x Troop

As one of the premier rap artists of the day, LL Cool J was the perfect candidate for a Troop endorsement deal. Aside from repping the jackets, not to mention flossing Troop on album covers, LL also had his own Troop signature sneaker. We're not sure how many were made, but not many have survived.

Troop Pro Performance

Troop Pro Edition

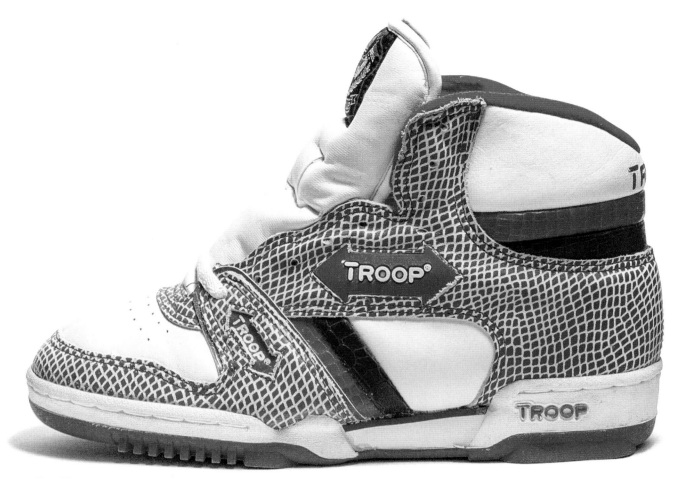

Troop Tiger

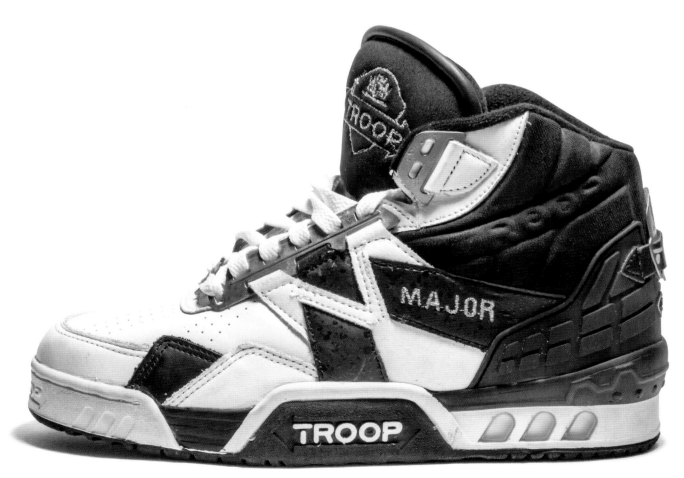

Troop Major High

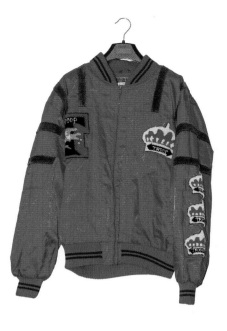

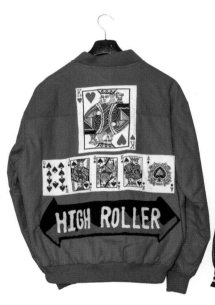

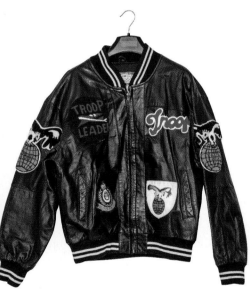

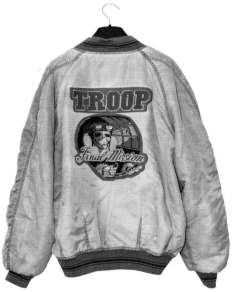

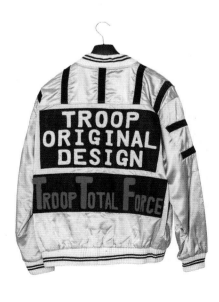

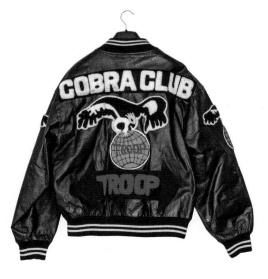

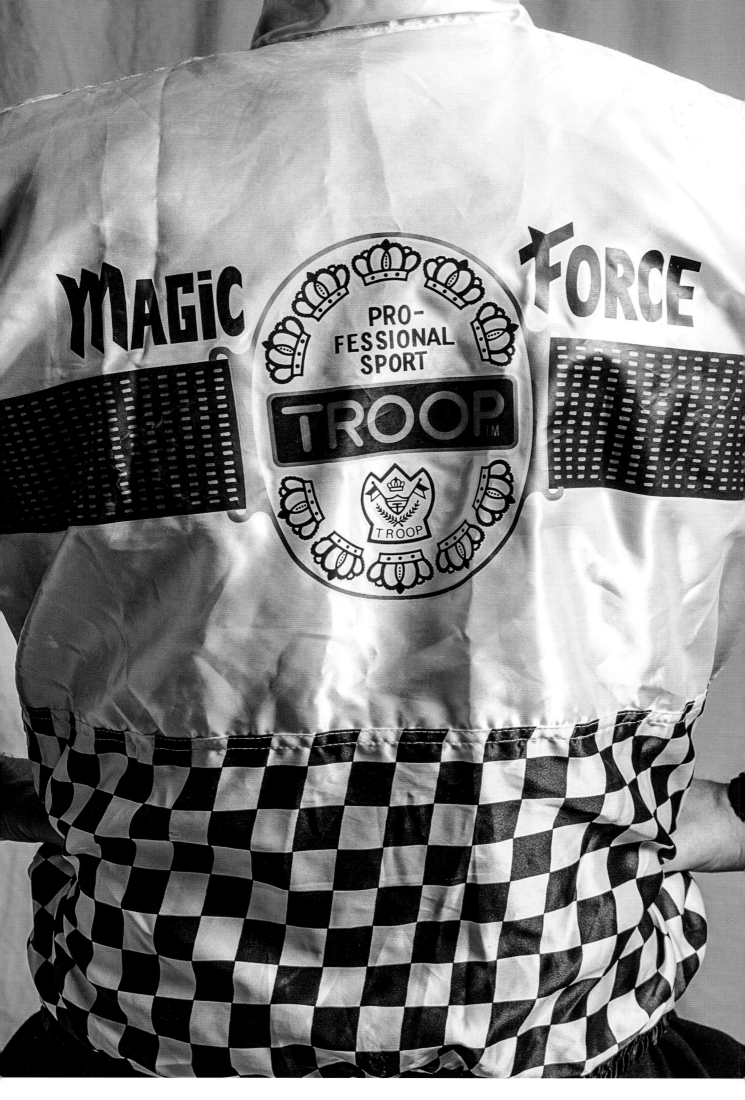

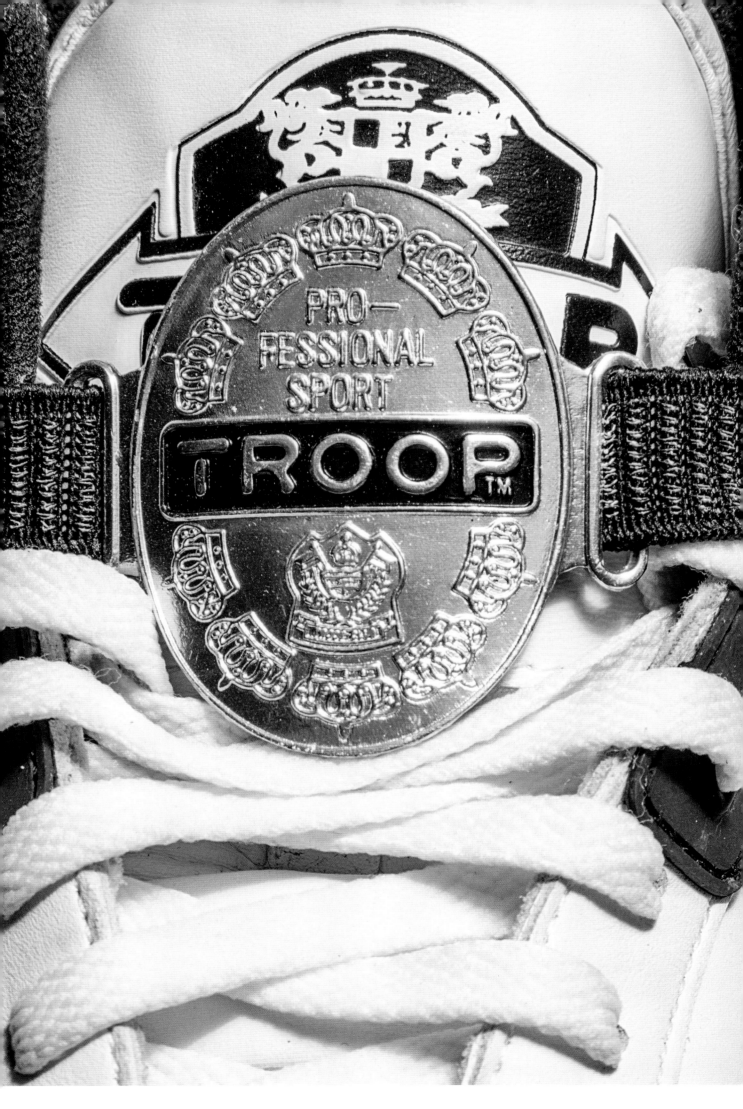

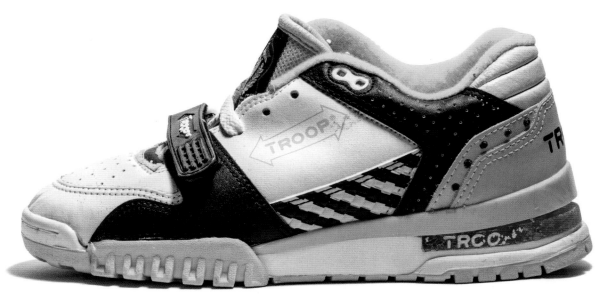

Troop Cobra Low

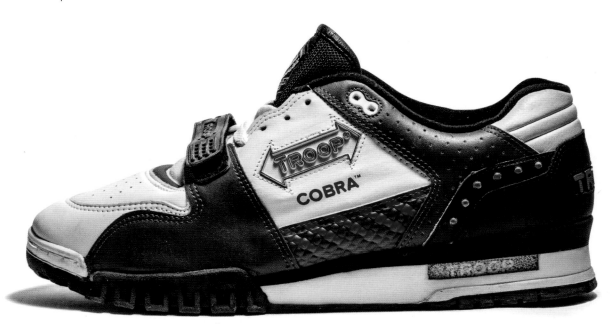

Troop Cobra Low

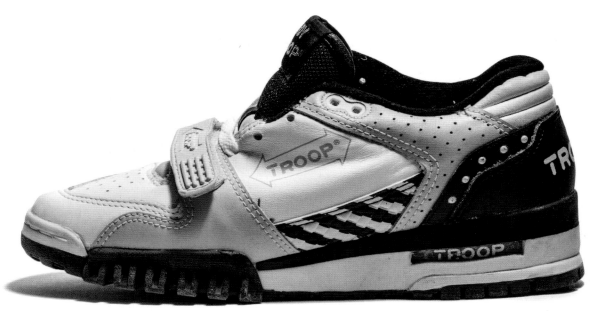

Troop Lady Cobra

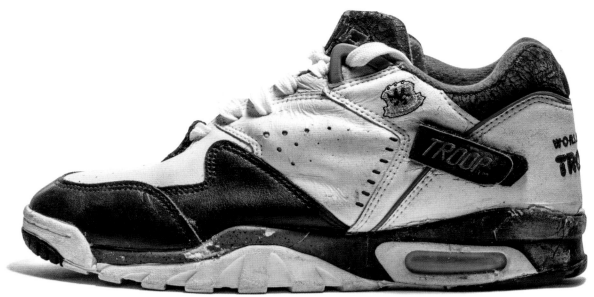

(Unknown Model)

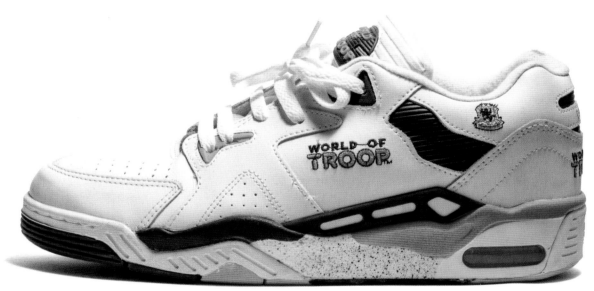

Troop Driver

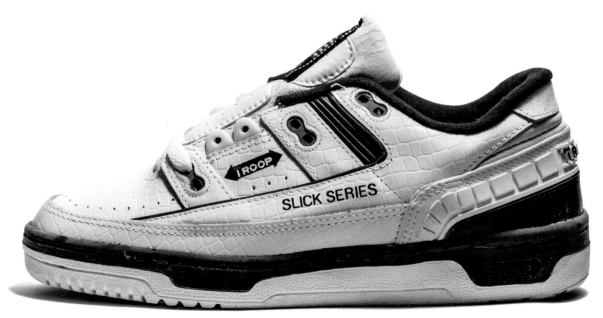

Troop Slick Series

Troop Flag Series

Troop Destroyer

Troop Power Slam Low

Troop Acid Tiger

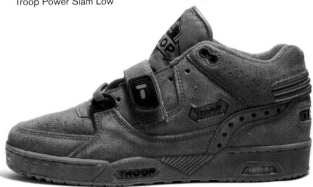

Troop Factor MC Low

Troop Major Low

Troop Cooling System

Troop ES Court

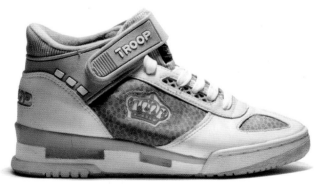

Troop Rapid Fire

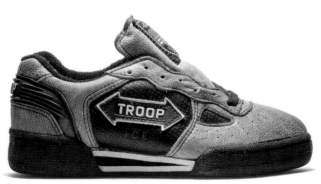

Troop Ice

Troop Supreme

Troop Smash

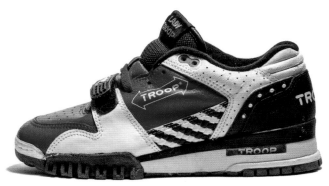

Troop Lady Cobra

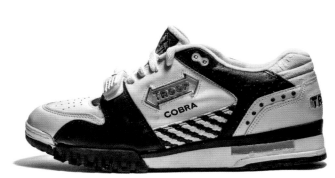

Troop Cobra Low

Troop Tracker

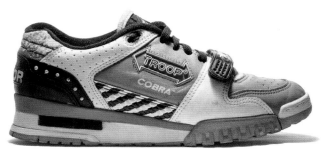

Troop Cobra Low

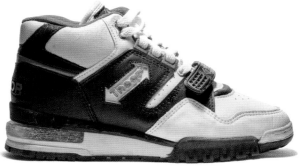

Troop Transporter

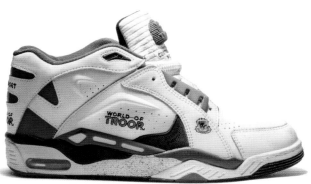

Troop Air Support

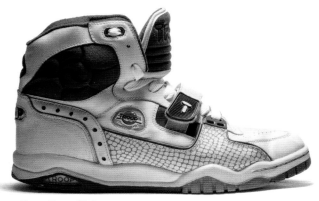

Troop Factor High

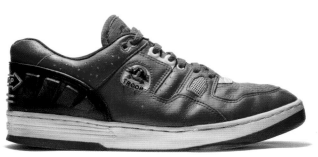

(Unknown Model)

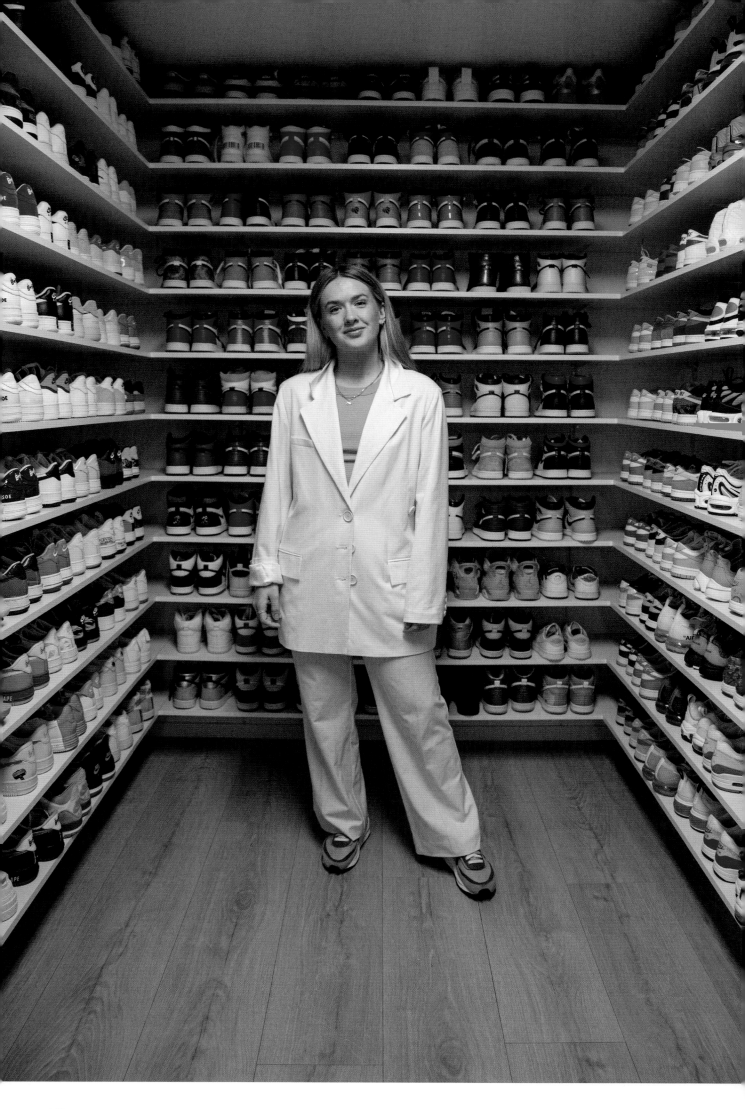

NORTHERN EXPOSURE

Hanna Helsø's artfully curated Instagram page documents her footwear obsession via daily updates brimming with wall-to-wall sneaker displays and kaleidoscopic fashion montages. From personalised BAPEs to Yeezy Slides and Air Force 1s, she's all in on the latest hype releases. And as demonstrated by the Jordan ink on her arm — and an Air Max inscription on the sole of her right foot — she's not afraid to wear her heart on her sleeve! Even more remarkable is her remote location. All this pint-sized heat had to be delivered to Stjørdal, a beautiful eight-hour drive from Norway's capital, Oslo.

Interview

WOODY

Images

AMUND JANSSEN

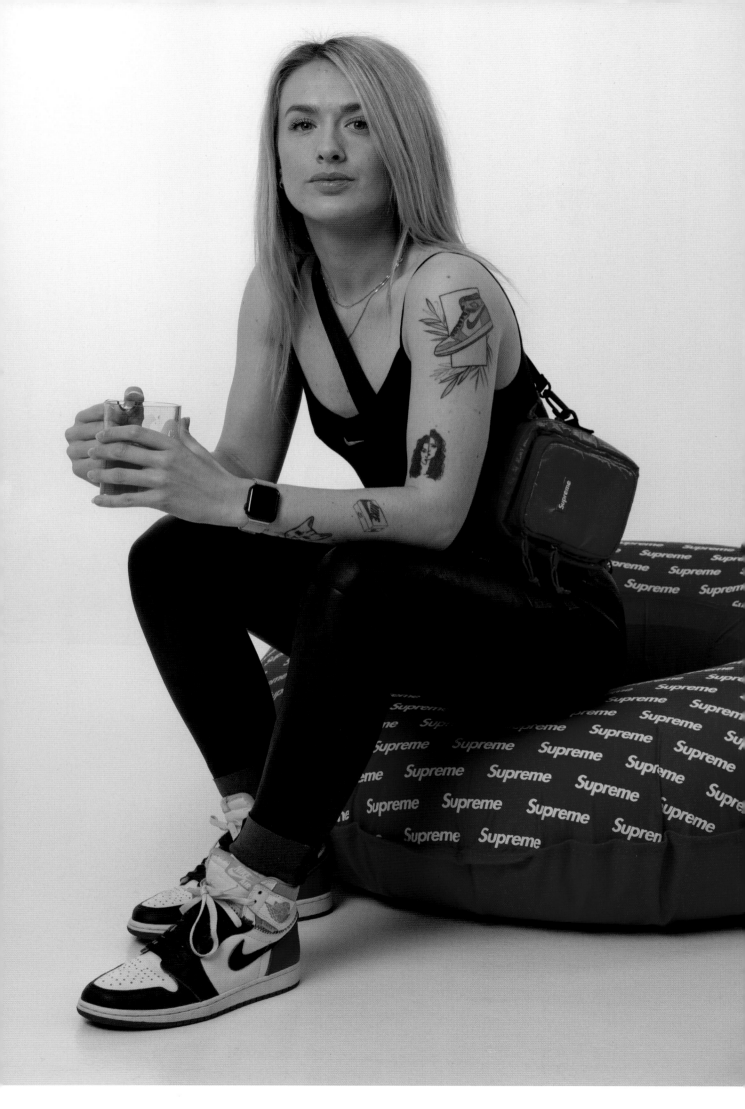

Hanna Helsø
New-School Collector
Norway

Norway is a beautiful place, but it's far from the heart of global sneaker culture. The community has grown a lot over the last couple of years, and it's fun to see local Facebook groups all of a sudden have 10,000 members. While our neighbours Sweden and Denmark are big in the fashion scene, we don't have many top boutiques here yet.

Besides that, Nike still haven't made SNKRS available in Norway, so the closest I've been to using the app are screenshots of everyone catching endless Ls. New Balance also don't ship from their own shop to Norway, so there's still a long way to go, even if the internet makes the world feel so much smaller.

I have a clear memory of when I got dragged into the crazy sneaker world. The coolest kids at my school all wore white Converse or Air Max 90s. I started searching the internet, ended up at Sneaker Freaker, and fell in love! I immediately understood that some pairs were harder to get your hands on, but that fear only inspired me to start searching.

With a little bit of luck, I got my hands on a women's exclusive Air Max. I felt a rush – like I managed to do something I didn't have the skills or knowledge to accomplish – and I loved it! But I didn't go crazy straight away.

I moved to another city when I was 16, and that's when the collection started to grow. Not having my parents over my shoulders made me prioritise money differently. I started off with some wall-hanging units, then moved over to IKEA's Billy bookshelf. In the end, I had five big and one small. Now I feel like the luckiest girl alive to have a proper sneaker room in my own house.

I don't even dare think about how many shoes I own. I once tried to put my collection into a portfolio to see the actual market value, but I gave up after adding around 200 pairs. All I can say is the numbers are scary.

Storage is, therefore, a never-ending problem. I love showcasing the collection in my house, but it's important to mention that I know it's not the best way to care for them. Best-case scenario is to double up – one to display and another deadstock in the box – but that causes other issues.

Sneaker boxes are a huge part of the appeal for me, and I don't ever want to get rid of them. Early on, I had the boxes in my loft, but now I have to rent a small warehouse. If anyone is inspired to display sneakers the way I do, be aware of the dust. I definitely clean my sneakers more often!

I started off displaying shoes sideways, but now they are toes-to-the-wall, which saves me a lot of space. Since I keep similar silhouettes grouped together, when a new pair turns up, I have to shuffle everything around to keep things in order. One more pair of Jordans will require a rotation of the whole closet!

I'm all about hype, but you can definitely find some older gems at my house. I used to love searching Norway's answer to eBay, but people are way more knowledgeable these days. A couple of years ago, I searched for 'Nike shoe' and found loads of older Dunks and a deadstock pair of pink Air Forces from 2005. Pro tip #1: to find good deals, you must go after people who have no idea what they're actually selling. I do search eBay as well, but it's harder to find steals these days. Recently, I managed to get my hands on a pair of deadstock Air Force 1s from 1999, so they're just one year younger than me.

I was about to say I only have shoes in my size, but that isn't entirely true. It's also important to say that my size can vary depending on how much I want the shoe! Normally I'm an EU38, but I also have EU39 to 40 as some releases don't offer smaller sizes.

Naming a favourite is the worst question to ask someone that loves sneakers. I think I'd have to say the Jordan 1 'Chicago' as it's a classic shoe with a lot of history. I would love to add an OG pair from 1985 to my collection, but for now, I'm more than happy with my 2015 edition.

My love for the Air Max 90 started a long time ago. I've always been aware of how I dressed – both clothes and shoes – but it was the Air Max 90 that opened up a new world. They are definitely a classic and will always have a special place in my heart. The 90 does seem to be quiet right now, but I know there will be some dope releases coming in the future.

I remember seeing Yeezy Slides for the first time and thinking Kanye had gone crazy. But honestly, I wear those slides way too much! The arrival of adidas Boost changed the game – definitely one of the more comfortable soles out there. The NMD was a big hit, and Kanye's Yeezy line was a must-have, but pushing out too many pairs and far too many re-releases has made them less attractive. Not every pair has to be exclusive, but I don't want to match shoes with every second person I meet.

My love for New Balance has grown a lot over the last couple of years. Chunky 'dad shoes' are a big hit with me, and they have been doing some very cool collaborations. The GANNI x New Balance 2002R warmed my Scandinavian heart.

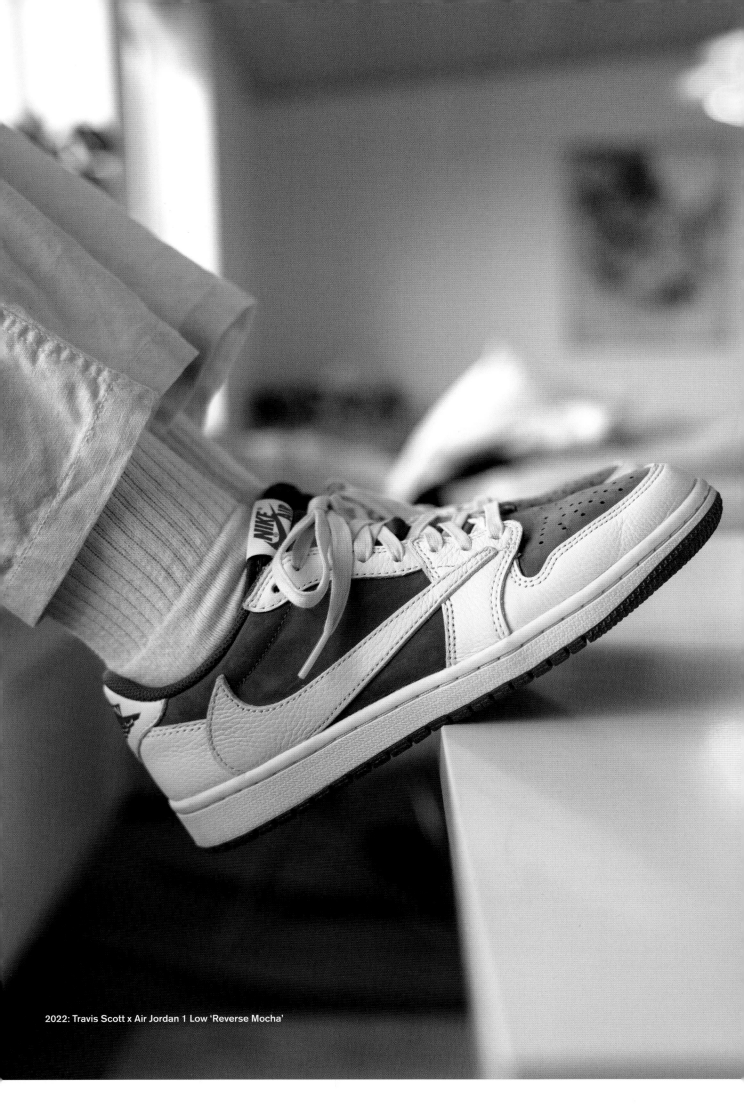

2022: Travis Scott x Air Jordan 1 Low 'Reverse Mocha'

2021: LEGO x adidas Superstar (Helsø Custom)

My personalised BAPE STAs are definitely a huge score. BAPE is a brand you can't find everywhere, especially in Norway. The pairs in my collection are the result of hours of online searching. I'm obsessed with the original shape, so only the older models work for me. My love was noticed, and I was honoured to receive some personalised BAPE shoes a while back. It was unreal looking around social media and spotting big names like DJ Khaled, Mayor and DJ Clark Kent receive their packages. And then me – Hanna Helsø from the small country of Norway! – getting the same pair with my own name on them!

The sneaker scene for women doesn't compare to how it was back in the day, and that's a huge improvement. We still have a long way to go, but I love seeing the female community grow every day. It's also lovely to see releases for ladies that men are a little jealous of – now they can see how we've been feeling for years! But yeah, there are still way too many releases that aren't produced in small sizes for women. We saw a lot more of the 'shrink it and pink it' options in previous years, but thankfully the brands are giving women way more respect now.

Speaking of which, my lovely pair of Travis Scott x Air Jordan 1 Low 'Reverse Mocha' is sadly two sizes too big. I'm pretty sure I'm not the only girl willing to wear an extra insole or thick pair of socks to squeeze into such a special pair. Too many releases, including this one, start at size EU40, which excludes a lot of females, but also boys with smaller feet. One final statement on the matter – can't we all just agree that sneakers should be unisex?

Recently, I've started to work with brands and retailers on campaigns, and I feel honoured for every opportunity. Living in the countryside of Norway doesn't always make logistics easy, but I've experienced some awesome things. Communicating on Instagram has long been my passion. The recognition in the sneaker game, as well as respect, has given me opportunities to go to the women's football World Cup with JD Sports and Nike, design my own LEGO x adidas Superstar and attend sneaker conventions like Crepe City.

Ultimately, I must highlight the huge campaign I did with Nike filming my own episode of *Outside the Box*. The Nike team flew to Norway to spend several days getting to know me better. They were probably very tired of me begging them for access to the SNKRS app in Norway!

After all this time, my appreciation of sneakers is still growing. Everything started for me by posting pictures on Instagram, and I'll continue spreading my love and knowledge. My dream is definitely to design my own sneaker one day, so I guess I'll just have to work my ass off and make that happen!

★

@helsoe

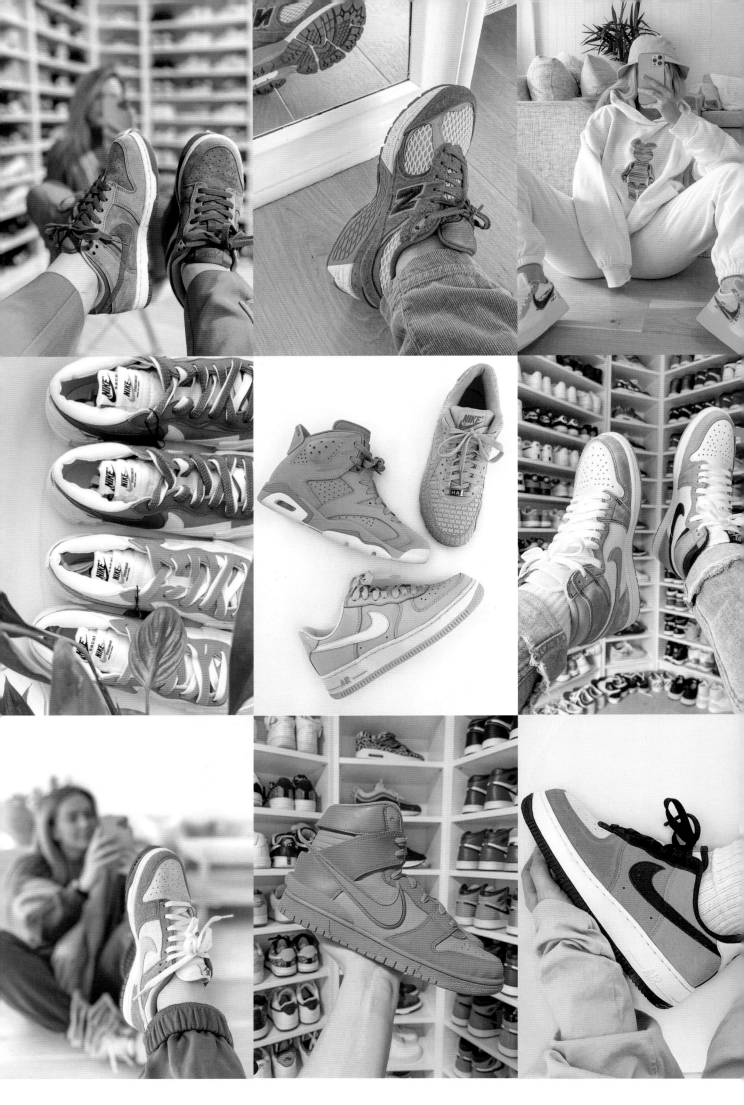

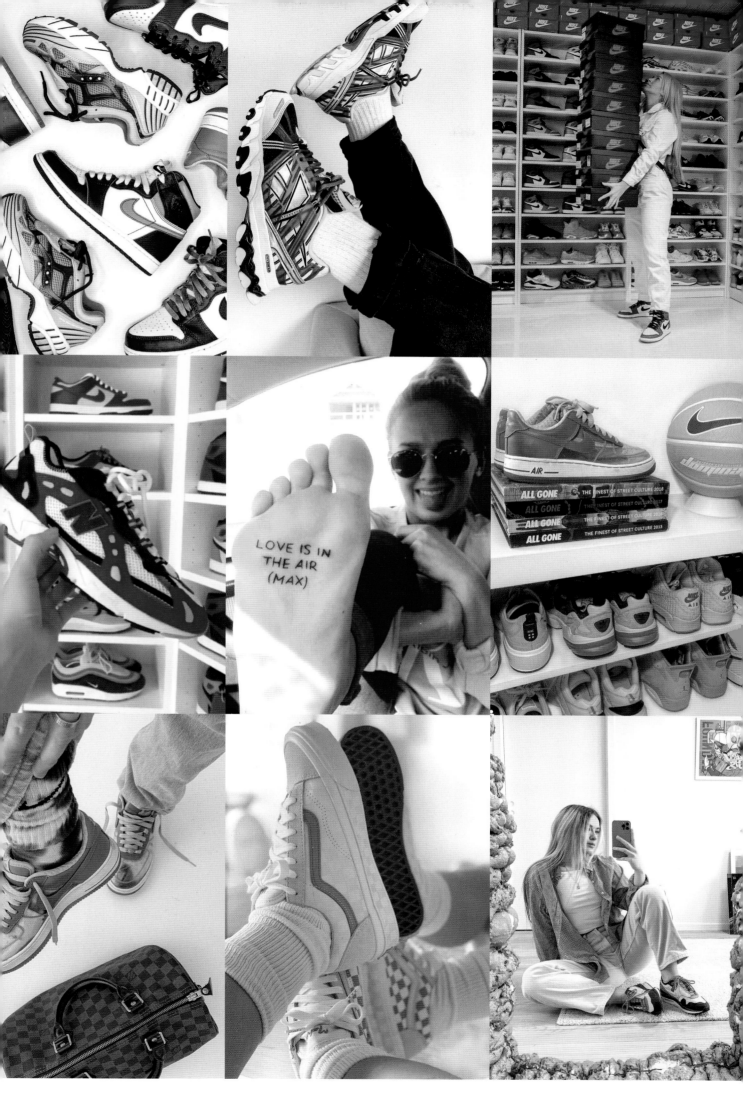

LOVE IS IN
THE AIR
(MAX)

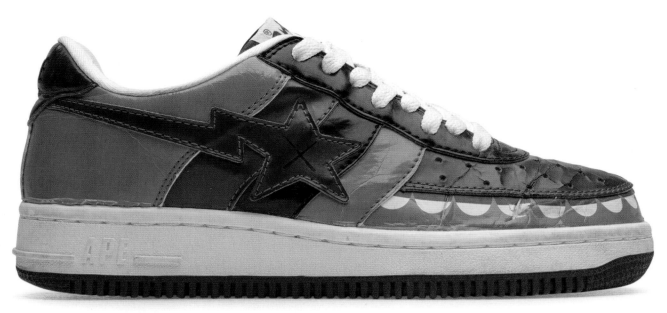

2006: KAWS x BAPE STA 'Chomper'

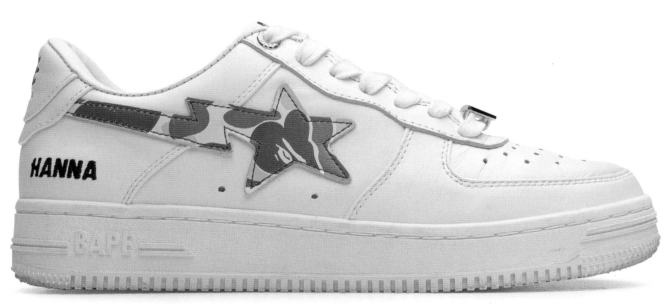

2021: BAPE STA 'ABC Camo'

2021: BAPE STA

2006: Marvel Comics x BAPE STA 'Thor'

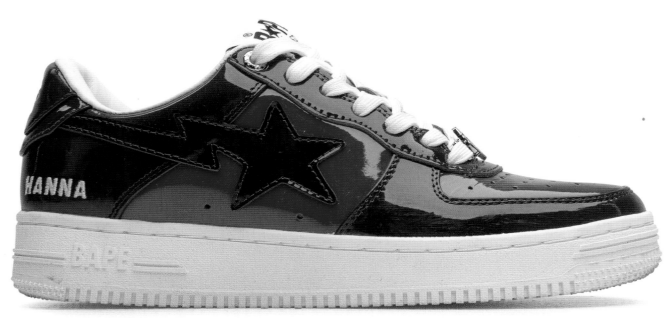

2021: BAPE STA 'Purple Patent'

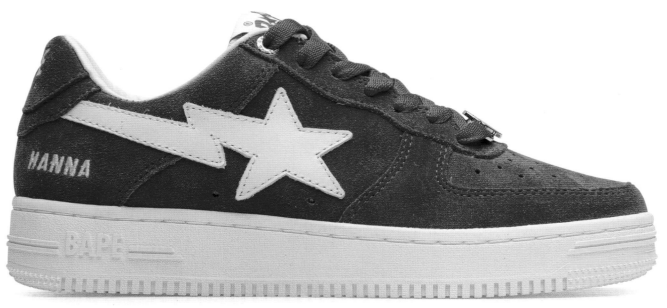

2021: BAPE STA 'Suede Pack'

2022: GANNI x New Balance 2002R

2022: JJJJound x New Balance 990v3 'Olive'

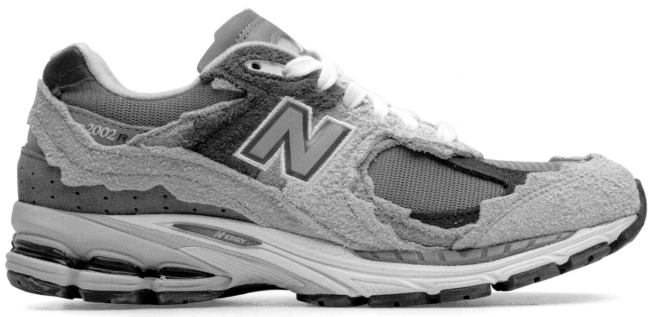

2021: New Balance 2002R 'Protection Pack' aka 'Refined Future'

2022: Yeezy Foam Runner 'Sulfur'

2017/2021: adidas Futurecraft 4D

2021: Yeezy Slide 'Green Glow'

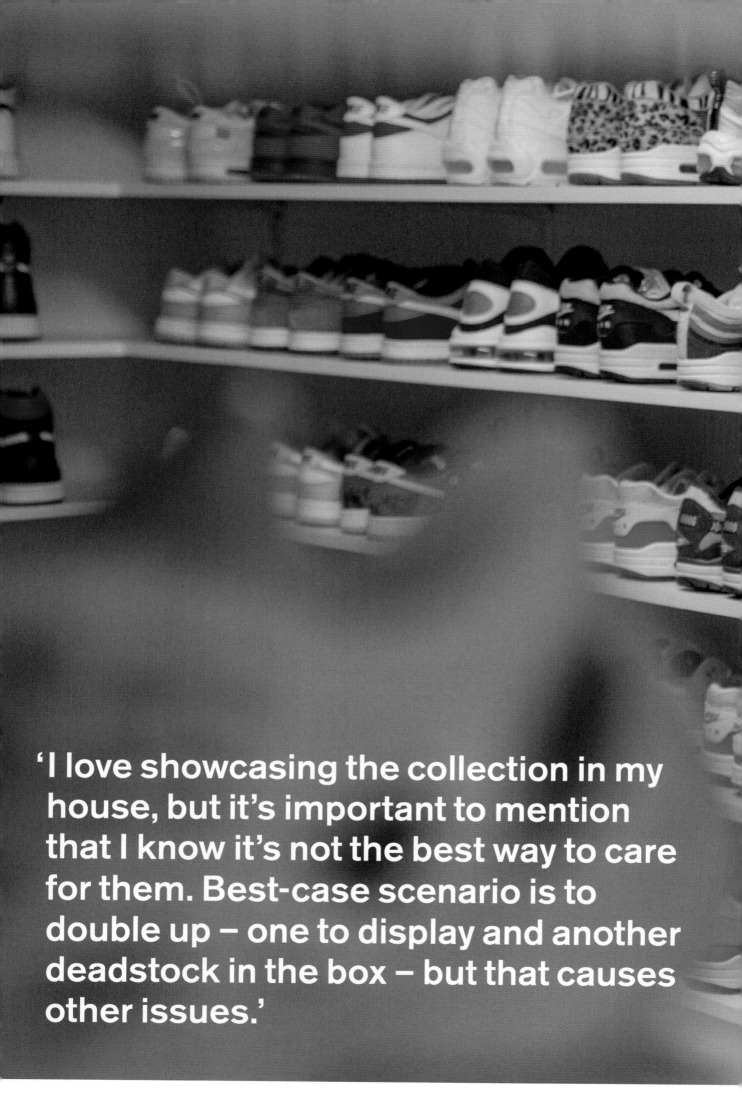

'I love showcasing the collection in my house, but it's important to mention that I know it's not the best way to care for them. Best-case scenario is to double up – one to display and another deadstock in the box – but that causes other issues.'

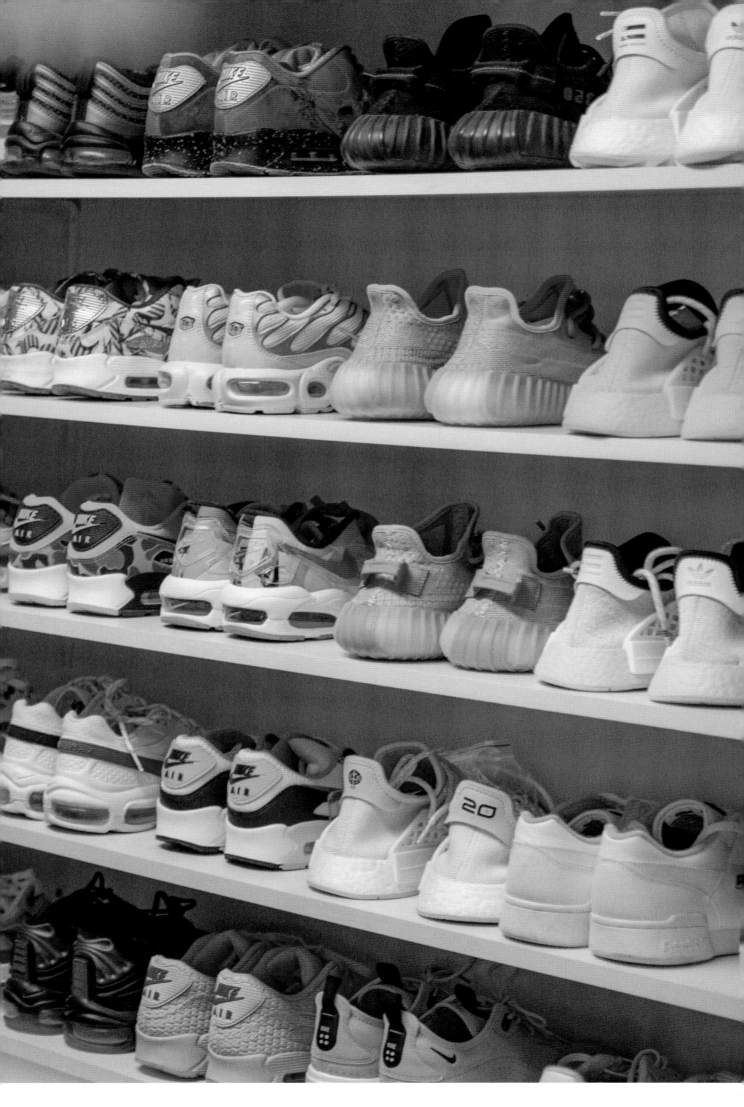

2017: Nike Air Max 97 'Silver Bullet'

2017: Sean Wotherspoon x Nike Air Max 1/97

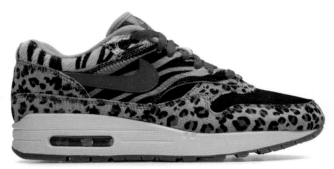

2018: atmos x Nike Air Max 1 'Animal 2.0'

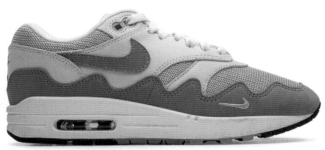

2021: Patta x Nike Air Max 1 'Monarch'

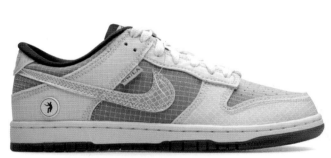

2022: Union x Nike Dunk Low 'Passport Pack'

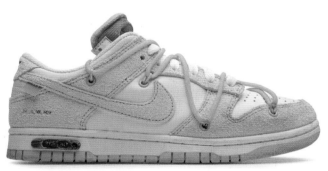

2021: Off-White x Nike Dunk Low 'Lot 31'

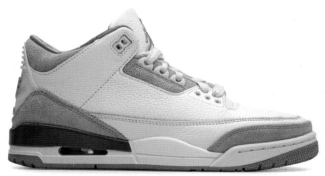

2021: A Ma Maniére x Air Jordan 3

2019: Nike Air Max 90 'Mars Landing'

2018: Off-White x Nike Air Presto 'Black'

2022: Travis Scott x Air Jordan 1 Low 'Reverse Mocha'

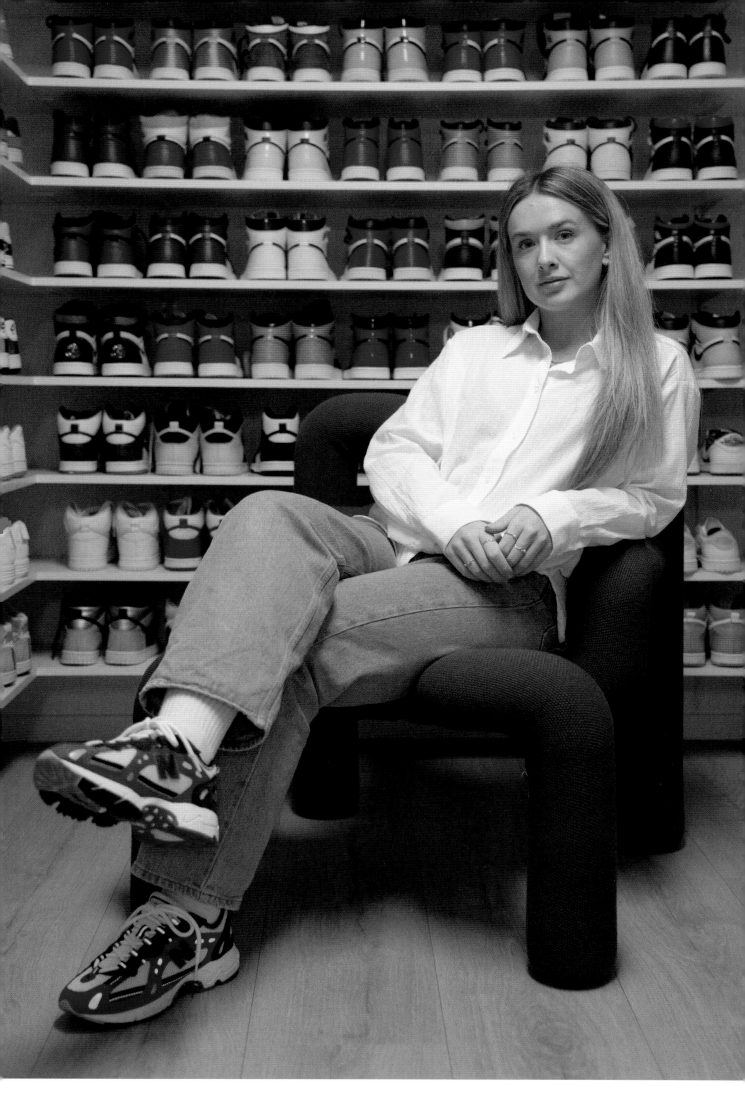

2020: PEACEMINUSONE x Nike Air Force 1 Low 'Para-Noise 2.0'

2006: Nike Air Force 1 Low 'Fantastic 4 Invisible Woman'

2019: PEACEMINUSONE x Nike Air Force 1 Low 'Para-Noise'

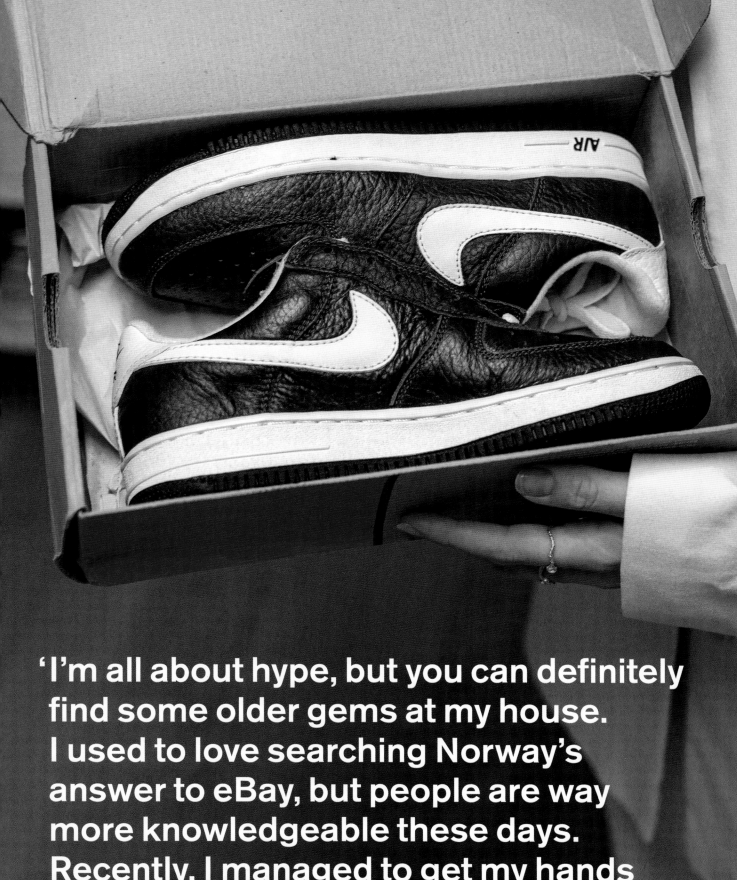

'I'm all about hype, but you can definitely find some older gems at my house. I used to love searching Norway's answer to eBay, but people are way more knowledgeable these days. Recently, I managed to get my hands on a pair of deadstock Air Force 1s from 1999, so they're just one year younger than me.'

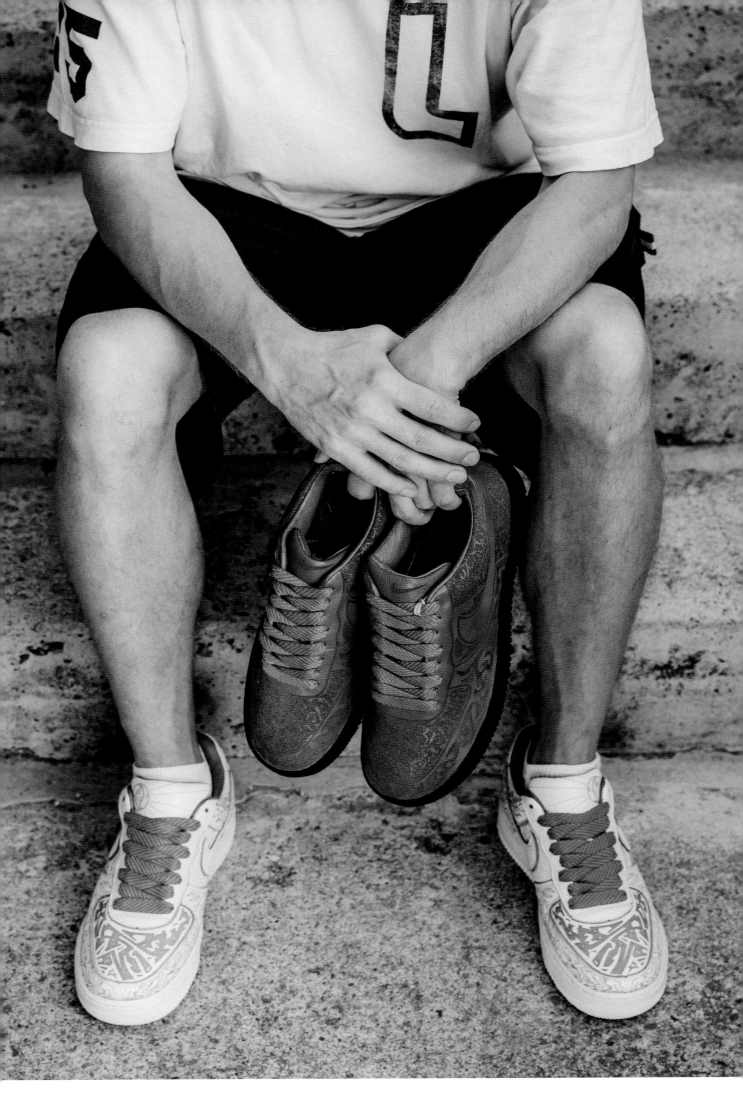

LASER
HAND-CRAFTED MASTERPIECES
QUEST

Curated by Mark Smith, Nike's Creative Director of Special Projects, the 'Laser Pack' was a collection of Swoosh staples laser-etched with unprecedented levels of detail. Each shoe was released in super-limited numbers and inspired by tribal tattoos, graffiti, hot rods or surf culture. Years later, these hand-crafted masterpieces have built a steady following, and prices have soared. We tracked down the mysterious Saint, who has been quietly hunting these rarities since they debuted in 2003, for a rundown on his impressive collection. Set your lasers to stun - these have flown under the radar... till now!

PHOTOS Runnerwally

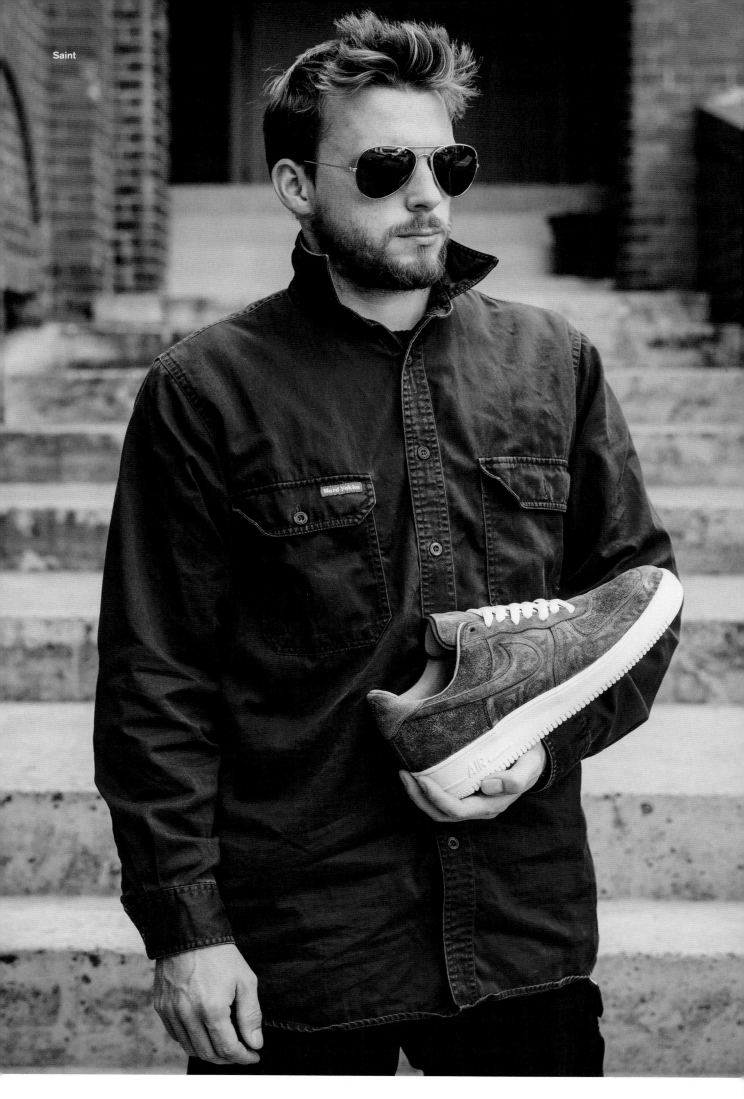

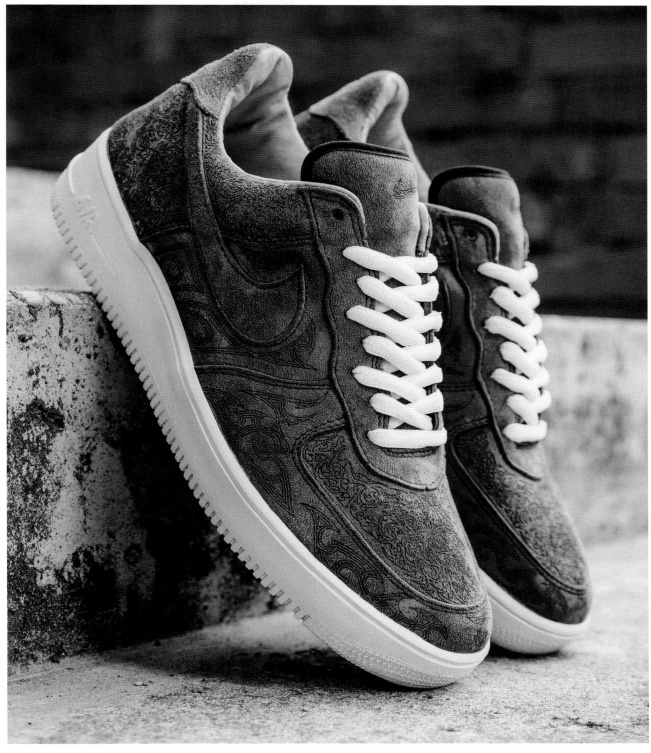

2003: Nike Air Force 1 Low 'Tattoo' by Mark Smith for Mark Parker (Former Nike CEO)

Hard to believe this Laser Series was released in 2003. Do you think they qualify as vintage by now?
I can't believe it's been that long. That means I am... getting old! [Laughs.] In my eyes, they're not vintage yet, but maybe the new generation of sneakerheads will look at them and think so.

Was it love at first sight, or did it grow on you? And at what point did you realise you were hooked?
I was at the Apartment Store in Berlin. There was a gallery upstairs where they showed the original samples, and I was immediately blown away and wanted them all, especially the white 'Maze Georges' Air Force 1s with the graffiti and the skyline on the side. Pure heat. And they were my size too!

I was only able to get the Celtic 'Luedecke' Cortez from the original release, but my interest was there for the rest as well. I just needed

the money and the connections to find them. It wasn't such an easy task because they were exclusively released in super-limited numbers in Berlin, Los Angeles, Tokyo, Sydney, Paris and New York. A couple of years after the release, I came across a sample pair while I was travelling, and two years later, I decided to buy that very same pair, which is when the obsession officially began.

Laser was launched at a party in New York with the usual industry types in attendance. Do you have any shoes from that night that were given only to Friends & Family guests?
I have about six or seven from that night, though there are two pairs I'm not really sure about. The exclusivity of the collection means that details can be hard to ascertain. All in all, I have around 15 samples from the Laser series, including 10 Air Force 1s, four Dunks and a Cortez.

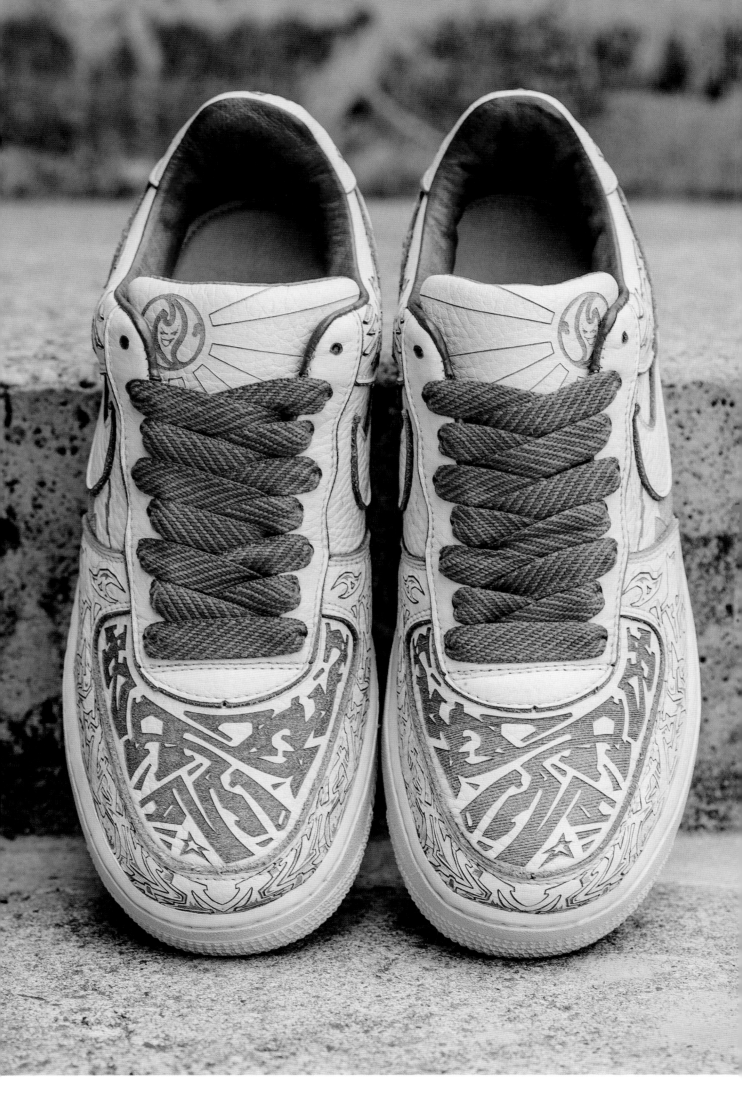

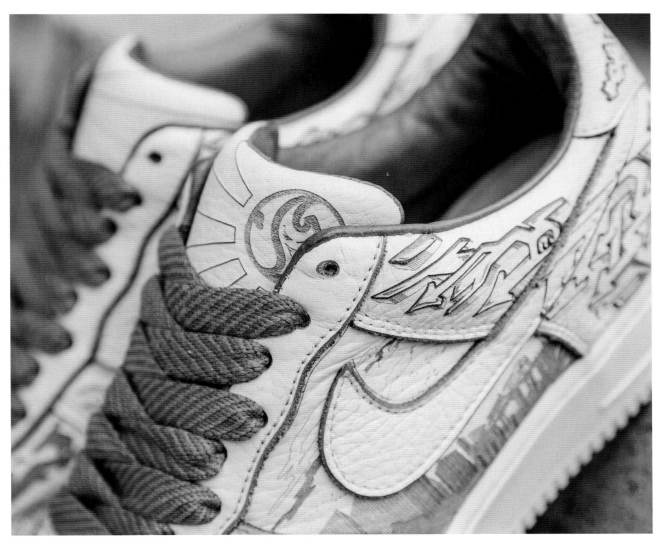

2003: Nike Air Force 1 Low 'Graf' by Stephan 'Maze' Georges (Sample)

How did the numbering work?

All the shoes from the opening night were numbered, as well as the versions that were released afterwards. For the opening night, they made 10 pairs of each model, which are all different colours and feature unique lasering techniques. They came in a chunky leather box with a dustbag, hangtags and a second pair of laces. The general release was numbered, too, but they made 200 pairs of each. The number on the insole tells you which pair it is, and the 'laser flame' hangtag reflects the size. They came in a slide-out box wrapped in cloth. Pretty dope packaging back then – it's a really solid unit.

Is this the kind of thing where you could ever hope to own the full set?

It takes quite a bit of detective work and a lot of luck as well… well, more luck, actually. [Laughs.] A full set of all the samples would be amazing, but I am not a millionaire, and I don't even know where they all are. There must be around 100 pairs in total. I am still trying to track down more photos from the gallery event and other places the collection was shown to document all the different Laser shoes that were produced. I have a full set of the general release, but even some of those took me a long, long time to find – especially for a decent price.

Some samples were handmade at Beaverton in Nike's Innovation Kitchen, and we know there are quite a few 1-of-1s by Mark Smith floating about. Do you have any of those special editions that were never sold at retail?

Yes, quite a few. I have a number of 'Mark Smith' AF-1 samples, as well as a Cortez. I have a 'Mike Desmond' sample from the gallery opening and a 'Chris Lundy' Dunk in an unseen colourway. I am missing the 'Luedecke' sample. I also have a seamless AF-1 in grey with 'BEE' lasered on the back. They are an amazing pair that came in a lasered leather dustbag, though I'm not sure who they were made for.

I'm sure somebody must know who 'BEE' is. There's no question who those black one-piece 'Saint' Dunks were made for, though. What's the deal?

Back in 2005, I travelled to Hong Kong to take a look at the sneaker scene there. It was pretty amazing. I managed to find a couple of never-before-seen Hyperstrikes and samples. Two years later, for my birthday, I went back to Hong Kong and bought one of those very same pairs, my very first pair of sample 'Mark Smith' Laser AF-1s.

I was a little cautious about whether they were the real deal as I had learned some hard lessons before, so I thought I should do a bit of research. I got in touch with the man himself, Mark Smith, and thankfully he confirmed their authenticity. He then asked if I'd be interested in a 'real 1-of-1'. Of course I said yes! Three weeks later, I received this amazing pair of 'Tuxedo' Dunks. He had laser-etched my name into the sides but even more amazing than that, if you flip them upside down, it reads 'Saint', which is my online nickname. They're a crazy pair to wear and hold a very special place in my collection.

The 'Entourage' Air Force 1s have to be the most hyped of all Lasers, especially the gold pair made for Jerry Ferrara's character on the show. I should have jumped on them when I had the buy-it-now chance for the golden pair. I have to say I'm not a big fan of the light blue pair, though.

Speaking of blue, that Smurf-looking pair of AF-1s really caught our eye. The Laser pack was known for using muted, earthy tones, so what's the real story behind them?

That pair holds a really special place in my collection. They were made by Mark Smith for Nike CEO Mark Parker and date back to a very early stage in development. They have a written inscription with the date '01.30.2003'. I call the colour 'royal blue', fit for the king of Nike! They're a bit different from to the shoes made towards the

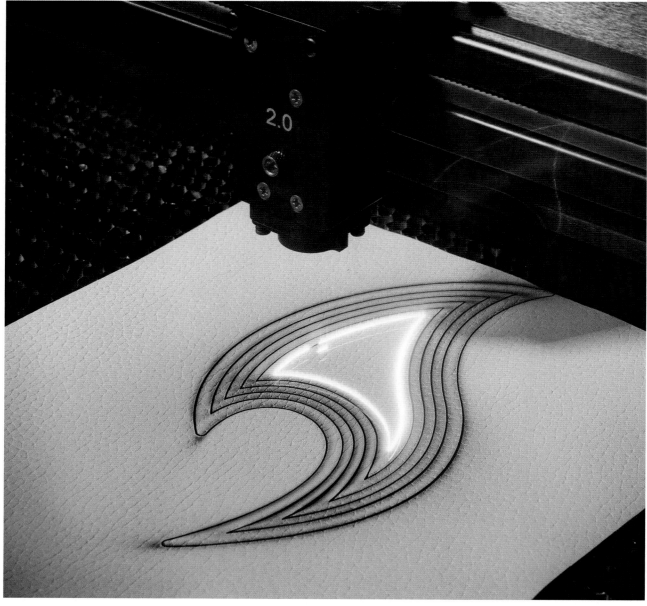

2003: Original Nike Laser press-kit image

end of the project. It's not a one-piece like the others – the leather is silky smooth on the inside, and the upper is nubuck with white oval laces. You can see that all the small pieces from the shoe have been lasered out of one big piece. Amazing detailing. Another difference is that the lasering is line-burn, not solid-burn like on the later pairs.

Dunks, AF-1s and Cortez were the main canvas for Laser, but you have what looks like a pair of Nike SB URLs. What's up with those?
That's the 'Tattoo' Zoom Terra made by Katsuya Terada. They were released in 2005, not too long after the original Laser Series. They feature some phenomenal laser detailing inspired by traditional Japanese illustration. I have the full image on a poster, and it's pretty wild. The shoes came in this crazy laser-etched wooden box and were limited to only about 200 or 250 pairs in the world – maybe even less.

We can't even imagine how hard it was to get all the Laser promo gear. Are you up against other big-time collectors?
I was lucky. No one ever really noticed until a few years ago, and when I finally found them, they came with lasered cards, which I didn't know even existed. The foam pieces were up for auction with the book and a pair of Mark Smith AF-1s, I just asked for them, and the guy later decided to sell them separately to me, which was pure luck!

eBay prices at the moment are totally nuts. People are asking serious amounts of money. I don't even know where in their imagination they get their prices from.

I've seen a couple of large Laser collections with the first- and second-generation shoes, but they don't have all the super impossible-to-get samples I've collected. There are a number of pairs that have disappeared or still remain unearthed, so I think there is definitely someone else collecting big-time out there. The other pairs are with AF-1 collectors or with friends of Nike who likely don't know or care what they have. [Laughs.]

Our favourite from an artistic point of view is the 'Chris Lundy' Dunk, which has the waves down the side of the shoe. Is the context of the artwork integral to your appreciation of the shoe, or are they all equal in your eyes as a collector?
They come from different artists working in different fields, and once you try to get the story behind them, you will widen your perspective and dig into their heritage.

Nowadays, I appreciate them all equally, but back when I started collecting the Laser pack, the Graffiti editions by Stephan 'Maze' Georges were the shoes that really turned me on. They are works of art made with true craftsmanship. You have to 'look into another box', as Mark Smith loves to say, because that's where the inspiration comes from.

All those little details and meanings of the words and pictures they used are what make them the best shoes Nike have ever crafted. The only other collection to come close would be the Nikes produced for the *White Dunk* exhibition in 2004.

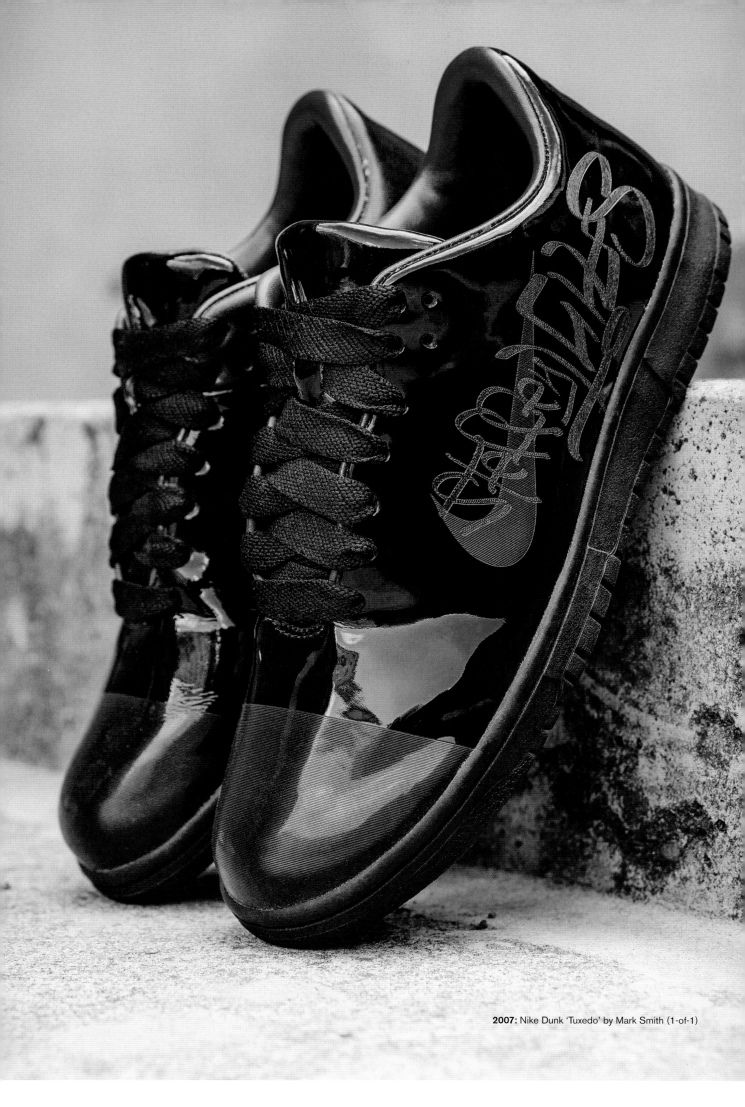

2007: Nike Dunk 'Tuxedo' by Mark Smith (1-of-1)

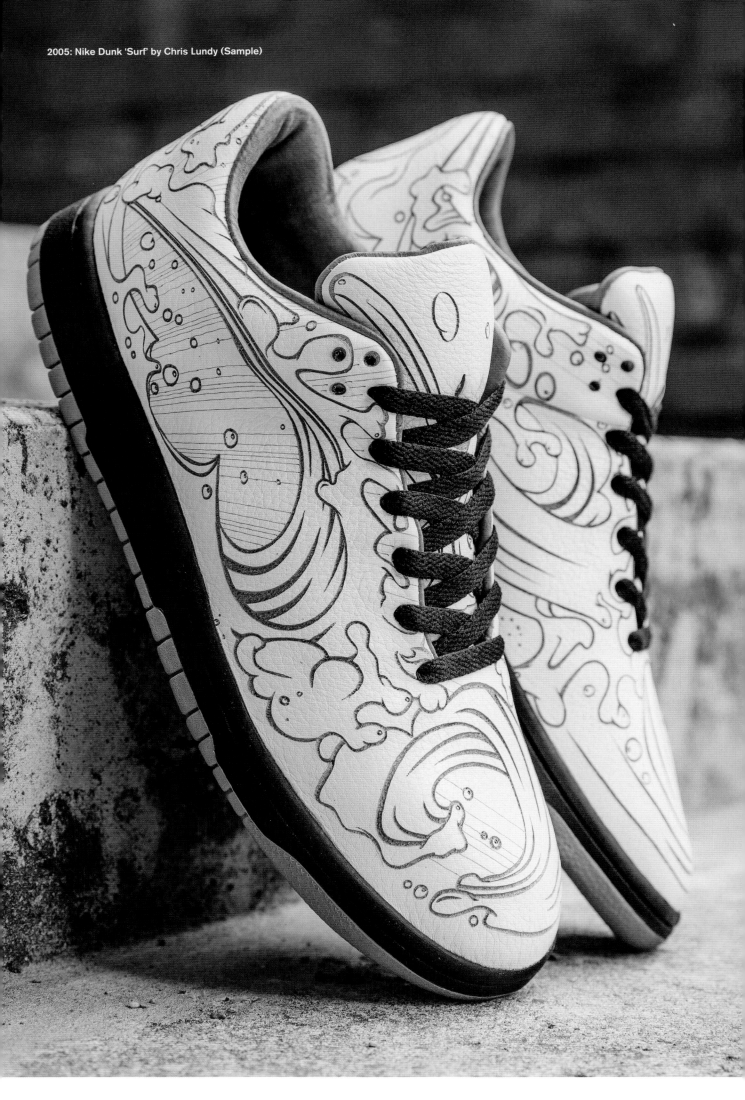

2003: Nike Dunk 'Hotrod' by Michael Desmond (Friends & Family)

The designs really seem to share a lot in common visually with tattoo artwork. Any temptation to mark your own skin with one of the designs?

It makes sense when you find out that the inspiration comes from Maori tattoos and Celtic artwork. I seriously thought about it, but I'd like to keep my body as a blank canvas for now – though you never know. The most interesting thing to get would be the filigree face from the Mark Smith shoes. But why get tattooed when you can get it on your clothing?

Mark Smith told us back in the day that the shoes were lined with soft leather and were perfectly fine with no socks. Do you wear any of them?

I doubled up on a few pairs from the first release, so most of the time, you'll see me wearing them, mainly the Cortez. They are really comfortable and look amazing on foot. I prefer socks as the leather will stick to your feet. The samples stay in their boxes, though – they just come out when I try them on at home in front of the mirror. Most are not even my size. I know some people will say, 'Wear your shit!' but hey, these are the only ones of their kind in the world.

Do you think Nike should retro the Laser pack?

Hell no! It would destroy the whole original collection, and with the quality Nike are producing at the moment, it would destroy it even more. Some things are better left untouched. In my opinion, they already overdid it on the Jordans, though maybe it's just me getting old. Nike are doing a good job developing new technology like Flyknit, Fuse and all the top running gear. The Innovation Kitchen will bring us some new heat in the next decade, so there won't be much time to dig into the past, hopefully.

Do you have a Grail still on your hit list?

No, my Holy Grail is officially off the list! It was the white pair of 'Maze' Air Force 1s. I finally got them a few years ago after seven years of hunting, and the best thing is that they're my size. But that doesn't mean I'm finished collecting. There are heaps of shoes out there that I still want – especially a certain pair of Jordan 3 lowtops that I know Woody (*Sneaker Freaker* Editor-in-Chief) has in his collection. Time and patience will lead them to me!

★

@Saint_5aint

Nike Air Force 1 'Tattoo' by Mark Smith (Sample)

2003: Nike Air Force 1 'Graf' by Stephen Maze Georges
(Friends & Family)

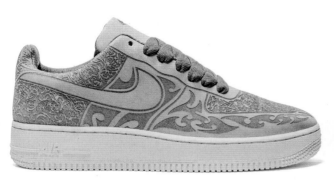

2003: Nike Air Force 1 'Tattoo' by Mark Smith (First Release)

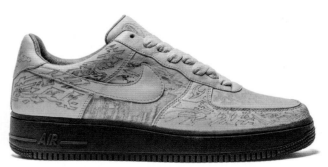

2003: Nike Air Force 1 'Graf' by Stephen Maze Georges
(First Release)

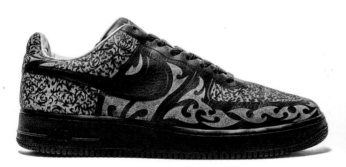

2003: Nike Air Force 1 'Tattoo' by Mark Smith (Friends & Family)

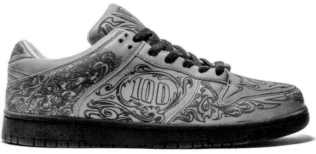

2003: Nike Dunk 'Hotrod' by Michael Desmond (Friends & Family)

2005: Nike Zoom Terra 'Tattoo' by Katsuya Terada

2003: Nike Cortez 'Celtic' by Tom Luedecke

Nike Air Force 1 Low One-piece (BEE)

2005: Nike Cortez 'Mayan' by Mark Smith (Sample)

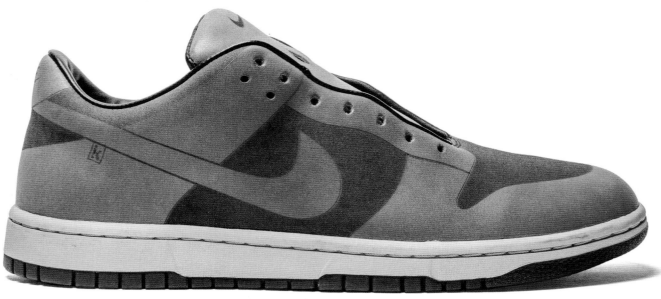

2004: Nike Dunk one-piece from the Innovation Kitchen (Development Sample)

SOCK
-A-
KNEE

SERGEY VETROV

With 650 pairs in his monumental collection and multiple Saucony-inspired tattoos, Sergey Vetrov is literally the brand's most decorated fan. We caught up with Vetrov at his home in Moscow, where he took us on a personal tour of his decades-long obsession. In his own words, 'Saucony is not for everyone, but that's just the way I like it.'

PHOTOGRAPHY: MARIA GARIBIAN @marygariba & NIKITA MOSKALENKO @moskalenko.nikita

Sergey Vetrov
Saucony Specialist
Russia

The first time I heard about Saucony was back in the early 90s. A friend of mine was involved in black-market business with foreign tourists. He used the dollars he earned to buy Levi's jeans, baseball caps, sunglasses and, of course, cool sneakers. Out of all the brands, I liked Saucony most of all.

I bought my first legit Sauconys from a sports shop in Moscow in 1995. I wore those GRID and Fastpack sneaks every day until they developed holes in the soles. I wanted fresh pairs, of course, but the store never imported any new styles. Years later, a friend went to live in America and sent me some Jazz Originals, which I wore with great pleasure.

The start of my serious collection dates back to 2012. Today, I have more than 650 pairs of Saucony collaborations, limited editions, premium packs and vintage pairs. The high cost of shipping to Russia has made things challenging, but my biggest problem right now is that I have acquired almost everything Saucony has ever made. There's just not much left out there for me to hunt down!

I recently gathered 448 pairs of Saucony and made a video for my new project, an interactive museum based on my collection. It will tell the history of each pair and my love for the brand. Right now, I'm looking for investors to help complete the project.

I got my first Saucony tattoo in 2015. On my left foot, I added the Saucony Elite logo, which turned out very cool. The right leg was jealous, so I added the Foot Patrol 'Only In Soho' collaboration, along with the BBQ and mayonnaise sauce packets from END.'s 'Burger' collaboration. In 2018, I added the Saucony 'foot with wings' logo just under my knee. I also have the 'Only In Soho' logo and Acht Amsterdam's logo under my other knee. A Jazz Originals burger is tattooed on my ribs, which was quite painful.

There are many, many favourites in my collection, but the White Mountaineering collaboration from 2014 is my all-time greatest pair. I love the milky monochrome colour scheme. The minimal branding is very cool, and the materials are superb.

I also have many obscure pairs, such as the Rare Breed 'Scoops' Shadow collaboration. I also have the Acht Amsterdam 'Gemini 8' GRID 9000, which was inspired by NASA but never released. In January 2016, my Saucony tattoos actually helped me secure a pair of 'Invictus' from Philip, the founder of Acht. Many people wanted them, but my tatts were evidence of my dedication to the Saucony cause!

The rollerskates are the most popular vintage item in my collection. They really are show-stoppers. I think they were made in about 1980. There are some rumours that Saucony are going to make them again. If so, I will be very happy! Another vintage pair I love is the Cross Sport, which I purchased from a big-time Russian collector. I think they date back to about 2000. The colours are really bright, and the materials are unusual. They are so beautiful. Saucony was really into conducting interesting experiments at that time. I like the style of this pair a lot.

I bought the Master Courts from a Japanese auction. They are another highly surprising pair. Saucony's skateboard shoes are very underrated, as are the models they make exclusively for the local Japanese market. This pair does look a lot like another famous shoe, but I still regard them highly, and it was super good luck to find this pair.

In the 1990s, Saucony were real trendsetters, especially with all the variations in GRID technology. I would like to see the brand return a few models from that era, like the GRID VANG, Wincyon, Fastpack and Jazz Court. The GRID Shadow ST is a very cool vintage pair that is the quintessence of sports, technology, convenience and lifestyle. I would love to wear them now. The GRID Web is another shoe I'm excited to see return in 2019. It still looks very modern all these years later.

As you can tell, Saucony is my great passion in life. For me, it's like a private club where the community is strong and very tight-knit. The sense of originality and the brand's deep heritage is inspirational. When people find out I'm a crazy sneaker collector, they think it's cool, but when they find out I collect only Saucony, sometimes they're confused, though I'm never upset by this reaction. I totally get it. Saucony is not for everyone, but that's just the way I like it.

★

@veter032
@russiansauconyteam

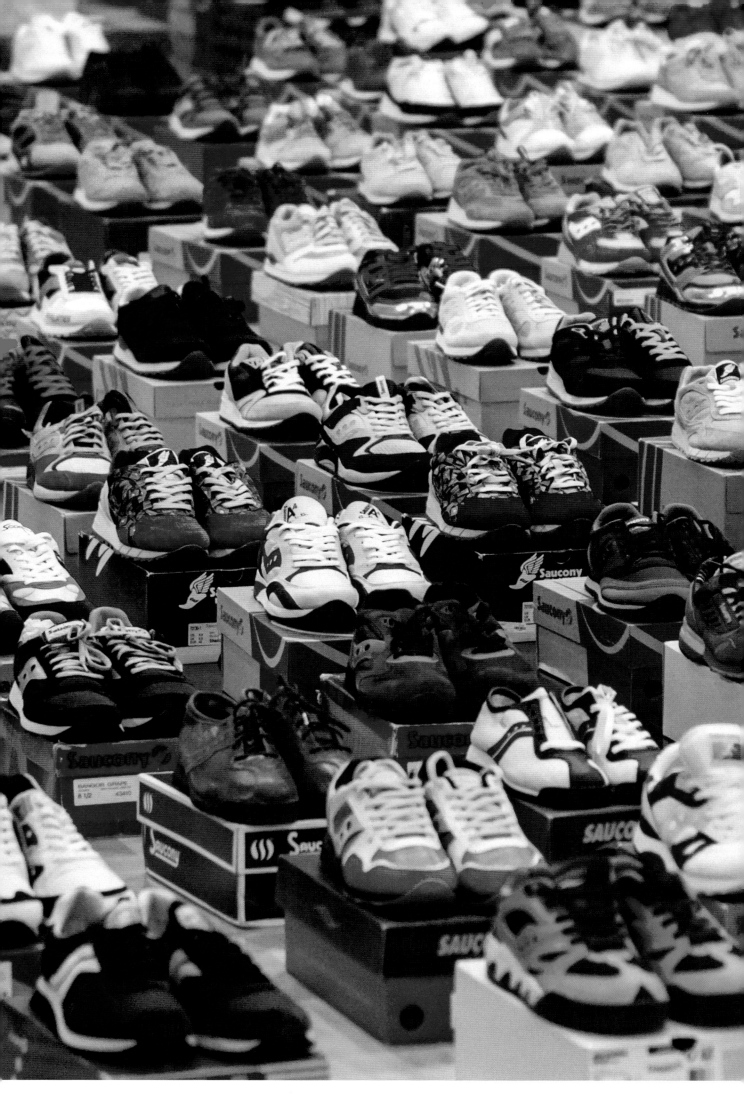

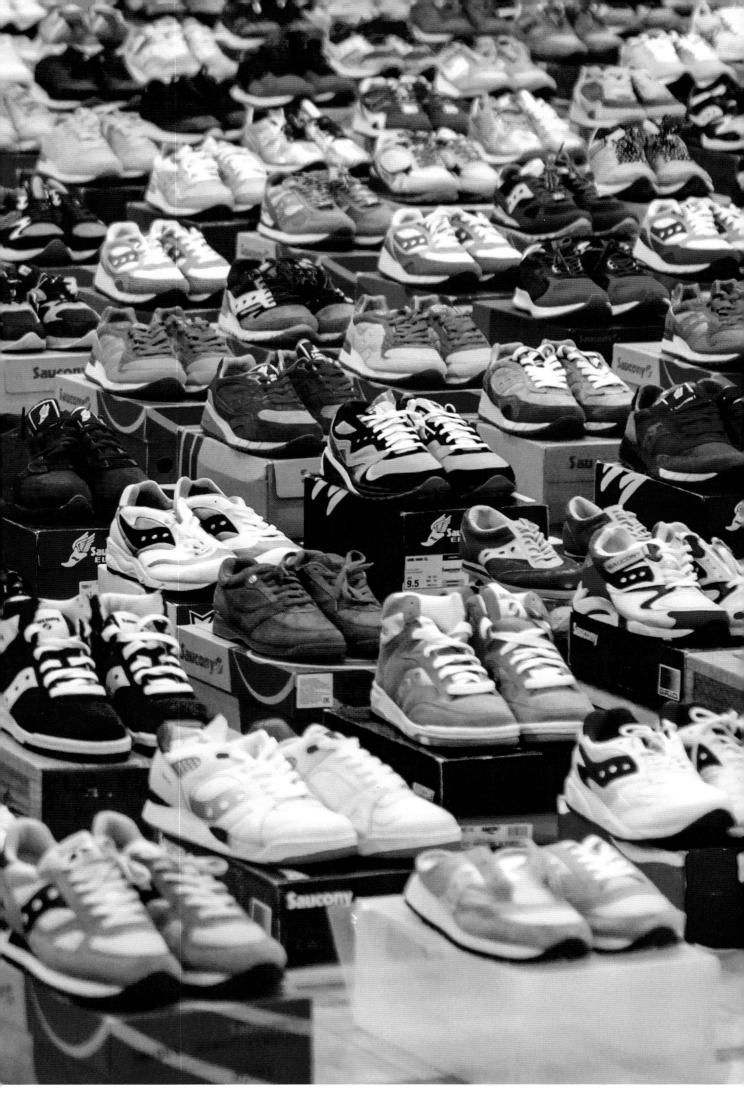

1993: Saucony International Control

2003: Saucony Hangtime Low 'Pony'

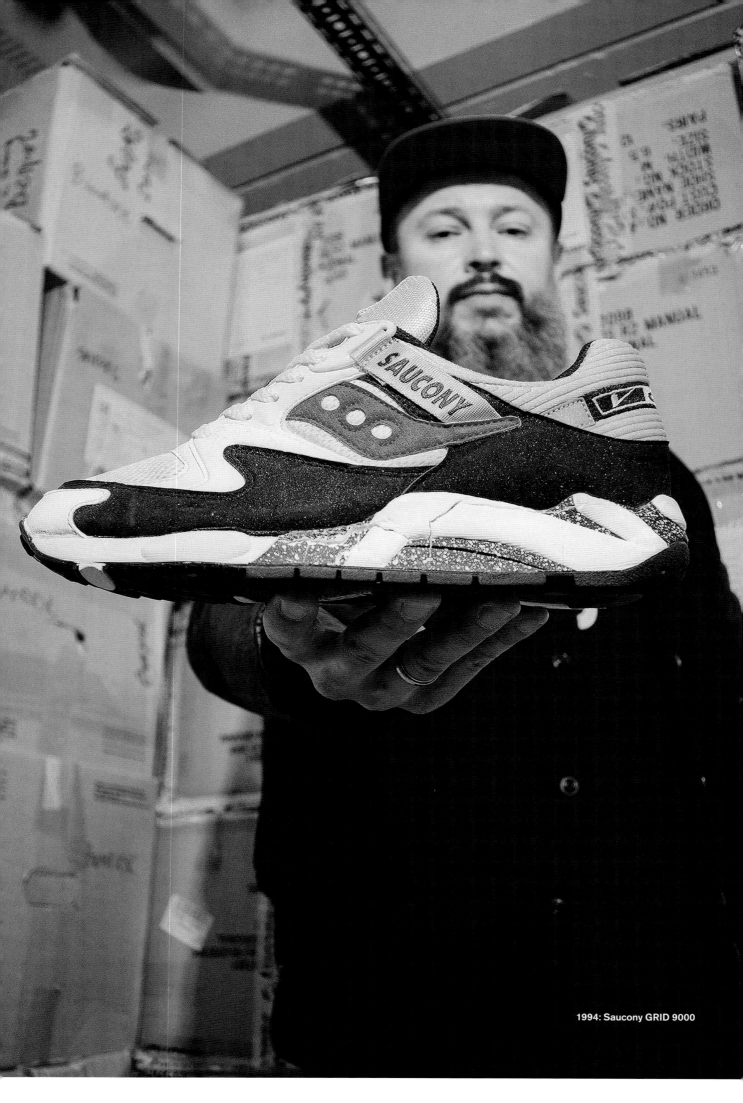

1994: Saucony GRID 9000

'The rollerskates are the most popular vintage item in my collection. They really are show-stoppers. I think they were made in about 1980. There are some rumours that Saucony are going to make them again. If so, I will be very happy!'

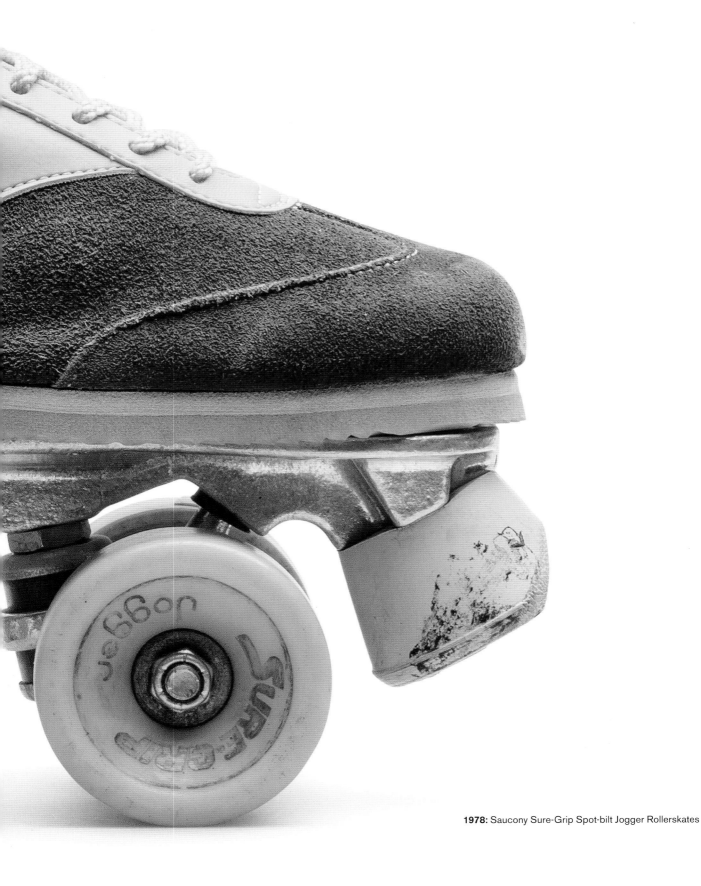

1978: Saucony Sure-Grip Spot-bilt Jogger Rollerskates

1991: Saucony Crosswave (Made in USA)

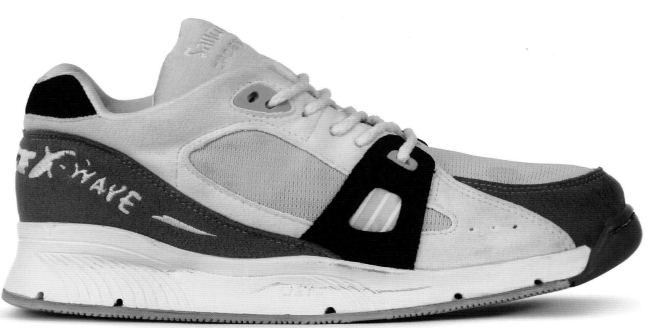

1991: Saucony Crosswave (Made in USA)

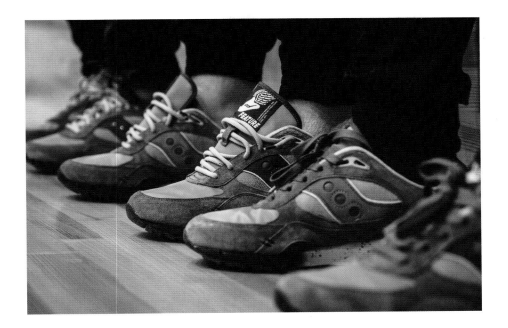

2018: Feature x Saucony Shadow 6000 'Living Fossil'

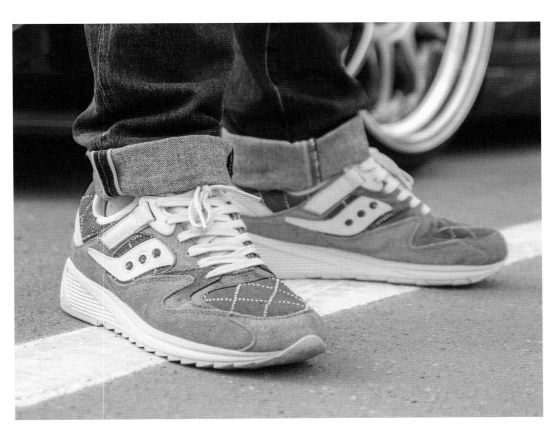

2017: Saucony GRID 8500 MD Denim Pack 'Blue Denim'

'The start of my serious collection dates back to 2012. Today, I have more than 650 pairs of Saucony collaborations, limited editions, premium packs and vintage pairs. The high cost of shipping to Russia has made things challenging, but my biggest problem right now is that I have acquired almost everything Saucony has ever made. There's just not much left out there for me to hunt down!'

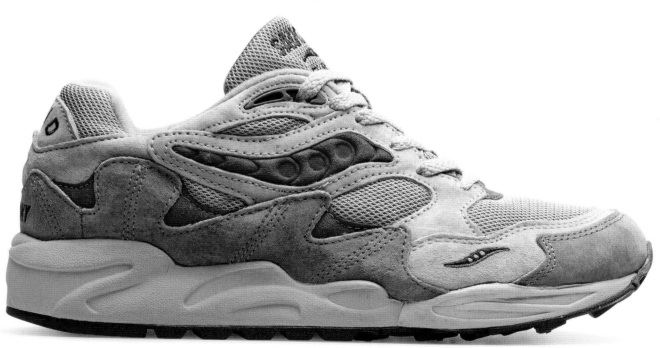

1997: Saucony GRID Shadow SL

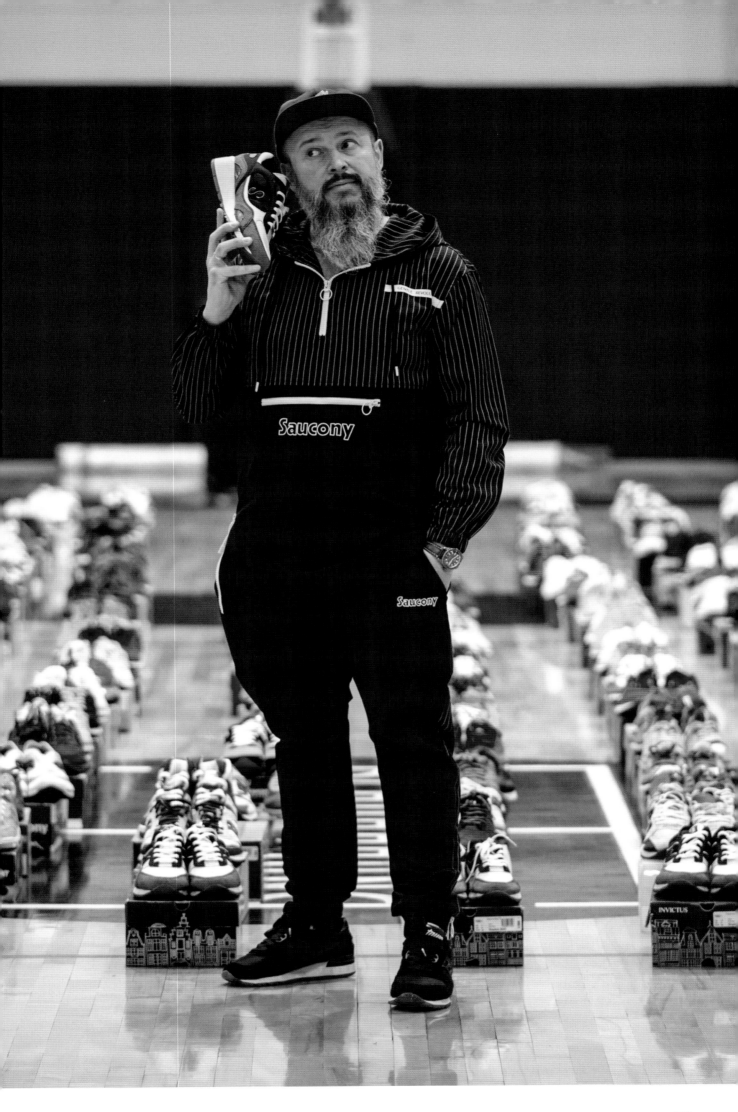

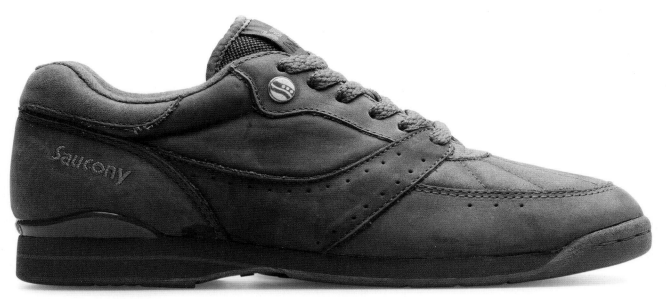

1995: Saucony Instep 6200

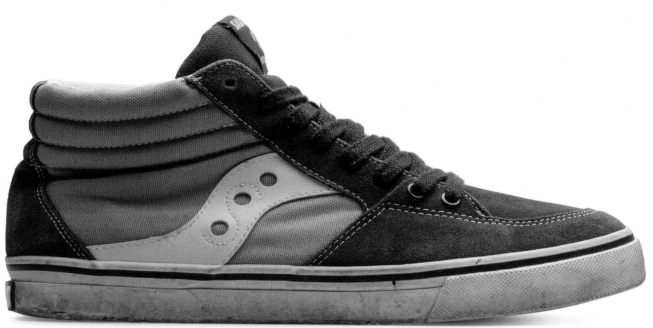

2006: Saucony Master Court (Japan)

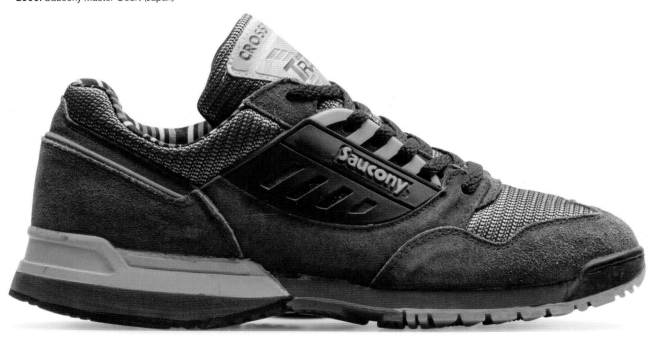

1991: Saucony Crossport Crosstrail LC

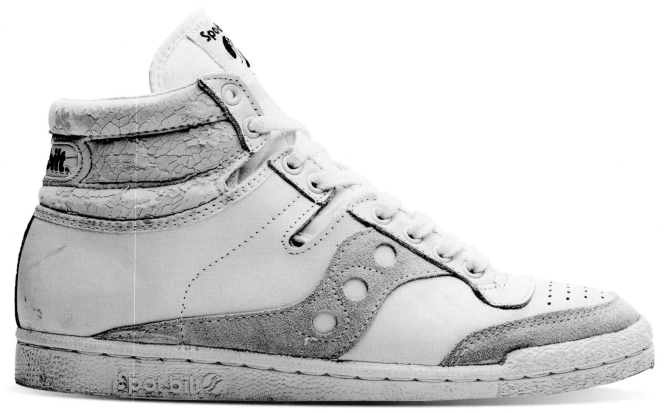

1984: Saucony Spot-bilt Basketball

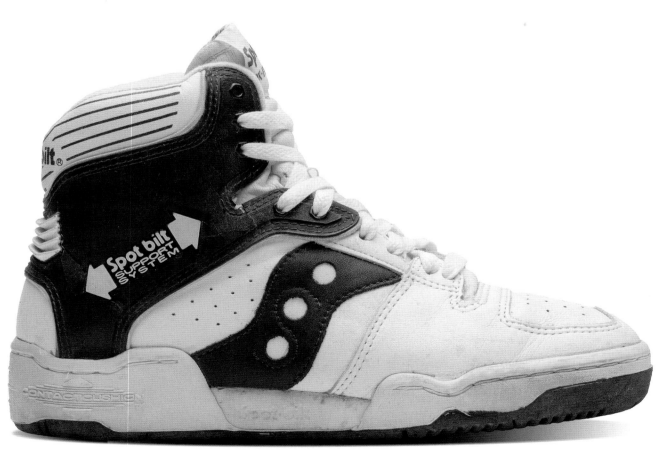

1986: Saucony Spot-bilt X-Press Support System

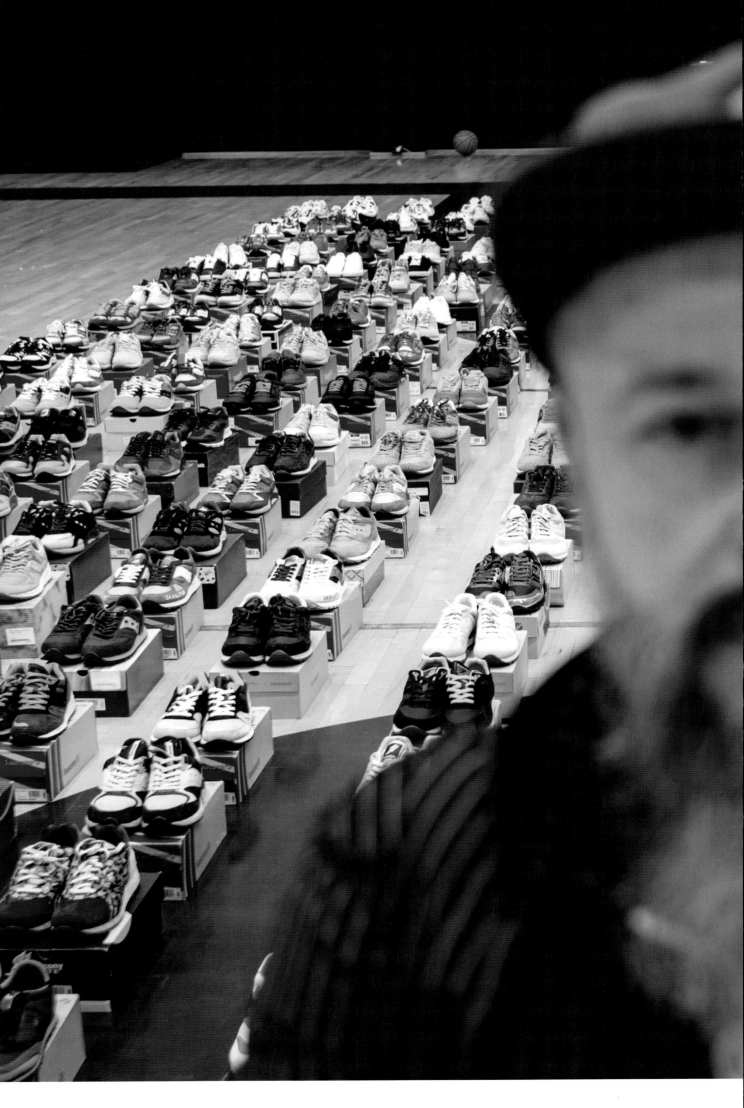

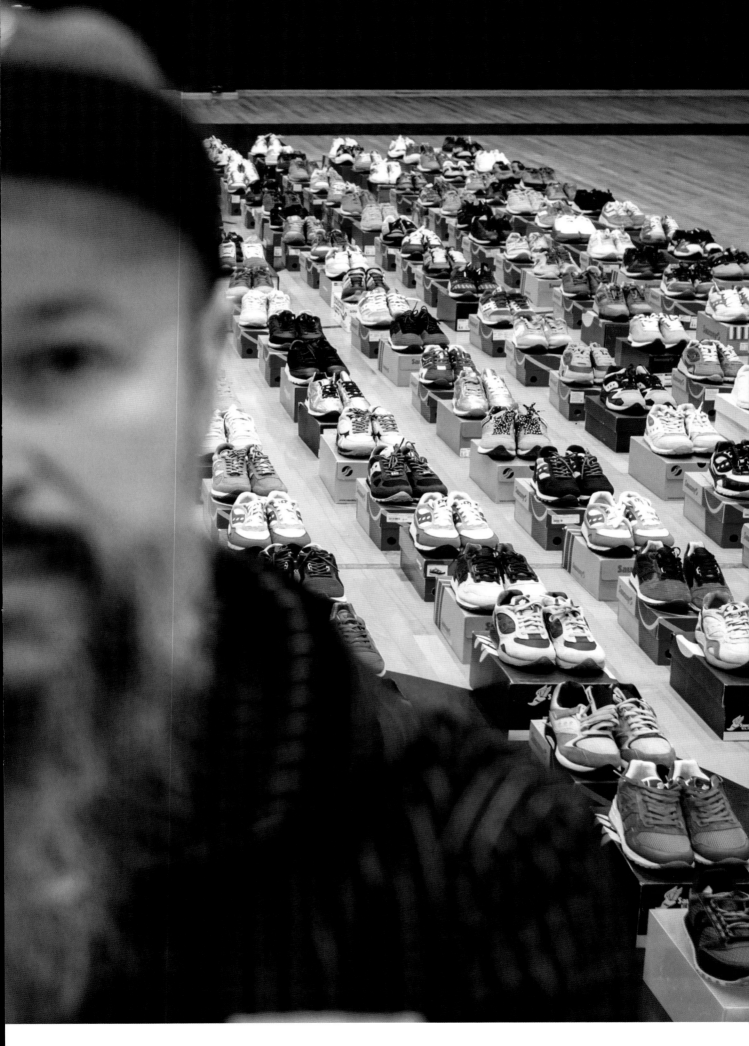

KHAN VEGAS

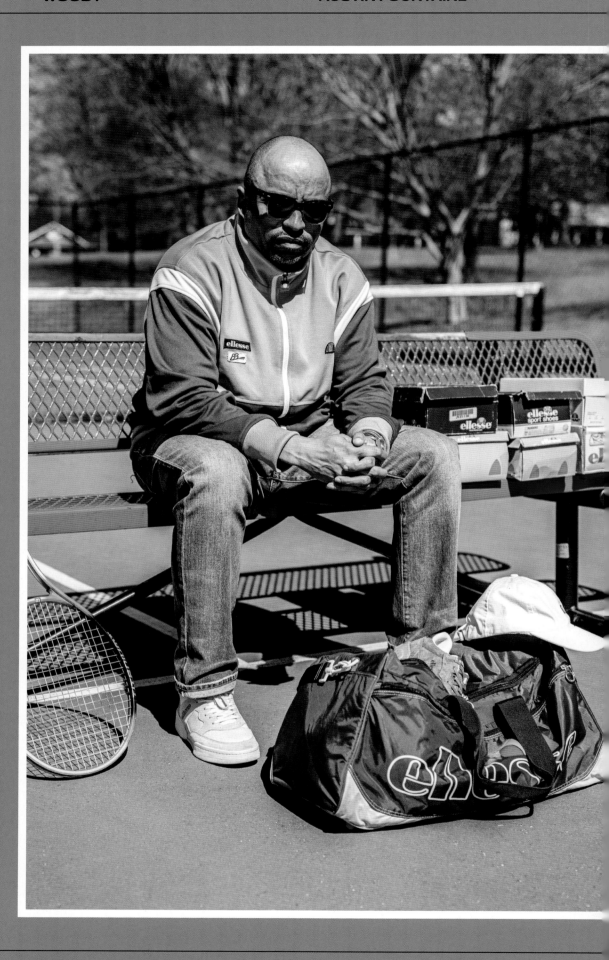

ELLESSE IS MORE

Khalli Vegas – aka Dr Frank Richardson and the co-founder of Vichstonian Athletics – is a man of many talents. While most consider him a sneaker professor, Khalli considers himself a professor who loves sneakers. His personal collection dates back to the mid-70s, and unlike most, he still rocks them all with local pride. So when it was time to talk ellesse, we knew exactly who to call!

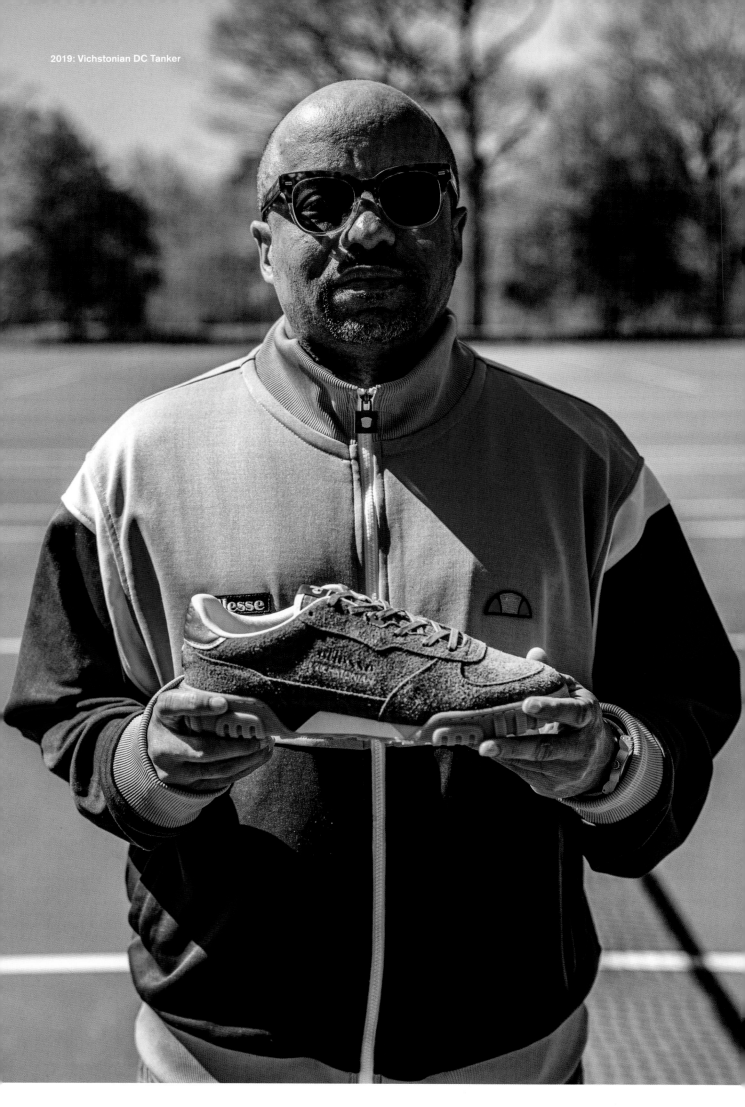

2019: Vichstonian DC Tanker

2012: ellesse Assist Hi (Retro)

Khalli Vegas
ellesse Expert
Washington, DC

Growing up in Washington, DC, during the 1980s, I always saw sneakers as a way to transport myself, both figuratively and literally. Whether you're an OG like me, a hypebeast, baller or skateboarder, your choice of footwear is an insight into your world. Your 'sneakers' define who 'you' are!

Saturdays were always a special time for me because I got to watch *Wide World of Sports* on ABC. That opened me up to Formula One racing, Grand Slam tennis and even alpine skiing, all of which were totally foreign in the 'urban' area where I lived. Tennis was a break from the gritty basketball courts that dominated my local streets. The matches were visually stimulating. The posh crowds, grass courts and beautiful venues like Wimbledon spanned the entire spectrum of colour and style.

The level of competition in tennis was fierce during the 80s. Incredibly majestic players like Björn Borg, John McEnroe, Guillermo Vilas, Ivan Lendl, Yannick Noah and Arthur Ashe were all at the height of their careers. ellesse was one of the major apparel sponsors in that era, and their classic logo was always front and centre on TV.

From my perspective, something amazingly unexpected happened through tennis. Instead of the brands coming to the streets, the streets came to the brands! The tracksuit designs and sneakers were bold and fresh! As a result, distribution diversified, and the shoes became plentiful on local streets. As local tennis shops and sports stores got in on the gains, big box stores were no longer the only players in the game.

Before social networks and the internet, we had to search magazines like *Tennis* and *Runner's World* to discover what players were wearing. I remember seeing Guillermo Vilas in ellesse apparel circa 1982. He was worth his marketing weight in gold! Not only was he a charismatic playboy, but his colourful yet classic tennis/ski garments were totally relatable as a daily fashion statement. By 1984, ellesse was wildly popular, especially during the Winter Olympics. That's when I began searching for many of the European brands advertised in sports magazines.

In the early 80s, b-boy culture boosted the popularity of Euro brands, while films like *Wild Style* helped spread the gospel of fashion-forward sportswear. At that time, however, hip hop wasn't all that prevalent in the District of Columbia – go-go music was the sound of the city! Everything from the Chance Band to Rare Essence was rocking on boomboxes in my hood. Euro brands then began to gain favour with the street crews, as the crazy prices bestowed an air of exclusivity on anyone who could afford the price tag.

To put things into perspective, in 1985, my first FILA sweatsuit was priced at $325. Many of the tennis sneakers from Euro brands were $100 or more, leaving a small budget for extras. In my experience, sneakers always came before apparel, but price and distribution definitely played an integral part in the decision-making process.

1984: ellesse Tanker Low

1984: ellesse Tanker High

374

2012: ellesse Assist Hi (Retro)

In addition to Jazzy Jeff & The Fresh Prince, many well-known urban icons helped to boost the appeal of sweatsuits. During the mid-80s, a lot of clubs and restaurants had strict dress-code policies that prohibited athletic wear and sweatsuits, but if you had style and money, entry was usually granted. This sparked a trend whereby matching sneakers and apparel were a must, fuelling a significant increase in demand.

The ellesse Tanker was a really innovative and futuristic model, especially with that big-print logo on the side of the shoe. The technopolymer rubber tips and aggressive sole profile made it one of the first cross-functional designs. Aside from the looks, the Tanker's major appeal was its versatility. Back then, it wasn't uncommon to dabble in loads of sports throughout the year, so you needed a shoe that allowed you to play on many different surfaces.

The fascinating thing about Marc Sadler, who designed the Tanker, is that he's still an enigma. In my mind, he deserves the same notoriety as other great sneaker designers that are household names. Having previously worked with brands like Lotto, Nike and Reebok, I have no doubt his industrial design background helped him push the envelope at ellesse. He went on to design scooters, furniture, orthopaedic legs and even rifles, making him one of the most diverse and influential designers in history.

One of my all-time ellesse models is the Vicenza, which Mike Packer rebooted and released as the Vinitziana in 2017. The blend of suede and leather made it an instant hit in my eyes, and Packer did a really nice job with the retro.

Running is another category where ellesse successfully bridged the gap between fashion and function. While the 'lifestyle' category is commonplace today, this wasn't the case in the 80s, as sneakers were used specifically for performance purposes only. The NYC Marathon 84 pair incorporated heavier materials and a darker grey colourway that allowed usage way past summer and into the colder months.

Another cherished ellesse sneaker, due to my mixed heritage, is the 'Franco Fava' signature model. He was a long-distance runner and competed in two Olympic Games on the Italian team. This model used premium materials and looked cool whether you were going for a run or out on a casual stroll.

A lot of my favourite sneakers are a direct reflection of my admiration for the players. Converse Eras, Dr Js, Magic and Bird Weapons, Nike Air Force 1s and New Balance 590s were in heavy rotation when I grew up. In ellesse's case, the Assist Hi basketball model was introduced in 1984, though it ended up being more of a hit within the skateboard community. I'd rank its popularity on the level of Vans and even Supreme today. The high ankle support, gum soles, protective lacing system and the Sadler-inspired logo definitely place it in my top 10 favourite ellesse sneakers.

★

1991: Unknown Model

1984: ellesse Vivictta

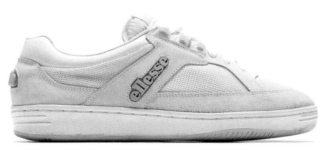

1984/85: ellesse Vicenza

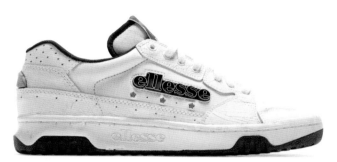

1983: ellesse Maurice Cheeks Lo

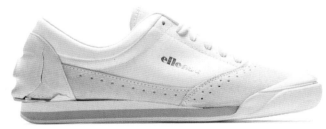

1981: ellesse Ababa 4101

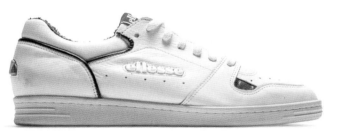

2018: ellesse Corfu 87 (Retro)

1985: ellesse Alchemy

1982: ellesse Sadler Tanker

2019: Vichstonian x ellesse DC Tanker

2017: ellesse Piazza (Retro)

1984: ellesse Franco Fava

2013: ellesse Franco Fava (Retro)

2017: ellesse A117 (Retro)

1985: ellesse A117

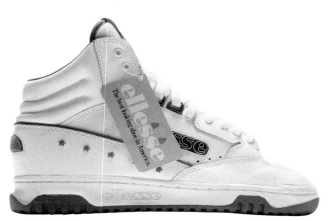

1983: ellesse Maurice Cheeks Hi

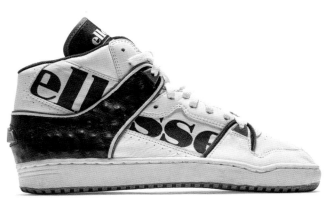

2012: Special x ellesse Fab Five Assist

Basketball Collectors

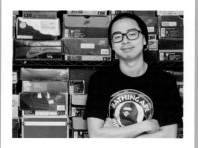

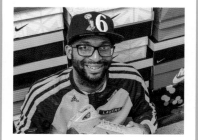
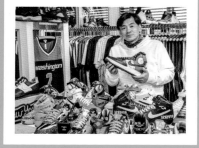
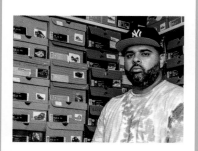

ALL HAIL THE SNEAKER QUEEN

Interview
WOODY

Photos
JULIA SCHOIERER

Julia Schoierer, aka Sneakerqueen, is a Berlin-born 80s kid with a decades-long affliction that has seen her acquire more than enough vintage sneaker relics to fill her apartment several times over. Digging deep into her own psyche, the Queen unpacks her eternal storage dilemmas and the existential meaning of a life surrounded by dusty boxes. From white leather trainers with neon pops to towering adidas hightops, via a side-order of oddities like the Status 1 and Air Pressure, this is a proper home-schooling from European royalty. Just remember that 99.5 per cent of this regal collection is in her size. Touché!

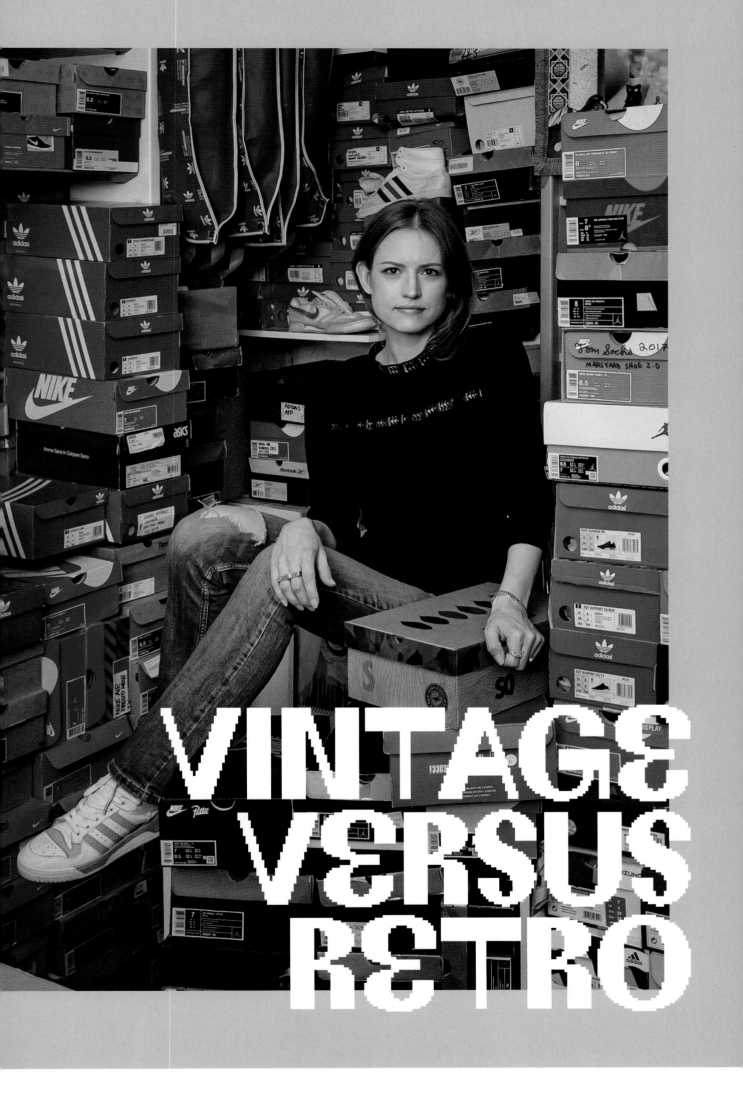

VINTAGE VERSUS RETRO

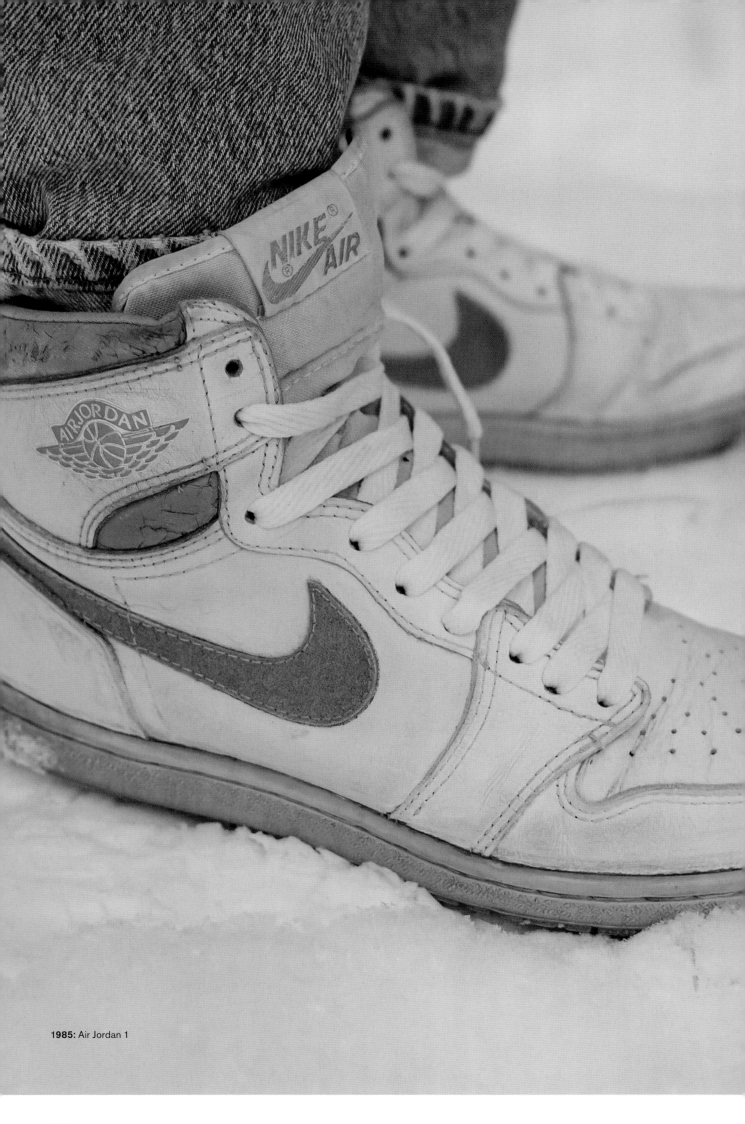

1985: Air Jordan 1

Julia Schoierer
Vintage Sneaker Hunter
Berlin, Germany

I'm a total 80s kid, born and raised in West Berlin, at a time when the Wall was still dividing the city. The biggest influence in my young life was my older sister and the things she and her friends were into. I was a tomboy, so my mother never allowed me to have white sneakers – they had to be mostly black so they would last longer! This obviously had a big impact on my taste because, to this day, a white-and-grey sneaker is the ultimate colourway in my eyes.

In the eastern part of Berlin, sports shoes were extremely limited because American brands were not allowed. Western Berlin was like a small island in a huge sea of Russian-occupied East Germany. French, American and English soldiers were stationed here, and the US Army had post-exchange stores where soldiers and their relatives could shop. They always had the latest American products, and that was a big influence on the local lifestyle. When the Wall came down, that was the start of consumerism for kids in the East, especially for shoes such as adidas EQT and ZX. They had been deprived for a long time, so the affection for runners was big, while kids from the West, who had been under the occupational influence of the US, tended more towards basketball hightops like Jordans.

Collecting sneakers is a constant tug-of-war between insanity, passion and reality. Apart from the financial aspect that you need to keep in check, there are many things to consider. Buying consciously is so important because when you start out, everything is new and amazing, and you can get carried away. I am sometimes conflicted about being this obsessed. On the one hand, you can have a very strong passion that you think about all day, every day, that never stops as you track down the next pair. On the other hand, how much time, and money, can you rationalise allocating for the passion?

For me, storage is the really, really big problem. I had so many sneakers at home, I had to put loads elsewhere because it was getting out of hand. My apartment is a real-life Tetris game. I think most serious collectors know the problem. And yes, of course, this situation also influences my relationships. I've always been a private person, so I don't like to invite just anybody to my apartment. Most of my friends have never set foot in my storage room because I think they would be quite shocked! I don't know when I last had people over for dinner because I don't have a table to sit down and eat. Then, when I go to bed, I'm not praying for better health – I'm praying that I won't be buried underneath a collapsing shoe rack next to my bed! [Laughs.]

To be honest, I have a discrepancy about the image of a perfect collection all stacked in perfect rows in a perfect house because you see that a lot on Instagram today. To me, this is highly unrealistic. Then comes the problem of boxes stacked on top of each other, boxes collapsing, squashing the shoes, then the shoes are old in squashed boxes, and the soles and foam start to crumble. It's an anxious storage war that you have with yourself and the lack of space in your apartment.

The other day I was sitting in my kitchen kneading some dough, and some flour came off the table. So I checked underneath and bumped into a pair of 'KAWS' Jordan 4s. I look around, wipe off the flour and then push the $2000 shoes into another corner because there is no other place for them. This is the reality that is not really shown on Instagram, as storage is really not a beautiful thing if you collect in an excessive way.

Most of the vintage shoes I own are from the 80s. By the 90s, colours were more of a subject, and the shapes became really soft and rounded. The older shoes are much more interesting because I really like edgy design and the groundbreaking mix of materials.

I try not to discriminate, but the Three Stripes and Swoosh are always prominent. Everybody knows Nike and adidas have the most potent designs, but I do have other brands like PUMA, Reebok, Converse and Vans. Michael Jordan was also a huge personal influence because Jordan Brand was a status symbol in the 90s. I really like watching the brands battle, like when Nike Flyknit and adidas Primeknit were released at the same time.

Anybody collecting for over 20 years remembers when eBay became the major player. Most of my vintage collection is from there and other online sources, but I also love travelling and checking out local stores. Sometimes you get lucky. Finding shoes in an old mom-and-pop sports store is a very rare occurrence, which I think happened maybe once or twice. A good network is also crucial to acquiring hard-to-find shoes.

My blog started because I wanted to explore the idea of 'vintage vs retro', which is what you'll find when you look up @sneakerqueen on Instagram. Most people know me by that name these days because sneakerqueen.de is where I often took on the idea of comparing vintage shoes with current releases. The main reason the older shoes are better is, in my opinion, the quality of the production. Shoes are made so much faster these days, and the materials are not as high quality. There are more machine steps and fewer hands involved, which makes a big difference. If you look at the Jordan 4, the OG vintage and the recent retros are miles apart. Same design, but almost a completely different shoe. The new leather is so bad, and it's really uncomfortable.

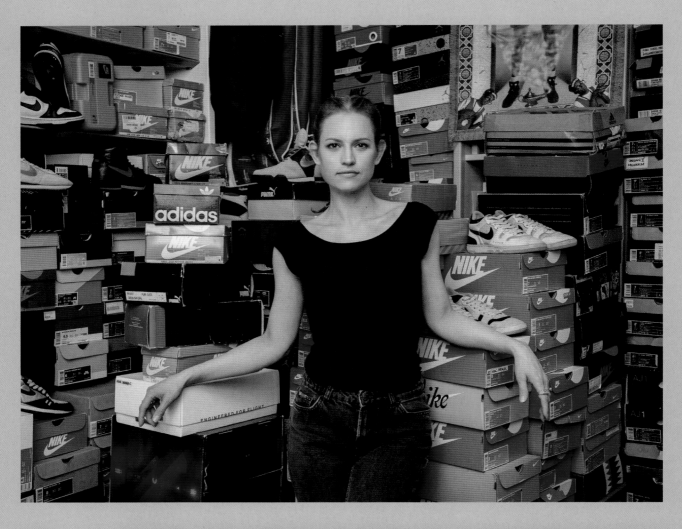

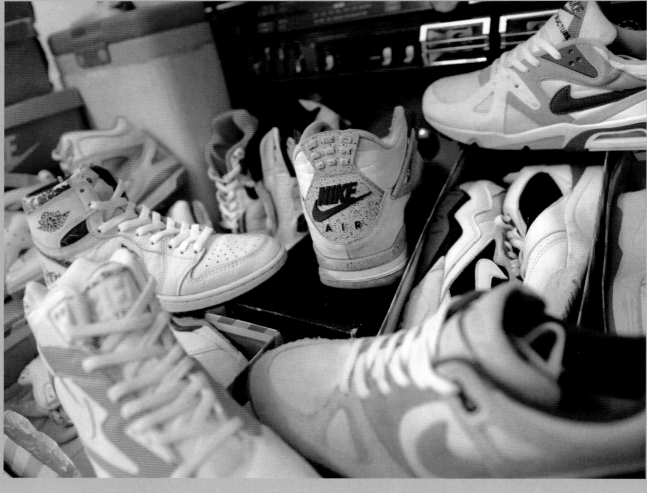

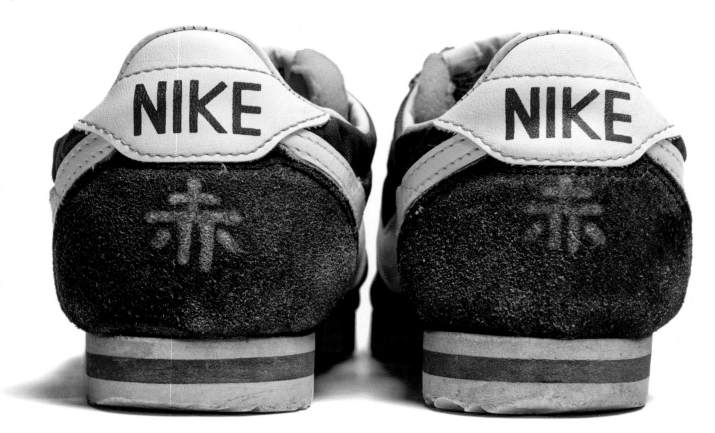

1979: Nike Nylon Cortez

I'm an all-or-nothing type of girl, so if I had to choose a single shoe over all others, it's probably… well, I just could not choose one! My love also goes through phases. There are times when I absolutely adore vintage runners, but then in winter, I love basketball hightops. Let's say I go to a desert island – a nice light shoe like a Nike Air Flow would be ideal. But in the end, it's impossible to choose just one.

A couple of vintage runners are still painfully missing from my collection. One of these holes was filled a couple of years ago when I was in Japan. Collectors already know the Soma store in Shimokitazawa, which has an amazing selection. I bought a pair of Nike Sierra Carib there. I love this model because it has an iridescent Swoosh, and I'm a sucker for special materials.

I played basketball in school, but my main connection with the shoes started in the 90s when Jordan returned to the NBA. I had a boyfriend at the time who had Pay-Per-View TV to watch the NBA, so I saw a lot of games. Some friends were ballers, and they took their fashion to the next level. When I was younger, adidas hightops were a staple in Germany and a status symbol. Shoes like the Rivalry, Forum, Conductor, El Dorado and Fleetwood (which is a snakeskin El Dorado) were highly sought after.

This melting pot of culture and sports in the sneaker world is so interesting. So many people think that hip hop was the only influence on sneaker culture, but I totally disagree. In Germany, football hooligans were a major factor. The techno scene was also pivotal in the rise of many specific shoes. Heavy metal also. The Anthrax cover with all the adidas Rivalrys was huge, and some groups were the middleman for all these cultures, like the Beastie Boys and Run-DMC, because they brought punk and hip hop together.

The other day I found a picture of Ricky Powell (RIP) standing between Run-DMC and the Beastie Boys. He was on tour as a photographer. The bands are mostly wearing Rivalry, but Ricky is wearing Nike Mac Attacks! I love this shot because it perfectly describes that crossover of music styles and how skateboarding influences the sneaker scene, which is more about having a 'no rules' approach to style.

I own two pairs of the Mac Attack, which is from 1984 and one of my favourite shoes. For me, it's a beautiful model to wear with feminine clothes. If you compare it to any Force or Flight from that time, it's a very slender and elegant shoe. I was hunting them for a very long time and finally bought both pairs via Asian auction houses. A few years ago, when Travis Scott wore a pair of Mac Attacks, then LeBron had a pair, it seemed like the shoe would be retroed soon, but so far, nothing has appeared.

I also love the Cross Trainer era, as the concept of white and grey leather with a flashy neon accent was so popular. The Velcro straps and netting on the sides of certain Nike shoes are cool touches that upgrade the designs. All the shoes from this family, like the TW, SC and Air Trainer 1, are beautiful and exceptionally comfortable shoes. Finding them in my size, which is rather small, was actually fairly easy. I'm really hoping that Nike will consider a retro of the Cross Trainer Low soon.

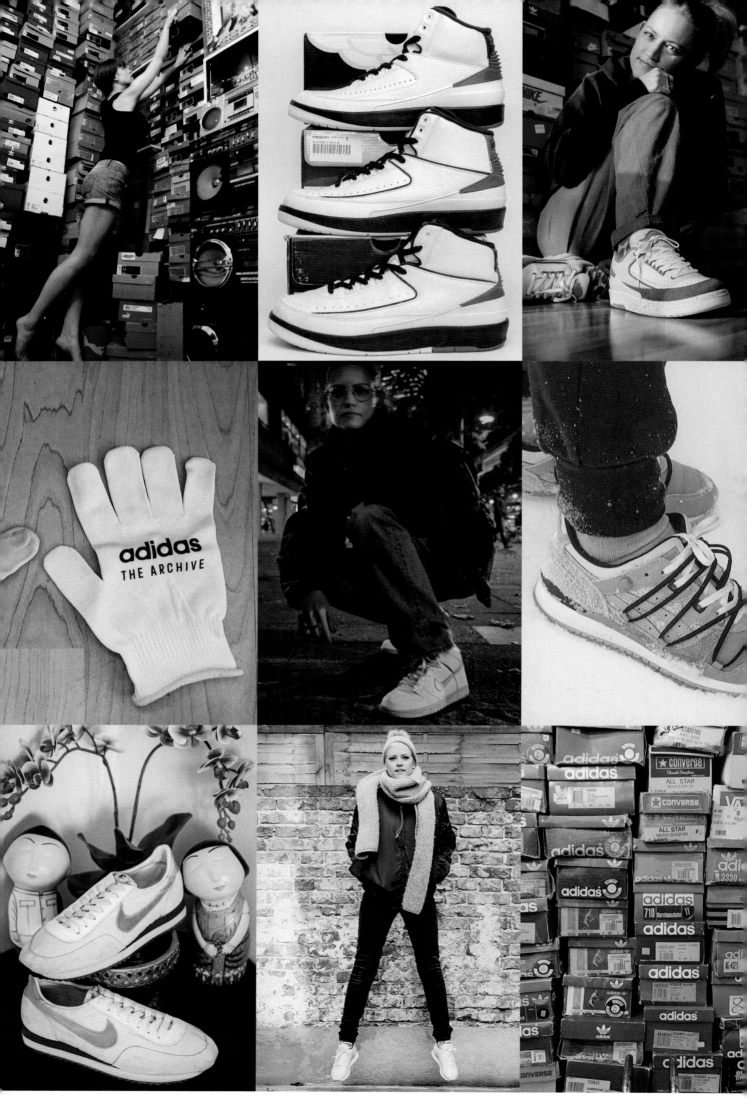

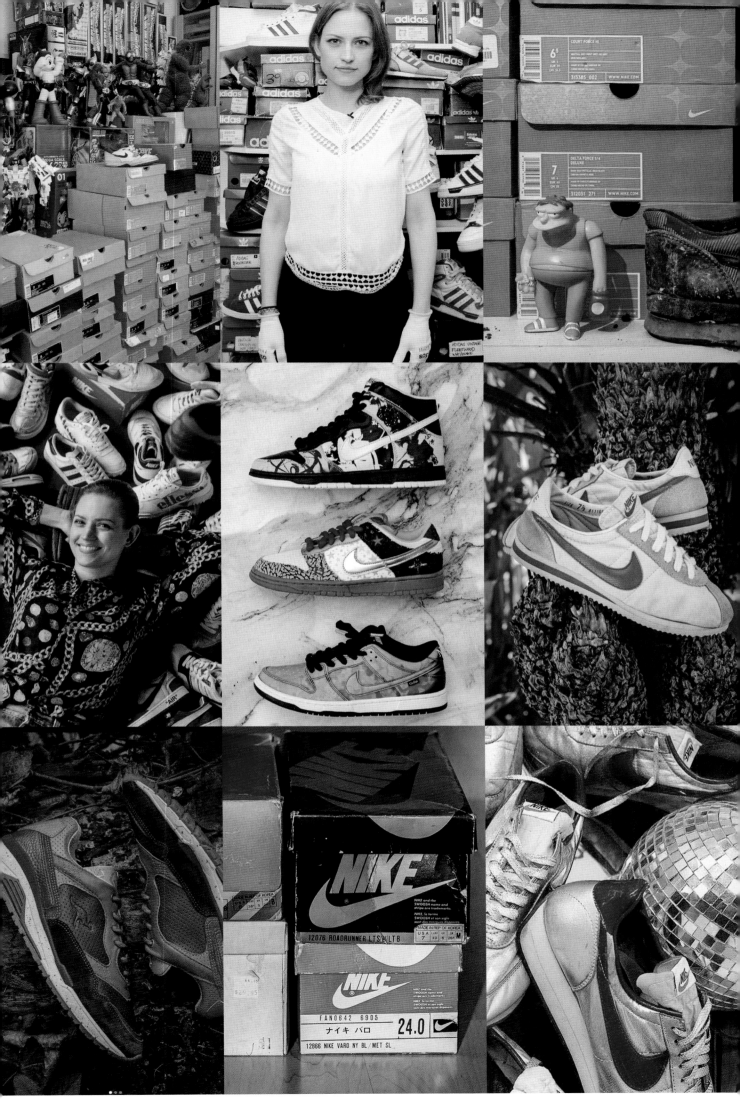

1985: Nike Terminator Hi

1985: Nike Vandal Supreme

1989: Nike Escape Son of Lava Dome

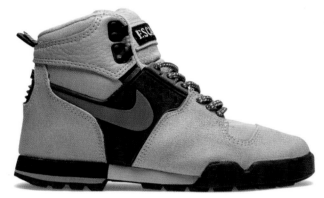

1988: Nike Escape Lahar 'Putty'

1990: Nike Air Tech Challenge 3 (Limited Edition)

1988: Nike Driving Force

1977: Nike Blazer

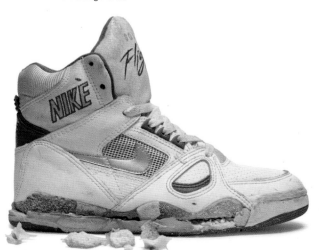

1989: Nike Air Solo Flight '89

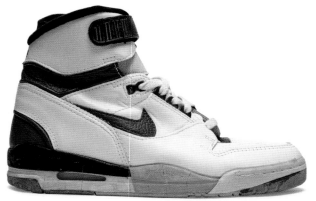

1987: Nike Air Revolution

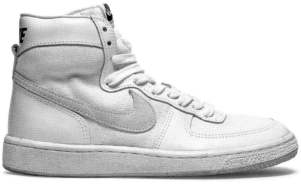

1985: Nike Legend

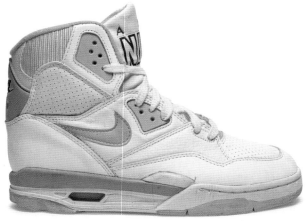

1989: Nike Air Ascension

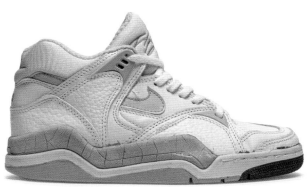

1990: Nike Air Bound

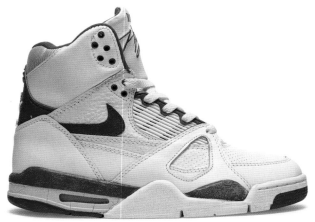

1989: Nike Air Flight Hi

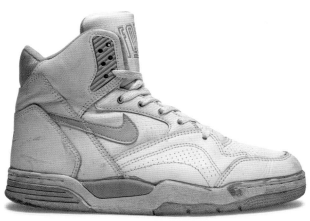

1990/91: Nike Quantum Force 2 High

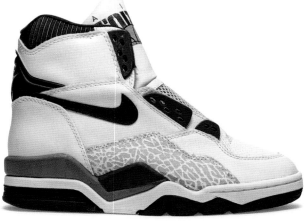

1989: Nike Air Force STS

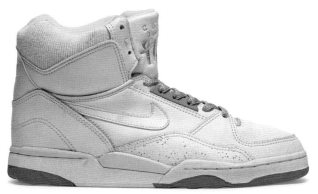

1991: Nike Court Flare

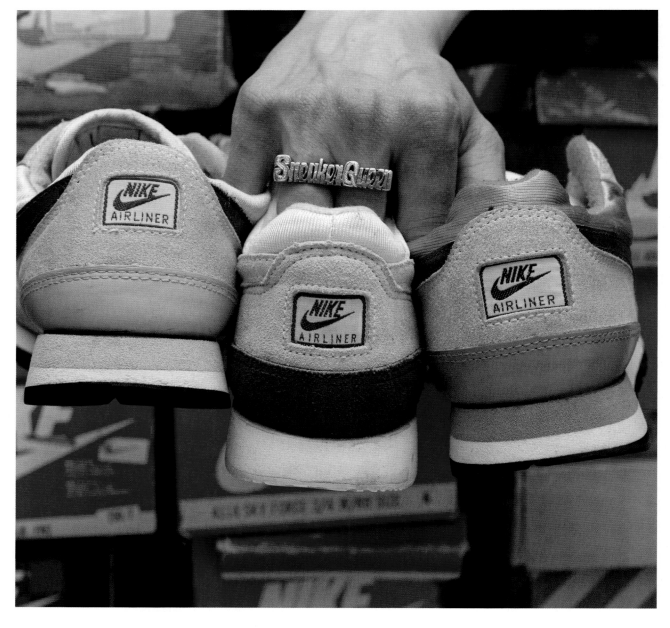

One thing I should say is that all the shoes in my collection – at least 99.5 per cent of them – are in my size. I don't buy them because they're hyped. I actually hope that no one will know about them because that means exclusivity for me. In the beginning, I totally hid my collection for almost 10 years because I would've been thought of as having a shopping addiction rather than being a genuine collector.

The most interesting shoes to me are things like the adidas Status 1. It's absolutely one of my favourites, yet most people don't know anything about them. I spent quite a few years Googling the shoe and could never find any pictures, so my pair seems to be one of few. A couple of catalogue pictures popped up, but that's about it. I've been asking the adidas archive to confirm my thoughts, as the Status 1 is an exceptional model with a really interesting mix of functional features from different sports. It has Soft Cell on the heel, for example, as well as a huge plastic component that makes it a bit of a Frankenstein from that time.

I also love the Nike Air Pressure, a shoe that still looks amazing due to the huge and insane heel pump mechanism. Nobody in their right mind would make a shoe like that for functional reasons, so it obviously is a gimmick to give you a feeling of extra 'air time' when you're jumping. I think it's a super-interesting model because it makes no sense and all the sense in the world at the same time. I love that!

Another shoe that I really love from my collection – and I don't even know its name – is a Nike 10-pin bowling shoe. It has a very unusual tongue label with a big X and laces with 'If the shoe fits, go bowling' printed on them. I also own a pair of Nylon Cortez that are made in Japan and have the word 'red' stamped on the heels, which is very unusual.

I've been hunting the adidas Rebound all my life. I still don't own a pair, but one day I found a shoe on eBay called the NBA Rebound, which is almost identical to the adidas version. The only difference is the tongue logo and the materials. So yeah, I also love shoes that are not general releases.

You don't always win every prize as a collector. More than 20 years ago, I was hunting the Nike Metro Grid. I was outbid several times, which was so annoying. I haven't seen a pair for a long time. Even a few weeks ago, I missed a pair of Nike Los 84, which was made for the Olympic Games in Los Angeles. There's a grey-blue and a brown version. On a Japanese auction, I found the blue for an insane price of €130, which is really, really, really good. But I missed out, and I'm still talking about it a month later because I'm so angry at myself!

There's always a new generation coming up that needs to write its own history. I think it would be preposterous for me to say that passion has to look this way or that. Collecting is a very personal thing, and this is why I write my blog and create exhibitions. I don't want to sound like the teacher and say, 'I want to educate the people', but that really is the idea behind sharing my knowledge. At this point, my collection becomes more than just a reflection of consumerism but rather a snapshot of my personal style. I really cannot stress this enough – style is not fashion! What I see in sneaker culture today is a lot of fashion and very, very little style.

I really enjoy seeing women getting a foot in the door and having more influence and power to change the direction of the industry. I'm not actively a female advocate, but just being in my position for more than 25 years is, for me, statement enough. I don't scream, 'Make women more relevant!' I'm out there doing it every day to the best of my ability. I think there's much more diversity in the sneaker world than there was 10 years ago, which is a great thing.

We are at a very interesting time. There's no clear style or trend direction, so there's a little bit of everything, and I find this situation the perfect environment for something new and exciting to emerge. When things are all very chaotic and not very precise, it's the most exciting thing when you see it crystallising right in front of you. I can't wait to see what comes next!

★

@sneakerqueen

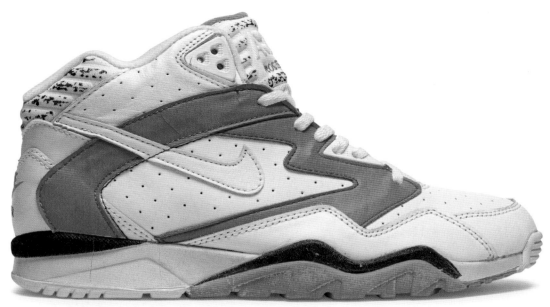

1991: Nike Air Cross Trainer 4 (Women)

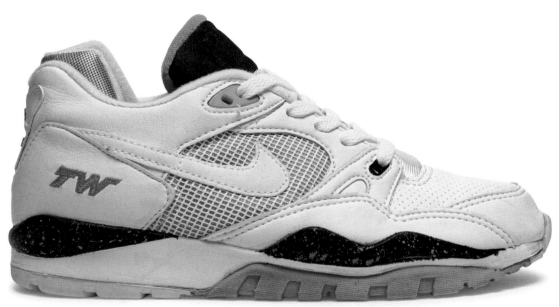

1990: Nike Air Trainer TW Lite

1990: Nike Air Trainer TW 3

1990: Nike Air Trainer TW 2

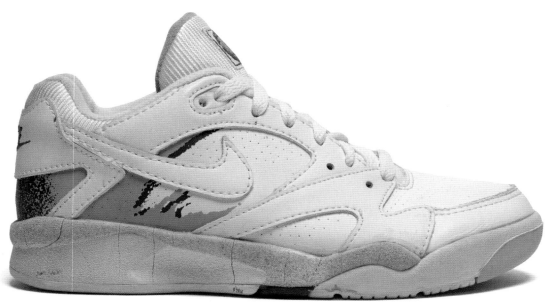

1991: Nike Air Challenge Pro 3 Low (Women)

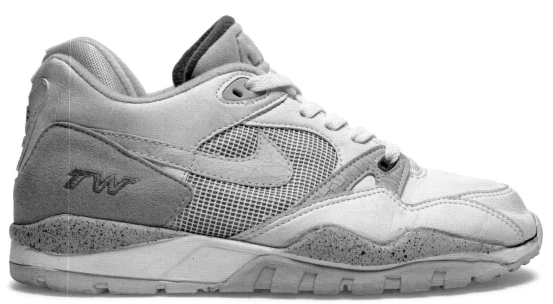

1989: Nike Air Trainer TW Lite

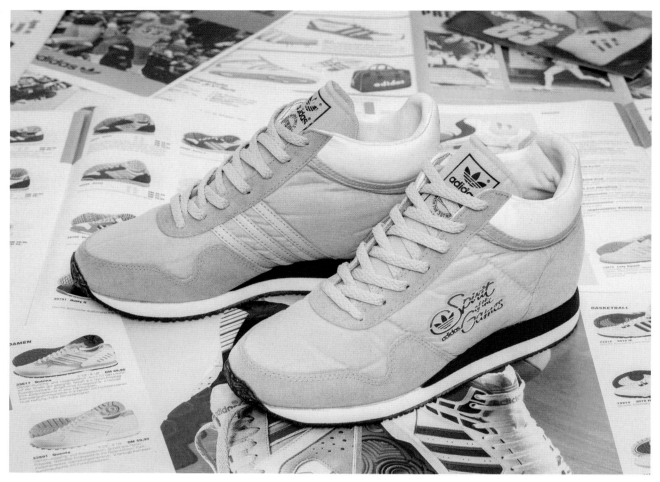

1984: adidas LA 84 'Spirit of the Games'

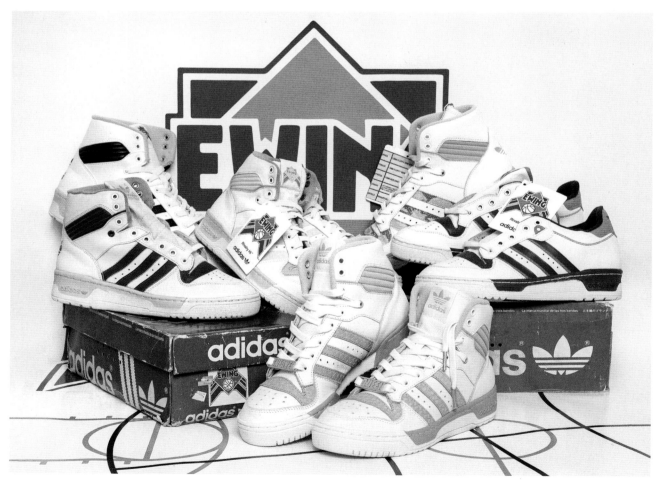

adidas Rivalry

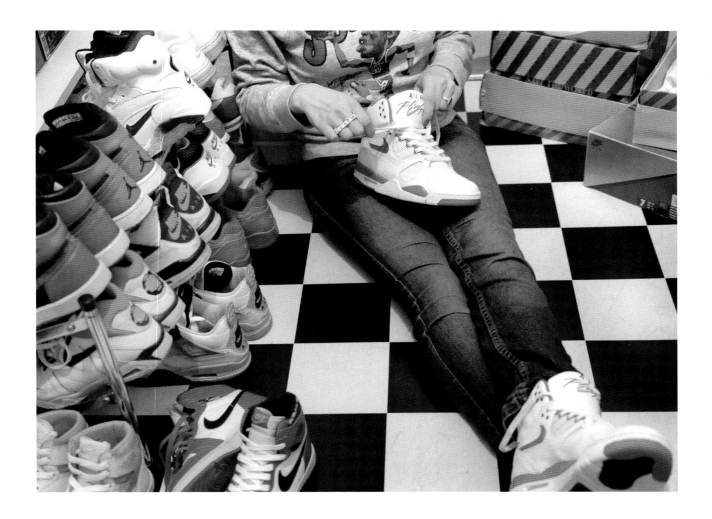

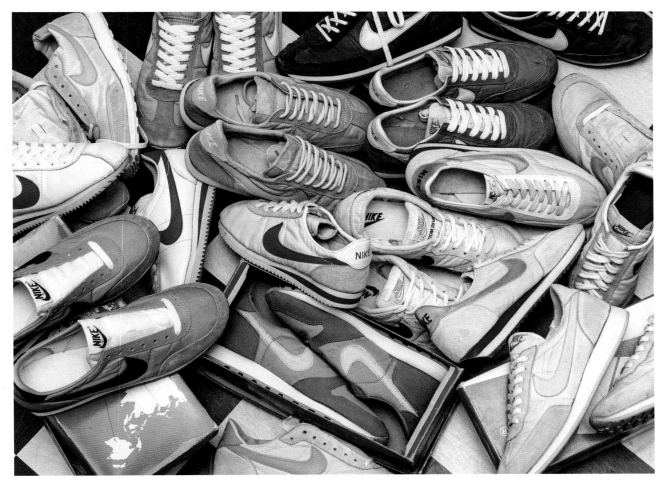

1985: adidas Cancha Hi

1985: adidas Americana Hi

1985: adidas Centennial Hi

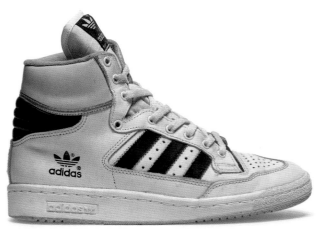

1985: adidas Centennial Hi

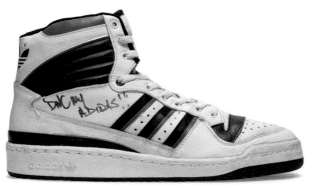

1986: adidas Eldorado Hi

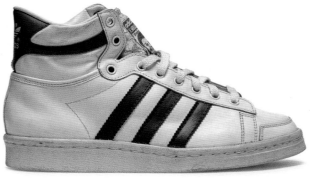

adidas Jabbar Hi

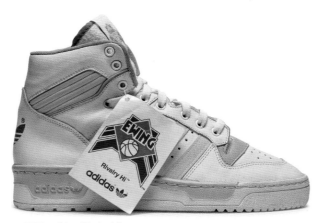

1986: adidas Rivalry Hi

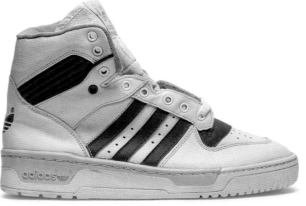

1986: adidas Rivalry Hi

'THIS MELTING POT OF CULTURE AND SPORTS IN THE SNEAKER WORLD IS SO INTERESTING. SO MANY PEOPLE THINK THAT HIP HOP WAS THE ONLY INFLUENCE ON SNEAKER CULTURE, BUT I TOTALLY DISAGREE. IN GERMANY, FOOTBALL HOOLIGANS WERE A MAJOR FACTOR. THE TECHNO SCENE WAS ALSO PIVOTAL IN THE RISE OF MANY SPECIFIC SHOES.'

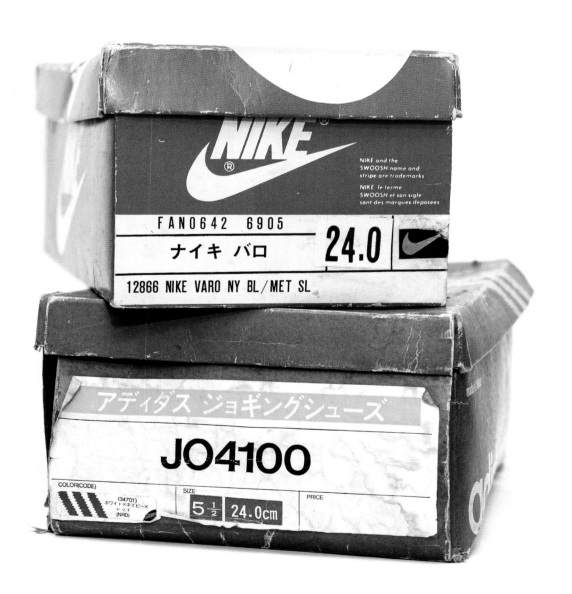

Nike Varo and
adidas JO4100

First published *Sneaker Freaker* Issue 47 – May 2022

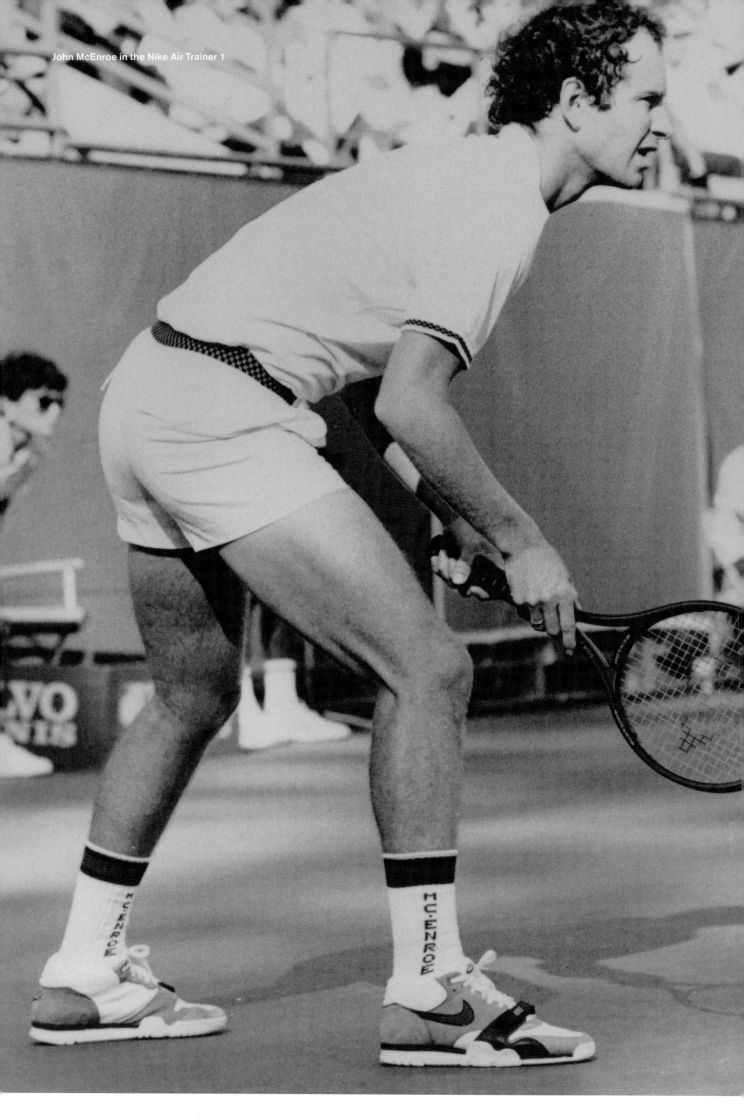

John McEnroe in the Nike Air Trainer 1

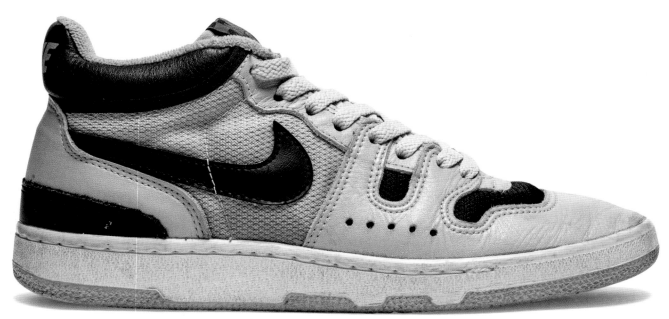

1986: Nike Mac Attack (Grey)

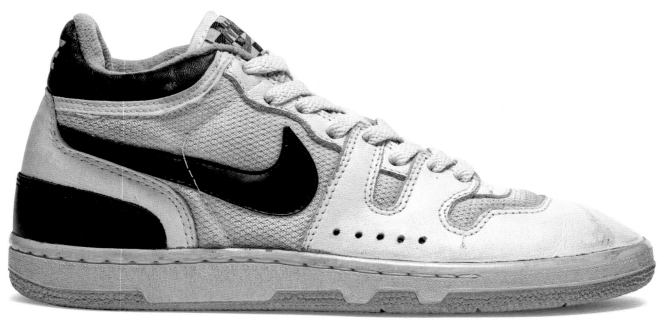

1986: Nike Mac Attack (White)

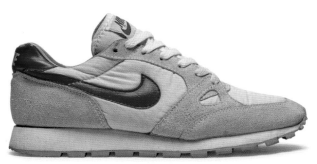

1989: Nike Eclipse

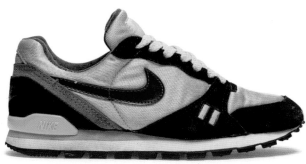

1989: Nike Target

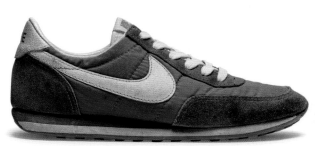

1982: Nike Diablo

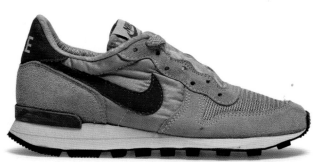

1980: Nike Equator

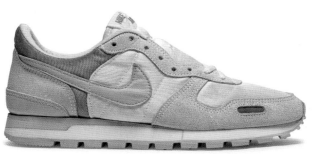

c.1986: Nike Roadrunner

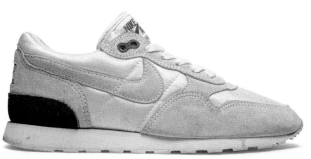

1988: Nike Windward AC

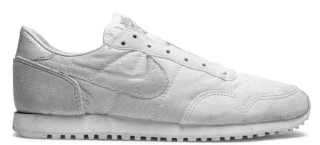

1991: Nike TR-II

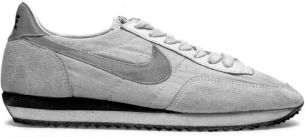

1983: Nike Sierra Carib

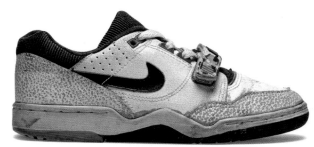

1988: Nike Alpha Force Low GS

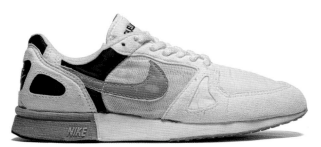

1989: Nike Duellist

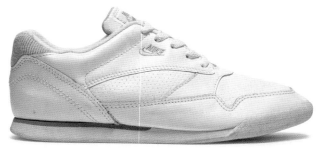

1988: Nike Intensity Plus (Women)

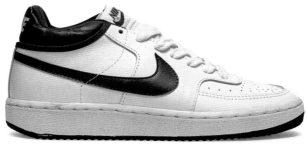

1983: Nike Sky Force 3/4

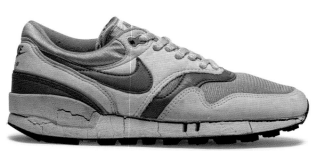

1987: Nike Air Support

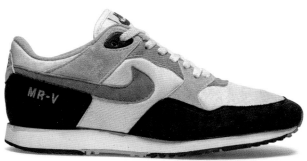

1990: Nike MR-V

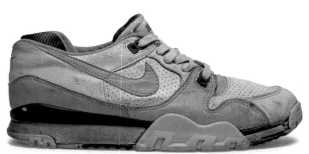

1988: Nike Air Trainer TW (Women)

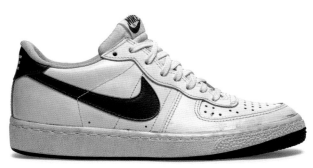

1983: Nike Vulcan

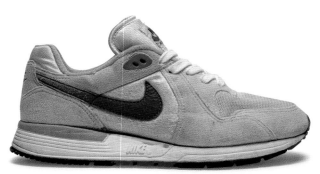

1990: Nike Air Craft

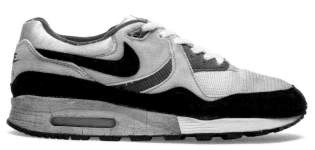

1989: Nike Air Max Light

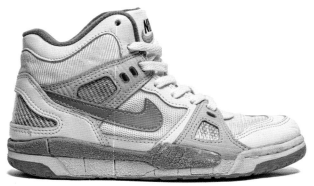

1990: Nike Air Digs

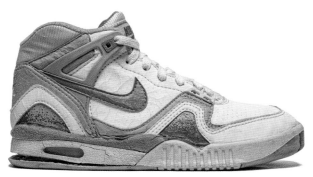

1989: Nike Air Tech Challenge 2

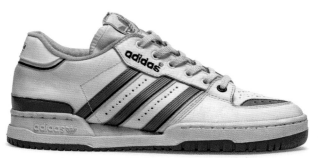

1984: adidas Lendl

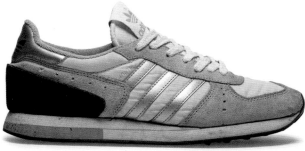

1987: adidas Montreal

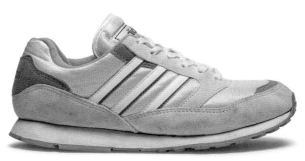

1991: adidas Myriad

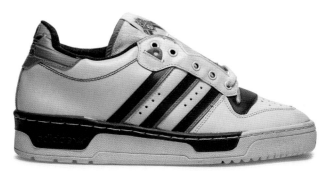

1986: adidas Rivalry Lo

1988: adidas Ontario

1986: adidas Phantom

1988: adidas Richfield

1988: adidas Desirée

1984: adidas JO4100

1988: adidas Jupiter

1986: adidas Conductor

1980: adidas Top Ten Hi

adidas Superstar (Made in France)

1990: adidas Tech (Softcell)

1988: adidas ZX220

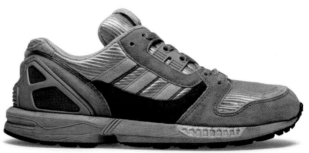

1998: adidas ZX8000

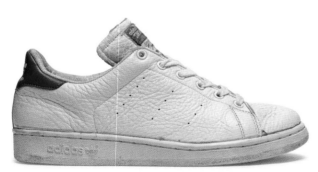

1990: adidas Stan Smith Supreme

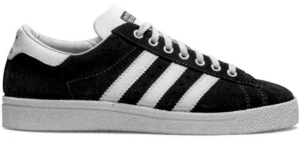

adidas New Jabbar

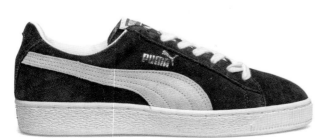

PUMA Suede

PUMA Suede

LUIS M
LOZANO

SPANISH
FLY

Air Force 1. Air Force 2. Delta Force. Air Alpha Force. Driving Force. Air Revolution. Terminator. Big Nike. Air Assault. Challenge Court.

404

Interview: **Woody** Photos: **Canicio Fotografía**

Spain isn't renowned as a hotbed of vintage sneaker aficionados,
but Luis Miguel Lozano is on a one-person mission to change that
perception. How's this for cool factor? Lozano's first pair of sneaks were
'Metallic Blue' Jordan 1s! That seminal moment would inspire a lifelong
devotion to Nike. His hunting adventures all over the world have netted
him a chunky collection of classic white leather basketball models.
Swish, swish, Swoosh!

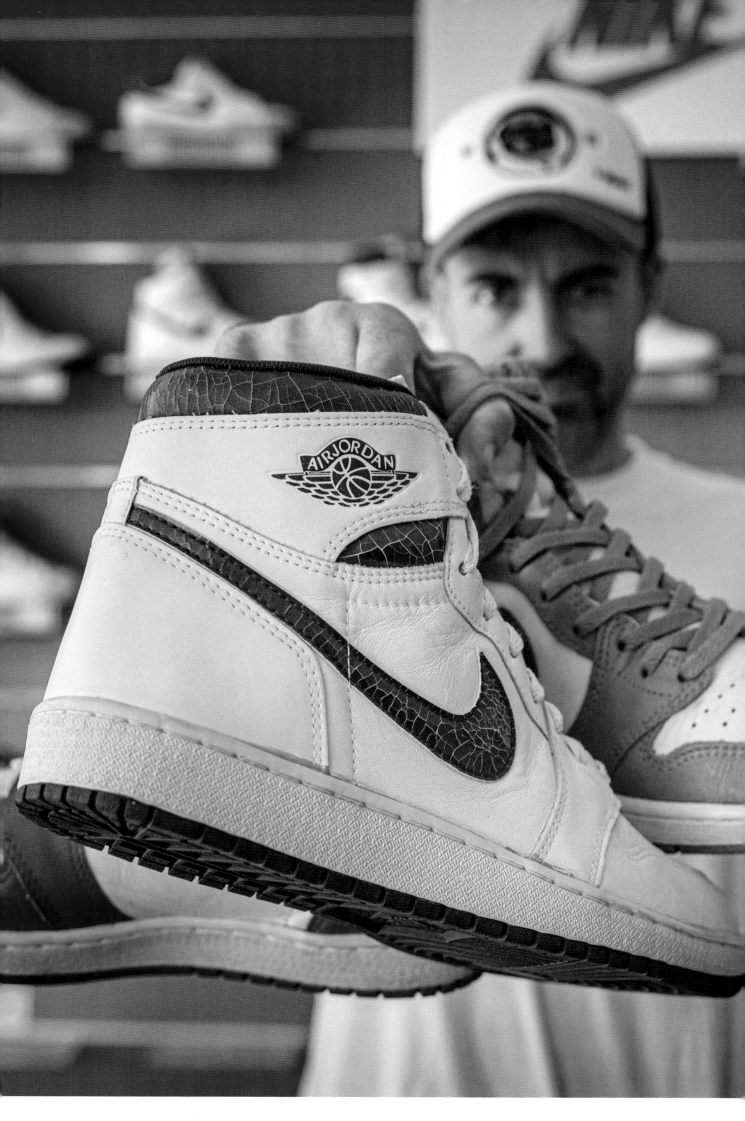

Luis M Lozano
Nike Vintage Specialist
Spain

My name is Luis Miguel Lozano, but you may know me online as 'jumi' or perhaps as @luisjumiguel. My early memories all relate to sneakers that were blooming in Spain in the 1980s. During those years, I was lucky enough to wear amazing kicks. My first pair was the 'Blue Metallic' Air Jordan 1. Nike's designs, their incredible marketing ideas and the technology concepts were mind-blowing.

Back in the early 80s, I didn't even know a brand called Nike existed, but I watched shows like *V* and *The A-Team*, where characters like Mike Donovan and Mr T wore amazing shoes with a flashy 'tick' on the side. When I watched *The Goonies* in 1985, I was shocked by Data's 'Slick Shoes' as they had the same logo. Damn!

There were no sporting goods stores selling those shoes with that strange logo in my hometown, but that same year, I was at school, and my PE teacher appeared wearing a brand new pair of running shoes. A friend came to me, 'Look, Luis! The teacher is wearing a pair of Nikes!' From that moment on, I discovered that the brand I wanted had a name. Later that year, we all found out about Michael Jordan, and that made my desire to own a pair of Nikes grow deeper.

When I finally got that pair of Air Jordans, I was the happiest kid on Earth. I desperately wanted the white/red/black (known as 'tricolour' here in Spain), but my mother could only find them in Metallic Blue. It wasn't Chicago's colours, but it was Data's pair! For many years, I thought the pair I owned was the same as the one in the film.

Around 1999, when I finally had a decent job and some money, a nostalgic impulse made me try to get a fresh pair of the same Jordans I had as a kid. It didn't take long, and the feeling of owning them again was amazing. From that moment on, I searched for all the shoes I had as a teenager. More than 20 years later, I'm still doing it, and the joy has never left me. I love collections that aren't ruled by hype and have their own identity. This doesn't mean I don't like new releases, but I would never want an entire collection based purely on the resell price.

The Circus

I find my shoes in all kinds of places. Old stores with deadstock, eBay auctions sometimes and other ways you can easily imagine. Many of them came from Spain, which may surprise some people. For two years, I used to work as a circus teacher and travelled all around the country, so I visited every single sports store where the circus stopped. Other times, I flew to countries where I had certain clues about stores with old Nike stuff. I can say I have found vintage Nikes in Spain, France, Belgium, Finland and, of course, in the US.

I especially remember a store I found in Los Angeles, which was totally unplanned. During the same week, I found a place on Broadway and another on Venice Beach. I was on a pleasure trip, and it wasn't time to come back yet, so I had to ship boxes full of vintage Nikes back home. But here in Spain, I've found plenty of Nikes too. Once I bought over 400 shoes for €3.50 per pair. The haul was so big, I had to get a huge van to take them all home.

Twenty years ago, there were still many physical stores where you could find amazing vintage shoes at really low prices. I didn't even have internet access, and I didn't know anyone else interested in old shoes. I used to think I was the only one searching. Most of my hunting back then happened quite easily. I used to take my car and travel around asking randomly in all the sporting goods stores I came across. A few years later, I started discovering different online forums where I met loads of people with the same passion, which was amazing. You could share info, show your shoes and make friends all over the world, which has helped me improve my collection.

Vintage Prices

Before eBay, I didn't have accurate references to vintage prices, although I know there was a large market in Japan, where Nikes from the 1970s always sold at really high prices. As recently as 2003, you could find Air Jordan 1s for around $200 or even less. In the last couple of years, the prices have reached crazy heights. I'm so thankful I got my pairs a long time ago, as the market is mad now.

In the last decade, everything has changed. Everybody seems to be collecting sneakers, and vintage stuff is sold using social media, so the visibility is very high, and that makes it really difficult to find bargains.

Big Love

I love all the early Nike basketball shoes. Aside from runners, this, to me, is the root of the brand. They are simple shoes in many ways, but at the same time, they are all very attractive. It's impossible to give you an answer to which one is my favourite. I love the 1970s era and the early 80s as well, but I also love the most technological ones like the Air Revolution, Alpha Force or Air Assault from the late 80s period. The white leather is amazing!

I still remember the first day I saw the Air Assault ad in a basketball magazine. The shoe was flying, surrounded by clouds. By that time, they were as cool as Air Jordans or maybe even better, in my opinion. It's the 'Safari' version of basketball, but the yellow colour gives it extra power. They need a good reissue soon, but this time it would be nice if Nike did not use a visible Air bubble in the sole.

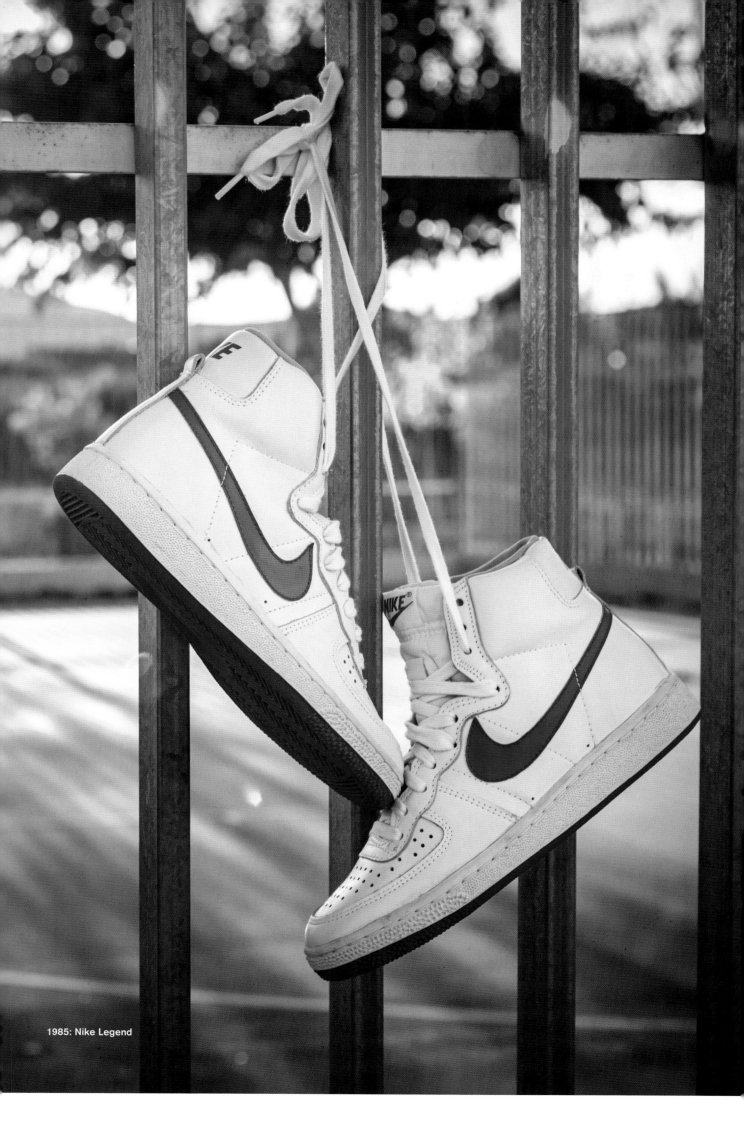

1985: Nike Legend

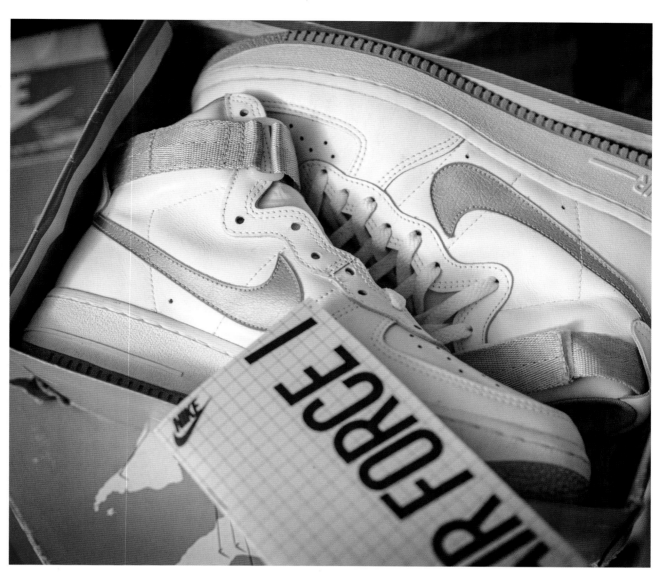

1983: Nike Air Force 1 High

When you hold vintage pairs in your hand, there is no comparison to the shoes made today. Sometimes Nike do that on purpose, as they did with the Assault, which featured a different sole unit. But when they put in a big effort and make great retros, like the Air Max III, ooooh, man! Such a great shoe! My filter is always the same. Do they take me back to 80s and 90s memories? If so, damn, they nailed it!

The Air Force 2 is a totally underrated shoe design. It was the top choice in 1986 and 1987. The Air Force 1 eclipses it in terms of hype and sales, of course, but I'm sure, sooner or later, it will be recognised as the great model it is. I think it's the same issue with the Jordan 2, which has big problems with crumbling foam midsoles. This is very common with shoes that have polyurethane midsoles and especially with pairs made in Italy, like the Nike Chicago. I guess the composition of that urethane was different from the one produced by other manufacturers.

McEnroe Versus Agassi

I have quite a few tennis shoes as well. Choosing between McEnroe and Agassi is really difficult. McEnroe represents the 80s, and Agassi is totally 90s with all the powerful neon colours. Both are amazing players and represent the rebel character of Nike in its origins, but if I had to choose one, I would go for McEnroe. I was a big fan of the player, and I also love the Mac Attack, the first Nike model sold in my hometown in 1987, so that is a special connection.

McEnroe also wore the Trainer 1 in his career. All the Cross Trainers were really revolutionary when they first arrived on the market in 1987. Those Velcro straps, the vibrant colours and the concept of a multi-use shoe were radical. I really love them all from 1987 to 1991. In my opinion, they are at the same level as Air Jordans or Air Max in terms of pure design. After 1991, the vibe went down, and I took my eyes off them.

Sometimes rare shoes aren't always super valuable. Some of my favourite pairs are not expensive at all, but they bring me really powerful memories. I could do a list here. Glyder, Wimbledon GTS, All England and Court Force.

Also, before people went crazy for the non-Air Jordan models used by Jordan, nobody paid attention to models like the Air Train, and you could get them easily. Now the vintage price is 10 times higher.

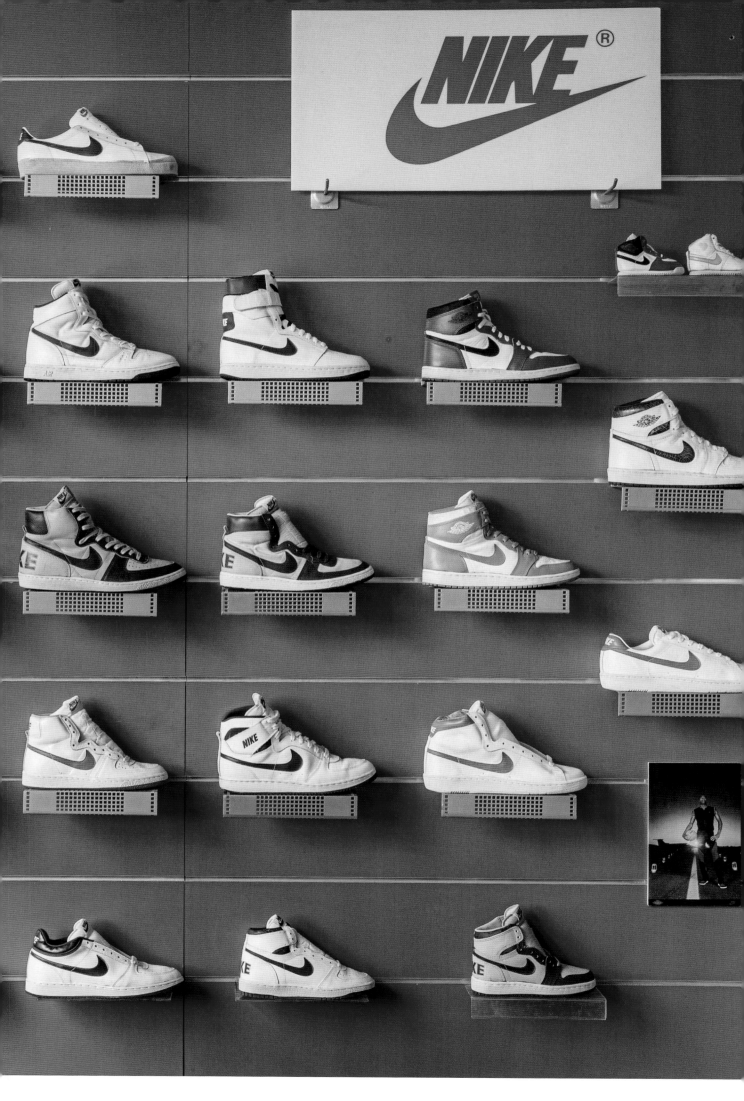

410

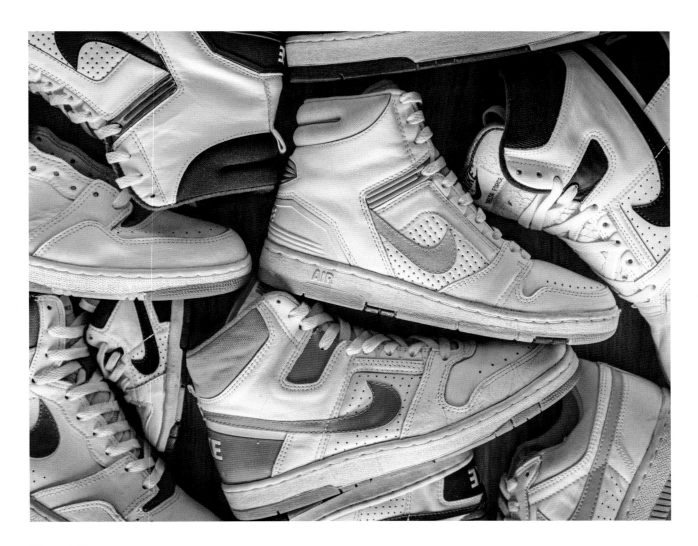

Wearability

In spite of all the issues with vintage shoes falling apart, I do wear some of the shoes regularly. The feeling of wearing an OG pair is unbeatable, especially if you wore them in the past, as it takes you back in time. It also makes me feel young again. Obviously, some pairs aren't wearable anymore, but that's okay for me as I already have so many shoes. Today I prefer to alternate OG pairs with new releases. I love trying all the new designs, especially the latest running models.

Vintage Nike apparel is another passion project, especially the pieces that were made in Spain in the mid-1980s. During that time, different countries, such as Japan, Italy and the UK, produced their own apparel under the licence of Nike in the US. Spanish-made apparel was what we had in our stores back then, so my memories are related to those pieces. I'm really excited about this stuff.

I also have some great Nike items from pro athletes who participated in the 1984 Los Angeles Olympic Games. Apart from that, I've got stickers, posters, hats, pins, bags and even some Nike Cross Trainer cassettes. I have never listened to them because I'm still waiting to find a Nike cassette player from the 80s to play them on!

Getting Personal

When I started looking for old stuff, I only wanted to get the pairs that meant something personal to me, so I left loads of pairs behind in the old sports stores. Years later, I tried to go back and buy them. Sometimes I was lucky, but other times the owners told me they had been cleaned out, given to charity or just thrown in the trash. When I heard those words, it felt like a knife in my heart.

I have spent a lot of time and money over the years, but it has always been a really cool experience. I've collaborated many times with Nike here in Spain, and it really pays off. My perception of collecting sneakers is not just owning hundreds of shoes but being able to tell their story. The fact of seeing my shoes exhibited as pieces of art makes me think that the collection I have curated over the years has some meaning. I'd love to learn more about vintage Nike history and apply that knowledge and my experience to the making of new retro releases. That's what I felt when I was invited to visit the Nike DNA in Beaverton. You know what they say – it never hurts to be dreaming!

★

@luisjumiguel

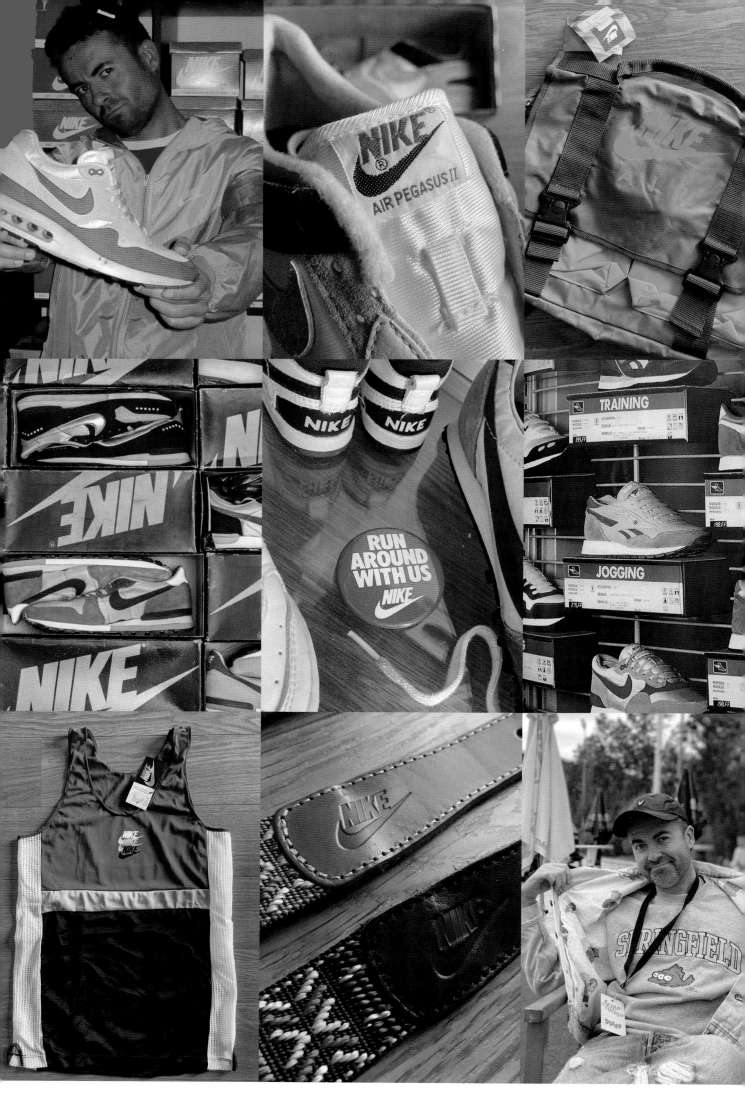

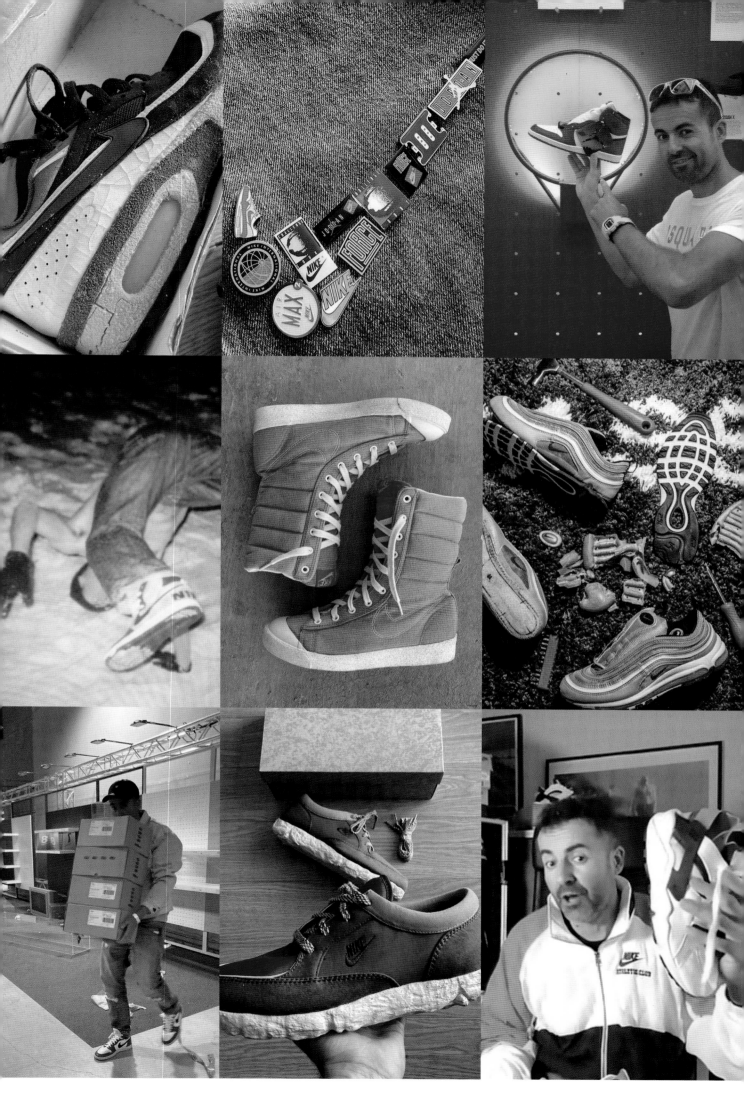

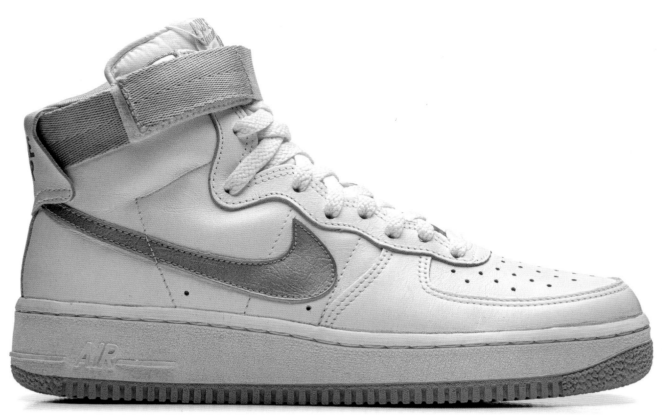

1983: Nike Air Force High

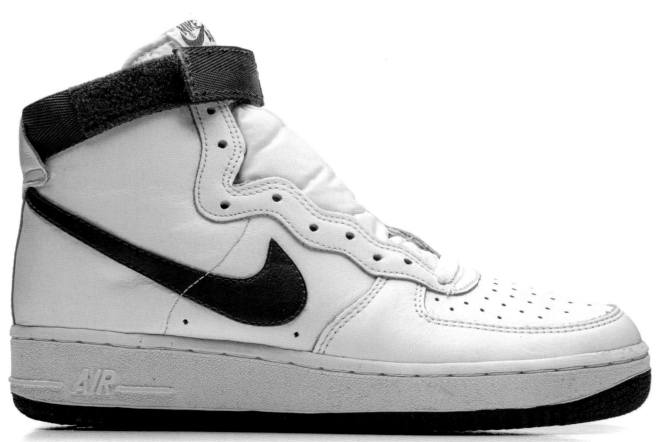

1989: Nike Air Force 1 High

1985: Nike Double Team

1984: Nike Air Train High

1987: Nike Air Revolution

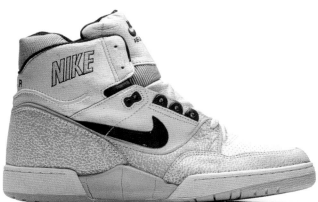

1988: Nike Air Assault

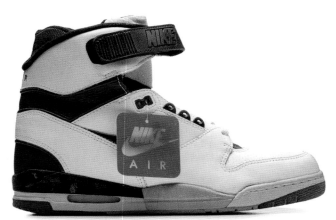

1987: Nike Air Revolution

1989: Nike Driving Force High

1982: Nike Legend

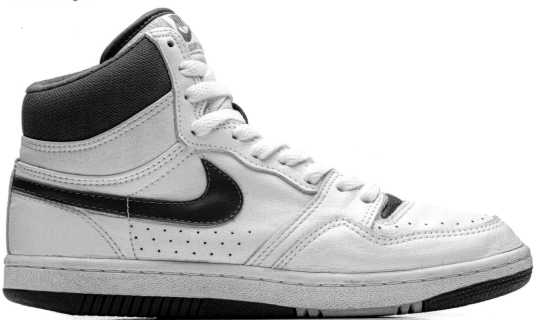

1987: Nike Court Force High

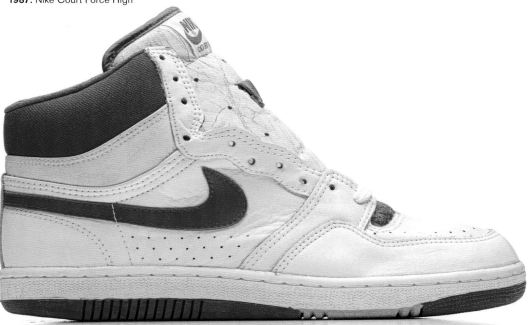

1987: Nike Court Force High

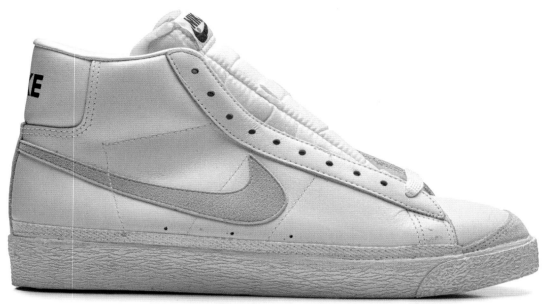

1980: Nike Blazer

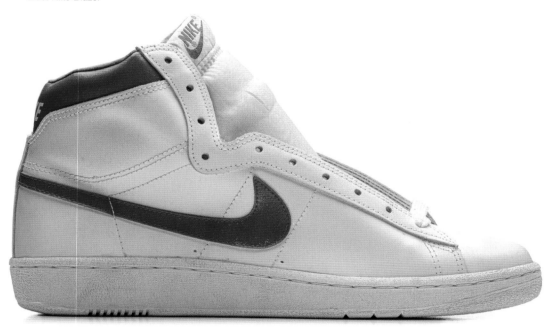

1986: Nike Glyder High

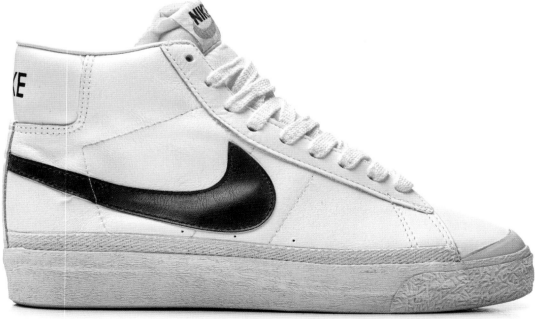

1978: Nike Blazer

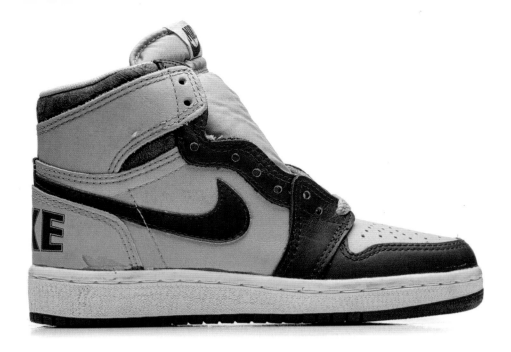

1985: Nike Terminator Hi Junior

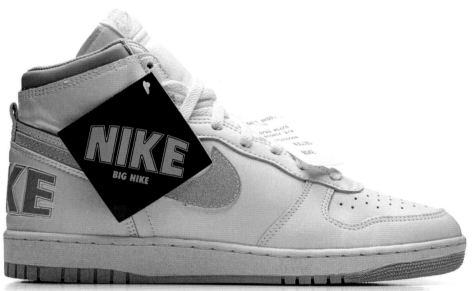

1986: Big Nike

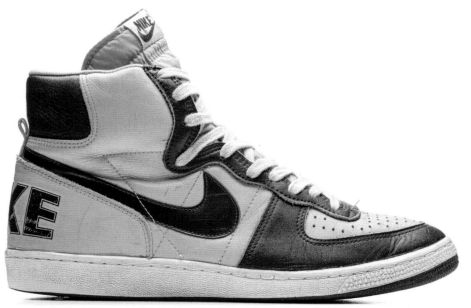

1985: Nike Terminator High

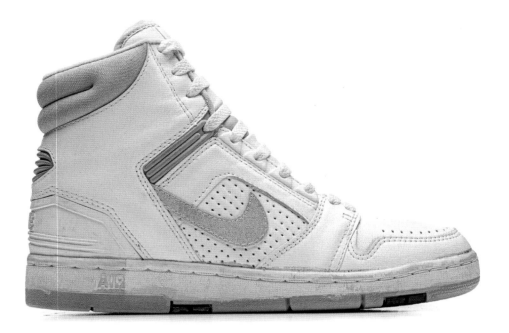

1986: Nike Air Force 2

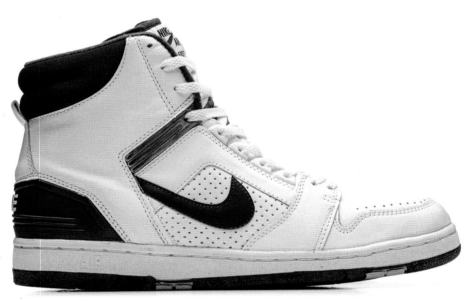

1987: Nike Air Force 2

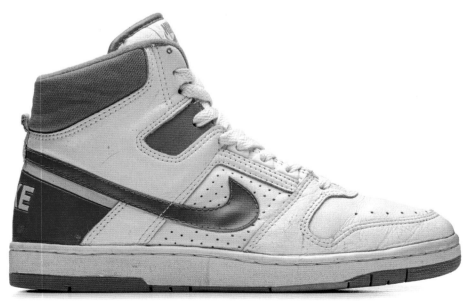

1985: Nike Delta Force AC

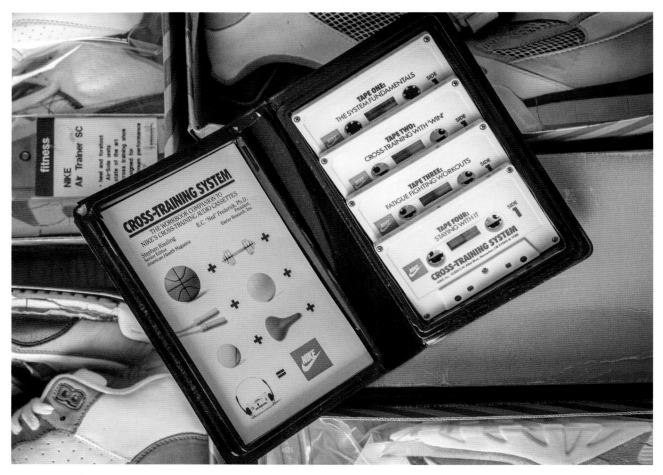

1987: Nike 'Cross Training System' cassettes

Nike ordering pads

1988: Nike Air Trainer TW

1982: Nike Legend

1988: Nike Multitrainer

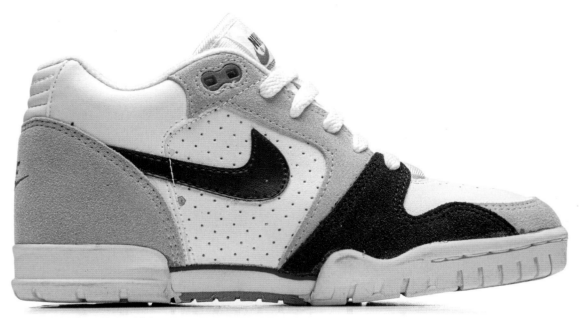

1987: Nike Cross Trainer High

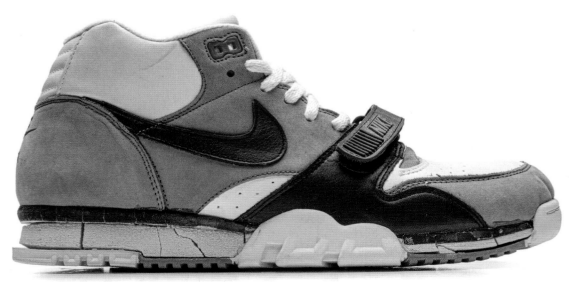

1987: Nike Air Trainer

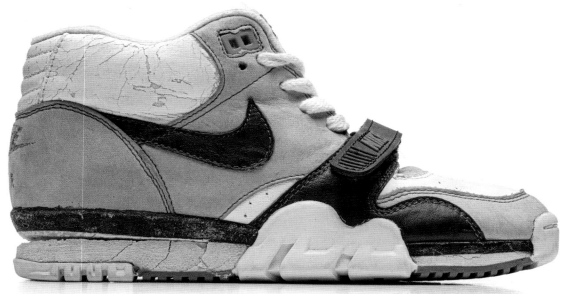

1987: Nike Air Trainer

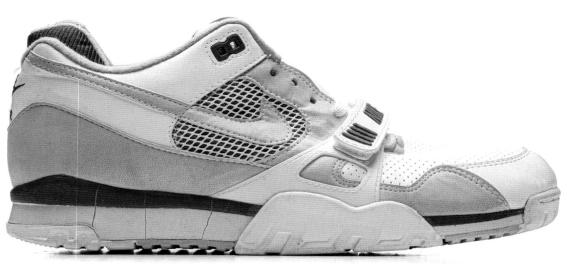

1988: Nike Air Trainer TW

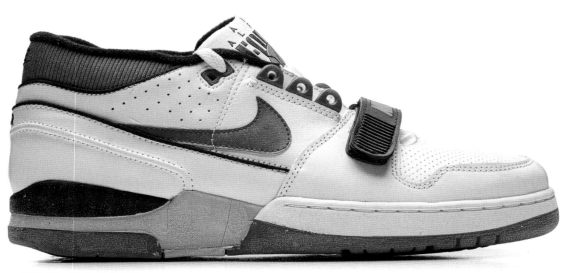

1987: Nike Air Alpha Force Low

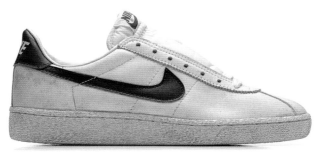

1985: Nike Bruin

1985: Nike Wimbledon GTS

1978: Nike Franchise

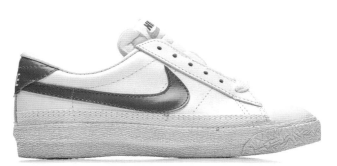

1979: Nike Lady Bruin

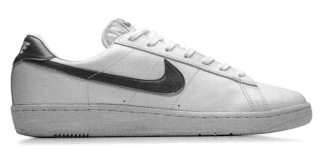

1986: Nike Glyder Lo

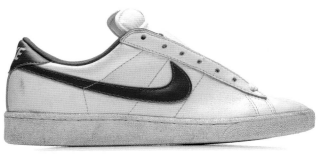

1986: Nike Tennis Classic

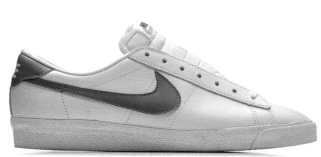

1980: Nike Wimbledon

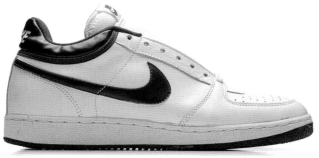

1985: Unknown (not Convention or Skyforce)

1987: Nike Court Force Low

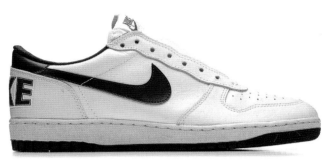

1986: Big Nike Low

1978: Nike Cortez Leather

1983: Nike Challenge Court

1986: Nike Delta Force Low

1987: Nike Air Force 2 Low

1987: Nike Court Force Low

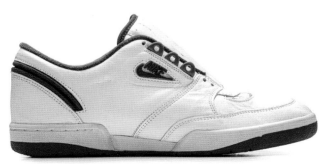

1987: Nike All England

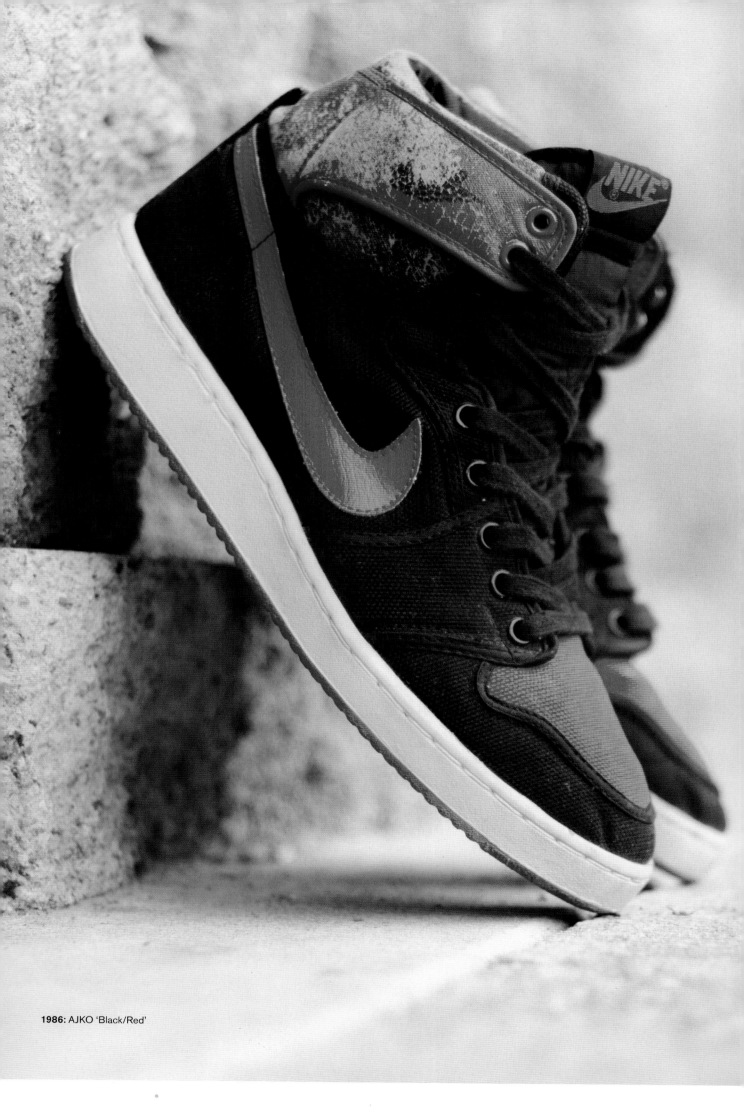

1986: AJKO 'Black/Red'

OG ONLY!

Photos:
Rolo Tanedo Jr

Head down to your local mall on just about any Saturday morning, and chances are high you'll find the Air Jordan faithful staking out Foot Locker, hoping to get the Jumpman on the latest retro release. But for a tight circle of vintage nerds, original pairs are the only Jays that matter, even if it means the use-by date has long since evaporated. For Rolo Tanedo Jr, cracked uppers and crumbled midsoles are all part of the intrinsic charm.

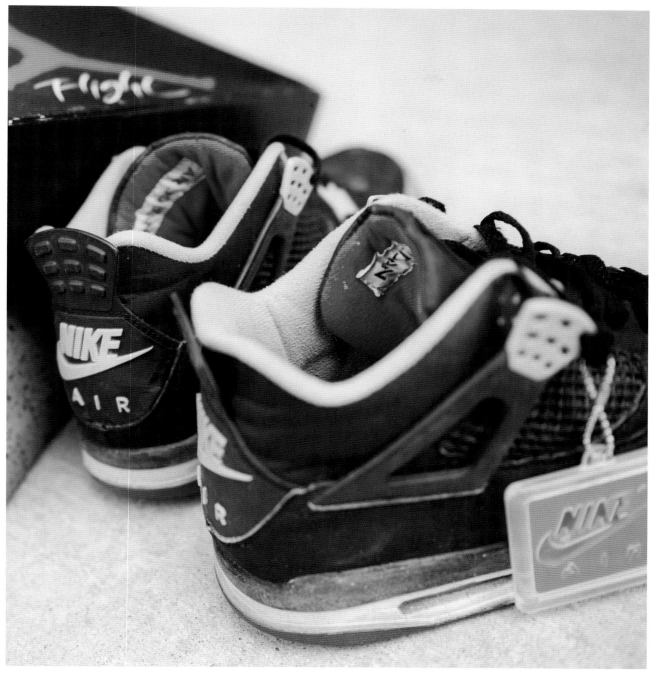

1989: Air Jordan 4 Black/Cement Grey

Let's get this straight. Your collection is totally dedicated to crumbling kicks?
If we're talking original Jordans, then yes! [Laughs.] Not all of them are dead, though. Some of them are still wearable today, like the original Air Jordan 1s. I actually wear them regularly.

Including the 'Military Blue' 4s? That bubble is clear as day.
Truth be told, those 4s have been restored and fitted with a fresh midsole. They were actually my first sole-swapped pair. Some people want to wear their original pairs and display them looking immaculate. Obviously, if you sole-swap a pair, they're no longer in original condition. I'd rather find OG pairs and leave them crumbled, as that way, they're a piece of history.

What about the 'Sport Blue' Jordan 6? They look in amazing shape.
Yeah, they have been sole-swapped as well, but the uppers are in phenomenal condition, so it was impossible to pass them up. With a lot of original Air Jordans, the state they're in today depends on who owned them prior. What I mean by that is that whoever owned the shoe before me really determines how long it will last in the future. The Jordan 6 midsole is made from polyurethane, so it's inevitable it

will die at some stage, especially the early releases. The uppers are what I usually look at when I'm hunting down pairs because they'll long outlast the sole unit.

Are there any OG models still considered safe to wear?
The Air Jordan 1 is almost always wearable because the stitched-on rubber cupsole lasts forever. The sole units on the rest of the early Jordans are made from polyurethane, so unless they've been sole-swapped, it's pure luck if they survive. In my collection, the Jordan 7 and 10 through 14 are all still perfectly wearable. I usually check my pairs pretty closely before I rock them, but I haven't had any major issues yet – touch wood! For the 11s, I normally just check for separation between the midsole and rubber outsole before wearing them. Even if they start coming apart, I add a little glue, and they're good to go.

What's the appeal of collecting vintage Jays? Especially the totally dead pairs. A lot of collectors would struggle with this idea conceptually.
It's all about the way they were made, the way they look, the shape, the materials and everything behind the creation of the shoe.

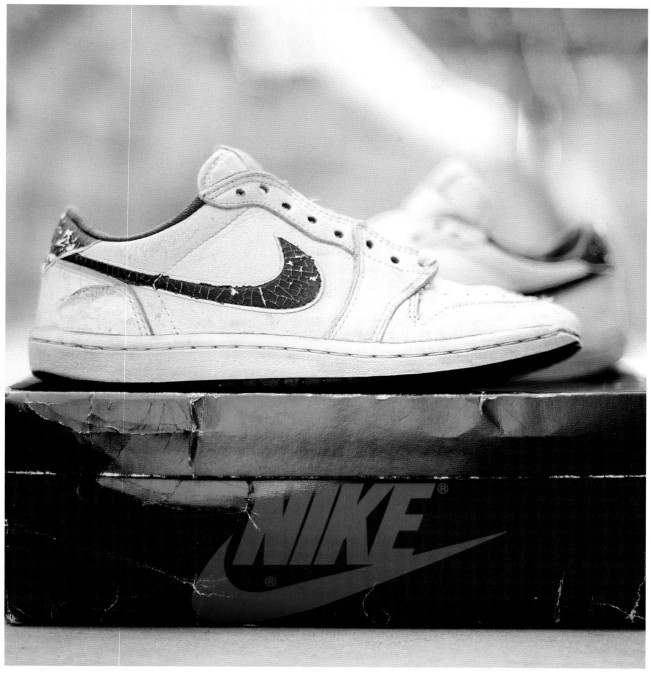

1985: Air Jordan 1 Low White/Metallic Blue

These shoes are a piece of history you can hold in your hands. That's why I always try to find them in their original condition, even if it means the midsole is falling apart.

When it comes to Jordans 1 to 4, I'll take just about any size because they're so hard to obtain. I can be a little pickier when I'm hunting for Jordan 5 onwards because there are more pairs out there, and I do see my size pop up now and then. It's all just a matter of waiting for a pair to show up in the right condition and for the right price.

It doesn't look like you're too far off completing a full set of Jordan 1s.
The 1s, by far, has been the hardest set to complete, especially if you're trying to obtain them in your size – which of course I am! [Laughs.] It's taken a long time to get to this level. If we exclude samples – and you are really diving into rare Air territory there – I'm only missing three of the original Air Jordan 1 releases, namely the 'White/Natural Grey' Low, the 'White/Metallic Orange' High and the 'White/Metallic Burgundy' High.

Having a lot of money to spend can make it easier to build up a collection, but it's not always about money. Some pairs are so hard to come by that it's rare to even find them for sale in any size

or condition, no matter how much you are willing to pay. When they do show up, getting the right size isn't quite so important, I'm just happy to finally have them in my collection, regardless of whether I can wear them.

We could have sworn there was a 'White/Metallic Red' Low in the original line-up as well.
Some websites have it listed as an original colourway, but personally, I don't believe they exist. It's been decades since they allegedly released, and not a single photo has surfaced – not even a bad one! I don't know anyone that has ever seen a red pair.

What's the story behind the 'Pro-Joggs' Jordans? Would you say they're lookalikes?
Those came from a homie of mine down in Los Angeles. He spends a lot of time scouring flea markets for rare sneakers. He hit me up, and the price wasn't bad, considering that even bootleg Jordans are hard to obtain. I couldn't tell you exactly what year they were made, but putting them side by side with the actual Jordan 1s from 1985 is really interesting, as the differences in materials and how they were made are obvious.

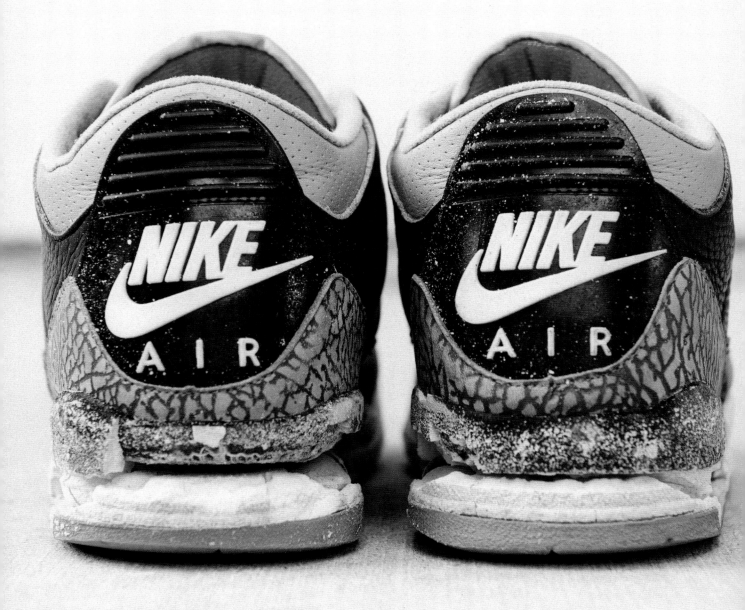

Bootleg manufacturers used a thick synthetic rubber-like material for the upper in place of leather, which is why they've held up better with age, especially around the collar. They might look okay in photos, but the quality is nowhere near as nice in real life. They might not be real Air Jordans, but they're something I like to have because I still feel they're part of Jordan history.

Do you take any special archival measures when it comes to storing your collection?
I make sure to keep them stashed away in a closet hidden from sunlight. I've been storing them this way for years, and it seems to have worked out so far. Some people say you should seal pairs in plastic bags with silica packets to soak up any moisture, but in my experience, that just dries out the shoe and causes it to age faster.

We always hear complaints about the quality of retros. How do you feel about that?
There's no denying the originals are noticeably better than the retro releases, especially the more recent ones. But honestly, some of them are pretty close. The first round of retro Jordans released between 1994 and 1995 are very similar to the originals in terms of quality. Not 100 per cent, but they're pretty close. Some of the

retros from 1999–2001 were pretty good as well, and they still featured the original branding. After 2001, the quality definitely took a hit, though. The materials were nowhere near the same, and they ditched the Nike branding entirely for the Jumpman. Honestly, I really enjoy comparing the differences between the retros and the OGs – it's a huge part of why I've invested so much in collecting the originals.

What's been the toughest pair to acquire?
That would have to be the 'Metallic Purple' Jordan 1 for sure. Money is always a huge factor when it comes to obtaining the rarest sneakers, but I know if I spend too much on a pair, I hate myself. I always set a limit, and if I spend over that amount, it has to be for a good reason. In five years of searching, it was the first time I'd seen the 'Metallic Purple' on eBay. I didn't care what the price was. I'd wanted to own that sneaker for a very long time, and it was one of the last remaining Jordan 1s I needed to complete the set. Condition and size didn't matter. I had to have them!

Do you have a secret source?
The days of finding pairs at thrift shops or flea markets are all but over. Most of my pairs come from eBay and occasionally from people

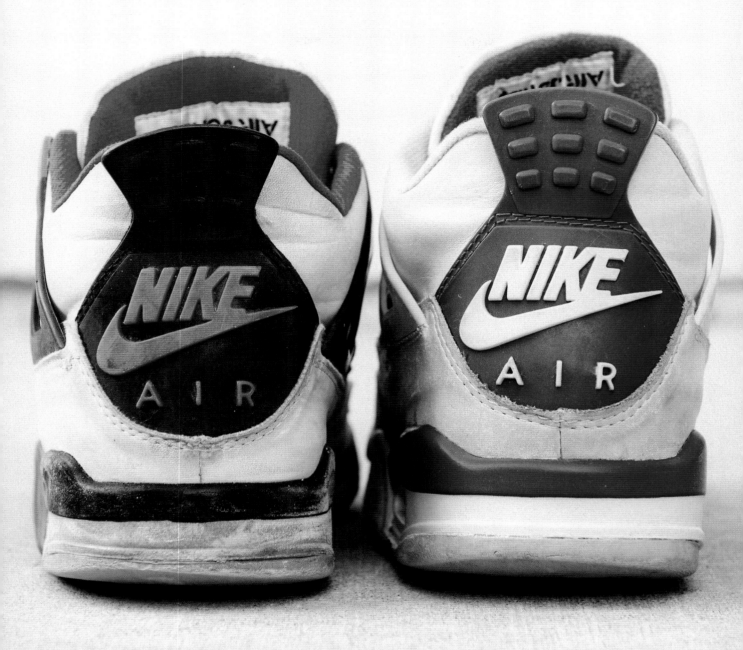

contacting me on Instagram, but I've had a lot of luck sourcing pairs from friends and other long-time collectors. I've also been fortunate enough to be gifted a few pairs over the years. One of my homies was selling his 'Black Tongue' Jordan 5s from 1990. After meeting up, he pulled out another box and said, 'Here you go, man, you can have these!' I opened the box, and the 'Aqua' Jordan 8s from 1993 were inside. They were his father's shoes, but he wanted me to have them, as he knew they were going to a good home. As if that wasn't amazing enough, it turned out they were in my size.

Do you ever sell to trade up?

It has crossed my mind. If I ever did, it would be the Jays I don't really have any emotional attachment to. I would keep the more sentimental pairs – the ones that have some significance or a great story behind how I got them.

Holy Grail?

For a long time, the OG 'Black Cement' Jordan 3 from 1988 was my Grail. It didn't matter how much I looked or how much I was prepared to pay – they were nowhere to be found. It took me ten years to finally secure a pair, and now I have two. Better still, both are in my size, complete with box and trimmings! I found the first pair on Craigslist.

I contacted the guy, and he lived an hour away. It was raining heavily that day, but bad weather wasn't gonna stop me!

When it rains, it pours.

When we linked up, he told me the shoes were crumbling and asked if I still wanted to buy them. Hell yeah! He told me he got them in 1988 when he was in college. When they started to crumble, he just left them in the box.

Sure enough, two months later, another pair of 'Black Cements' showed up on eBay. It's wild that two pairs arrived in such a short amount of time, especially given how long it took to find the first pair. I guess I just got lucky. Over time, I have had countless offers, including some insanely high numbers, but I don't think I'll ever part with them.

Where does the obsession end?

I told myself I would stop at the Jordan 14, but since then, my mindset has changed. Right now, I want to obtain a complete set of every original pair from the Jordan 1 to the 23. And a few later models as well. If I were to complete that goal and obtain every original pair, well, I'd probably set my sights on the retros and try and complete them as well!
★

@dunksrnice

Honors Sport (Air Jordan 1 Knock-Off)

Pro-Joggs (Air Jordan 1 Knock-Off)

1985: Air Jordan 1 Black/Red

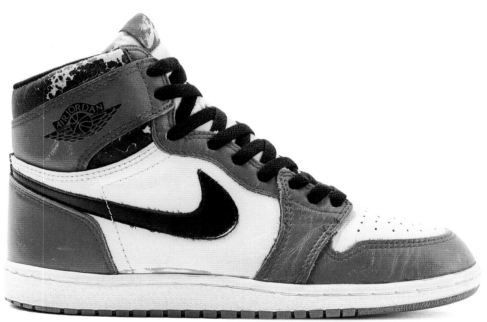

1985: Air Jordan 1 White/Black-Red

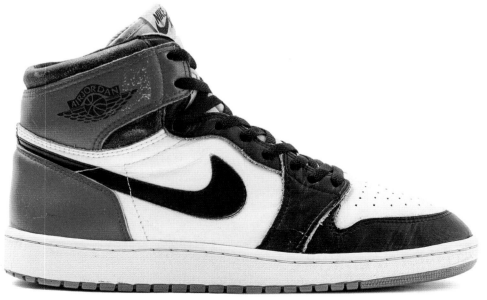

1985: Air Jordan 1 White/Black-Red

'Money is always a huge factor when it comes to obtaining the rarest sneakers, but I know if I spend too much on a pair, I hate myself. I always set a limit, and if I spend over that amount, it has to be for a good reason. In five years of searching, it was the first time I'd seen the "Metallic Purple" on eBay. I didn't care what the price was. I'd wanted to own that sneaker for a very long time, and it was one of the last remaining Jordan 1s I needed to complete the set. Condition and size didn't matter. I had to have them!'

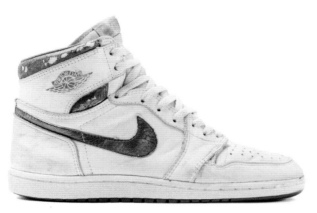

1985: Air Jordan 1 White/Metallic Purple

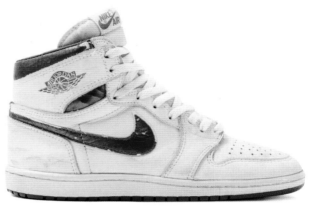

1985: Air Jordan 1 White/Metallic Green

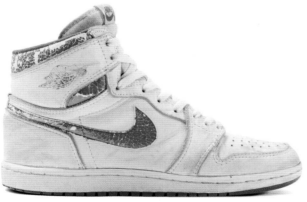

1985: Air Jordan 1 White/Metallic Red

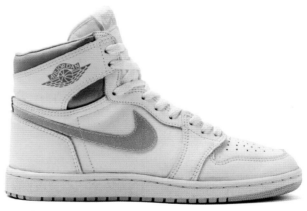

1985: Air Jordan 1 White/Natural Grey

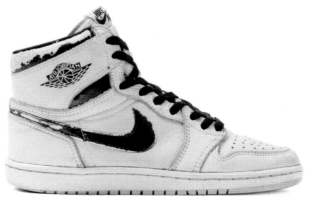

1985: Air Jordan 1 White/Metallic Black

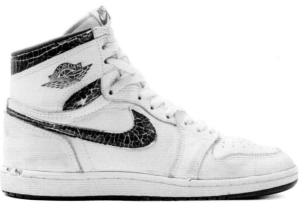

1985: Air Jordan 1 White/Metallic Blue

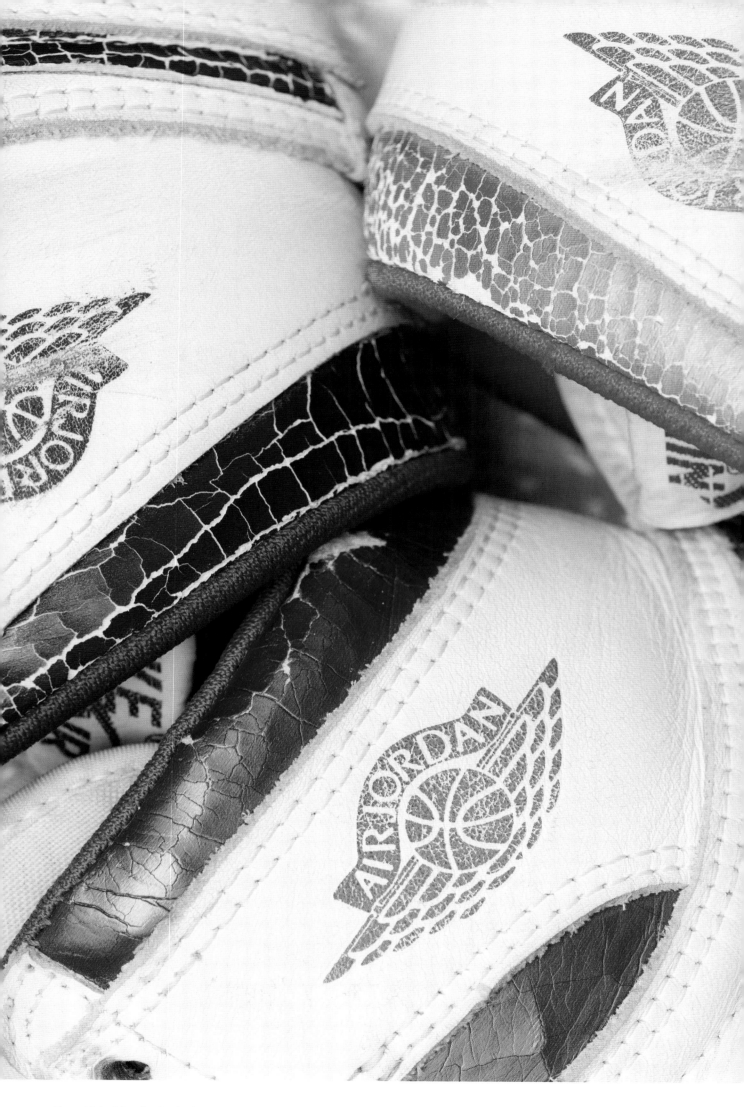

1985: Air Jordan 1 White/Blue

1985: Air Jordan 1 White/Dark Powder Blue

1985: Air Jordan 1 Black/Royal Blue

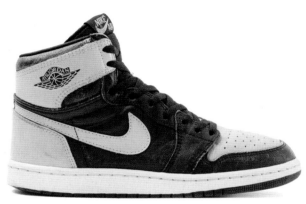

1985: Air Jordan 1 Black/Grey

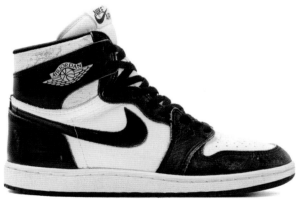

1985: Air Jordan 1 White/Black

1985: Air Jordan 1 Low White/Metallic Blue

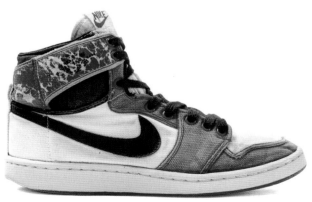

1985: AJKO White/Black-Red

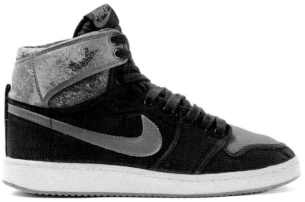

1986: AJKO Black/Red

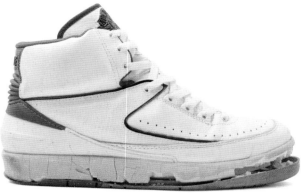

1987: Air Jordan 2 White/Red

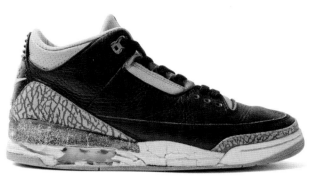

1988: Air Jordan 3 Black/Cement Grey

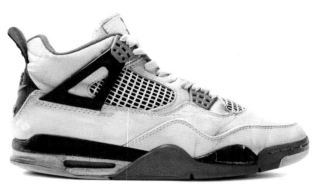

1989: Air Jordan 4 White/Fire Red

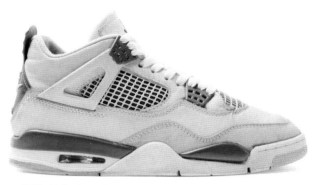

1989: Air Jordan 4 Off White/Military Blue

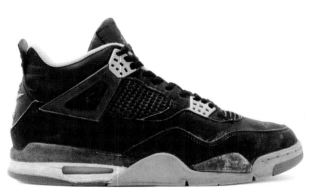

1989: Air Jordan 4 Black/Cement Grey

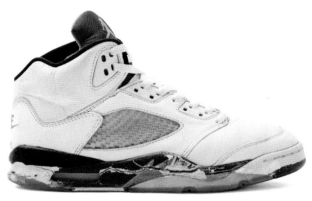

1990: Air Jordan 5 White/Grape Ice-New Emerald

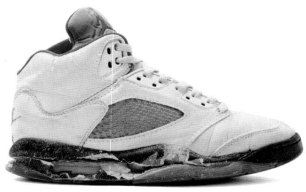

1990: Air Jordan 5 White/Black-Fire Red

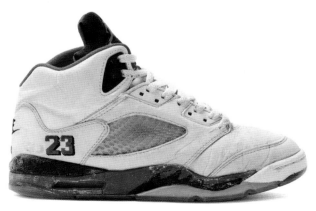

1990: Air Jordan 5 White/Fire Red-Black

1991: Air Jordan 6 White/Carmine-Black

1991: Air Jordan 6 Black/Infrared

1991: Air Jordan 6 White/Infrared

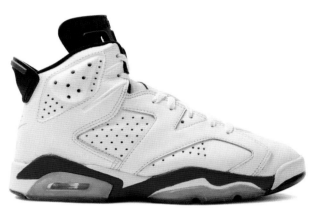

1991: Air Jordan 6 White/Sport Blue-Black

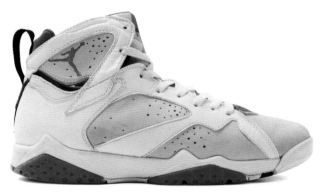

1992: Air Jordan 7 White/True Red-Light Silver

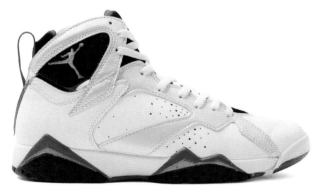

1992: Air Jordan 7 White/Midnight Navy-True Red

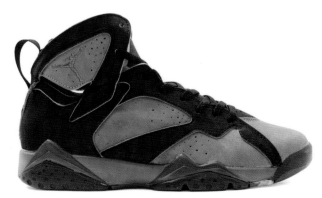

1992: Air Jordan 7 Black/Light Graphite-Bordeaux

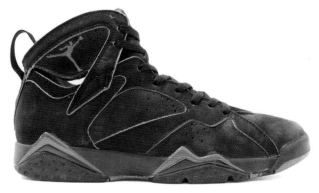

1992: Air Jordan 7 Black/Dark Charcoal-True Red

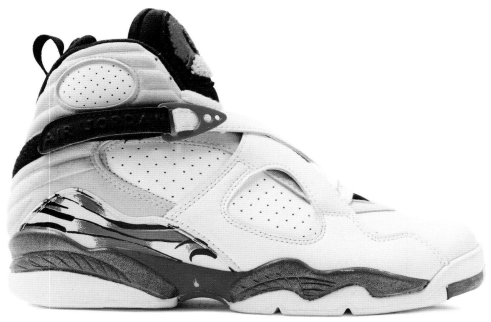

1993: Air Jordan 8 White/True Red-Medium Grey

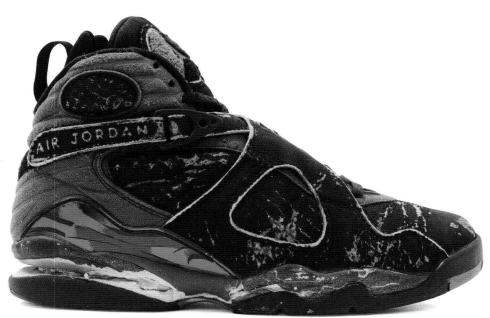

1993: Air Jordan 8 Black/Bright Concord-Aqua Tone

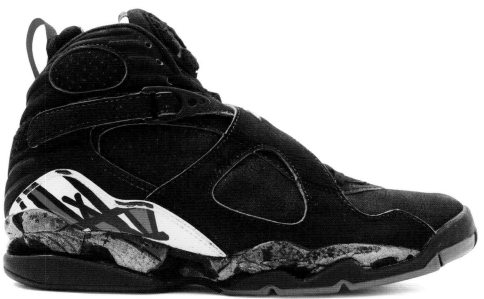

1993: Air Jordan 8 Black/Black-True Red

PATRICK

IS BACK IN TOWN!

Story: **Woody**
Photos: **Roman Wong**

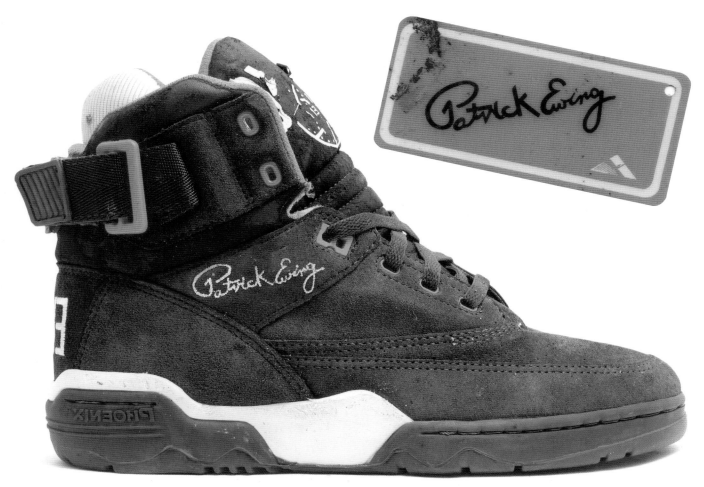

Ewing 33 Hi

DAVE GOLDBERG
EWING COLLECTOR
NEW YORK CITY

Patrick Ewing played 1039 games for the Knicks, made All-Star 11 times, won Dream Team gold at the 1992 Olympics, scored 24,815 points in the NBA and is recognised as one of the best 50 players in NBA history. But that's not what this feature is about. In 1986, Ewing signed an endorsement deal with adidas, but within five years, he was a free agent dominating Madison Square Garden in chunky hightops that flaunted his own name and jersey number. While Ewing Athletics would only survive until 1996, the footwear legacy remains vivid. As a native New Yorker and Knicks fan throughout the Ewing era, Dave Goldberg had a ringside seat, developing a crush that would bring him full circle decades later.

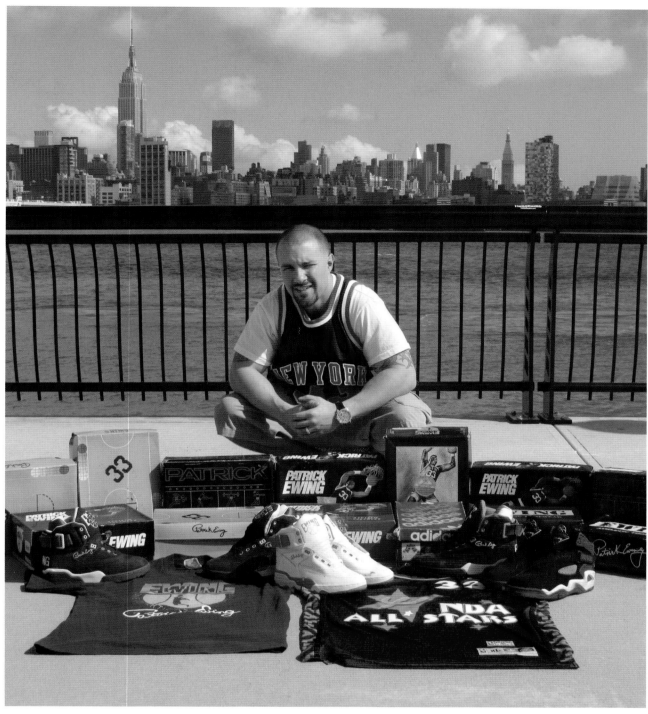

Dave Goldberg

Were you a Ewing fan, or was it all about the shoes?
Both actually. I grew up in New York, and my interest in Ewing Athletics was the culmination of the Knicks being my favourite team and Patrick Ewing being my favourite player. I loved his sneakers as well.

As a nine-year-old, I noticed Patrick was wearing the 33 Hi in games and figured they must have been adidas customs since I was aware he endorsed the brand. Then one day, I saw someone wearing 'Ewing' sneakers and realised it was his own company. By late 1991, Ewings were the hottest shoes, and I finally convinced my mom to get me a pair.

Myriad colourways were available of the 33 Hi, and soon they had other models, not just his signature game shoe, but cross trainers and runners too. It's funny, but I can recall somehow finding the phone number of the Ewing Athletics office and ringing to tell them my family owned a store – which we certainly did not! Every season after that, they sent me sales catalogues.

How did the collector bug start all these years later?
I was always into sneakers and took note of all the models and styles, especially by the time the Jordan 3 came out in 1988. My first proper pair was the Jordan 5 in black and silver, and then after that, as I said, I got the Ewing 33 Hi. To this day, when you mention Ewing to anyone, nine times out of 10, they always think of the 33 Hi model. In 1996, Ewing released the Empire – which turned out to be the final model and was sold through Foot Locker and direct to consumers via phone sales.

As the years went on, I managed to find a few vintage pairs for dirt cheap. But as more people picked up on the shoes, prices began to rise. It got to a point where I was paying $300 for a pair of 33 Hi deadstock in the box! At least they were in perfect condition – and in a previously unseen black/white colourway.

Score! You must have some good hunting stories.
There are a few. As time went on, I acquired more and more Ewings, but they were either obscure models or in broken-down condition.

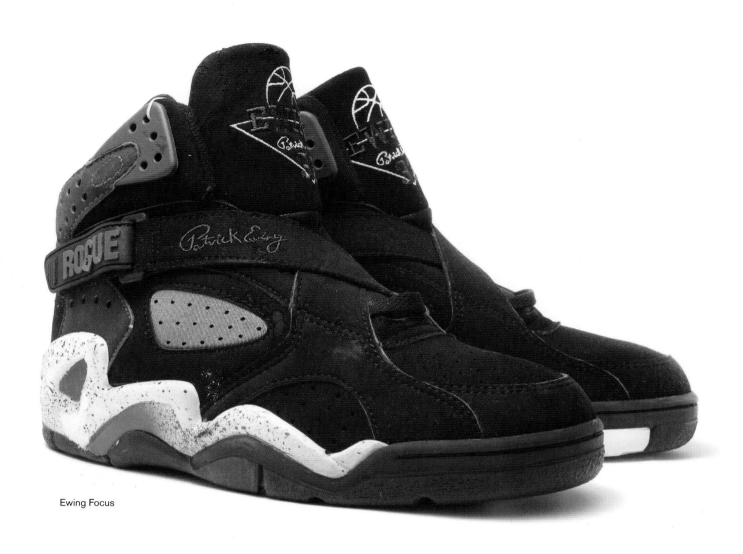

Ewing Focus

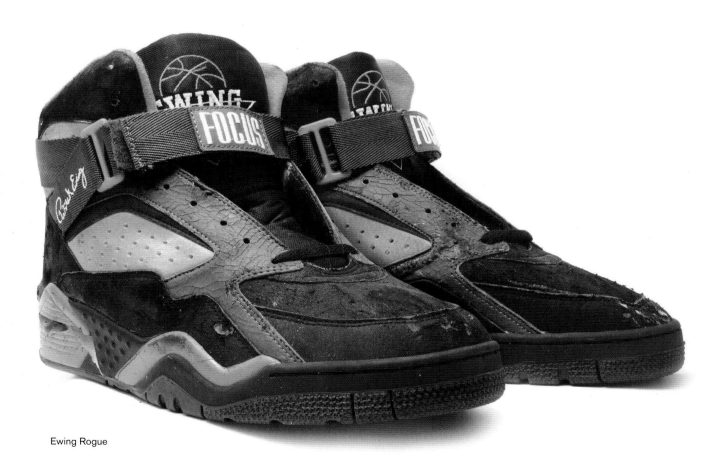

Ewing Rogue

The Ewing Orion tag

One day I noticed an eBay seller put up a few pairs. Long story short, I ended up paying about $1000 for more than 30 pairs in what is my greatest deal to this day. Most of the shoes were super-rare colours.

Since then, I've scoured the world, and I now have pretty much every Ewing model. I have Patrick's Olympic shoe, known as the Eclipse, as well as a few PEs and autographed samples. I recently picked up an unworn pair of the adidas Conductor in the original box with the tissue paper. They came from Yahoo Japan.
I also have a pair of Nikes with his name and number on the tongue from his final season at Orlando Magic. Even though he wore adidas early in his career and Nike at the end, the Ewing Athletics models are the best.

Any models you don't have?

There is one model missing from my collection. Patrick wore the Image in the 1994 All-Star Game and liked it so much that he wore it through the entire 1995 season, including the playoffs. It had a Nike Huarache-like upper and a ventilation system on the sole. I have never been able to find a pair, unfortunately, but they'll turn up one day.

The Rogue still looks fresh.

The Rogue II in black and purple with the straps has gained a ton of internet fame in recent years. Most people don't realise that the shoe was a European exclusive and never came out in the US. I bought a pair from Italy a few years ago. It's definitely a solid shoe, but for me, it drew too much inspiration from the Jordan 8 in both the design and colourway. Many of the later Ewings went this route, and it negatively affected the public's perception of the brand, at least here in New York.

And the Focus?

The Focus was Patrick's game shoe in the 1992–93 season. It's extremely bright, and I consider the blocking to be years ahead of its time. Back then, NBA players didn't wear loud, bright or exotic colours. They wore all-white or all-black shoes with highlights based on their team colours. The Focus was ridiculously bright. I remember TV announcers talking about how insane the orange was. Nowadays, of course, this is standard practice.

The Wrap Hi is another classic.

The Wrap Hi from 1994 was not worn by Patrick in games, but it is pretty distinctive with its built-in ankle strap and the way it attached and detached from the shoe. Years later, the Jordan 20 used the same idea, but Nike made it attachable at the front of the foot, not the back. It was the most original idea I had ever seen at the time, and I remember playing with it in the store, trying to understand exactly how it worked. Funnily enough, I picked up a pristine deadstock pair two years ago from Poland. They look practically brand new.

I never knew Ewing made cross trainers like the Swatt.

Actually, the Swatt was a basketball shoe, but it was a lower-end model with a gum rubber sole. The Ewing game shoes and performance models retailed for about $75 in the mid-90s at a time when Jordans and top-tier Nikes were about $120. The lower-end Ewings were toned down in terms of features and were closer to $50, but these became very popular as they provided kids with a hot NBA name at an affordable price. The higher price tag on the game shoes kept the brand cool and close to the bigger competitors.

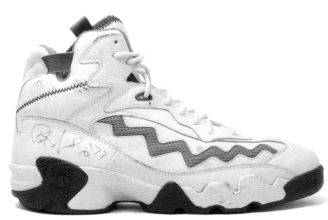

Ewing The Empire

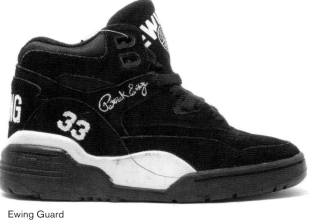

Ewing Guard

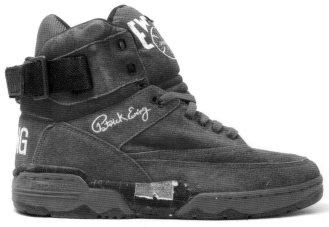

Ewing 33 Hi

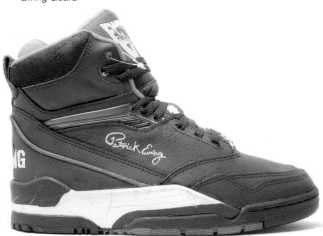

Ewing Centre

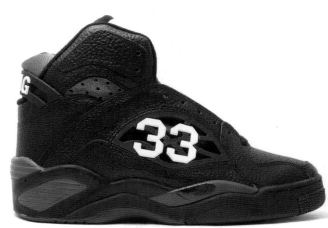

Ewing Domain

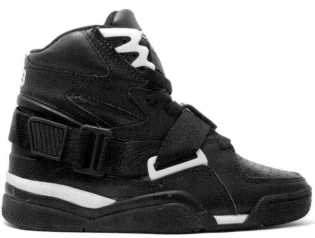

Ewing Concept

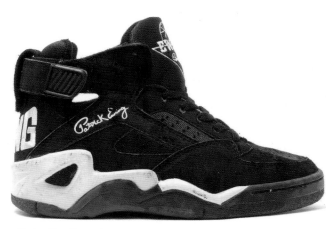

Ewing Baseline

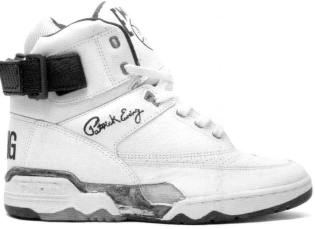

Ewing 33 Hi

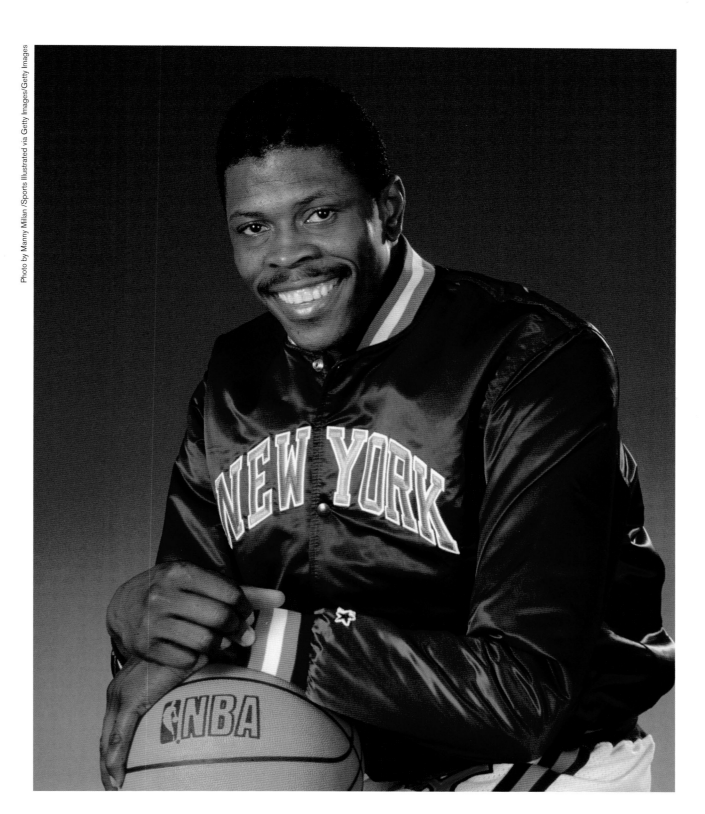

The big logo boxes still look mighty impressive.
I love all the boxes! The Ewing branding was definitely strong, and the look was a huge part of the appeal. You have to remember there was no big brand like Nike or adidas behind them, so they had no choice but to rely heavily on the Ewing name and the extreme branding. The distributors, Phoenix and Next Sports, sometimes had their names on the tags or boxes, but they just did the production and distribution for Ewing Athletics.

I'm not sure any current player will ever start their own brand.
I agree. People forget that Patrick Ewing was the first player to have his own brand and that he did it well before Michael Jordan. MJ just endorsed Nikes until they created his sub-brand in 1997. Years earlier, Patrick had his own brand with his own name on the tongue! And just like the Jordan Brand of today, they were releasing up to 20 different models a year, as well as apparel.

I think Ewing deserves more recognition for this achievement. I often wondered if Kobe or LeBron would leave Nike and build their own company. It could be a lot more lucrative, but it's also riskier, which is probably why no one has ever tried it seriously since.
★

@biglescobar

Update: After this article was published, Dave Goldberg connected with Patrick Ewing, and together they resurrected the long-dormant brand. The 33 Hi was re-released to wide acclaim, along with many OG Ewing models.

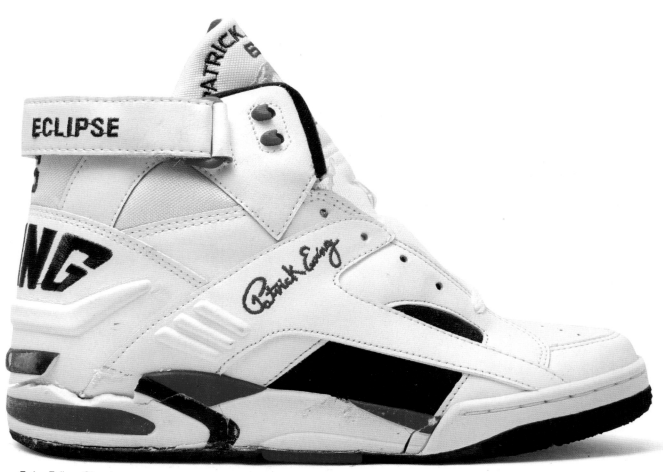

Ewing Eclipse Olympic

Ewing Warrior

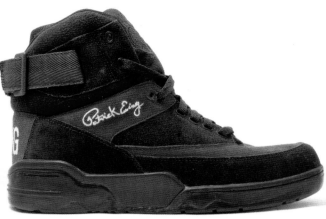

Ewing 33 Hi

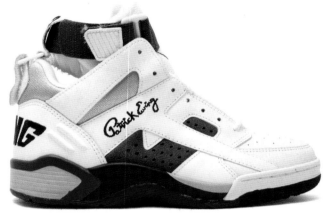

Ewing Wrap

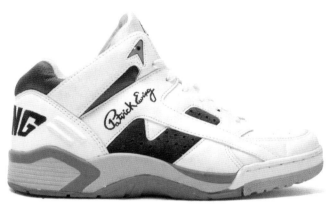

Ewing Wrap

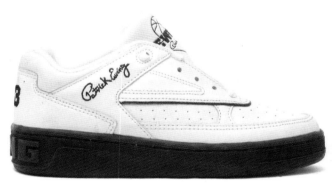

Ewing Orion

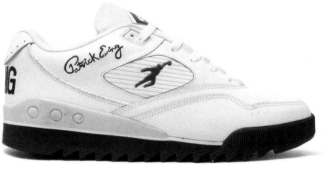

Ewing Turf (Sample)

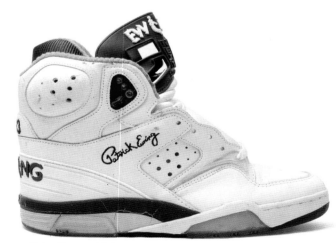

Ewing Extreme High

Ewing Sport

Images: Beau Ridge

DARRYL GLOVER

KING KOBE

COLLECTOR FEATURE

In 1996, at the age of 18, Kobe Bryant became the youngest player in the history of the NBA. Two decades and over 1300 games later, the Lakers superstar racked up five championship rings, back-to-back Olympic gold medals and one hard-earned MVP award. To pay tribute to this legend of the hardwood, we searched far and wide until we came across Darryl Glover. From moon boots based on the Audi TT sports car to exotic Player Exclusives, Glover has a serious case of Mamba Mania.

This feature was initially published in 2016. Tragically, Kobe Bryant was killed in a helicopter crash in 2020.

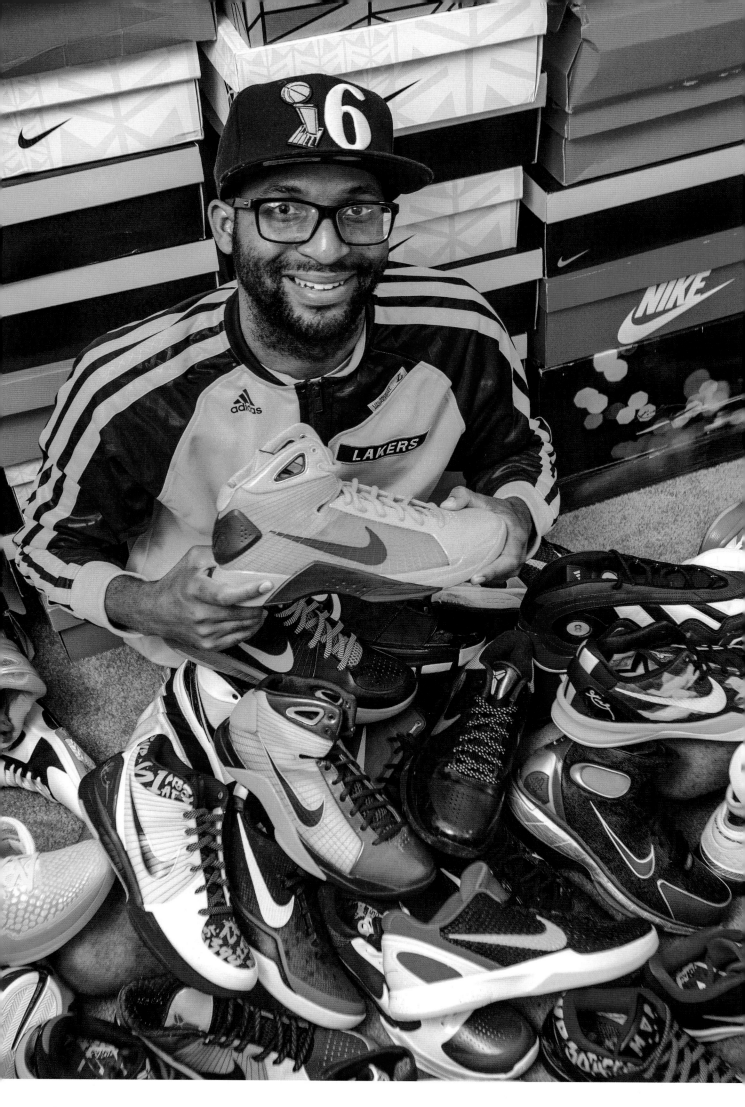

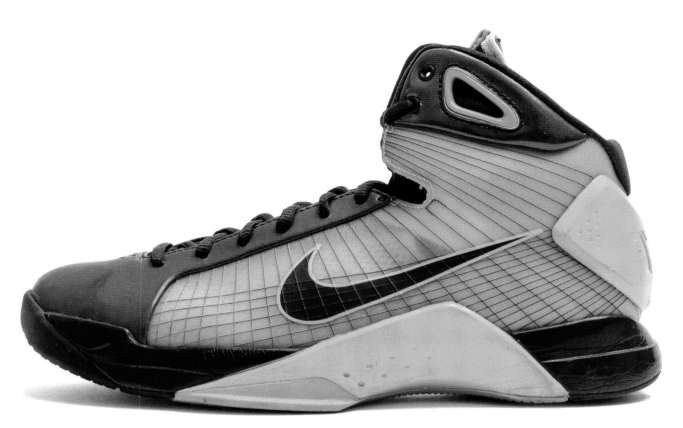

2008: Nike Hyperdunk 'Lakers Home' (Kobe Bryant PE)

First things first. Nike or adidas – who did it best?
What Nike have done with the Kobe line is nothing short of amazing. They've pushed the envelope and produced real classics. I'd argue the Zoom Kobe series has delivered some of the best models in Nike's entire basketball history, both in looks and performance. The tech in their products is on another level.

Why Kobe?
Dad was a Lakers fan, so I grew up a Lakers fan. As for Kobe, to see someone so young, with so much talent and drive, really impressed and inspired me. Before Kobe, I followed Jordan, of course, but who didn't back then?

We can imagine you copped a bit of flak as a Lakers fan in Jersey.
All my friends dogged me for it. They were all Sixers fans back in the Iverson days.

When did you make the transition from newbie to full-blown collector?
I was already a sneakerhead before I started collecting Kobe's shoes. The first pair I bought was the Zoom Kobe 1 in 2006, back when I was 16. They were sitting on a sales table at the mall marked down to $90. I didn't even know they were Kobe's new shoe when I saw them. Once I realised, I just had to have them. I'm a huge fan of the player, but I'm just as big a fan of his shoe designs. Currently, I've got about 260 pairs, with at least 60 pairs of Zoom Kobe 5s alone.

We're not going to lie. The adidas Kobe 2 is divisive.
People just weren't ready for such a radical design. I remember my friends calling them 'moon boots'. The Kobe 2 was inspired by the Audi TT, so it's really no different from the Air Jordan 14, which took design cues from the Ferrari 550M. When it comes to design, Kobe was performance first and looks last. I thought the Kobe 2 was interesting, but I must confess that I never bought a pair back in the day, as people would just look at you weird. Apparently, adidas were hard at work on the Kobe 3 before he jumped ship.

I've never seen a pair. Are they in your collection?
No, but I know someone who owns the samples. They are extremely nice and really well made. It would have been great if adidas released them, with or without Kobe's name. The design was a lot sleeker than the Kobe 1 and 2, and I think it would have been much more

widely accepted, even by non-Kobe fans. They still look futuristic. I've also heard good things about the HUG closure system that adidas incorporated into the design, but it's hard to say how it would have performed on court. It's a shame adidas abandoned the tech after Kobe switched over to Nike. I will admit, though, while the adidas designs were nice, Nike really nailed it when they took over the reins.

Undeniably so. Which is your favourite?
I like them all, but the Zoom Kobe 5 definitely stands out. As does the ZK 1. And the ZK 2. And the ZK 3. And the ZK 4… Don't make me choose! I try to collect every shoe that is connected to Kobe and the Lakers. I've got Kobe Hyperdunks, Flight Huaraches, Air Force 1s and the Huarache 2K4, but the Zoom Kobe 5 is definitely my favourite. The look, the fit, the on-court feel… it's perfect. An absolute ton of insane colourways, like the 'Bruce Lee', 'Dark Knight' and 'Chaos' releases that have come out over the years.

Kobe also won his fifth ring wearing the ZK 5. I really started going crazy with collecting around this time and bought probably 40 or 50 pairs, including doubles and triples. I even quadrupled up on the 'Lower Merion Ace' Kobe 5s that were inspired by Kobe's former high school. That sneaker is absolute perfection.

With its super-high-cut stance, the Zoom Kobe 9 was a totally different look. Are you a fan?
I am. Kobe injured his Achilles playing against the Warriors when he was wearing the ZK 9s, so Nike had to regroup and design something that supported his ankle better. I think Eric Avar from Nike proved that you can't put him in a box and that he can meet and rise to the challenges and standards set by Kobe and create a great shoe. I wear my pairs often, both high and low. The comfort and set-up are a little different, one being Engineered Mesh and the other Flyknit, but both are comfortable as can be.

Must take a whole lot of confidence to pull off that bright pink duo.
They were created in honour of Kay Yow. She was one of America's most highly regarded basketball coaches and led the Olympic team to victory in 1988. Sadly, she passed away from breast cancer back in 2009, so Nike released the sneakers to celebrate her life and raise awareness. I wear them a lot, actually. My mum is a breast cancer survivor, so I have absolutely no shame wearing pink.

The KOBE found at select stores 11.03.2000
www.adidas.com

KOBE adidas

2000: adidas The Kobe print ad

2002: adidas Kobe 2

Nor should you. What's the crown jewel of your collection?
The Nike Hyperdunk 'Snake Pool' is my favourite Kobe ever. They were inspired by a Nike basketball commercial made with *Jackass* to promote the Hyperdunk, where they had Kobe jump over a pool filled with snakes. They only made 36 pairs for the launch of House of Hoops in LA, and I must admit, I didn't even really know about the release at the time. I was in Harlem camping out for the Zoom Kobe 4 'Finals Home' back in 2009, and this guy camping with us had a crazy Hyperdunk collection. He was wearing a different pair each day and showed up in the Snake Pools. My friend told me the story, and I was like, 'I'm gonna own a pair one day!'

A year or two later, I was trawling through eBay and came across a pair for a steal. The first thing I did was call my friend. He couldn't believe it! I'll admit, I've never actually worn them, and I don't think I could bear to UN-DS them. I wear some of my other samples on occasion, but the Snake Pool is just too special. That said, I've actually told my family and friends that they're the pair I want to be buried in, so they will be worn one day! [Laughs.]

You've got a stack of PE in your collection. How difficult is it to get your hands on a Kobe PE?
That all depends on how rare the shoe is and how much you're willing to pay. You see people bidding well into the thousands for the right pair. Prices are insane! I've been extremely blessed to get most of my pairs from friends and avoid price gouging. Some of the PEs I've managed to add to my collection include the 'Rice' ZK 1, 'China Home' Friends & Family ZK 2, 'Lower Merion Ace' ZK 3, 'West Chester' ZK 5 and 'Rice' ZK 3. I only ever buy a PE if it's in my size, though, even if I may never wear the shoe, which can be a real challenge.

Most of those PEs were given exclusively to high school teams. Were players peddling them out the back door?
You hear all sorts of stories, but I don't know the exact route they take. Most of my pairs are early Kobe models, and I wouldn't want it to be confused with what's going on nowadays with players selling pairs for money, especially since my pairs are so much older. I'm sure some players were issued multiple pairs and used only one pair. Maybe they were given the wrong size and were allowed to keep both.

Are the earlier PEs harder to get hold of than the later releases?
Yes, very much so. They didn't make many, so there aren't many pairs left in great condition. Most of the pairs given to athletes back then were typically played in. The new releases are easier to get as there are so many more being made, and it seems some players have

wised up to the demand of the reseller market. There are a lot more deadstock pairs changing hands nowadays, that's for sure. I don't have any PEs of the newer Kobe models, though. There's just nothing that I've really wanted bad enough to go searching for.

How did you feel when Kobe announced his retirement?
My heart dropped as I've been watching Kobe since his rookie year when I was a kid. It wasn't a complete surprise, but I was sad nonetheless. Everyone knows I'm a huge fan, so heaps of people texted to ask if I was okay. I generally give a basic answer when people ask, but it's bittersweet. His 'Dear Basketball' epithet was iconic and actually put his decision to leave into perspective and brought all Mamba fans back to reality. He's human, and his time had come. In the mind of a Kobe fan, he's immortal, but then you remember that immortality is imaginary. Both his skill and talent are the product of sheer hard work. His insane work ethic is what we all fell in love with and strive to emulate.

Real talk. Who was the better player – Kobe or MJ?
I don't think it's fair to pick as they are the two greatest players in the history of the game, but I think that Kobe would beat Jordan. Kobe is a better shooter overall, plus Jordan had trouble in the past against taller players like Magic and Penny. It was really exciting watching Kobe take on Jordan back when he was playing for the Wizards in the early 2000s. I've gotta admit, it was maybe a little unfair since Jordan was much older, but Kobe really had his way!

Will collectors still be fiending over Kobe retros in a decade?
Jordan's sneakers are iconic – they're legendary. Yes, Kobe's are, too, but not to the level of Jordan's. They say that Jordan made more money from shoe endorsements in one year than he made in his entire basketball career. That's major. I don't think anyone will top that anytime soon.

Lastly, is there a Kobe Grail still out there?
The Zoom Kobe I PE 'Lakers Home' – the all-purple, yellow and white colourway that was created exclusively for Kobe's home games. I have no idea how many pairs are out there, but it's not many. I've seen them show up on eBay for big money, but I just can't drop that kind of cash. Those things are amazing! They just scream 'Lakers' all over. I'm still holding out hope that one day I'll find them… for a decent price, of course!
★

@brotha_d

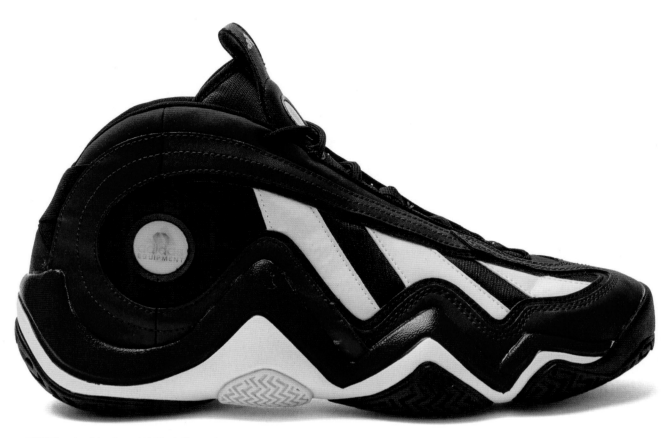

EQT Elevation (aka Crazy 97) 'Dunk Contest'

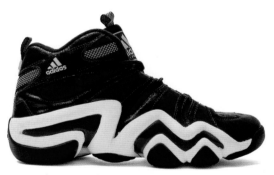

KB8 (aka Crazy 8) 'Regal Purple'

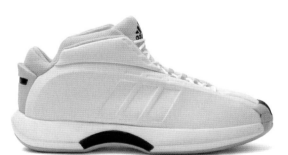

Kobe 2 (aka Crazy 1) 'Lakers'

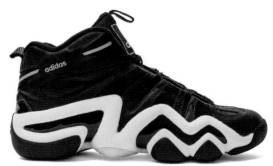

KB8 (aka Crazy 8) 'All-Star'

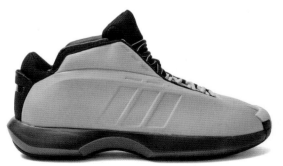

Kobe 2 (aka Crazy 1) 'Sunshine'

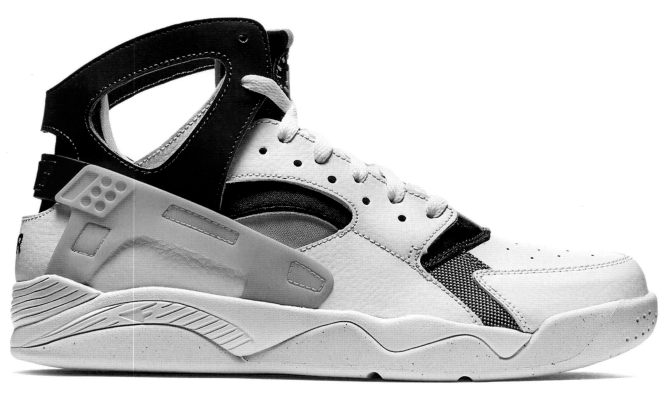

Air Huarache Flight 'Lakers'

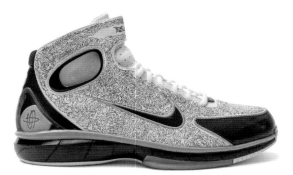

Zoom 2K4 KB 'Lakers Laser'

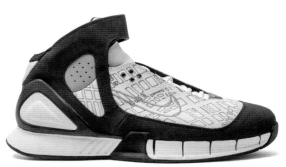

Zoom 2K5 KB 'LA Map'

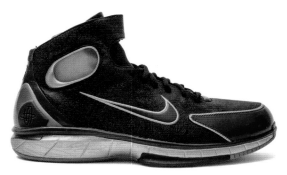

Zoom 2K4 KB 'Laser'

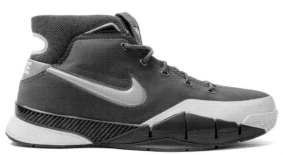

Rice High School PE

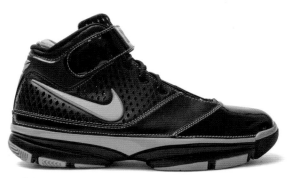

Skills Academy PE

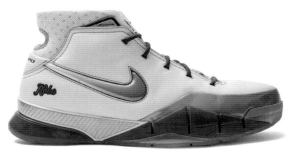

Friends and Family PE (Home)

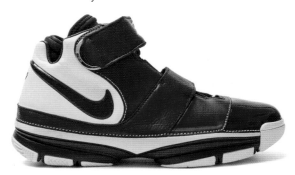

Lower Merion High School PE

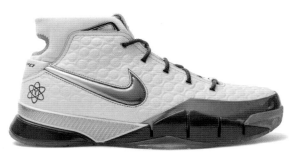

Premium Goods x Nike 'Atomic'

'Lakers Away' (Asia Exclusive)

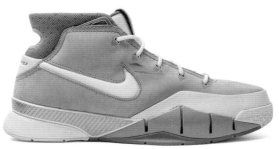

'Minneapolis'

'Prelude Pack'

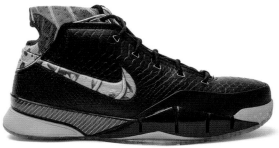

'Prelude Pack'

'Supernatural'

'Orca'

'USA'

'Olympic'

'Asia'

'MVP'

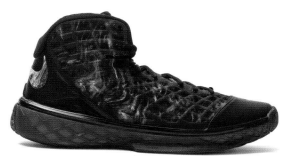

'Prelude Pack'

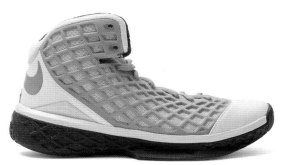

'China'

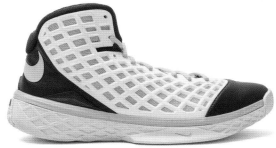

Rice High School PE

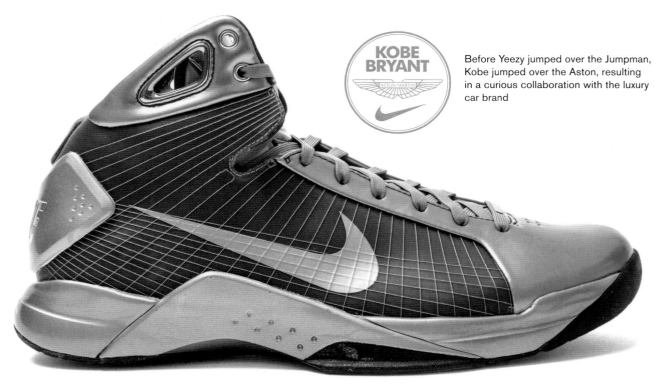

KOBE
BRYANT

Before Yeezy jumped over the Jumpman, Kobe jumped over the Aston, resulting in a curious collaboration with the luxury car brand

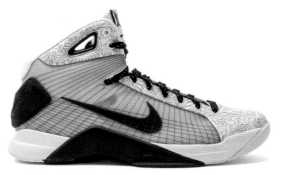

'United We Rise'

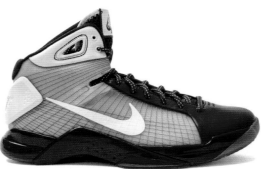

Lower Merion Aces PE

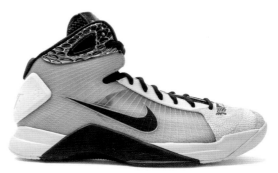

'Mamba' PE

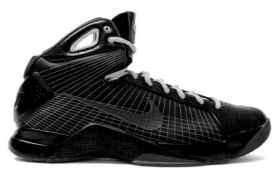

McDonald's All-American PE

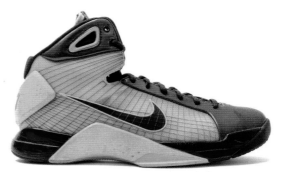

Lakers Home PE

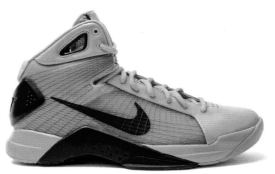

'Snake Pool'

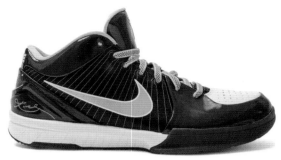

Rice High School PE (Home)

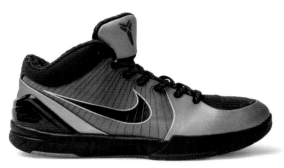

'Chaos'

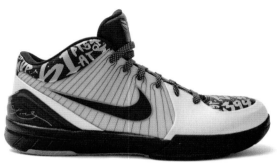

'61 Points'

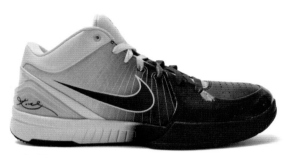

'4 Rings'

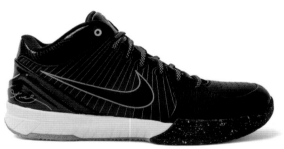

'Dirty Del Sol'

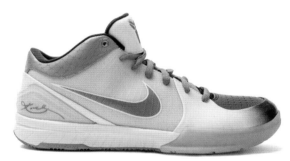

'Gold Mamba'

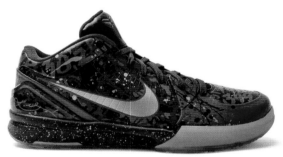

'Prelude Pack'

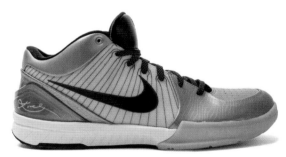

'Gold Medal'

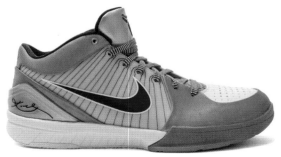

Lower Merion High School PE (Home)

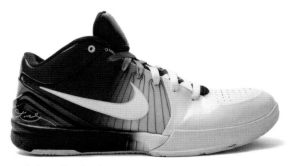

'Lakers Gradient'

'All-Star'

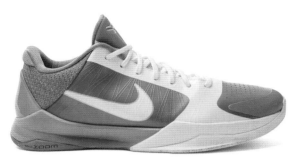

'Carolina Blue'

Lower Merion High School PE (Away)

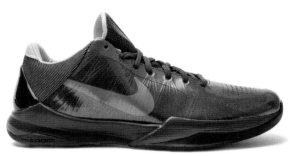

'Aston Martin'

Rice High School PE (Away)

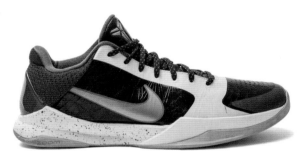

'Chaos'

'Kay Yow'

'5 Rings'

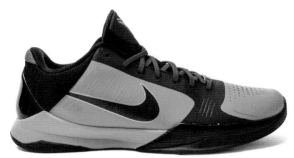

'Bruce Lee'

'Dark Knight'

'Del Sol'

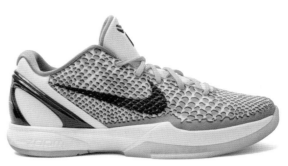

'Lakers 3D'

'Imperial Purple'

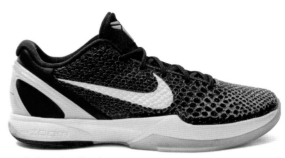

'Lakers Gradient'

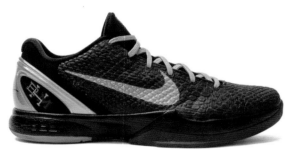

'Black History Month'

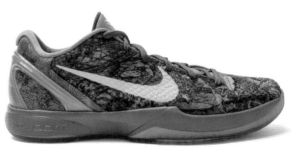

'Prelude Pack'

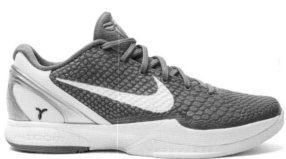

'Kay Yow'

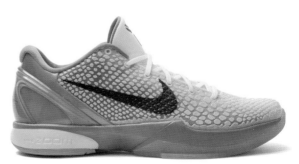

'Grinch'

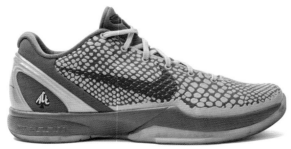

'Lower Merion Aces'

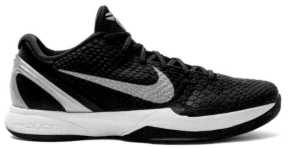

'Purple Gradient'

'Invisibility Cloak'

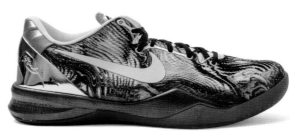

'Prelude Pack'

'Gold Medal'

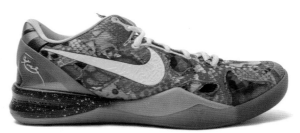

'What The Kobe'

'Yin Yang'

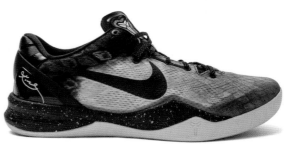

'Easter'

'What The Kobe'

'Black/Yellow'

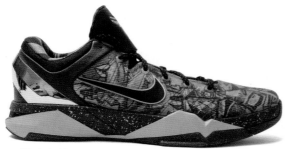

'Prelude Pack'

'Mambacurial'

2014–15 **Nike Zoom Kobe 9**

2015–16 **Nike Zoom Kobe 10**

'Maestro'

'Grand Purple'

'Masterpiece'

'Opening Night'

'Philippines'

'5AM Flight'

'Peach Jam'

'HTM'

'China'

'Eulogy'

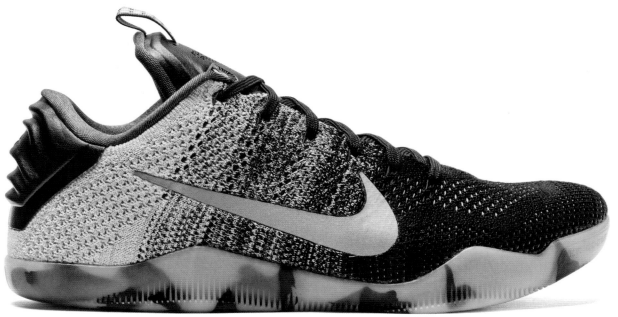

'All-Star'

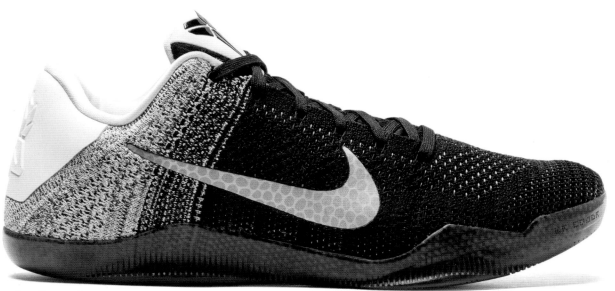

'Last Emperor'

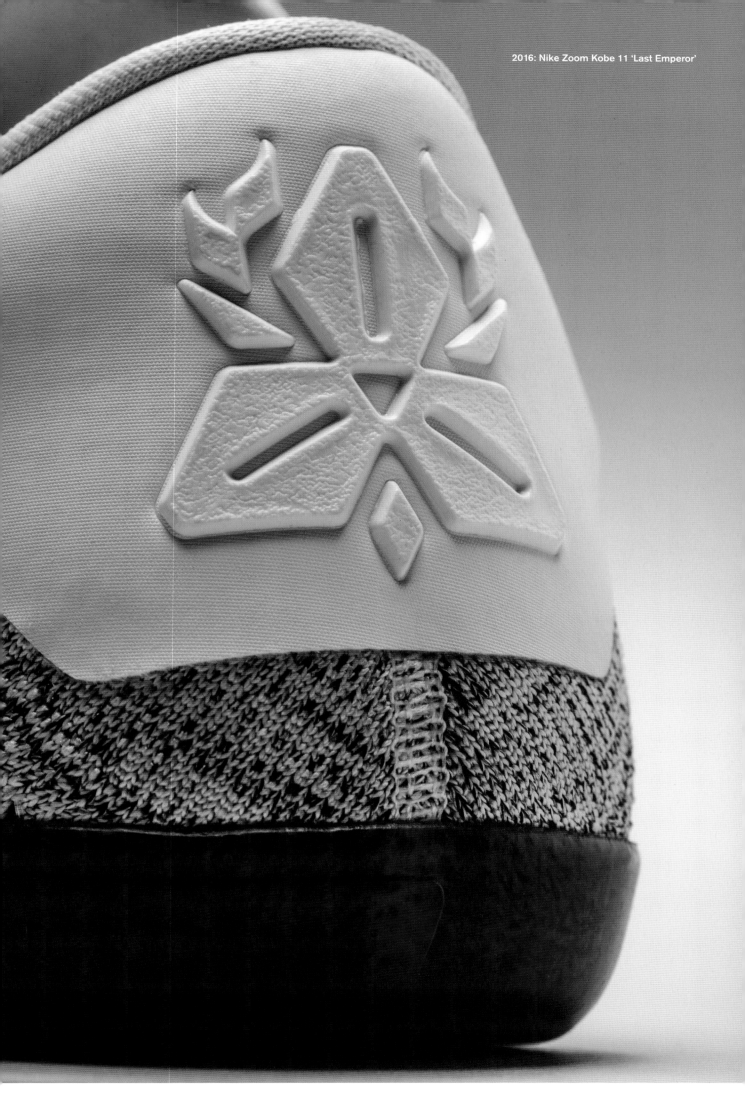

Thanks, Kobe

Whether you loved him or not, you have to straight-up respect the basketball legend that was Kobe Bryant. I still vividly remember seeing this fresh-faced teenager straight out of high school, complete with mini-fro on his head and Three Stripes on his feet, causing a ruckus during his debut season with the Lakers. I can't specifically pinpoint the catalyst for my rabid fascination, but I suspect it was the combination of on-court panache and his off-court persona. He was a generational talent with a will to win rivalled only by MJ.

I used to get teased for wearing his jersey to every family outing, despite it being three sizes too big and looking more like a dress. 'You'll grow into it', my parents insisted, and they weren't wrong, I guess. The affinity with Kobe was a fundamental building block of my youth and inevitably influenced my growth into adulthood. I'll never forget the hours in front of the TV catching Kobe's highlights and then convincing my parents to spend their savings on a pair of adidas KB8 IIs for my birthday. I've also insisted they keep the giant, fraying poster of him hanging in my old bedroom forever.

Nostalgic memories aside, Kobe's never-say-die approach is something I and so many others will continue to look to for inspiration. Above all the on-court accolades, this may very well be the crown jewel in his legacy.

The aftermath of this tragedy has been a heartbreaking grapple between grief and the celebration of a unique athlete. Kobe Bryant is gone, and inherently, so is part of all of us. However, if there's anything he'd want us to do, it's to keep grindin' – because that's the Mamba mentality. So that's what I'll try to do, albeit with a heavy, heavy heart.

Thanks for everything, Kobe. The world is forever grateful.

Boon Mark Souphanh
SneakerFreaker.com
January 28, 2020

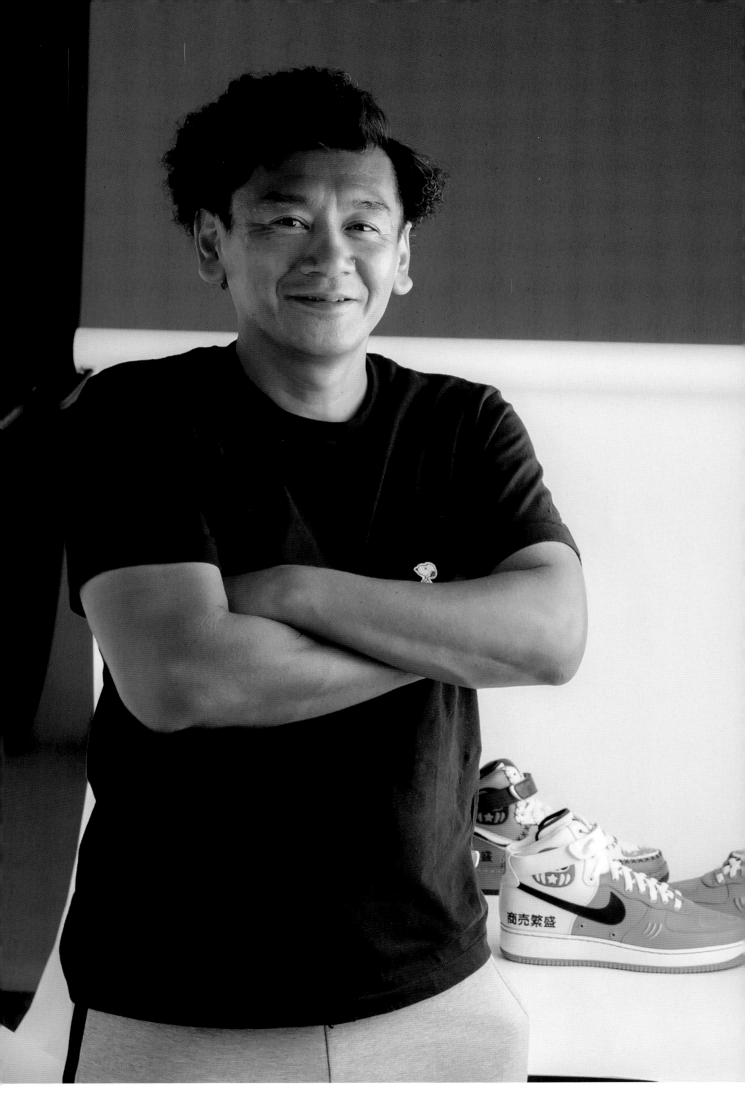

Photos: **Kentaro Sawaguchi**

WIZARD OF IZ

Tadahiro Hakamata

Sitting down with a personal Nike design consultant to create your own 'Bespoke' Air Force 1s – with zero limits on concepts or materials – is the stuff of sneaker dreams. Having created close to 100 pairs of these outrageously ornamental 1-of-1s over the years – with a whopping price tag of $800 a pop – Tadahiro Hakamata must therefore rank as the dreamiest dude on planet pillow. We ventured into his world-famous Layupshot Museum in Tokyo to get the vanilla scoop on his unique sneaker style.

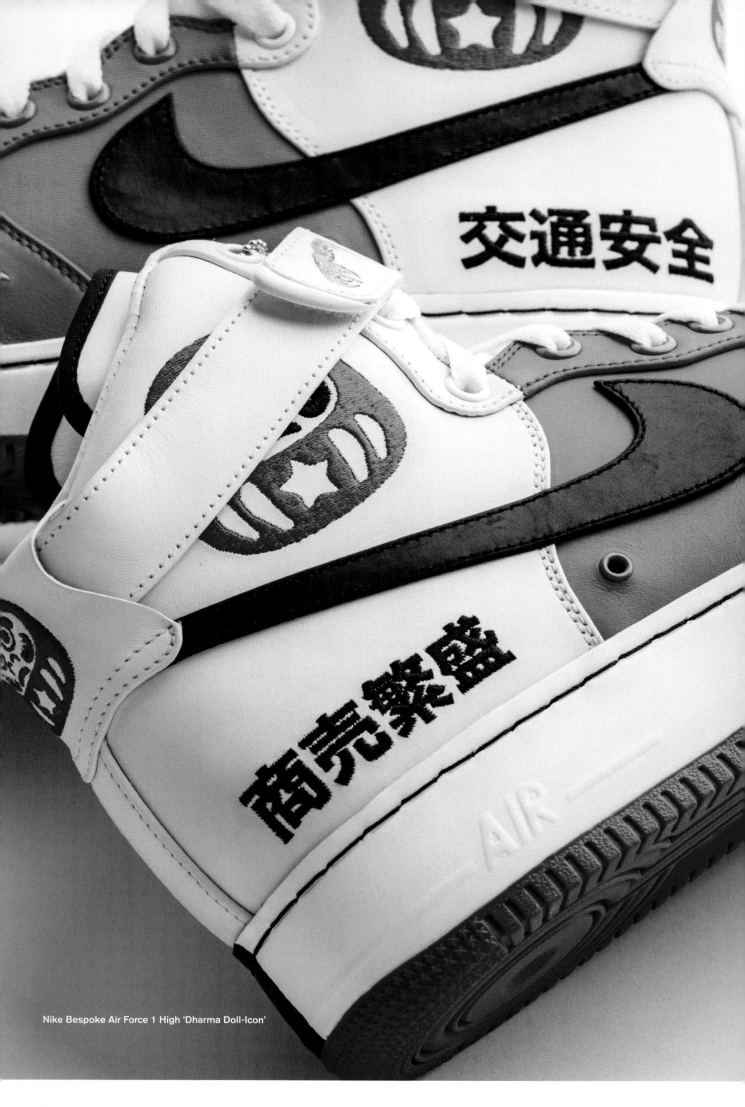

交通安全

商売繁盛

AIR

Nike Bespoke Air Force 1 High 'Dharma Doll-Icon'

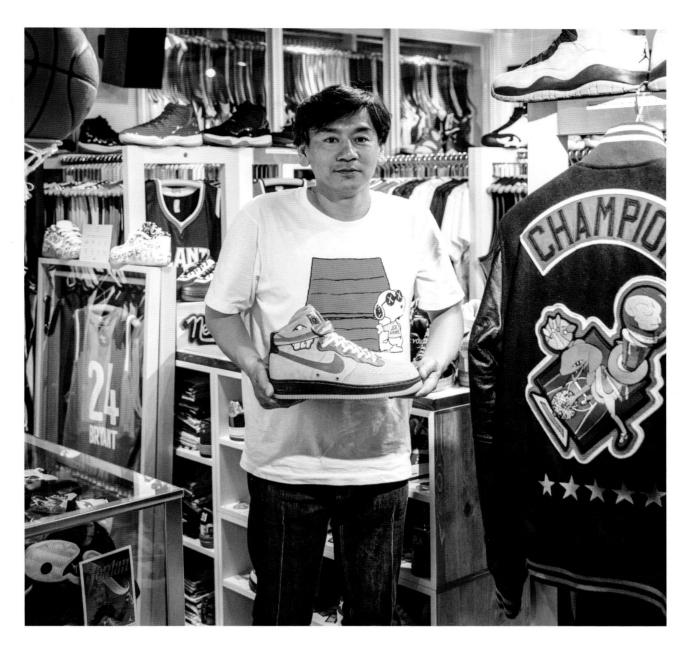

Tadahiro Hakamata
Bespoke Air Force 1s
Tokyo, Japan

I started playing basketball when I was 10 years old, after my teacher showed me the 1983 NBA finals. Watching amazing athletes in their prime started a lifelong obsession, especially Michael Jordan at the LA Olympics during his rookie year. Since then, I've always had an interest in athletic clothing and footwear.

Japan has its own unique sneaker culture. You'll notice it if you compare the designs at Foot Locker to those at atmos, who are known for developing rich stories behind their crazy colourways. Ultimately, that's what I love about Bespoke – I can tell my own story however I want.

I have designed close to 100 pairs of 'Bespoke' Nikes, each with its own intricate story, mostly connected to my childhood memories. My first pair was created in 2010 at an event in Harajuku. I had already made 100 pairs of NikeiDs by then, so I jumped at the opportunity to go deeper with the storytelling. If I'm honest, the first pair was really uncomfortable, as I focused solely on materials. I used a combination of faux tiger and white tiger hides, which were the most expensive materials available at that time.

The ability to reflect my thoughts and feelings through the creation of an Air Force 1 is a powerful feeling. Even though I've experienced it many times, the excitement has never worn off. In my case, new ideas keep coming and I'm always thinking about the next session. It's fun to discuss ideas with the design consultant and turn them into reality. As every day of life is different, my thoughts continue to be influenced by many things. When new materials come out, naturally, I think about what I'll make next. I always try to surprise my friends. The possibilities available through the program are infinite.

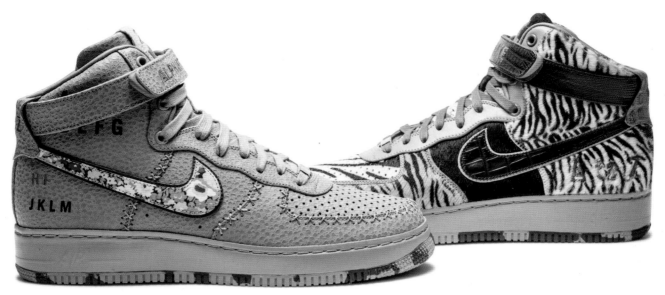

Nike Bespoke Air Force 1 High 'A to Z, 1 of 26'

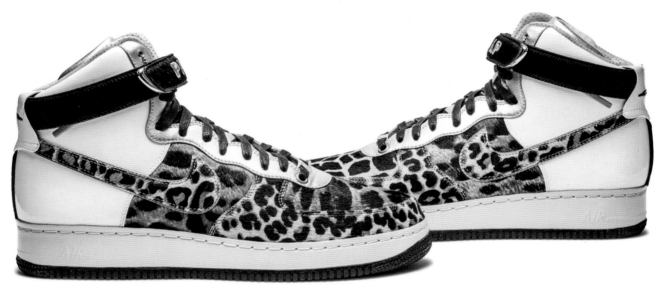

Nike Bespoke Air Force 1 High 'Pen-Pineapple-Apple-Pen'

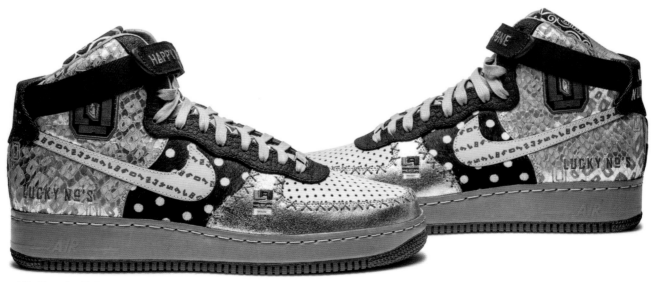

Nike Bespoke Air Force 1 High 'Lucky Numbers No.00'

Nike introduced the Air Max 1 into the Bespoke program years ago, but I prefer the Air Force 1. I love the simple design, the comfort they provide, and their connection to the NBA. The Air Force 1 fits my feet so well, and the stitched sole unit is perfection. I do appreciate the Air Max 1, though. For a long time, I've been begging to make a hybrid Air Force 1 sole fused to an Air Max 1 upper. That would look pretty cool!

I order all my shoes with the intention of wearing them, but I have so many amazing pairs now I rarely have the chance these days. After being photographed, they simply end up on display. There are 10 pairs I wear regularly.

When creating a shoe, I think about memorable moments, interesting people and curious creatures I encounter in my everyday life. For example, I went to lunch with my friends one day, and I was so happy. We were chatting over a bacon, lettuce and tomato sandwich, so I thought it would be fun to make 'BLT' Air Force 1s to remember the moment. The lateral sides are the bread, and the medial sides represent the bacon and tomato. The tongue represents the lettuce. My experiences give me hints as to what materials to pick and the imagery to use.

I haven't had too many requests turned down, but I don't want to say too much because I'd be disappointed if another customer were to make the same request and have it accepted. [Laughs.] I love the unlined version of the Air Force 1, which removes the inner padding. When I ordered my first 'Reverse' pairs, I requested the Swoosh be inside out to keep with the back-to-front theme, but that was knocked back.

The craziest design is a pair based on the comedian Pikotaro and his song 'PPAP' (Pen-Pineapple-Apple-Pen). The design features wild animal prints inspired by his crazy costume. I also made 26 pairs with 26 materials – one for each letter of the alphabet – called '1 of 26, A to Z'. Sometimes an original design might not work as hoped during the idea stage, but in the end, we always manage to rework it into something amazing.

My most cherished pair is based on the 'Top Three' Air Jordan 1, in tribute to Michael Jordan. Every sneakerhead and NBA fan should have a favourite Jordan. It could be the first Jordan you bought or the most impressive model worn on court. Retros remind you of memories like a clock reminds you of passing time. My Bespoke tribute is named 'MJ's Watch' and features both analogue and digital watches with the inscription '6:23'. This represents Jordan's six NBA Championship wins and his famous #23 jersey number.

I've watched a lot of outstanding players wear the Air Force 1 since I was a kid. I respect legends and All-Stars, but I also respect contract players who may only play a grand total of 10 days. I want to present 100 Bespoke designs I've created to 100 NBA players and take them through why I designed them the way I did, as well as explain the materials and colours. I'd love to design a pair for Russell Westbrook. Vince Carter is also a favourite. It's hard to pick just one player, though, so I'd struggle to narrow it down to even my top 100! Of course, if we also include retired players, then I'd have to choose Michael Jordan, without a doubt. He is my hero. My dream is to connect with Nike and make this idea become a reality.

The 'Eight Stars' design represents infinity. In Japanese, it literally means 'widen towards the end'. The stars represent star players, like glowing stars in the night sky. The design is surrounded by growth rings, like the inside of an old tree, and expresses a player's growth every year. Camouflage on the outsole represents the players who duke it out every day on the battlefield, aka the basketball court.

If I was designing an all-new model for myself, it would probably be a hybrid combination of the Jordan 2 and Jordan 11. I competed in national basketball competitions in Japan throughout junior high school. The Jordan 2 wasn't sold in Japan when it first released, so I bought a pair in the US when I was 14. I was probably the only person wearing the shoe in local competitions at the time.

As for the Jordan 11, it's a very popular model and one of my favourites, so how could I resist? I would take the most iconic materials of the Jordan 11 – black patent leather and white nylon mesh – and apply them to the Jordan 2. I would also request they are made in Italy, just like the originals. That was a significant part of that model's appeal.

For the 'Lucky Numbers' series, I ordered 10 pairs in one go, then added an additional pair at the end of the session titled 'Number 100'. The 11 pairs came out so great that I created one more pair, featuring a combination of all the odd and even numbers. Over a period of 10 days, I also designed 28 Bespoke AF-1s and made multiples for a total of 55 pairs, though Nike never give me a discount! [Laughs.]

My friend Izzy, the design consultant who helped create my first pair of Bespokes, gave me some important words. 'If your design seems too complicated, it's better to simplify the original idea.' This turned out to be the best advice! But if you're serious about doing Bespoke, then I recommend talking to me about it. I'll help you make the best design because no one's made more than me!

I also run a museum called 'Layupshot' that exhibits 1500 game-worn NBA jerseys. You can view it online or make an appointment to experience it in person. That way, you can also get up close with my Bespoke collection. It would be my great pleasure to conduct a Bespoke session at my museum one day. That's my ultimate dream!

★

@tadahirokini

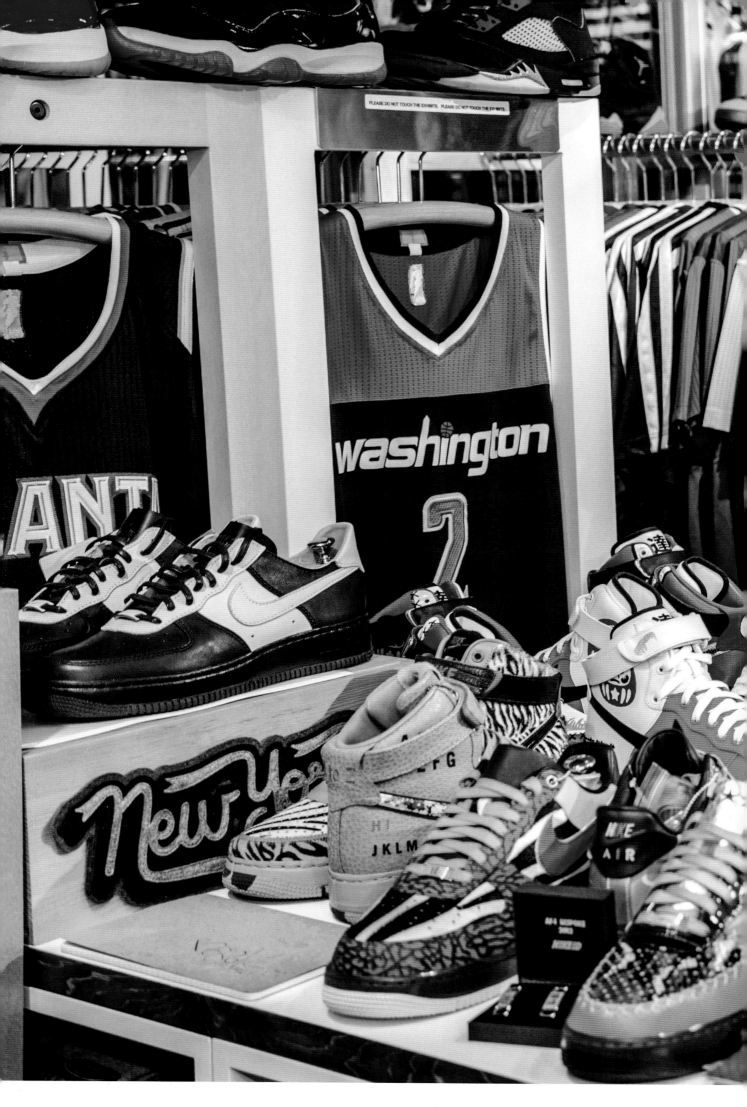

PLEASE DO NOT TOUCH THE EXHIBITS. PLEASE DO NOT TOUCH THE EXHIBITS.

washington

2

ANT

New Yor

HI
JKLM

NIKE
AIR

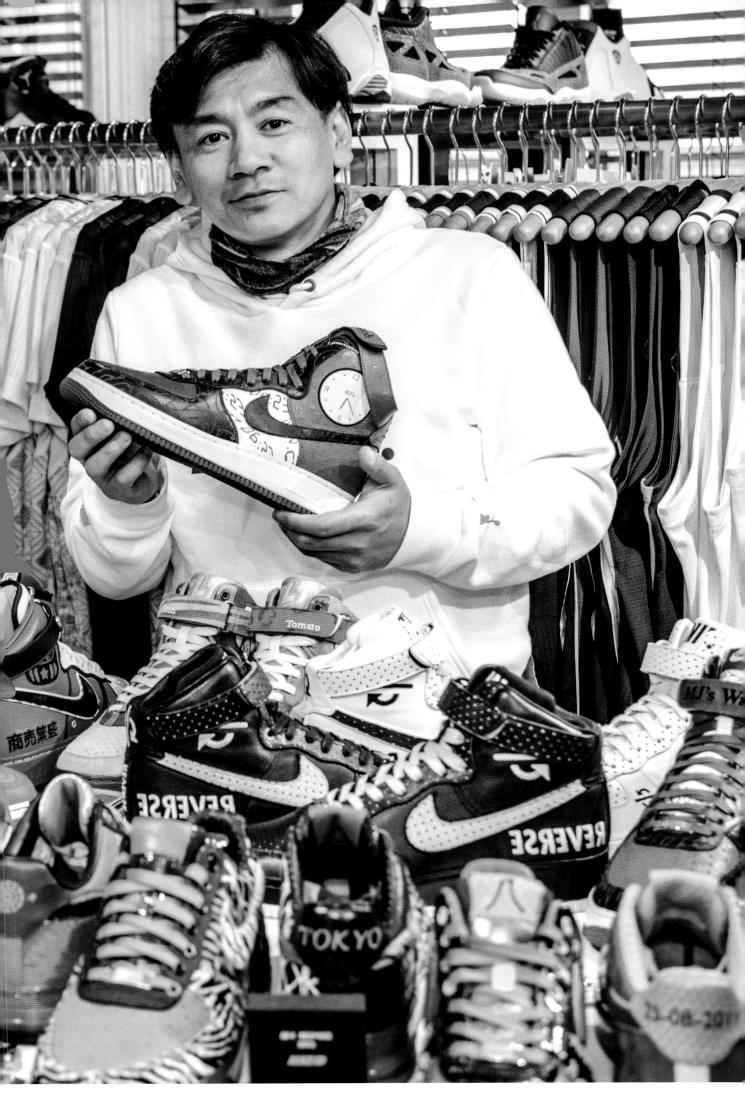

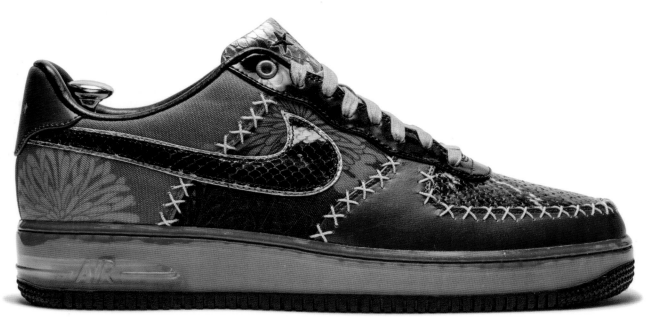

Nike Bespoke Air Force 1 Low 'Japanese Pink Panther'

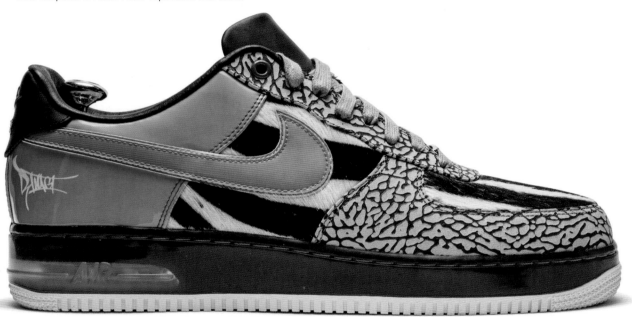

Nike Bespoke Air Force 1 Low 'Family Likes Kindergarten'

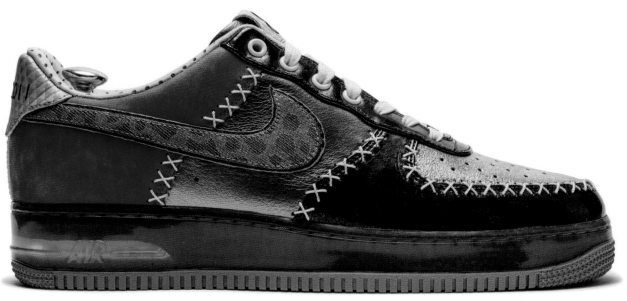

Nike Bespoke Air Force 1 Low 'Eight of Bright Restoration'

480

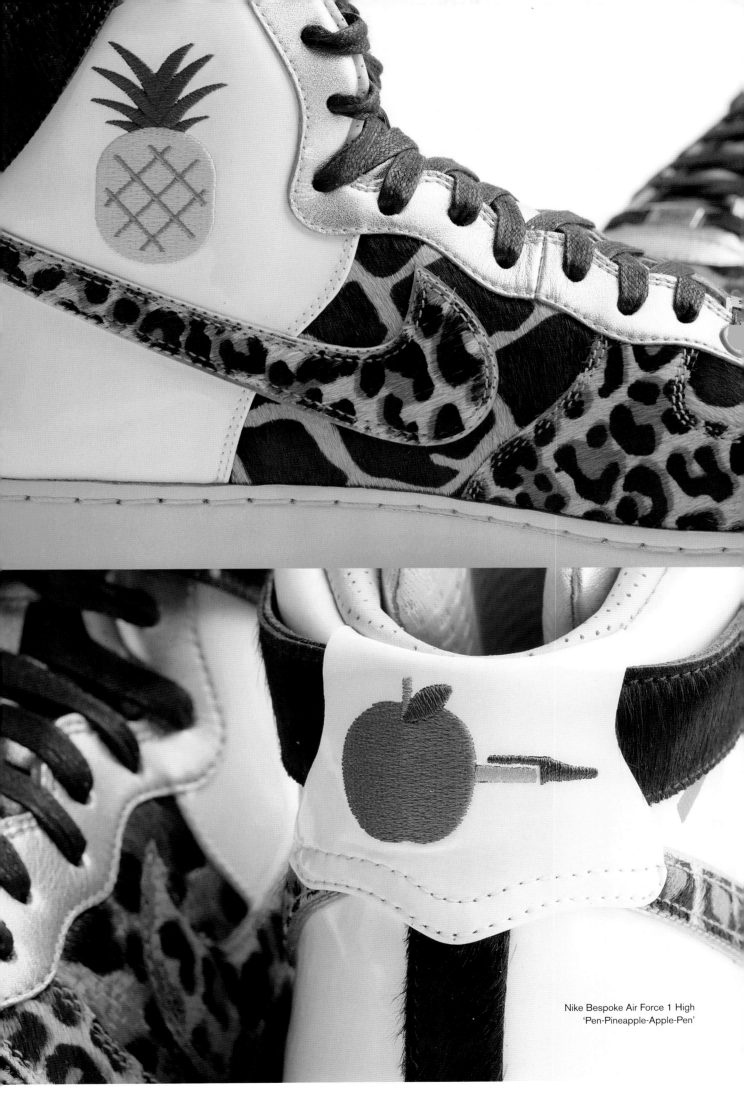

Nike Bespoke Air Force 1 High
'Pen-Pineapple-Apple-Pen'

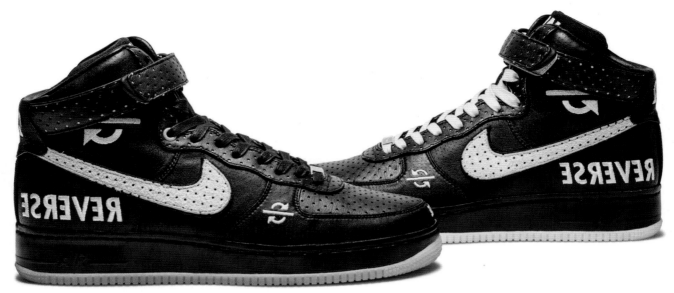

Nike Bespoke Air Force 1 High 'Reverse On Black'

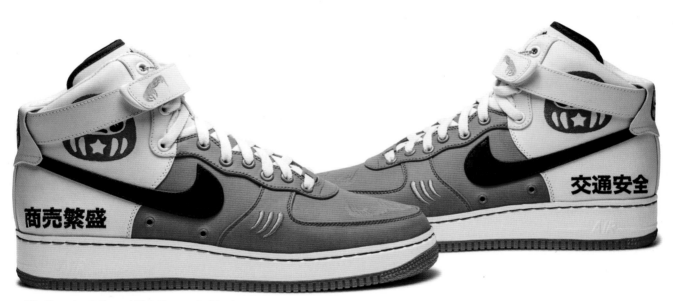

Nike Bespoke Air Force 1 High 'Daruma Doll-Icon'

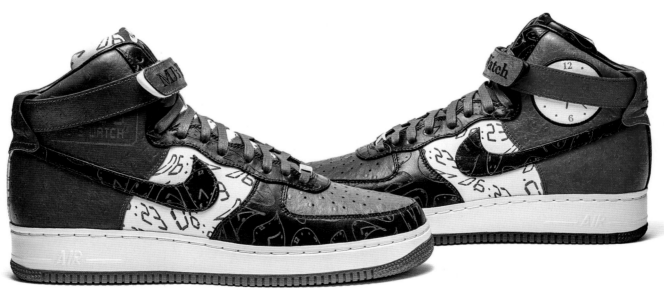

Nike Bespoke Air Force 1 High 'MJ's Watch'

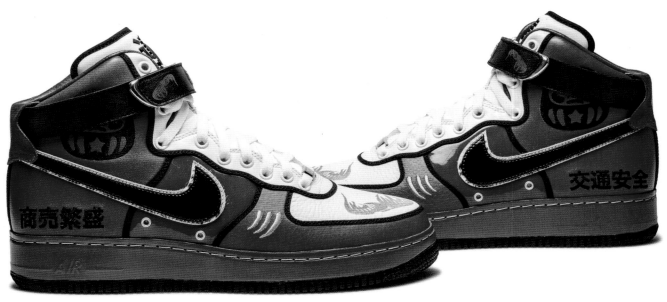

Nike Bespoke Air Force 1 High 'Daruma Doll-Prayer'

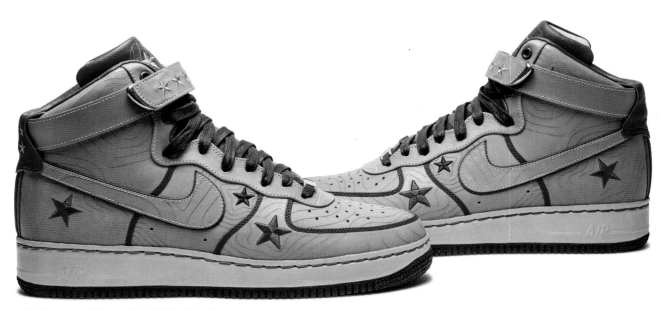

Nike Bespoke Air Force 1 High '8 Star Gucci'

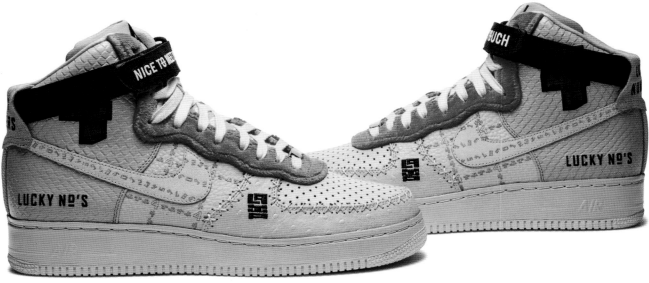

Nike Bespoke Air Force 1 High 'Lucky Numbers No.44'

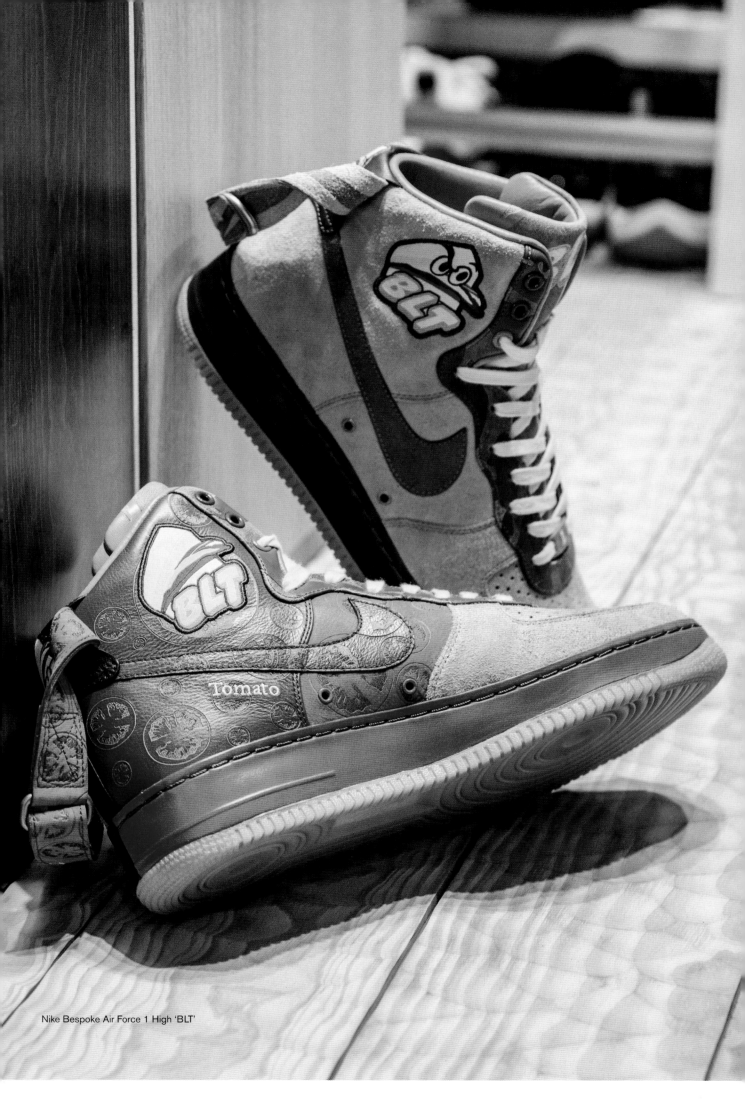

Nike Bespoke Air Force 1 High 'BLT'

'When creating a shoe, I think about memorable moments, interesting people and curious creatures I encounter in my everyday life. For example, I went to lunch with my friends one day, and I was so happy. We were chatting over a bacon, lettuce and tomato sandwich, so I thought it would be fun to make "BLT" Air Force 1s to remember the moment. The lateral sides are the bread, and the medial sides represent the bacon and tomato. The tongue represents the lettuce.'

A BRIEF HISTORY OF
NIKEiD.

Vans may have made one-off shoes for Californian customers as far back as 1966, but NikeiD perfected the concept of making customised sneakers available to the masses.

Launched in 1999, Nike's online desktop design system was highly selective in the early years. To avoid confusing punters and keep the factory workers from losing their marbles, colour choices and materials were kept deliberately tight. New models and options joined the iD inventory with each season, but they didn't stick around long. Limited edition became the new norm, leading to fever-pitch FOMO with each new addition to the palette. If you were an educated user, you could pick the season in which any NikeiD shoe was made simply by colour selection and model.

In 2004, Nike opened their '255 Elizabeth Street' experiential space in New York. Loads of significant events went down there, but the joint was generally used as a NikeiD studio for so-called influencers, not that the word was invented then. Anyone who was anyone could hit up 255 to bust out a batch of unique Nike shoes when they were in town. With madcap colour combos and sweet materials, some of the iD shoes made in this era definitely had serious street clout.

NikeiD reached its pinnacle with the birth of the Bespoke program in November 2008. Based in the rear of Nike's Mercer Street store (now closed) in NYC, Bespoke was a premium one-on-one experience. A design consultant guided initial discussions through to a sketch before hundreds of different colours and materials were considered. Unlike the standard iD system, there was no computer simulation, and the possibilities, while not exactly infinite, were expansive. Loopwheeler fleece, elephant print, reflective 3M, iced-out soles, asymmetrical blocking, sandalwood lasts and a bewildering variety of eyelets and dubraes were available. Like a classy degustation menu, each step in the creative process was savoured as a juicy part of the culinary experience. At $800 a pop back in 2008, NikeiD Bespoke was not cheap, but it was definitely a memorable experience. Today, NikeiD is known as Nike By You.
★

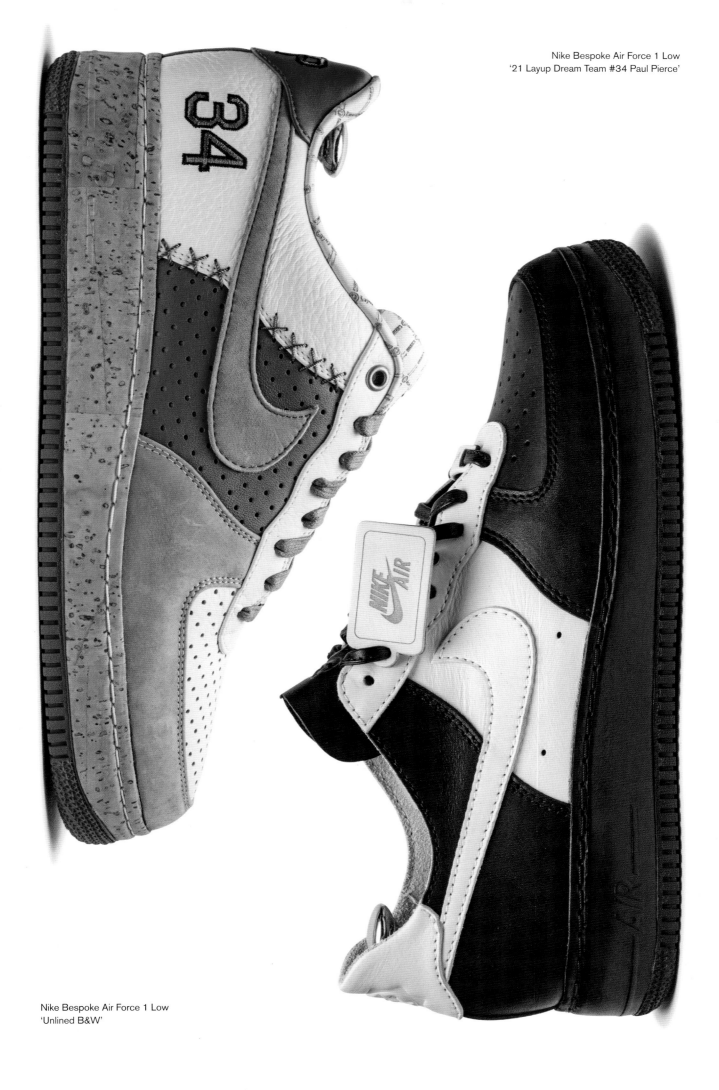

Nike Bespoke Air Force 1 Low
'21 Layup Dream Team #34 Paul Pierce'

Nike Bespoke Air Force 1 Low
'Unlined B&W'

NOSTAL BY NATURE

INTERVIEW: SCRAM

PHOTOS: DARREN HIROSE

SOUTH MILLS, NORTH CAROLINA

Chris Rosario has played for keeps since the day he was born. A graduate of the 'fitted and kitted' mindset, Chris powered through adolescence with a vengeance, flaying all-comers with his trademark 'sandwich' fashion combos. The filling was head-to-toe Nautica, Akademiks, ENYCE, Ralph, Hilfiger, GUESS, COOGI and Avirex, while his bread game was dominated by Posites of all persuasions, Uptempos, Bakins, Jamgasmics, Vroomlicious, Hyperdunks, Zoom Flights, Flight Ones, Flight Lite and, holiest of holies, the unassuming Air Flight 89. Those competitive instincts stayed strong as his ridunkulous collection of misfits multiplied. Don't get the dude wrong — he loves his Air Max, Air Jordans and cross trainers too, but what really floats his boat is bonkers basketball kicks that even discerning sneakerheads have never heard of. Prepare to be schooled as Rosario takes us back to where it all began — flexing on cats, girl dramas by the dozen and dressing for success!

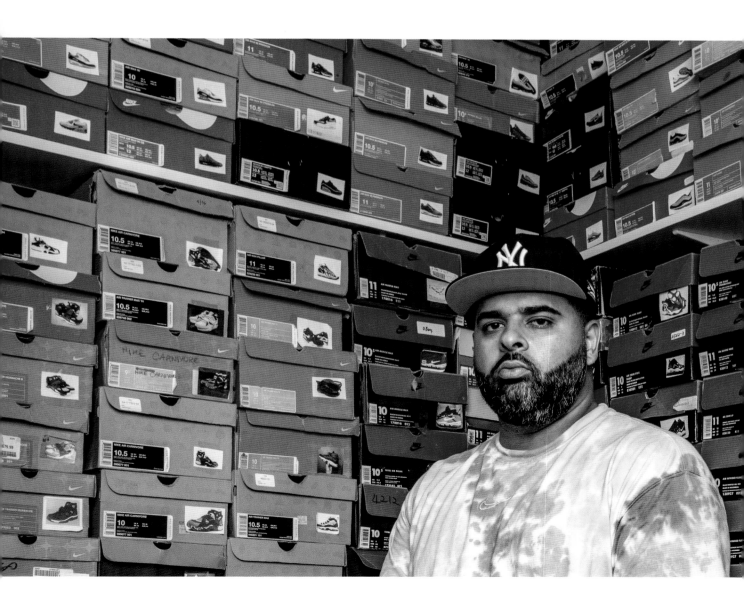

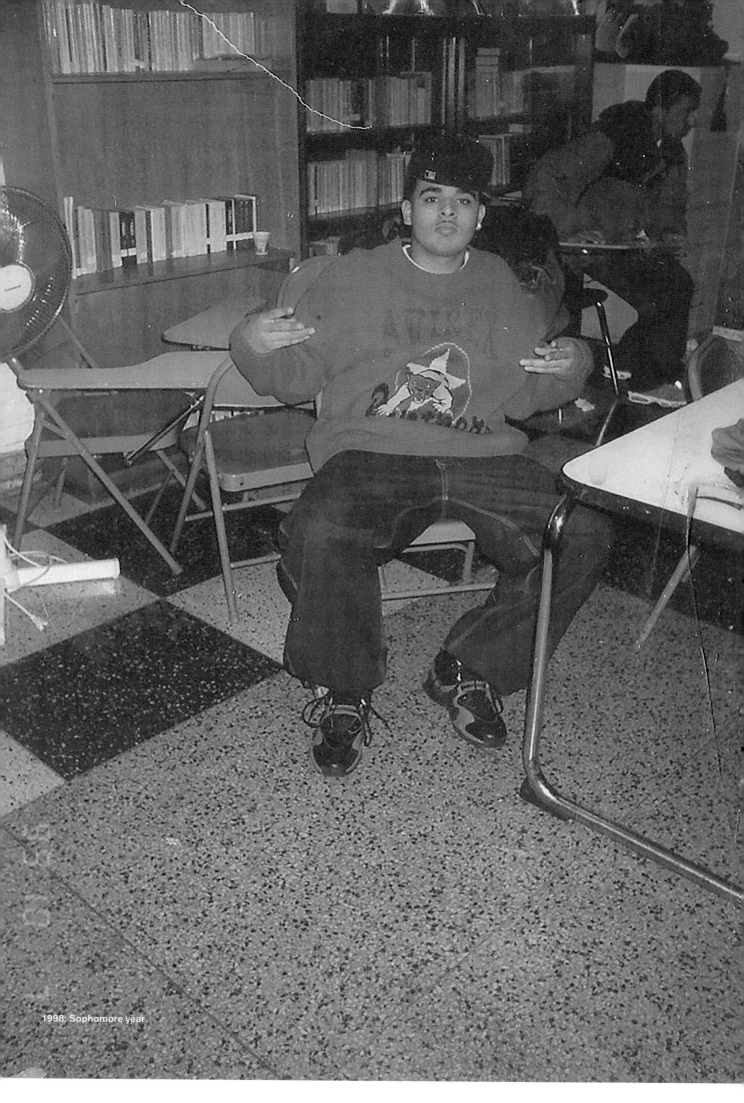

1998: Sophomore year

Chris Rosario
Nike Basketball
North Carolina

I was born and raised in Brooklyn, with Marcy Projects as my stomping ground. School was dope, at least for me it was. I was living the dream every single day. Girlfriend dramas, school fights, flexing on cats daily… what more can you ask for? I always walked into school with a competitive mindset, and fashion was literally all I would think about.

Laying down an entire outfit on the bed and making sure the kicks matched your gear was a crucial part of my day-to-day operations. I had to step into school with the better footwear choice that day and every day after that. There was no other way to look at it. You couldn't come in with the same shoes the next man got on – that was a big 'you played yourself' moment. You had to one-up every time! I can go on and on about how important looking good was, but shit like rocking Columbia jackets and making sure people didn't rob you for your JanSport Strings is pretty important if you ask me.

I was into basketball heavy. Imitating all the dope players like Scottie Pippen, Lil Penny and Mike definitely introduced me to sneakers, which created the crazy obsession. At that time, brands were in their bag when it came to gimmicks. Reebok had you Pumping your shit up, while Nike had you literally walking on Air. Cross Trainers were a huge part of my arsenal as well, especially the Air Trainer SC, but the first pair I really remember is the Air Sonic Flight. I remember kids asking me to show them the crazy multicoloured soles. The Flight logo on the tongue had everyone staring.

Reebok and adidas got love from me, too, and I can't forget Etonic and Avia. I even had a pair of Travel Fox that my mom forced me to wear. I was getting clowned in middle school for those bad. Two weeks later, right around the time *Above the Rim* came out at the cinema, I showed up in some Reebok Blacktops, and it was game over. Along with Tupac, Bernie Mac and Marlon Wayans, there's some heavy Reebok action in that flick.

I shopped at a lot of places, but in Brooklyn, it was mainly the strips, so I was on Knickerbocker, Graham and Grand St. You could also catch me on Broadway at Mr Lee's. I was always waiting for him to get his Jordan shipment in so he could give me my size before they hit the shelves. Spicy Action was my secret spot. Not only could I get Jordans three weeks before they dropped, but they also had vintage deadstock pairs from the early 90s. I got my original 1991 Flight Huaraches from there. And don't forget about Tom D, because that's where I bought my COOGI suits and Iceberg sweaters.

The fitted-hat-and-sneaker-combo era was epic in my world. That shit had me creating what I called 'sandwiches', which is when your hat matches your shoes perfectly and the garments act like the tasty filling between two slices of bread. I still rock fitteds, especially now that patches and custom embroidery are bringing the game back. Nautica Competition was the freshman choice, along with the sweatpants. I was heavy on that Akademiks vibe too. ENYCE velour suits and, of course, Ralph was on rotation, along with Hilfiger and GUESS. But when I wanted to go a little extra with it, I pulled out a COOGI suit with the leather Hudson jacket. I was notorious for the Avirex knit sweaters, and they were not cheap!

In terms of all-time favourites, it's a toss-up between the Air Max Uptempos and the 'Galaxy' Foamposites. Back in 1997, the Uptempo was crazy because it sported that full-length air bag and had those hits of 3M. My OG Uptempos didn't last all that long, though. As I walked home from school, I stepped on a broken glass bottle and popped the bags, so they were cooked after that. The 'Galaxy' Foams are self-explanatory. Man, that intergalactic graphic print and the glowing outsoles… I'm a total dweeb when it comes to astronomy.

The Nike Flight 89 is a classic. I actually hate that it gets compared to the Air Jordan 4 all the time because it deserves to be recognised in its own right and not as some cheap takedown. For me, it's all about the cut and the shape, especially the older editions from 1991 to 2004, which definitely have that little something extra about them. With so many panels, Nike can play with different textiles and come up with fire combos. You know it's a good shoe when they drop them in so many flavours. The Swoosh placement is perfect.

I was hoping Nike would do something crazy for the 30th anniversary back in 2019, but they never did. So I took it upon myself to celebrate by wearing a different pair for an entire month, which ended up being a six-week mission by the time I was done. It was fun because the whole idea was not only to celebrate the Flight 89 but to bring awareness that this shoe is a fucking problem. That's how #vivalaflight89 was born.

There are a few shoes I wanted but couldn't get my hands on over the years. I'll give you three just to keep it simple. The Air Foamposite Lite 'Kryptonate', the 'McFly' Hyperdunks and the 'Blink' Yeezys in black and pink. Aside from that, I have a ton of Air Max 90s and 97s, Trainer Huaraches, Trainer SCs, Court Forces and Nike TR1s, just in case anybody is trying to test the kid. Honestly, if you have just one colour of a classic in your arsenal, you are playing yourself!

You gotta stay ready. Like I said before, I always viewed collecting sneakers as not only a hobby but a sport, and this shit is a competition to me still. When it's no longer fun, I'm out.

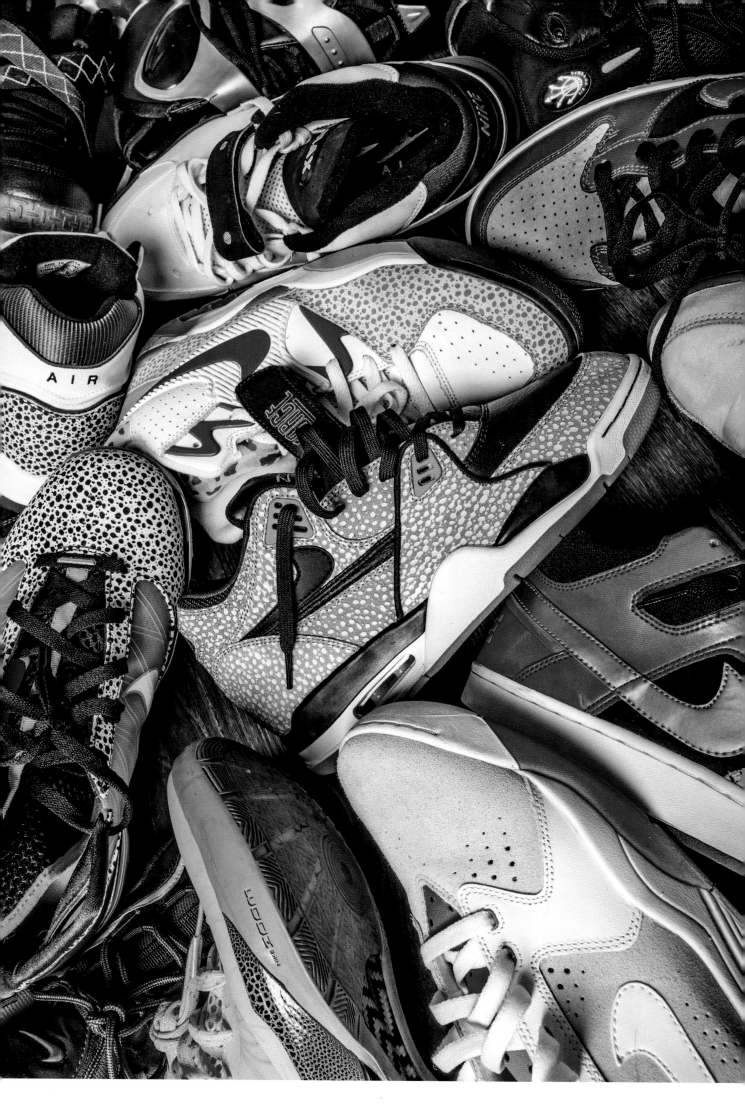

2001: Nike Air P Phaze

I'm in the services, so I missed a lot of big releases while I was deployed. One time in Spain, back in 2009, I copped the 'All-Star' Air Force 1s that DJ Clark Kent cooked up. The ship was about to leave, and I made it back on board with just two minutes to spare. My whole naval career would have been thrown away for some leather and rubber! It was a different time back then as we didn't have social media to contact any local shops while we were at sea. But I did have copies of *Sneaker Freaker*, which I always read from cover to cover, over and over. I vividly remember the Vintage Voltage section in issue 12, which was printed on aged-looking paper and featured Trainerspotter, Sports & Things, Lo-Head Bags and Kish. I love that issue, and I always said to myself and everyone on the ship, 'One day, I'll be in the magazine!' And here I am.

I still hit up stores when I get a chance, but for the most part, I'm hunting on eBay every day. At this point, it makes no sense to be bitter about resellers because this shit has been going on forever. Resellers just adapted to the times. Don't get me wrong, it sucks not being able to get shoes when you were once flourishing, but it's a different game now. We actually need resellers. How else can you get a pair if you strike out? At the end of the day, you have a choice. If you miss out on a release, then deal with it and let it go because there's always something new coming out next week. As long as consumers continue to pay the premium, the resell game will never die.

I honestly don't even bother with raffles, as I'm convinced it's almost impossible. If I want a pair, I'll put my pride away and ask for help, but then I feel terrible about it because I've never been the guy to ask. If I did, it's because I really felt like someone could help me out, and there was no other way. I was always about making relationships with stores, but that doesn't cut it these days. Now you gotta jump through hoops, tag 100 friends and repost three times just to be considered. I ain't about that life.

I joke with my wife about my sneaker obsession all the time. She was into sneakers way before I met her, but she just didn't understand I was that deep with it. I told her plenty of times that sneakers were my first love, but she hates when I say that. [Laughs.] It definitely helps when I bless her with some heat as well. When I come home with two pairs, she won't be happy, but then I pull out something cool for her. You just gotta play the balance game when it comes to looking after your women and kicks. If not, things can get spicy!

★

@nostalchris

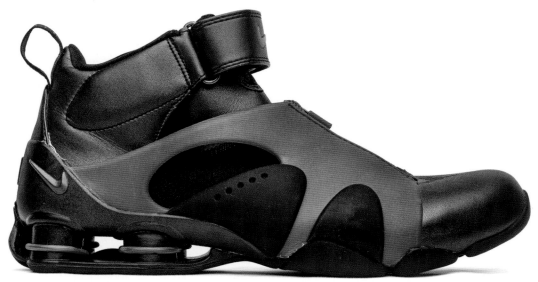

2002: Nike Shox Stunner

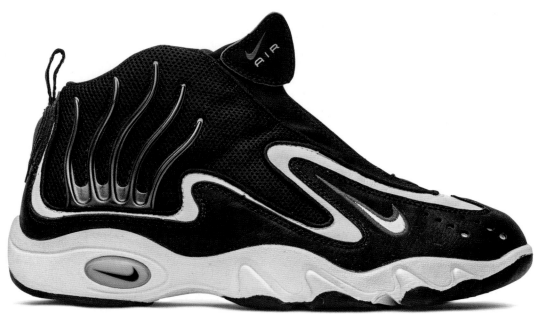

1998: Nike Air Zoom T-Bug Flight

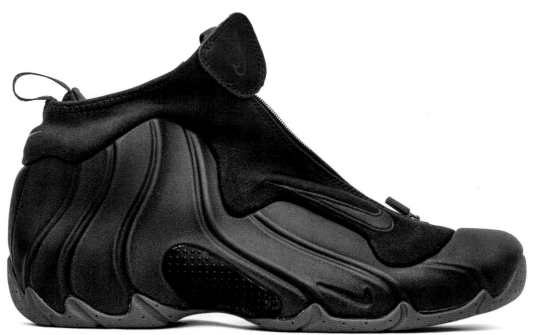

2000: Nike Flightposite 'Charcoal'

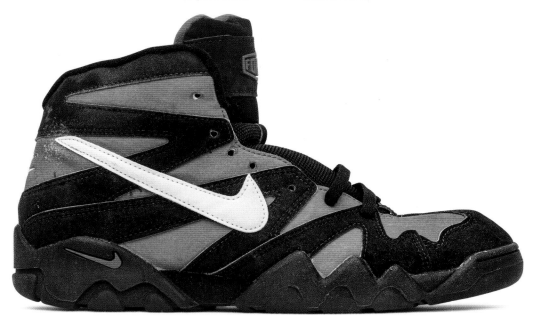

1994: Nike Air Authority

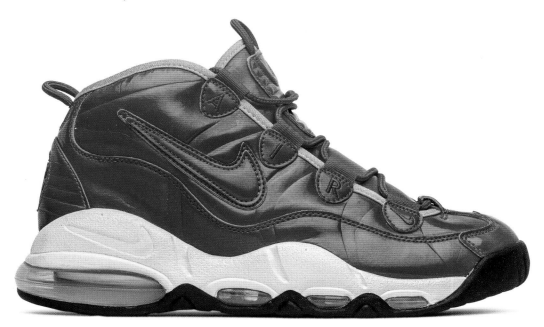

2004: Gundam x Nike Air Max Uptempo 'Char Aznable'

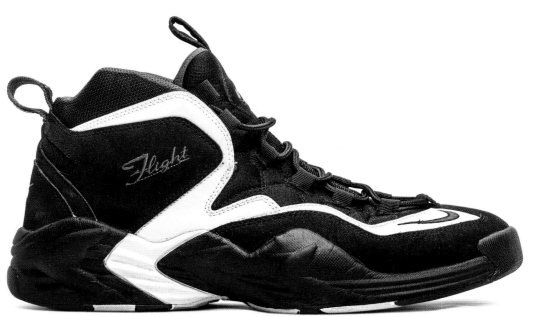

2011: Nike Air Go LWP

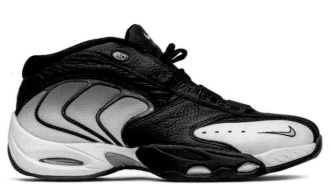

1999: Nike Air Flight Vroomlicious

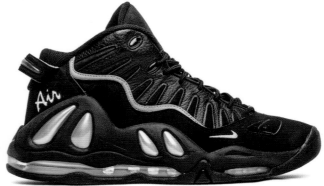

2010: Nike Air Max Uptempo 97

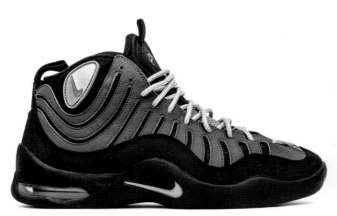

2008: Nike Air Bakin

1993: Avia Acelot

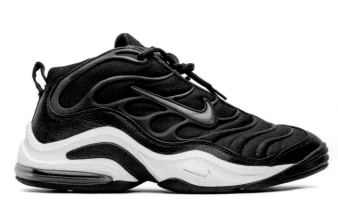

1999: Nike Air Flight Determination

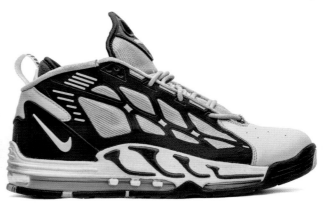

2012: Nike Air Max Pillar

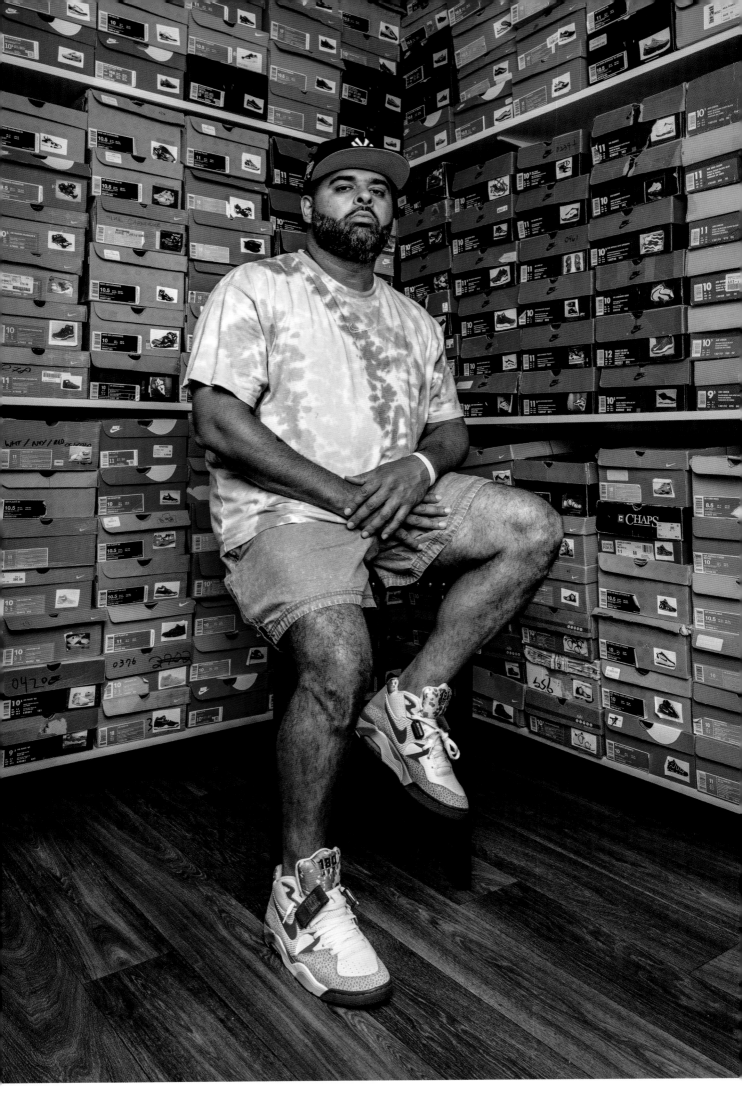

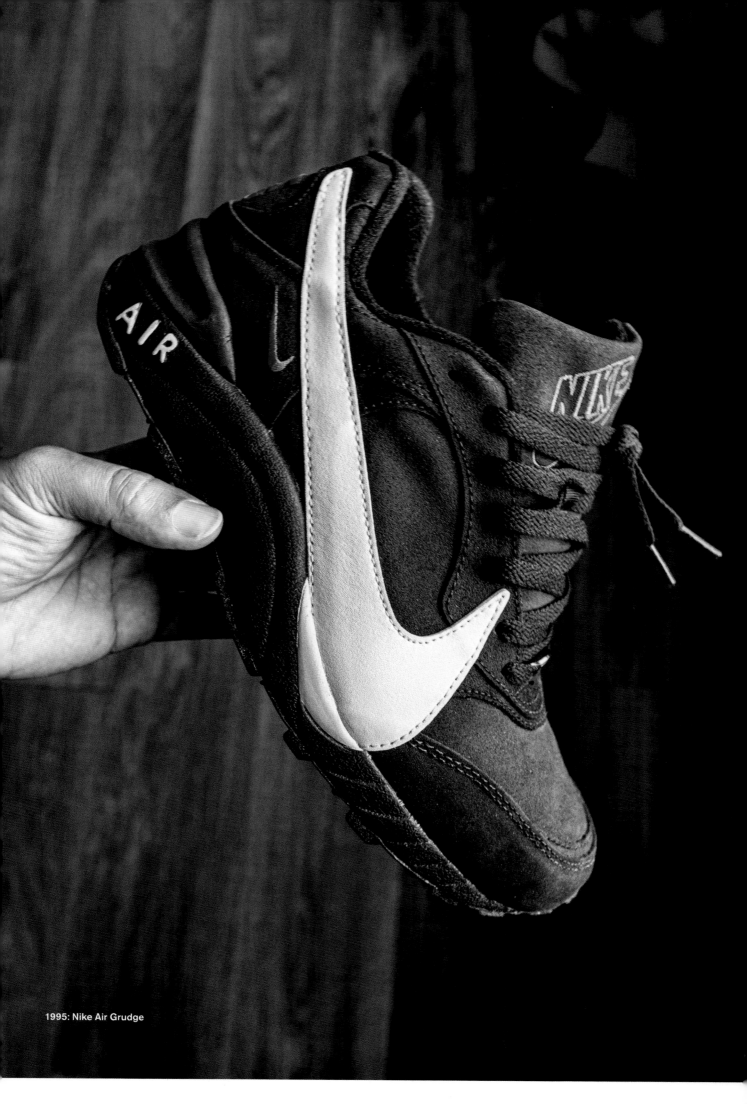

1995: Nike Air Grudge

1999: Nike Air Zoom Citizen

TOP FIVE
CHRIS ROSARIO
AIR FLIGHT 89

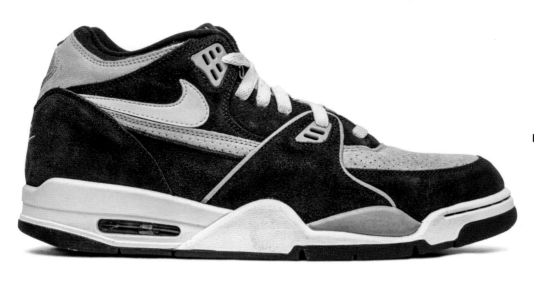

1

2006: A Series
With premium suedes throughout, the 'A Series' releases from 2006 are primo. This dark cinder/maze combo worked so good with a throwback Padres jersey.

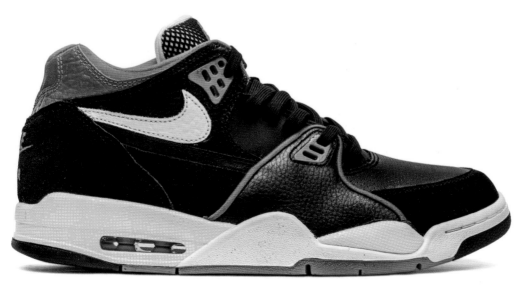

2

2013: Spanish ñ
These are rare because they didn't drop in the US. The colours represent Spanish sporting uniforms and the netted tongue has an 'ñ' logo instead of the traditional 'Flight' script. Suede and leather dress things up, with hits of glitter adding pop. That printed midsole is super vibrant in real life!

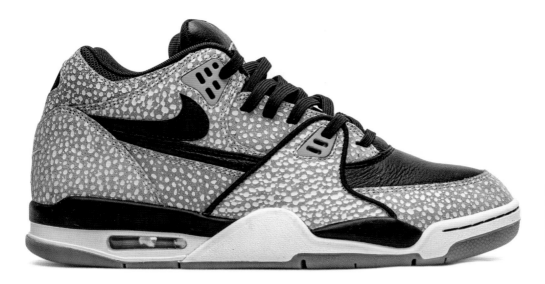

3

Safari Sample
All I'm gonna say is whoever dropped the ball and stopped this Safari 89 sample from becoming an official release should be fired!

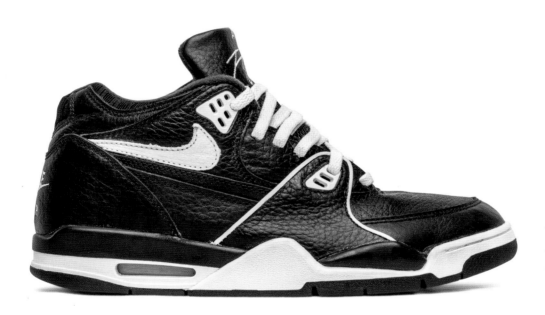

4

2000: Obsidian
The Obsidians from 2000 are pure butter. The leather is softer than your next-door neighbour! What more can I say?

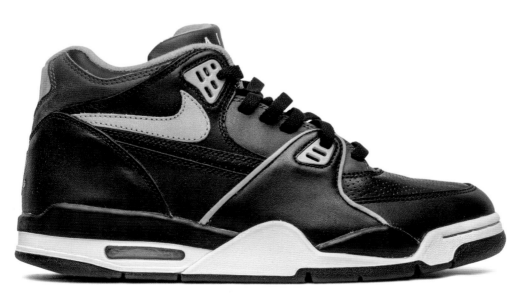

5

2005: Phoenix
In 2005, Nike released nine different basketball models exclusively in international markets. This model sported a Phoenix Suns colourway, perhaps as a nod to Charles Barkley when he rocked Flight 89s in Philly. Instant classic if you ask me!

'Nautica Competition was the freshman choice, along with the sweatpants. I was heavy on that Akademiks vibe too. ENYCE velour suits and, of course, Ralph was on rotation, along with Hilfiger and GUESS. But when I wanted to go a little extra with it, I pulled out a COOGI suit with the leather Hudson jacket. I was notorious for the Avirex knit sweaters, and they were not cheap!'

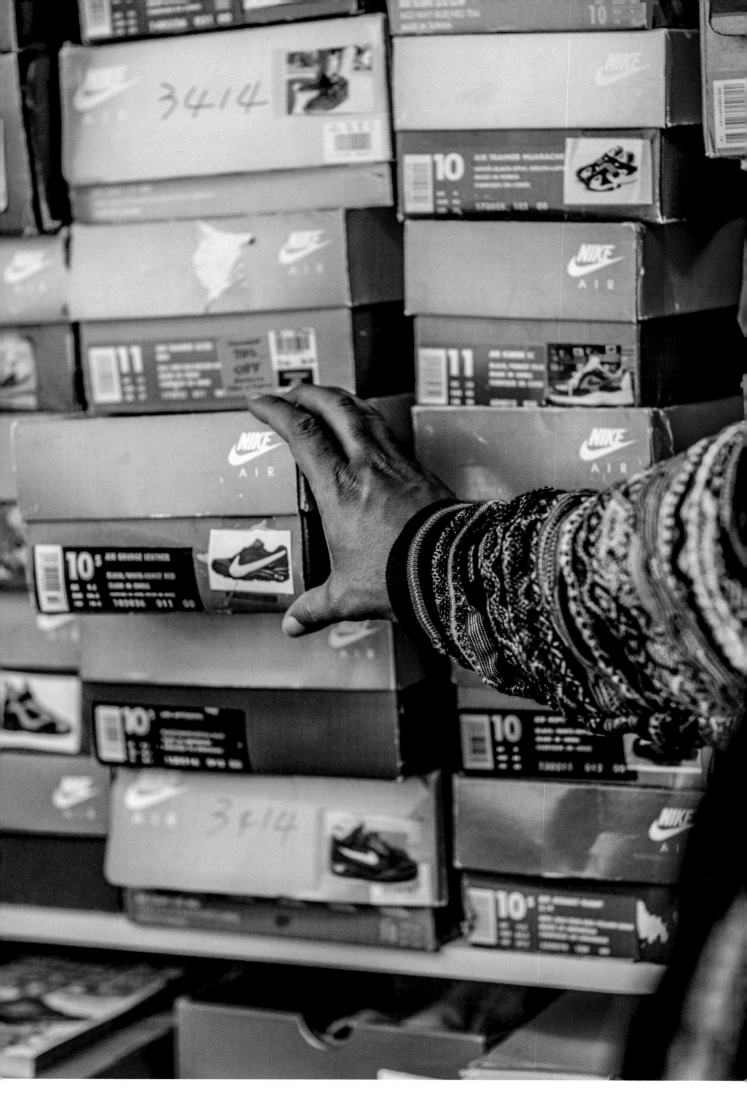

2011: Nike Air Trainer Max

2004: Nike Air Trainer Max

2011: Nike Air Trainer Max 96

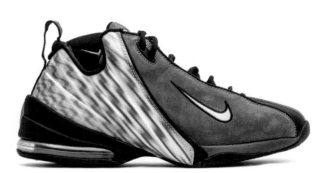

2001: Nike Air Max Uptempo IV

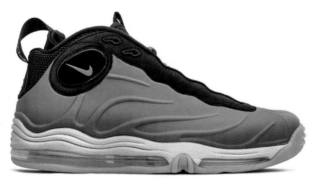

2005: Nike Total Air Foamposite Max 'Wheat'

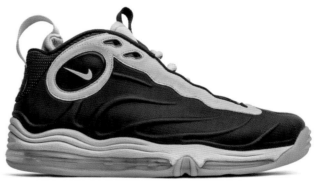

2005: Nike Foamposite Max 'Baroque Brown'

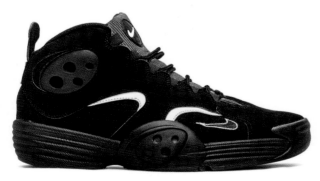

2012: Nike Air Flight One

1996: Nike Air Zoom Flight V

1992: Nike Air Flight Huarache

1997: Nike Pure Uptempo

1998: Nike Air Aggress Force

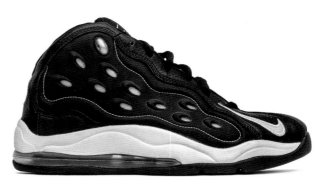

2002: Nike Air Max Shake 'Em Up

1999: Nike Air Jamgasmic Flight

1998: Nike Garnett

1998: Nike Air Zoom GP

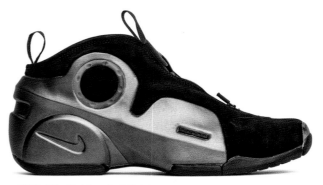

2000: Nike Flightposite 2 'Asia'

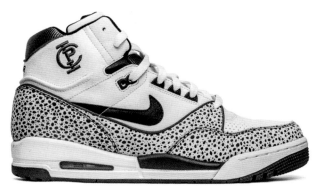

2006: Nike Air Assault 'IPC'

2004: Nike Air Alpha Force 2 'mita sneakers'

2015: Nike Air Flight Lite 'Hare'

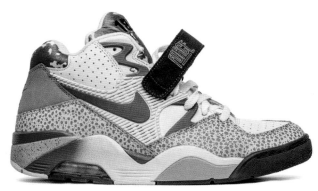

2005: Union x Nike Air Force 180

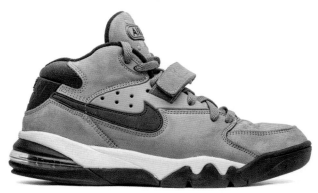

2003: Nike Air Force Max 'Wheat'

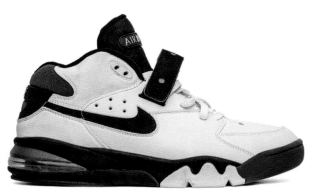

2001: Nike Air Force Max 'Royal'

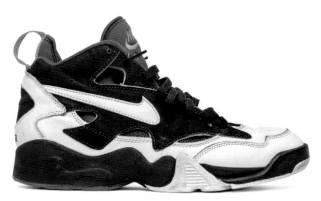

1994: Nike Air Prevail 'Suns'

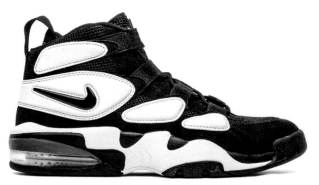

2011: Nike Air Max Uptempo 2

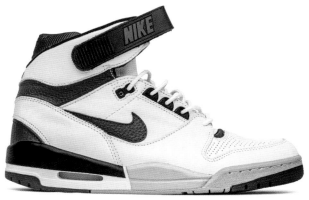

2002: Nike Air Revolution

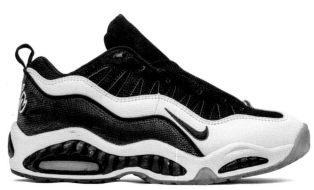

1996: Nike Air Movin' Uptempo

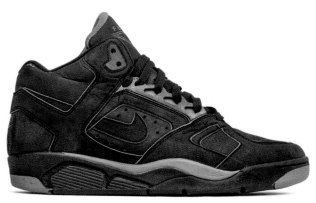

1990: Nike Air Flight Lite Mid

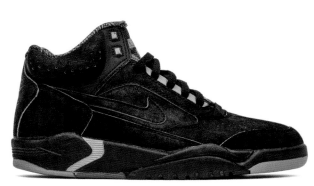

1991: Nike Air Flight Mid

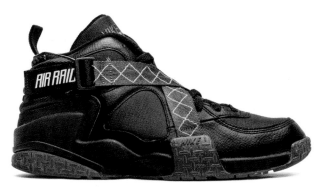

2008: Nike Air Raid 'HOH'

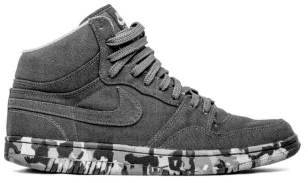

2008: Nike Court Force High 'Graffiti'

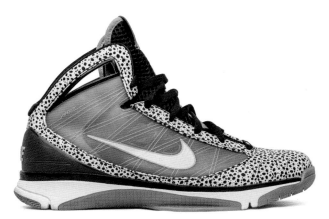

2009: Nike Hyperize 'Safari'

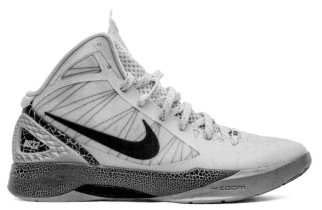

2011: Nike Zoom Hyperdunk 'BG'

Outdoors
Collectors

Interview
WOODY

Photography
PETE CASTA

SUPER LADY

UNCUT GEMS

With three decades invested in footwear fiending behind her, Lalla is a paid-up veteran of the legendary Paris scene. Her eclectic taste ranges from 'perfect-shape' Air Max 1s to OG hoops shoes, but teched-out trail runners and hiking boots are her most beloved pairs. Just like the Nike ACG models she covets, Lalla is rugged, strong, waterproof and unbreakable – so get ready to duck as she tees off in this frank interview. As she freely admits, 'I'm too old to change now!'

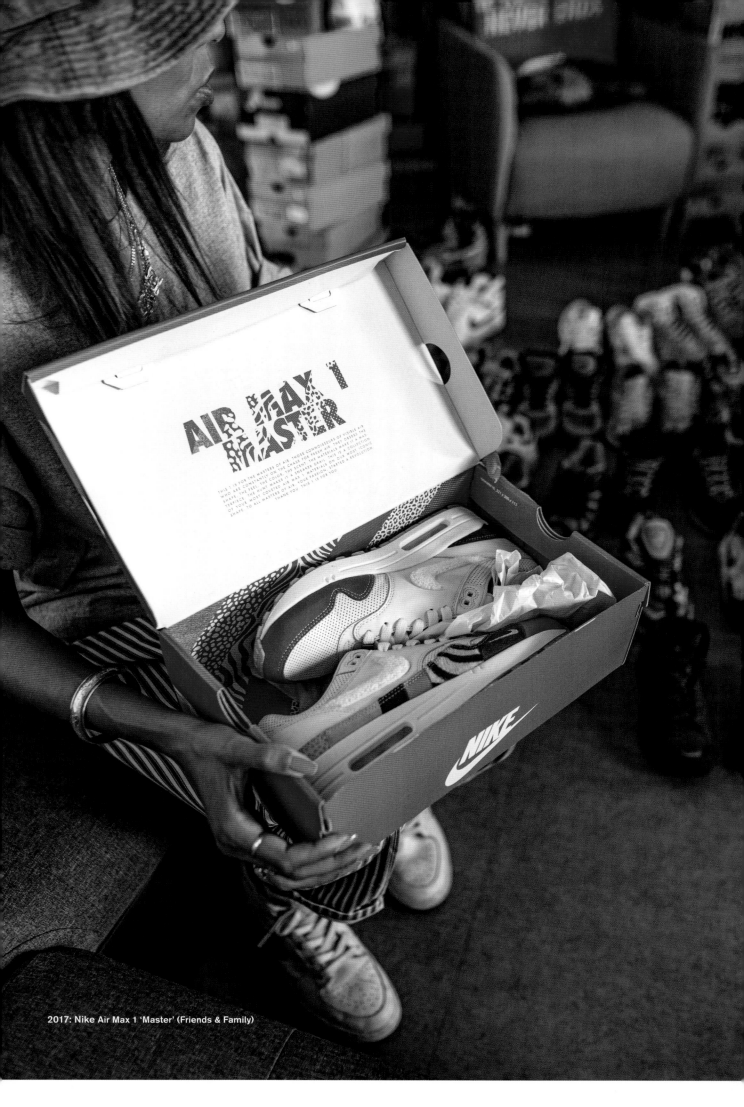

AIR MAX 1 MASTER

2017: Nike Air Max 1 'Master' (Friends & Family)

Super Lalla
All Conditions Gear
Paris, France

I was born and raised in Paris, though I'm French-Moroccan. I've been a high school teacher for the past 12 years, and I absolutely love my job. I guess you'll figure out my age through my profile and what I like. Hip hop was big when I grew up. Just like all the good people from my generation, I do vinyl only – rap from the 1990s to the early 2000s. Outside of sneakers, clothes are important. You always have to match the shoes. Other than that, I'm still thinking about my long-awaited PhD, but for sure, laziness will get the best of me before it happens.

My parents have always been stylish. Sneakers are linked to so many family memories, moments, people and certain times in my life. I will always remember my dad building shelves in the bedroom I shared with my brother because we didn't have enough room to store everything. My mum always wanted my brother and me to shine, so we used to spend weekends shopping. Sometimes girls from school would come with us as well. Kicks were an important part of those expeditions. Reebok and adidas were strong back then, as the Classic and Freestyle were must-wears. With that big logo on the side, Chipie was also super cool. Girls rocked them in every colour.

It's funny how images of people stay stuck in your mind forever. Jeanne, an older student, had the Reebok Freestyle in every colour. One of my best friends, Anne-Laure, came to school one day with the craziest pair of shoes we had ever laid our eyes on. It had a huge air bubble incorporated in the sole. We thought it might explode if we jumped on it or pressed them too hard. That was my first introduction to the Air Max BW, and I had to have a pair!

So yeah, I've been 'into sneakers' for almost 30 years now. I'm definitely a Nikehead at heart, but I am also into adidas, mostly basketball hightops like Jabbars, Top Tens and Attitudes but also low-cut classics like the Rom, Country and SL80. I was never into basketball, but the Sky Force – despite its plainness – is also beautiful. The height is perfect, as are the overall thickness and proportions. I would say the same for the adidas Pro Conference. I put these two on the same page as they are my two favourite ball shoes. I have a lot of love for the Blazer also, but Nike killed it with too many ugly releases, so I cannot look at it again. Once the shape is messed up, I'm outta there!

The pairs featured here are my most beloved pairs. Limiting yourself to one shoe is impossible, but if I had to, I would choose the Air Max 1 in white on white. This is the pair that featured in the Nike 'Masters of Air' video. It was so hard to pick one pair that day, so I decided to keep it clean and simple. Nice bubbles at the back, good proportions, not too wide, not too thin. It's like a little piece of art. Most people don't appreciate it because it's kinda plain and simple, yet it's timeless. You might think all-white is boring, but it is absolutely stunning in my eyes. The Air Max 1 shape in 1999 was amazing. The leather is gorgeous, and when everything seems plain, that's when you actually realise the inner beauty.

My love of outdoor shoes was triggered, then born again after I had surgery in 2016. I had my toes and entire feet basically destroyed and rebuilt, which was one of the most painful periods in my life. Afterwards, my foot shape changed, and they became much more sensitive to comfort and width. Even though I was a big bubble fan, I needed something different.

Since I could barely move my toes anymore, I needed thicker soles, softer inner soles and more flexibility. I was also over the ugly banana-shaped Air Max that Nike has been serving up for a while, so I started digging into the ACG catalogue to look for gems.

It's funny because if you rocked Humaras at school, you would be laughed at as they were definitely seen as hiking shoes for dads to wear on Sundays. Not cool at all! But the more I looked, the more I liked them. ACG shoes from the early 2000s are more discrete than Air Maxes of that era, at least among my people, even though you'd see the Wu-Tang Clan or some other super-influential artists rocking them like gold. Maybe it's because I'm older too. Wearing big bubbles in certain situations makes you look like you're trying to be a bit too young.

The truth is, outdoor shoes are way comfier than an Air Max 1 today. When you really start digging, you realise how many different designs ACG made back in the day. Every little detail, from the sole pattern to the lacing systems, has so much thought put into it. I really appreciate those intricate details more than ever. Sometimes I cannot believe a pair was conceived 30 years ago yet still looks fresh and innovative.

I'm not into hybrid sneakers, but I love a good slip-on for their easy-to-put-on functionality, but also because sometimes you need a little twist on an old shoe to keep the love alive. Also, laces are sometimes boring! Like the Air Humara, you still want to wear a shoe but with a different vibe. I've always thought slip-ons have a feminine look about them.

At the end of the day, I'm drawn to rugged, strong, waterproof and unbreakable shoes. I like to know I can run, jump, swim, climb or crawl about in them, even though I don't do any of these things. I just appreciate the idea of having tough shoes, but I also love the Air Approach with the Liberty flower print. I bought them from Starcow even though I'm not at all into girly stuff. They are the perfect mix of rugged style with cute details, which you would never expect to be seen together.

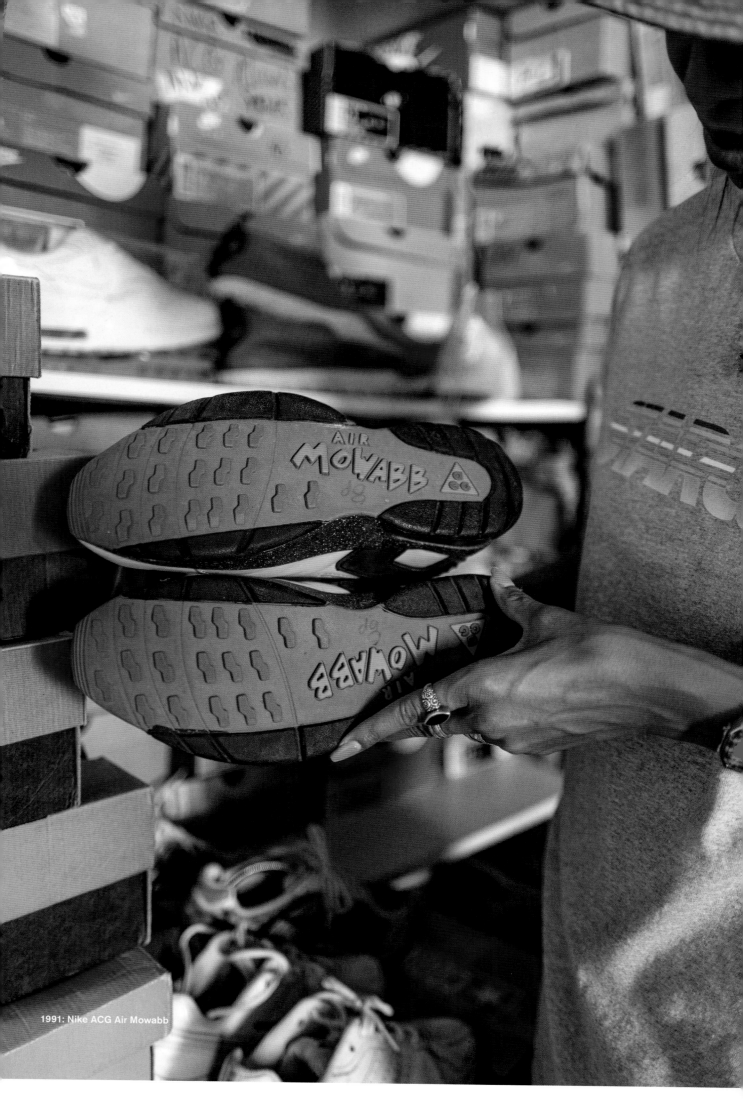

1991: Nike ACG Air Mowabb

A few decades or so ago, nobody really cared about sneakers, but the ones who did had real love. To me, it was just something normal. It was just about you and your personal taste. I don't know how to explain it, but it was never about showing off. Everything was easily reachable too. Shoes could stay on shelves in a store forever – no raffles, no lines, no bullshit. For instance, in the early 2000s, nobody cared about the Air Max 1. You could get the 'Crepe Hemp' for $50 or the 'Grape' for $40 – at least, that's how much I paid for them!

A few years ago, in my eyes, the Paris sneaker scene was pretty strong, mostly Air Max, specifically the 1, 90, 95 and TN. I have always thought Europe was more into running shoes than America, but that might not be the most objective opinion. These days, the Paris scene is just like everywhere else worldwide – generic and homogeneous. It's sad to see that everybody craves the same stuff over and over. Social media feeds your brain with the same images on repeat, so much so that even if you hate it at first, you end up wanting it. This brainwashing is so powerful even I sometimes fall into the trap. Just like a cheesy commercial song on the radio you hear all day long, you just end up liking the tune because it's stuck in your head. To me, there is no 'Paris scene' anymore, or in New York or London for that matter – it's just an 'everywhere' global scene.

2003: Nike Air Steens

I honestly feel my generation still has that pure love for sneakers. We saw the beginnings of it. We lived it. We had it in front of our eyes, just like the Golden Era in hip hop. Today, personal taste seems to have gone, opinions don't exist, and you are simply into sneakers because hype says a shoe is cool or valuable. Money seems to be the only thing that determines popularity. Just check the price, and that's it! Cash kills everything in our modern society, making it hard to get your brain excited. I will stop here because I could talk about this forever!

The Nike 'Masters Of Air' campaign was definitely a highlight in my sneaker adventures. To even be considered was astounding. Being chosen was incredibly flattering and exciting. I'll never forget meeting Tinker Hatfield at Nike's headquarters in Portland. The little exposure it gave us was something interesting too. If it wasn't for that, we wouldn't be talking right now, would we?

On the other hand, recognition is never something I looked for. I am into shoes for one and only reason – the love of it! Nothing more. The passion, the obsession, the search for the perfect shape, materials, colours and technology behind every shoe… I can spend hours just staring at a shoe, contemplating how it's made and why it looks the way it does. I never got into it thinking I would become well known – it just happened. Some people collect stamps and rocks. I collect sneakers.

I don't have too many regrets. There are always pairs I could have bought but didn't, plus a few pairs I sold for nothing after surgery because they didn't fit my feet anymore. There are a few gems I killed and put in the trash as well, but I always figured that when it's dead, it's dead! Years ago, keeping shoes you couldn't wear anymore seemed foolish, so it's funny to me watching kids brag about broken-into-pieces hype pairs they bought over the internet.

When you really think about regrets, that's when you realise you shouldn't have them at all. I feel extra blessed for everything I have and for all the great people I have met through my love of sneakers. I still feel the excitement of a new pair, and that's all that matters. I will always do me. I will always like what I like. And I'll always say out loud when shit is wack! At the end of the day, it's only my opinion, so who really cares? I can't help it, and I'm too old to change now!

★

@superllalla

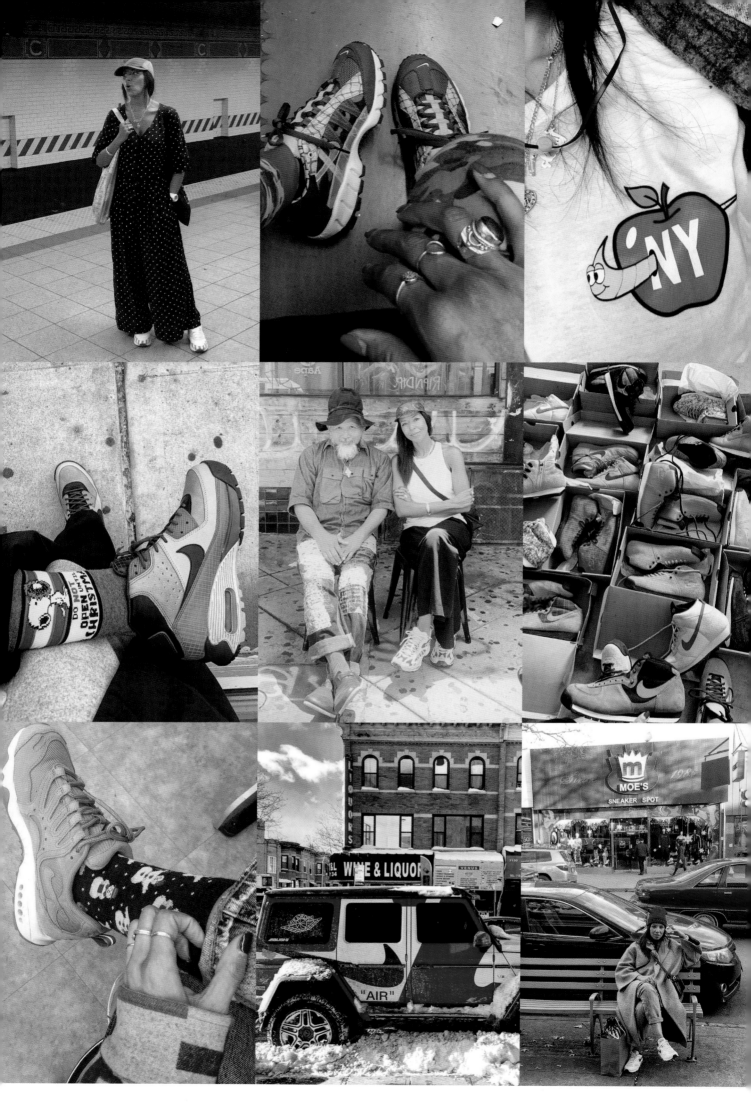

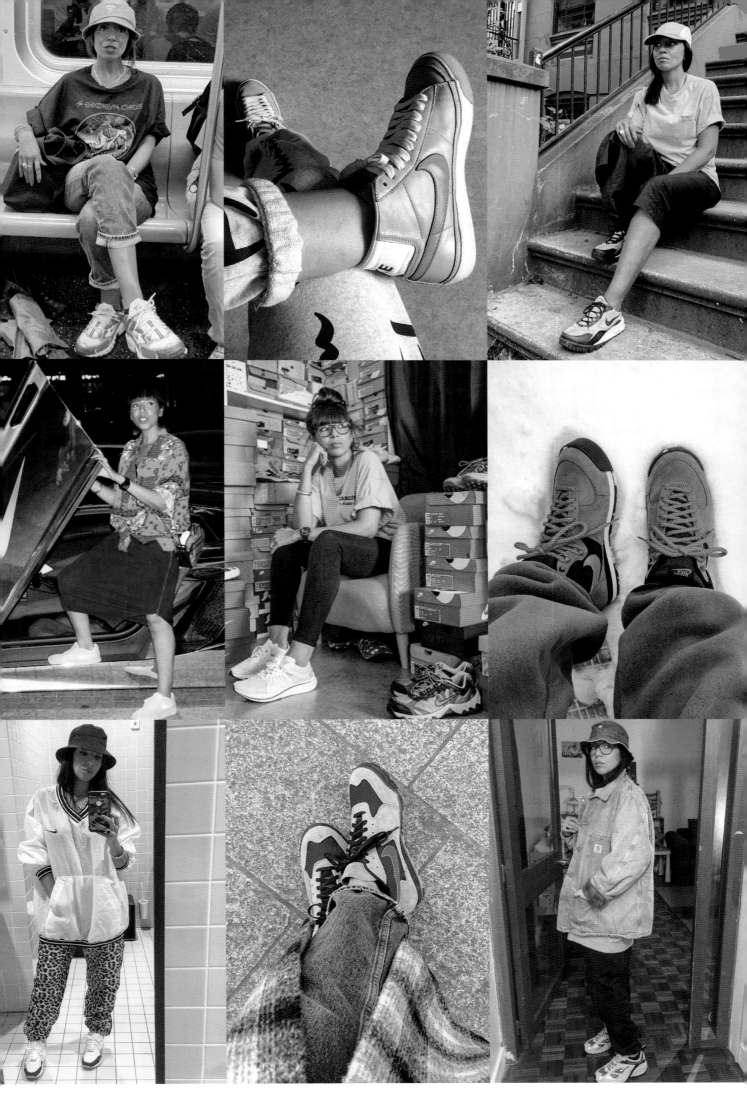

'Nice bubbles at the back, good proportions, not too wide, not too thin. It's like a little piece of art. Most people don't appreciate it because it's kinda plain and simple, yet it's timeless. You might think all white is boring, but it is absolutely stunning in my eyes. The Air Max 1 shape in 1999 was amazing. The leather is gorgeous, and when everything seems plain, that's when you actually realise the inner beauty.'

1999: Nike Air Max 1 Leather

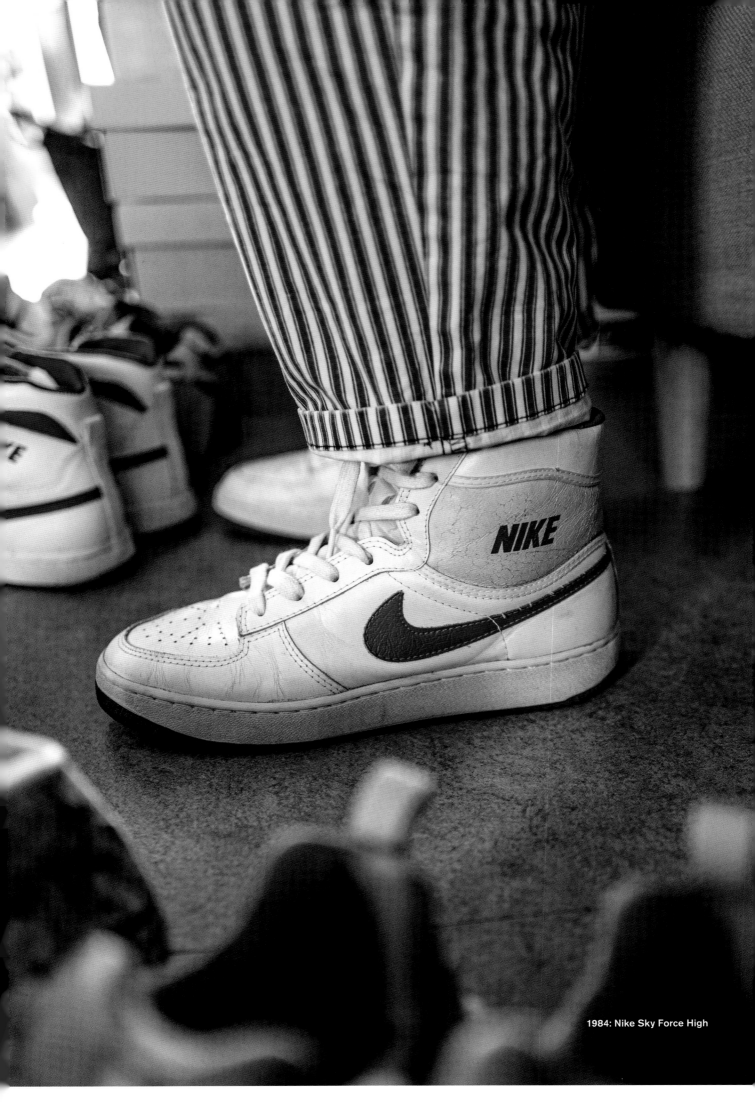

1984: Nike Sky Force High

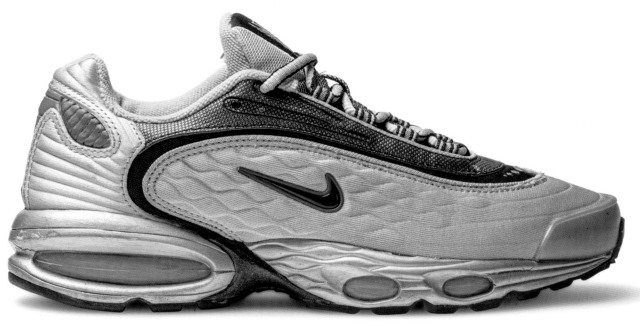

Nike Air CVG Max (Sample)

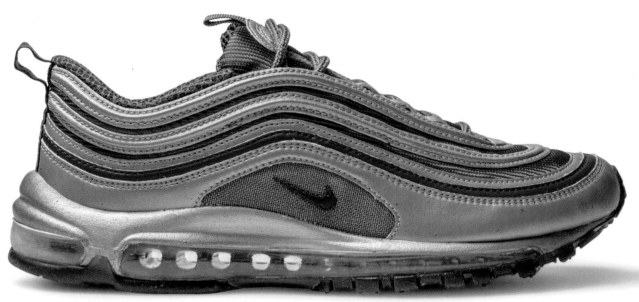

2006: Nike Air Max 97

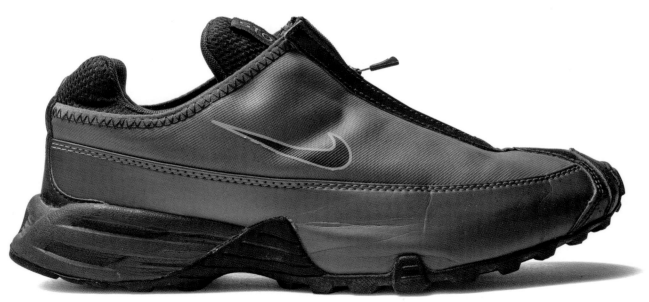

2001: Nike Air Terra Contega

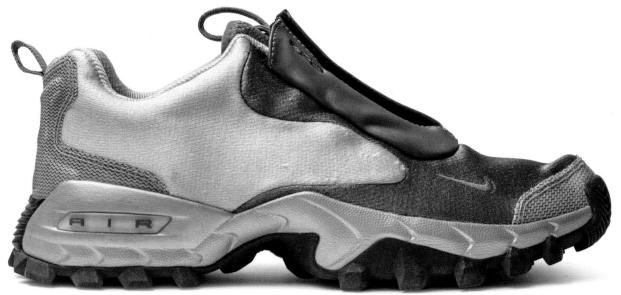

2001: Nike Air Wailuku

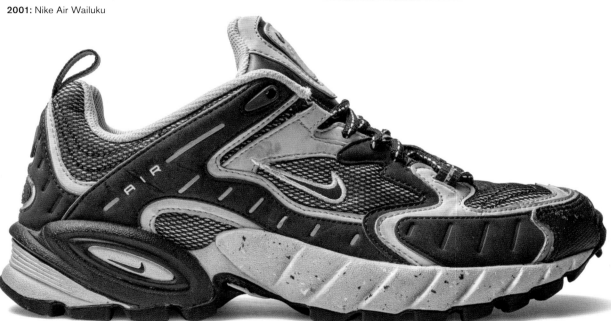

2002: Nike Air Terra Sebec

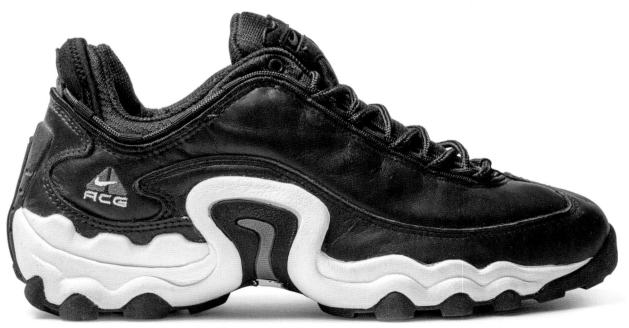

1997: Nike Air Skarn SC

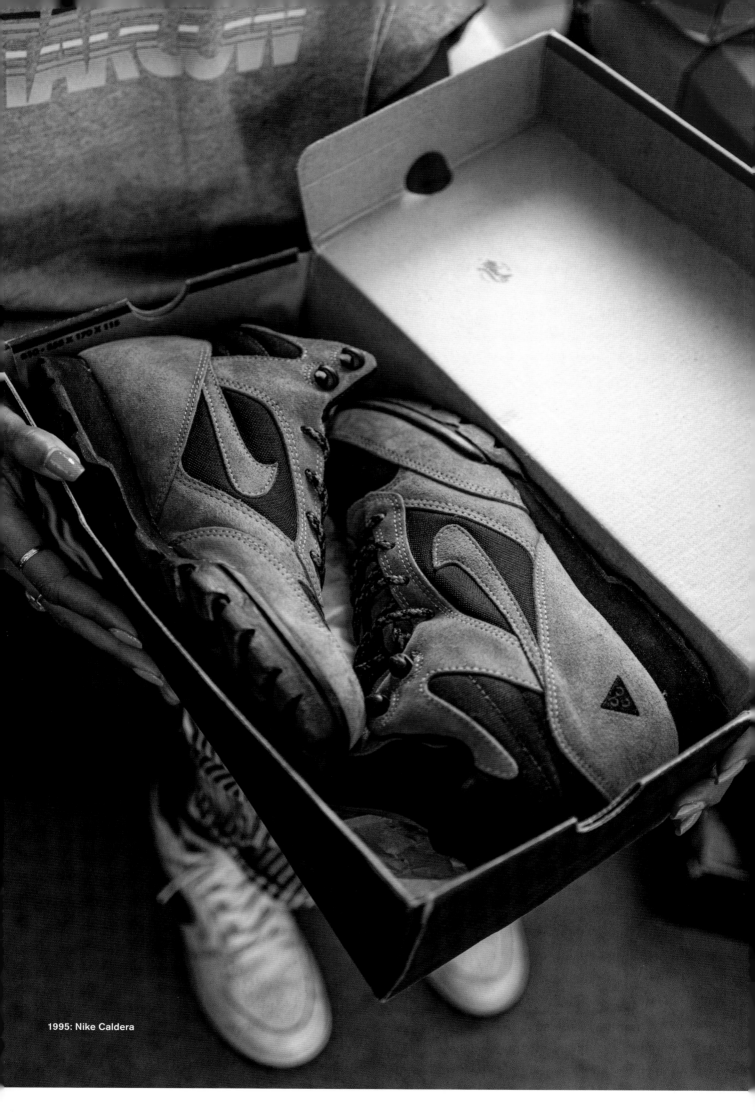

1995: Nike Caldera

522

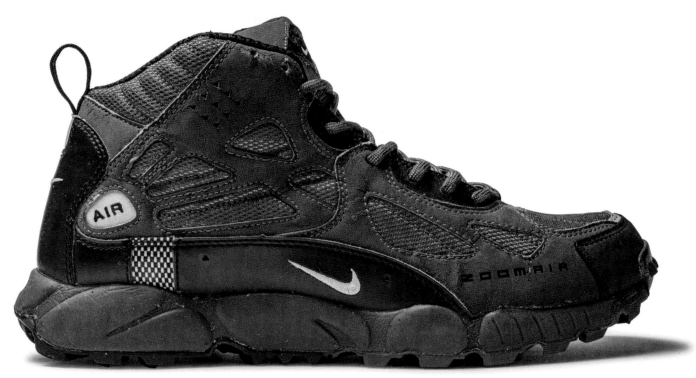

2010: Nike Air Terra Sertig

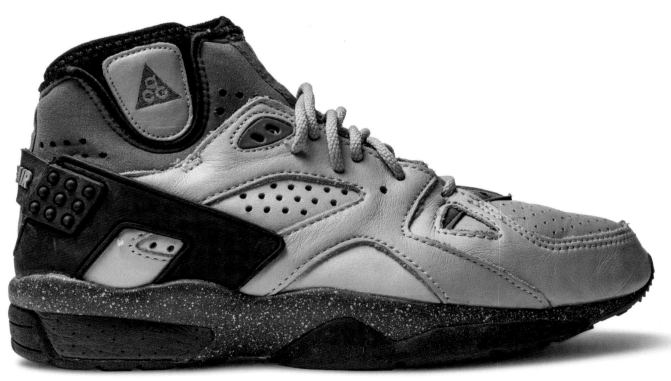

1991: Nike Air Mowabb

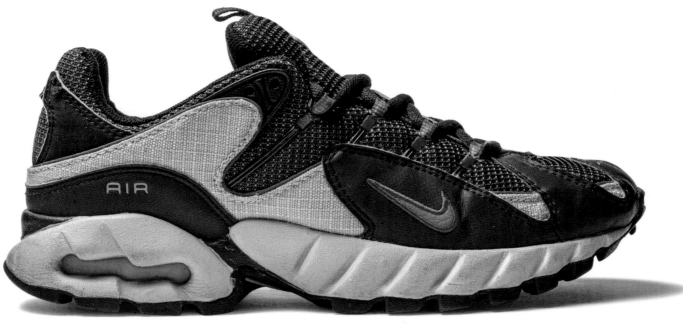

1999: Nike Air Terra Reach

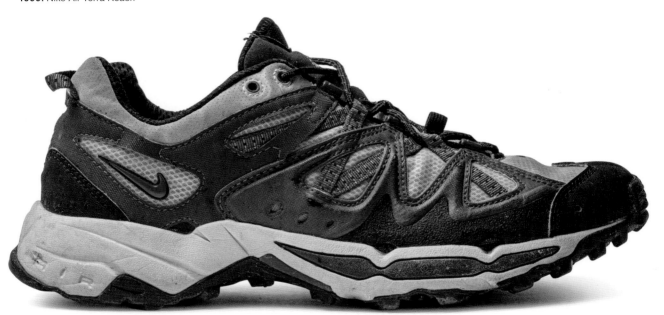

2005: Nike Air Orizaba

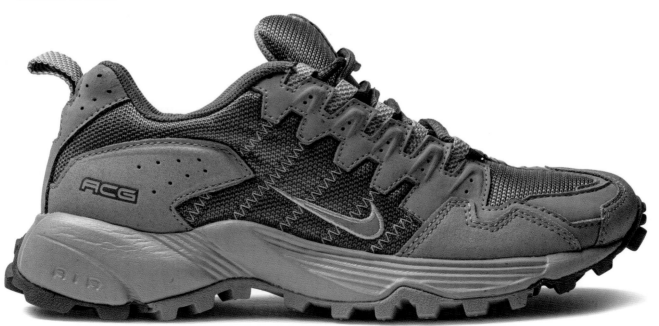

2003: Nike Air Alvord

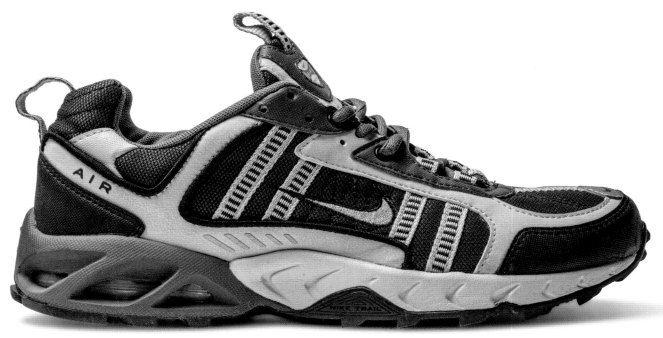

2000: Nike Air TR9000

2001: Nike Air Humara Slip-On

2000: Nike Air Terra Humara Slip-On

1992: Nike Terramac

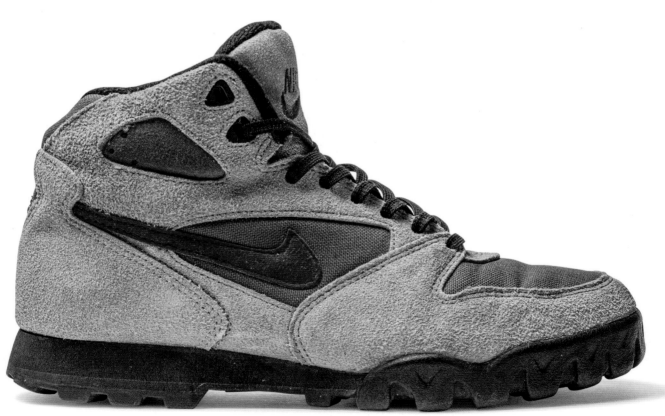

1994: Nike Caldera

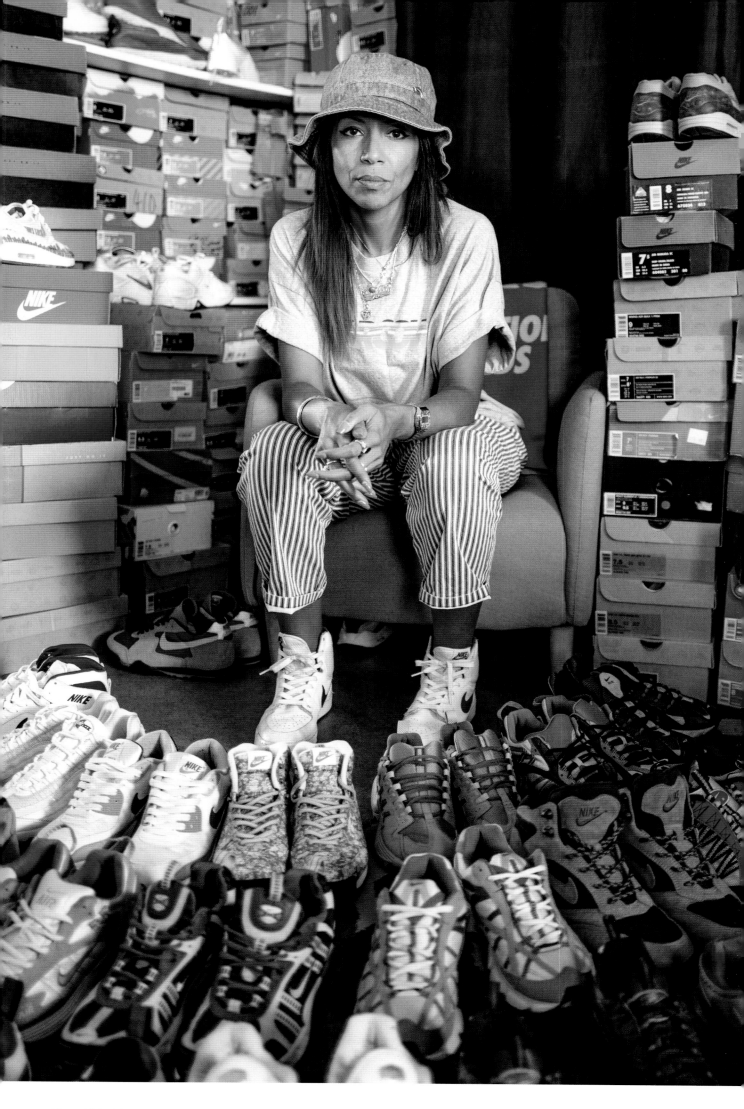

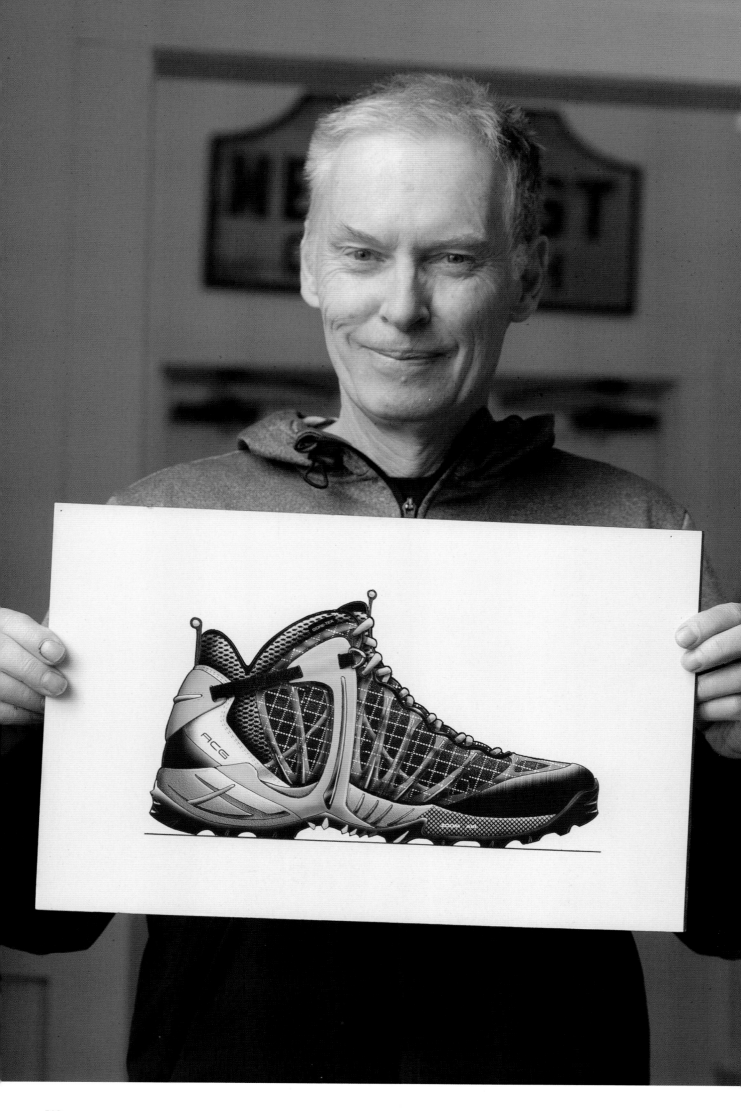

Interview: **Nick Santora** Photos: **Todd Westphal**

PETER FOGG

All Conditions Gear

Connecting with nature through hiking, biking and trail running was big business in the 90s. Brands like The North Face, Timberland and Helly Hansen cashed in, making teched-out gear for outdoor adventurers and suburban wannabes. In 1991, Nike expanded their horizons with the official launch of All Conditions Gear (ACG). On the frontline was Peter Fogg, architect of the legendary Air Humara, Terra Humara, Terra Sertig, Terra Albis and Air Minot, among others. Straight from the veteran designer's Oregon studio, it's time to look back at his career highlights.

These sketches helped Fogg land the Nike job

You have an incredible list of sneaker designs to your name. How did you come to work at Nike?
I was up in Seattle designing Boeing aircraft interiors, feeling that my design career had hit a dead end when I received the frightening news that I had Hodgkin's disease. After recovering from cancer, I needed a change. I discovered that an old classmate, Dave Schenone, worked at Nike.

In the weeks before my interview at Nike, I would draw shoes and rollerblades at night. That was my attempt to show them I was more than an aircraft interior designer. They took a chance and hired me. I was a 39-year-old guy with one scuba-diving boot as my total footwear experience.

Do aeroplanes and sneakers have anything in common?
Not really. An aeroplane is very engineer driven, and the designer is most likely part of a large team working on a three- to five-year timeline. In the end, most of your work will never go further than Foam Core mockups. I was pretty good with an X-ACTO knife by the end!

With footwear design, one inline designer can be responsible for two or three shoes per season, which was a bit of a shock, so the transition wasn't as smooth as you might think. I remember there were

four projects assigned to me. I had to give two of them to another designer because I just couldn't get everything done on time. There were days when I was definitely second-guessing my decision to come to Nike.

What does designing a new shoe involve?
If you work in Nike Basketball, the process is driven by performance, athletes, stories and wear-testing, whereas Nike Sportswear is driven by comfort, colour, lifestyle and retro design. My process would start with a marketing brief defining items like target consumer, problems to solve and the final price.

From there, it was collecting info, rough idea sketches and getting out into the world of your consumer. I'm a big believer in mockups, working with your hands and getting early samples from the factory to evaluate ideas. I spent way too much time sketching, but that's one of the fun parts. I always felt I needed to explore every possible option in the time I was given.

How much consideration did you give to the fashion perspective of your designs?
A great deal of consideration goes into the look. I think it's fair to say

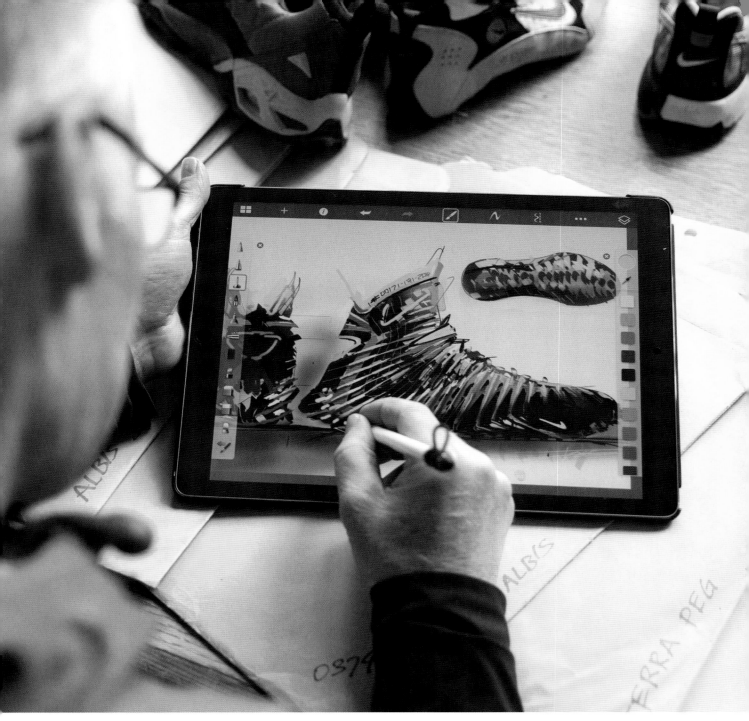

Peter Fogg at work

that every designer is trying to achieve both great performance and appealing aesthetics. Performance can be tested and evaluated, while aesthetics are subjective. I understand that a lot of people bought my trail shoes and never used them for that purpose, and that's cool. I never went out of my way to ask non-runners what they thought of my designs unless it was my wife or kids. [Laughs.]

What influenced the amazing colours you chose for your shoe designs?

Colour makes or breaks a shoe. I remember drawing inspiration from mountain bikes and outdoor gear for trail shoes. When I worked on the Sertig and Albis, the colours were inspired by European consumers. I also looked to race cars for inspiration. The original Terra Humara colourway was inspired by the Air Max 95 and the shoe's black midsole. When I started with Nike Running – before computers and colour specialists – the marketing and design departments would sit in a room colouring in the line art for the entire season.

Why did Nike get into trail running?

New Balance and adidas had some success with trail, and Nike wanted to get serious about the category. The need for quality trail

shoes is real. A lot of runners enjoy being away from cars and the city. It's nice to have boosted traction, durable materials and darker colourways because your shoes get dirty when they're exposed to the elements. At the time, I believed the shoes would only be used for the trail, so the lug traction was extra aggressive of the first versions on shoes like the Sertig and Albis.

What inspired the Humara?

Inspiration comes from everywhere. Images, athletes, stories, words and research all help to define a design. A lot of my shoes have several points of inspiration. For example, the Humara was inspired by lightweight camping tents, webbing, climbing shoes and a Nike cross-training shoe with a fabric-wrapped midsole. The Sertig and Albis names came from mountainous areas in Switzerland. I wanted the shoes to look low, fast and balanced like a Formula One race car. The Minot took inspiration from slow-moving vehicles, caution signs and reflective 3M. Every shoe has a story.

I heard the Zoom Tallac is your favourite.

Yes, the Zoom Tallac is right at the top. I like it because we created something entirely new. Every decision was driven by a single goal.

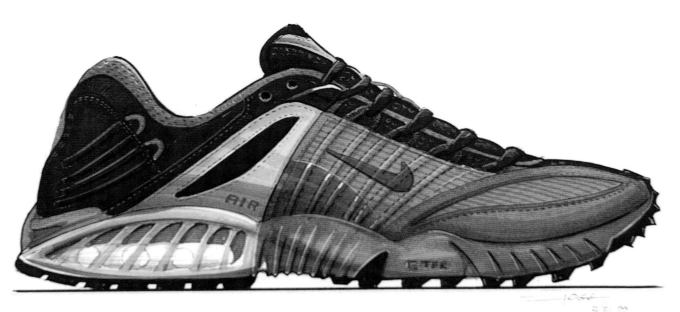

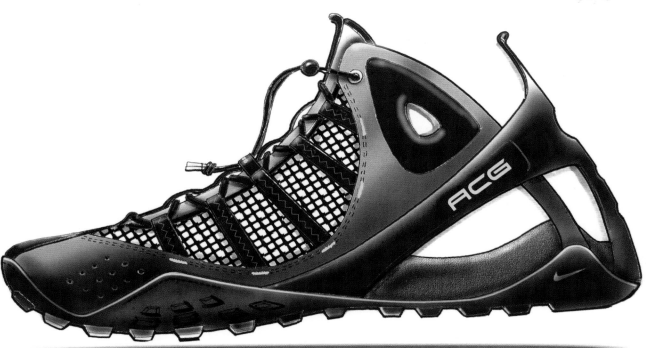

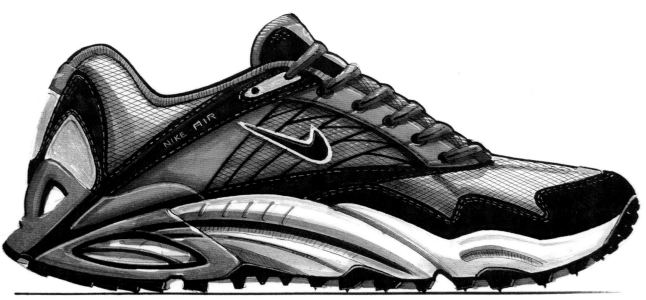

Original design sketches

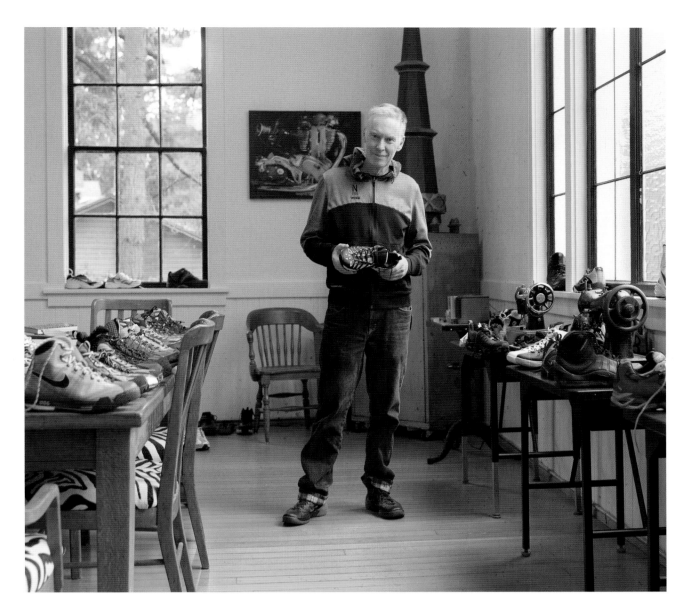

We wanted to design a boot that weighed 16 oz and could still do everything other heavy boots could. I had a great team that went all-in for this crazy-looking boot, which was my first. The factory performed some magic with the moulded plastic support and GORE-TEX construction. The wear testing was done by professional mountain guides and rock climbers.

The Zoom Tallac is an example of designing for the top-of-the-mountain consumer, but in the end, it also tries to appeal to everyone. The design inspiration was drawn from the skeleton of a bat wing, moulded supports on basketball shoes and materials used in backpacks.

Is it cool to see your old designs back on shelves?
When one of my shoes, like the Humara, is brought back, it's always exciting to see the new colourways and materials. I'm no expert on why certain shoes are brought back, but I'm pretty sure it has to do with the original model's popularity. Trail shoes are versatile, practical and go with everything. Just don't put trail uppers on blow-bag tooling.

Here's a nerd question. Why was the Humara in the Nike Running category instead of the ACG catalogue?
ACG and Running were completely separate categories. All the trail shoes I designed in the 90s were actually designed for Nike Running. Trail shoes need to be great running shoes, first and foremost. Later, when I was in ACG, the category started designing trail-running shoes because Nike Running had stopped featuring them.

Trail running was always the red-headed stepchild in the running category, and pushing trail shoes into the mainstream was an uphill battle. All the money and advertising budgets went into the brand's well-known running shoes. I just tried to design the best shoe I could and

hoped it would gain a following in the trail community. Having a shoe break into the mainstream was always a surprising bonus.

The Terra Humara was featured in *Vogue* magazine. How did that article change people's impressions of trail running?
That article made me laugh so hard. The idea that models and Hollywood actors were wearing the Humara was funny. I was under the impression that my trail-running designs would be used for trail running. The article created a lot of pressure on every trail shoe that followed the Terra Humara. It also helped bring some attention to trail running and what was possible, so that was cool.

Another nerd question. What was up with the Air bubbles in the Terra Humara midsole?
The Terra Humara was one of the earliest trail shoes to use a visible airbag in the midsole. Naturally, one of the concerns was punctures caused by sticks and rocks. I wanted to protect the airbag but still make it visible, hence the recessed circular windows. The medial side had smaller windows for improved stability on that side of the shoe. The circles also referenced my disc brake inspiration.

Why do you think you were able to capture the ethos of this category so well?
I think I was there at just the right time. Marketing and the design team leadership trusted me even when my early sketches looked a bit rough. The success of the Humara helped. I also had the opportunity to design loads of trail product, which helped my odds of coming up with some winners. Some of my designs never made it to icon status, but they were still good shoes to run in. There is no magic formula to ensure a design becomes iconic.

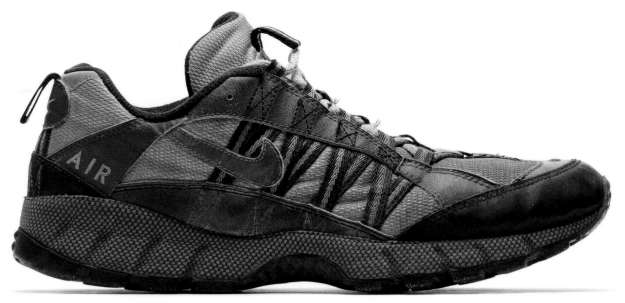

1996: Nike Air Humara

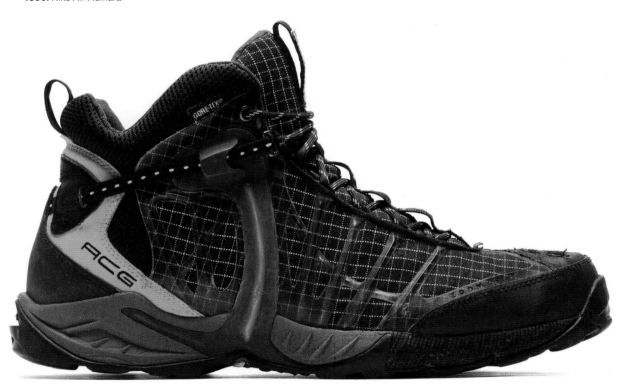

2003: Nike Zoom Tallac

You ended up transitioning into basketball. How did that come about?

I was working for a small group called Elements doing boots and sport slides. Leo Chang called me up one day. Going from a little group like Elements to Basketball wasn't going to be easy, and I thought about it for a day or so. I actually had to interview for the job because other designers were interested, which meant I needed to update the portfolio I hadn't touched since the day I interviewed at Nike 16 years earlier! But it went well, and I was hired. In the end, I designed some pretty cool shoes, such as the Hyper Mayhem, Hyperposite, Hyperdunk, Venomenon, Hyperfranchise and the Hyperrev 2015, to name a few.

Every sport has a different list of performance requirements, and I think basketball is right there at the top. Every movement is considered and specifically designed for. A good basketball shoe considers traction, side-to-side support, locking the foot down, weight and comfort. You also have to consider a professional NBA player's size, strength and speed. All those demands require an extensive wear-test program.

Was there one particularly challenging design?

There are times when you need to redesign a shoe, put in extra work, fly to Asia to save the project, and in the end, it still might get dropped. The Slot, named for slot canyons, was the ultimate water shoe, and I thought it was great. The design was cool and functional, but in the end, it didn't make it into production. That's always disappointing, but it happens.

Another challenging project was the ACG Watercat. The upper was woven into the tooling to reduce waste and adhesives. Basically, I was working on an innovation project but with inline timelines. We could have used a lot more testing time on that model, but it did get produced in small numbers.

What's the best advice you've ever received?

When I started at Nike, I wrote down two words. Have fun! That was my advice to myself. Overall, fun definitely played out in my designs and choices throughout my career at Nike.

★

@peterfogg

Original Air Humara sketch

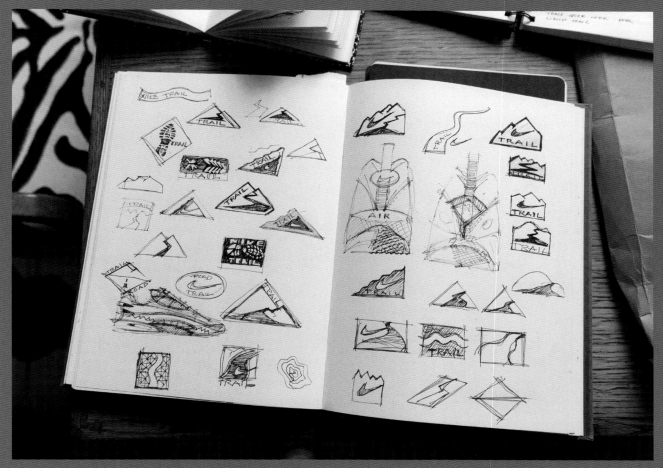

Nike logo experiments

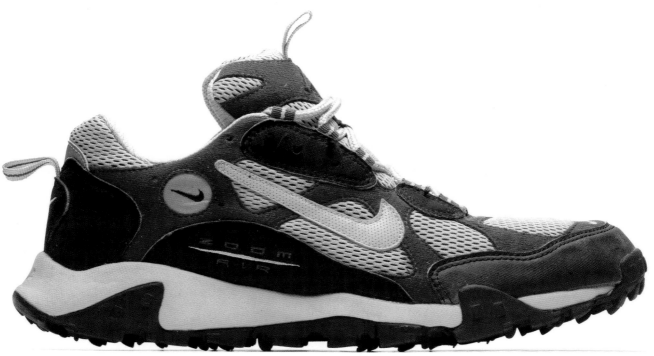

1997: Nike Air Terra Albis

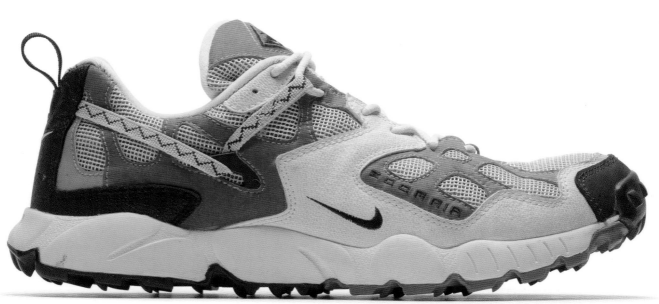

1997/98: Nike Air Terra Albis 2

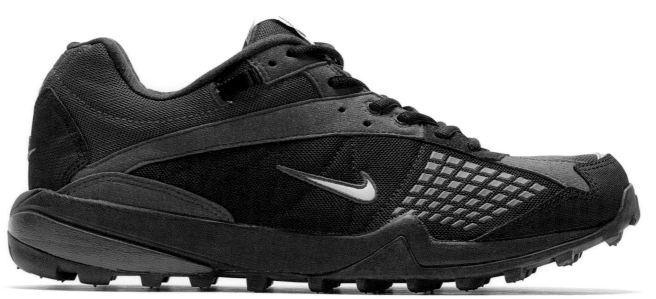

2003: Nike Air Tupu

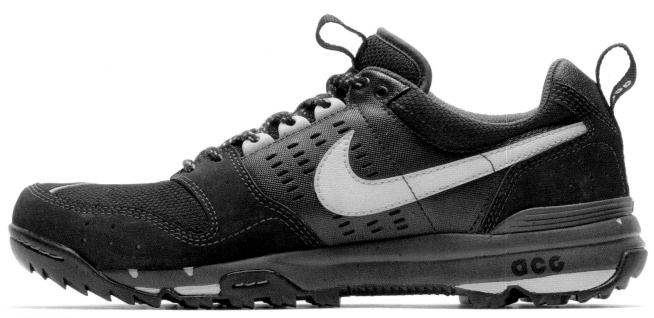

Nike Air Chantse

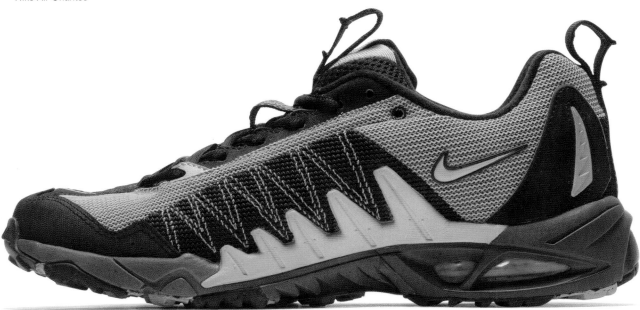

Nike Air Terra Grande

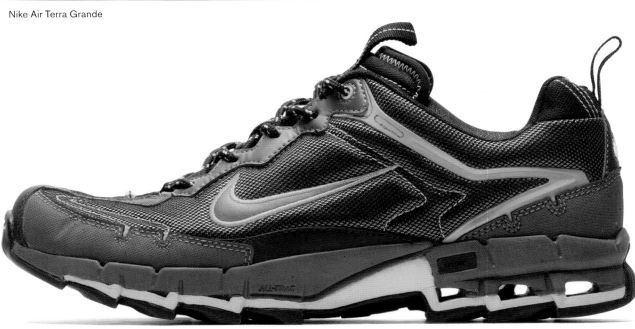

Nike Prototype

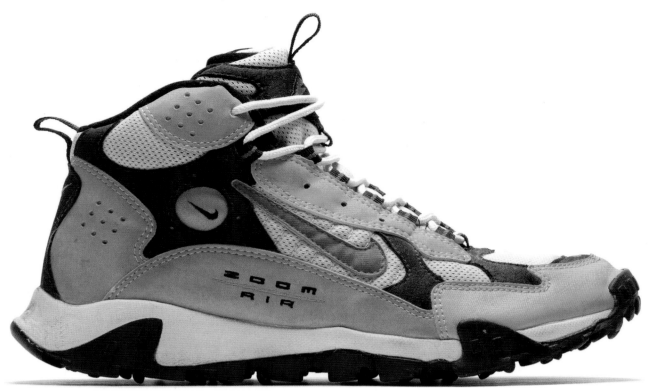

1997: Nike Air Terra Sertig

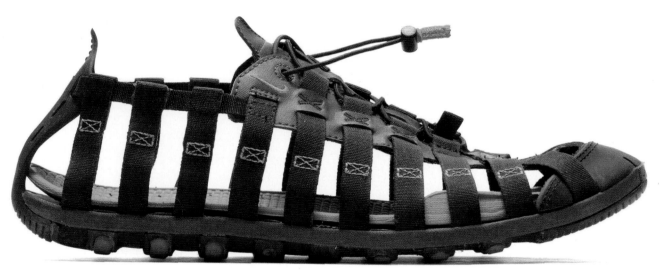

2006: Nike Watercat

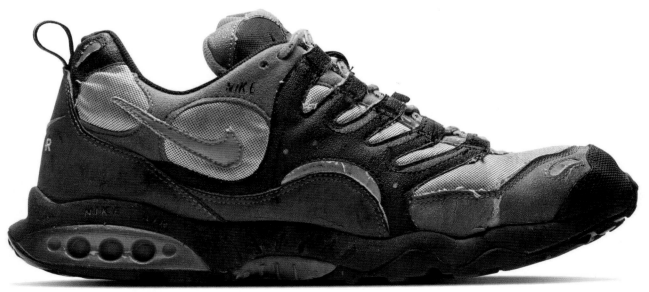

1997/98: Nike Terra Humara

'The Humara was inspired by lightweight camping tents, webbing, climbing shoes and a Nike cross-training shoe with a fabric-wrapped midsole. The Sertig and Albis names came from mountainous areas in Switzerland. I wanted the shoes to look low, fast and balanced like a Formula One race car. The Minot took inspiration from slow-moving vehicles, caution signs and reflective 3M. Every shoe has a story.'

1998: Nike Air Terra Central

2003: Nike Air Structure Triax

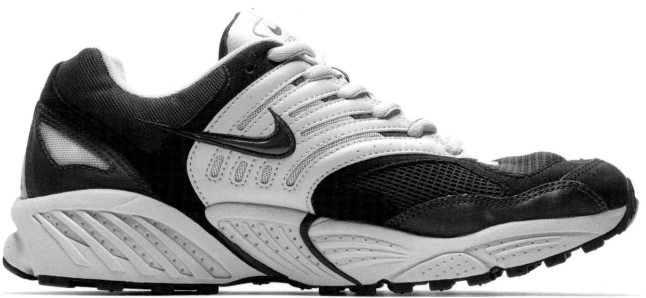

2002: Nike Air Pegasus

1997/98: Nike Air Terra Albis 2

2003: Nike Air Arches

2004: Nike Air Teocalli GTX

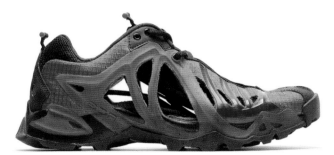

Nike Air Zoom Patrol (Prototype)

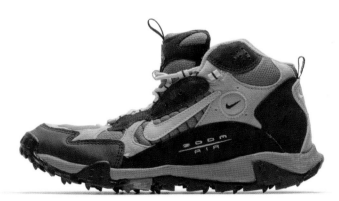

1997: Nike Air Terra Sertig

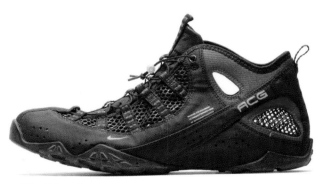

Nike Reinvent

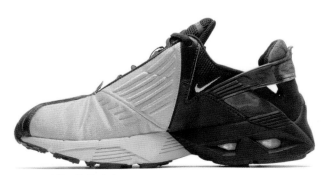

2002: Nike Air Turbulence

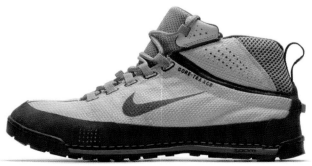

Nike Slot (Unreleased)

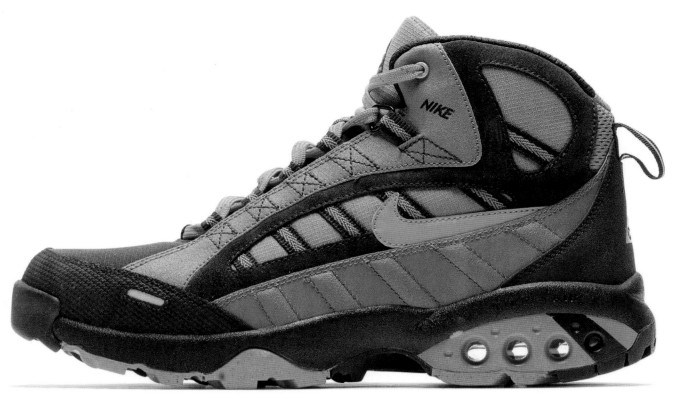

2011: Nike Air Umara

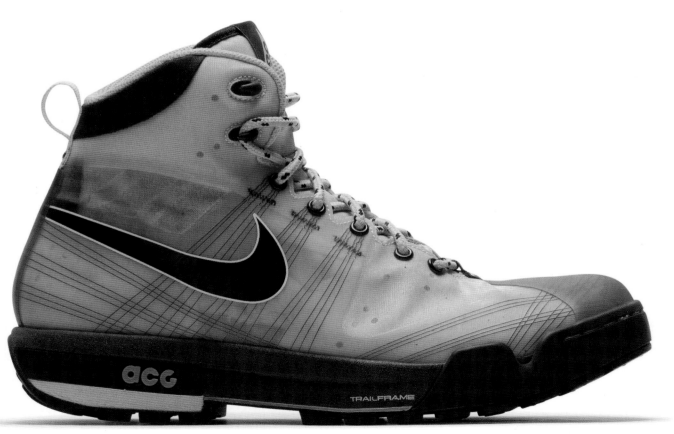

2009: Nike Ashiko

2008: Nike Air Blazer Mid GTX

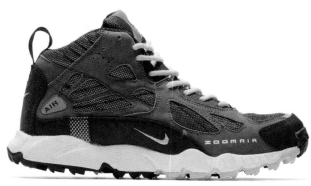

1998: Nike Air Terra Sertig

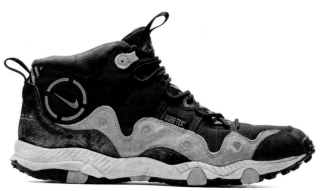

1997: Nike Air Minot

2005: Nike Air Zoom Tallac Pro GTX

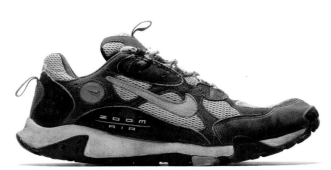

1999: Nike Air Terra Albis

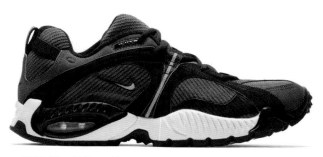

1999: Nike Air Terra Abrupt

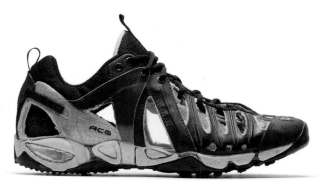

Nike Zoom Patrol (First Sample)

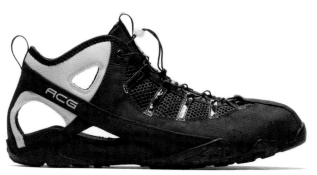

Nike Slot (Unreleased)

Julien Pradeyrol, better known as Teki Latex, is a Paris-based DJ and music impresario with a deep appreciation of tech outerwear and trail-busting footwear. You might not find him hauling ass on La Grande Traverseé des Alpes anytime soon, but Teki is a passionate brand savant with a mountain of Japanese secondhand vintage expeditions behind him. During the quiet times of lockdown, Teki started documenting his daily rotations via @tekilatex, where he fine-tuned his colour-matching skills and developed a unique approach to layering incongruous apparel. As he reveals in this thoughtful interview, dressing for the Great Outdoors is all about harnessing the abstract flow of energy.

PHOTOS
PETE CASTA

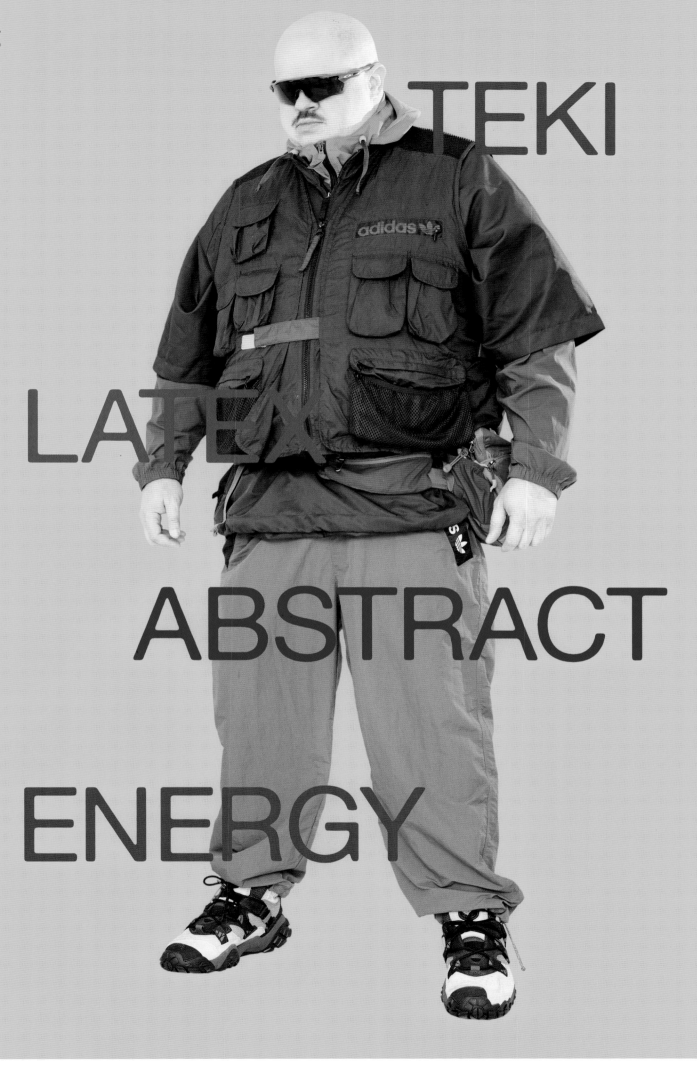

TEKI

LATEX

ABSTRACT

ENERGY

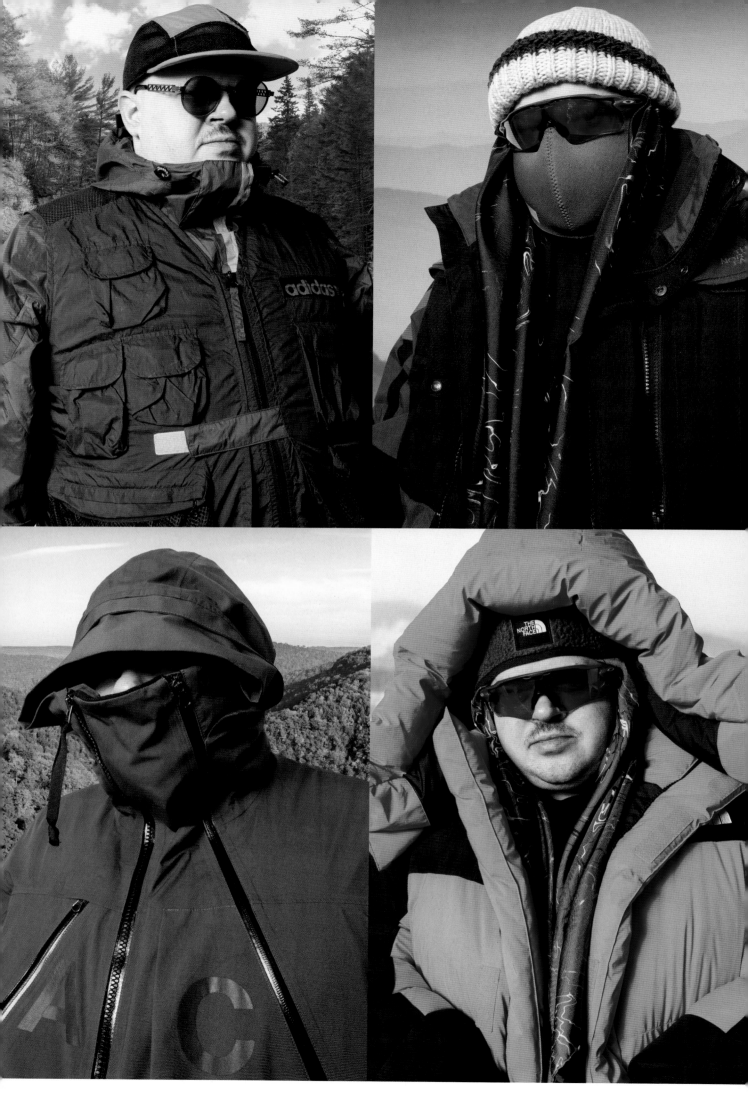

Teki Latex
Outdoors Specialist
Paris, France

The first part of lockdown hit me super hard. I was uninspired and unable to do anything but play *Animal Crossing*. Then gradually, I switched my state of mind from 'the music industry is dead' to 'Okay, let's use this time to focus on side projects I would never have explored if I was travelling every weekend to play at 4 am!' So I started putting more emphasis on my love of style and clothes. Taking mirror selfies with a different outfit every day was a good way to avoid staying in my boxer shorts. It's good for your mental health to dress nicely, even if it's just to buy groceries.

Showing off my wardrobe every day has led to the fulfilment of an idea I had with my friends Tez and Jérôme Hervé. We are bringing people from our entourage together under the 'Outerwear Enthusiasts' banner in the streets of Paris. On top of my radio shows and mixes, I'm doing more and more style-related stuff and working on inspiring projects, which will soon see the light of day.

I have always been attracted by the aesthetics of outerwear – the jackets, shoes, straps and futuristic style. Aside from rap, Armand Van Helden videos and the whole Japanese hiking vibe, maybe it subconsciously comes from the toys I played with when I was a kid. *M.A.S.K.* and Star Wars action figures have that multi-pocket look and the idea of different outfits serving different functions. G.I. Joe had ninjas, tactical gear, snow stuff and camouflage, all inspired by the military, obviously, but with a degree of fantasy that elevated and separated it from boring old soldiers. Starcom's toy-packaging design is kind of similar to Polo Sport – the little American flag is insane.

Do you remember the obscure Rock Lords toy line from the 80s, where the robots transformed into plain rocks? I look back, and they instantly make me think of multi-layered jackets and ACG shoes. The rock parts are similar to the rugged earth-tone exoskeleton of a shoe or the solid aspect of an outer shell, while the robot parts and technology hidden underneath the rock make me think of the neoprene booties in outdoor shoes and the pops of colour on the lining or inner layers. I guess that clash of technology and nature left a big impression on me.

I like to tap into an 'abstract flow of energy' when I put together my outfits, which is a bit like a chef who sits in front of his pans and gets an idea for a new way to assemble ingredients and create something better than the sum of its parts. Same with selecting tracks from different eras that complement each other nicely when I'm DJing. I try to lure people in and then surprise them with something they don't know, highlighting common sonic traits, which come from very different places, while maintaining a certain coherence.

I also try to do the same thing when I select an outfit, finding one detail that calls back to another completely different piece from another brand, another era or world. I'll look at something, and ideas will cascade. For example, I'll look at a shoe with a set of colours, and that gives me a blueprint, and then I'll keep that in the back of my mind when assembling my outfit.

I also try to layer things in an original way. I often like to do illogical things like wear fleece over a windbreaker. If the jacket is breathable enough, the result is usually cool and more comfortable than one would think. There are times when you just feel like trying something counter-intuitive, and sometimes it works really well and becomes your thing.

When I was a kid, I used to go to Japanese bookstores to look at manga, and now I'm older, I go there to check out outerwear mags. I have an issue of *Town & Field* that tells the parallel stories behind The North Face and Patagonia. I can't read what's written, but the images are cool. I love looking at Japanese magazines like *Go Out* and *Outstanding*. I don't know if it exists anymore, but I have a few copies of *HUNT*, a Japanese magazine with strong forest vibes and the recurrent use of an elderly Western man as the model. It's kinda cool to see the same bearded dad clad in old-school and sometimes high-tech outdoors gear.

In the early 2000s, I started performing in Japan, and I was lucky to get introduced to the streetwear and outerwear Tokyo scenes early on. I love shopping in Tokyo for secondhand pieces as well as Japan-only lines, even though most of the time I'm too big. But it's like going to a museum, and I love it.

I think the 90s rap influences are a subliminal reference for me at this point as they're distant memories now, but every once in a while, I'll stumble upon an old Boot Camp Clik video from 1994 and say to myself, 'Wow! That fishing vest really looks like something from the latest Snow Peak x TONED TROUT collection.' String vests are great for layering. You can wear them on top or underneath jackets according to the weather, and they still look good. That's the kind of piece that makes you want to build up your outfits like LEGO.

Personally, I think it's cool to mix traditional outdoors brands and the new generation. Once again, a recurring theme of the outerwear aesthetic is layering and hiding technical materials behind more rugged traditional ones, or vice versa. I think a truly original fit can and should combine the old with the new. Because the pieces are built to last and stand the test of time, they can remain in a wardrobe that evolves throughout the years without losing functionality or becoming outdated design-wise.

Like with music, I'm interested in outerwear that is made with the intent of being futuristic, whether it's the future of the 80s, 90s or 2020s. When you look at objects through that lens, you start to highlight certain common threads, and that's how my vision for what I want to look like and how I want to carry myself came together.

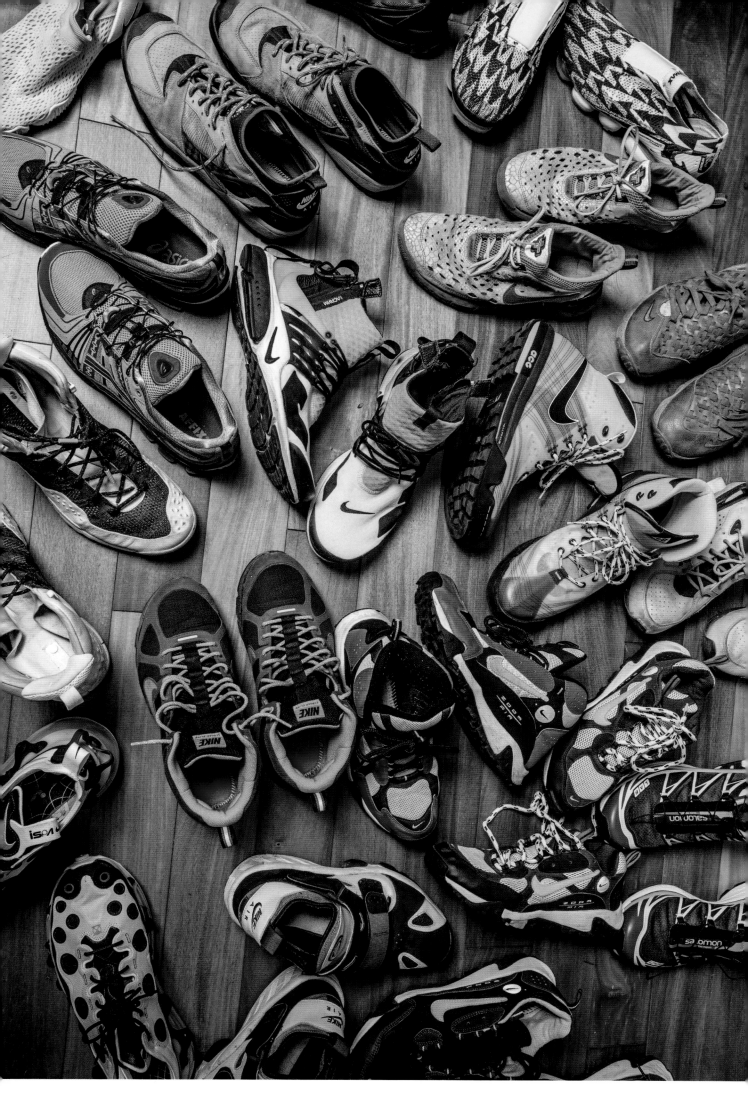

2020: Nike Zoom Terra Antarktik

Some of the designs of these jackets, fleeces and shoes from the 90s or early 2000s still look timeless and more advanced than what mainstream fashion looks like today. A couple of years ago, Acne Studios were still ripping off designs from old adidas trail shoes, and the result was so futuristic. To a certain extent, the Balenciaga Triple S looks like a Terra Albis with an extra layer of midsole, and that's a 23-year-old shoe.

I rarely (if ever) go hiking out in the mountains, but even in the city, I like the idea that my garments were created for extreme conditions and would protect me and keep me dry and cosy, just like I was in my living room. The idea of having armour against the elements is very reassuring and motivating. You don't have to climb Mount Everest, but if your down jacket or GORE-TEX shell helps you walk to your next meeting instead of using your car or the subway in the rain or snow, that's gotta be a positive thing for your well-being and for the planet.

In the mid-2000s, I was a rapper. Early in my group TTC's career, we developed a relationship with Nike. Pascal Monfort (now a renowned fashion history teacher and trend expert) was working at Nike at the time and gave me a pair of Air Revaderchis and told me, 'This is what cool Japanese people wear. Technical outdoor shoes with crazy colourways from the ACG line.' Right away, I was like, 'YES. Give it to me… This is who I want to be!' Later on, I saw Grand Puba from Brand Nubian rocking Polo and Revaderchis on the set of the 90s TV show *In Living Color.* Suddenly it all made sense.

I like ACG's underdog status as I find it coherent and more successful in the long run. ACG's quiet development over the years slowly and surely gave it status as THE cool alternative to mainline Nike, almost like it's a hidden secret you have to look for or have to deserve in order to have access. This is why it's still strong after all these years and incarnations. From the early ravey vibes of the 90s to the industrial lung-logo era and the tech-ninja look developed by Errolson Hugh from ACRONYM, right up to today's style, which blends the technical and the natural, ACG has a strong and faithful following.

The fact that it is not overly pushed by Nike yet and manages to reinvent itself every decade makes it desirable without being unaffordable. Again, it's just like the Rock Lords. Most kids were into *Transformers*, and some were into *Go-Bots*, but you had to be a really cool kid to be into robots that transformed into rocks! It was not for everybody. ACG is not for everybody, either, and that's fine with me. At the moment, it's not just a bunch of old nostalgic hip hop heads or granola hippies – I see cool young kids getting into it via ACRONYM and all the techwear stuff. On top of the fashion aspect, it's making city kids want to go outside and hike, which is wonderful.

I remember as a kid seeing people on TV talking about the Mowabb maybe 30 years ago. 'It's a shoe with a built-in sock! It's a revolution!' That really stuck with me as it sounded and looked incredibly advanced, like a toy vehicle I could put my action figures in. The materials and details are so on point and charismatic. Later on, I discovered the whole story. Tinker Hatfield's inspiration for that original colourway was the blue sky, orange sun and beige sands of the Moab desert. It's really an incredible design that merges nature and technology perfectly.

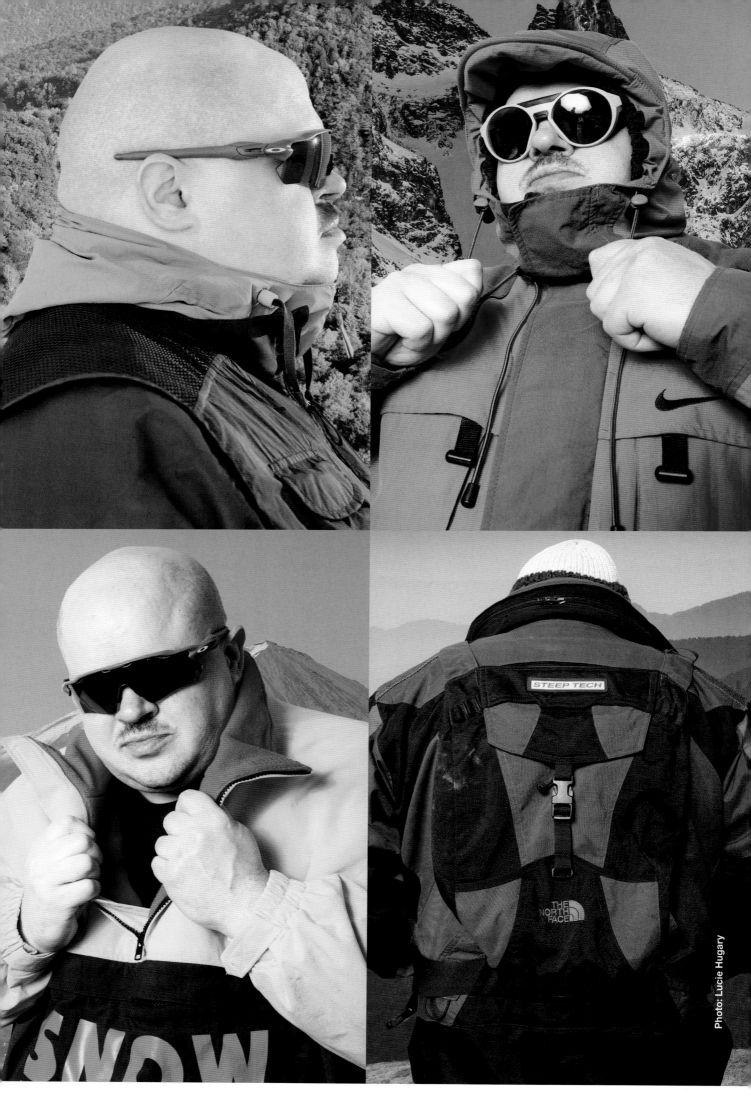

Photo: Lucie Hugary

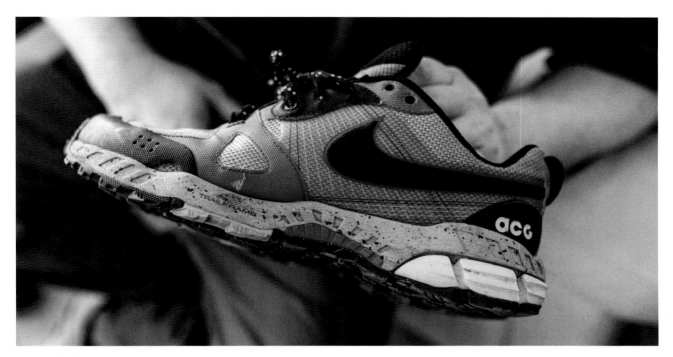

2010: Nike Zoom Morizaba

I'm tempted to say the Mowabb is my favourite for all the reasons cited above, but in terms of versatility, the Mowabb is not an everyday shoe. It doesn't go with every type of pant. It's not for every kind of weather. It's a spring/fall shoe, so it's not as versatile as I wish it was. So I'm gonna go with another masterpiece – the classic Terra Sertig designed by Peter Fogg. That shoe goes with everything! I could wear it every day, probably all year long, in any kind of context. You can rock it with shorts (like Raekwon), and it goes perfectly with baggy pants or tapered pants if you lace them up to the top. It's light and breathable yet rugged and protective. It looks like something straight out of a manga. I think Peter Fogg was super inspired by motorcycles and cars when he designed the Terra line, so it has that vehicle look to it. I love nearly every iteration of it. It is truly the one to rule them all.

Snow Peak is another brand on my radar. Their Tokyo Design Studio x New Balance Niobium is an amazing boot/ mule hybrid. Basically, you have one common exoskeleton that you can adapt into two different shoes. One version transforms it into a boot, and the other is a low-cut mule. It's really cool. I'm wearing them as we speak, in mule form, as I'm indoors. It was initially meant for hiking, so you can use the boot all day as you walk across the countryside to protect your feet from the elements, then you'll set up camp in the evening and slide into the mule, which lets your ankles relax, but you can still walk around basecamp and feel protected. That shoe is also useful in Paris if I have to walk around all day. In the rain or snow, I'll use the boot. Then when I get home, I switch to the mule form. If needed, I can still go out for a baguette from the bakery, just like Tony Soprano keeps his slippers on when he grabs the newspaper in front of his house!

Assembling colours is an art form, and I try to do it by instinct, even though I know there's an actual science behind it. Most of the time, I'm trying to replicate and expand upon a pre-existing colour scheme that works well. It's great to match your outfit to your shoes, but it's more interesting to do it in a less obvious way and paint a picture with different colours.

The common system of most outdoors gear is the balance between earth tones and pops of neon. I don't know anything about colour theory, but there are some things that just naturally work, like mixing burgundy with purple, orange with green, grey with beige, pink with different tones of blue and black, and so on.

The same rules apply to branding. You can't mix two big rivals like adidas and Nike. Same for The North Face and Patagonia, but you can wear Patagonia with Nike or adidas. Ralph Lauren goes with pretty much everything. I also can't wear non-ACG Nike shoes with ACG apparel! I'll give a pass to ISPA, Nike Trail and Terra, which I consider ACG-adjacent lines, and I'll make another exception for Timberland boots, which I wear with everything. All of this is based on nonsense, really, as these are imaginary rules I put in my head. I don't know why. I can't explain or justify it, but I can't wear a single piece of ACG apparel if I'm wearing ASICS, New Balance or adidas shoes.

I'm also sensitive to mixing pieces with vastly different functions, such as wearing ski and fishing gear. I've relaxed a bit now, but I used to have a problem if I was wearing a Ralph Lauren shirt picturing a guy hunting a boar alongside pants with little embroideries of duck hunters. I'm like, 'It's not the same animal. There's no coherence in this outfit! I'm going to disintegrate!' Truly this felt like wearing a sports team jersey together with a hat from a different team or, even worse, mixing totally different sports. This is unacceptable, but clearly, I also need to relax. The brain works in mysterious ways.

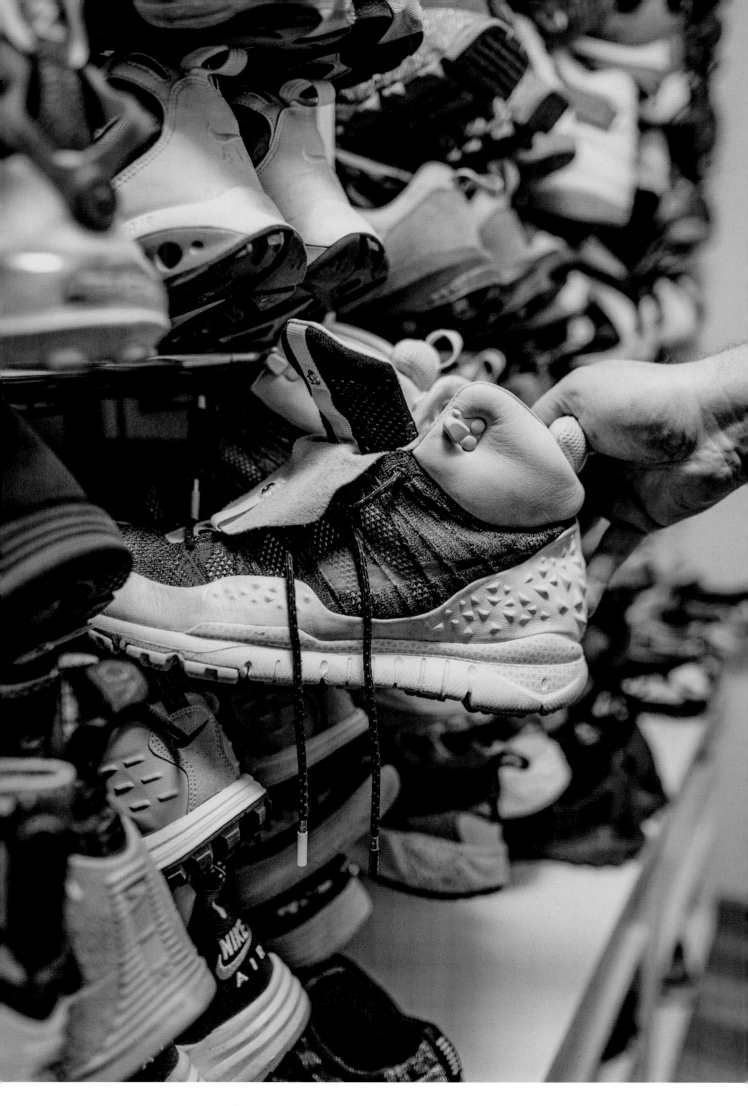

1997: Nike Air Terra Albis

Adding little rules like 'no cross-branding' when I select my clothes every day gives me a sense of purpose and direction. I have a big wardrobe, so it's good to have constraints that limit my options. But I do get stuck often, which is generally an indication that I'm having a bad day where nothing seems to work, and the outfit I have in mind is not compatible with the weather outside or the situation I will be in that day.

I'm never a fan of big words written on shoes, but that seems to be GORE-TEX's new policy for collaborations these days. I much prefer it when the tag is cleverly integrated into the design. I think it's weird having the name of the material on clothing. I don't need a sweater with 'wool' written on it in big letters! I used to love the tiny GORE-TEX tags – they were a super-cool detail on jackets and shoes. That big logo comes across as a bit insecure on GORE-TEX's part, to be honest.

I rock basketball shoes from time to time, and I just love the alien shape and technology of the Foamposite, which is a very water-resistant shoe! From 2012 to 2014, I was obsessed with Foams and the strong design statement they embodied. Nike gave me what might be one of the only, if not the only, pair of 'Paranormans' in France. They were like, 'Teki, no one else in France understands Foamposites!' It's probably the most expensive shoe in my collection. I'll rock them every once in a while with the appropriate outfit, but it's quite a rare moment.

Apparently adidas are currently in the process of resuscitating their Adventure line and giving it more coherence and synchronicity between the apparel and shoes. I am absolutely crazy about that stuff! The outerwear side of adidas is slept on by the general public, but it's full of formidable pieces and sub-divisions, from the OG Adventure stuff to modern incarnations like Atric and the Gardening Club collections. I even own an Atric foldable chair! I love the outdoors Feet You Wear models like the XTA and the Banshee, which kinda inspired the Novaturbo in the awesome Gardening Club capsule. I'd love to put my hands on a pair of EQT Tridents. I'm currently waiting for an EQT Escalante to arrive in the mail. The Badlander is a mad Rock Lord vehicle with an evil carnivorous potato/clam hybrid-monster vibe. It's so beautiful!

Recently, I stupidly missed the opportunity to purchase the ACG Abaziro, and I've been losing sleep over it since. Sneakerheads of the world, please help me find a pair of Abaziros! They look like the ACG Morizaba but with the black ripstop grid and a purple Swoosh. I would also love to find a pair of Terra Tors in good condition. Something in the Nike Air Azona family too. Resell prices are a bit high right now, but eventually, I'll get myself a pair of the Apartment x New Balance x GTX 'Toucans'. I'm also a fan of the apparel from and wander, nonnative and Meanswhile. My eyes are on the latest and wander x Salomon and nonnative x ASICS colabs as well!

It's important to also say that I don't consider myself a collector of shoes or clothes. I'm a dresser, and I wear everything I own. I don't buy things to let them sit in my closet. I come up with different looks and combinations every day. That comes from being on stage most of my life and being photographed at parties. I'm always trying to be the best-dressed person in the room, and I want people to analyse and dissect my looks – I want people to notice me and the way I dress. I know this might come across as arrogant and annoying if you don't know me, but I feel like this should be inherent in any form of business that puts you in the spotlight. Being charismatic and noticeable, being able to shine and give people something to think about visually, is essential in my line of business.

★

@tekilatex

2005: Nike Air Zoom Terra Sertig

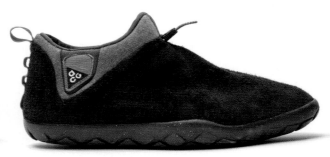

2011: Nike Air Moc 1.5

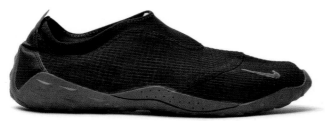

2003: Nike Aqua Sock

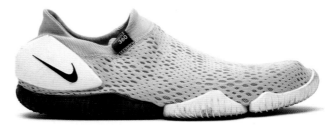

2018: Nike Aqua Sock 360

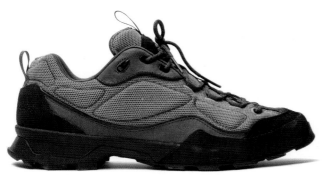

2020: adidas Sahalex

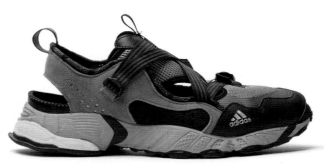

2019: adidas Novaturbo

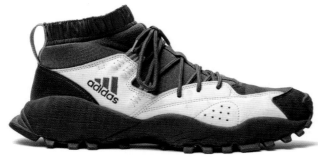

2016: adidas Seeulater

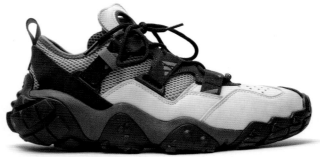

2020: adidas FYW XTA

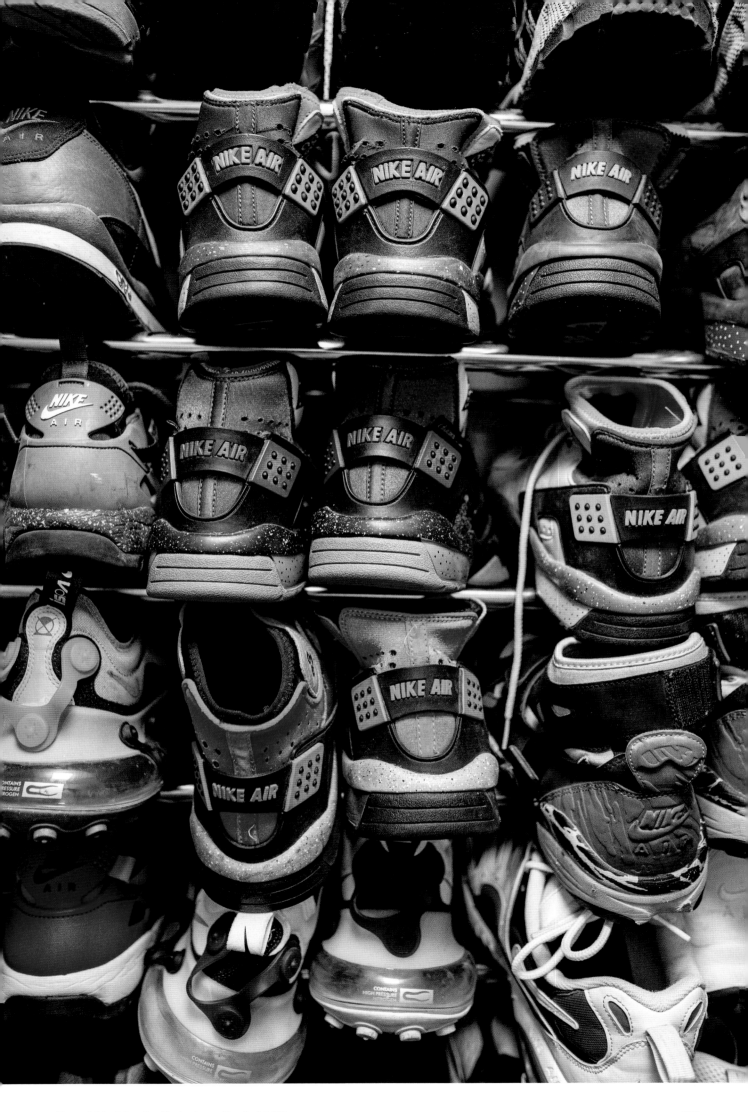

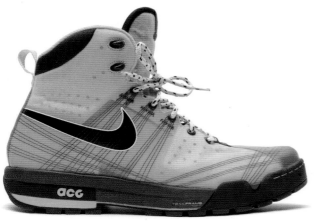

2009: Nike Ashiko

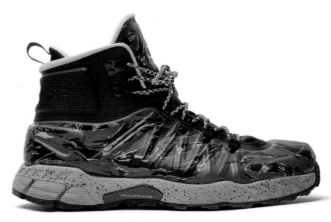

2014: Nike Meriwether Posite

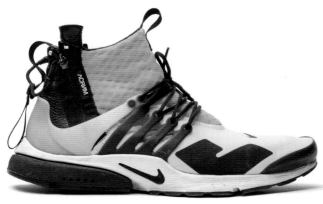

2016: ACRONYM x NikeLab Air Presto Mid

2010: Nike Air Carnivore

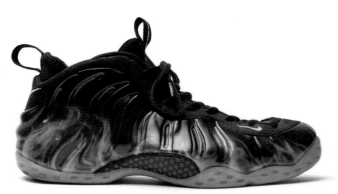

2012: Nike Air Foamposite One 'Paranorman'

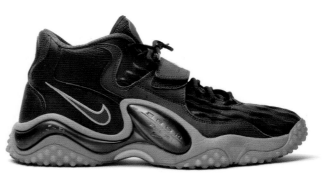

2013: Nike Zoom Turf Jet 97

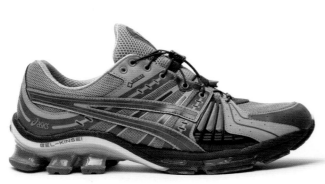

2019: Affix x ASICS GEL-Kinsei

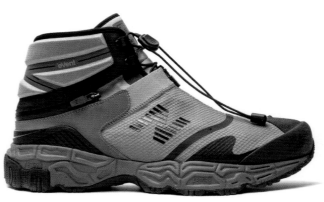

2020: Snow Peak x New Balance TDS Niobium Concept

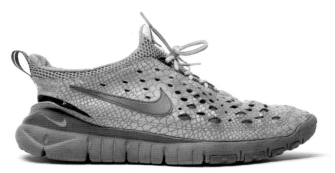

2006: atmos x Nike Free Trail 5.0

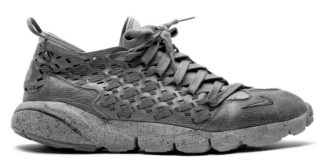

2011: Bodega x Nike Air Footscape Woven 'Night Cat'

2014: Nike Air Trainer Huarache 94

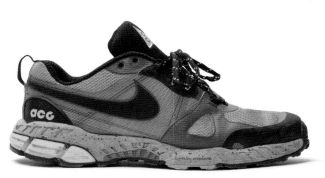

2010: Nike Zoom Morizaba

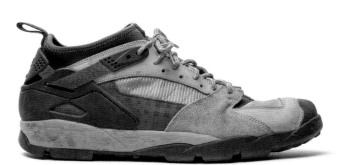

2008: Nike Air Revarderchi

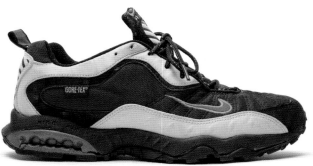

1998: Nike Air Terra Ketchikan

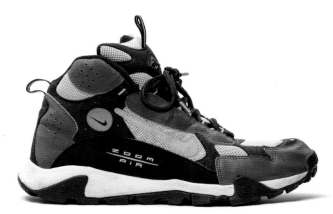

2005: Nike Air Terra Sertig

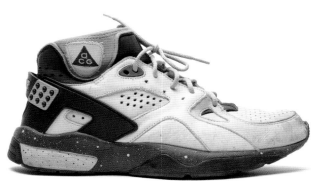

2008: Nike Air Mowabb

Running Collectors

RUNNING p560
The Long Distance Specialist
Lindy Darrell

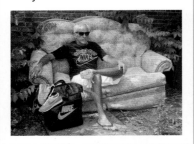

RUNNING p572
#365daysofNB
Richie Roxas

RUNNING p590
Maxed Out!
Ria Rascal

RUNNING p602
Air Huarache
Gooey Wooey

RUNNING p622
GEL-Lyte Lee
Lee Deville

RUNNING p648
The Thrill is in the Hunt
Matt Kyte

RUNNING p666
Mr EQT
Marc Leuschner

RUNNING p680
The Great Footscape
Krazeefox

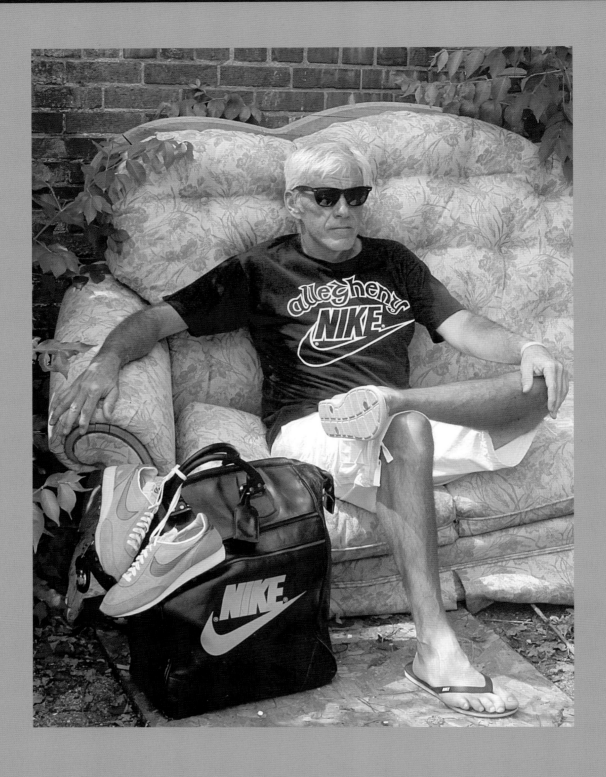

Interview: Woody

LINDY DARRELL

THE LONG-DISTANCE SPECIALIST

Back in the early 70s, Phil Knight started a distribution brand called Blue Ribbon Sports, which in turn became the athletic colossus known as Nike. Few know this early era better than Lindy Darrell. With a closet full of super-rare Nike racing flats and runners – not to mention 1-of-1 'SMU' constructions handmade for top athletes – Lindy has methodically assembled one of the finest stockpiles in the world. Strap on your spikes as we hurdle through the ups and downs of his collection. Behold the power of nylon!

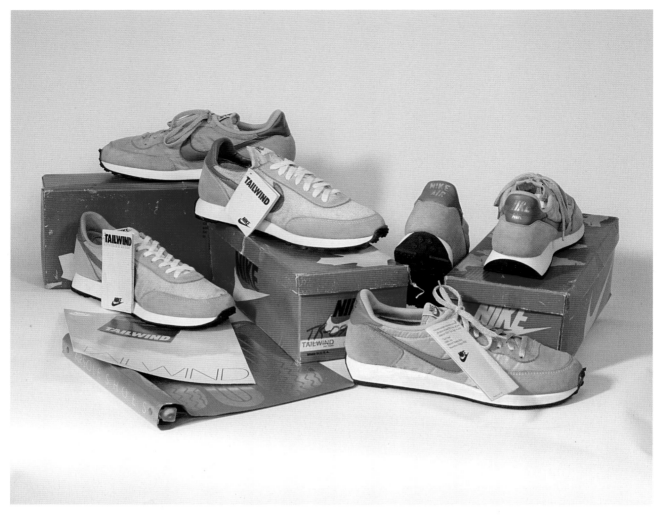

Nike Tailwind Mesh and Nylon

How did you first become interested in track and field, especially distance running?
When Frank Shorter won the marathon gold in Munich, the running boom hit America. A lot of folks wanted to take a shot at running 26.2 miles, and I was one of them. In the late 60s and early 70s, I would jog a bit, but after 1972, I went crazy for the next three decades. My last race was in 1996 at the 100th Boston Marathon. Although I don't race these days, I stay active in the running scene, having a son that runs at the college level. He's faster than I was. Ouch!

Steve Prefontaine was a hero to most distance runners. Do you think he would have made his mark at the 1976 Montréal Olympics and beaten Lasse Virén?
Pre was an animal, but so was Virén. Pre was young and had plenty left. Who knows? I'll always admire him for taking on the AAU and the impact he had on helping the American Olympic and Pro runners to be able to train and compete with the rest of the world. Nike also had a big part in this.

How do you define vintage in regard to sneakers?
Vintage to me is 1972 to early 1980. I only collect vintage Nike running shoes and track spikes made in Japan and the US. Again, this is just my opinion. I purchased my first Nike Waffle Trainers in 1974. Over the next few years, I ran in many different Nikes, including the LD-1000, Sting, Eagle and LDV. In the early years, I became fond of the Elite. From 1979 to 1985, Nike produced some of the best running shoes ever made, such as the Mariah, American Eagle and Air Edge, to name a few. To this day, it is my opinion they haven't even come close to making a shoe as good as the Terra TC.

First-generation Phylon and Permafoam were two fantastic Nike inventions. What made Nikes from this era so outstanding?
There was really nothing like Nike when they first started. Racing flats were more like house slippers. The running boom started, and only a few companies were making shoes. Nike was cutting edge. From 1972 to 1985, they really knew what they were doing. I guess I still have that old school in me, and that's why I collect the vintage ones.

For me, the most amazing part of this era was watching how it evolved because I grew up with it. From 1975 to the early 80s, Nike had arrived with nylon, mesh, leather, suedes, waffles and a crazy, brilliant rainbow full of colours. I really have a passion for the wild colourways of the SMU Nike releases. These are super rare and hard to find.

When did you start seriously collecting?
My collection started a few decades ago. It's hard to say which are the rarest or have the most value. Although I purchase different models, my collection only consists of Nike running shoes and track spikes made in Japan and the US. I have about 10 pairs of SMU Nikes that are super rare. I have a pair of first-generation Astrograbbers made in Japan that look like dinosaurs. At one point, my collection was over 100 pairs. But there are two pairs that I would still love to get my hands on, the Obori and Boston 73.

Where are you finding this stuff? I'm guessing it's not all over eBay.
I find things in a number of ways. I still have friends from back in the 70s running boom that, for some reason, kept stuff tucked away in their closet. Many of them live in Eugene, Beaverton and Portland – places you might find a few pairs from years past. I use eBay a lot, but most of the time, you better be willing to dig very deep in your wallet. There are still a few collectors out there who want these relics as much as I do. That's when the pain sets in! Most of the really good SMUs seem to be in Japan in the hands of collectors. You see a lot of them on auction sites in Japan, and they fetch insane prices! Perfect example of this is the collection of Takatoshi Akutagawa (author of the *Blue Ribbons* book), which is now at the Nike Archives.

'Purple Monster' (SMU)

This was found on eBay. I made an offer and stood pretty strong because this was the big one! The guy called me from Liverpool in the United Kingdom, where he said he found them at a flea market. I could tell right off it was made from an exotic material, which turned out to be pig skin. I'd say it was made in 1975, maybe earlier. Basically, it's similar to an Obori or Boston 73, only instead of nylon, it's suede. It's amazing. It has probably one of the ugliest and most beautiful Swooshes I've ever seen on a Nike. I regard the Purple Monster as the number-one shoe in my collection.

LDV (Transparent Prototype)

This is an early LDV made from clear plastic. You can see the tongue inside has fallen down. I found out the Nike tech guys videotaped someone running in them on a treadmill and watched the movement of the foot. It's absolutely crazy, I couldn't imagine running in these things, being hot and having it rub against your feet, but that's what they did. It's amazing it's held together this long and hasn't decomposed. The plastic is pretty thick. I was stoked when I found these.

'From 1979 to 1985, Nike produced some of the best running shoes ever made, such as the Mariah, American Eagle and Air Edge, to name a few. To this day, it is my opinion they haven't even come close to making a shoe as good as the Terra TC.'

His collection of SMUs is insane! Do you ever trade some of your heat to clinch a really big deal? That must be tough.
I will always be willing to trade if there is an SMU involved. What I seem to get myself into is that one of these crazy shoes will surface, and I need quick cash. I then have to sell a pair from my own stock to make it happen. I don't like to do this, but you gotta do what you gotta do! I've made some good trade-offs, but I wish I could get some of them back.

Run us through some of your key collector moments.
I have a friend who was a very good distance runner. When he was in high school back in the late 70s, he wrote to Nike. They endorsed him and put him on the freebie list. His name was Chris, and he had a size eight foot. Thinking he was a woman, Nike thought he was a 'stud' female athlete, and for two whole years, they sent him the most incredible SMUs you've ever seen. I was able to get my SMU Columbia and SMU Mariah from him.

I would have to say the best deal I ever made was from a guy that lived in Exeter, New Hampshire. His brother worked for Nike and had left him a bunch of things in his basement. They were just tennis shoes to him, so I was able to land the mother lode! The LDV Nylon and Internationalist that he sold me are one-of-a-kind prototypes.

How do you know when you've got an SMU on your hands?
In the late 70s, the SMUs were made in the US at the Nike factory in Exeter, New Hampshire, for endorsed athletes and teams. Many were prototypes, but for the most part, they were the same as the shoes sold to the public but with different colours. Nylon and foam companies would send Nike rolls of different materials to try, and this was used on the SMUs.

I saw a pair of Roadrunners in Jamaican colours that had 'Rasta' on one shoe and 'Man' on the other! They were made for the late Bob Marley. The 'Elton John' Cortez is sick as well. Nike made a lot of these types of SMUs, but you just never see them.

Are they all holding up okay?
I wouldn't recommend wearing vintage sneakers, should you want to keep them in collectible condition. In many cases, it can be done, but the shelf life is not that good. The glue, nylon and foam start eating themselves over time. I keep my shoes on a slat wall with shelves, and they're holding up real nice. I try not to pick them up much. I only do this because I'm trying to preserve a bit of history.

How do you determine the rarity of this super-early stuff? There are no known production figures, are there?
It's rare enough to find a good deadstock standard-production shoe, let alone an SMU. My thinking is that people are keeping the ones that are still around in their collections. Many of them were probably worn out and ended up in the garbage. Last week, I spoke with a guy who told me his wife got sick of looking at a pair he had in his closet. She tossed them in the trash! Just like flushing five notes down the toilet!

Finally, can you explain what it is about old shoes that makes them so beautiful and alluring?
It's a number of things. First and foremost, the materials that were used. For example, hold a deadstock Boston 73 in your hands – feel the nylon and the big fat Swoosh and how the stitching is not quite uniform like the mass-produced versions these days. The thick foam rubber tongue and that Japanese Gorilla Glue running on the midsole. Even the smell. There's something about them – it's like being frozen in time. It's my passion.
★

@swoosh262

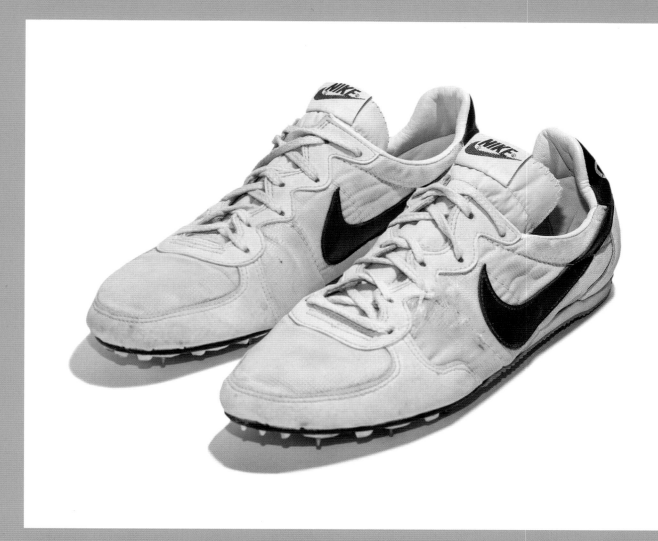

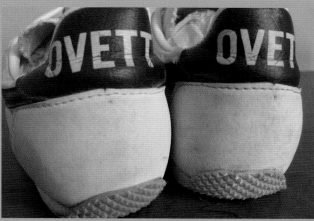

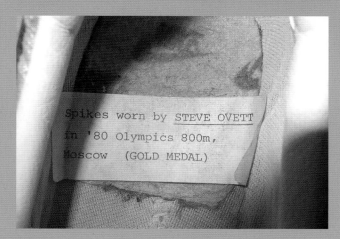

The First Nikes to Win a Gold Medal

Before the Kenyans dominated middle-distance track running, a pair of Englishmen owned the sport back in the 80s. Unbeaten for three years, Steve Ovett was the mad favourite for gold in the 1500 metres at the 1980 Moscow Olympics. His great rival was the charismatic Sebastian Coe, himself a favourite for the 800. As it turned out, Ovett took gold in the 800, and less than a week later, Coe beat him in the 1500m. It's a quirky flip-flop footnote in Olympic history, but what really makes this tale interesting is the fact that Ovett was wearing a pair of Nikes. Yep, Steve Ovett was also the first Nike athlete to win an Olympic gold medal. Ever!

Given that Nike were only a few years old and the fact that the US boycotted the Moscow Olympics, it does put Ovett's achievement into an understandable context. Naturally, you can also imagine putting a value on these bad boys as well… let's just say somewhere way beyond priceless.

When news of their existence in private hands got out a while back, it attracted the interest of every Nike collector in the world. I'm not at liberty to reveal the entire story of how these shoes were unearthed but suffice to say I'm very pleased they ended up exactly where they should be, which is safe in the Nike vault. I've never been involved in anything like it, and I never will again.

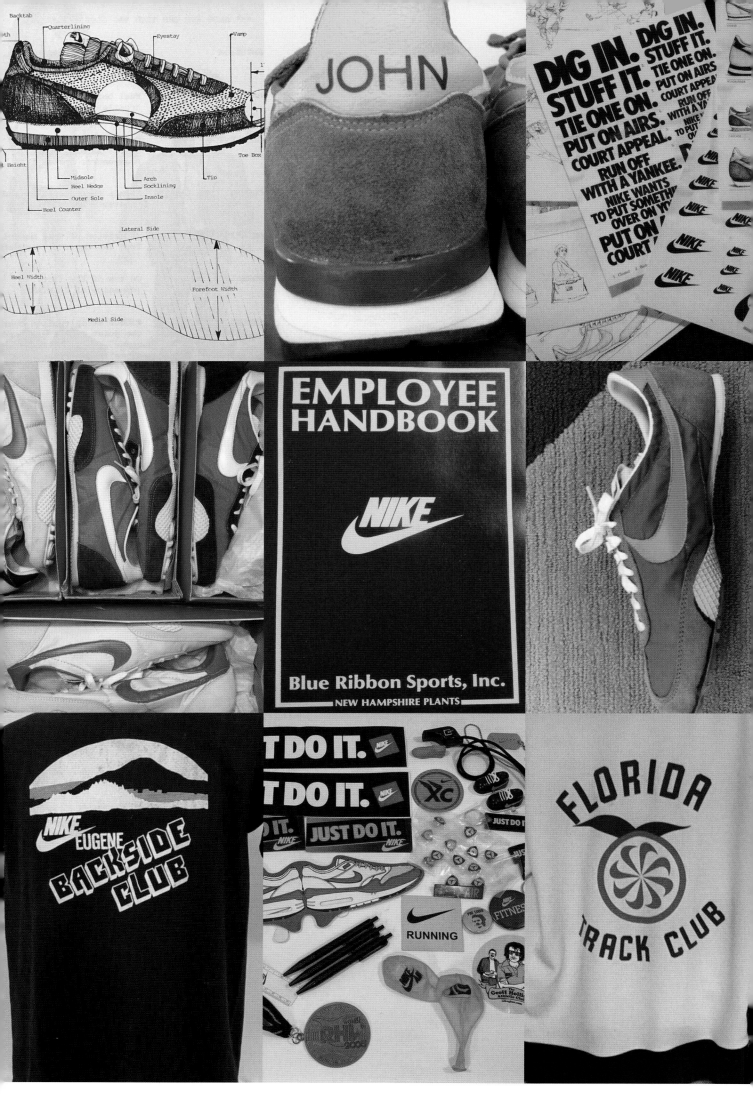

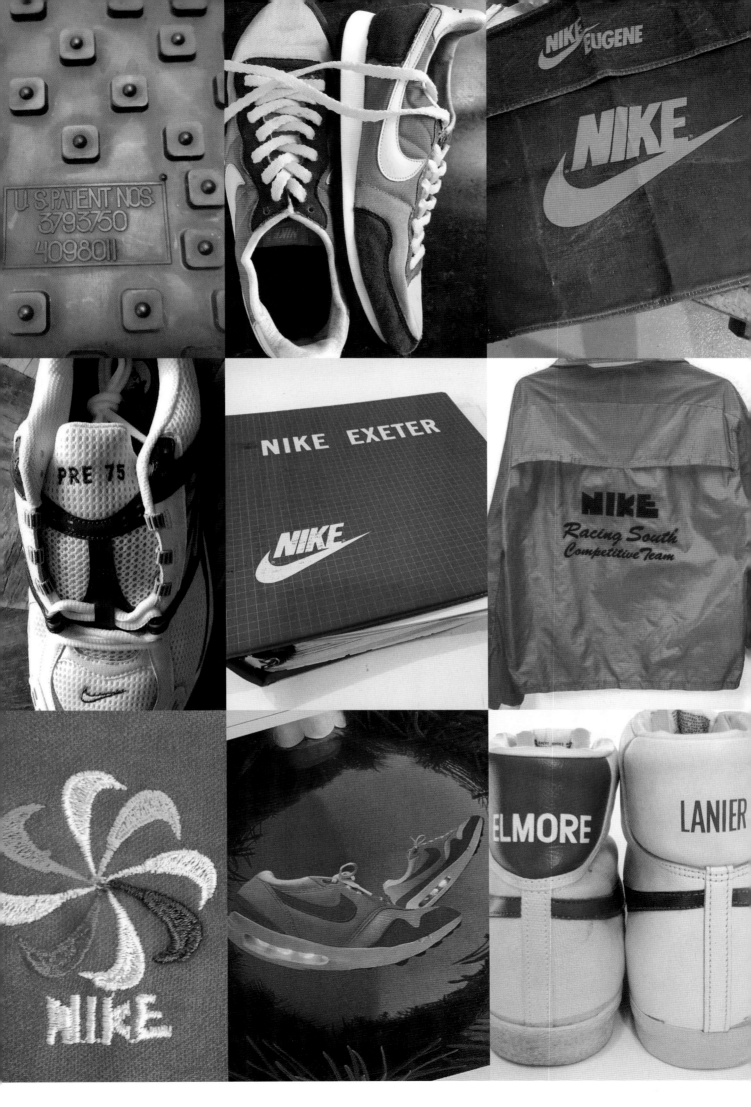

Gold Leather (Distance Spike)

These are an experimental spike design that combined the old Pre Montréal upper design with added support straps on the forefoot above a Nike Skylon last. Killer colours and design!

American Eagle

With its classic red-white-and-blue colourway, this is one patriotic American Eagle! Regular runners were only able to buy Nikes like this made from nylon, and since these used open, breathable mesh, they were definitely designed for the feet of an elite athlete.

Open-Net Eagle

Built using mosquito-net mesh to reduce weight and improve breathability, these are an Eagle prototype destined for Benji Durden's 1980 USA Olympic Marathon Trials. These came from the Dan Norton collection and are now residing in the Nike Archives.

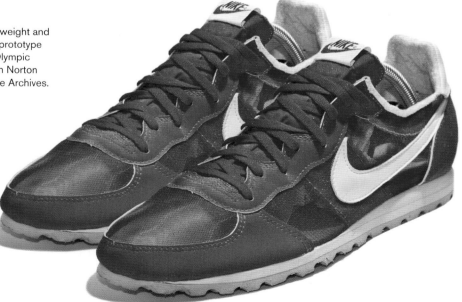

Carl Lewis Custom LJ (SMU)

This was one helluva find! How often do you dig up vintage Nikes that busted a world record? Custom made for Carl Lewis using Nike's first raised-toe design, they must have worked a treat, as Carl broke the world indoor long-jump record wearing these spikes in 1982. They popped up with a number of one-off Exeter prototypes. They now also reside in the Nike collection at Beaverton.

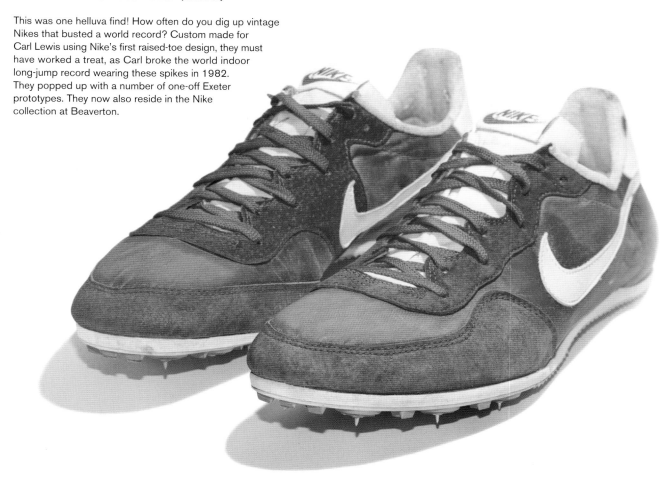

Pre Skylon CC Spikes

Here's a prototype spike with a Pre Montréal upper design on a Skylon last. This version had a unique soccer-style spike for cross-country racing in muddy conditions. This shoe and many other experimental prototypes were found this past summer. Great history!

Nike Skylon (SMU)

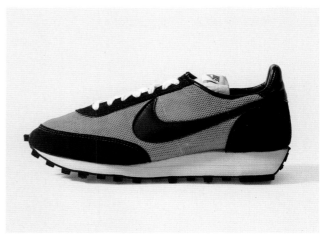

Nike Jade East LDV

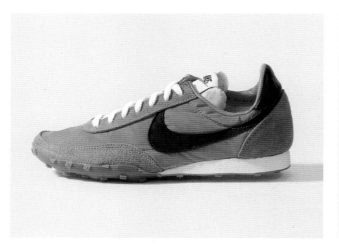

Nike Universe (SMU)

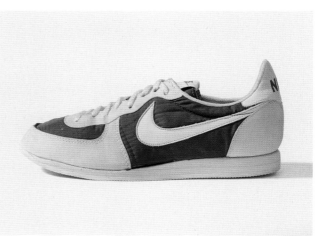

Nike Eagle (SMU)

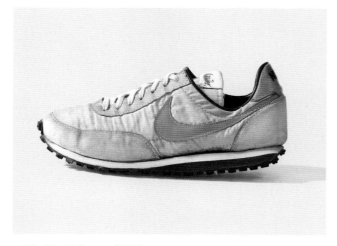

Nike Elite Halloween (SMU)

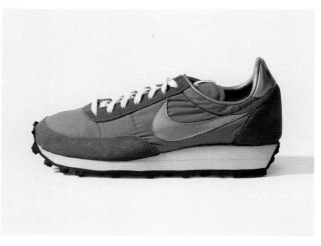

Nike Elite Pre Last (SMU)

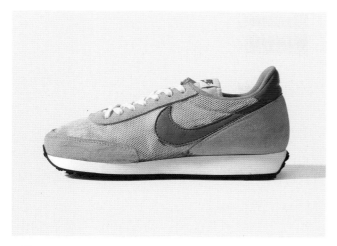

Nike Air Tailwind 79 Mesh

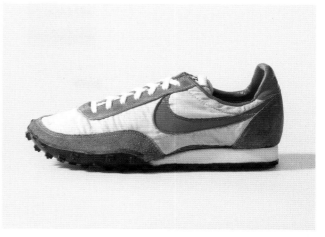

Nike Waffle Racer (SMU)

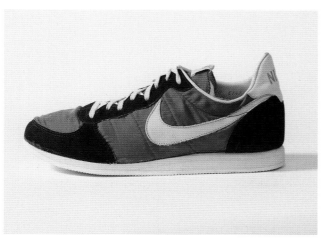

Nike Eagle (SMU)

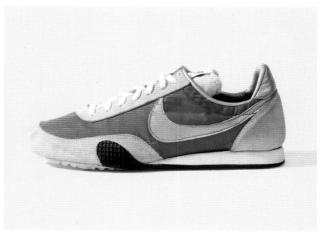

Nike Vainqueur (SMU)

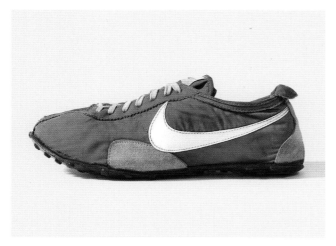

Nike Moon Shoe

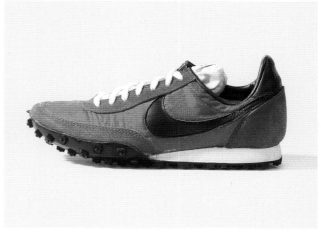

Nike Waffle Racer (SMU)

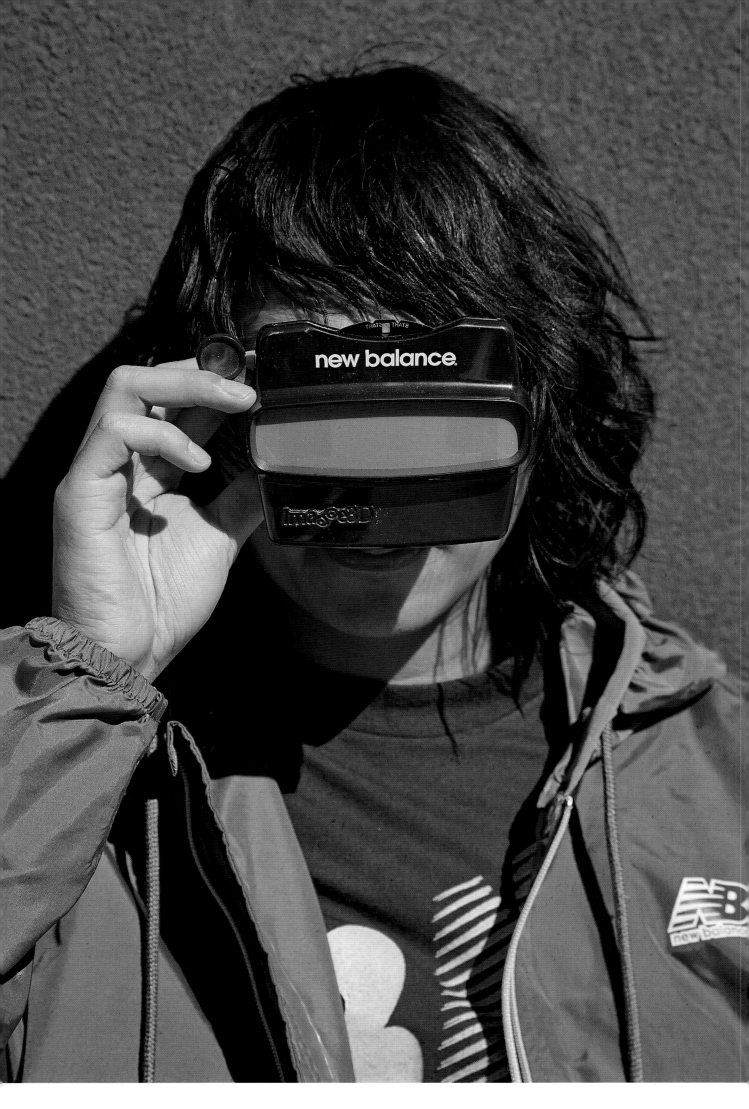

Interview: **Woody** Photos: **Manuel Dominguez Jr**

Richie Roxas

Richie Roxas caught our attention when he set out to prove his collector credentials by posting a unique vintage New Balance image to IG every day for a year. Watching from afar, we thought he'd exhaust supplies and tap out at some point, but Richie powered home, hitting the '365' target with ease. A true sneaker detective and purist at heart, Richie's love of obscure Newbies makes him one of Philly's most thoughtful footwear connoisseurs.

First published *Sneaker Freaker* Issue 32 – January 2015

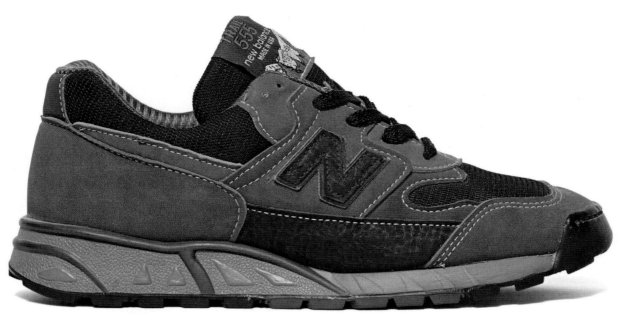

New Balance 555 Trail

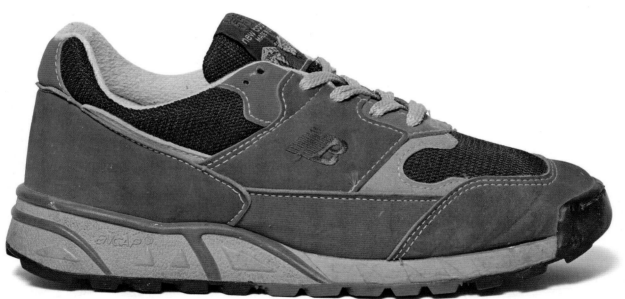

New Balance 555 Trail (Women)

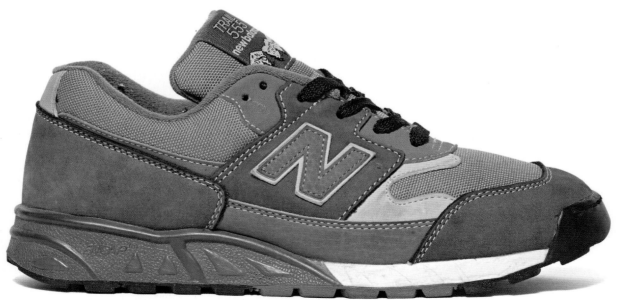

New Balance 555 Trail

Richie Roxas

Tell us how you got into the game.

As a teenager in the early 90s, I really got into skateboarding and spent countless afternoons at Love Park in Philly. Skate shoes get messed up pretty quick, but I was able to use my allowance at the local surf shop. My closet started to pile up with Vans and Airwalks, all with holes on the sides. I wasn't aware at the time, but that was my first shoe collection.

In the mid-90s, I really looked up to the Supreme, DLX, Droors, Menace, Girl, Zoo York-kinda style of skateboarding, which was baggy jeans and cargos, fitted hats, crewnecks and windbreakers. These guys were skating in PUMA, adidas and Converse instead of Vans, etnies and Airwalks. I remember Mike York skating in adidas Shelltoes and an ad in *Thrasher* with Eric Koston on a bicycle wearing a pair of New Balance 585. Seeing a pro in a skate mag without a skateboard or even wearing skate shoes was rad!

Love Park locals were soon skating Reebok Workouts, adidas trail runners and even hiking shoes. When I turned 15, I got my first job and started to buy shoes from athletic stores instead of surf and skate shops. I even skated Nike Huaraches to death. If only I knew they'd be worth money one day!

Where have you found all your shoes?

I have quite a few secret spots. Some are still around, and some have closed down over the years, having suffered the wrath of big business and internet shopping. I've managed to snag a few pairs from thrift stores and sports stores. One time, me and my friend Bryan went to a spot where they let us in the stockroom, and we found full-size runs of vintage NB and ASICS GEL-Sagas in black/purple and white/teal. We bought the whole lot! RIP to all the mom-and-pop stores that couldn't make it in today's economy. I shed a tear for you guys.

We heard your mother is involved in your sneaker hunting as well.

She was going on vacation to the Middle East one time. The New Balance 577 BSL is made specifically for the Israeli Army and is super hard to get outside of the country. I printed out a picture and gave her $200, just in case she came across a pair. I knew the chances were slim, and she'd be too busy to look, but you never know.

One day she ended up at a mall in the middle of nowhere and found a shoe store. She showed the guy the picture, and they had them in stock – in my size 8! She asked how much and he said $150, and then she declined, thinking they were too expensive. I hadn't explained to her how hard to find they are and that $150 was normal. My jaw dropped when she came home and told me the story – I was that close!

Ouch! You don't seem to gravitate towards the modern scene so much. Colabs just don't ring your bell?

I do enjoy colabs. It's just that most of them are ugly and designed in poor taste, so I'd much rather spend my money on vintage. I can't always afford the few colabs that I do like, and sometimes they just sell out too fast. At that point, I'm at the mercy of resellers. Sometimes I'll get lucky and track down a rare pair after it's been worn by someone else for a few years.

Vintage shoes don't last forever.

Crumbled shoes are still beautiful! I can't get sad when a sole breaks down because I know they're not meant to last for eternity. I don't even mind buying shoes that are unwearable from the get-go. For me, it's cool just to own it, whether you can wear it or not. The older and rarer, the better.

I've been wearing vintage less and less lately because I want to preserve them as long as I can. If I double up, it's no question – wear one and keep one. Sometimes a shoe gets reissued, and I'll buy and wear those to keep the original intact. But as most of us know, the reissues are always inferior to the originals.

With New Balance, are you devoted to the brand, or is it just the shoes?

I'd be lying if I said it was quality alone or the fact they are still 'Made in USA', or even that the shoes are great for running in. As a teenager, anything extreme or underground – like skating, punk, graffiti, techno and rave, jazz, goth, metal, film, tattoos – appealed to me. I was at gigs all the time, especially hardcore and punk shows. The scene was full of energy and activism, and I really looked up to the older guys who set up everything before me. The style was a lot of camo cargos, hoodies and New Balance sneakers.

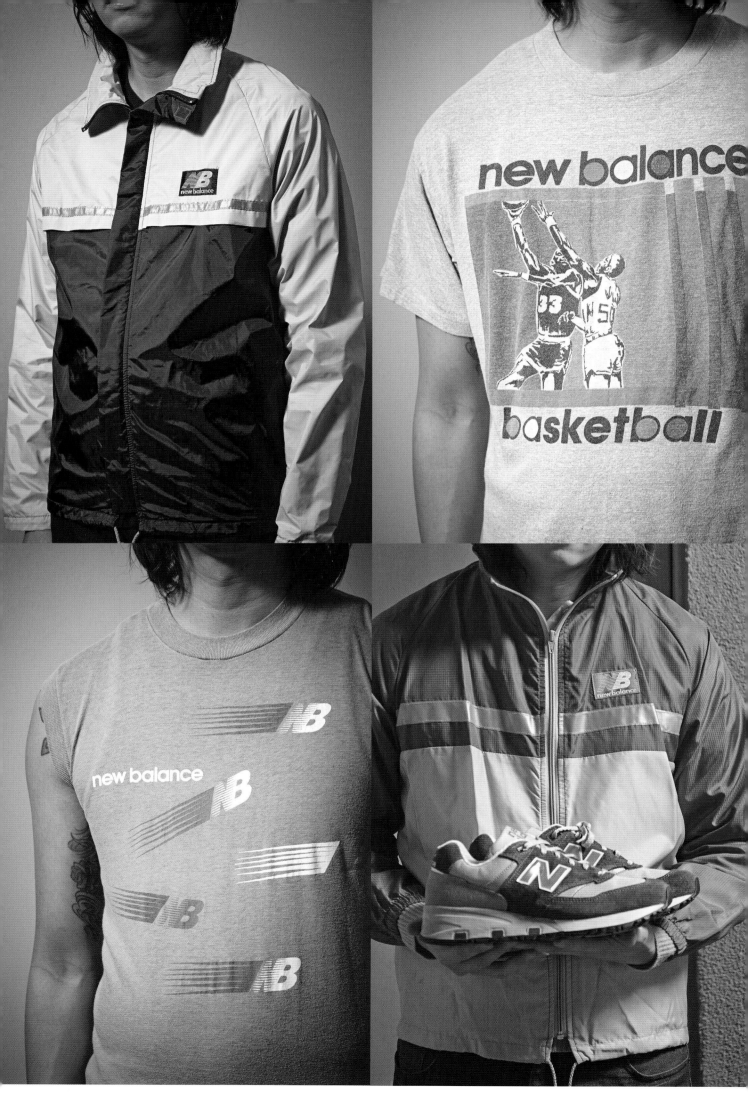

New Balance 990

New Balance 678

New Balance 690

New Balance 495

I bought my first pair of NB496 in 1995 from a store down the road called Just For Feet. I loved the chunky sole and the bold 'N' logo. That pair made me realise how comfortable they are and that the quality was excellent. ASICS and Saucony are comfortable, too, but they had fewer models and less of a presence. NB already had classics like the 496, 574, 585, 998, 999, 1300 and 1500, so from that time on, I saved my money and bought one pair at a time. When I think of New Balance, I think of grey, navy and burgundy as the signature colours. Grey NBs go with almost any outfit, and that's why I have so many. The perfect pair for me is grey and blue, with a little flash of white and a gum sole.

I found out later that the hardcore scene rocked NBs because some of the shoes were made from synthetic 'vegan' leather. To this day, I'm still a vegetarian, but my footwear features loads of suede and leather!

No need to feel guilty! What was your NB365 challenge all about?

I challenged myself to post a different picture of an NB item in my possession every day for a year. I had never counted how many pairs of NBs I had, so I wasn't sure if I would reach my goal. Of course, I bought a few items over the course of that year, but I ended up using #365daysofnb over 400 times.

Out of everything, what's your most cherished piece?

It's hard to pick just one, but I'll go with the Crooked Tongues x NB991. It's one of just 99 pairs, and the packaging was designed by tattoo artist BJ Betts. He was nice enough to autograph the box when I met him at an adidas event. Is that rude of me to bring a pair of NBs to an adidas event?

You gotta do what you gotta do!

I've met BJ a few times and he's a super-nice guy and an insanely talented tattoo artist. Mine might be the only pair with a 'BJ Betts' Sharpie autograph.

Is there a Grail that has so far eluded you?

I will never be satisfied, which is why this never gets old to me. But since you asked, there are three. The Stüssy MT580 in Avocado/ Goldenrod, the solebox x Crooked Tongues x NB1500 from the Bread & Butter tradeshow and the Offspring 577 in Safari colours. I almost had my hands on the Offspring pair multiple times. A local store had them, but I couldn't spend the money because I had to tour with my band. When I returned, they had sold out, of course. I even tried on a 9.5, but they looked like clown shoes, so I passed.

Let's talk specifics. I've never seen the MT555 before.

I was obsessed with the MT575 out of Japan in the early 2000s. Most Japanese sites didn't ship to the US then, and the few that did charged insane money. That's where I came across the MT555, which seems like the MT575's cousin, though it was cheaper and has a more aggressive midsole. However, both shoes share the same amazing tongue tag with that little scene of mountains and trees. A handful of shops in the US imported Japanese NBs, and that's how I was able to get them without paying crazy shipping prices. I have three pairs.

One time, I walked into Reed Space in NYC, and Jeff Staple complimented me! He told me he had the same pair and wore them every day for a month while on vacation. Another time, I was walking around NYC in my grey/purple pair, and the sole on the left shoe came apart from the upper. I had to buy an emergency pair of sneaks and haven't worn them since.

My third pair is strange. I got them on eBay for cheap. It's a women's version with the tiny NB logo. I always thought the shoe was a modern creation until I got this pair. It has the same tongue tag as my other pairs but says 'Made in USA' on the sole. That detail proves it's vintage, as the two modern pairs are made in Asia. There's no information on the inside tongue, so this remains a mystery. They are too small for me and totally unwearable, but I love them. I've never seen another pair since.

New Balance 1500

New Balance 1500

New Balance 1500

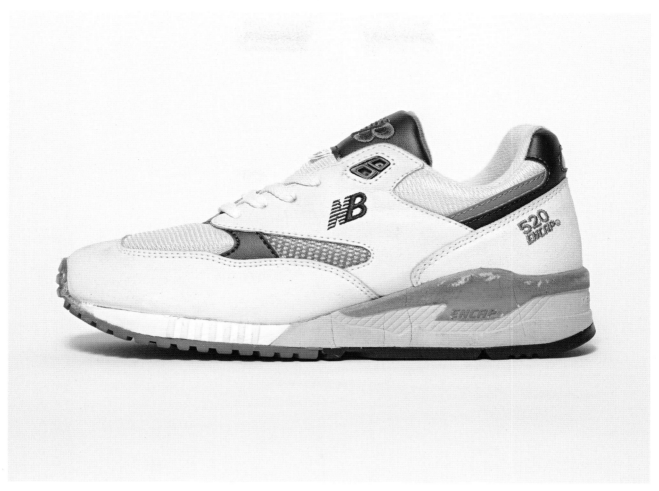

New Balance 520

I'd love to see the tiny NB logo on the 680 and 997 make a comeback.
I'm a big fan of the tiny logo. The 680 is very underrated. I have two vintage pairs and four reissues from the early 2000s. It has a similar sole to the MT575, and I always had a theory that the MT575 drew inspiration from the 680. I remember when the shoe was first reissued and didn't sell. There are two I'm after from this era. One is black with orange, and the other is black with red. I would love to see the little NB logo make a comeback.

That animal texture on the 677 is bananas.
The 677 is another favourite and is real hard to find. My homie Jim157 sent them from England as a gift. They have an insane blue panel with an ostrich leather effect, plus the grey, blue and white work so well together. The sole is crumbled, so I've never been able to wear them. The entire 67X series is incredible. The 678 was given a reissue in 2006 in Japan only, and they're now super rare.

The midsole on your deadstock 997s features that lovely shade of bone or mustard. It's a nerd question, but do you think they started as white, and do they all turn that same colour regardless of whether they've been unboxed?
Yeah, the 997 midsole was originally white in the front and grey in the rear, which is the area that turns 'mustardy' over time. I'm pretty sure it would turn that colour regardless of whether it was deadstock or worn. I'm curious whether these current 997s with the grey midsole will have the same thing happen to them in the future.

Time will tell, I guess. It still amazes me when NB uses the same numbers for totally different models. I know it's a pedant thing to care about, but it's damn confusing trying to work it out.
NB is notorious for using the same name on different models. It truly is confusing. New Balance USA, UK and Asia are almost like three separate entities, so there's a lot of variation with model names, sizing, construction and labels. I can't really clarify anything as it's still confusing to me.

Your vintage 1500s are razor sharp. Are you one of the haters who obsess about the 1500 toe box being way off these days?
The shape of the 1500 went downhill over the past few years. For a lot of NB collectors out there, the importance of the colourway versus the shape is an equal 50/50. For me, the ratio is more like 70/30. I will still buy and wear 1500s with a poor shape if the scheme is amazing! My homie Justin from Ohio does great NB reshape surgery. I've sent him a few pairs, and he literally slices up the shoe and puts them back together so that it has that nice, wedge-shaped toe. Recently, there was a petition for New Balance UK to step up and solve the problem. [*Note: the petition was started by Thomas Lindie from New Balance Gallery and did, in fact, force NB to remaster the 1500's toe shape.*]

You also have an amazing collection of jackets, tees and other NB paraphernalia. Are you dipped head to toe when you go out, or do you mix and match?
I wouldn't say dipped in NB on an average day, but once in a while, it is fun to be totally NB'd out. There is so much product from over the decades that I can't even begin to decipher and date it all, so I just buy something if I think it looks cool. I have a lot of vintage NB shirts and jackets, and it's only a sliver of what's actually out there. I have socks, underpants and pyjamas, too, so what's next? Matt Kyte designed a 1300 tattoo for me a few years back. I haven't actually gotten it yet, but I still plan on doing it!
★

@newbalance365

580

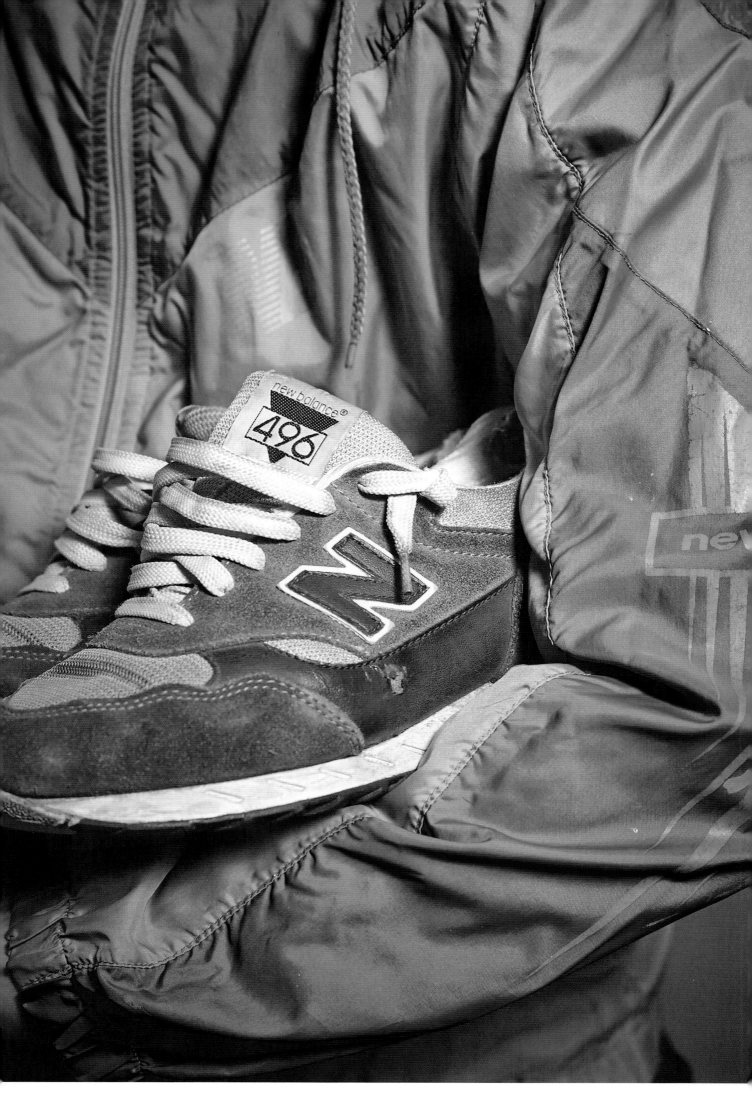

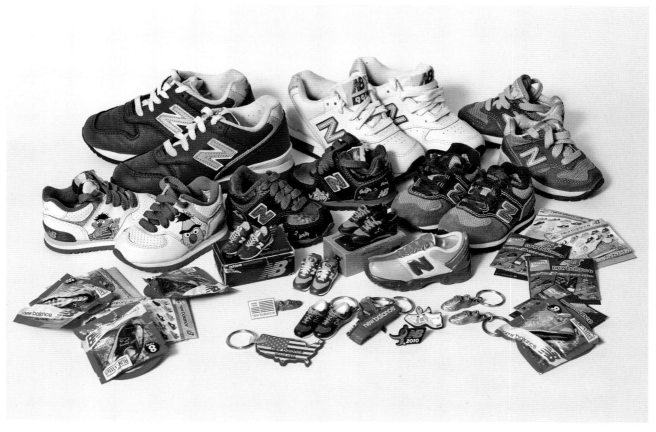

New Balance promo materials

New Balance RC100 ('Trackster' UK Reissue from 2006)

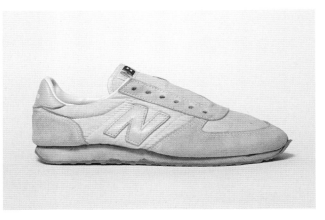

(Unknown)

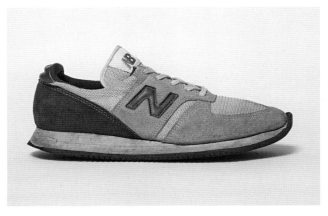

New Balance 540

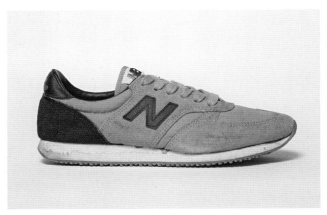

New Balance (Unknown)

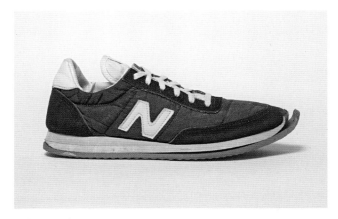

(Unknown)

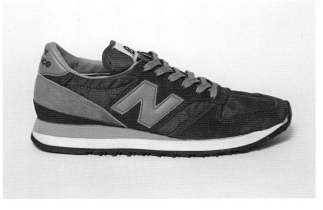

New Balance 730

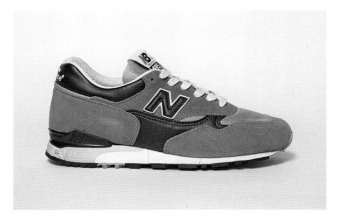

New Balance 495

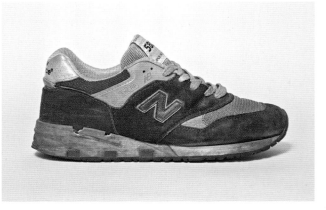

New Balance 580

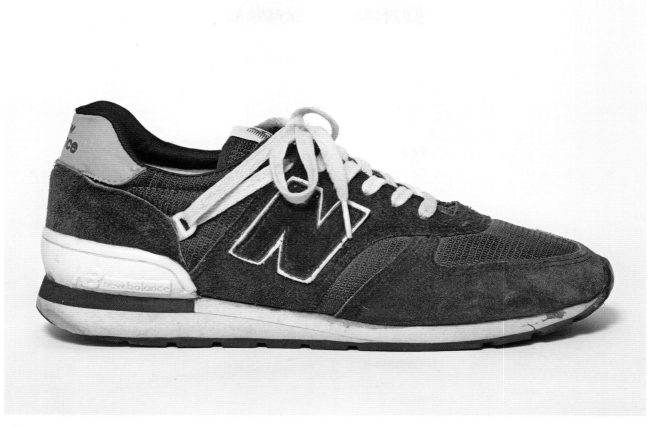

This version of the classic NB1300 really had us puzzled, especially the D-ring lace loops on the side of the shoe. Richie wasn't exactly sure, but his educated guess is that they were made by NB in the 1980s under the Moonstar label in Asia, most likely in Korea. He has also seen them in burgundy and grey.

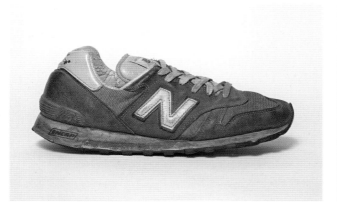

New Balance 1300CL

New Balance 1300JP (Early Version)

Just For Feet x New Balance 1600

New Balance 1600 (Limited Edition)

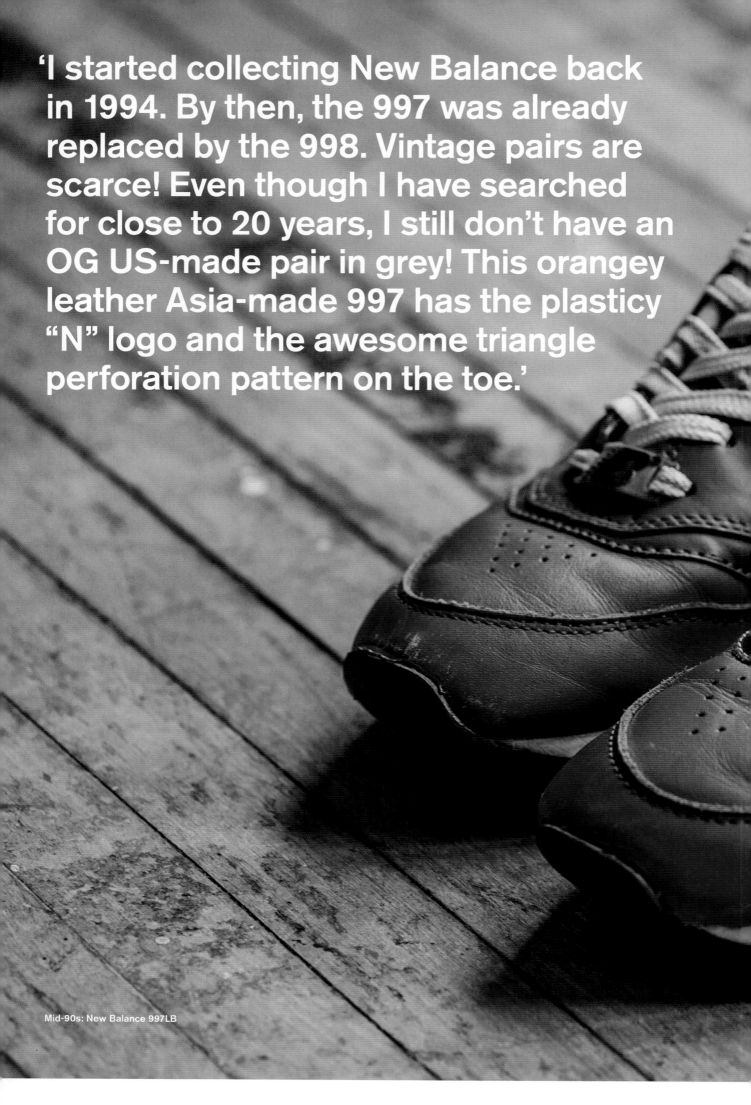

'I started collecting New Balance back in 1994. By then, the 997 was already replaced by the 998. Vintage pairs are scarce! Even though I have searched for close to 20 years, I still don't have an OG US-made pair in grey! This orangey leather Asia-made 997 has the plasticy "N" logo and the awesome triangle perforation pattern on the toe.'

Mid-90s: New Balance 997LB

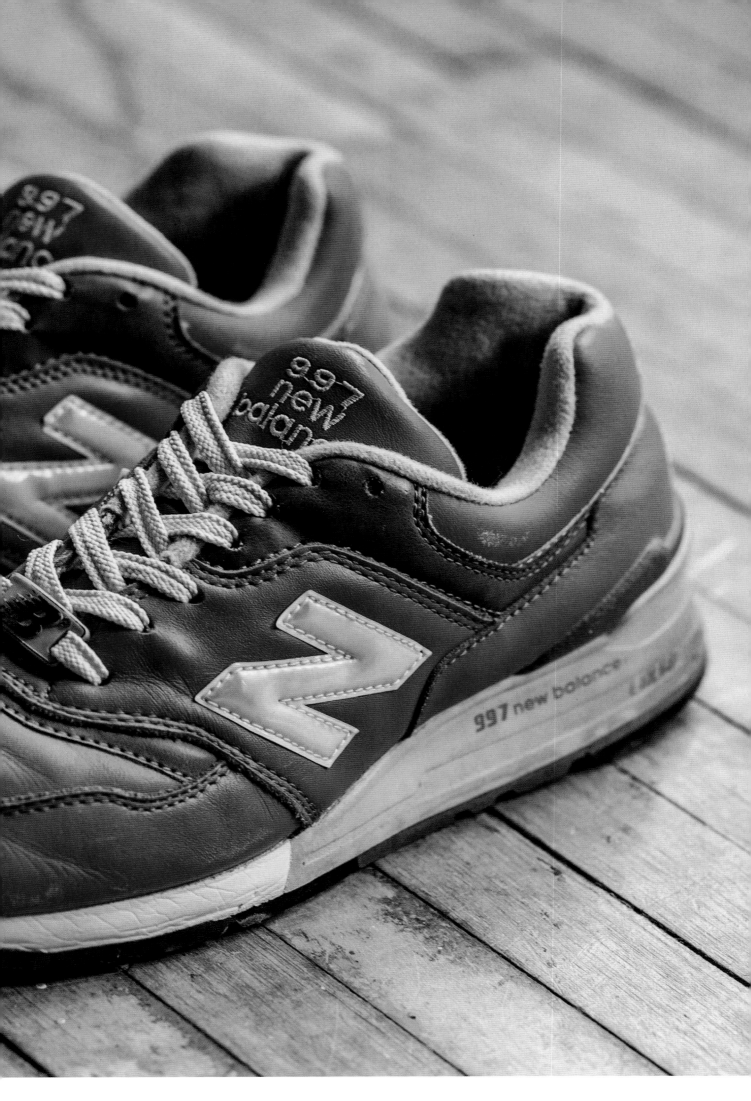

New Balance 999

solebox x BEINGHUNTED. x New Balance MT575

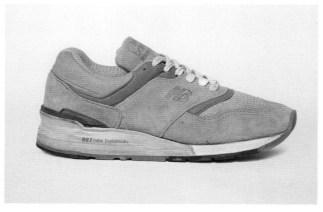

New Balance 997 (Women)

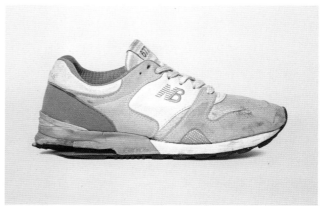

New Balance 677 (Women)

New Balance 640 NBX

New Balance 480

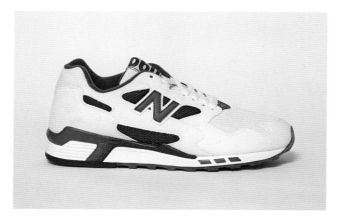

New Balance 660

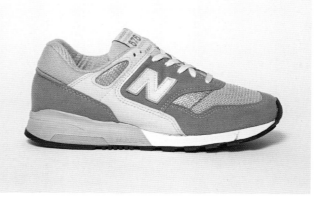

New Balance 676

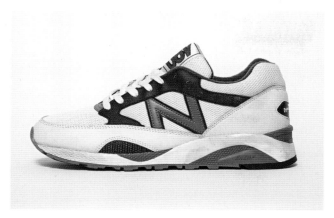

New Balance 480

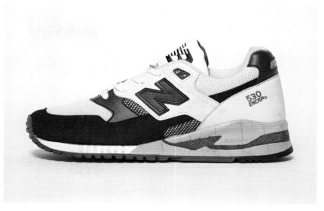

New Balance 530

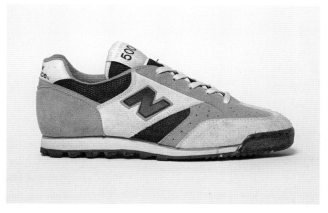

New Balance C500 (Cycling)

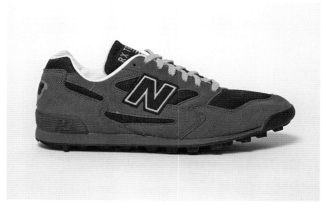

New Balance RX Terrain

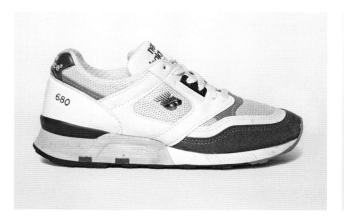

New Balance 680

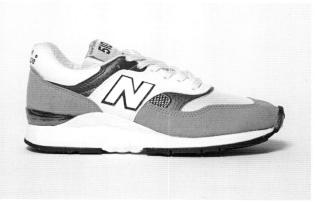

New Balance 510

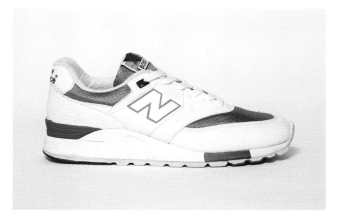

New Balance Boston

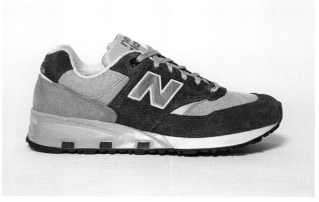

New Balance 1001

RIA RASCAL MAXED OUT!

Ria Rascal's commitment to the cause is undeniable. Read on as we delve into her well-stocked Air Max crates!

Interview: **Audrey Bugeja**

Blessed with size 4.5 feet, Ria Rascal has been forced to work harder than most to build up her big bubble bonanza. From 'Swarovski' Air Max 97s to the elusive Air Max 1 'Masters', alongside a gaggle of general releases, not much has eluded her keen eye over the years. According to Essex-native Rascal, 'There's something quintessentially British about Air Max.'

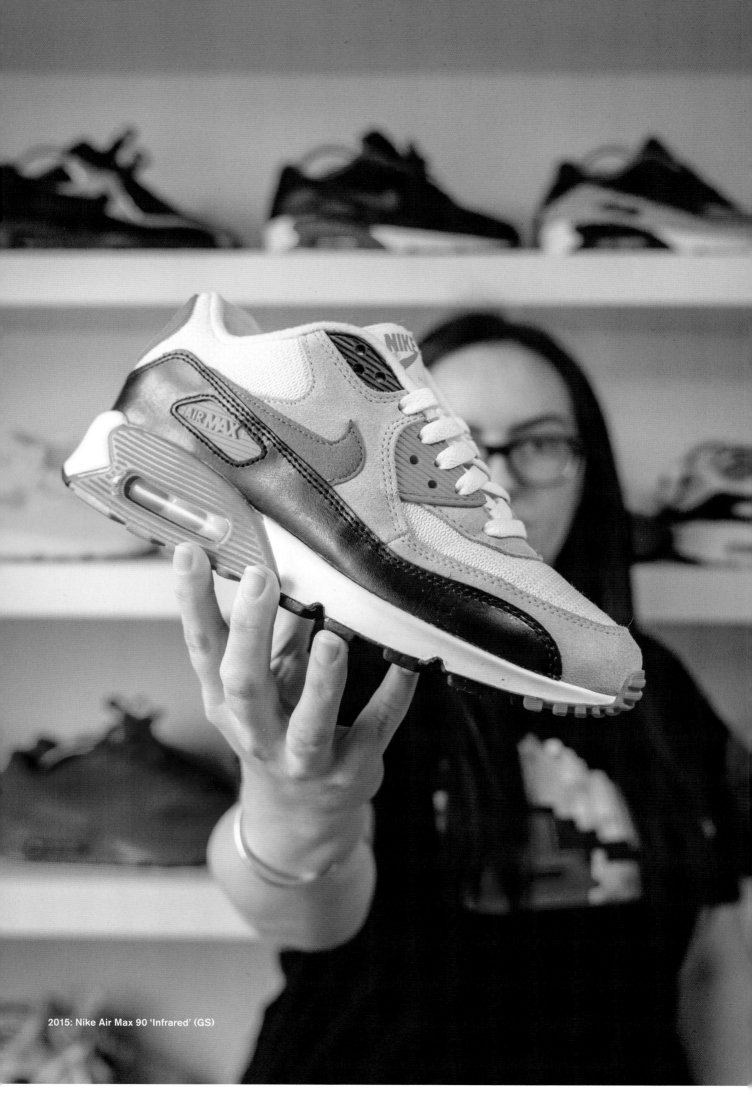

2015: Nike Air Max 90 'Infrared' (GS)

Ria Rascal
Air Max Aficionado
London, United Kingdom

I've always been into trainers. Back when I was in school, I used to rock K-Swiss Tongue Twisters and hightop FILAs. I was a tomboy and was often around cars and motorbikes, so I feel like that's where the obsession came from. When I started getting into the Swoosh, it was predominantly NikeiD Dunks. I had a weekend job and saved and saved for weeks to pay for my trainers. BWs are what opened me up to the world of collecting Air Max.

There's something quintessentially British about Air Max! I'm a massive sucker for the Air Max 97 as they look great on smaller feet. The midsole is the ultimate Air unit! The 95s and TNs are big UK shoes as well. As I got older and made some money, I moved into Air Max 90s. The bubble is always clean. It's my classic go-to and doesn't ever go out of fashion. Not many of my friends and people around me are into trainers. They all think I'm a bit mad, but it's what I'm known for.

When you're a UK4.5, finding deadstock pairs in your size is an achievement. I'm happy with my collection now. I have a few Holy Grails, with two that I wear most being the Air Max 90 'Powerwall' and 'Swarovski' 97s. I have the 'Bacon' and the 'Duck Camo', but these never came in my size. I bought them anyway and have just kept them as part of my collection. When the Swarovskis dropped, I was so desperate to get them because I'm getting married on Air Max Day, and it was so special to me to have those as my wedding shoes.

It didn't help that my size was the hardest to source, especially the silver edition. And there was no way I was dropping £1000 on them! On Christmas Day back in 2019, I was opening presents when Rob, my partner, said he had another gift upstairs. I could tell what they were straight away because of the slide box. To this day, he hasn't told me where he got them from or how much he paid.

There's so much hype around Off-White and the big collaborations, but Nike needs to focus on older stuff as well. I always tell people to get the OGs. The 'Infrared' 90 is classic. Same with 'Laser Blue'. When it comes to Air Max 1, it's either the red or blue. I prefer the latter. Some of my all-time favourites are general releases.

The Air Max 1 'Masters' is one shoe I never thought was even made in small sizes. A friend told me someone was selling a pair in my size. I questioned if they were genuine, and they put me in touch with Ella, one of the Masters of Air, to continue the chat. She confirmed they were legit. What luck! That was an amazing project because it was all about the community for once. It makes you think maybe Nike is paying attention to what people are saying.

Everyone knows my name is Ria, but up until this year, no one knew what I looked like, and that's how I liked it. When I lived at home, I was very conscious of keeping a low profile. Even now, I won't wear certain pairs out on the street because you never know who's about. I still love communicating with other people – I just don't plaster myself all over Instagram.

I used to buy six or seven pairs a month, but when we moved house, I downsized. Now I just buy what I really like. You should be selective, and it's good to be picky. I love a splash of pink every now and again, but brands seem to think that all girls want are pink trainers.

Don't get me wrong – I'm all for open-sized runs because I miss out on so many releases due to my small feet. UK releases start at size 5 or 6, so sometimes I have to buy them even though I'll never be able to wear them. I really don't get why brands still divide releases into men and women.

If I'm honest, I've fallen a little out of love with certain aspects of the scene. It's all raffle entries and potluck these days, and sometimes complete randoms just want the trainers to resell, which is disappointing. Years ago, when I first started collecting, there was no such thing. I guess it's also down to the fact that there are a lot more collectors around now. I'm not really sure what brands can do about the situation. They can make more shoes, but that would take the fun out of it in some ways. When you're searching for something and know it's really hard to get, that's the ultimate reward!

I'm part of a UK group called The Real Sole Family, which is very much about community. There are London meet-ups on weekends, but I'm often working and can't go, so I just keep as connected as possible in other ways. Some of us are really close, and we group-chat every day. I answer loads of questions and help whenever I can. If there's a Jordan release, I'll enter raffles for my friends, and they help me with Air Max releases. The Real Sole Family is about what goes on behind the scenes. It's about getting into trainers for the love of it, not for resale.

COVID lockdowns put a lot of things into perspective. Some members have realised that it's not even about the trainers – it's the friendships they're really missing. The Real Sole Family is literally a family in the traditional sense. If you need to vent, it really is like a proper support group. This year especially, I'm definitely grateful. When you can't go out and see friends and socialise, that's when you realise how important being part of a community really is. ★

@ria_rascal

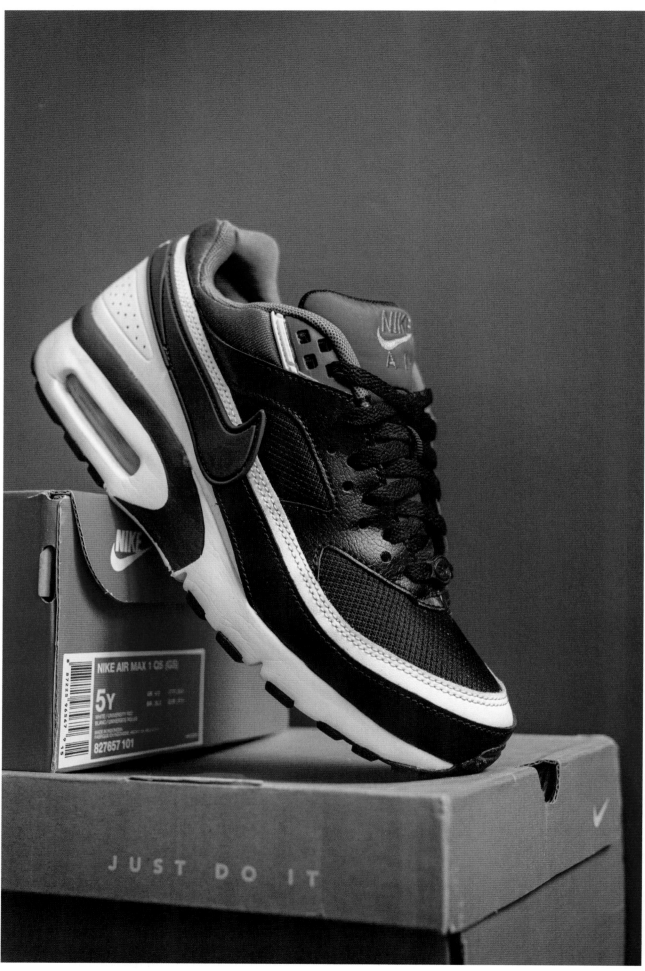

2016: Nike Air Max BW 'Persian Violet' (GS)

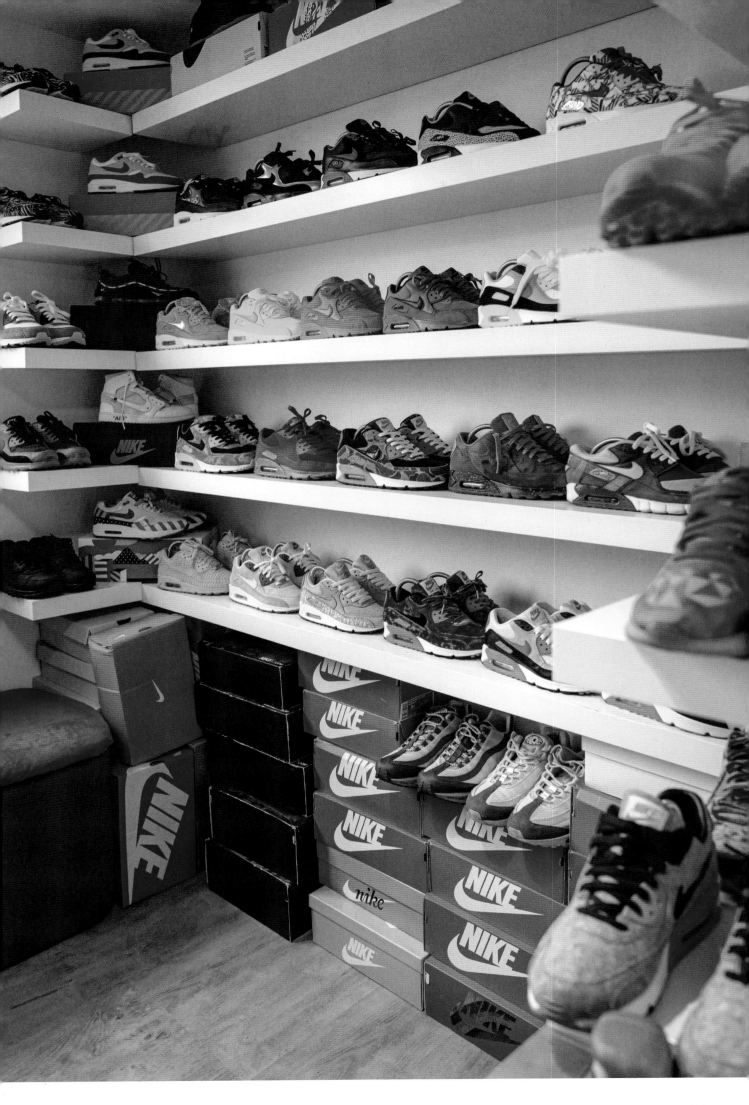

2015: Nike Air Max 90 'Digi Camo'

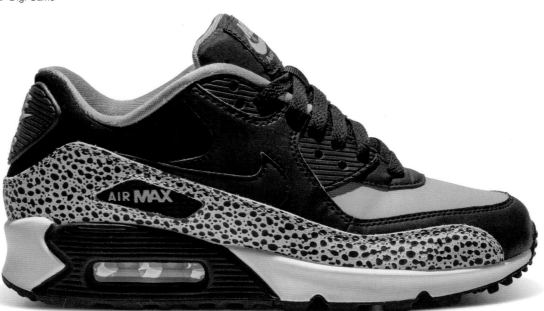

2016: Nike Air Max 90 'Safari' (GS)

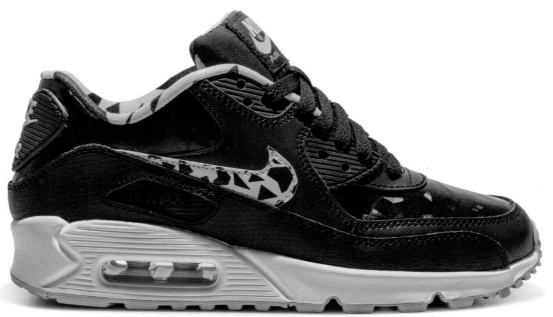

2015: Nike Air Max 90 FB 'Black/Total Orange' (GS)

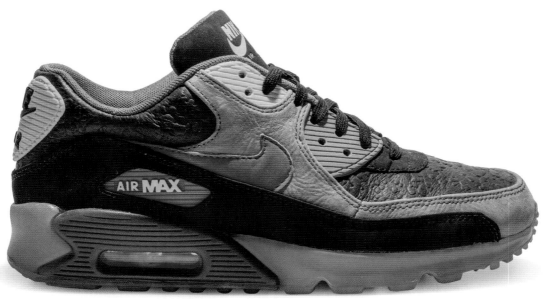

2014: Nike Air Max 90 'Halloween'

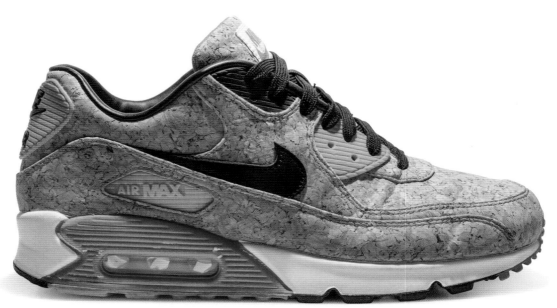

2015: Nike Air Max 90 'Cork' (Anniversary)

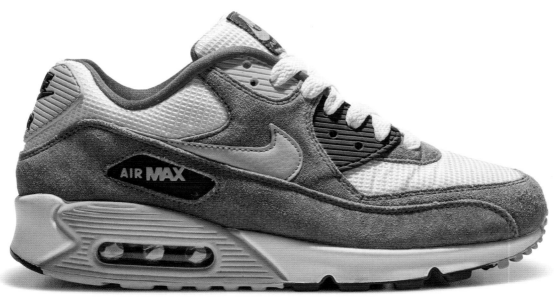

2015: Nike Air Max 90 'Curry'

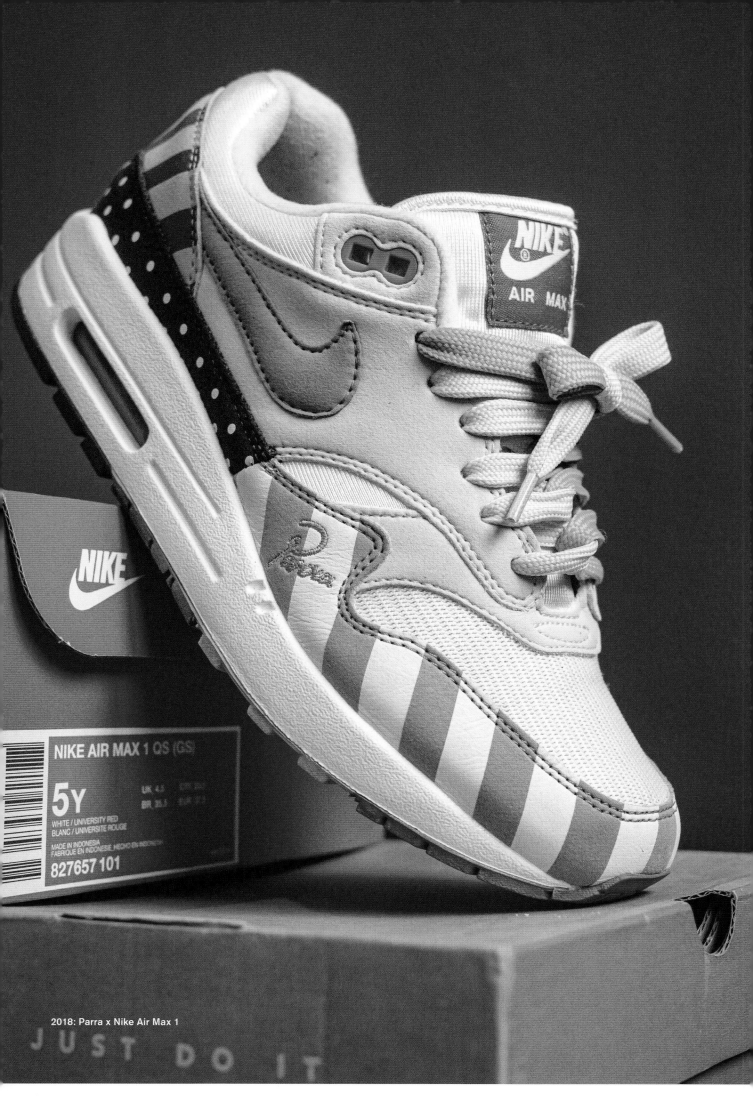

NIKE AIR MAX 1 QS (GS)

5Y UK 4.5 CM 24.0
BR 36.5 EUR 37.5

WHITE / UNIVERSITY RED
BLANC / UNIVERSITE ROUGE

MADE IN INDONESIA
FABRIQUE EN INDONESIE MECHO EN INDONESIA

827657 101

NIKE

2018: Parra x Nike Air Max 1

JUST DO IT

598

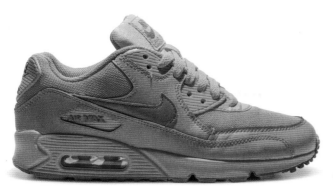

2014: Nike Air Max 90 'Hyper Pink' (GS)

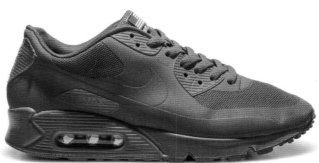

2013: Nike Air Max 90 Hyperfuse 'Independence Day' (Red)

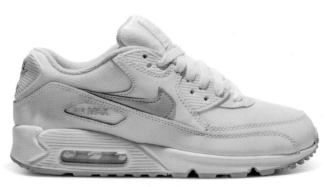

2014: Nike Air Max 90 'Volt' (GS)

2015: Nike Air Max 90 'Shanghai – Must Win Cake' (City Collection)

2014: Nike Air Max 90 'Photo Blue' (GS)

2015: Nike Air Max 90 'Red Velvet' (Anniversary)

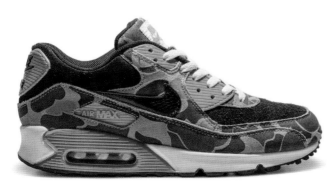

2013: atmos x Nike Air Max 90 'Duck Camo'

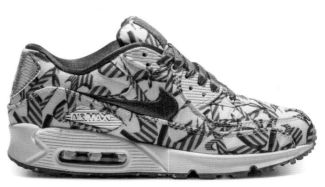

2015: Nike Air Max 90 'Christmas'

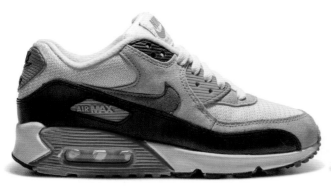

2015: Nike Air Max 90 'Infrared' (GS)

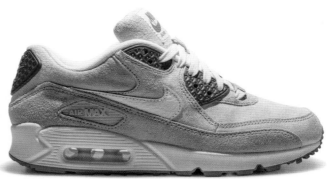

2015: Nike Air Max 90 'New York – Strawberry Cheesecake' (City Collection)

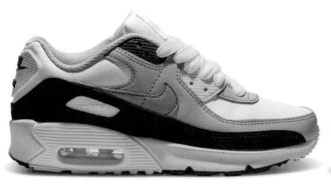

2020: Nike Air Max 90 Volt (GS)

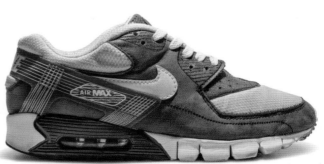

2009: DQM x Nike Air Max 90 Current Huarache 'Burnt Bacon'

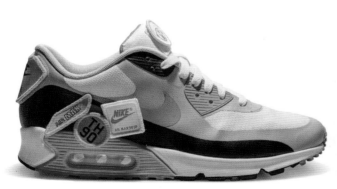

2015: Nike Air Max 90 'Infrared' (Patch Pack)

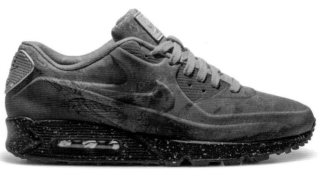

2019: Nike Air Max 90 'Mars Landing'

2006: Nike Air Max 90 'Sunblush' (Powerwall)

2014: Nike Air Max 90 Gamma Blue/Total Orange

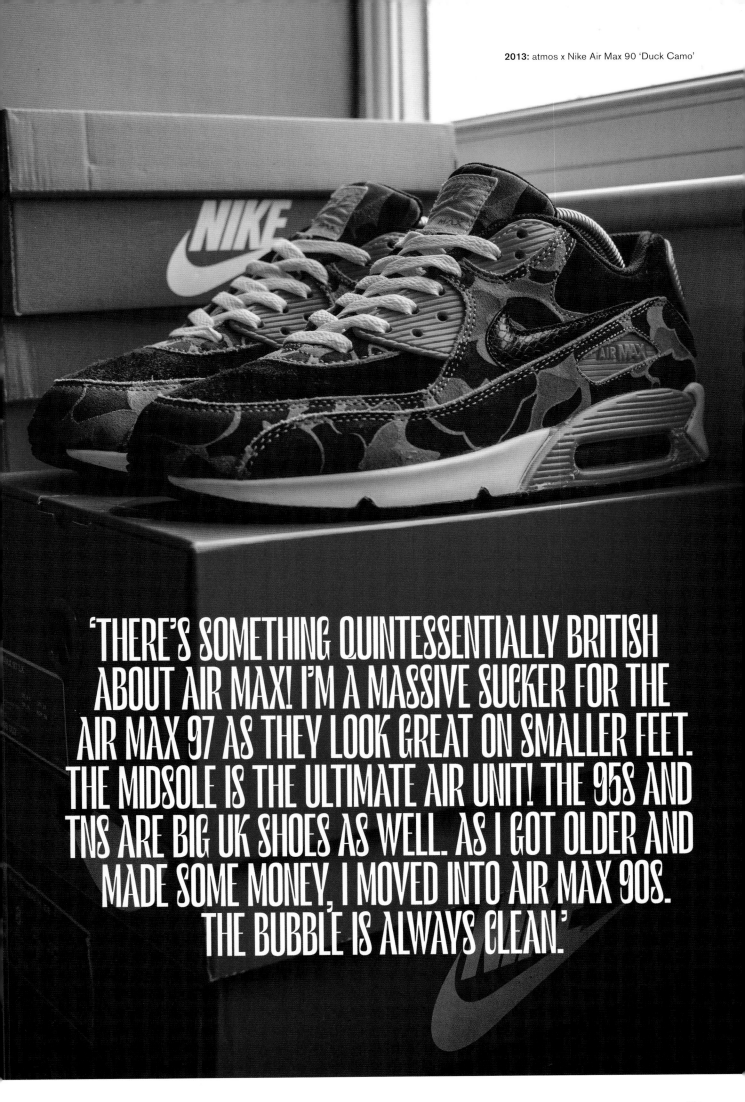

'THERE'S SOMETHING QUINTESSENTIALLY BRITISH ABOUT AIR MAX! I'M A MASSIVE SUCKER FOR THE AIR MAX 97 AS THEY LOOK GREAT ON SMALLER FEET. THE MIDSOLE IS THE ULTIMATE AIR UNIT! THE 95S AND TNS ARE BIG UK SHOES AS WELL. AS I GOT OLDER AND MADE SOME MONEY, I MOVED INTO AIR MAX 90S. THE BUBBLE IS ALWAYS CLEAN'

HUAC

AIR

Interview: **Oliver Georgiou** Images: **Dom Moore**

The Air Huarache arrived in the midst of a golden era at Nike, when bigger was better and bolder was best. The fresh two-colour fusion accenting, thick rubber heel strap and lycra-lined Neoprene collar made a provocative statement of futuristic intent. Mammoth midsoles with 'Air' bumper plates and a coalition of silky mesh and tumbled leather sealed the deal. The Huarache in-box booklet described it as 'a radical departure from conventional shoe design', and Nike weren't kidding!

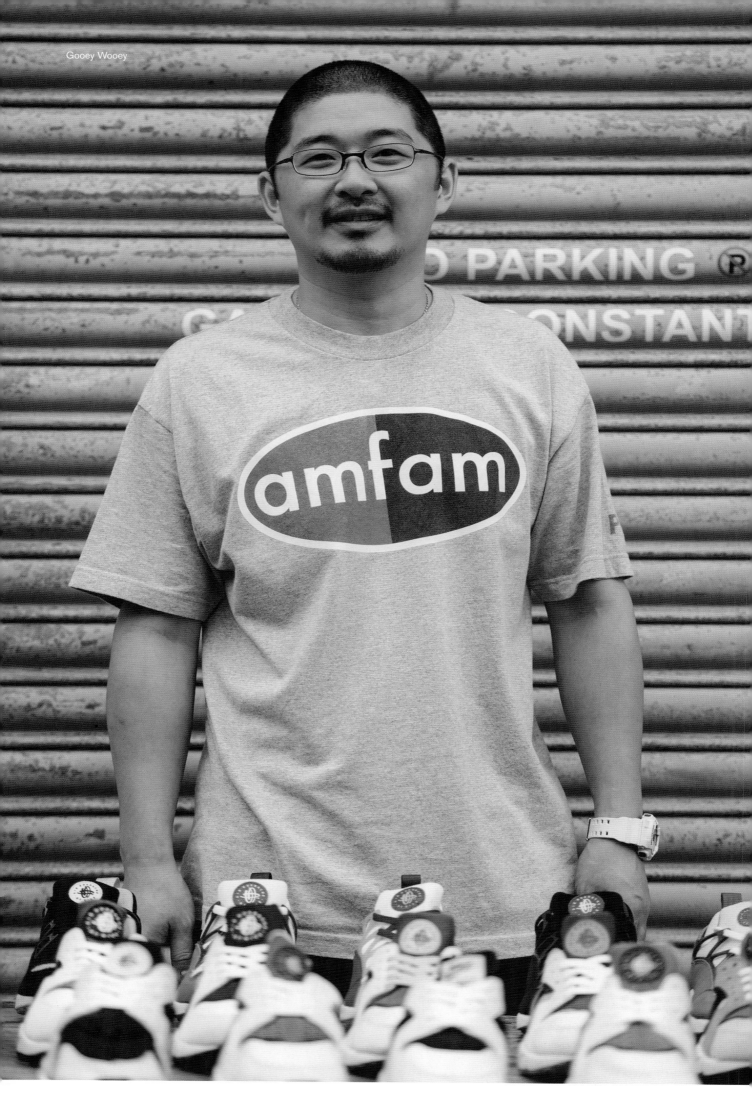

Gooey Wooey

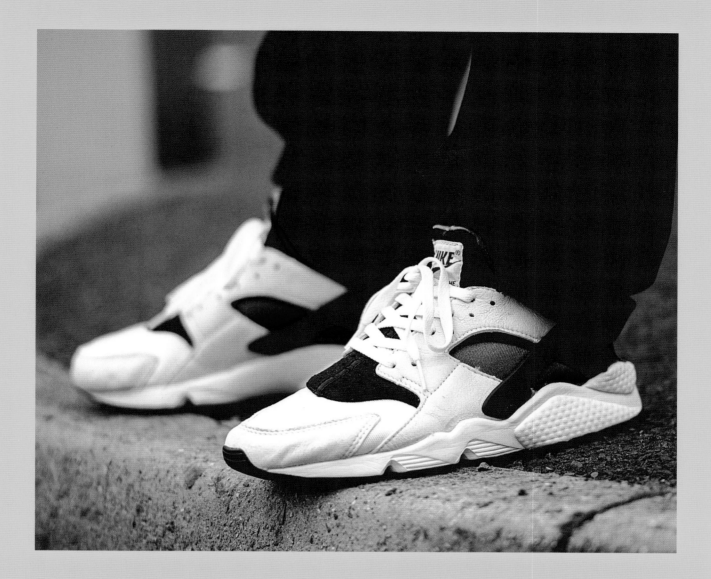

It was no surprise to learn that the shoe was designed by none other than Tinker Hatfield. Still glowing white-hot from his success with the first Air Max, not to mention shoes worthy of Michael Jordan's rapidly escalating blue-chip status, Tinker let it all hang out, and the end result was another righteous trailblazer. The actual concept was inspired by a water-skiing experience. Noticing how snugly the rubber booties conformed to the contours of his ankles, a lightbulb went off, and another Hatfield hero was born.

As it turned out, quite a few Nike execs thought the Huarache was too ostentatious to find a commercial audience. Retailers initially ummed and ahhed, and the shoe almost failed to launch. Fortunately, Nike marketing director Tom Archie was ballsy enough to commission 5000 pairs without a single order in the system.

That original batch of Huaraches was taken to the New York marathon and sold out in three days. Validated by the approval of serious athletes, the Huarache went into full-blown production in 1991, and over 250,000 pairs were rinsed by the end of its rookie year. This was another home run for the underdogs in the face of bean-counter conservatism.

Subsequent Huarache spin-offs included the velcro-strapped Air Trainer Huarache and Air Flight Huarache basketball edition, followed by the Air Huarache Light, International and Plus in 1993. The Air Huarache Racer arrived in 1994, and the Light Burst appeared a decade later.

While no longer a fresh-faced radical on the running scene, the Huarache's enduring street appeal is a testament to the shoe's quirky persona and brawny street smarts. Retroed countless times, Nike's tactical approach has nurtured the shoe's cultural lifespan, ensuring Hua-heads always have something to fiend over.

When consulting Dr Google recently, we stumbled across Gooey Wooey, a true-blue Huarachehead with a taste for tangy trainers. Residing in Plymouth, in the southwest of England, Gooey first rocked Huaraches back in 1992, making him a true OG. Recalling memories of his teenage fling, Gooey has been a man on a mission since, snatching up Hua gems over the years.

You are here.

1991: Nike Air Huarache print ad

First off, tell us about yourself, Gooey Wooey. There must be a very good reason for a handle that juicy.

I always get asked that, but there's no exciting story. I was setting up my eBay account back in 2002 and had to come up with a username. The given example was something really basic like 'Jim Slim'. I was in a hurry, and 'Gooey Wooey' was the first thing I could think of. I regretted it straight afterwards and tried to change it, but eBay said I would have to wait 30 days before I could switch, so I just never got round to it. I then set up my Flickr account with the same name years later to tie it all in, so now I'm stuck with it. [Laughs.]

Where do we really start?

I've been around since the 70s and have seen pretty much every kind of shoe come and go. As a kid, I was always picky about what I wore, and my passion really began in the hip hop and breakdancing days of the early 80s. I've loved trainers all my life, but it wasn't until I discovered eBay in 2002 that things really took off. I did the whole Nike SB thing, lurked NikeTalk on the daily and then finally moved on to runners, proudly becoming a member of Team AM Fam. Nowadays, I'd like to think that I've calmed down somewhat, buying a more varied selection.

How did you get into Huaraches? Is there one pivotal moment?

I bought my first pair back in 1992. They were the Slate colourway from the Limited Edition series. I wore the hell out of them, and for some crazy reason, I never bought another pair again until years ago. I have a terrible OCD-like habit of buying a silhouette in endless colourways and then moving on to the next one. So when I reached my last transition phase, I thought, maybe it's time to treat myself to some 'Scream Greens'. Once I had them in hand and experienced the comfort of that neoprene sock... I was hooked all over again!

What's the state of your rack these days?

I don't really keep track of the numbers, but overall I'm quite happy with it. There are still a few I would love in my size, but that makes hunting all the more fun. Besides, I was nearing 300 pairs, so I've been trying to downsize my collection. I'm now down to about 230, which is better but still excessive.

It seems great having so many, but in reality, it's easy to forget what you have. Pairs can just sit there in your collection and become unwearable or get overlooked, or worse still, you see another pair you want to buy, and you have pairs in the stacks you don't even want anymore.

We feel your pain. I noticed that you move a few pairs now and then. Would you call yourself a collector or a flipper?

I spend a lot of time hunting for shoes and chatting with people from all over, hooking up or getting hooked up. Of course, I end up finding the odd bargain now and then, which I know I can flip for profit. I know this might not sound right to some people, but I certainly don't have a problem with it. I, for one, have spent a fortune in the past, so this just goes towards all that.

Totally, it's the circle of life! The Huarache is definitely a tight all-around package. What makes Tinker's design pop, in your opinion?

For me, I think it's the combo of the neoprene collar and, in the case of the OGs, the bright colourways. The straps and some of the other details here and there are cool, too, but the shoe still has a simple yet well-balanced appearance. The little matching neoprene overlay is also a very nice touch, in my opinion. Take the neoprene collar away, and I think it would lose most of its character.

A I R

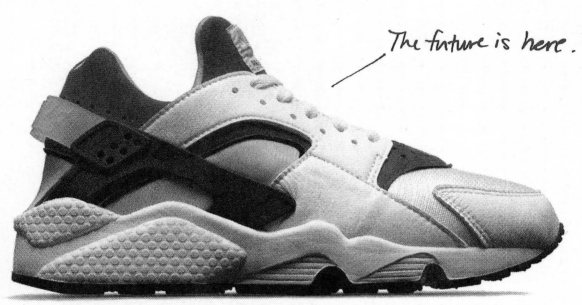

The future is here.

The future is staring you right in the face. And it's incredibly light (try 9.5 oz. on for size). Incredibly stable. Incredibly well-cushioned. Incredibly comfortable. Incredibly innovative. It's the Nike Air Huarache running shoe. Incredible, isn't it, just how well the future turned out.

Judging from your Flickr, the Scream Green edition is number one. Drop some knowledge on us. How does the Scream Green retro from 99 stack up against the OG?
Well, I'm quite embarrassed to say this, but I don't actually own the OGs.

Great question, then. [Laughs.]
Not for the lack of trying, of course! The only retro I'm aware of was released in 1999, so it's well overdue now. From what I have read, though, like most Nike retros, the shape is not quite as true as the OG, and the colours are not as vibrant. I only just found out yesterday that they also made a leather (rather than synthetic) women's retro in 1999. I have a pair on their way to me right now, which I can't wait to see.

The first few runs of Huaraches back in 1991 came with a square sewn-on Nike tongue tag that soon changed to the circular logo tag. Does the OG tag have an impact on their value?
No, I wouldn't say so. All the early releases are highly sought after anyway, so this nice little detail just adds to the appeal.

Any epic Hua-hunting tales to tell?
Not really. A couple of major bargain purchases and a six-week delivery duration thanks to customs for one pair, but that's about it.

Samples aside, I would say any of the original 1991–92 releases are the hardest to find. 'Purple Punch' and the Black/White men's colourways are particularly scarce, as well as any of the OG women's shoes in big sizes. One extremely rare pair I own is the OG 'Ultramarine' Light from 1993, with the 'Nike Air' logo stitched on instead of the plain red Swoosh. I've never seen another pair of them except in print ads. My girlfriend also has a pair with a manufacturing error, where the

Swooshes are both on the same sides, so if you look at them from the other side, they're Swooshless. As far as value, the Purple Punch is up there, along with both Stüssy releases.

How do you rate the retro releases?
Personally, I like my Huaraches quite basic with the OG-style colours, and I'm a bit fussy with materials, so not many of the recent releases have really appealed. Again, the issues with shape have been mentioned, but nevertheless, it's great to see them back out on the market!

Your girlfriend seems to have a pretty epic collection herself. Was this your influence or is it simply a match made in Hua-Heaven?
Yeah, she certainly has some nice gems building up, some of which are pictured on these pages, I must add. I do pretty much all the shoe hunting, so I suppose my influence is there, but she certainly wouldn't have anything in her collection she wouldn't want. It's also a handy way of spreading my buying obsession.

Finally, is there an essential item missing from your collection?
Easy, OG Scream Greens, of course!
★

@gooey_wooey

TOP FIVE GOOEY WOOEY HUARACHES

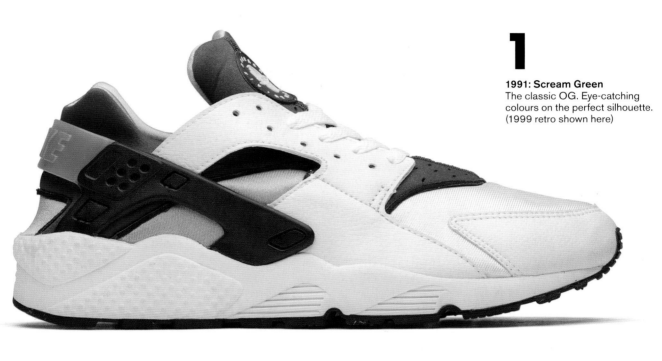

1

1991: Scream Green
The classic OG. Eye-catching colours on the perfect silhouette. (1999 retro shown here)

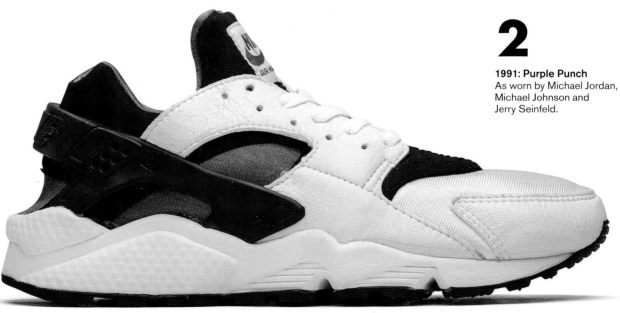

2

1991: Purple Punch
As worn by Michael Jordan, Michael Johnson and Jerry Seinfeld.

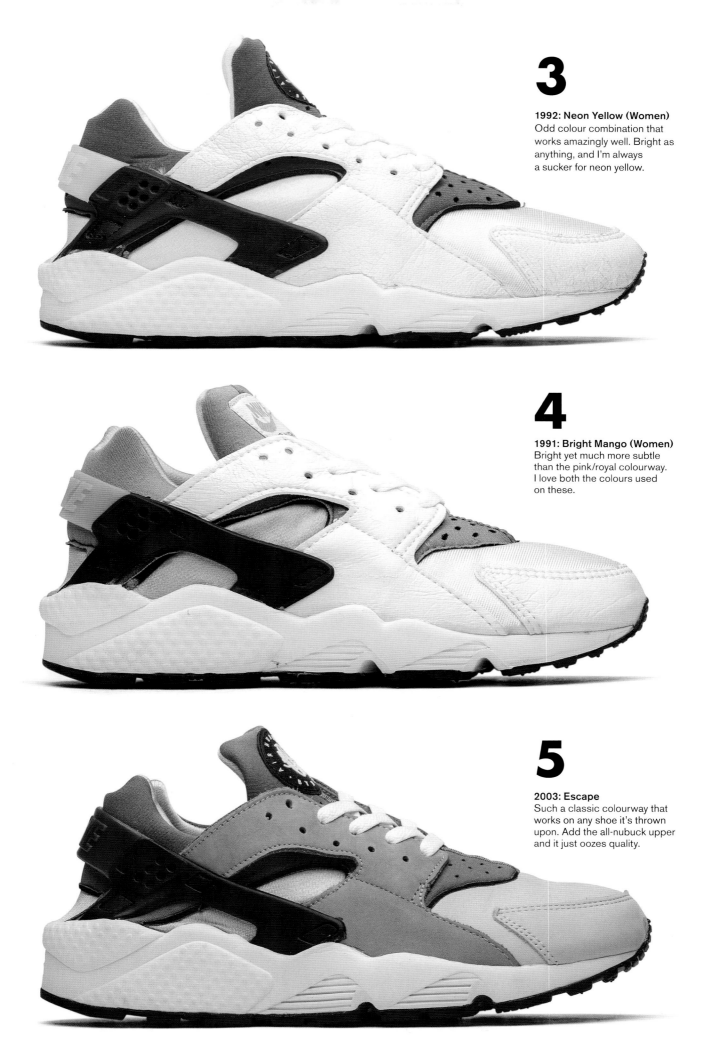

3

1992: Neon Yellow (Women)
Odd colour combination that works amazingly well. Bright as anything, and I'm always a sucker for neon yellow.

4

1991: Bright Mango (Women)
Bright yet much more subtle than the pink/royal colourway. I love both the colours used on these.

5

2003: Escape
Such a classic colourway that works on any shoe it's thrown upon. Add the all-nubuck upper and it just oozes quality.

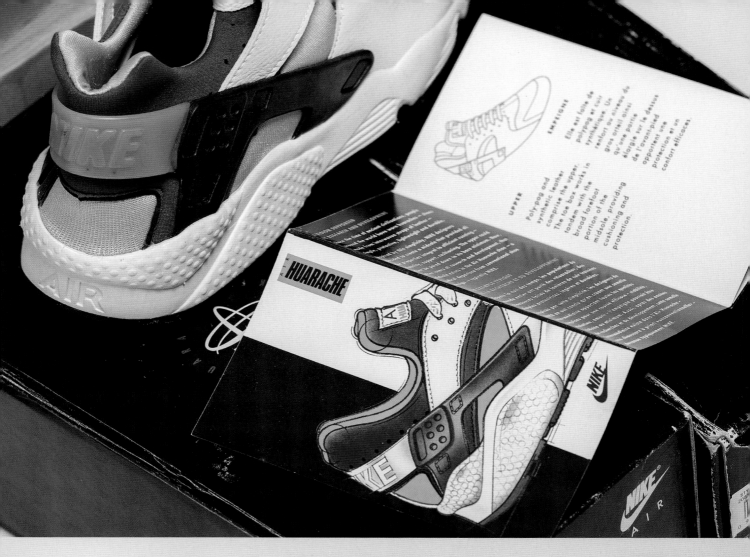

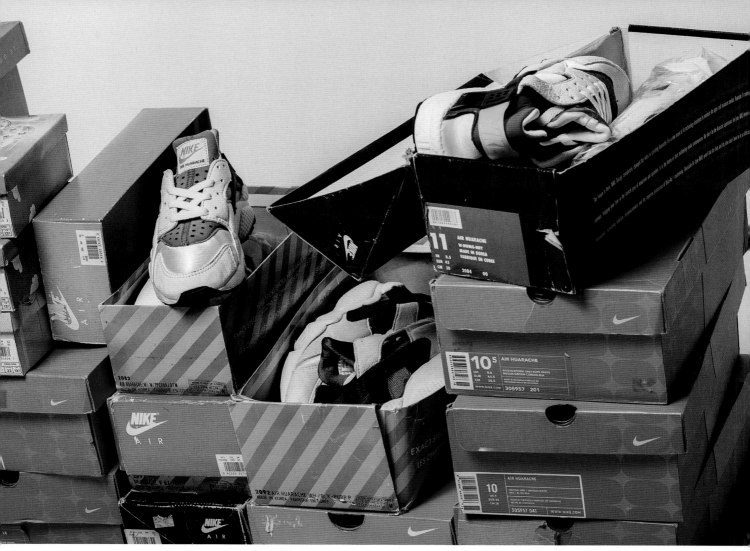

610

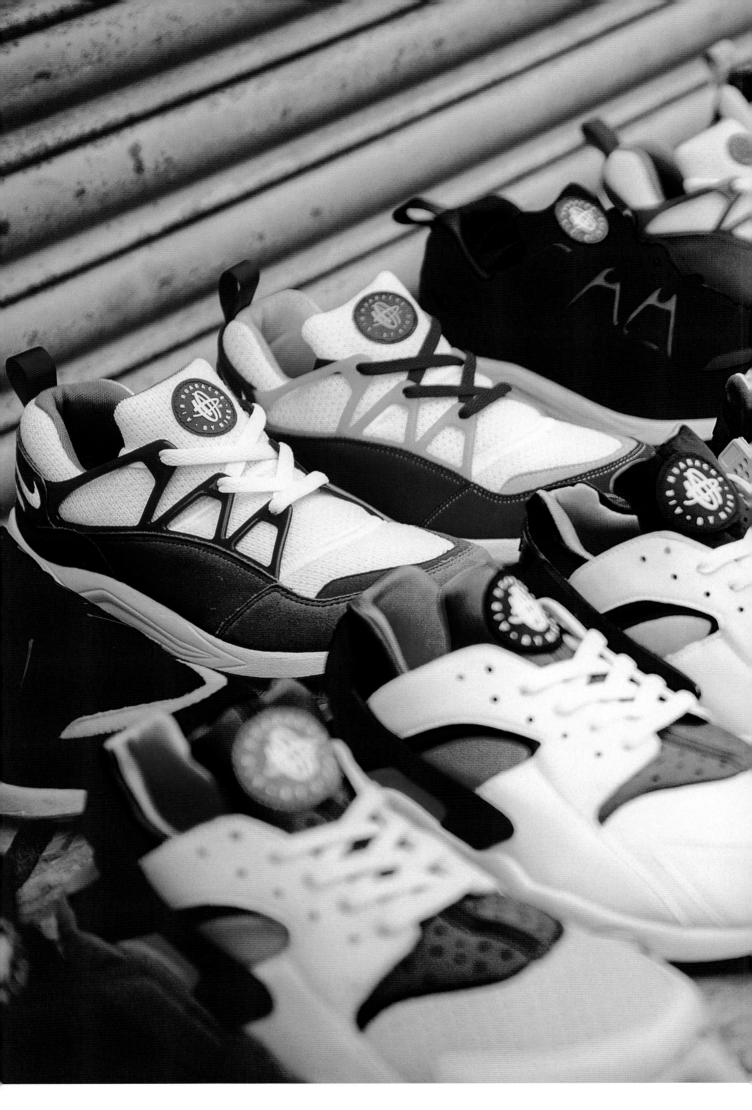

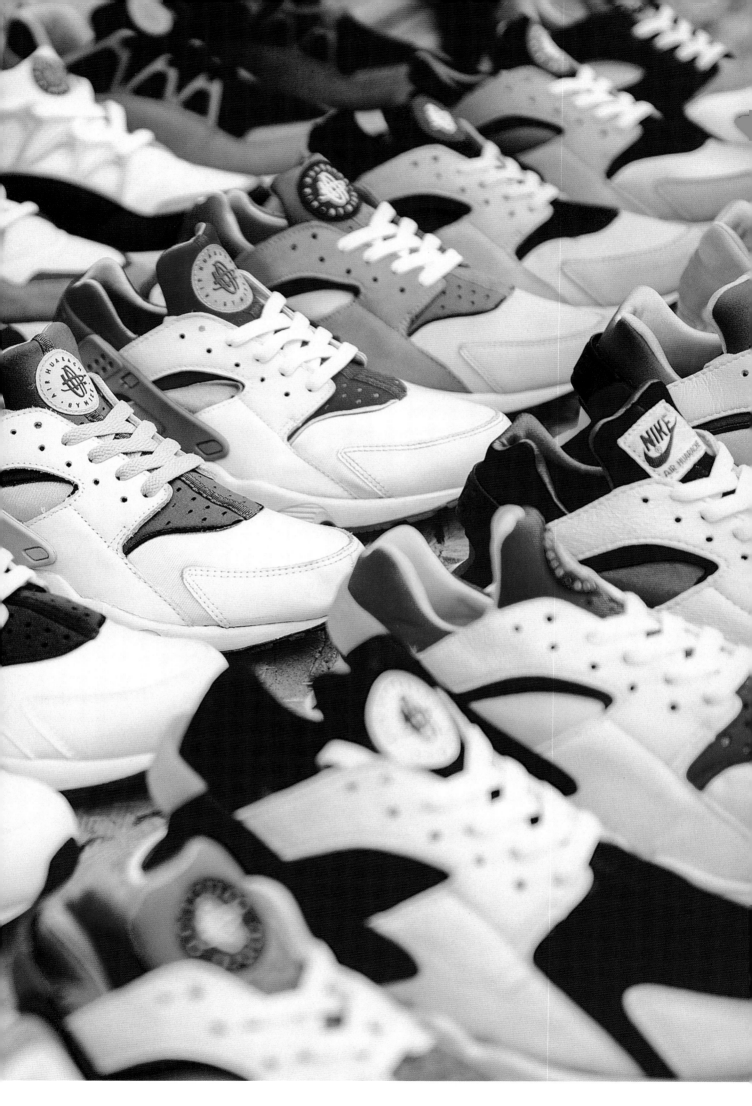

2004: Nike Air Huarache 'Classic Green'

2001: Nike Air Huarache 'Varsity Red'

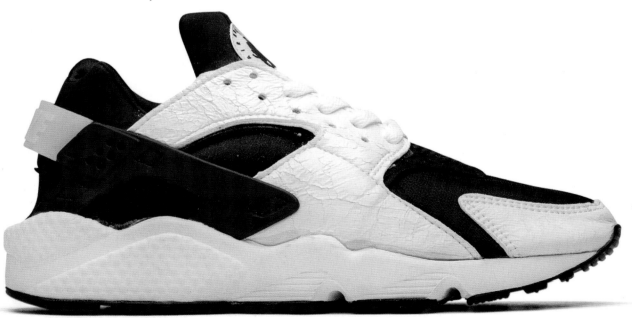

1992: Nike Air Huarache 'Black/White'

1991: Nike Baby Huarache 'Blue Emerald/Resin'

1991: Nike Baby Huarache 'Royal Blue/Pink Flash'

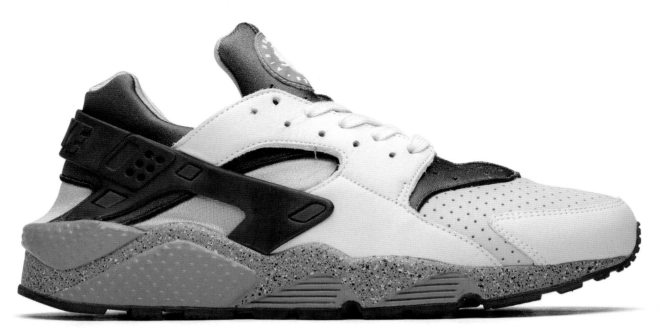

2007: Nike Air Huarache 'Mowabb'

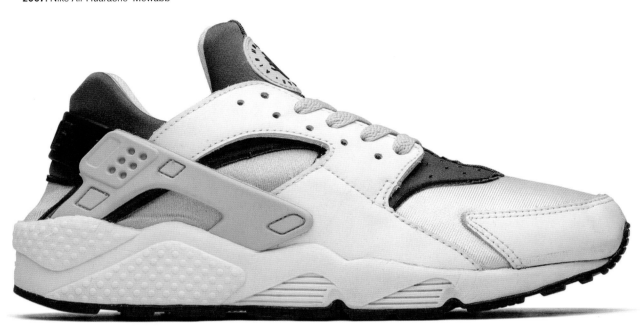

2001: Nike Air Huarache 'Dark Grape' (Women)

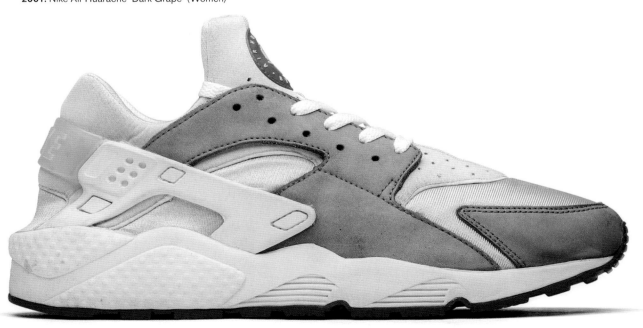

2000: Stüssy x Nike Air Huarache 'Dark Olive'

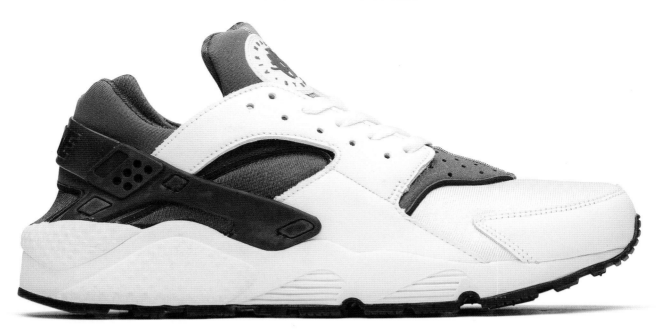

2004: Nike Air Huarache 'Metro Blue'

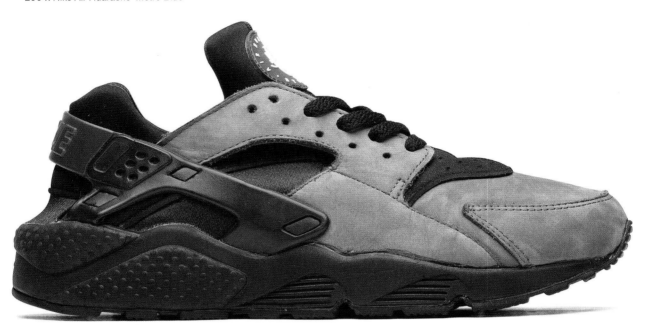

2000: Nike Air Huarache 'Slate' (LE)

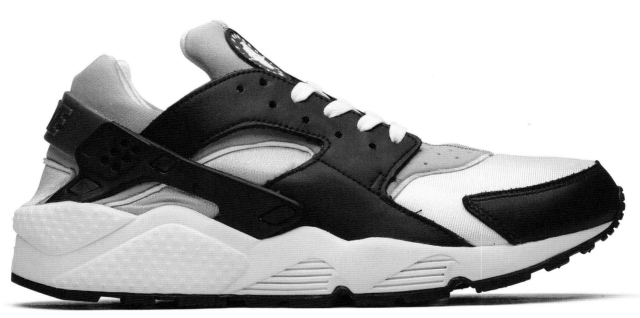

2003: Nike Air Huarache 'Neutral Grey' (CO.JP)

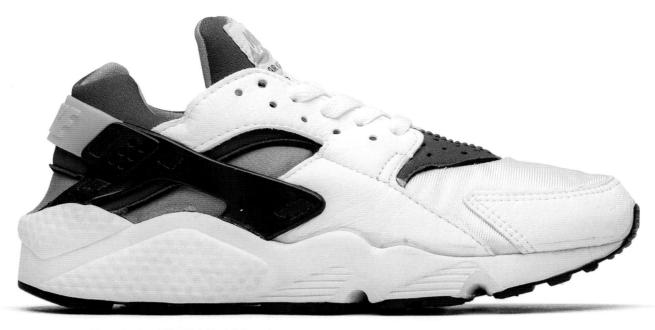

1991: Nike Air Huarache Royal Blue/Pink Flash (Women)

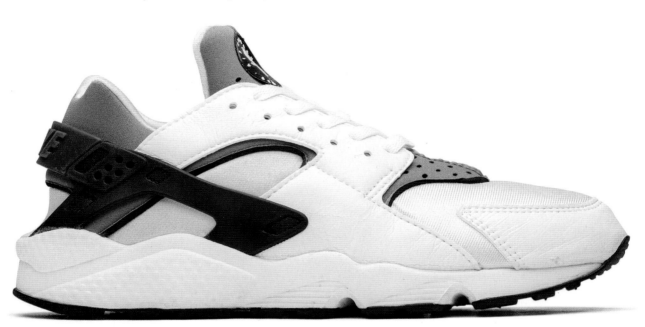

1991: Nike Air Huarache 'Resin'

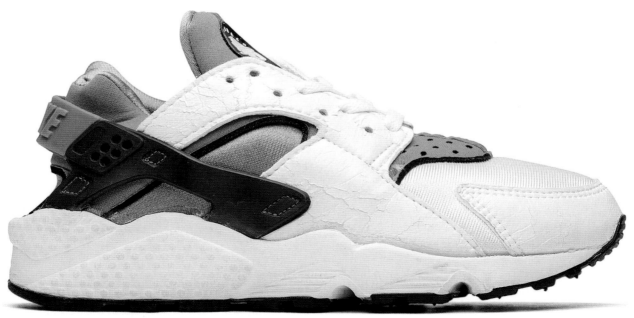

1991: Nike Air Huarache 'Aquatone' (Women)

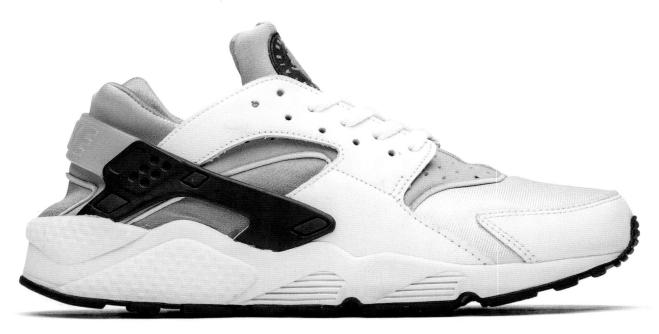

2005: Nike Air Huarache 'Orange Blaze'

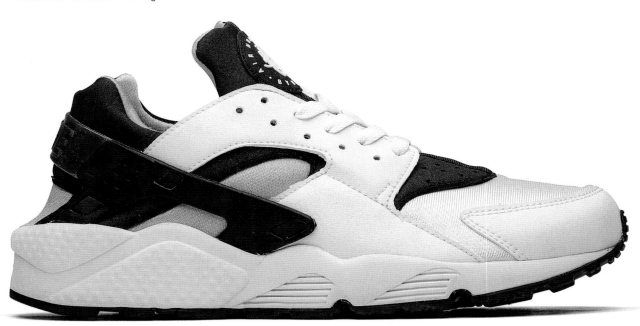

2003: Nike Air Huarache 'Michigan'

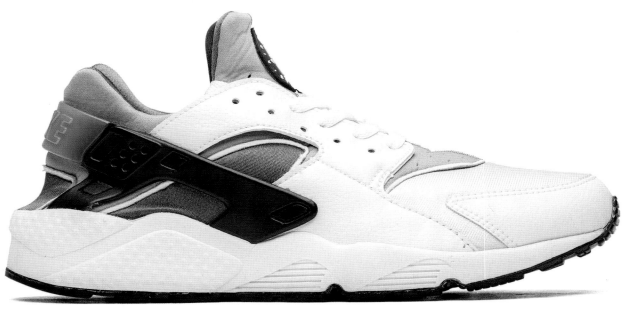

1999–2000: Nike Air Huarache 'Columbia Blue'

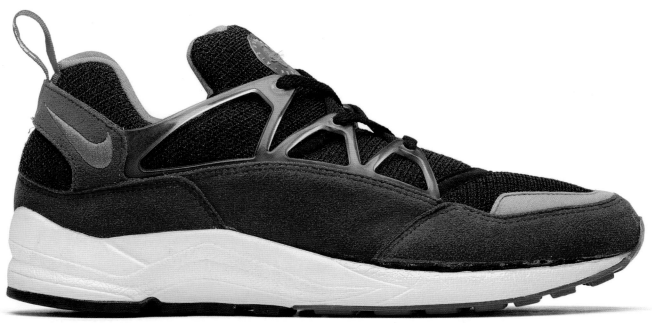

1993: Nike Air Huarache Light 'Ultramarine' (OG)

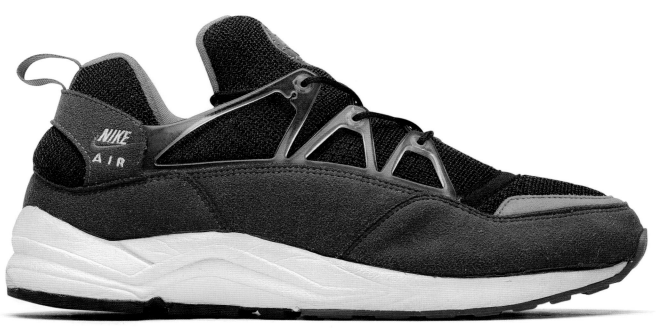

1993: Nike Air Huarache Light (With Mystery 'Nike Air' Logo)

2013: Nike Free Huarache Light 'Ultramarine'

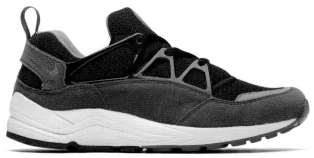

2004: Nike Air Huarache Light 'Ultramarine' (Retro)

AIR HUARACHE LIGHT 'ULTRAMARINE'

Since the Huarache first appeared in 1991, several spin-offs have been graced with a hybrid Hua nameplate. Appreciated by a 'sophisticated' clientele, the Air Huarache Light from 1993 is best known for its distinctive 'Ultramarine' colourway. As seen here, one of Gooey's most prized possessions is this mystery pair with a 'Nike Air' embroidery flanking the ankle – this may be the only pair in existence! The Ultramarine was retroed in 2004, with minor tweaks such as the black TPU cage that replaced the OG transparent unit, though Nike did reprise the colours on a Free x Huarache Light hybrid in 2013. It's definitely time for another Huarache Light retro!

The **average person** has a sexual thought every fifteen seconds. Which **means** if we talk about the Air Huarache® Light running shoe long enough, and **go on and on** about its unique and comfortable fit, all while using **highly descriptive** phrases such as "fits like a second skin" and **"literally hugs** your foot", chances are you'll find it (the shoe we referenced earlier) kind of, you **know**, sexy.

running

1993: Nike Air Huarache Light print ad

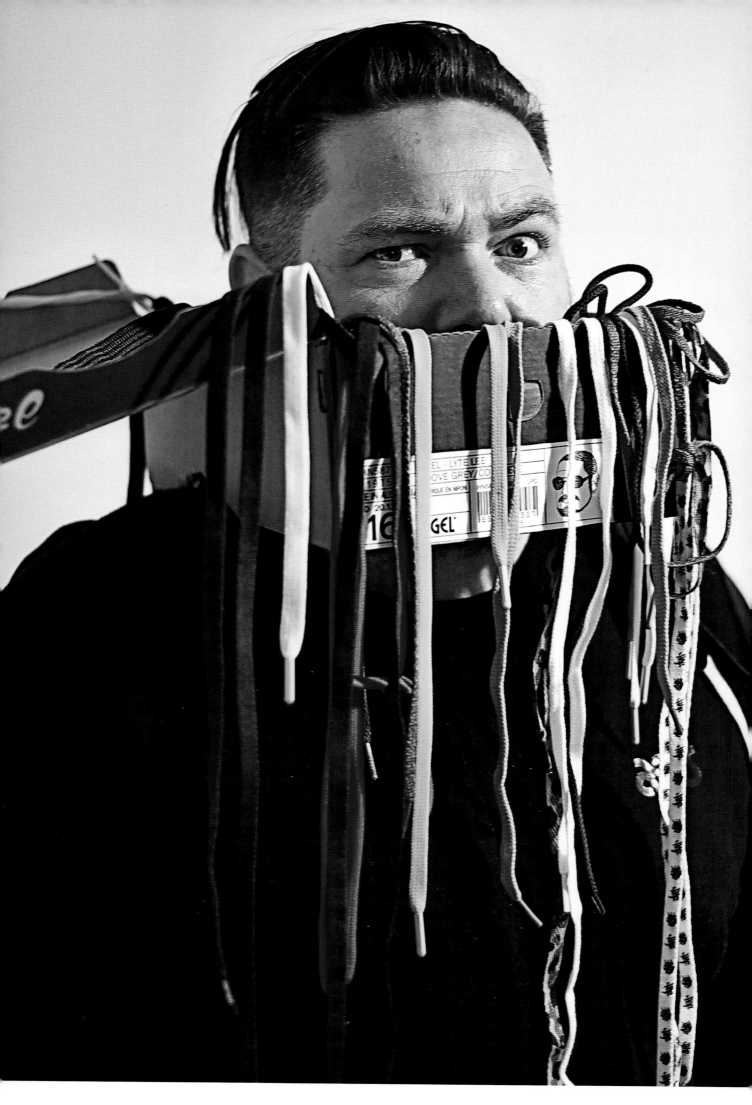

Lee Deville

GEL -LYTE LEE

Images: **Lee Deville & Jed Steele**

Some call him obsessive-compulsive. Others say he's as mad as a cut snake. But we just call him Lee Deville because that's his name. With the grand ambition of locking down every ASICS collaboration ever made, Deville is afflicted with a deadly case of tiger-stripe fever. From the batshit crazy rumours behind the 'Super Green' GEL-Lyte III to the curse upon Concepts' GEL-Lyte V 'Phoenix', we simply could not resist documenting the detailed knowledge that powers his complete collection.

First published *Sneaker Freaker* Issue 35 – March 2016

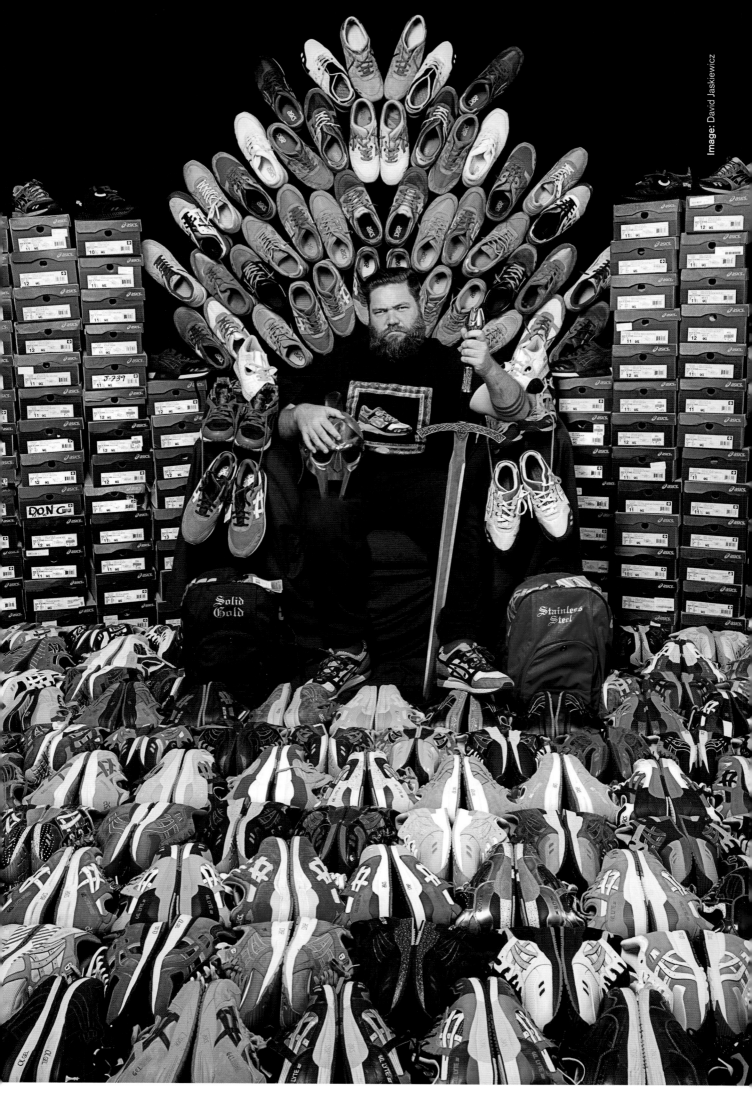

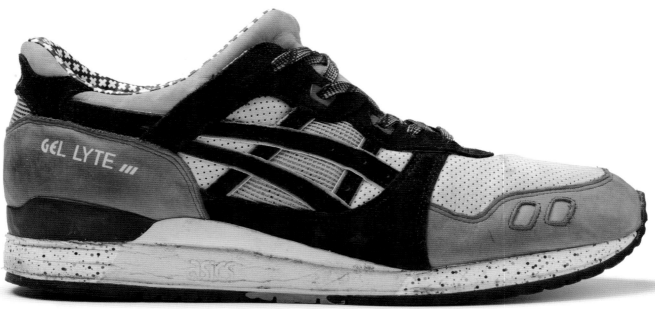

2007: Patta x ASICS GEL-Lyte III

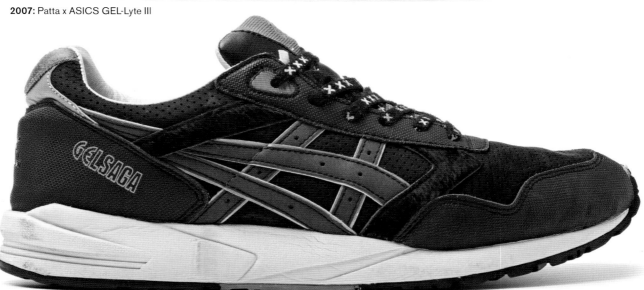

2009: Patta x ASICS GEL-Saga

We hear you've managed to get your hands on every ASICS colab ever released. Surely not?

My bank account sure wishes it was an exaggeration! It's taken years of research to, first of all, identify and then track down every colab, but I'm happy to say that, at this point in time, I have every single pair released. [*Note: this feature was published in 2016.*]

Even the 'Super Green' GEL-Lyte IIIs?

Absolutely! The 'Super Green' is one of my most prized possessions.

Weren't they all sent off to Haiti?

Well, we are delving into contentious territory here. Urban legend has it that a stockpile of 750 pairs is still hidden in a secret vault deep below the Kith store in NYC. Word spread over the years that, once 2016 arrived, the vault would open, and the market would be flooded – if you can call an extra 750 pairs 'flooding the market'! [*Note: this never happened!*]

Either way, once the rumour started, those lucky people who owned a pair got a little nervous that their pairs would drastically lose value, so they decided to shift them while the market was still peaking. Three separate people hit me up within 24 hours wanting to offload their pairs fast.

Great story. Still, I'm guessing they weren't exactly cheap. Do you think there's any truth to it?

I'm not worried about the rumours coming true. I don't buy shoes to make money – I buy them to add to my collection and wear them. If they do release this year, I'll just take it as an opportunity to double up.

Let me recap for a second. How many pairs do you have in your collection?

To be honest, I couldn't give you an exact figure. At last count, I had approximately 750 pairs, with about 250 being ASICS.

How many colabs?

By the end of 2015, there were 183 ASICS colabs. This number is increasing every day, though. In 2015, they had a crazy year with 57 colabs released, and there is no sign of things slowing down.

What was the pair that kickstarted your obsession?

It all came about purely by accident. I was searching for a cheap pair of Nike Air Max 1s on eBay when I came across a pair of the black-and-yellow GEL-Lyte III 'Stingers' that had been listed incorrectly. Ten minutes to go, and they were sitting at $10, so I grabbed them, thinking they were a nice colourway I could always wear for mowing the lawn. Up until that point, I wouldn't have even considered owning ASICS. I always thought of them as those ugly metallic running shoes.

When they arrived, I opened up the box, looked down and thought, 'What the hell has happened to the tongue?' Then I put them on my feet, felt the comfort, and the rest is history. I certainly wouldn't say it was love at first sight, but it was definitely love at first wear.

At first, that tongue scared the hell out of me. I'm pretty sure I was taught not to put my feet in things that looked like that! [Laughs.] But once I did, there was no turning back. The comfort level could not be denied, and I liked the fact that very few people were interested in them. Even with the low production numbers on early colabs, I was still able to track pairs down with relative ease for next to nothing.

2013: Ronnie Fieg x ASICS GEL-Lyte V 'Volcano'

The GEL-Lyte III got me into ASICS and remains the closest to my heart. I also love the GEL-Lyte V, though I feel like the unsung hero of the fam is the GEL-Saga. It's got such a low profile and is very rarely used for colabs – it definitely needs to be shown some more attention.

What was the hardest pair to track down?

I trawled through countless pictures of seaweed smoothies on Instagram while searching #supergreen, but in the end, they found me. The 'Hello Kitty' GEL-Lyte IIIs were tricky, as there are a load of fakes out there and very few real pairs. I narrowly missed a pair on eBay, but then I managed to track down the guy who bought them. Often it's just a waiting game – people come and go from the sneaker scene faster than you might think. I just let them know I'm interested and that when they finally decide to check out, or they don't feel the love for a certain pair that they used to, I'm ready to buy.

I definitely rate them among the ugliest shoes in my collection! [Laughs.] They released two pairs of GEL-Lyte IIIs in September of 2009, followed by a pair of GEL-Lyte Speeds a month later, as part of the 35th Anniversary of Hello Kitty. As you can imagine, with the popularity of the franchise, these shoes have been faked a lot. Interesting little factoid for you – reps from Sanrio, the company behind Hello Kitty, recently stated that Hello Kitty is actually a little girl named Kitty White and not a cat at all! Needless to say, my mind was blown.

You're on a sinking cruise ship – which pair do you take to the lifeboat?

Come on now, that's like asking me if I have a favourite child! Undoubtedly the greatest colab ever designed – and I'm not just talking ASICS colabs here – is Slam Jam's GEL-Lyte III '5th Dimension'. Colours, materials, everything about this shoe just works. This is the shoe I most want to double up on. There are five pairs in Perth, where I live, and I'm pretty sure I could beat every guy that owns them in a cage fight. They know not to wear them to a campout unless they want to sleep with one eye open.

Something tells us that's not your rarest pair.

If we're talking about the rarest officially released pair, a few of the early colabs were rumoured to be around the 100-pair mark, including Patta's GEL-Lyte Speeds and the Colette x La MJC x Sold Out pack. I actually managed to double up on the GT-II from that series.

If we include samples, my rarest pair would be Proper's GEL-Lyte III samples from 2005. They were set to become the first-ever ASICS GEL-Lyte III colab, but the release never went ahead. They sampled three colourways, and so far, I've managed to track down two of the three. For now, the blue-and-red pair still eludes me. These are such an important part of ASICS history as far as I'm concerned, so you can imagine my surprise when a second pair of the grey-and-green samples showed up on eBay late last year for just $89! Needless to say, I snapped them up and reunited them with their brothers.

What about the 'Mossad' GEL-Lyte III? Apparently, only one pair was ever made. Tell me you're not the lucky soul with those stashed away?

I would love to tell you I am that person, but sadly it would be a lie, as those shoes are my Grail. I have spent near on four and a half years searching forums and the like, just trying to get a shot at them. On June 23, 2011, they finally reared their head, but alas, I was not ready, and I missed harpooning them.

About a year ago, they showed up for sale on Instagram. Crazy offers started rolling in before the seller finally got cold feet and withdrew. To be honest, if I am going to drop that kind of cash on a shoe, I would prefer to wear it. I've been known to squeeze my size 11.5 foot into a size 9, but it isn't a pretty sight, and I certainly wouldn't do that to such a beautiful shoe. In my mind, if you were to replace the mesh lining with calfskin leather, it may just be the perfect shoe.

Can we settle a nerd argument? What was the first ASICS colab?

Proper in Long Beach may have missed out on becoming the first-ever GEL-Lyte III colab, but they do have the honour of holding the title of the first-ever ASICS colab with their GT-II. There are 150 pairs of the Proper GT-II released back in 2004, and I'm happy to say I have a pair to wear and a pair on ice for later.

How do the colabs of today stack up against those from the early years?

Obviously, ASICS have grown over the past decade. This has seen a spike in production numbers for most releases to meet demand. Those that have dropped numbers back to the low hundreds have seen immediate Grail status – though, in some cases, this is based purely on rarity over actual design aesthetics. Shape, materials, colours – all of these things fluctuate throughout the years. It's not like other brands, like New Balance and Nike, where the shoes of today don't hold a candle to those from 10 years ago.

Are any pairs off-limits?

I'm happy to wear pretty much all of my shoes. I have tried to double up on those that hold a real special place in my heart so I can keep a fresh pair. Honestly though, with so many shoes in my collection, it takes a couple of years for a pair to make it into the rotation, so I manage to keep most of them fresh. Still, some pairs obviously get worn more than others, and some get beaten to death. I'm not one of these people that started buying shoes to make money by reselling. I buy them because I want to own them.

The only pairs that are off-limits are those I bought for historical reasons but consider too ugly to wear. I still have pairs I haven't cracked out yet, but I'm just waiting for the right moment. I see shoes in a similar fashion to rings on a tree, with each pair representing significant memories of my life. I can tell you the pair I was wearing when I proposed to my wife, the ones I wore when I got married in Vegas, the ones I wore the days my children were born and the ones I wore when they came home from hospital.

Whenever I wear those shoes again, they bring back such vivid memories. I always try, where possible, to match the significant pair to the moment. For example, when my daughter Taylah Rose was born, I finally cracked out my 'Rose Gold' GT-IIs.

She wasn't named after the shoe, was she?

The real answer is that my daughter's name was purely coincidental, but I have a running joke with my wife that I wanted to call my daughter GEL-Lyte. [Laughs.]

Surely you could have settled on Jill Lyte Deville? ASICS definitely exploded in popularity in recent years. How has this affected your approach?

It has certainly made it harder to get shoes on release and inspired the reseller presence. On the upside, it's also meant a massive increase in the number of colabs. It took 10 years for the first 100 ASICS colabs to be released, but in 2015 alone, there were 57 releases!

The Concepts GEL-Lyte V 'Phoenix' is often considered cursed. Do you think there's any truth to this?

Let it be known that I am burning a bushel of sage and standing in a ring of salt, for fear the curse shall come back once more to claim me! The 'Phoenix' is undoubtedly cursed. Riots in Vietnam saw the factory in which they were made burn down. The remaining stock rose from the ashes and was sent across the seas to the land of the great bald eagle, but the grim reaper had not finished with this shoe, as floodwaters claimed another righteous chunk.

A few pairs escaped both assassination attempts and made their way across the rough seas, eventually landing upon the western shores of the land we call 'Straya. Finding their way into my hands – their final destination – I thought I could offer them sanctuary and fear hardship no more. But the reaper had other ideas, and as I travelled to work with the shoes in the saddlebag of my motorcycle, he sent his final element of destruction. Crossing over a bridge on the freeway, a windy squall of unnatural origin swept over me, reaching down into my saddlebag and lifting the box out, crashing it down upon the road beneath me. I managed to catch this in my rearview mirror, and after making my way across to the emergency-stopping lane, I turned my bike around and headed back to attempt a rescue.

I was met with the sight of small pieces of grey and blue cardboard dancing past me in the wind. Then I saw the shoe in the furthest lane, as cars repeatedly ran over it. I leapt into action, dodging through oncoming traffic to sweep down and rescue the first shoe, partially scarred from its encounter. The second shoe was not so lucky. I watched as a convoy of trucks drove over the top of the shoe, eventually sucking it up into the engine bay and travelling off down the freeway. Through squinty, tearful eyes (it was dusty, I swear!), I watched and waited until, some distance away, I saw the shoe free itself from Death's clutches, and its lifeless body fell back to the tarmac. I lifted it and clutched it to my chest, returning to my bike and collecting the lace bags between traffic on the way. Some say that if you return to that spot in the darkest hour of the night, you can still hear the flapping of the box in the wind. Now let us never speak of this again.

You have our word. What did you make of the 25th-anniversary collection?

I'm happy to say that I liked most of them. They were all quite different, and considering there are now close to 300 GEL-Lyte III releases, it's good to see fresh ideas. I was happy that AFEW released the Koi – the handmade one-off sample from 2012 was a thing of beauty. The Packer one is such a nice shoe that transcends sneakers due to the 'Dirty Buck' influence. It's a nice dress shoe I can throw on when I want to act like a grown-up. The Footpatrols were gangbusters, and Concepts are definitely up there.

To be honest, it wasn't until I had the Highs & Lows samples sitting in front of me when I was working on the poster for their release that they really grew on me. As I've said, I like a shoe that represents a moment in my life, and as this shoe is based on the Astor Theatre in my hometown, it takes me back to my childhood.

We heard you were the man behind those posters packaged with each release. How did that come about?

It all came about after I posted my *Game of Thrones*-inspired picture on Instagram. ASICS saw the picture and commented. We got to chatting, and when I found myself in Europe, I popped over to Amsterdam to meet the team. I spent the day at the HQ and was privileged enough to see the upcoming year of releases. After I got home, I was contacted by one of their marketing people, who asked if I'd like to come on board and design a poster for each of the 25th-anniversary releases. How could I say no?

Sounds like a dream come true.

Early on, the posters were really just about showing the shoe. Then, with each subsequent release, I managed to add the concept behind the shoe into the artwork. I love finding the inspiration and researching the themes and concepts – I learned all about the Sons of Liberty thanks to the 'Boston Tea Party' release by Concepts.

You were also fortunate enough to attend a very special anniversary dinner with GEL-Lyte III creator Shigeyuki Mitsui. Did Mitsui-san offer any great insights?

It was such an honour to meet the man behind the shoe. Mitsui-san often states that he thinks of the GEL-Lyte III as his daughter, so I told him I am his #1 son-in-law. We spoke for a while after the event about design, specifically the importance of hand skills in a digital era. When I first started teaching design at Curtin University, I was hired to teach marker rendering, which I'm currently trying to reintroduce. Anybody who's seen Mitsui-san's original concept visuals will attest to the fact that they have so much more to offer than the modern CAD files used for design.

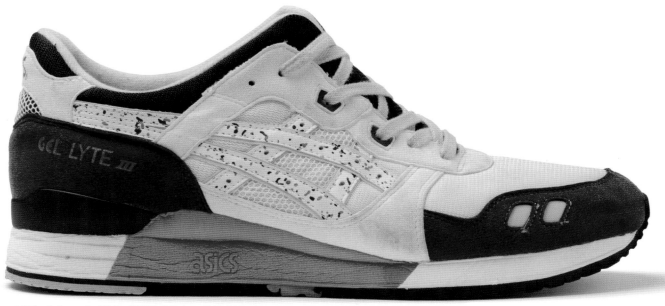

2008: Colette x La MJC x ASICS GEL-Lyte III 'Sold Out'

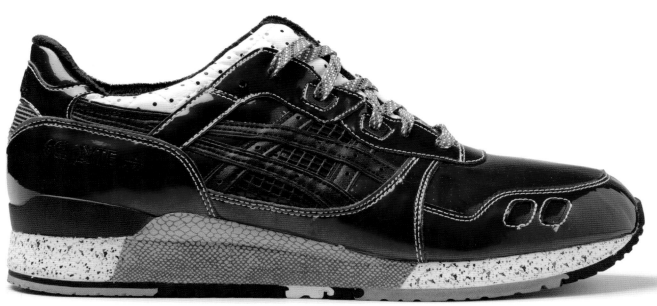

2008: mita sneakers x ASICS GEL-Lyte III 'Purple Haze'

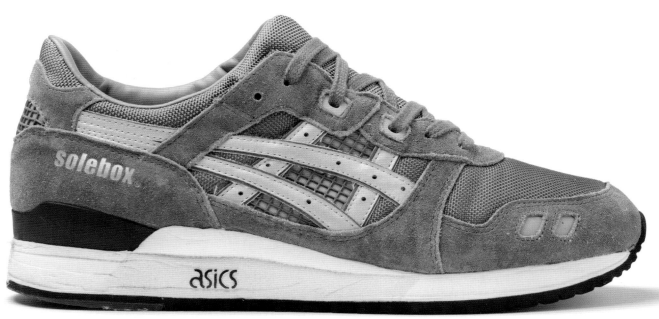

2008: solebox x ASICS GEL-Lyte III 'The Sun' (Branded)

2010: Sneaker Freaker x ASICS GEL-Lyte III 'Alvin Purple'

2008: mita sneakers x ASICS GEL-Lyte III 'Blueberry'

His skills certainly haven't dulled over the years. We heard the anniversary dinner was an amazing night. Did you agonise over which pair to wear?

It was a very hard decision, to be honest. I mean, which shoe do you take to meet their maker – literally! I originally narrowed it down to three pairs – Slam Jams, Pattas and my Super Greens. In the end, I went with my Super Greens, as I thought it was unlikely anyone else would be wearing them. After managing to get them signed by Mitsui-san, they hold a real special place in my collection now, which made it all the more heartbreaking the following day.

Coming from Perth, I'm not used to water falling from the sky, and I certainly wasn't prepared for the constant Melbourne drizzle. I checked out of my hotel the next morning with the AFEW 'Koi' on foot, and my Pattas and Super Greens secured safely in my suitcase – or so I thought. After spending the day walking around in constant rain, I was drenched from the top of my head to the bottom of my fish-themed shoes. When I finally reached the airport later that day, I couldn't wait to throw on some dry clothes and shoes. I was shocked to discover that my suitcase was not waterproof – not even in the slightest! The clothes and shoes in my case were wetter than the ocean, including my Super Greens.

Ouch! How bad was it?

Thankfully after a couple of days in the Perth sun, they came back good as new.

Do you pick up general releases as well?

I have a lot of the older GEL-Lyte III general releases, but due to the prolific rise in the number of colabs, I've found myself being a little pickier these days. There's only so much room in the house to keep them, and even with my grey-and-green Tetris skills, I have recently had to relocate as my collection outgrew its old habitat. That said, the past year has seen plenty of great general releases that easily rival the quality and design of the colabs, especially the 'After Hours' pack.

Finally, any advice for budding ASICS collectors?

For all those new to collecting, regardless of brand – buy what you like and buy what you actually want to own. I have seen the bottom fall out of many sections of the sneaker market over the past 10 years, so don't buy shoes in the hope that they will be worth more in the future. Don't believe the hype! Also, be kind to those new to collecting. Everybody started somewhere at some time. It upsets me to see people that have been collecting for three years ripping the shit out of guys that have just started. Spread knowledge, foster the culture and keep hunting!

★

@leedeville

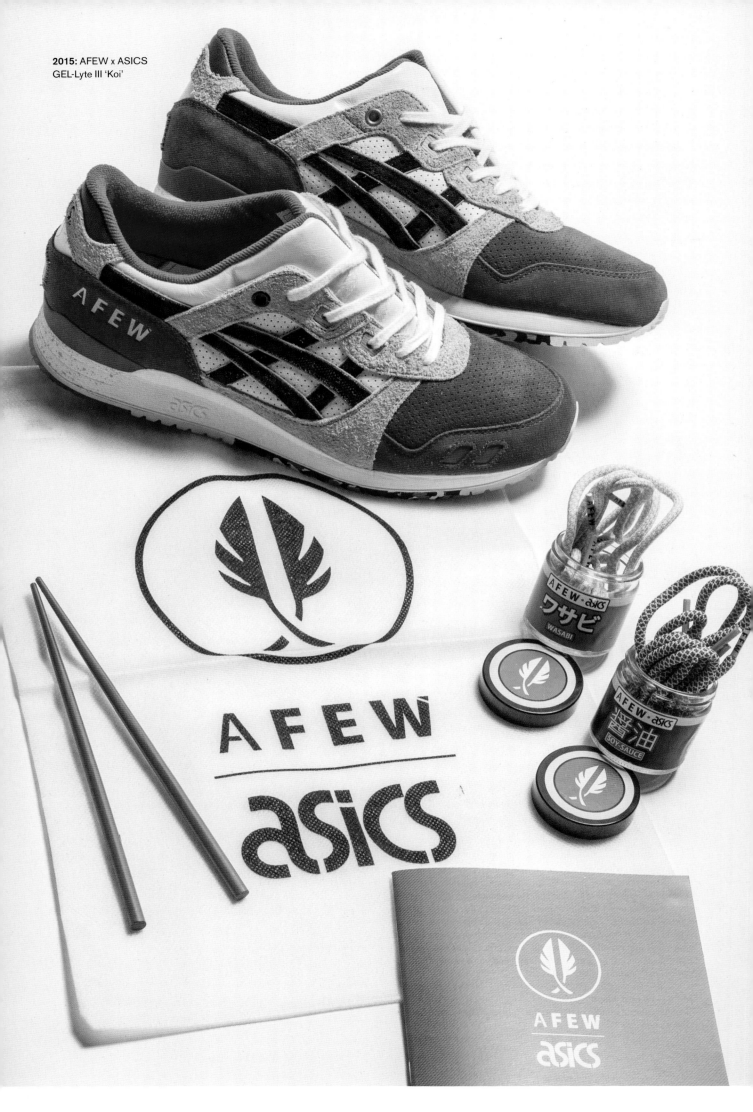

2013: Slam Jam x ASICS GEL-Lyte III

2011: Patta x ASICS GEL-Saga (Unreleased Sample)

2015: Concepts x ASICS GEL-Lyte III 'Boston Tea Party'

2014: Bodega x ASICS GEL-Lyte V 'Get Wet – Vapor Blue'

2015: Colette x ASICS GEL-Lyte III 'Dotty'

2007: ALIFE x ASICS GEL-Lyte III 'Green Monster'

2009: Sanrio x ASICS GEL-Lyte III 'Hello Kitty – Stars'

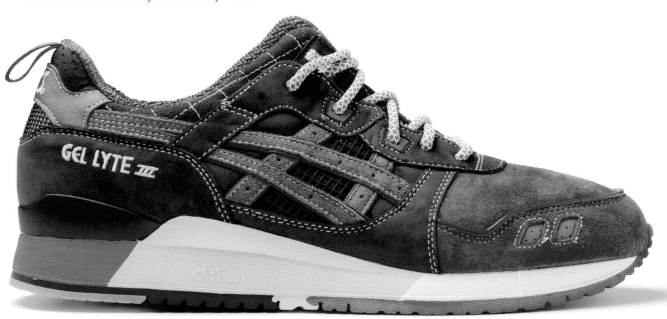

2015: mita sneakers x ASICS GEL-Lyte III 'Trico'

2004: Proper x ASICS GT-II 'Long Beach'

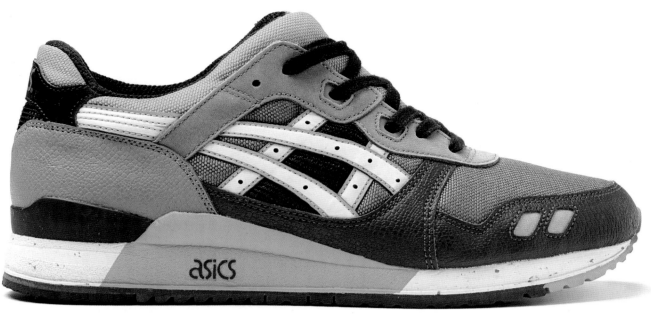

2005: Proper x ASICS GEL-Lyte III (Unreleased Sample)

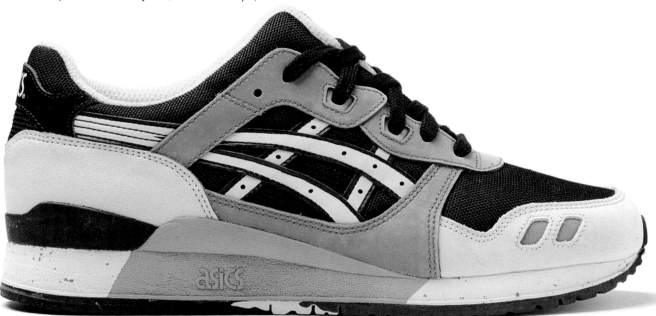

2005: Proper x ASICS GEL-Lyte III (Unreleased Sample)

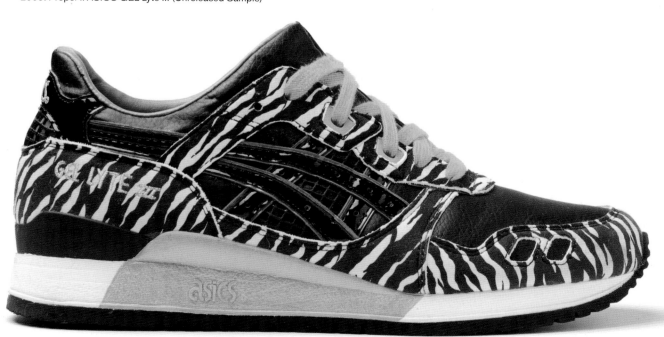

2011: Junya Watanabe x ASICS GEL-Lyte III

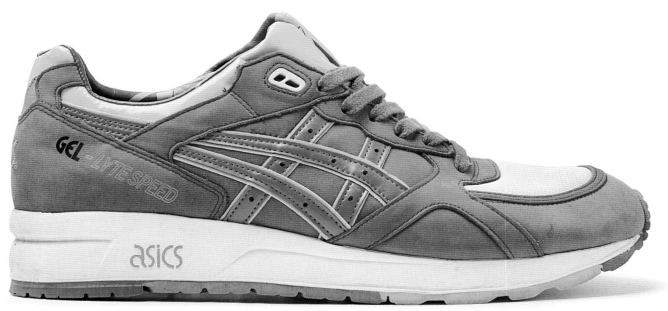

2009: Patta x Parra x ASICS GEL-Lyte Speed

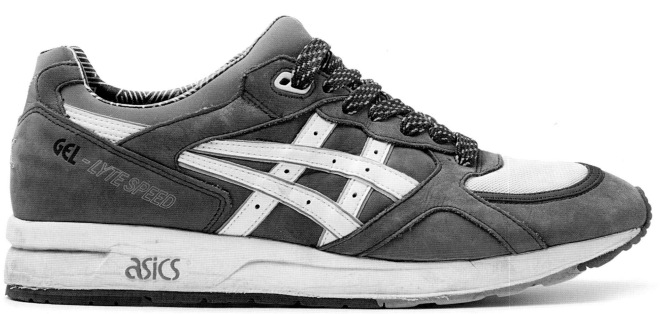

2009: Patta x Eric Elms x ASICS GEL-Lyte Speed

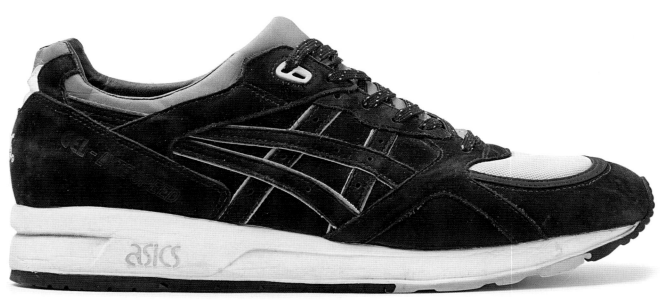

2009: Patta x Delta x ASICS GEL-Lyte Speed

Ronnie Fieg x ASICS Colab History

Ronnie Fieg is one of the most instrumental figures in ASICS' modern renaissance. Championing the Tiger Stripes since his days working the shop floor at David Z in New York, the partnership began in 2007 with a trio of technicolour '252' GEL-Lyte IIIs. Under his burgeoning retail banner Kith, Fieg's natural prowess for tasteful colour-blocking and premium materials, combined with personal storytelling, has since netted him over 100 collaborations with ASICS, including multiple retro bringbacks and one-offs for runway events.

Ronnie Fieg x GEL-Lyte III

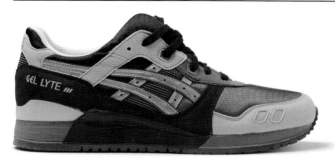

2007: David Z x ASICS GEL-Lyte III '252 Pack'

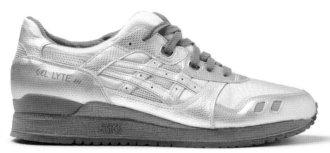

2007: David Z x ASICS GEL-Lyte III 'Stainless Steel'

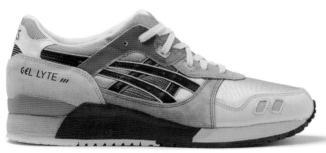

2007: David Z x ASICS GEL-Lyte III '252 Pack'

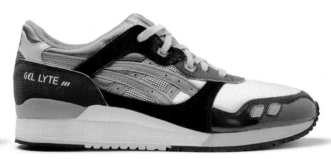

2007: David Z x ASICS GEL-Lyte III '252 Pack'

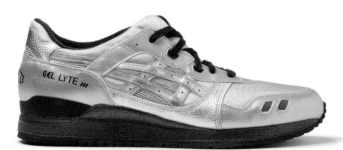

2007: David Z x ASICS GEL-Lyte III 'Solid Gold'

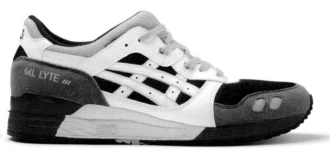

2008: David Z x ASICS GEL-Lyte III 'Flip OG'

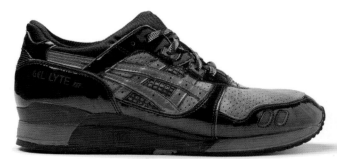

2008: David Z x ASICS GEL-Lyte III 'Vader'

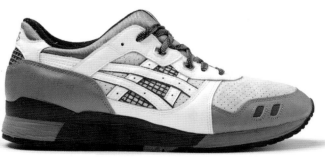

2009: David Z x Culture Shoq x ASICS GEL-Lyte III 'Trilogy Project'

2009: David Z x Nice Kicks x ASICS GEL-Lyte III 'Trilogy Project'

2009: David Z x Highsnobiety x ASICS GEL-Lyte III 'Trilogy Project'

2010: David Z x ASICS GEL-Lyte III 'Super Blue'

2010: Ronnie Fieg x ASICS GEL-Lyte III 'Super Red'

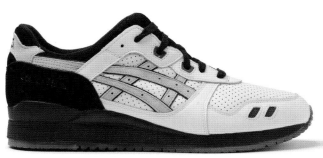

2010: Ronnie Fieg x Culture Shoq '2.0'

2010: Ronnie Fieg x ASICS GEL-Lyte III 'Navy Aqua'

2010: Ronnie Fieg x Nice Kicks x ASICS GEL-Lyte III '2.0'

2010: Ronnie Fieg x ASICS GEL-Lyte III 'Cove'

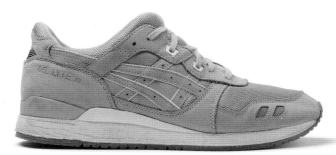

2011: Ronnie Fieg x ASICS GEL-Lyte III 'Mint Leaf'

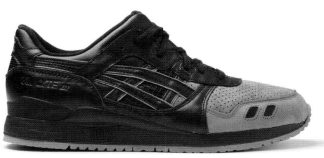

2011: Ronnie Fieg x ASICS GEL-Lyte III 'Leatherback'

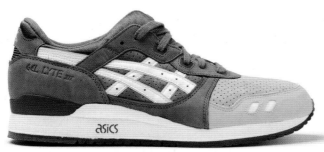

2011: Ronnie Fieg x ASICS GEL-Lyte III 'Salmon Toe'

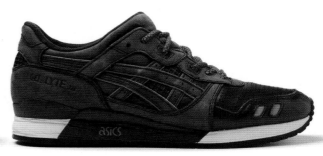

2012: Ronnie Fieg x ASICS GEL-Lyte III 'Eclipse'

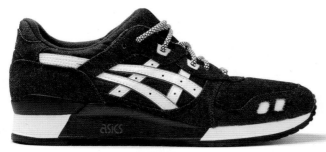

2012: Ronnie Fieg x ASICS GEL-Lyte III 'Selvedge Denim'

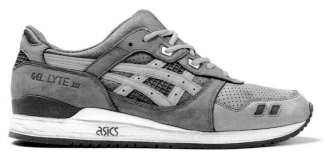

2013: Ronnie Fieg x ASICS GEL-Lyte III 'Super Green'

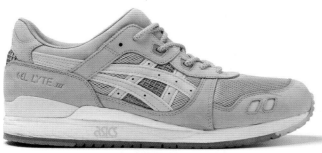

2013: Ronnie Fieg x ASICS GEL-Lyte III 'Flamingo'

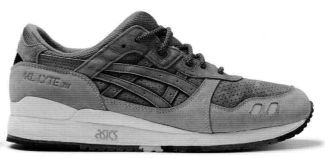

2013: Ronnie Fieg x ASICS GEL-Lyte III 'ECP Pack – New York City'

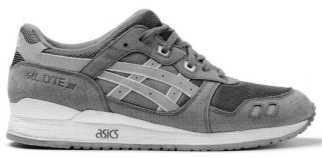

2013: Ronnie Fieg x ASICS GEL-Lyte III 'ECP Pack – Miami Beach'

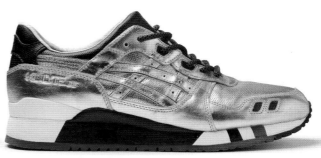

2014: Ronnie Fieg x ASICS GEL-Lyte III 'KFE Project – USA'

2014: Kith x ASICS GEL-Lyte III 'Grand Opening'

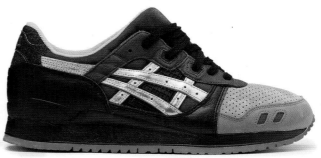

2015: Ronnie Fieg x ASICS GEL-Lyte III 'Homage'

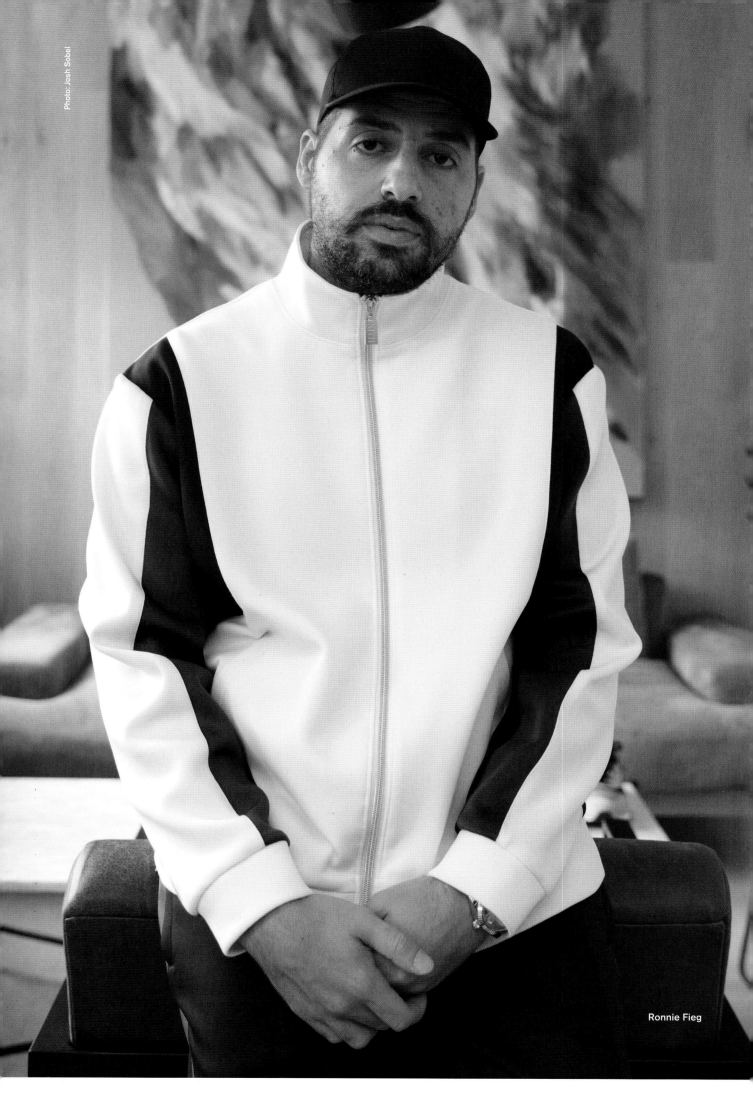

Ronnie Fieg

Ronnie Fieg x GEL-Saga

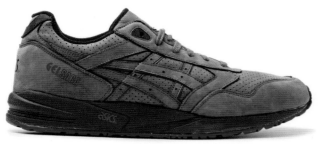

2011: Ronnie Fieg x ASICS GEL-Saga 'Mazarine Blue'

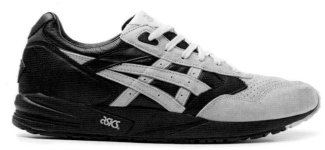

2015: Ronnie Fieg x Diamond Supply Co. x ASICS GEL-Saga

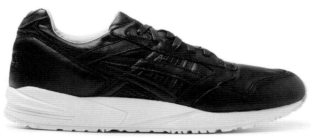

2014: Kith x ASICS GEL-Saga 'Grand Opening'

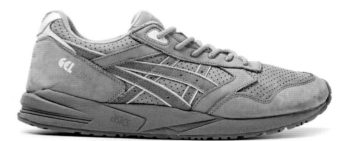

2012: Ronnie Fieg x ASICS GEL-Saga 'Neptune'

Ronnie Fieg x GT-II

2013: Ronnie Fieg x ASICS GT-II 'High Risk'

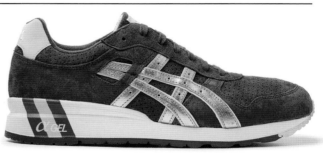

2014: Ronnie Fieg x ASICS GT-II 'KFE Project – Brazil'

2015: Kith x ASICS GT-II 'Grand Opening'

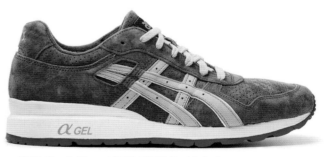

2011: Ronnie Fieg x ASICS GT-II 'Ultra Marine'

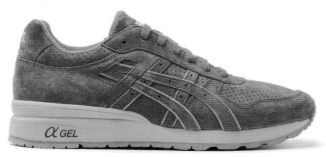

2012: Ronnie Fieg x ASICS GT-II 'Super Red 2.0'

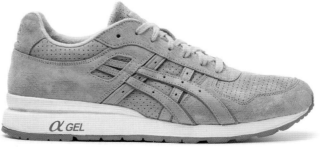

2012: Ronnie Fieg x ASICS GT-II 'Rose Gold'

Ronnie Fieg x GEL-Lyte V

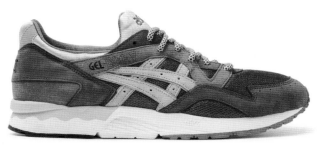

2013: Ronnie Fieg x ASICS GEL-Lyte V 'Volcano'

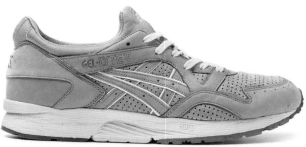

2014: Ronnie Fieg x ASICS GEL-Lyte V 'Cove'

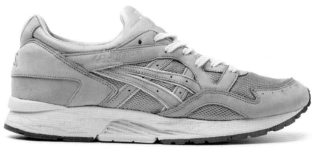

2014: Ronnie Fieg x ASICS GEL-Lyte V 'Mint Leaf'

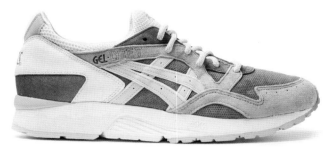

2014: Ronnie Fieg 'Sage' x ASICS GEL-Lyte V

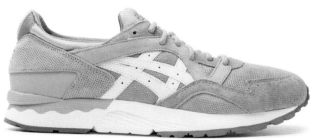

2014: Ronnie Fieg x ASICS GEL-Lyte V 'Rose Gold'

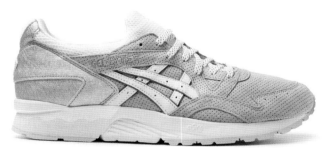

2015: Ronnie Fieg x Diamond Supply Co. x ASICS GEL-Lyte V

Ronnie Fieg x GEL-Sight

2015: Ronnie Fieg x ASICS GEL-Sight 'Atlantic'

2015: Ronnie Fieg x ASICS GEL-Sight 'Pacific'

Ronnie Fieg x GT-Quick

2008: David Z x ASICS GT-Quick

GEL-Lyte III Colabs

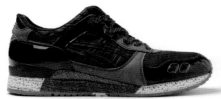

2008: mita sneakers 'Kirimomi'

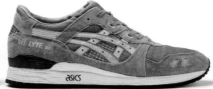

2008: solebox 'The Sun' (Unbranded)

2008: ALIFE Rivington Club 'Clerks Pack'

2008: ALIFE Rivington Club 'Clerks Pack'

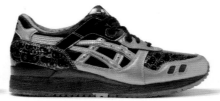

2009: Sanrio 'Hello Kitty – Dollars'

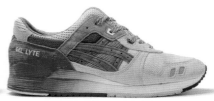

2010: Slam Jam '5th Dimension'

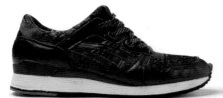

2010: mita sneakers 'Far East'

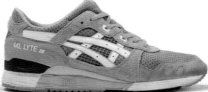

2011: PickYourShoes 'Teal Dragon'

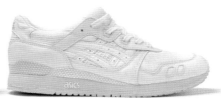

2011: Zillion

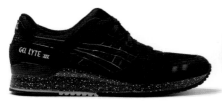

2011: atmos

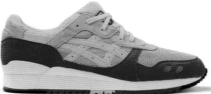

2011: HANON 'Wildcats'

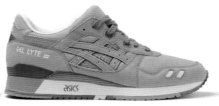

2012: BAIT 'Blue Ring'

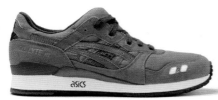

2012: BAIT 'Green Ring'

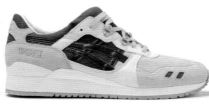

2012: WOEI 'Cervidae'

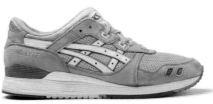

2012: Highs and Lows 'Mortar – Nylon'

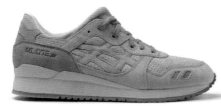

2013: Saint Alfred

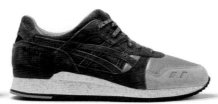

2013: Concepts 'Three Lies'

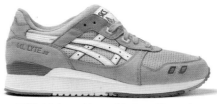

2013: Highs and Lows 'Mortar – Canvas'

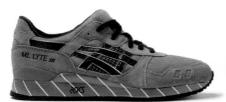

2013: Extra Butter 'Copperhead'

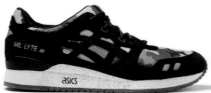

2013: BAIT 'Basics Model – 001 Vanquish'

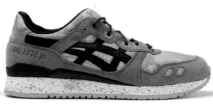

2014: BAIT 'Basics Model – 002 Guardian'

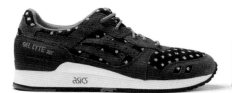

2014: BAIT 'Basics Model – 003 Nippon Blues'

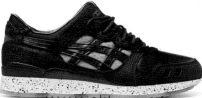

2015: BAIT 'Nightmare'

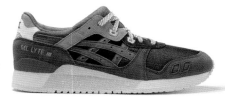

2014: Sneaker Freaker 'Alvin Purple' (Reissue)

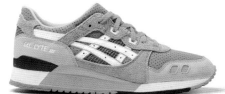

2014: PickYourShoes 'Teal Dragon' (Reissue)

2014: Solefly 'Night Haven'

2015: mita sneakers 'Trico'

2015: size? 'Tsavorite'

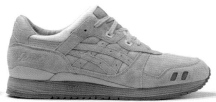

2015: Packer Shoes 'Dirty Buck'

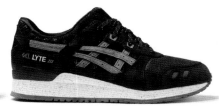

2015: Wale x Villa 'Bottle Rocket'

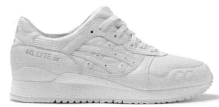

2015: atmos 'Birthday Party'

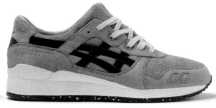

2015: Footpatrol 'Squad'

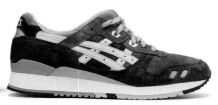

2015: J.Crew 'Blue Ribbon'

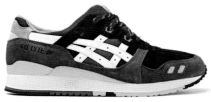

2015: J.Crew 'Evergreen'

2015: Invincible 'Formosa'

2015: Limited Edt 'Vanda'

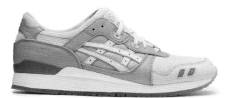

2015: Highs and Lows 'Silver Screen'

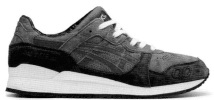

2015: HANON 'Solstice'

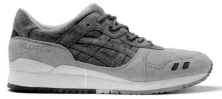

2015: size? 'Iris'

2015: CLOT 'Lavender'

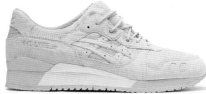

2015: CLOT 'Sand'

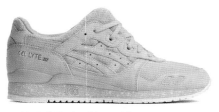

2016: Reigning Champ 'Grey'

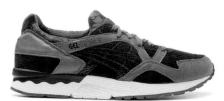

2014: Extra Butter 'Snake Charmer'

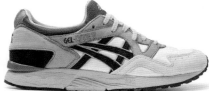

2014: UBIQ 'Midnight Bloom'

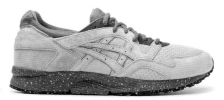

2014: Concepts 'Ember'

2014: Concepts 'The Phoenix'

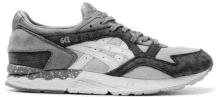

2014: Offspring 'Desert Pack'

2014: Commonwealth 'Gemini'

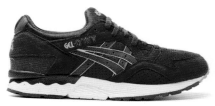

2014: The Good Will Out 'Koyo'

2014: Bodega 'Get Wet – Pewter'

2014: Bodega 'Get Wet – Vapor Blue'

2014: LimitEDitions 'SurrEDaliste'

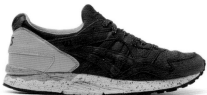

2014: UNDEFEATED 'False Flag'

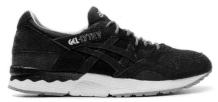

2014: mita sneakers 'Dried Rose'

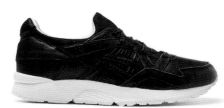

2015: Kith 'Grand Opening'

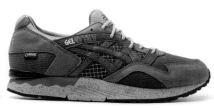

2015: Packer Shoes 'GORE-TEX'

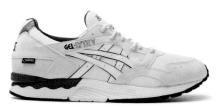

2015: UBIQ 'Hazard'

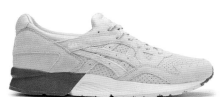

2015: Concepts '8-Ball'

2015: Sneakersnstuff 'Tailor Pack'

2015: Commonwealth 'Da Vinci'

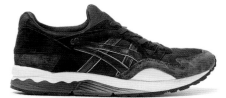

2015: BAIT 'Splash City'

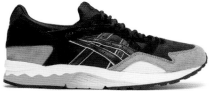

2015: BAIT 'Misfits'

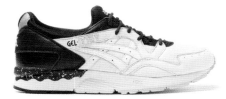

2015: monkey time 'Lights & Shadows'

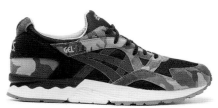

2015: atmos 'Camo'

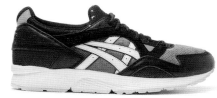

2015: Highs and Lows 'Medic'

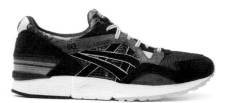

2015: mita sneakers x Whiz Limited

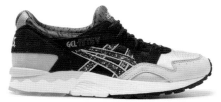

2015: Naked 'Hafnia'

2015: A Bathing Ape

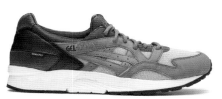

2015: Concepts 'Mix and Match – Purple'

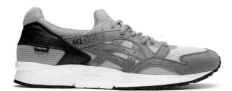

2015: Concepts 'Mix and Match – Coral'

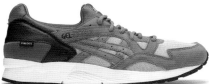

2015: Concepts 'Mix and Match –Teal'

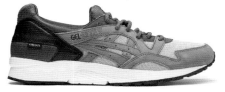

2015: Concepts 'Mix and Match – Blue'

2015: monkey time 'Sand Layer'

2015: Saint Alfred 'After Dark'

2015: emmi (Japan Exclusive)

2015: Kicks Lab x SBTG 'Phys Ed'

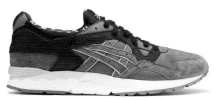

2015: Extra Butter 'Karaoke'

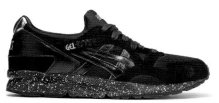

2015: atmos

GEL-Kayano Trainer

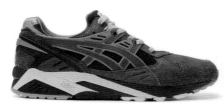

2014: Packer Shoes 'All Roads Lead to Teaneck'

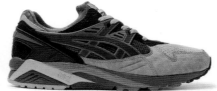

2014: Packer Shoes 'All Roads Lead to Teaneck Vol. 2'

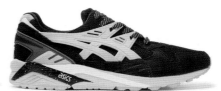

2014: Sneaker Freaker 'Melvin, Son of Alvin'

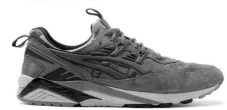

2014: Footpatrol

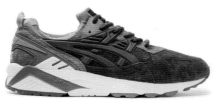

2015: Footpatrol 'Storm'

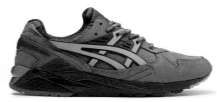

2015: size? 'Trail Pack'

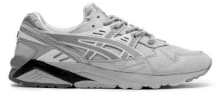

2015: size? 'Trail Pack'

2015: ALIFE 'NYC Marathon Pack'

2015: A Bathing Ape

GEL-Saga

2012: 24 Kilates 'Tio Pepe'

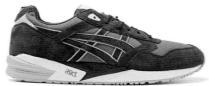

2013: BAIT 'Phantom Lagoons'

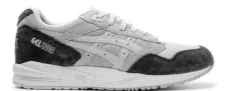

2014: atmos x Lily Brown

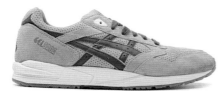

2012: Footpatrol

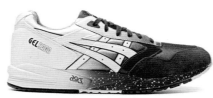

2013: Extra Butter 'Cottonmouth'

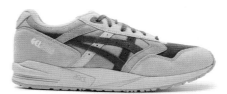

2014: atmos x Lily Brown

GEL-Respector

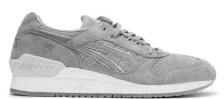

2015: Concepts 'Coca'

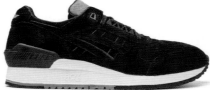

2015: Concepts 'Black Widow'

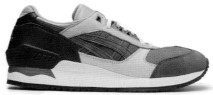

2016: 24 Kilates 'Virgen Extra'

GEL-DS Trainer 14

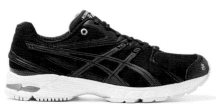

2011: Surface to Air

GEL-Classic

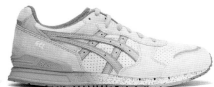

2016: Bodega 'On the Road'

GEL-Sight

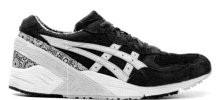

2015: Overkill 'Desert Rose'

GEL-Lyte Speed

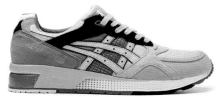

2009: mita sneakers 'Tropical'

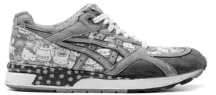

2009: Sanrio 'Hello Kitty'

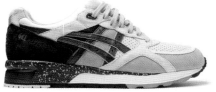

2015: UBIQ 'Cool Breeze'

GT-II

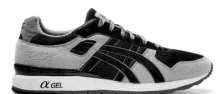

2008: Colette x La MJC 'Sold Out'

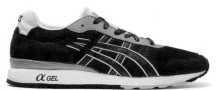

2009: Yeahboy Department

2009: Bread & Butter 'Butter'

2009: Bread & Butter 'Salmon'

2010: HANON 'Northern Liites'

2011: Sneakersnstuff 'Runestones'

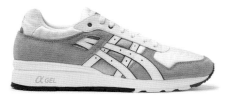

2012: Netherlands Olympic Team

2012: BAIT 'Yellow Ring'

2012: BAIT 'Red Ring'

2012: Sneakersnstuff 'Seventh Seal'

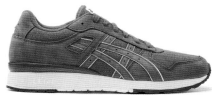

2013: Highs and Lows 'Brick'

Interview
Woody

Photos
Daniel Edwards

NEW BALANCE 997

THE THRILL IS IN THE HUNT

With a double degree in New Balance nerdery and a post-grad in advanced internet sleuthing, Matt Kyte just might be the ultimate 997 fanboy. One of the original diehards who lobbied to bring back the shoe in its original 'Made in USA' form, Matt has since researched and documented every single 997 release. Given the scarcity of this handmade 'mythological' masterpiece, we reached out to the NB fraternity in all four corners of the globe to compile a long overdue 997 retrospective.

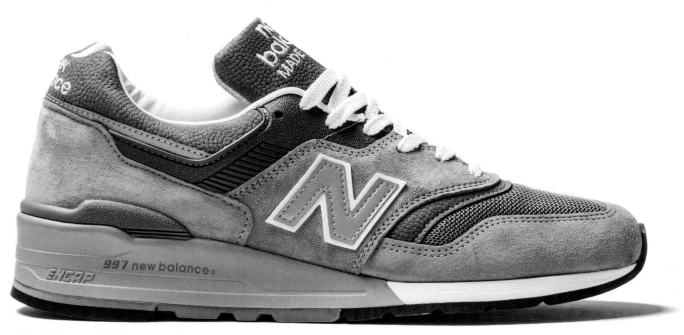

New Balance 977GRY (Pre-production Sample)

Take us back to 2014. I know you were super hyped when the 997 was announced.

I had definitely been campaigning for years to bring it back, and I'm pretty sure plenty of other people in the industry were doing the same. This would have been in late 2012. Needless to say, I was ecstatic at the prospect of the 997's return. By that time, most of the Holy Grail sneakers had all made a retro reappearance, but the 997 remained a glorious unicorn. The Crooked Tongues forum even had an ongoing thread dedicated to bringing the model back as a members-only special.

I'd argue the 1500 is the greatest New Balance shoe of all time, but the 997 had mythology. The 997 was largely undocumented outside a few pairs in the hands of OG collectors and random sightings on Yahoo Japan. The lack of info was excruciating. It's hard to know what New Balance produced because these shoes were truly handmade, which means strange variances are common. The 997 wasn't exactly scarce in its day, but vintage pairs are still one of the hardest New Balances to track down.

It's a shoe we all agree is cherished by every NB nerd, yet finding a legit collector has been a challenge.

Yeah, when you think about it logically, it's a shoe that came out in 1991 and then disappeared. Compared to its 99x family members, the 997 was the only model that was never revived. Except for some unusual multicoloured, Asia-made CO.JPs in the 1990s, there was nothing! With such a huge gap in production, we're getting to a point where there simply aren't any pairs anywhere.

If they don't exist, how can anyone even think about owning one pair, let alone a collection?

To be clear – there are three original 997s. There is a light grey, charcoal and white edition. I've only seen a couple of pairs in white ever, and I've never even seen the charcoal except as a catalogue image. So when I say there's really only one true OG 997, you can see why. The others are beyond rare.

The 997 looks different from every other Newbie. The sharp profile kills me. The heel elevation is perfect.

Aside from the 996, the 99x series has always packed junk in the trunk! But, with the 997, you get a really good balance and perfect proportions. Steven Smith managed to incorporate a good amount of wedge while keeping the profile sleek.

The 997 moved the 99x series away from stacked foam soles and introduced ENCAP by exposing the internal foam on the medial side and incorporating Hytrel thermoplastic. I've always been quite fond of that gumby piece of XAR-1000 rubber tacked onto the heel, as it gives them a notable rake that reminds me of an old hot rod.

I'm really into the toe angle of the 997 and how the OGs are really snub-nosed. The toe rubber gets really chunky, and then the thick-cut suede sits prominently over the delicate mesh. It's the nerdiest thing in the world, but there's something about it that gets me every time.

How do you stack it up against the rest of the 99x series, including the 998 and 999?

I'll be honest and say I never really got behind those models. I know they're more comfortable thanks to the ABZORB foam, but there's something a bit over-complicated about the designs. The 998 and 999 just aren't as refined as the 997. To run with the automotive metaphors, the 997 is like a sleek Lamborghini Miura from the 70s, while the 998 is the crazy 80s Countach with huge spoilers and a brick car phone.

My favourite 998 is that odd hybrid with the white-and-green upper fused with a 997 sole. That made me look at the 998 in a completely different light. The 999 is another step in that direction, as the toe gets rounder and the midsole chunk goes to another level. I was never attracted to the 999, as it seemed a bit of an awkward transition.

The best of the 99x series are the 990, 997, 991 and 990v4. The 99x series has always been the best representation of the brand since its inception, and I think those models really nailed the subtle 'NB tech' look cohesively.

In your mind, what does the perfect 997 look like? Is the original grey-on-grey scheme the one and only?

I mean, yeah, of course, I love the shoe for what it was the first time I saw it, and that's the original production version in tonal greys. If I want to be a total shoe nerd and go super obscure, the white leather versions are the low-key fave. I'm just a sucker for white sneakers. Of course, I also have my own 'what if' versions drawn up and ready for the day New Balance sends me an email!

The first sample of the 997 retro was controversial. The 1990 catalogue shows the midsole as light grey, but several inconsistencies challenged the notion of a 1:1 reproduction.

I don't know how deeply I should go into this, but basically, the retro was definitely wrong, although it was much better than the first samples. As you said, the correct colour was a really light grey. On the OGs, this faded to a yellowed beige, as most foam compounds do over time. Needless to say, there was a feisty email written by myself sent to NB at the time of the first retro outlining my position.

The toe box mesh was different as well. The retros have it in a charcoal grey that is visibly darker than the suede, but the OGs were much more closely colour matched, which I feel throws off the overall balance totally. To this day, it still irks me! Funnily enough, I own all three of the retro 997 in the OG grey.

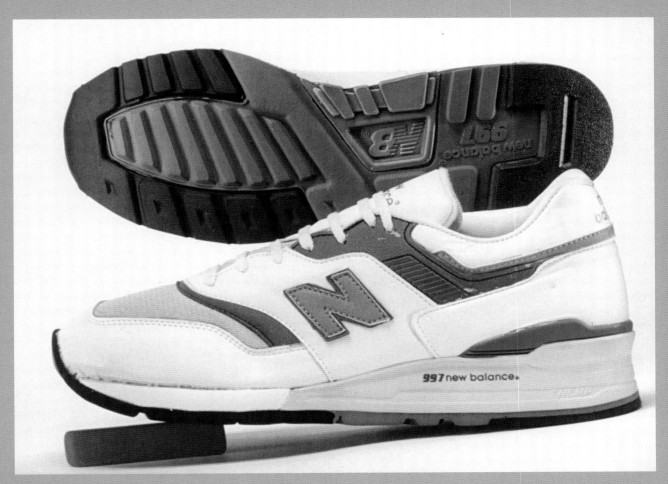

1991: New Balance M997WT (Prototype)

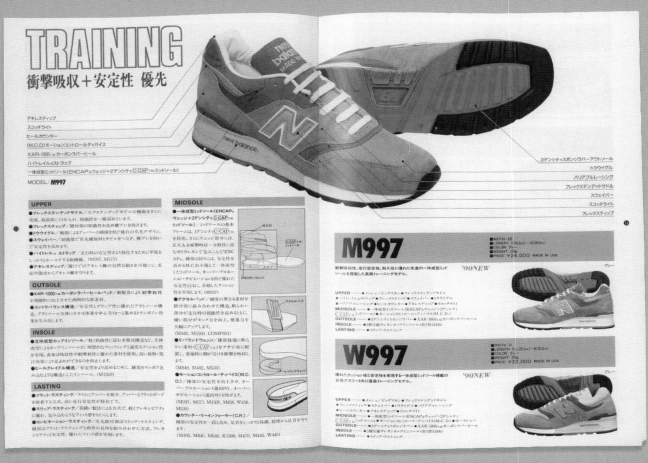

1990: Japanese catalogue

2008: Contentious 997 images from Crooked Tongues

Mystery solved! New Balance 997 'Made in England'

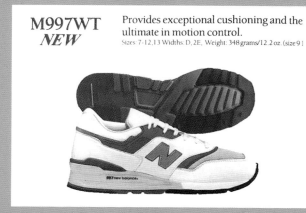

M997WT
NEW

Provides exceptional cushioning and the ultimate in motion control.

Sizes: 7-12,13 Widths: D, 2E, Weight: 348 grams/12.2 oz. (size 9)

997WT early prototype with weird design details

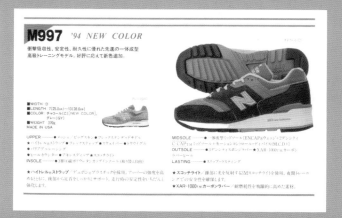

M997 '94 NEW COLOR

衝撃吸収性、安定性、耐久性に優れた先進の一体成型
高級トレーニングモデル。好評に応えて新色追加。

■WIDTH D
■LENGTH 7(25.0cm)〜10(28.0cm)
■COLOR チャコール(C)[NEW COLOR]、
 グレー(GY)
■WEIGHT 370g
MADE IN USA

UPPER ━━━ メッシュ、ピッグスエード、フレックスタンダード●ジュ
 ●ハイトレルストラップ、フレックスティップ、スウェイバー、トウガイド●
 ●アブゾーション━━━
 ●ヒールカウン、マー●ブルーミディンプ●スコッチライト
INSOLE ━━━ ●1層仕組ポリウレタン、ナップインソール(高さ調節可能)

MIDSOLE ━━━ 一体成型1レドソール[ENCAP&ウェッジ+2アンクル/
 C-CAP&レドソール+モーションコントロール・ディバイス(MCD)]
OUTSOLE ━━━ ●1デンシティ&ボンラバー★XAR-1000ラム カーボン
 ラバーヒール
LASTING ━━━ スリップラスティング

★スコッチライト/踵部に光を反射する3Mスコッチライトを使用、夜間トレーニ
ングアビの安全を確保します。

★XAR-1000ラム カーボンラバー/耐摩耗性を飛躍的に高めた素材。

1994: Japanese catalogue

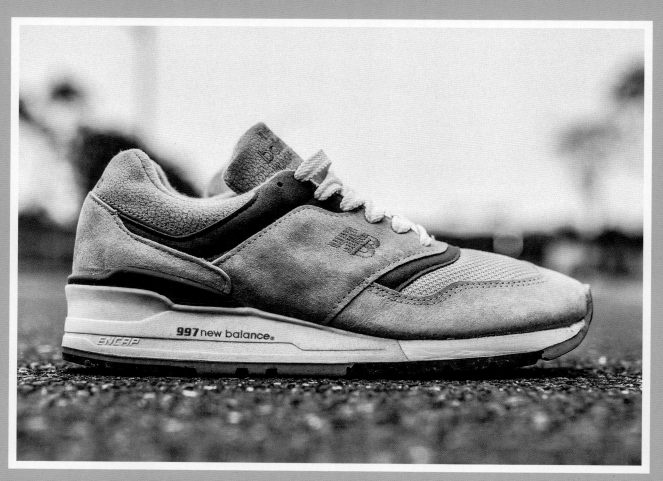

1991: New Balance 'Mini-logo' W997 (Women)

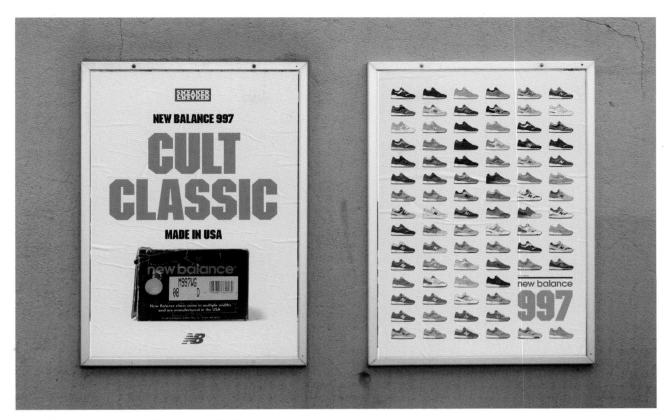

Matt Kyte x Sneaker Freaker 'New Balance 997 Cult Classic' poster

Well, you can definitely care too much, that's for sure. It's bound to lead to tears. The early catalogue images didn't always have '997' written on the midsole, either.
Yeah, I think that can be put down as a promo sample oddity. I can't say I've ever seen a pair in the real world that lacked the model name and number on the midsole. Even the NB Japan archive models have it. There was a single pair shared by NB around the time the 990v3 came out that didn't have the midsole branding, but again, who knows?

Random stuff in catalogues isn't uncommon, especially with New Balance. The test is finding the real-world example as proof. Often it's the opposite case with NB. There are things that officially don't exist, but then people turn up with pairs to prove all the theories wrong!

Speaking of which, you once told me the 997 was definitely made in the UK, though the folks at Flimsy have no recollection. Time to put up or shut up!
After that random pair appeared on the Crooked Tongues forum in 2008/09, with blurry photos that didn't show the tongue label, it has taken years to settle this mystery. The story was finally corroborated when a collector named Juan posted images of his 997s, complete with 'Made in England' embroidery. I immediately bombarded him with questions and he obliged with a bunch of low-res (sorry, Juan!) images. To say I felt vindicated is an understatement, though it didn't do much to deflate my already enlarged ego.

As you can see, they look nothing like US-made 997s. There are no thermoplastic panels, and they sport shiny 'N' logos in 3M that are similar to the 576s that came out of Flimby in the 90s. I still haven't worked out why the 997 was made there, though I suspect trade tariffs are the likely cause. I'd also love to know if they were only sold in the Spanish market and what sparked the cultural connection. The lack of documentation is the cause of much excitement and frustration for New Balance nerds!

I'm definitely feeling the mini-NB logos they put on the women's 997s. Not sure we'll ever see them again.
I think footwear has got to a point where there's not much else to do except bring back weird stuff, so I wouldn't rule it out. I can't say I love them, but given that the 997 was the first time there was a women's-specific style in the 99x lineage, I think it's cool from a historical perspective.

Purists typically struggle with new-gen designs like the 997S. Given you aren't even old enough to remember the OG, is that stance a bit hard to justify?
I think I could just remember the OG if my family had the money to buy them back in 1991! I get your point, though. Hybrids are not intended for the OG purist anyway, so it's no biggie. I think the point of the hybrid is to take some of the proven design principles of a classic and then repackage them for a contemporary customer. If brands are drawing up hybrids in the hope of a cosign from guys debating the correct shade of a midsole colour, they're setting themselves up for disappointment.

Now, tell me about your 997 illustrations. What made you start? Attention deficit? Boredom? Pure nerding out?
The purest form of adoration is to painstakingly replicate something. It might sound super wanky, but drawing every model gave me a much deeper appreciation for the 997 design. There's definitely part of me that was simply excited by the prospect of researching and documenting such a mythical model.

What level of research are we talking?
My archive is the result of a decade of information acquired through my own research and the help of many of my peers back in the days when sneaker forums were popular. Most of the information came from examining genuine pairs, catalogue snippets, tiny random images from Japanese blogs and deep YahooJP auction listings with no semblance of English in the titles.

Now that you've finished, how do you feel?
I'd feel better if NB stopped making 997s! I had a similar problem with the 1500 archive. Flimby announced 1500 production would halt, but they kept making more and more. A complete 997 archive is way more achievable. When you're simply documenting a shoe that came out last week, it loses any sense of intrigue. Much like collecting sneakers, the thrill is in the hunt.

★

@smallgainz

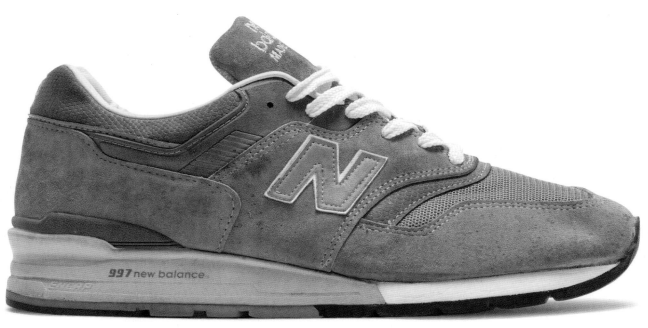

1990: New Balance M997 (OG)

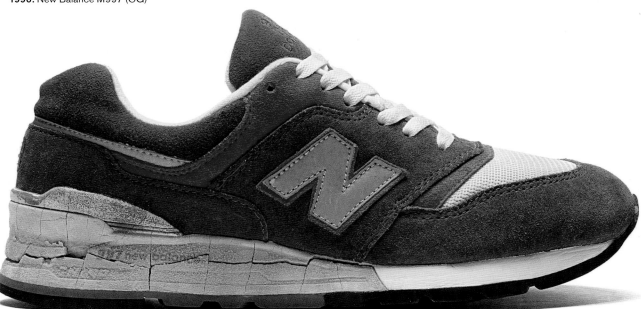

1990s: New Balance CM997BR

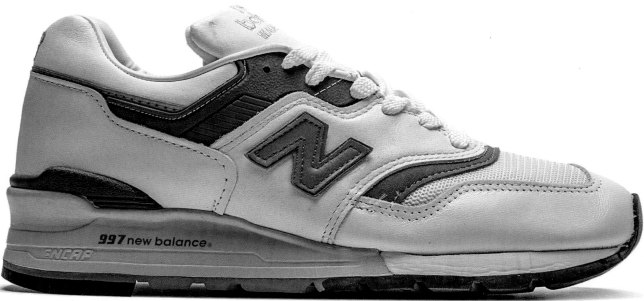

1994: New Balance M997WG

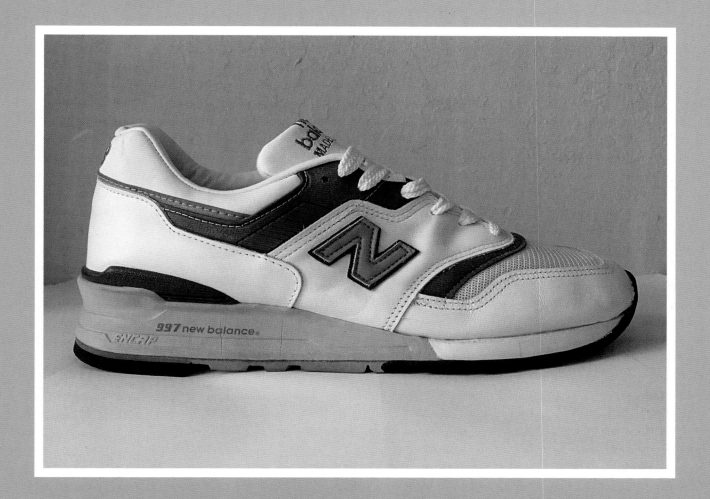

'This white leather 997 with the blue accents is the rarest of the three original releases. Among New Balance aficionados, this is the Holy Grail of Holy Grails! Jene Conrad picked them up around 2010 when a well-known sneaker collector liquidated their entire stock. They are remarkably well preserved for their age, especially the polyurethane midsole, which is prone to crumbling. This is quite possibly the only deadstock vintage example left in the world.'

Woody – *Sneaker Freaker*

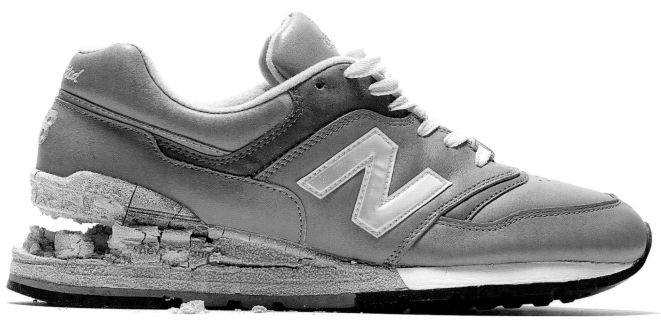

Mid-90s: New Balance 997LF

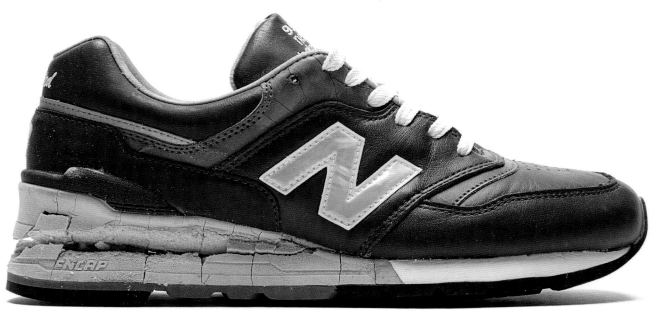

Mid-90s: New Balance 997LV

'My all-time favourite is the OG in grey with the reflective "N" logo. That diesel midsole and pigskin suede mixed with mesh is pure perfection. The 997 is good in any climate. It's indestructible. Throwing that Brolic Wedge midsole with the ill ENCAP unit onto a perfectly revamped upper is dope. When the US-made reissue rumours hit the forums, I was verklempt. I copped multiples!'

Mike 'Crispy' Coyle – 997 Collector

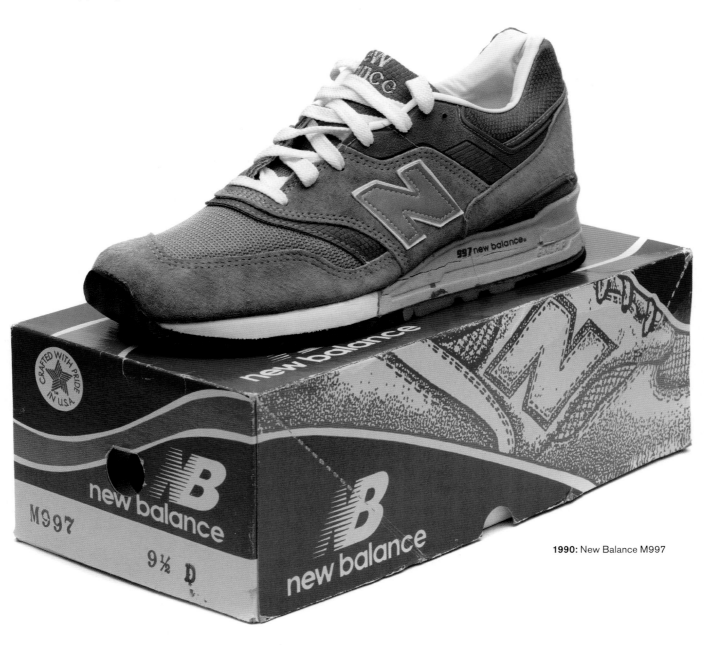

1990: New Balance M997

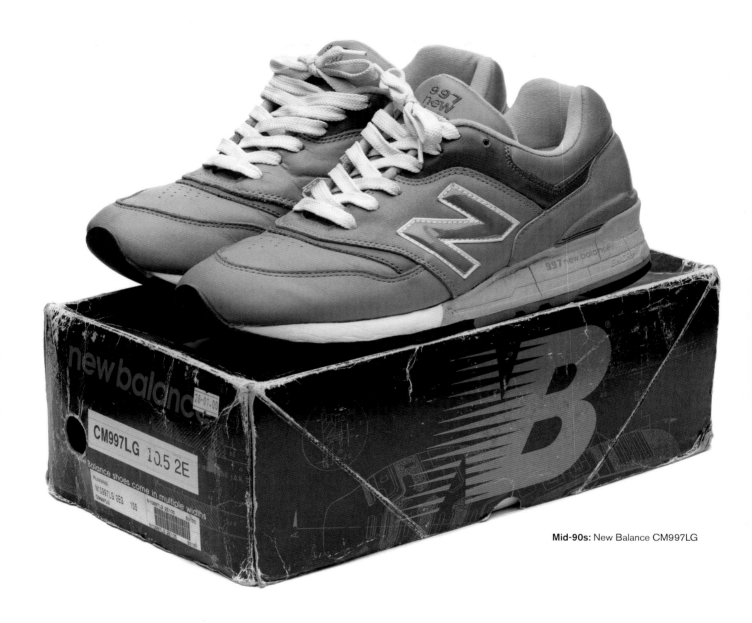

Mid-90s: New Balance CM997LG

'New Balance is the only sports brand that keeps the handmade process of making shoes alive. When it comes to the 997, I'm crazy about the Asia-made 997 in suede with the neon plastic "N" logo from the late 90s. In fact, all of the CM997 versions are super rare!'

Tiago Ramos – 997 Collector

2018: Horween Leather Co. x New Balance M997
(Unreleased Sample)

'I was too young when the 997 was originally released! Thankfully, New Balance got it 100 per cent right. The 997 is now a wardrobe staple, which speaks volumes for the brand's ability to maintain relevance. I love that New Balance always stay true to themselves.'

Jason Paparoulas – 997 Collector

Wai Cheung Fong

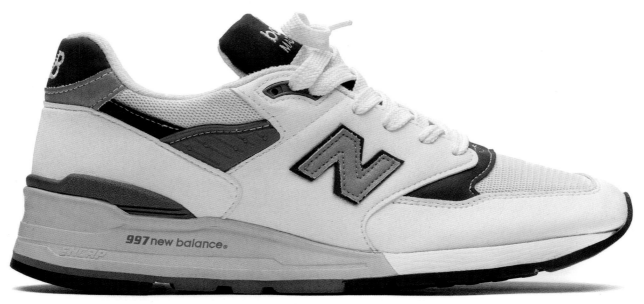

1990s: New Balance 997.5 (998 upper with 997 sole)

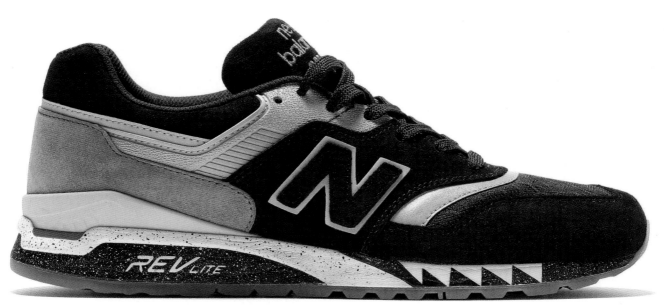

2016: Sneaker Freaker x New Balance 997.5 'Tassie Tiger' (Unreleased Sample)

'I have about 30 pairs of different 997s in my hands. The most special pair is actually a 997.5, which has the 997 sole and the 998 upper. Yes, you are not mistaken! I still can't find any information about this shoe and I've only seen two pairs ever. I don't know if it was a production error or just a strange one-off sample. Hopefully we will find out the story at some point!'

Shunhang Li – 997 Collector

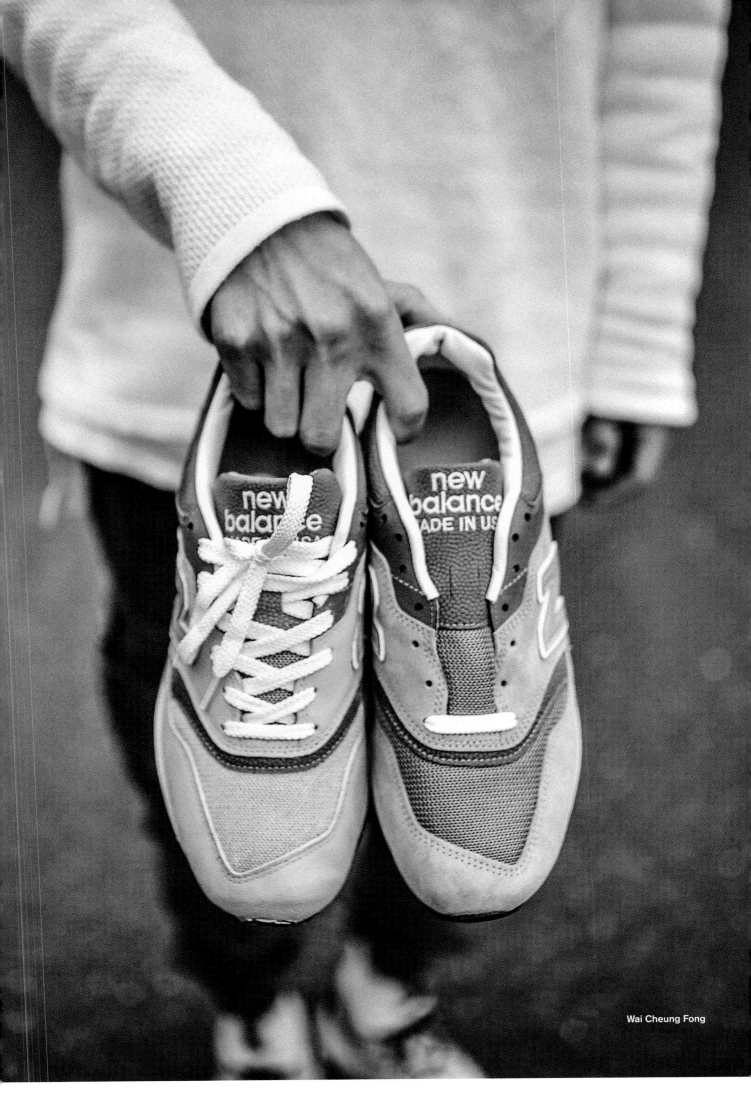

Wai Cheung Fong

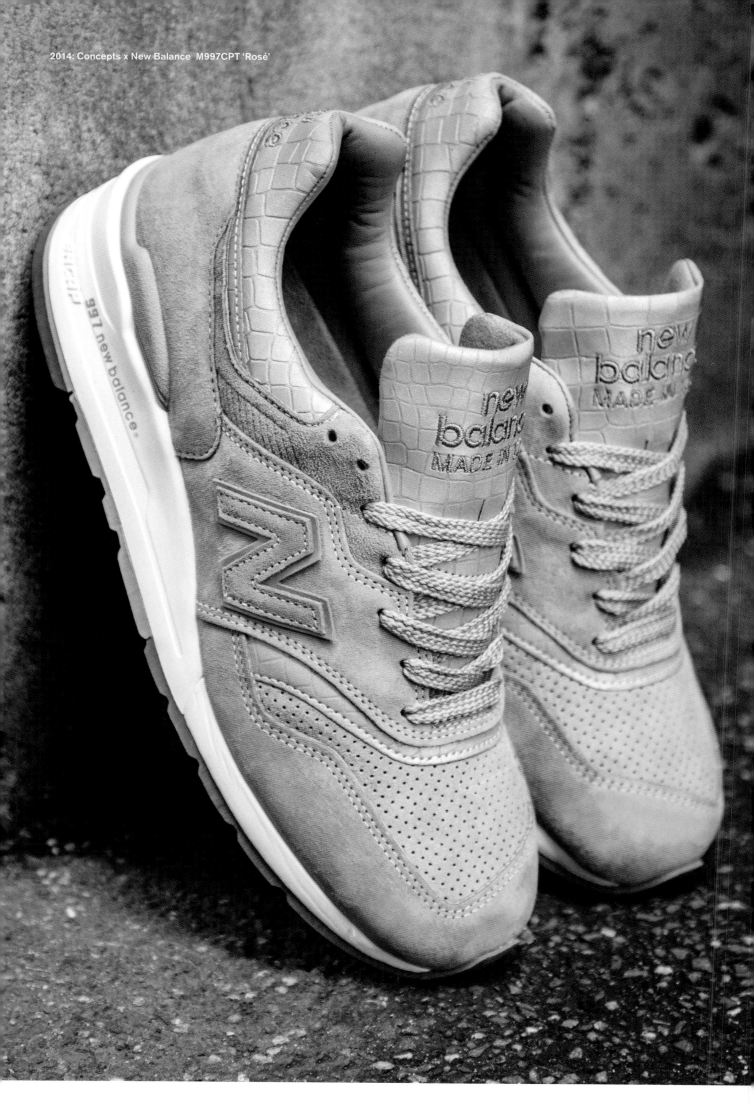

'Back in 1998, I was at the NB outlet in Boston. They had the 997.5 for $20 but I skipped because I was broke. My best friend copped and his dad ended up using them to mow the lawn! I still bug him but they're long gone. Would've tripled up if I knew what I know now. They are beyond rare!'

Richie Roxas – 997 Collector

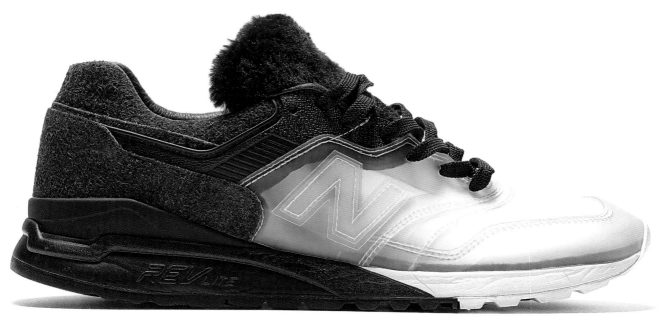

2016: PHANTACi x New Balance 997.5 Jay Chou 'The Orcs' (1-of-10)

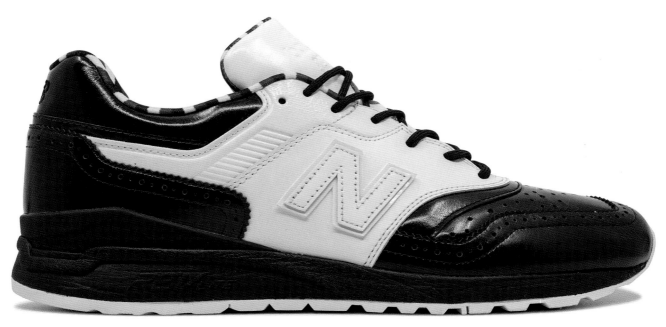

2016: PHANTACi x New Balance 997.5 Jay Chou 'Chaplin' (1-of-10)

TEXT: Paul Kampfmann PHOTOS: Phillip Himburg

MARC LEUSCHNER IS....
MR EQT

For the uninitiated, adidas EQT is a revered performance range from the 1990s. Like the radical Lamborghini Countach, EQT runners were designed to deliver the ultimate in uncompromising power and style. Combining manufacturing excellence with brilliant product design highlighted by definitive colour schemes, EQT was destined for the top shelf at sports stores from day one. They weren't cheap in the 90s, and they're certainly not cheap now, with vintage prices exploding in recent years. The adidas slogan said it all. EQT was – and will always be – 'The best of adidas'.

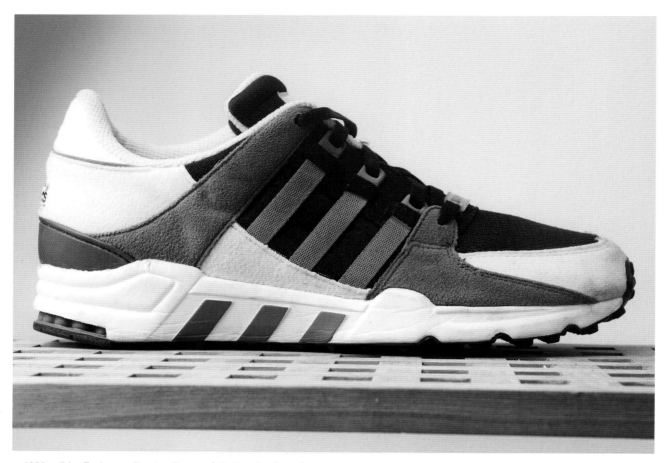

1993: adidas Equipment Running Support (1Ca Running Shoes)

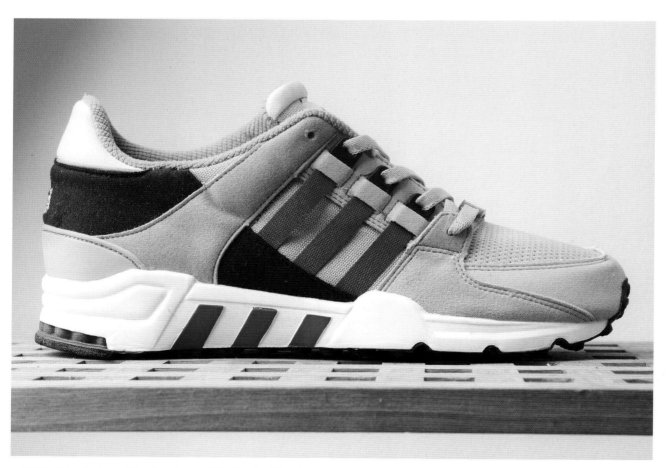

1993: adidas Equipment Running Support (1Ca Running Shoes)

Berlin's Marc Leuschner is a self-confessed adidas aficionado. His passion began in 1998, at the tender age of 12, when the ZX8000 and ZX9000 ruled the streets in his hometown. Like many with the same affection, adidas EQT has always been his holiest of Holy Grails, and we are very fortunate to have access to his collection, which is the finest and most complete in the world.

Unlike many survivors of the 90s, the EQT line has aged well. They're magically comfortable, and their rarity alone affords them serious cult status. The fact that they were hardly retroed adds another mysterious dimension to their desirability. [*Note: the first EQT retro arrived in 2014.*] 'I like to show off a bit, and EQT is still the best to be hype,' says Marc, 'but they're also understated. People don't think these shoes are expensive as they are old!'

EQT colour systems also stayed distinctively pure, with grey and teal as the signature motif. The blue-and-red models are almost as classy, and the trademark grey panelling gives them that instant EQT look.

As Marc knows better than anyone, EQT was very popular in East Germany, where they were viewed as statements of affluence. Except for the red Cushion model from the second series, all his EQT models were acquired fresh in the box. Most of his treasures are stored safely, but he also takes them out on the street from time to time.

Unfortunately for Marc, competition is fierce. Collectors are prepared to spend big to secure even the most common EQT models. Depending on condition and colourway – even models that have been worn regularly – EQTs only change hands when serious coin is put on the table. Prices in excess of €1000 are proof of any collector's dedication to the cause.

We asked Marc about his first EQT experience. 'They always used to be expensive, and therefore, my first from this line was a blue Support out of the second EQT series from 1994. Although it was already worn, I paid much more than other people would have considered reasonable. But even nowadays, those shoes are still upscale!'

Equipment.

Equipment. The best of adidas.
Everything that is essential. And nothing that is not.

Adventure.

Equipment.

In jedem Sport gibt es Dinge,
auf die es ankommt.
Equipment.
The best of adidas.
Das Wesentliche. Sonst nichts.

1991: adidas Equipment print ads

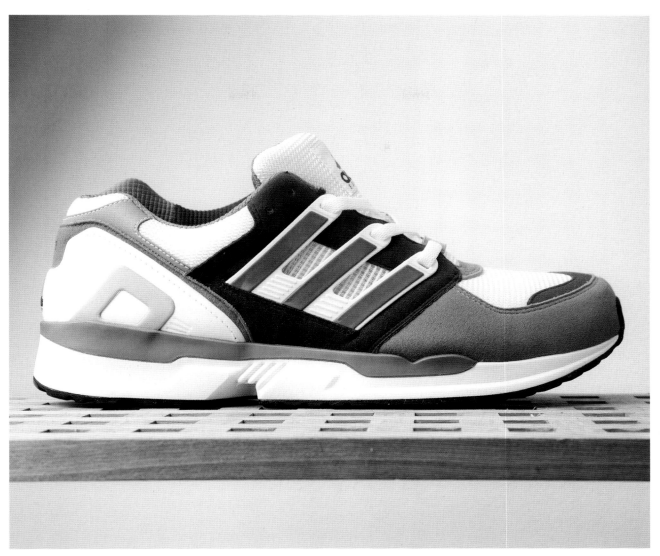

2005: adidas Equipment Running Support Retro

Twenty years later, like fragile museum pieces, the first edition from 1991 can only be found in glass cabinets. Unfortunately, this series of shoes inherited production flaws that limit their durability, which has severely ravaged vintage supplies. Good luck finding them on the 'Bay.

Fortunately, the second edition was produced from 1992–94 by another manufacturer. With a little care, these are still wearable, and for that reason alone, they are popular among collectors. You still get the brilliant EQT design and trademark colourways wrapped up with optimal production quality.

There are significant differences between the originals and retros. 'In comparison, the soles are different, and some elements of these shoes are just painted, not dyed. Back then, the quality was so different.' Marc's opinion about this issue is ambiguous. 'Personally, I am into the original vintage styles, but in terms of wearability, retros gain more and more space in my apartment. Being a collector, I wish for originals. But I appreciate relaunches reviving the spirit of these sneakers. The Support's version from 2005 was a perfect imitation of the original – brilliant manufacturing and true to detail. The shoe was limited to 1991 pairs, but you gladly spent a little more for such a nice retro production. It was €250 back then. But I can see why so many collectors, who believed they were offered a unique opportunity, are upset right now when confronted with another retro version for €130 in 2011.
They didn't have a clue and felt like they got punked. On the other hand, some people could not afford the shoe at that time and are happy to get another chance now they're even less pricy yet not as true to detail as the 2005 version.'

Perhaps it is simply impossible to satisfy everyone, especially the whims of diehard collectors. Another uncertain issue is the production of retro EQT apparel. Marc explains, 'adidas are divided into Performance and Originals collections, with apparel positioned within Performance. Meanwhile, retro EQT shoes are regarded as Originals and carry the Trefoil label, which is complicated. I bought my first EQT T-shirt from a friend when I was about 12, and I wore it until it fell apart. I loved that thing.'

Marc's love for sneakers and fashion has led him to join Overkill, the best-known sneaker store in Berlin. 'I had the choice between opening my own store or joining Overkill. At first, I was a collector, but then I got involved in business. Over the years, we had always been in touch, and because I was impressed by the redesign of the store, the decision was easy. Overkill possesses all features that enable the store to be a serious player.'

The EQT exhibition held at the Berlin store was an amazing preview. Dozens of rare and famous styles were displayed, fresh in the box, with all the info material and booklets introducing diverse production techniques. EQT sneakers were shown with their predecessor in order to illustrate the technical development of the Cushion, Support and Guidance models.

When Marc's collection is not on display, he carefully stores his originals in a climate-controlled environment protected from ultraviolet light. Still, he's not the type of guy to hide away his treasures, allowing them a little promenade from time to time. Now that he owns more than 400 pairs, he knows what it means to be spoiled by choice.

There's one more thing he'd like to announce. 'adidas still have some models locked inside the kingdom that deserve a retro edition. I got the keys, so please get in touch!' We know Marc's right. Maybe someone from Herzogenaurach will be in touch.
Our fingers are crossed.
★

@overkill_marc

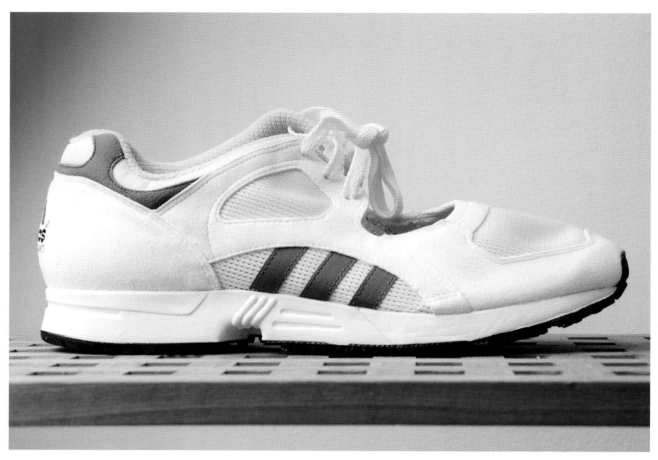

1991: adidas Equipment Running Racing

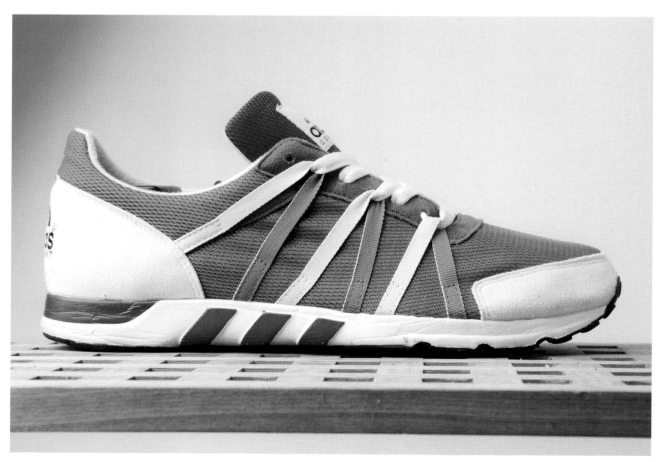

1992: adidas Equipment Racing

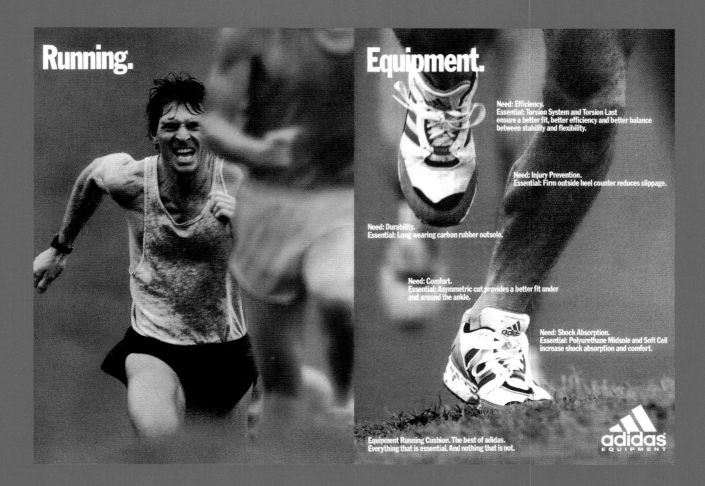

Running.

Equipment.

Need: Efficiency.
Essential: Torsion System and Torsion Last ensure a better fit, better efficiency and better balance between stability and flexibility.

Need: Injury Prevention.
Essential: Firm outside heel counter reduces slippage.

Need: Durability.
Essential: Long wearing carbon rubber outsole.

Need: Comfort.
Essential: Asymmetric cut provides a better fit under and around the ankle.

Need: Shock Absorption.
Essential: Polyurethane Midsole and Soft Cell increase shock absorption and comfort.

Equipment Running Cushion. The best of adidas.
Everything that is essential. And nothing that is not.

adidas
EQUIPMENT

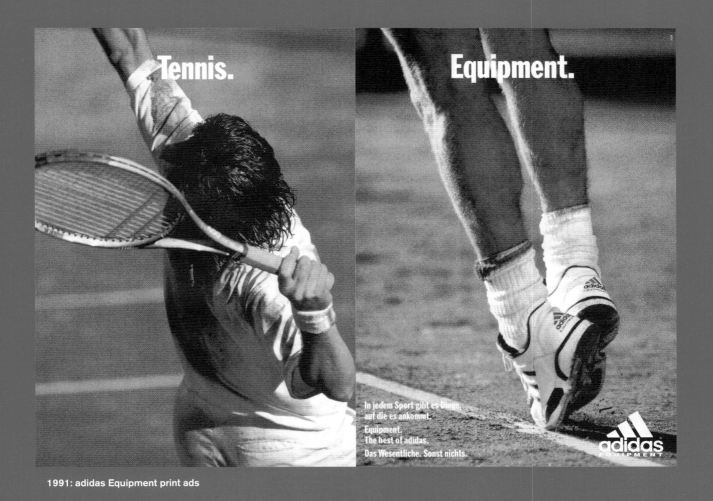

Tennis.

Equipment.

In jedem Sport gibt es Dinge,
auf die es ankommt.

Equipment.
The best of adidas.

Das Wesentliche. Sonst nichts.

adidas
EQUIPMENT

1991: adidas Equipment print ads

1991: adidas Equipment Running Cushion

1993: adidas Equipment Running Guidance (1Ca Running Shoes)

1991: adidas Equipment Running Guidance (1Ca Running Shoes)

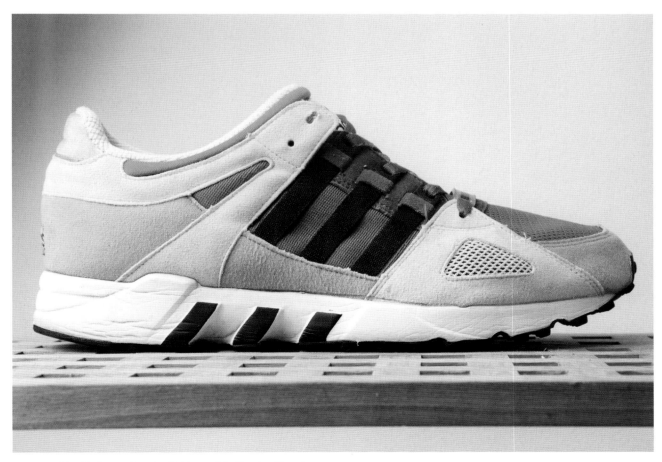

1991: adidas Equipment Running Guidance (1Ca Running Shoes)

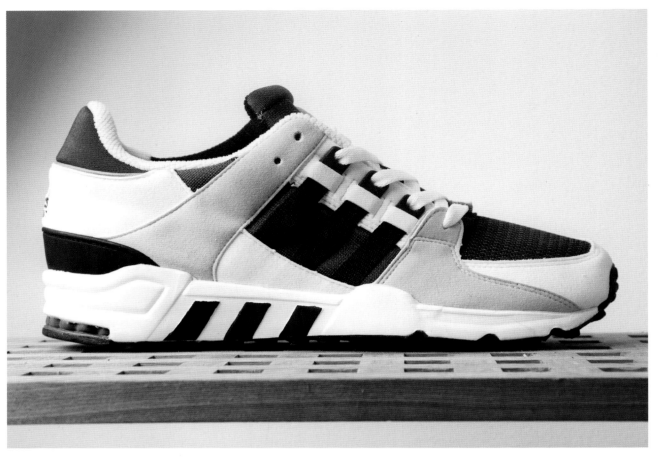

1994: adidas Equipment Running Support (1Ca Running Shoes)

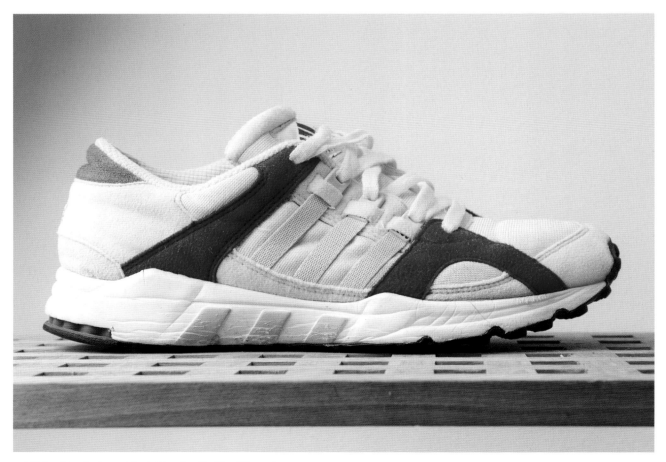

1994: adidas Equipment 'Lady' Running Cushion (Women)

Tennis Equipment.

Equipment. The best of adidas.
Everything that is essential. And nothing that is not.

adidas
EQUIPMENT

1991: adidas Equipment print ad

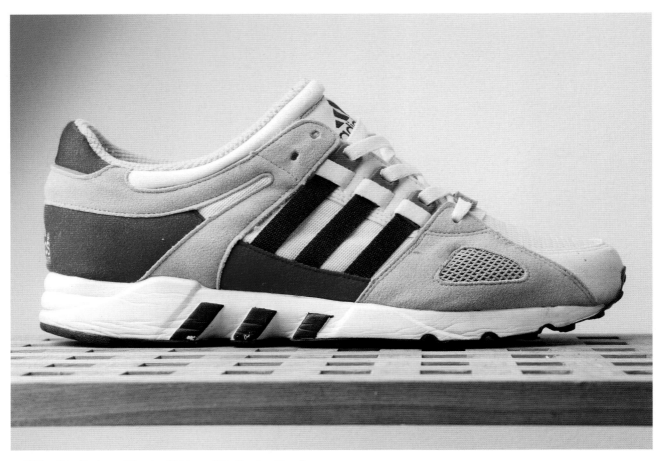

1992: adidas Equipment Running Guidance (1Ca Running Shoes)

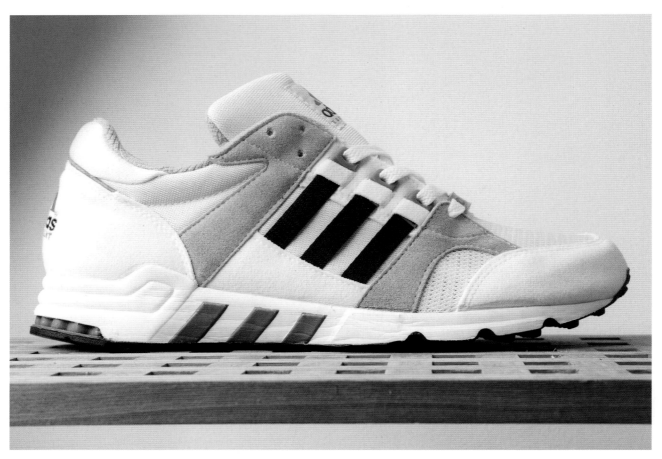

1993: adidas Equipment Running Cushion (1Ca Running Shoes)

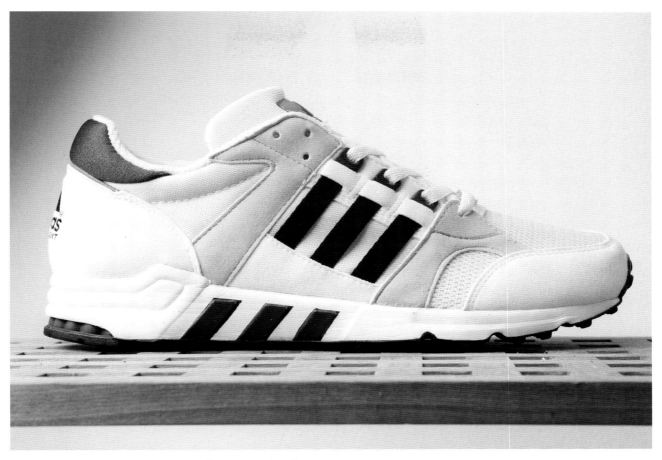

1993: adidas Equipment Running Cushion (1Ca Running Shoes)

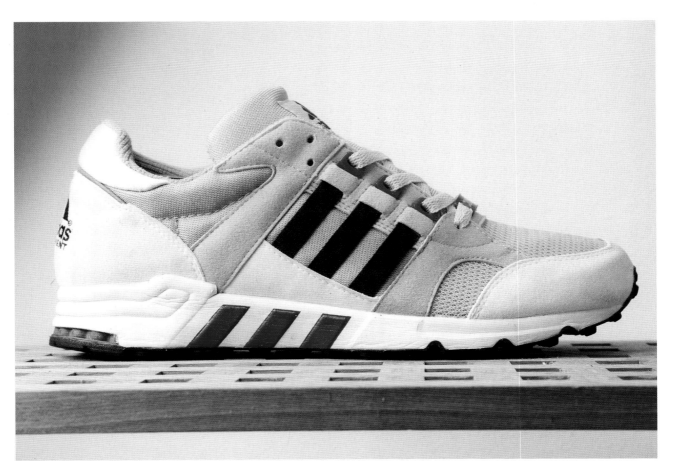

1993: adidas Equipment Running Cushion

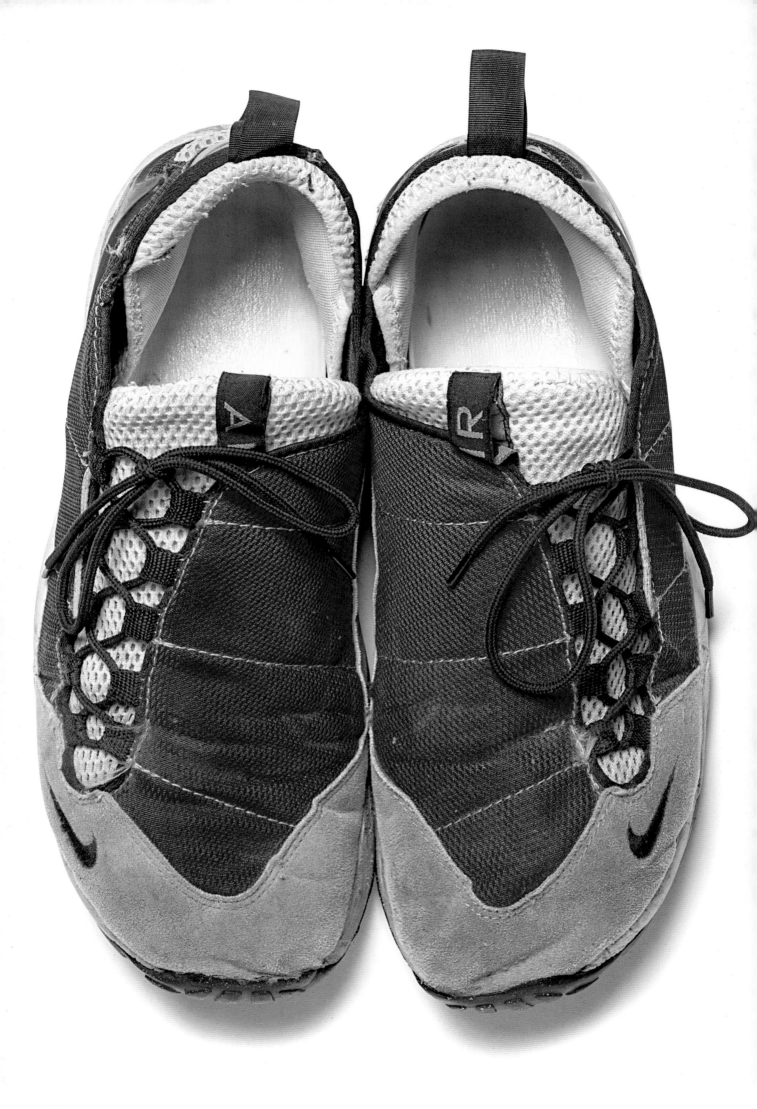

Interview: Mike Ward Photos: Ella Haines & Tim Daws

THE GREAT
FOOTSCAPE

KRAZEEFOX

Our SneakerFreaker.com forum fam know him as 'Krazeefox'. The internet recognises him as 'Yoblessed', but we simply bow down to the 'King of Footscapes'. Having assured us that he has tracked down each and every single iteration ever released, fabulous Mr Fox is officially anointed the world's greatest Footscape aficionado.

AIR FOOTSCAPE

UK	10	VARSITY RYL/NEO TEAL-LT ZEN GY
EUR	45	MADE IN TAIWAN
CM	29	FABRIQUE EN TAIWAN / HECHO EN TAIWAN

11 104053 431

AIR FOOTSCAPE LEATHER CL

UK	10	MED GREY/BLACK – MAGNOLIA
EUR	45	MADE IN TAIWAN
CM	29	FABRIQUE A TAIWAN / HECHO EN TAIWAN

11 305211 001

AIR FOOTSCAPE AP

UK10 EUR45 CM29

WHITE/WHITE-NEUTRAL GREY
BLA/BLA GRIS
MADE IN TAIWAN / FABRIQUE A TAIWAN
HECHO EN TAIWAN

11 313189 111 WWW.NIKE.COM

AIR FOOTSCAPE HF TZ

UK_10	CM_29
BR_43	EUR_45

ELECTROLIME/NEUTRAL GREY-BLACK
ELCTLM/GRIS-NOIR
MADE IN CHINA
FABRIQUE EN CHINE, HECHO EN CHINA

11 369188 301 WWW.NIKE.COM

Nike has reinvented the running shoe and called it the Air Footscape (because it mirrors the natural shape of the foot, see?). Eyes: "It's weird-looking." Feet: "Shut up, it feels great."

Trust your feet, not your eyes.

1996: Nike Air Footscape print ad by Wieden+Kennedy

Was it love at first sight?

I vividly remember the first time I saw the original Footscape. I had just finished inhaling a souvlaki at Lamb's on Chapel Street with my brother and dad. We wandered past Sports Lords (big-ups to Lou and John), and my eyes were immediately drawn to this crazy-looking shoe in the window. Varsity Royal/Zen Grey with that sweet pop of teal is total perfection. The asymmetric lacing, mini-Swoosh, abstract midsole and a bunch of other technical stuff I don't know the name of so can't properly explain were like nothing I'd ever seen before.

I was a povvo student at the time, and the price was $210, which meant there was no chance I could afford them. So I guilt-tripped my dad, telling him that he hadn't bought me a birthday present for about two years and that these would make up for his uselessness. He agreed, and we agreed that this was the last pair of shoes he'd ever buy me until the day he died. He's still alive, though. [Laughs.]

Your description says it all, but have you really looked at the shoe closely since then and thought about why you dig it so much?

Yes and no. I just look at them and think they're dope! Everything about them, from the different design elements on each side of the shoe to the side-lacing, futuristic styling and subtle speckling on the original, is fresh. I love that outsole! At the end of the day, I reckon they're super cool and try not to overanalyse things too much.

Anyone can rock Air Max and look good, but it takes a certain confidence to pull off the Footscape. That sleek side-lacing profile poses some interesting style dilemmas.

I suppose I have always liked shoes that are a bit different. Once upon a time, it was about not wearing the same shit as every other person in your social group. Things have obviously changed, but I've stayed pretty much the same. I have no rules about what I wear on my legs apart from skinny jeans and those horrible jogger pants.

Footscapes look good with pretty much anything apart from baggy jeans. I tend to rock jeans during the week – LVC, Imperial, APC – and my weekend trousers tend to be Maharishi Snopants or stuff from Kloke, which is an underrated Melbourne label. I've rocked Scapes with cords, chinos, vintage military pants, sweatpants and even a suit. They're perfect with shorts when the sun's shining.

You on that Paul McCartney Suit 'n Scape steez?

Yeah, that guy who did some song with Rhi-Rhi and Kanye not long ago! Yeezy actually asked for my autograph once. True story.

This sounds too good to be true! Spill the beans.

I used to paint little canvasses of my sneakers – I won't go into the reasons as I'm still not really sure myself – but basically, I had a bit of time on my hands back then. I made a few for friends and then took a few to the first Sneaker Freaker swap meet. I was chatting with Scotty from Evolve, and we discussed doing a few SB Dunks to put up in the store. I was strolling Chapel St again when I saw Kanye, Common and one of the De La Soul guys having lunch at Caffe e Cucina.

I was a big fan of *College Dropout* and was going to Kanye's concert at Festival Hall that night, so I walked right up and introduced myself. Shock horror, he was humble and asked me where I got my sneakers as I was rocking HTM Court Forces in Alaska Blue. I then pulled out my painting of the 'Diamond' Dunks, and as he had just dropped the track 'Diamonds Are Forever', it seemed only fitting to give it to him. He said it was 'dope' and asked for my 'details' in return. I grabbed a pen and signed my autograph and put my email down. I never received an email from Kanye, yet the Evolve guys did say when he returned for his next tour that his entourage exclaimed when they were in the store, 'Kanye, that painting is like the one you've got up in your house!' I imagine it's in a bin somewhere now, yet it's pretty funny to be able to say that Ye asked for my autograph once upon a time.

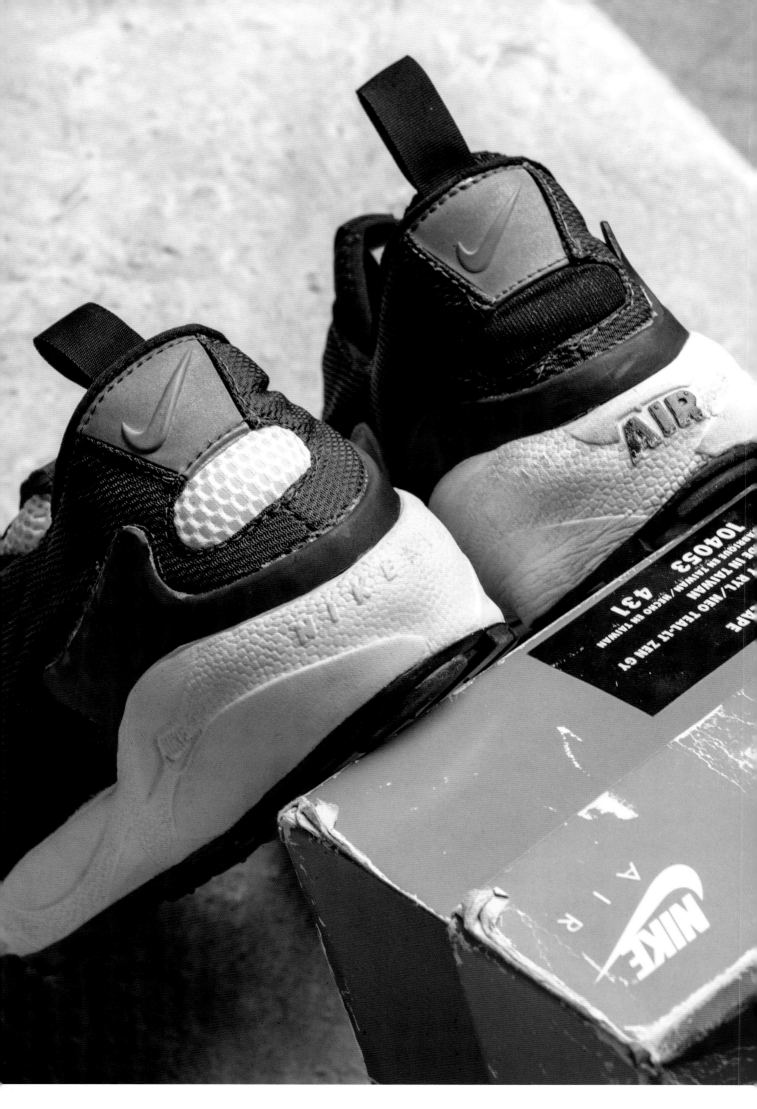

684

THE LEGENDARY PROTOTYPE

'While I've managed to accumulate every Air Footscape ever released – a totally incredible and utterly pointless feat – one mythical pair always eluded me. The "Blue Prototype" is the sample featured in the original print advertising – this is the Holy Grail! To be perfectly honest, the Blue Proto is not that different from the OG release from 1996. But if you're a nerd like me, the tiny details are more important than life itself. The OG pair ended up with white waffle mesh, whereas the Blue Proto used a black neoprene-type material. Tory Orzeck, who designed the original Footscape, suggested in a *Sneaker Freaker* interview back in 2006 that the change in materials was likely due to white being more efficient at reflecting heat, while waffle mesh was more breathable than neoprene.

 The Blue Proto is rare as hell, but there's also a one-off yellow sample with an amazing "Footface" logo debossed on a reflective heel strap, photographs of which appear in the same article. During my daily wanderings through the interwebs, I came across a pair of Blue Protos for sale on a Japanese auction site, the first and only time I had ever seen them (except in the ad) in two decades of searching! I figured that no other idiot would have my level of interest, but I did get a message from another Footscape fanboy who kindly offered to step away from the auction if I was bidding. Thanks, Roy! In the end, I paid a fair whack, but when you consider what the young'uns of today spend on ghastly crap, I'd say it was a bargain. As soon as they arrived, I knew my mission was complete!' – Krazeefox

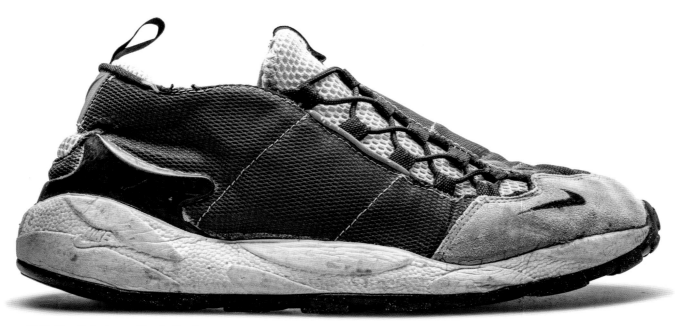

1996: Nike Air Footscape 'Varsity Royal'

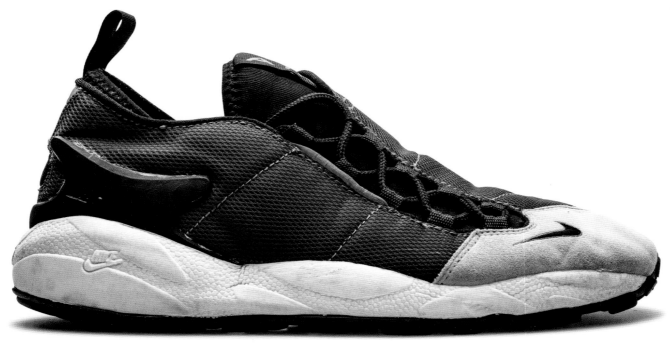

1996: Nike Air Footscape 'Varsity Royal' (Prototype)

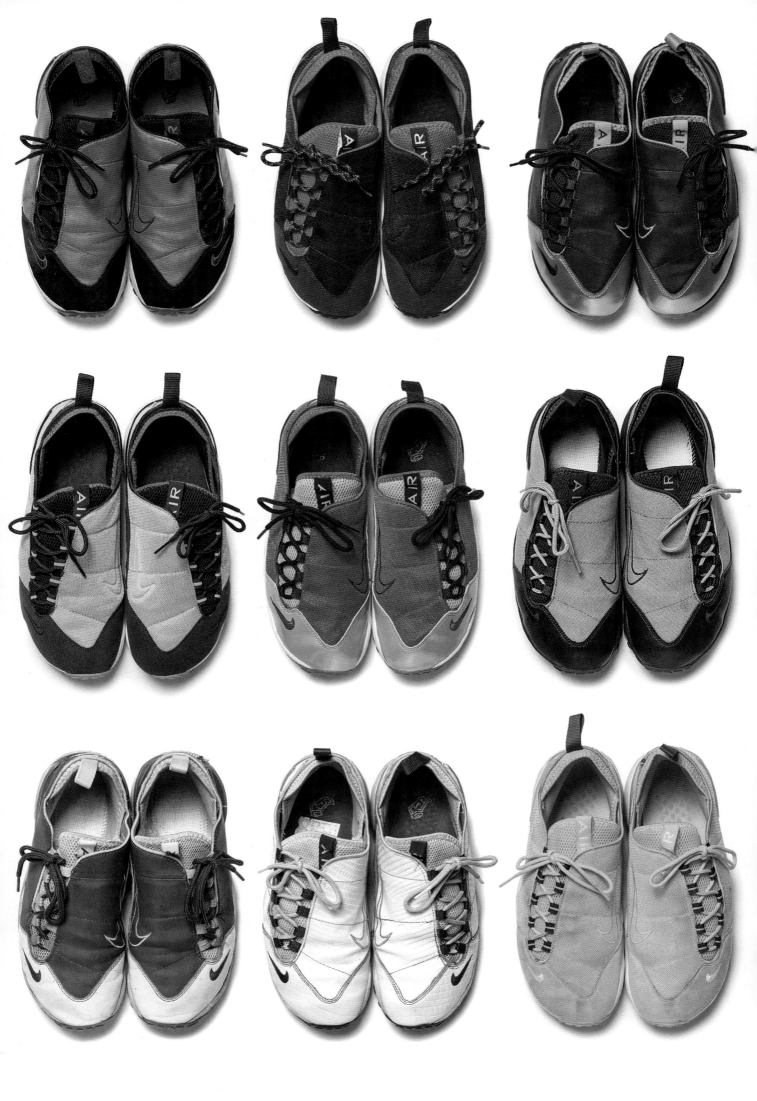

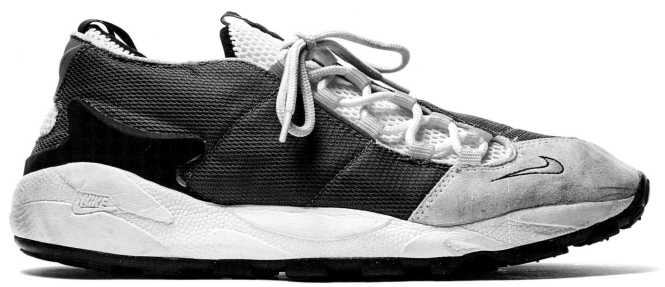

1996: Nike Air Footscape 'Mystic Teal'

To what extent do the Footscape's obscurity and general weirdness appeal to you? Let me ask it this way... if everybody was wearing them, would you still dig it as much?

If everyone was wearing them, I'd still wear them as long as I could still afford reseller prices. Growing up was about busting something out no one had seen, so the weirdness and obscurity definitely played a part, but it was always good to see someone else wearing them. I once offered to buy an OG pair off the feet of an old rich guy I saw stepping out of his Porsche, but he politely declined. They're definitely one of those 'if you know, you know' shoes – if you know what I mean.

I know. On paper, they come across as a road-warrior, but 20 years later, it seems hard to believe this was a legit performance model. I guess you could say the same for a lot of Nikes.

I have read old reviews that suggest it was a solid running shoe. I recall seeing a picture in the paper with a bunch of Brisbane Lions AFL players wearing them at training, so naturally, I figured they must've been good for high mileage. I'm not much of a runner. I'm like a dog in the sense that unless I have a ball to chase, I don't run, but I have vandalised many a dance floor with my crazy dope moves!

There are three solid waves of Footscape releases: the OG era in 1996, then 2002 to 2006 and 2009 to 2012. Has the shoe changed much over time?

Probably, although I'm not that much of a shape-ist. They all look basically the same, yet different materials in different years have slightly different sizing but nothing too noticeable. A bunch of pairs have 'massage pimple' insoles, which add an extra bit of freakiness.

Do you really have them all?

As far as I'm aware, I own every pair of proper Footscapes ever released. I saw one sample on eBay a few years ago that was in UCLA colours (Uni Blue/Maize/White) with different mesh on each side, but I've never seen them in real life. As they were in sample size, I didn't want to go crazy and ruin it for someone who really wanted them, so I made a decent bid and was gazumped. If the person who scored those shoes is reading this, feel free to send them over!

Have Nike released enough pairs over the years? What would you like to see them do with the shoe? More or less?

There are definitely enough releases. It's just that the majority were not widely available. Most seem to have been Asia-only and even then, they were seemingly limited to a few areas. China and Japan were the two main places you could buy Footscapes. Part of me would like to see a wider release, as inevitably, I would be able to get them easier and cheaper. Yet they're a shoe that polarises opinion, and the niche release strategy is probably best suited to this model.

In your travels, have you ever stumbled across one of those mystical hush-hush treasure-trove sneaker stores full of Footscapes?

London in the early 2000s was the first place where I saw numerous colourways in one place. The Supra store in Notting Hill and a vintage store at the top of Portobello Rd were parallel importing a bunch of Asia-only Nikes, including Footscapes. MyTrainer in Covent Garden was mind-blowing – with prices to match – and you could also buy the latest-release ACG pairs in places like Offspring.

I even grabbed the 'White Croc' from Footpatrol's original store on opening day. Tokyo is still the spiritual home of the Footscape, and I was lucky enough to play tag along with Gustodaninja as he hit up stores. Mong Kok in Hong Kong is also a good place to find Footscapes.

I don't like giving out secrets to anyone, as the 'yoof' these days want everything handed to them on a silver platter (#oldmanranting!), but if anyone hits me up, I'm happy to point them in the right direction. I've probably spent way too much time seeking out style codes and translating web pages, pre-Google Chrome translate days.

Are the OG pairs still rockable?

The most banged-up pair I have is the OG I've worn ever since the original release. They've been through hell and more yet always scrub up well after being thrown in the washing machine. Like most vintage sneakers, if they've been worn gently over the years, they'll be fine. The worst you'll get is sole separation or the plastic around the heel separating or crumbling. A simple re-glue, and they're wearable once again.

You have a full set of Fujiwara's 'Fragment' Footscapes. Has that 'Big in Japan' tag made tracking down pairs in your size a lot harder?

To my understanding, I do have the full set of Fragments, but I was unaware of the whole Hiroshi Fujiwara link with Footscapes until recently. That guy is obviously doing something right! From my experience at a Bon Jovi concert at Tokyo Dome, the Japanese do seem to like uniformity. All 55,000 people at that show busted the exact same move simultaneously. If someone pumped their right fist, everyone pumped their right fist. If one person thrust both hands high in the air, everyone did. I felt a bit 'special needs' rocking out to Sambora's guitar solo when everyone around me was politely nodding in unity.

Perhaps this partly explains why Hiroshi is such a guru and I'm a nobody, but more than likely, this has absolutely nothing to do with it. The 'Big in Japan' label has made me learn Kanji for Footscape or *futtosukepu*. The fact most releases have been Asia-only and that they tend not to make many – if any – sizes over US11 has made it tricky. My own sneaker aesthetic probably falls more in line with Japanese influence than European or US.

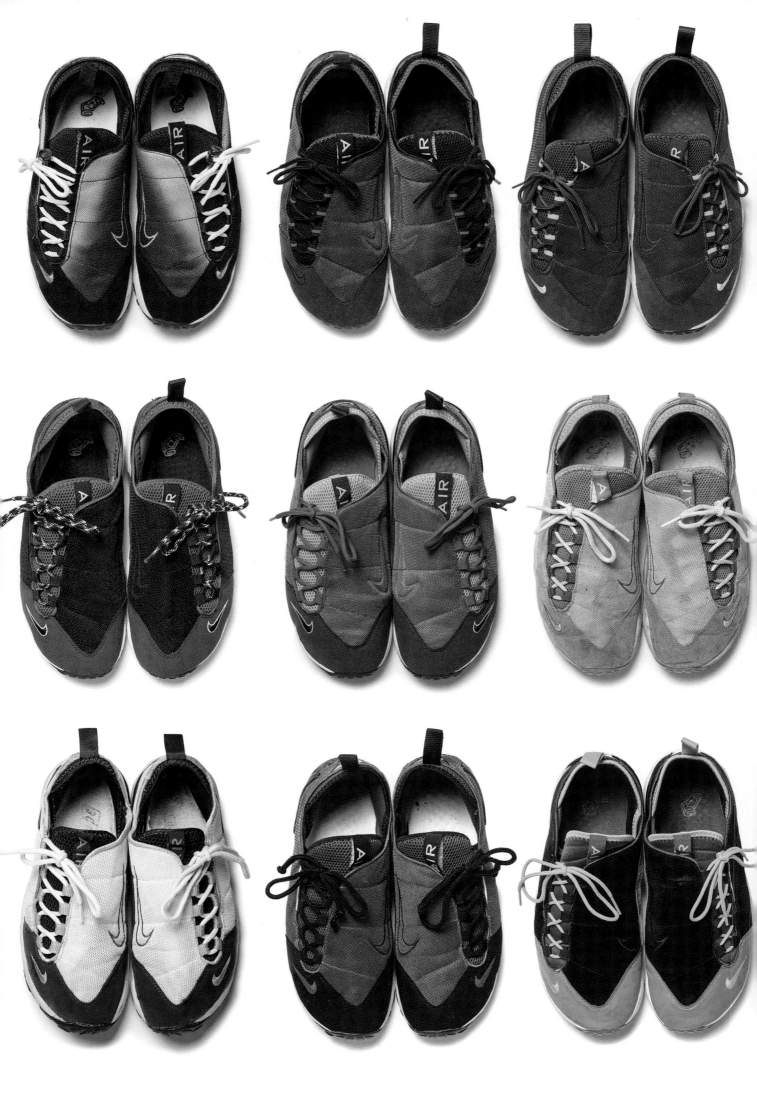

FRAGMENT DESIGN

'The "lightning bolt" symbolises everything from the Greek God Zeus to the hand dealt by Satan. In the streetwear world, it represents Tokyo's Fragment Design. Founded by Hiroshi Fujiwara, renowned the world over as the Godfather of Harajuku streetwear, Hiroshi's CV, if he had one, would be epic, with just about every major brand in the world listed at some point. He is the "H" in Nike HTM and was also a mentor to a youngster named Nigo, who started BAPE. Ludicrously shallow history lessons aside, next time you spy two mysterious "lightning bolts" on a pair of sneaks, you'll know what you're dealing with.' – Krazeefox

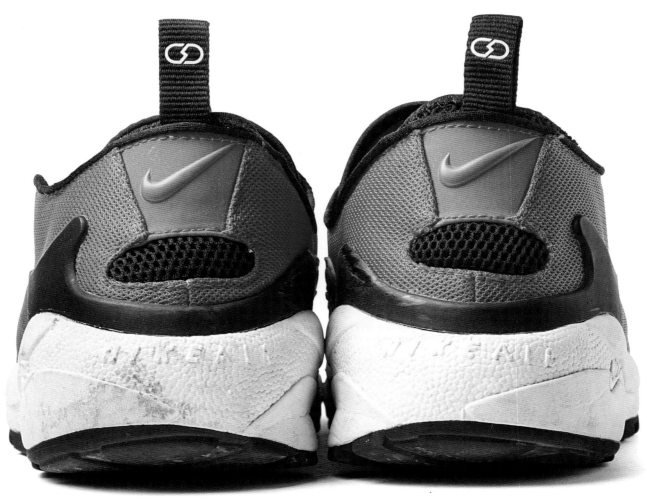

2009: Fragment Design x Nike Air Footscape 'Chile Red'

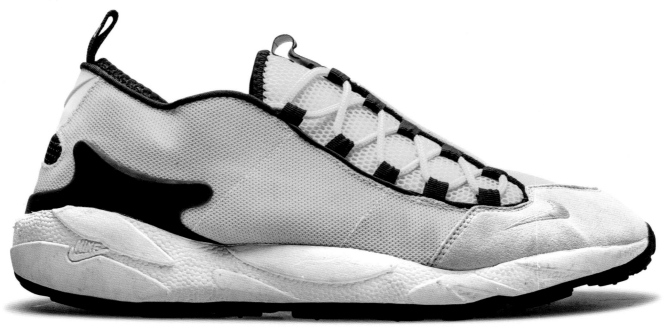

2009: Fragment Design x Nike Air Footscape 'Electrolime'

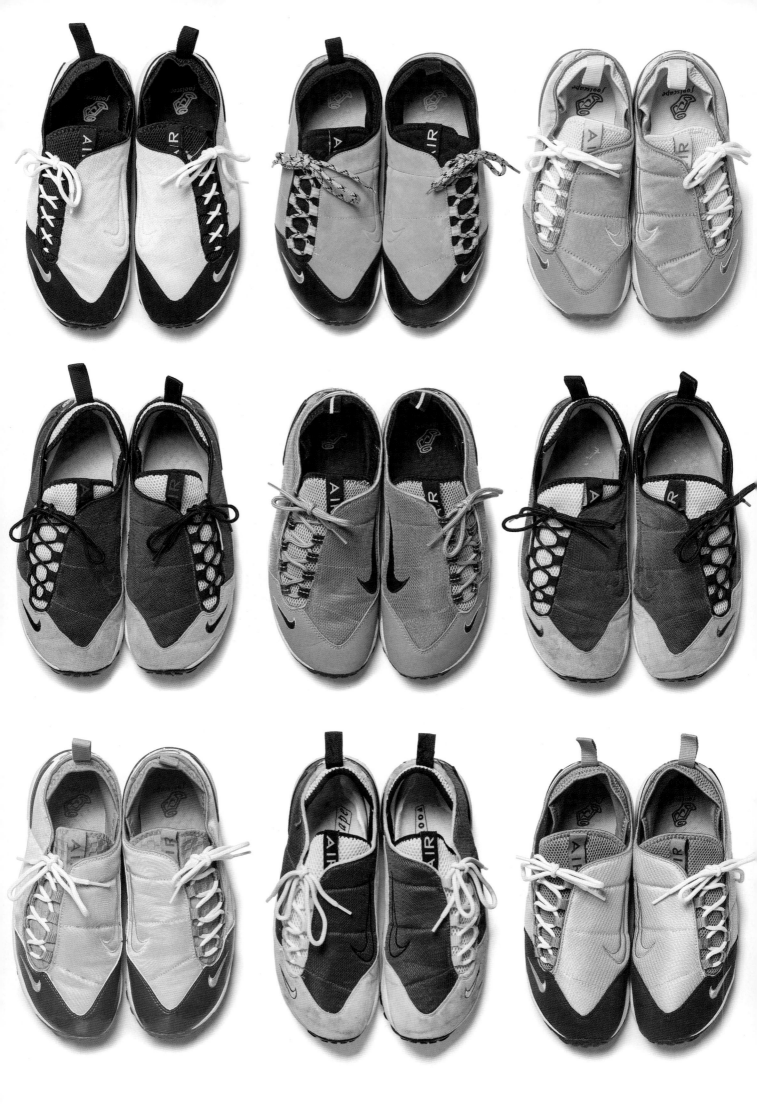

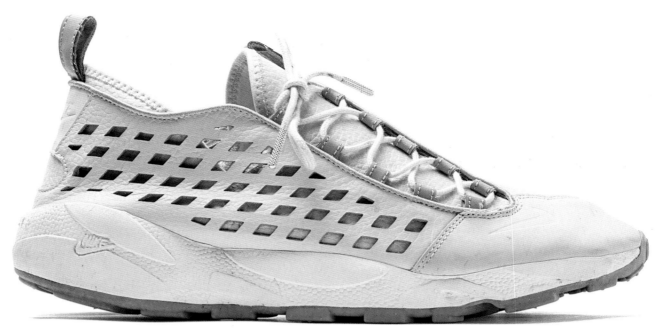

2009: Nike Air Footscape Supreme ND 'Haystack'

How many other Footscape colabs have there been? I'm trying to think… I know there's a Medicom one. Any others?
A couple of early-2000s pairs were linked to the Hideout store in London, apparently part of a Ueno 'City Attack' pack and limited to 500 pairs. There's also the suede and Flywire pair that was released for the AD21 anniversary [*Note: Nike's defunct Harajuku concept store.*], but again, I don't know 100 per cent because I'm not a super-knowledgeable streetwear historian.

Methinks you're being a tad modest. What was the hardest pair to track down?
Probably the 'Pink Satin' pair. I have only ever seen one for sale. Those and both of the hemp pairs, especially the one with the dark midsole. I have seen only two for sale ever. The women's 'Baby Blue/ Yellow' satin jobs were the final piece to the puzzle, and it took three to four years of searching to find those, having let a pair regretfully slip through my hands once before, thinking no one else would buy them.

What's up with that leather pair with all the chunks cut out? They seem familiar.
They're Supreme, but not that Supreme! It's basically one of the first – if not the first – sneaker releases under the Nike Sportswear banner. I don't even think NSW had been properly launched at that point. I'd seen them online and thought they were cool, yet when I saw them in the flesh at SampleKickz's little store in Hong Kong, I was blown away by the quality. Unfortunately, the pair he had was too small, but luckily there was a pair in my size for a great price on eBay, which I snapped up immediately.

You ever broke the bank for a pair?
Not really, especially compared to what clowns drop these days. The most I've paid is around $250 for the teal OGs. I consider that a real bargain. Most pairs have been grabbed for around $100, depending on the Aussie dollar value at the time of purchase and where they were shipped from.

We understand this topic sparks some debate between enthusiasts. What's your take on Nike's approach to diluting the Footscape DNA?
I draw a parallel with the Air Max franchise. They are all 'Air Max', yet each model is unique and should not be thrown together under one name. An Air Max 87 is different from an Air Max 90, which is different from an Air Max BW.
 The Air Footscape is what I call the one true 'proper' Footscape. The Footscape Woven is a totally different shoe. There's another bunch of weird skate models under the Footscape banner. There's also the Footscape Stasis and variations such as the Footscape Woven Chukka, Footscape Free, Footscape Freemotion and those horrible new soccer ones.

And Wovens?
I love the look of Wovens and have owned a fair few over the years, yet they're one of those shoes that look better on other people's feet than mine. I sold a bunch for cheap a few years back and only kept the white 'Hideout' and 'Aussie World Cup' pair because, you know, Oi!Oi!Oi! I have the 'Leopard' and the 'Black Rainbow' Woven Chukkas, but I don't really get the crazy hype behind these. I suppose it's one of those shoes that trendy fashion types foam over.
 One of my favourite and most-worn pairs is Bodega's Footscape Woven Motion, which I picked up for $72 off the back wall at Nike's Smith St outlet in Melbourne. Like many, I'm a sucker for a dark, speckled midsole. I got love for the recent Footscape Motion release, which is basically an updated version of the original Air Footscape. I grabbed all the OG colourways, and their comfort level is out of this world. I bought my daughter all the OG colourways of the Footscape Free toddlers in staggered sizes so she could wear them over the years. Unfortunately, she's very strong-minded, independent and a 'girly' girl, so she presently refuses to wear anything that is not pink! Safe to say, I may be selective in what I collect, but I have mad love for the Footscape family nonetheless.

Do you ever think about why you get so nutty about collecting shoes?
Sneaker accumulating is a strange business, so I figured I might as well see how ridiculous I could be and track down every pair of one of the more obscure Nike models ever made. Now that I've accomplished my goal, it all seems a bit absurd, yet I do feel a sense of achievement in completing something – albeit meaningless – that I set out to do. Perhaps my next goal in life can actually be related to something useful. I must send massive love to my beautiful and understanding wife, who allows me to indulge in one of the more pointless exercises one could think of, just so long as it doesn't take up too much space at home.

Any last Footscape words?
Dear Nike, let me design my own Krazeefox Footscape!
★

@yoblessed

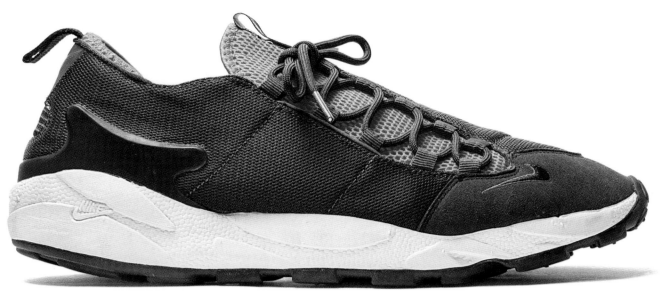

2009: Nike Air Footscape 'Wicked Purple'

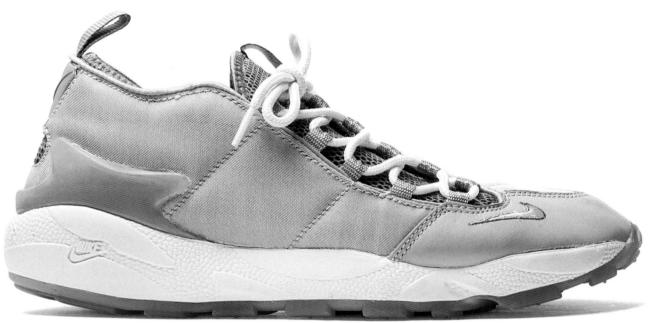

2001: Nike Air Footscape 'Pink Satin' (Women)

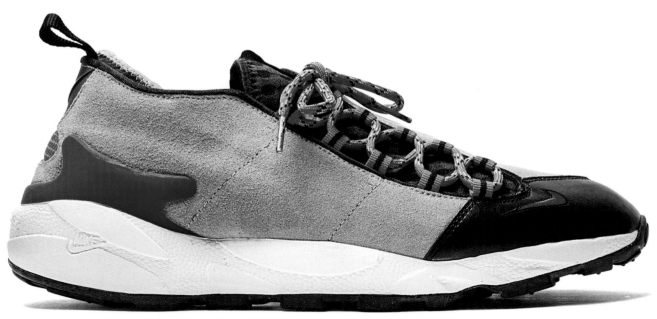

2010: Nike Air Footscape Obsidian/Vivid Pink

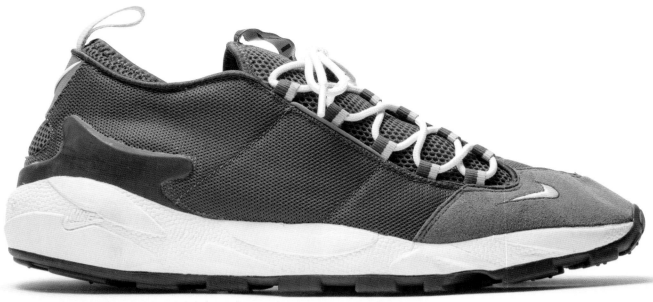

2006: Nike Air Footscape 'Island Blue' (Brazil/World Cup Pack)

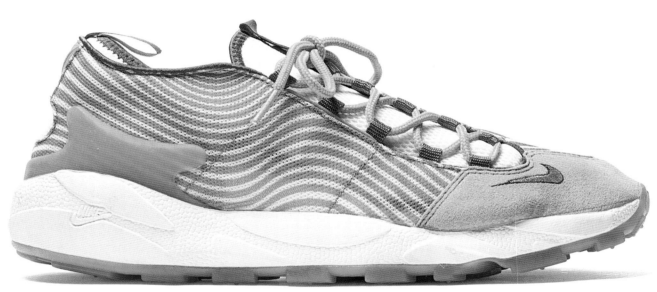

2000: Nike Air Footscape 'Carotene'

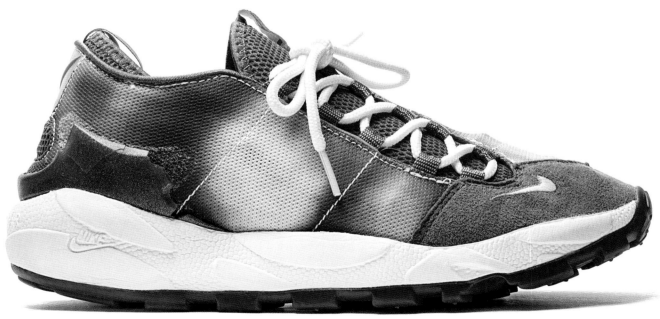

2000: Nike Air Footscape 'Medium Navy'

TOP FIVE KRAZEEFOX FOOTSCAPES

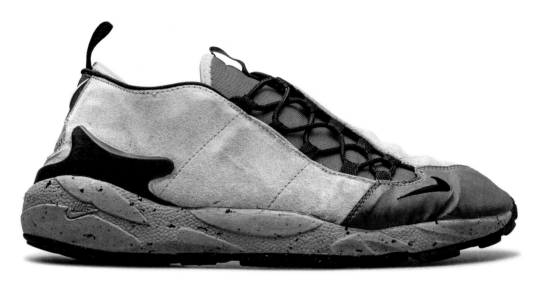

1

**Footscape Leather CL
Medium Grey/Black/
Magnolia**
The Air Revaderchi is an
awesome ACG model with an
OG colourway that is straight
perfection for the outdoors.
This combo of grey and pinky-
purple pops with a touch of
yellow is sublime – just like the
rose that grew from concrete
(RIP Pac!). Speckled midsoles
are always a winner.

2

**HF Footscape Tier Zero
Obsidian/Neutral Grey**
These are my most-worn
Footscapes of all time and
one of only a few that I have
duplicates of. They work
well with anything and never
seem to age. I can't really
do straight black, so these
are my attempt to rock it
très Melbourne-style!

3

Footscape 'Limestone'
Limestone/Oxford/
Olive-Bronze
Autumnal tones work really
well with my complexion,
as they bring out the rich
chocolately tones of my eyes.
I'm really earthy and touchy-
feely about nature as well,
so I appreciate materials like
hemp and textured leather.
The dark midsole really grounds
the shoe and makes me feel
closer to Mother Earth!
Ohmmmmm, shanti, shanti!

4

Footscape 'Obsidian'
Medium Grey/DK
Obsidian/Neutral Grey
There are many sweet and
subtle touches on this pair.
The rubberised grille lace
doovalacky with a grey
pinstripe, grip tape around
the toes, metallic mesh, silver
mini-Swooshes, speckled
midsoles and that sneakily
transparent sole: mmmmm!
These are just like the 2010
AFL Granny – the more you
look at it, the better it gets.

5

Footscape 'Kenya'
Forest/Atom Red
To 'da hype kidz' these are
straight Gucci. To me, they
represent six years of constant
searching, which is precisely
what it took to track them down.
I once saw a homeless guy
rocking them in Japan and
offered to buy them off his
feet. He was totes swaggy
in his swag, but it all felt a bit
wrong, so I passed.

Skate
Collectors

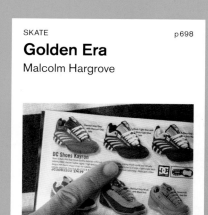
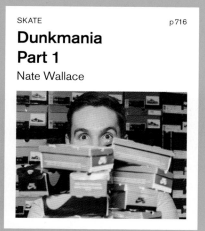
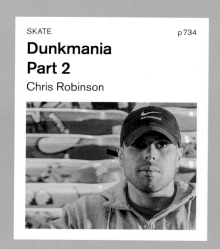

THE WILD BUNCH

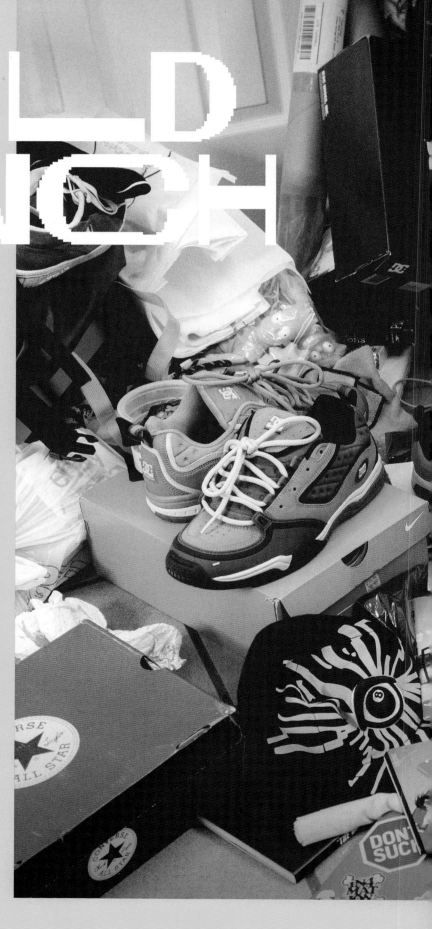

Interview
WOODY

Photos
BRANDON (@BADQUALITYHD.TV)

Malcolm Hargrove faced serious adversity growing up, which certainly left him with an appreciation for acquiring the finer things much later in life. In his case, lusting over skate catalogues predisposed his juvenile mind to a major jones for late 90s footwear, an era when too much flair was never enough. Fast-forward 20 years, and Hargrove has accumulated over 400 pairs of DC, éS, Osiris and C1RCA, along with a serious cache of hardware. What were once considered ungodly, ungainly and seriously unloved shoes are finally having their moment in the sun as coveted objets d'art. Just don't ask him to keep his laces loose — for Hargrove, it's all about rocking the wild bunch!

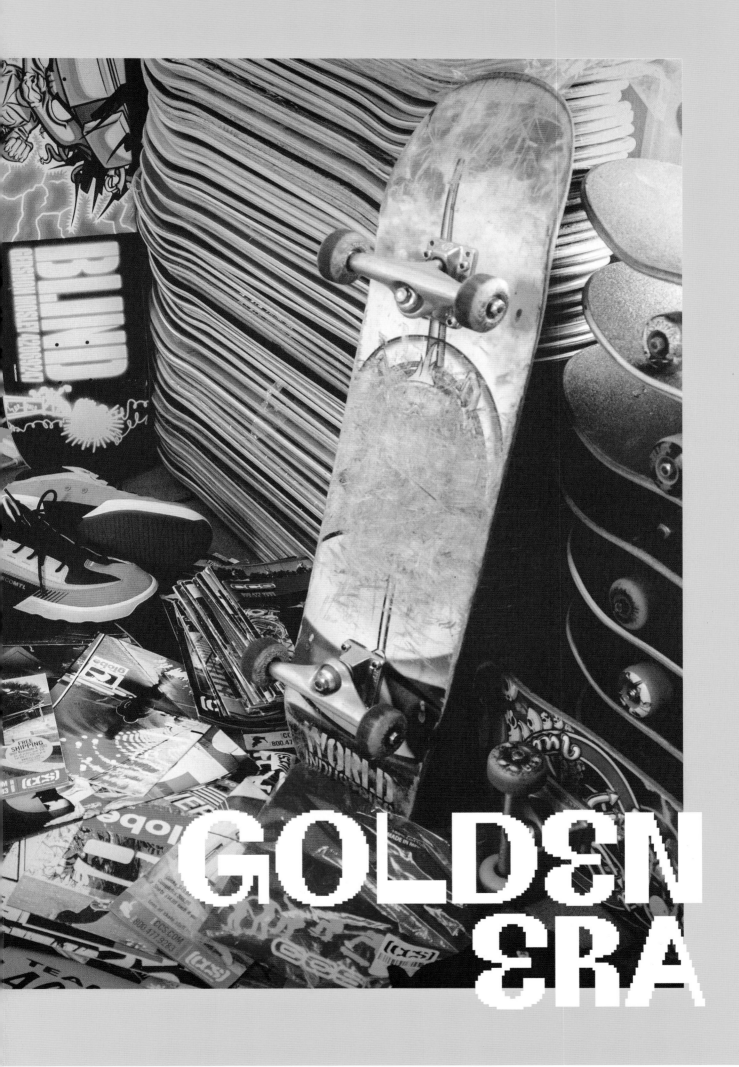

GOLDEN ERA

700

Malcolm Hargrove
90s Skate Aficionado
Biloxi, Mississippi

I grew up in a small town called Athens, Alabama. Started off like most kids riding BMX bikes with all my friends in the neighbourhood, then one day, everyone was talking about skateboarding because they had seen *The X Games* on TV. They all got nice legit gear right out the gate, while my broke ass had a cheap board from Walmart. Eventually, I started getting all their old hand-me-down shoes and unwanted junk. I would flip through catalogues and drool over all the sick shit and imagine what it would be like to own this or that. Pops barely had money to pay for our trailer, much less buy me skateboards, so all I could do was dream.

My parents divorced, and my mom and I moved to Biloxi, Mississippi, which had a pretty big skate scene at that time. I was sponsored by the local shop and did my first few competitions, but I never placed because I'm too inconsistent and always had a bail or two. I always leaned more towards street skating as it's raw, and there's so much more you can do than at any park.

I finally grew up, and one day I had my own place and decided to look on eBay for some shit my dad promised he would buy me but never did. I came across an old World Industries board that looked exactly like the one a friend once tried to sell me, so I immediately scooped it up. Never had a collection before, but this moment sparked something. That feeling of finally owning what I always lusted after was intense. I would stare at that board with a big-ass smile on my face every single day. Then I thought about all the shoes I saw at CCS back in the day, so I started hunting.

At the time, old skate stuff was cheap because no one wanted it anymore. The late 90s was an era that was best forgotten by a lot of folks, and I now had the money to buy instead of dreaming, so I did just that and started accumulating a decent shoe collection and some boards too. Here we are, seven years later, and I somehow have around 400 pairs and a decent stash of other bits and pieces.

Everything I have was mostly found through eBay, with a few extra things coming from other collectors via Instagram and whatnot. I also note that the #sk8shoewars tag opened my eyes to the other crew who appreciate this era of skate stuff as well.

Though my collection is mostly shoes, I still hunt for little hardware pieces and promo items from the millennial era. Wheels, trucks, bolts, grip tape – I love all of it. It's come full circle to the point where I almost have an entire CCS catalogue of stuff in my room!

My favourite shoe right now would have to be either the Converse Chany or the DC Aerotech. Both are insane designs! The amount of detail put into both of these models is wild. Super-tech shoes honestly don't need all the bells and whistles to perform, but that's what makes them so interesting. Skate lost that sense of visual flair for a while. They went back to the bare basics of what you need to skate, with no style whatsoever. That's why I love the 90s era I grew up in. Style was key, performance second. [Laughs.]

As you can tell from these photos, DC Shoes is my favourite brand. They really put mad flavour into their designs. A few of them are basically Nike shoes with DC logos, which is kinda funny in retrospect. The DC Avatar is like the Air Force 1 of skateboarding. Some of the details were a bit over the top, but they made you look and feel good both on and off the board, and that was so important when I was coming up.

The air bubbles on skate shoes started with the Koston 1, then DC started using that feature as well. To me, it doesn't help one bit, but it's one of those design details that drastically changes the look of the shoe, and I'm more than fine with that.

You can see me pointing at the DC Kayron in one of my old skate catalogues. That shoe has eluded me for years! I never once had the chance to buy the Kayron, and I won't stop hunting until they're mine. The crazy styling has been imprinted in my head since I first saw a pair.

Looking back, I think DC was the first skate brand to do colabs with other companies. The DC Artists Series from 2001 was pretty amazing as well. From Obey to KAWS and even Linkin Park, that was a great initiative that I believe was started by Damon Way, who co-founded DC.

But I do have other brands. I totally dig the etnies Vallely, which looks like a tank and lasts through years of tough street skating. A couple of other favourites would be Osiris models like the Kama or Cyon, the Ipath Grasshopper and the Emerica Johnson 2.

My hands-down favourite skater has to be Chad Muska. That dude *is* skateboarding, IMO! Chad had the best style on and off the board. All of his shoe models were absolutely bonkers. The first 901 from C1RCA is an all-time greatest. It looked like a Nike ACG hiking boot tweaked for skating or some shit like that. I never really dug his signature Supra shoes, but his éS and C1RCA models will always be in the back of my head. I even lace up shoes like I've seen Muska lace them before! Those big-ass loops randomly busting out are weird, but it's something wild that aesthetically appeals to me.

2002: Savier Anderson

2020: DC Shoes Lukoda (Reissue)

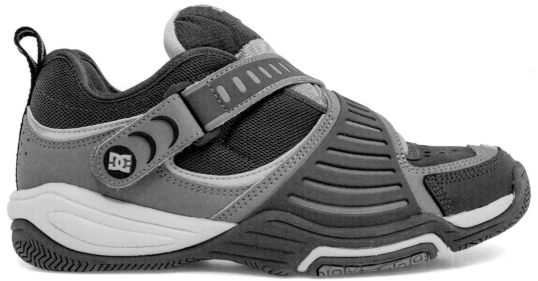

2001: DC Shoes The Solution

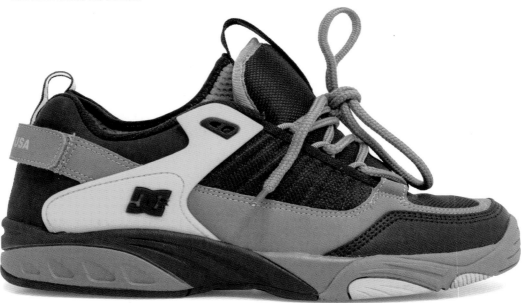

2002: DC Shoes AVE

Ahhhhh man, the Dunk SB. First off, I'm not a Nike hater or anything. I don't own any Dunks because I don't like how they puffed up the original release. IMO the original Dunk is amazing and one of my favourite basketball shoes, but I would have preferred Nike never got into skateboarding. There was an allure to skating in Nikes back in the day. Same with Jordans. Most of the skate world despises the brand, mostly due to Nike damn near taking over the entire industry. They busted in at a time when skate shoes were at their worst, with plain boring designs no one wanted. Then bam! Up pops Nike offering the shoes you love to wear normally, but now you can skate in them.

It's funny how much Consolidated hated Nike. They made their own Dunk rip-off with a banana for a Swoosh and loads of little details that had a crack at the way Nike did business. To be fair, I feel like Nike lit a fire under skate shoe companies' asses, which got them back to making better designs to compete and become popular again.

It's wild to see my era coming back into vogue. Skate companies are finally emulating the big brands – copying Nike basically – and reissuing vintage board graphics apparel and shoes like the éS One Nine 7, a remake of the original Koston 1, which so many skaters really love. All the original pairs are non-wearable thanks to the foam midsoles that crumble due to exposure to oxygen. I'm super cool with that, as it means we can enjoy the shoes all over again.

I never set out to have such a huge collection, and I'm still not sure what I'll do with all these shoes and accessories. I'm just happy to keep searching eBay and looking for rare shit and stuff I didn't even know existed. Something that blows my mind is how many people seem to dig this era of skate shoes these days. One day I'll stop buying and start selling some pieces, but I have zero desire to move anything on anytime soon. What's mine is mine, and that means a lot considering where I've come from.

★

@goldeneracollector

704

1998: ADIO Thomas

2000: AXION KC2000

2002: DC Shoes Avatar

1996: DC Shoes Clocker

1998: DC Shoes Cozmo

2002: DC Shoes Dyrdek Exacta

1997: DC Shoes Dyrdek 2

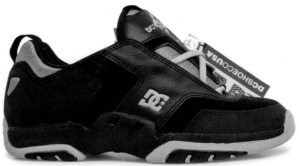

2002: DC Shoes Quasar

2001: Osiris Kama

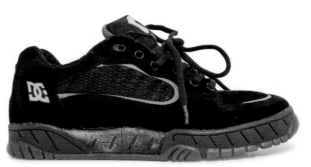

1997: DC Shoes Rick Howard

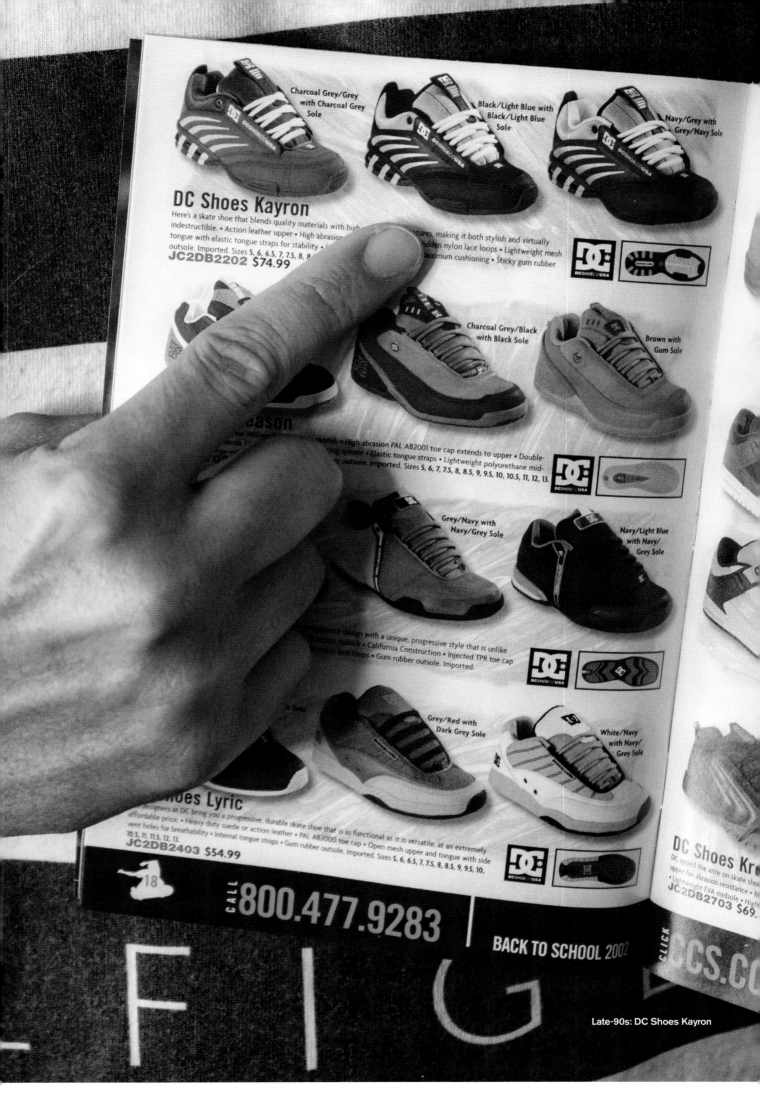

DC Shoes Kayron

Here's a skate shoe that blends quality materials with high ... indestructible. • Action leather upper • High abrasion ... tongue with elastic tongue straps for stability • ... outsole. Imported. Sizes 5, 6, 6.5, 7, 7.5, 8, 8 ...
JC2DB2202 $74.99

Charcoal Grey/Grey with Charcoal Grey Sole

Black/Light Blue with Black/Light Blue Sole

Navy/Grey with Grey/Navy Sole

...tures, making it both stylish and virtually ...idden nylon lace loops • Lightweight mesh ...aximum cushioning • Sticky gum rubber

Charcoal Grey/Black with Black Sole

Brown with Gum Sole

...eason
...el • High abrasion PAL AB2001 toe cap extends to upper • Double-
...ing system • Elastic tongue straps • Lightweight polyurethane mid-
...r outsole. Imported. Sizes 5, 6, 7, 7.5, 8, 8.5, 9, 9.5, 10, 10.5, 11, 12, 13.

Grey/Navy with Navy/Grey Sole

Navy/Light Blue with Navy/Grey Sole

...design with a unique, progressive style that is unlike
...utsole • California Construction • Injected TPR toe cap
... loops • Gum rubber outsole. Imported.

Grey/Red with Dark Grey Sole

White/Navy with Navy/Grey Sole

...hoes Lyric
...esigners at DC bring you a progressive, durable skate shoe that is as functional as it is versatile, at an extremely
affordable price. • Heavy duty suede or action leather • PAL AB2000 toe cap • Open mesh upper and tongue with side
vent holes for breathability • Internal tongue straps • Gum rubber outsole. Imported. Sizes 5, 6, 6.5, 7, 7.5, 8, 8.5, 9, 9.5, 10,
10.5, 11, 11.5, 12, 13.
JC2DB2403 $54.99

DC Shoes Kr...
DC upped the ante on skate shoe...
upper for abrasion resistance • ...
• Lightweight EVA midsole • Hig...
JC2DB2703 $69.

F I G

Late-90s: DC Shoes Kayron

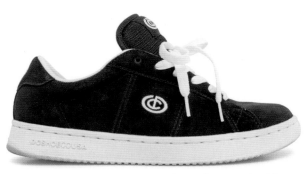

2021: Pop Trading Co. x DC Shoes Striker (Friends & Family)

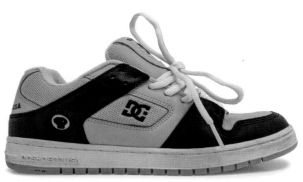

2002: Metalheadz x DC Shoes Manteca

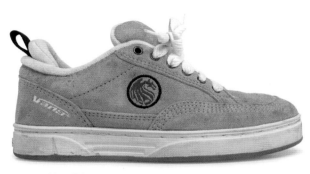

1997: Vans Tab 4

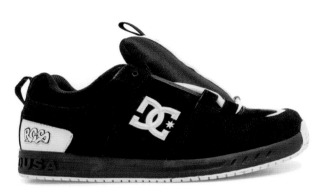

2004: DC Shoes RCS Lynx 2

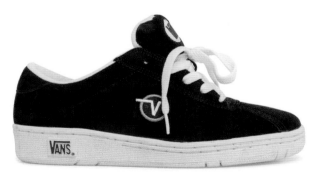

1995: Vans Wally

2002: Tony Hawk Pro 4

2001: ipath Grasshopper

2004: Quicksilver x DC Shoes Lynx 2

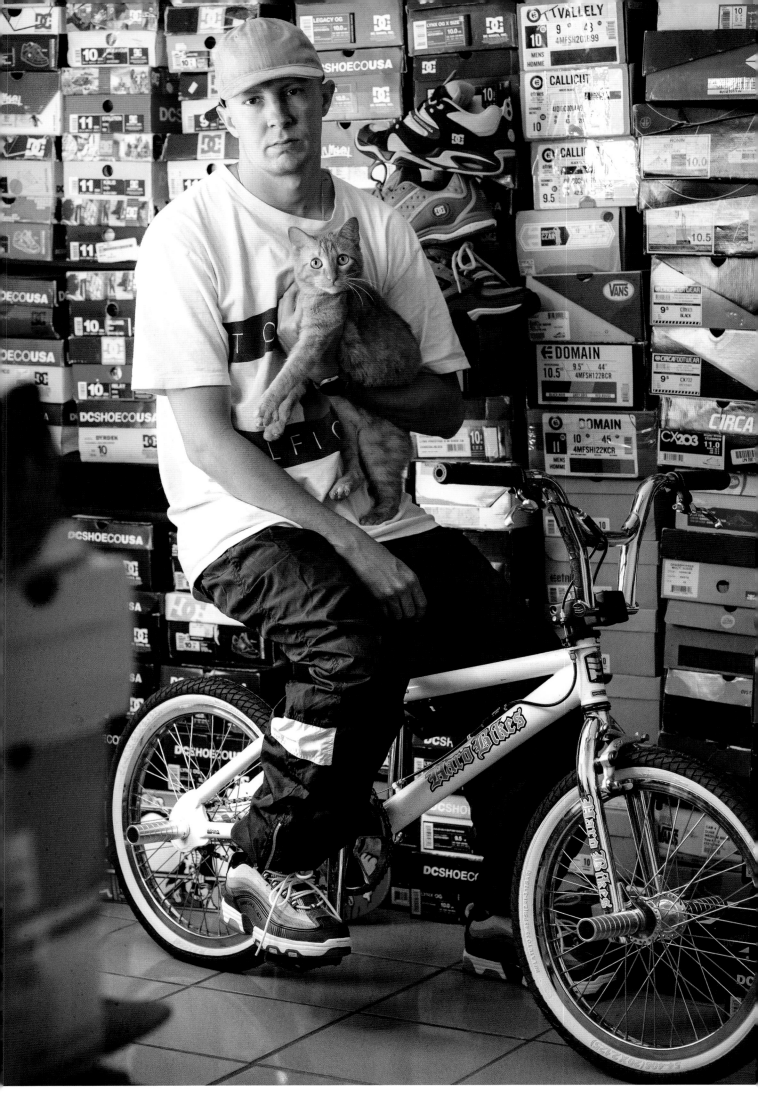

2001: etnies Czar

2000: DVS Getz

1999: Supreme x DC Torsion

1999: DC Shoes Royal

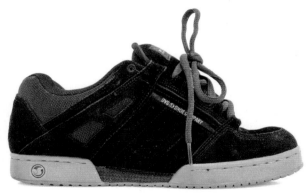

2000: DVS Getz

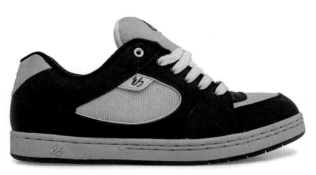

1995: éS Accel

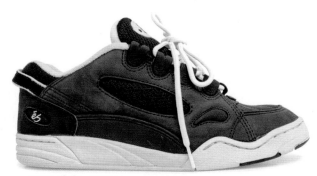

1998: éS Chad Muska

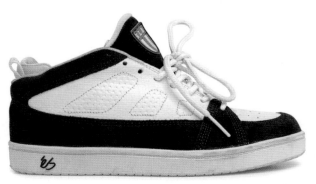

1995: éS SLB Mid

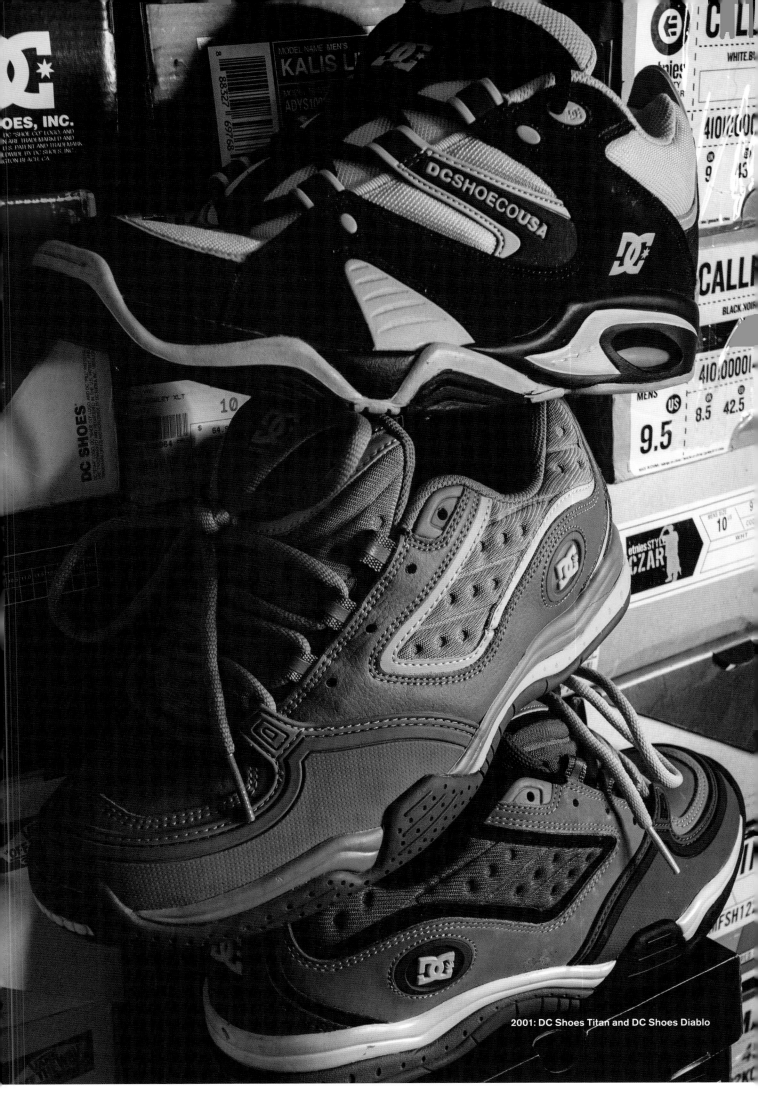

2001: DC Shoes Titan and DC Shoes Diablo

2006: Consolidated BS

1999: C1RCA Chad Muska CM901

1999: Converse Chany Jeanguenin Pro-1

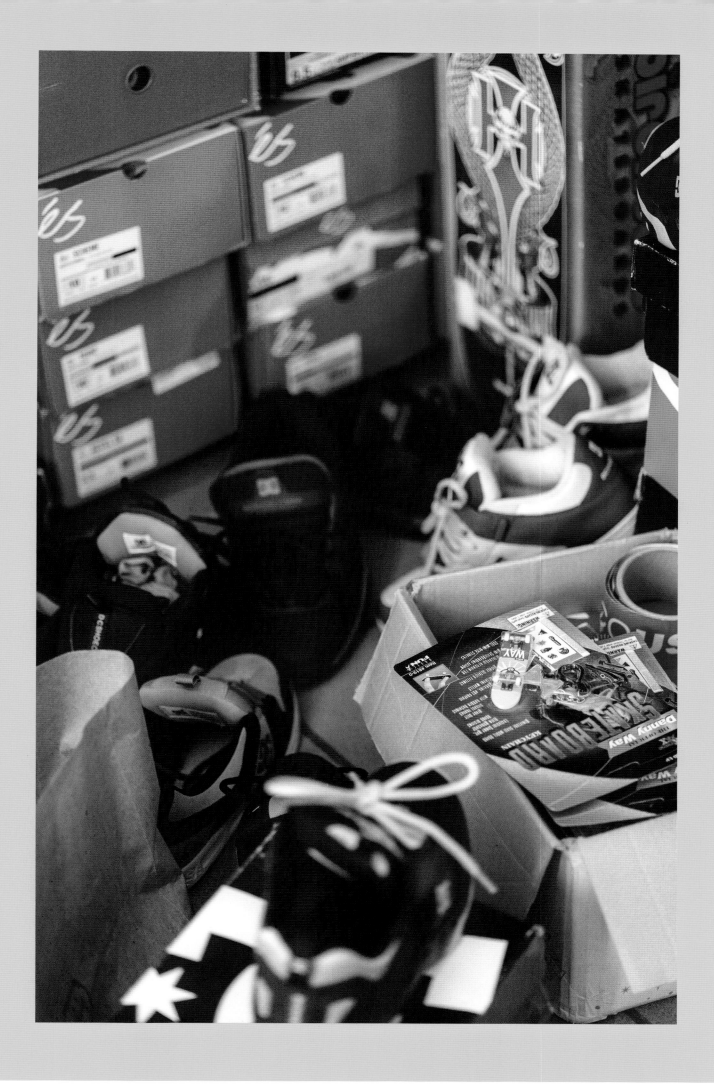

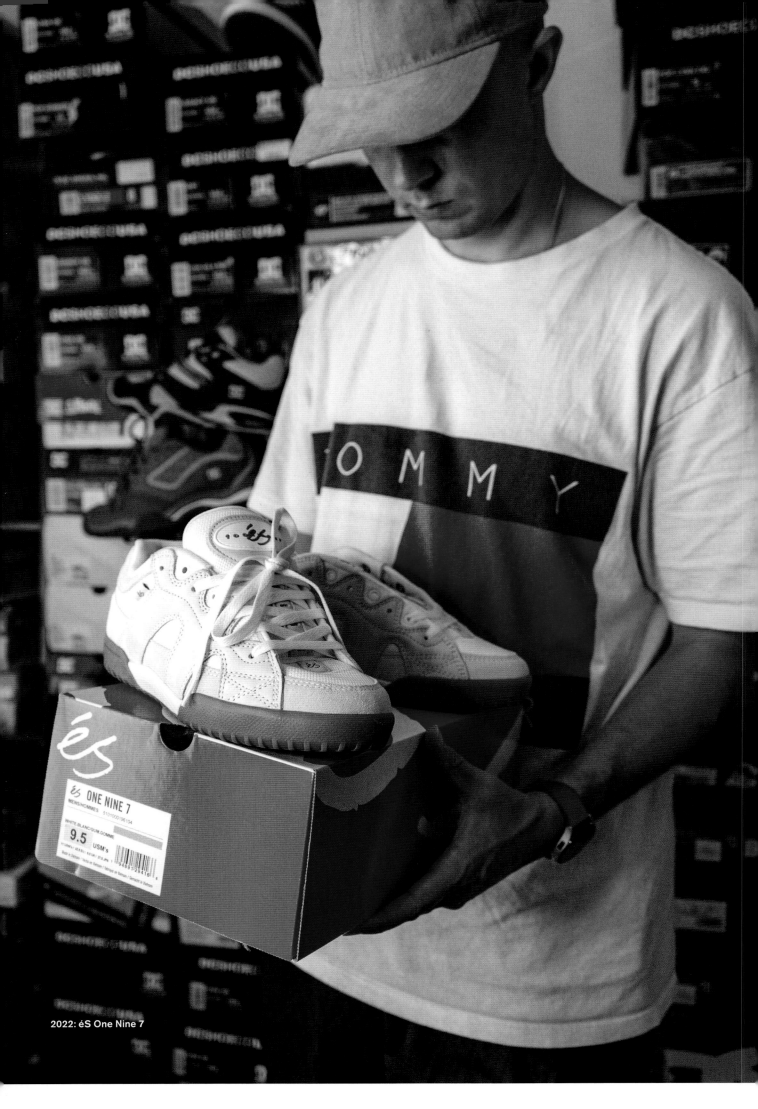

2022: éS One Nine 7

1997/98: DC Shoes Clocker 2

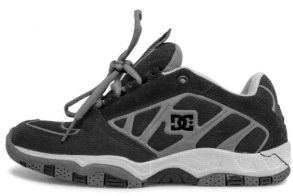

2000: DC Shoes Danny Way Evolution

1998: DC Shoes Rick Howard 2

2002: DC Shoes Danny Way Aerotech

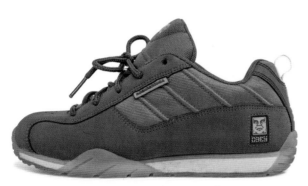

2001: OBEY x DC Shoes Swift (Artist Series)

1996: DC Shoes Syntax

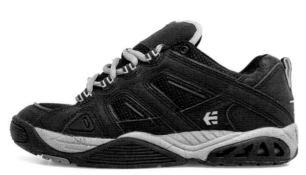

2001: etnies Oracle

2002: DC Shoes Tekron

2001: OSIRIS Cyon

2000: etnies Mike Vallely

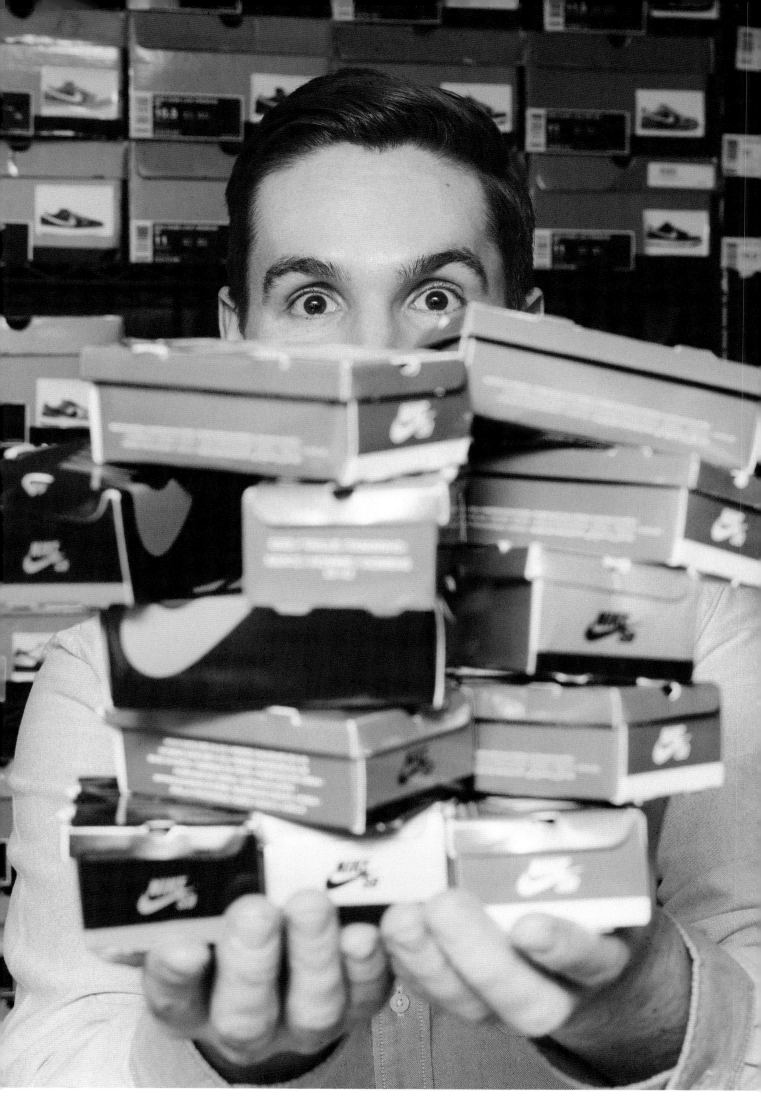

Photos: **Ant Tran**

NIKE SB PART 1

NATE WALLACE

Having powered through two decades of creativity, the Nike Skateboarding catalogue is now a sprawling era full of different box colours, models, styles and countless samples. We figure there are well over a thousand SB releases to date – a realisation that shattered *Sneaker Freaker*'s dream of compiling a complete retrospective. While the thought seems ludicrous in hindsight, Nate Wallace has given it a fair crack since he started fiending in 2004. With the Dunk as his model of choice, this passionate Scottish sneakerhead has amassed over 550 pairs that span every generation.

2003: Nike SB Dunk Low 'Barf'

2003: Nike SB Dunk Low 'Buck'

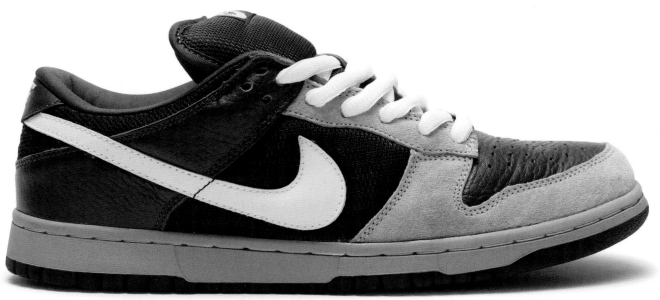

2003: FUTURA x Nike SB Dunk Low

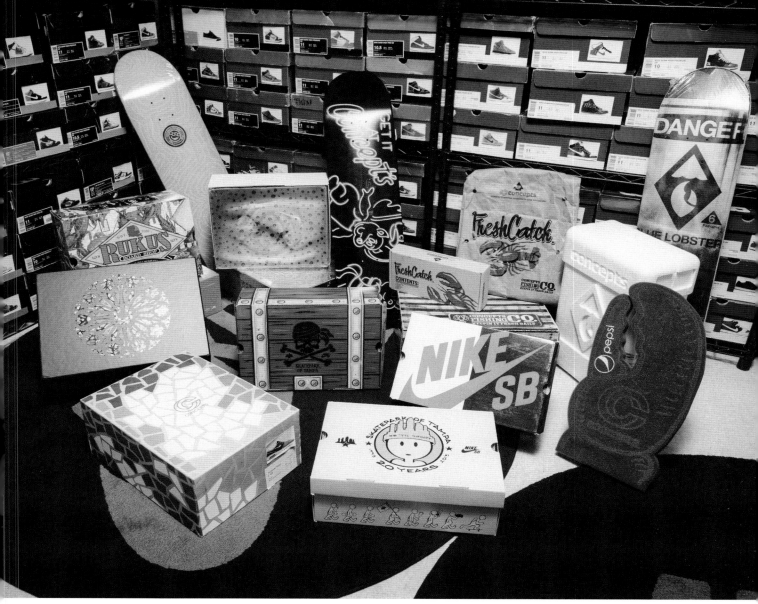

Nike SB packaging concepts always set the bar high

Quite the collection of Dunks you've got here.

Over 550 pairs and counting. I've been buying SBs since late 2004. It all started with a pair of 'Shimizu' Dunk Highs. I was already a fan of the Dunk and thought the Shimizu was cool, but I didn't totally understand its significance. Around 2006, that all began to change. I started to look into things a bit deeper, reading up on the inspiration behind the shoes. I was instantly hooked and have been ever since.

They aren't called 'golden years' for nothing.

The execution and material choice were second to none at that time. Hype was crazy back then too. You could only get SBs from your local skate shop, and if they didn't have them, you would have to scramble and call other stores around the country, hoping they would accept orders over the phone. Things are obviously very different nowadays.

A lot of the collectors that were around when I started have moved on to other brands or sold off their collections entirely. There isn't quite the same buzz for newer releases, either. The shape of the Dunk has changed a lot from the early years, and releases are also more readily available. Collectors tend to go after older pairs that they either couldn't get at the time or released before they started collecting. Personally, I would like to see Nike SB go back to selling exclusively at skate stores and also collaborate more, like in the early years.

What has kept you so loyal after all these years?

My love of Dunks. Aesthetically, it's the perfect silhouette, and nothing comes close, in my opinion. There is such an extensive back catalogue, and they're still coming out with great colourways and concepts. And there is still a great tight-knit community of collectors that converse on social media. For the most part, these groups share the same qualities as the sneaker forums from back in the day, like Crooked Tongues and NikeTalk.

Surely you must be close to full sets from the early eras?

I wish! I have the complete Orange Box series from 2002 with the original 16 releases, which was no easy task to achieve – at least not in my size. It took years of hunting to track down a pair of 'Denim Forbes'. I searched eBay, forums and Instagram every single day and never saw them show up in larger sizes. I've also nearly completed both the Silver Box and Pink Box sets – I'm just missing two pairs from each. I have the majority of Dunks from the Black Box and Gold Box eras as well. From the Blue Box onwards, it gets trickier. They started to release multiple Dunks every month, as well as a lot of Japan-exclusive GRs. It's almost impossible to keep track of.

Any plans to fill the gaps and call it a day?

Nope! The 'City Pack' is the main set I would love to complete, but I can't see that happening anytime soon. I need the 'Paris' and 'Pigeon' pairs to finish it off, and they don't come cheap. I also need the 'FLOM' Dunks to finish the Silver Box era, but they're even harder to find! I still need to pick up a pair of the 'Medicom 3s' to complete the Pink Box set, but other than that, I think I have everything. Eventually, my dream is to own a complete collection of every Dunk from the Orange Box to the Gold Box era.

Your shoe room is intensely organised. Are all shoes worn on the regular?

Admittedly, I'm a little bit obsessive when it comes to keeping the collection in order. I arrange them by box series first and then by model.

2003: Nike SB Dunk High 'Hulk'

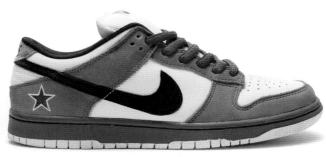

2003: Nike SB Dunk Low 'Heineken'

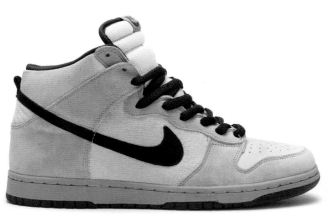

2004: Nike SB Dunk High 'Sea Crystal'

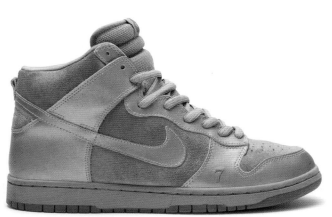

2004: Nike SB Dunk High 'Lucky'

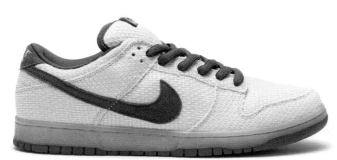

2004: Nike SB Dunk Low 'Hemp Pack – Bonsai'

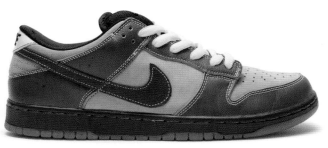

2004: Nike SB Dunk Low 'Jedi'

2004: Nike SB Dunk High 'Unlucky'

2004: Nike SB Dunk High 'Tweed'

2006: Medicom x Nike SB 'Three Bears' pack delivered 'Baby Bear', 'Mama Bear' and 'Papa Bear' together with matching Be@rbricks

Years ago, I purchased a little Polaroid Bluetooth printer to print pictures of each shoe attach to the box. That's a lifesaver. I've always been a strong believer in wearing my shoes. Don't get me wrong, I have a lot of respect for people who keep their pairs deadstock, but the enjoyment for me – especially after the hunt and finally obtaining a pair – is lacing them up and wearing them. The only pairs I still have deadstock are doubles that I simply haven't gotten around to wearing yet.

Must be hard to pick a fave on that basis.
The Orange Box is my favourite series, hands down – because that's where it all started. In my opinion, it's also the most consistent series in terms of easy-to-wear colourways and the quality of materials. The fat tongues on the Dunk Highs are also a plus. If I were to pick my favourite pair, though, I'd have to pick the 'Friends & Family' version of the 'Denim Forbes' Dunk High. Someone from Nike SB sent me a pair to coincide with the 15th anniversary of the brand. The fact that Nike SB actually reached out to me is still surreal and makes them special to me.

Do you have a favourite Nike skate model besides the Dunk?
That's a tough question, as I love a lot of non-Dunk models that SB have put out. Looking at my collection and the number of pairs I have, I guess it would be the Janoski first, with the Blazer a close second. When the Janoski first surfaced, I didn't like them at all. It wasn't until I went into my local skate shop to pick up a pair of Dunks that I tried them on and was immediately sold. After that, I picked up nearly every colourway for the first couple of years.

Even with a collection this big, you must still be hunting for a Holy Grail?
That word holds a lot of different interpretations when it comes to sneakers. For me, it's the pair that is essentially unobtainable regardless of how much money you have. The 'eBay' Dunk is my ultimate SB grail. They were auctioned off back in 2003 and sold for nearly $30,000 to an anonymous bidder. Even if I had the money, I wouldn't know where to look!
★

@_nate_w

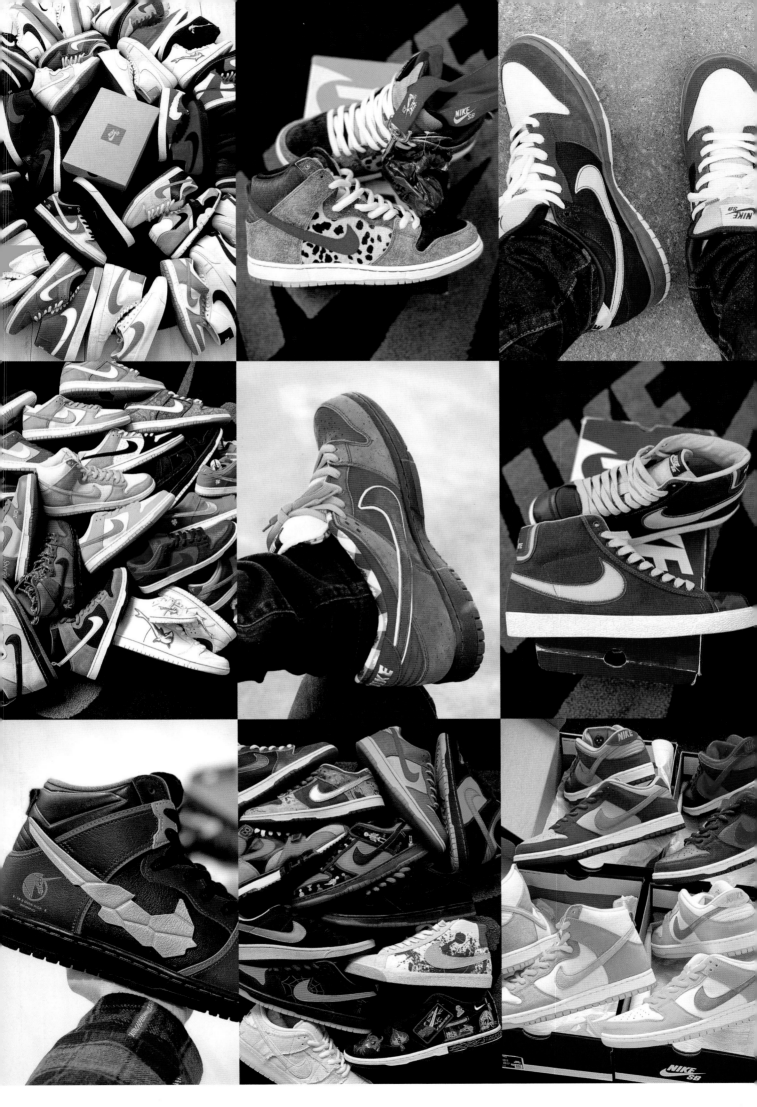

Diamond Supply Co.

Back in 2005, SB connected with other skate industry icons to produce the 'Team Manager Series'. Real Skateboards, Alien Workshop and Stüssy were part of the gang, along with SB's own Hunter Muraira, who designed a Zoom Team Edition. But it was the 'Tiffany' contribution from Diamond Supply Co. that really sent the hype machine mental. Sporting a heavy dose of inspiration from high-end jeweller Tiffany & Co., including silver Swooshes and a not-quite-trademark-infringing 'blue' upper, these gator-infused Dunk Lows were an instant sell-out that quickly found their way to eBay at a significant premium. Nicky 'Diamonds' Tershay later stated that the colab was a major turning point and that, without it, Diamond Supply Co. 'probably would have never broken away from the stigma of just being another skate brand'. In 2014, the 'Diamond' Dunk returned as SB's first retro release. Remade as a hightop, demand was still bananas. Skate shops were inundated, with the 561 store in Florida announcing they would only sell to customers that could bust out a legit kickflip on demand! The 'Tiffany' is definitely one of the most-loved SB concepts of all time.

2005: Diamond Supply Co. x Nike SB Dunk Low 'Tiffany'

2014: Diamond Supply Co. x Nike SB Dunk High 'Tiffany'

2004: Nike SB Dunk Low 'Medicom 1'

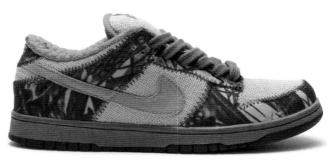

2004: Nike SB Dunk Low 'Hunter'

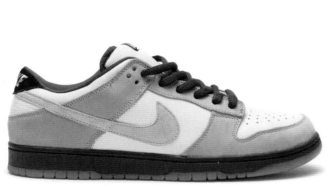

2004: Nike SB Dunk Low 'Homer'

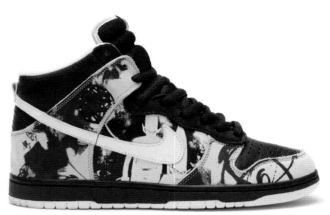

2004: Nike SB Dunk High 'UNKLE'

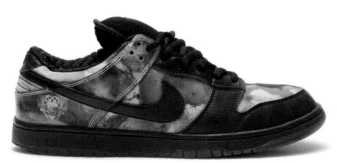

2005: Pushead x Nike SB Dunk Low

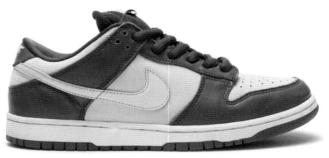

2005: Stüssy x Nike SB Dunk Low

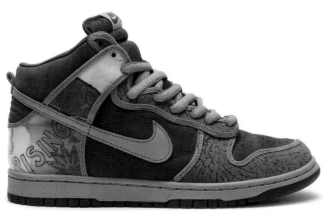

2005: De La Soul x Nike SB Dunk High

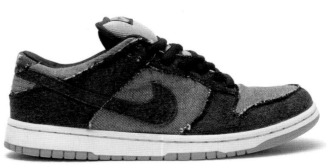

2005: MEDICOM x Nike SB Dunk Low 'Medicom 2'

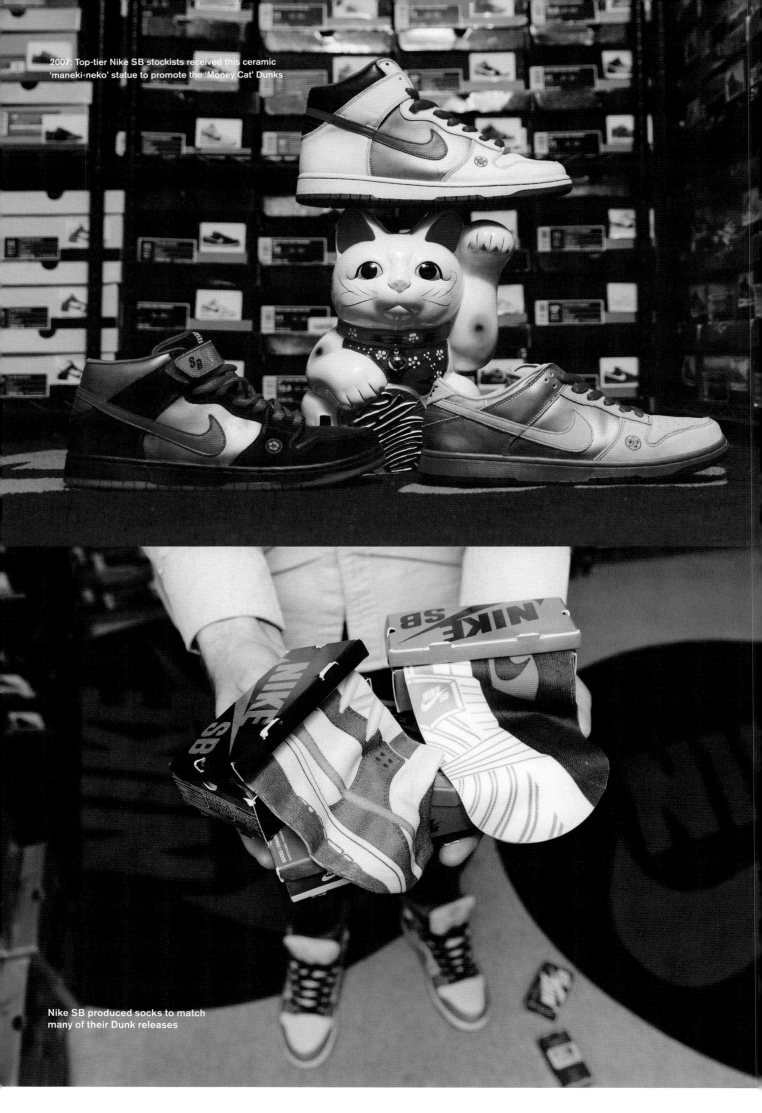

2007: Top-tier Nike SB stockists received this ceramic
'maneki-neko' statue to promote the 'Money Cat' Dunks

Nike SB produced socks to match
many of their Dunk releases

What The Dunk

'What The Dunk' was produced in 2007 to commemorate *Nothing But The Truth*, Nike SB's feature-length skate film. A mash-up of the craziest shoes made during the first five years, the design was a hilarious dose of visual overkill. Elements included the neon 'Jedi' laces, elephant print, tie-dye, baseball stitching, plaid and a phalanx of logos, including a 'Raygun' alien and pigeon, plus the numbers 7 and 13 from the 'Lucky' and 'Unlucky' Dunks. The left and right shoes were asymmetric, tipping the scales towards total insanity and making this easily the most bonkers shoe in SB history. Like the 'City Pack' before it, 'What The Dunk' was only released in cities that coincided with the film tour. Curiously, the design was spotted in counterfeit form long before the official version was even acknowledged, creating mass confusion among collectors who originally dismissed it as a grotesque Frankenstein!

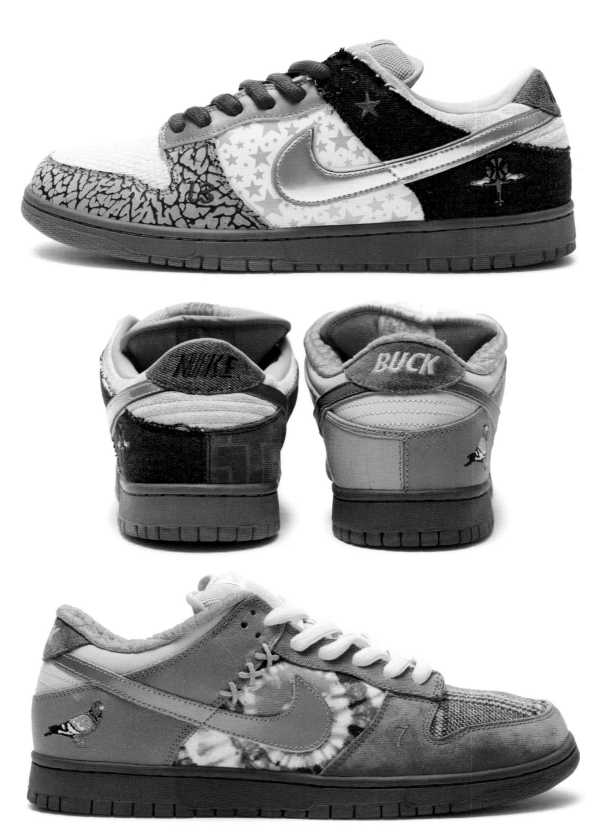

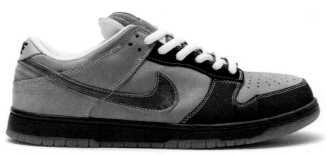

2005: Nike SB Dunk Low 'Slam City'

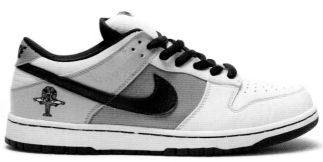

2005: Nike SB Dunk Low 'Rayguns – Away'

2005: T-19 x Nike SB Dunk

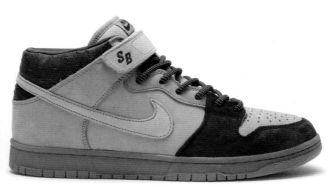

2006: Nike SB Dunk Mid 'Wheat'

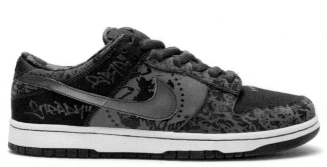

2006: SBTG x Nike SB Dunk Low

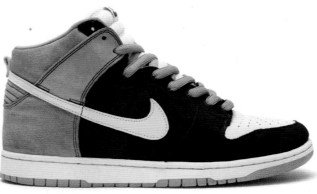

2006: Todd Bratrud x Nike SB Dunk High 'Send Help'

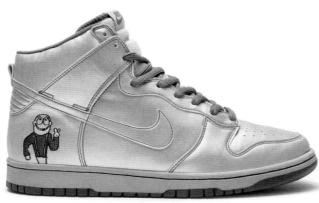

2007: Dinosaur Jr. x Nike SB Dunk High

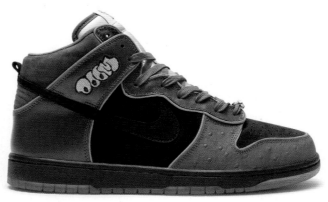

2007: MF DOOM x Nike SB Dunk High

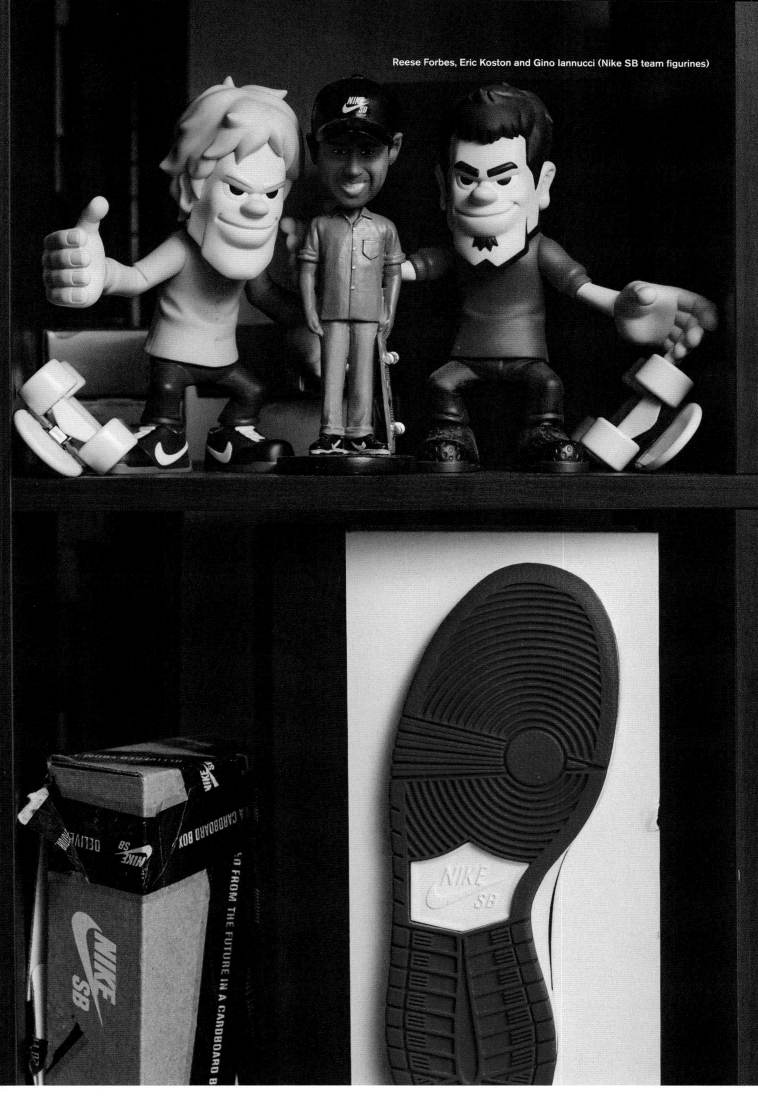

Reese Forbes, Eric Koston and Gino Iannucci (Nike SB team figurines)

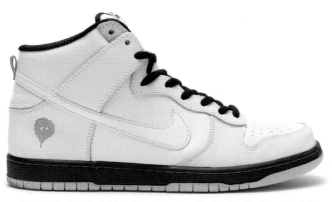

2007: Nike SB Dunk High 'Brazil Custom Series 2 – Rodrigo Gerdal'
(Brazil Exclusive)

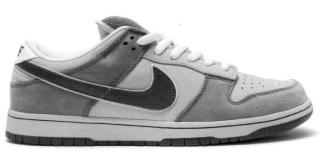

2008: Nike SB Dunk Low 'Newcastle'

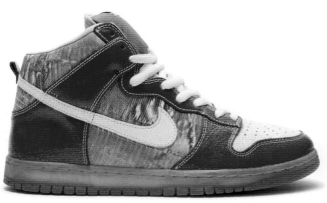

2008: Nike SB Dunk High 'Shoe Goo'

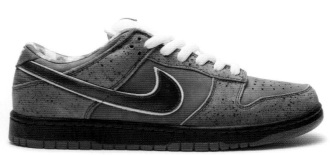

2008: Concepts x Nike SB Dunk Low 'Red Lobster'

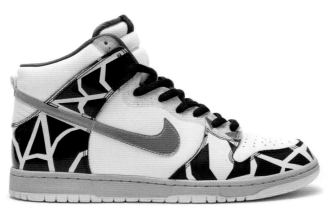

2008: Nike SB Dunk High 'Thrashin'

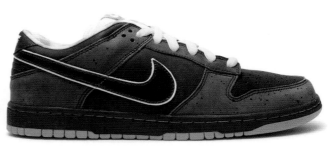

2009: Concepts x Nike SB Dunk Low 'Blue Lobster'

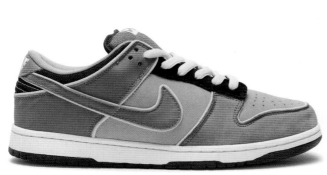

2009: Nike SB Dunk Low 'Ms Pac-Man'

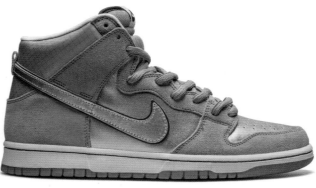

2010: Eric Koston x Nike SB Dunk High 'Thai Temple'

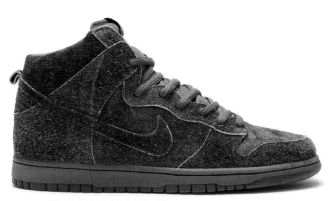

2010: Nike SB Dunk High 'Skunk'

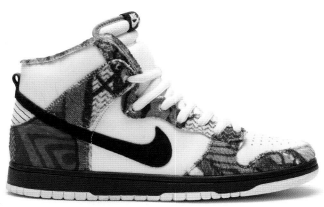

2010: Nike SB Dunk High 'Huxtable'

2011: Nike SB Dunk High 'Cheech & Chong'

2011: Nike SB Dunk Low 'Space Jam'

2012: Pushead x Nike SB Dunk Low 'Pushead 2'

2012: Concepts x Nike SB Dunk High 'When Pigs Fly'

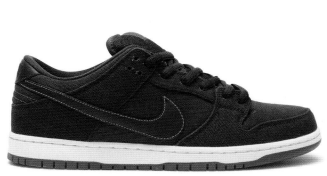

2012: Levi's x Nike SB Dunk Low (Hyperstrike)

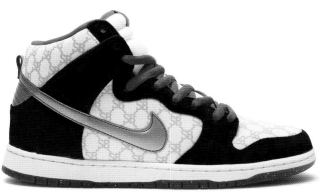

2014: Black Sheep x Nike SB Dunk High 'Paid in Full'

March 2002–December 2002

March 2003–September 2004

September 2004–December 2005

February 2006–September 2007

October 2007–March 2009

April 2009–June 2012

July 2012–December 2013

December 2013–December 2019

January 2020–Current

January 2020–Current

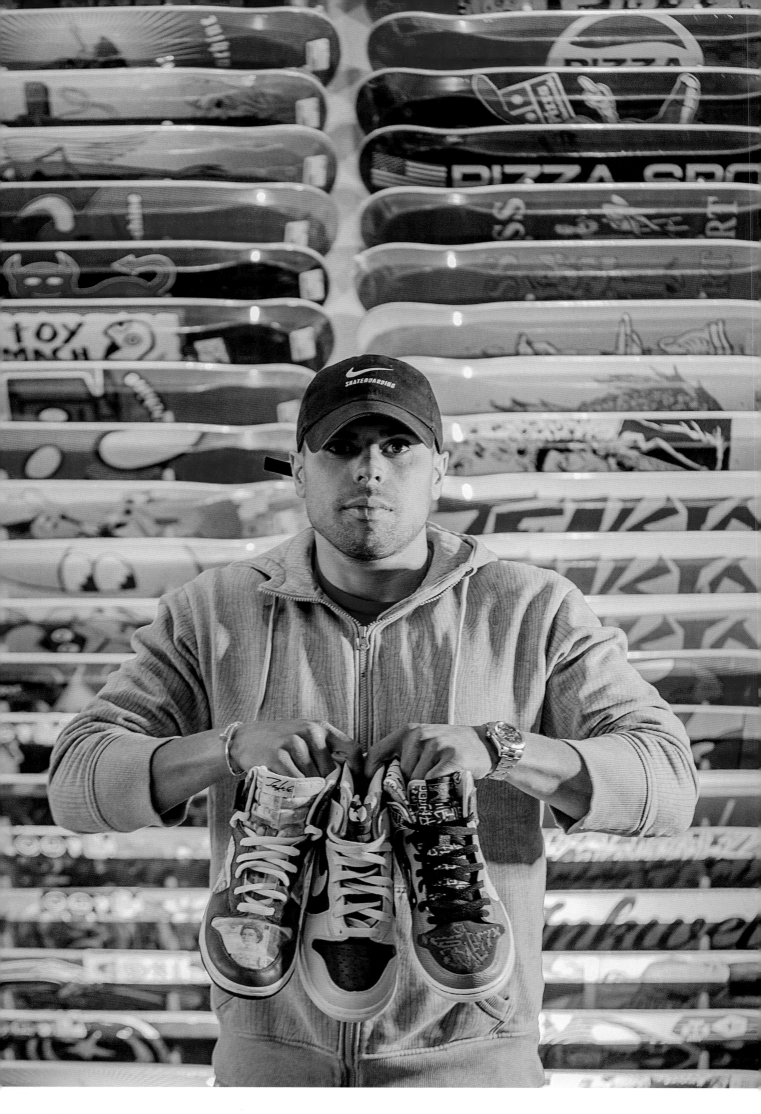

Photos: **Stan Chan**

NIKE SB PART 2

DUNK MANIA!

CHRIS ROBINSON

For Chris Robinson, collecting sneakers is way more than a part-time hobby. Robinson lives up to his @sbcollector handle with a jaw-dropping stash of killer samples and ultra-exclusives. Now the owner of Branded, a skate shop in Long Branch, New Jersey, he invited us to take a look at some of the most prized pairs in his crib. Time for Nike SB 101 to commence!

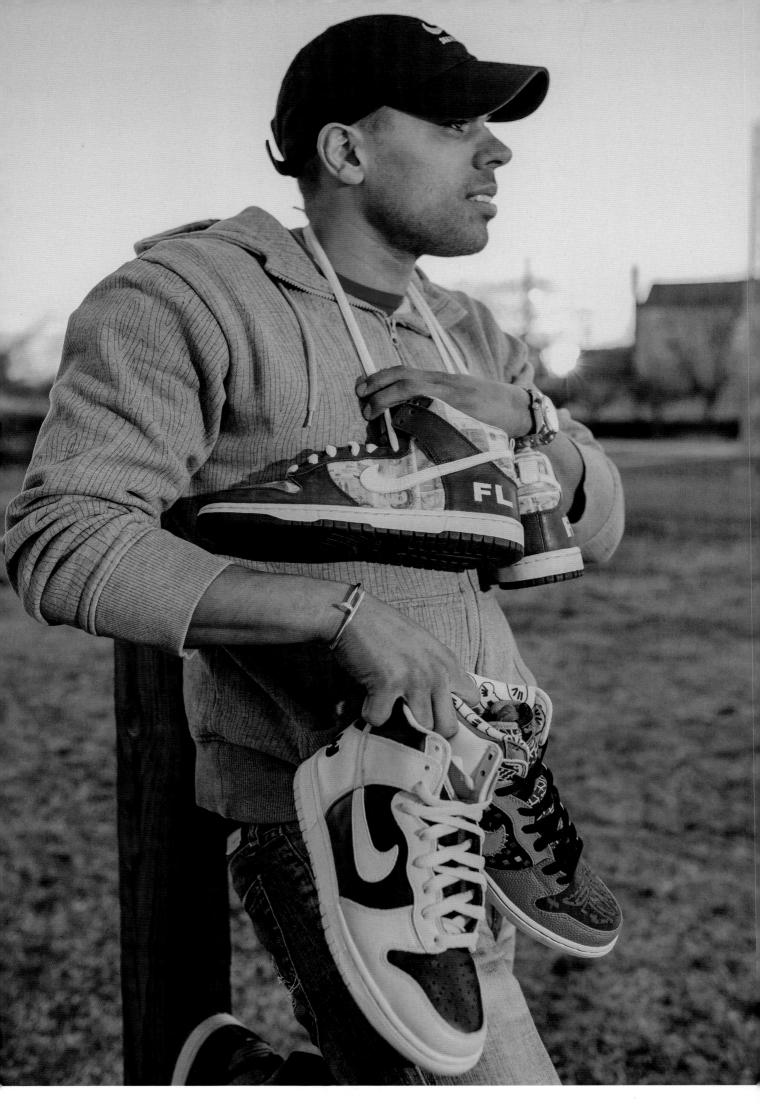

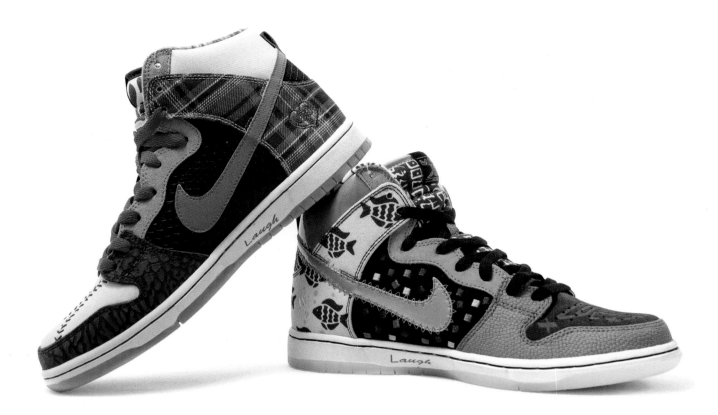

2015: Just 11 pairs of 'What The Doernbecher' Dunks were auctioned off for charity, selling for as much as $23k a pair

You own a skate shop and one of the best SB collections in the world. We heard you don't skate?
You're right – I don't skate at all. [Laughs.] I used to when I was real young, but I stopped when I got older.

What got you started on this journey?
I don't come from money, so as soon as I got a job, I started collecting sneakers. I would go to the store and just go crazy. I'd buy too many sneakers to even wear. It started with Air Force 1s, and then I really got into Jordans as well. I had some pretty amazing pairs, like the 'Vibe' AF-1s and 'PlayStations'. By 2006, I'd started getting bored.

My friend told me about a pair of Dunks called the 'Mork & Mindys'. I was intrigued as I used to watch the TV show as a kid. Not knowing anything at all about Nike SB or where to buy them, I started asking around and found out that my local skate shop would be carrying them. It's actually the very same shop I own today. I begged the owner to make sure he held me a pair as soon as the shipment came in. Thankfully he did.

I'll never forget opening the box and instantly noticing the strong resemblance to Robin Williams' character on the show. I was even more blown away when I flipped them over and saw the rainbow outsole, just like Mork's suspenders. I was hooked and ended up selling off all my Air Force 1s so I could buy more SBs!

From customer to store owner, do you see things differently since becoming a retailer?
Nike SB always gears everything towards the skaters, which is understandable because they're skate shoes, after all. But I own a skate shop with a skate park right behind it, and I swear I've never in my life seen one kid skate in a pair of Dunks.

Never?
Not once. I mean, I'll go out to dinner with the skaters, and they're wearing Dunks. It's like their go-to casual shoe, but they never skate in them. Janoskis are still big. So are Blazers and Bruins. A few guys used to skate in the Classic, but SB has since got rid of those. I've been to Street League, and I've seen the Nike SB team skate the Dunks, but I've never heard an actual kid say, 'Hey, I'm gonna skate these Dunks!'

You do know this article is about the Dunk, right?
I know! They've actually tried to slim the Dunk down a lot over the years to cater to skaters, but they're still not skating them. It's just not a skate shoe.

With a collection like yours, I don't think we'd be skating them either! [Laughs.] What's your rarest pair?
If you're talking most expensive, that'd be the 'What The Doernbechers' by far, but I wouldn't say they're my rarest pair. Some of the samples I own are the only known pairs in existence.

Such as?
The 'Off Spray' and 'Joker' Dunks are tied for first place as my favourites. I wanted them for so long. After about eight years of waiting, the people who owned them were finally ready to part ways. I've also been told that the only other people who own the original 'Entourage' prototype with the blue Swoosh are Mark Wahlberg and one of the show's producers. The laser-engraved 'Pigeon' Dunks were actually the hardest pair to track down. They sold to the first 30 people in line at Reed Space on release day. I'm still yet to see a pair in my size, which is US9, so I had to settle for a 9.5. I'm pretty lucky, though. About 90 per cent of SB samples are size 9, so I'm fortunate. As long as I can get doubles, I have a pretty strong practice of 'one to rock and one to stock'. However, there are a few singles I still wear. I like the fact you don't have to worry about SBs falling apart after a decade, unlike a lot of the old runners.

Must be a hard decision when you've got the only pair in the world. What kickstarted you collecting samples?
I love the samples because they are simply some of the rarest shoes ever made. I used to check the sample thread on 'N-SB' daily to see all the latest leaks. When I saw the 'Loon' and 'Gucci' samples, I just knew I had to own them one day. Since then, I have owned almost every SB sample out there at one time or another. I have had to sell a few from time to time, but I try to keep them. I wish I had kept my 'Iron Maiden' and 'Deftones' samples, but I have my eyes open, and I'm sure I'll get them back one day.

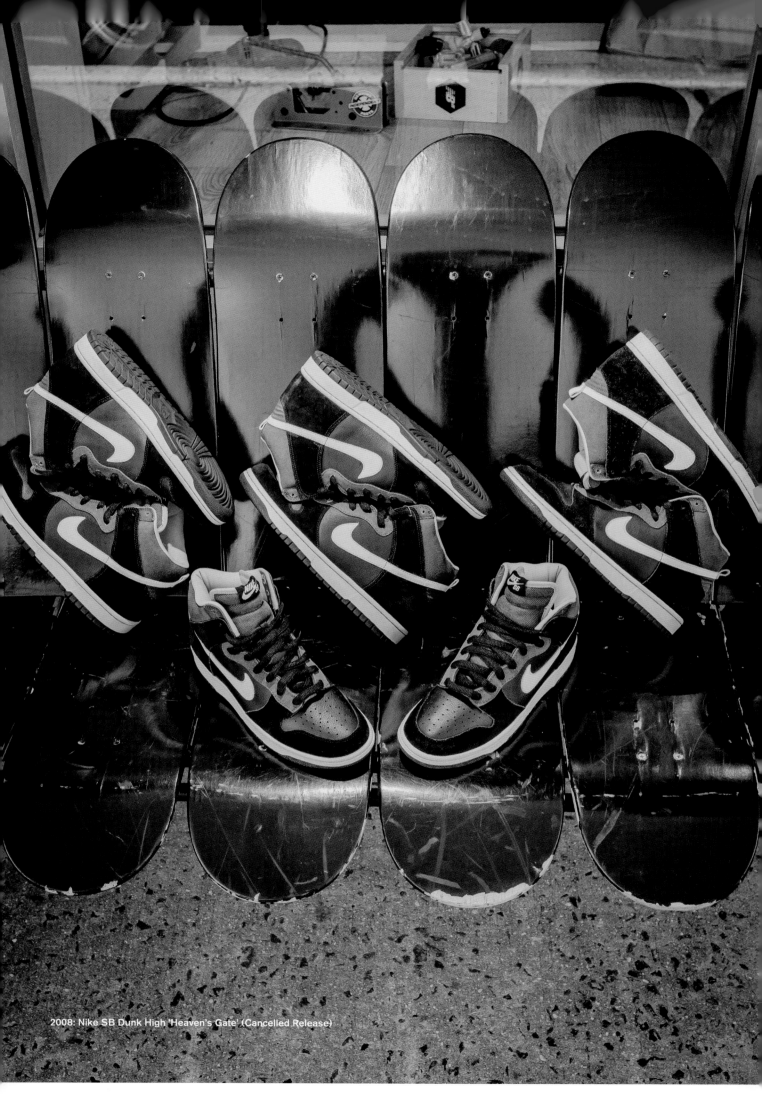

2008: Nike SB Dunk High 'Heaven's Gate' (Cancelled Release)

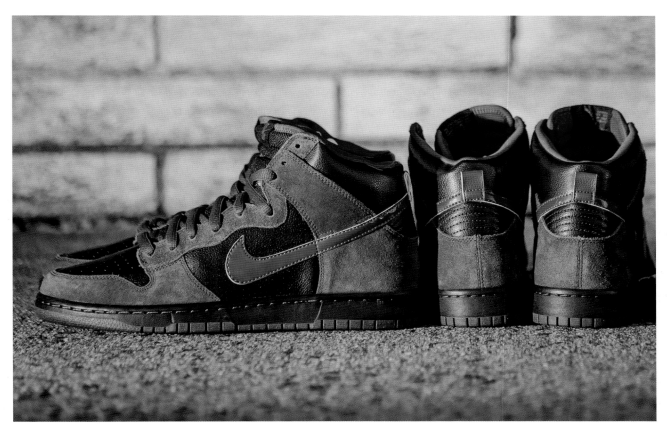

2009: Nike SB Dunk High 'Purple Haze' (Unreleased Sample)

It's all about the waiting game. Where do you get all this stuff?
From wherever I can. Outlets, eBay, sneaker events – it's all luck of the draw. Sometimes, when I've been really lucky, I've met someone who either knows someone who works or used to work for Nike. I would honestly attempt to buy any Nike SB sample I come across. It's an addiction!

We hear you. You've got four pairs of the infamous 'Heaven's Gate' Dunk Highs, which is insane.
A sneaker as limited as that is so rare that if you tried hard enough, you might be able to own the majority of pairs in existence. I owned seven pairs at one point but sold a few. Personally, I don't understand why they made a Dunk in memory of an event like that, but I do love the colourway. I honestly just love samples and wouldn't mind owning every pair of every sample. One of the hashtags I use on Instagram is #nikesbhoarder because I love to hoard multiples.

Why so much love for samples?
A lot of shoes are much better in sample form than the released version, like the 'Entourage' samples, which actually feature *Entourage* branding. Other pairs like the 'Peacock' and 'Goofy Boy', where they changed the materials slightly, just look much better than the released version. However, in some cases, the released version actually came out better than samples, like the 'Donatello' edition. Even the 'Freddy Krueger' Low that was never released looks better than the original prototype, so it does vary. In some cases where the sample wasn't altered aesthetically, you still find that the sample is made with much better-quality materials.

Speaking of the 'Kruegers', are there any canned samples you wish had come out?
I think all of them are amazing, but honestly, I'm happy that they haven't brought any of them back besides the 'Loon' and 'Neon J' packs. It's their mystique as unreleased samples that cemented their place in SB history. Back when they were samples, those pairs would trade hands for thousands of dollars, but after release, you could find them all over eBay for 50 bucks, which I feel takes away from SB as a whole. People want to be unique, which is why they pay so much to obtain them and ensure they are the only person with that style. Retroing an iconic sample just doesn't sit well with collectors, whether they have that specific shoe or not.

Sounds like this happened to you.
I actually purchased a pair of 'Loons' for a lot of money some years back, but thankfully I sold them way before the retro dropped. It is a risk because Nike can ultimately do whatever they want. I just hope they see retroing works when they do the high-to-low conversions, like with the 'Tiffanys'. It keeps the original unique. Bringing back samples – or even just older SBs in their original form – ruins the fun of collecting. People want something way more if they can't have it, and like the UNDEFEATED and 'Eminem' Air Jordan 4s, shoes that are iconic still have an effect on the entire brand. They will forever create hype for the brand as a whole, and I believe it's the same with some of the more unobtainable Nike SB samples.

Is there a Grail that still eludes you?
My ultimate Grail is the scrapped 'Supreme' Dunk Low. They were similar to the 'Supreme' Dunk High released back in 2003, but instead of gold stars, they feature the Nike logo repeated in gold with a Swoosh underneath. I've got the released versions, but I like the samples more because they are super limited. [Laughs.]

I'm sure they'll set you back a bit. What are prices like nowadays?
SB goes up and down like crazy. Three years ago, 'FLOM' Dunks were going for $10k, and now you can't even sell them. 'Paris' Dunks were going for the same money, too, but some dude just offered me three pairs for $6k each. SB fluctuates so much. I think part of that is because SB is a lot more mainstream now. You can find them in stores everywhere, whereas SB used to be sacred to skate shops. Anyone can get a pair nowadays, and they're practically all general releases. It takes away the charm and the demand. I would never get my money back for some of the samples I bought for $3–4k.

Would you ever sell them?
No. I bought them because I wanted them. My collection is still growing, and I don't have any plans to stop collecting SB!
★

@sbcollector

City Pack

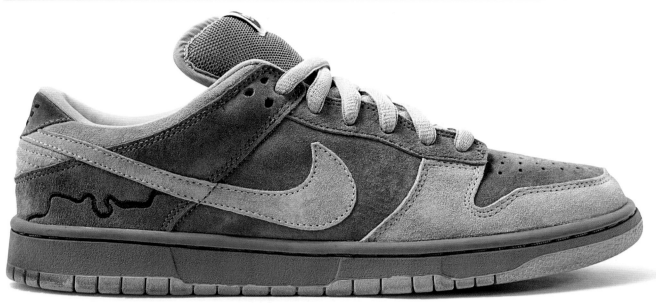

2003: Nike SB Dunk Low 'London'

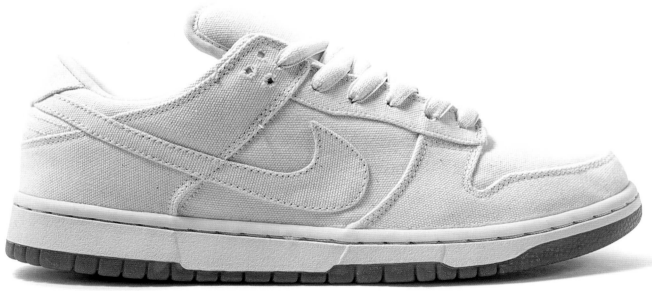

2004: Nike SB Dunk Low 'Tokyo'

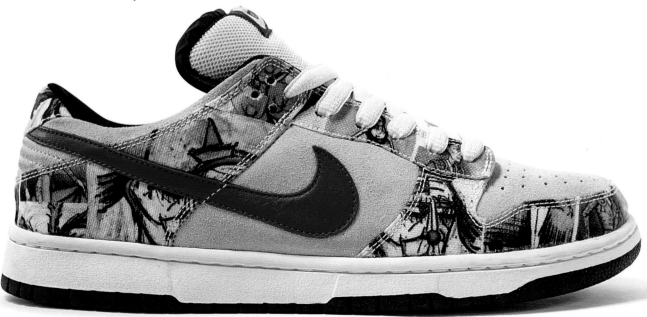

2005: Nike SB Dunk Low 'Paris'

This is the epicentre of the hype explosion that sent the Dunk SB skyrocketing into four-figure territory. A globetrotting exercise, the 'City Pack' sent the Dunk on a world tour that was limited to a minuscule 202 pairs per colourway.

The story begins with the release of the 'London' Dunk in 2003. Sold through Footpatrol, the shoe was an appropriate blend of drab grey suede with the River Thames embroidered in blue across the heel.

The following year, the 'Tokyo' Dunk was timed to celebrate the arrival of the *White Dunk: Evolution of an Icon* exhibition. Featuring a pristine, all-white canvas upper, the minimalist design was notable for the absence of Nike branding (aside from the Swoosh).

The third release arrived in 2005, just as the exhibition made its way back to Europe. The 'Paris' Dunk featured a collage of imagery by French painter Bernard Buffet, with no two pairs alike.

The final Dunk in this quartet was designed by Jeff Staple. Themed after the city's ubiquitous airborne pest, the 'Pigeon' made the front page of the *New York Post* after riots erupted. The 'Pigeon' was sold at a handful of NYC skate shops, but it's the 30 individually numbered and laser-engraved pairs released through Reed Space that remain highly coveted. Robinson owns number 11 of 30.

2005: One of 30 limited-edition Dunks

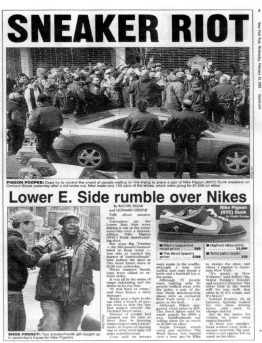

2005: *New York Post,* 'Pigeon' Dunk riot article

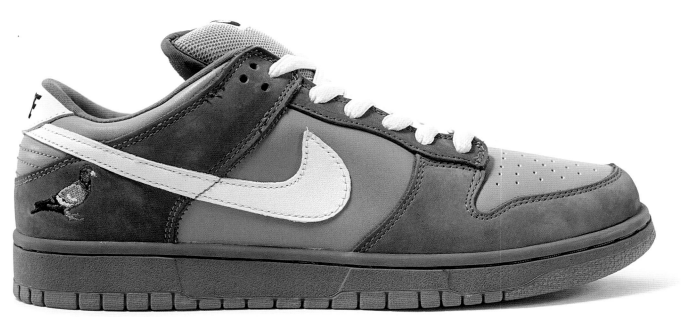

2005: Nike SB Dunk Low 'Pigeon'

Entourage

To celebrate the final season of *Entourage* in 2011, the 'Lights Out' Dunk was gifted to the show's cast and crew. They're obviously rare, but Robinson has gone one step further by unearthing this variation with bright blue branding on the Swoosh – only three pairs reportedly exist! The others are owned by Mark Wahlberg and the show's producer. A second version was released to the public a few years later, with the gum outsoles and *Entourage* branding deleted. That pair is known within the SB community as the 'Nontourage'.

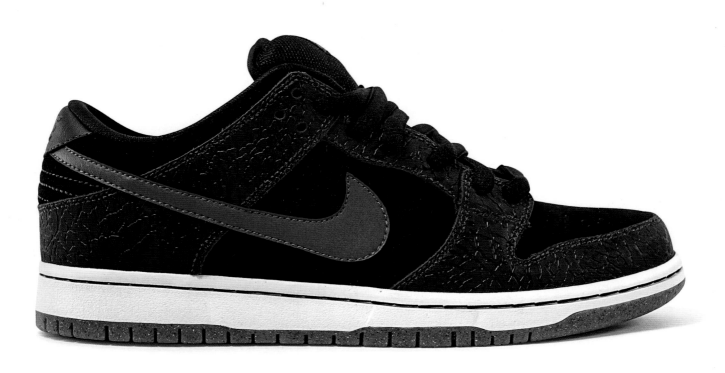

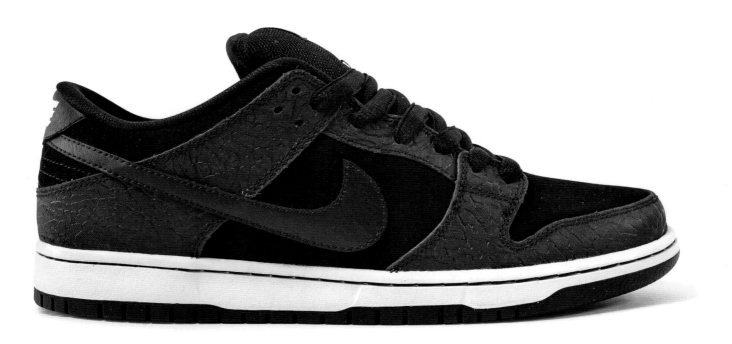

Joker

These Dunks are reportedly based on the Batman villain and were timed to release at the same time as *The Dark Knight*. However, after the controversy around Heath Ledger's untimely death, the release plan was junked. The version with the black midsole is made from denim, while the other is a combination of nylon and suede. As Robinson told *Sneaker Freaker*, he missed out on these Jokers the first time around, and it took another five years to track them down.

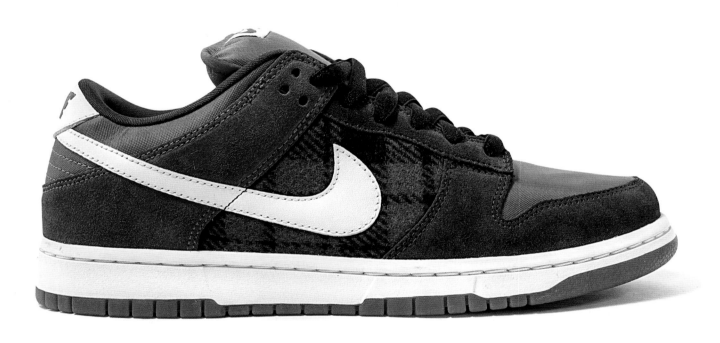

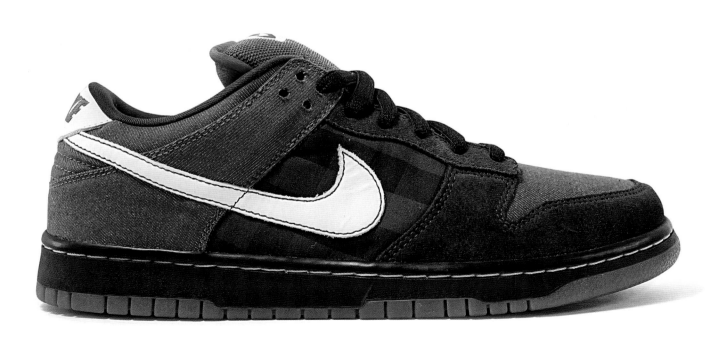

Freddy Krueger

Intended to release in 2007 as part of a horror movie pack that also included a 'Jason Voorhees' Dunk High and 'Dawn of the Dead' Air Trainer 1, these Dunks were 'allegedly' based on horror icon Freddy Krueger. Sadly, New Line Cinema, who own the rights to *A Nightmare on Elm Street*, were pissed when they found out about this unofficial tribute. A cease and desist was dispatched, but unfortunately for Nike, the notice arrived just after the shoes had been shipped. The entire production run was destroyed, but a few pairs still managed to find their way out, reportedly from a Mexican skate shop that flipped them way early. Another batch with oil-stained uppers was 'allegedly' saved from a fiery demise by a savvy Nike employee. What we do know is that there are two versions. Robinson also owns the early prototype, of which only a handful are known to exist, while the retail version can be identified by the knitted sweater-like upper and blood-splattered overlays.

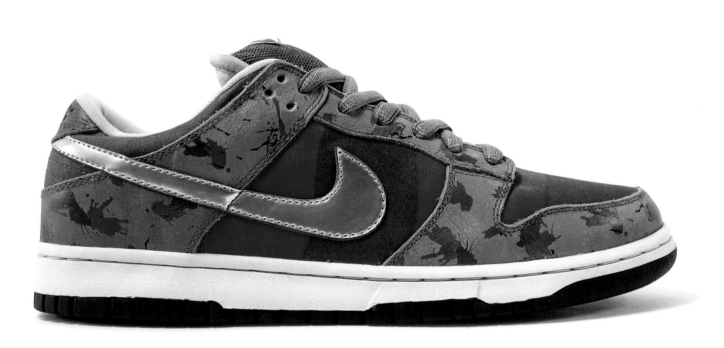

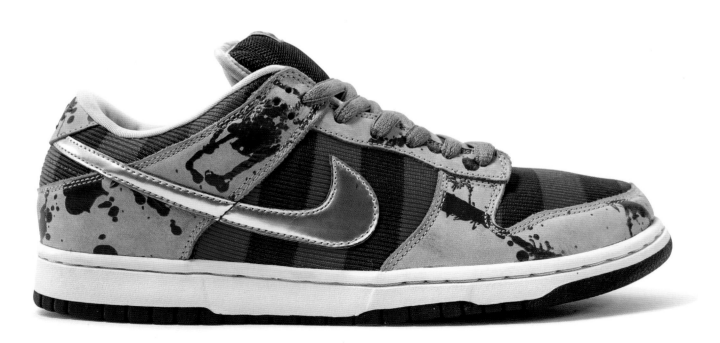

Charlie Brown

Another Dunk rumoured to have suffered from legal issues, this midtop duo are Charlie Brown-themed samples, with the zigzag stripe resembling the polo shirt worn by the cartoon character. Other rumours suggest they were based on Homer Simpson as a symbolic reference to his distinctive hairline. Regardless, neither pair saw the light of day. Robinson supposedly has the only two in existence! D'oh!

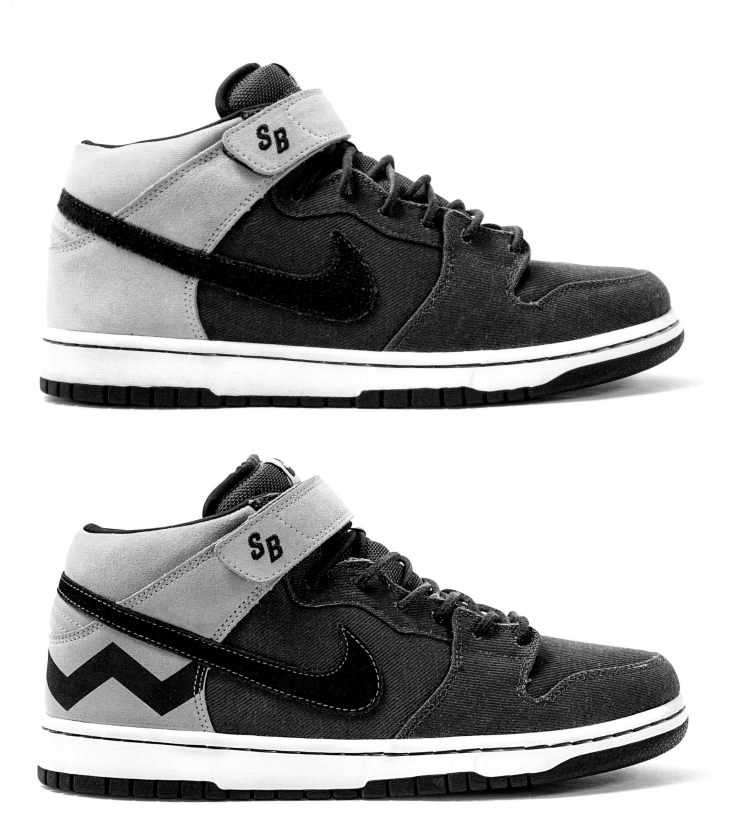

Geoff McFetridge 'MOCA'

Every Nike SB is designed to shred, but you'll need a massive set of cojones if you plan on hitting the half-pipe in these limited-lifespan Dunks. Produced for the launch of the *Art in the Streets* exhibition at the Los Angeles Museum of Contemporary Art (MOCA), artist Geoff McFetridge created just 24 pairs. Each was assembled from a unique piece of the artist's work, which was applied to reinforced paper. The pairs were auctioned off for charity, with all proceeds donated to the MOCA Foundation. Alas, the pair Chris owns is a size too big, so he's unsure if he'll ever wear them out and about. Once it rains, these are one and done!

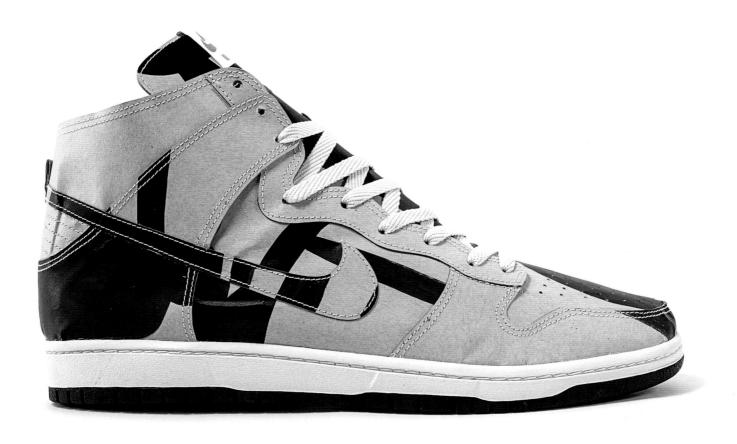

Heaven's Gate

Even though it was never officially released or endorsed by Nike, the most controversial SB of all time was the 'Heaven's Gate' Dunk High. Inspired by the cult of the same name, the shoe was designed by SB skater Todd Jordan. In 1997, the cult's members committed mass suicide in a misguided (to put it mildly) attempt to board an extraterrestrial spacecraft trailing Comet Hale-Bopp. The bodies were found covered by purple cloth, dressed in matching uniforms and black-and-whites Nike Decades – one model the Swoosh definitely have no plans to retro anytime soon. When Todd Jordan disclosed the story in an interview, the release plans were immediately scrapped, and only a handful of samples made it out. Chris currently owns four pairs.

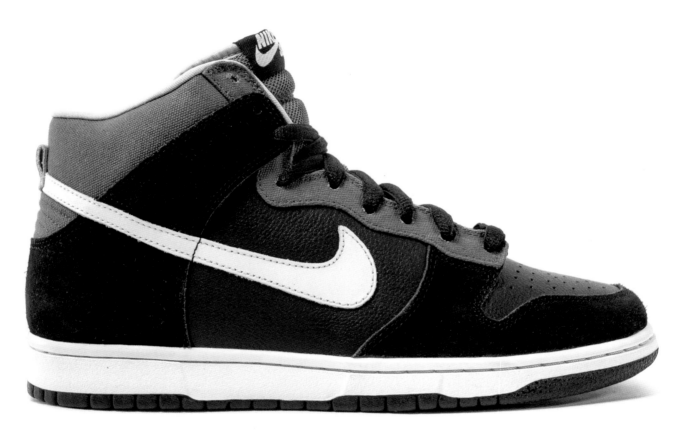

OFF! Bug Spray

These garish Dunks bear an uncanny resemblance to the palette of OFF! bug spray. They were allegedly slated for release around the same time as the 'Mosquito' Dunk Low, though the reason for the shoe's cancellation remains unknown. As far as Robinson knows, this is the only pair in the world.

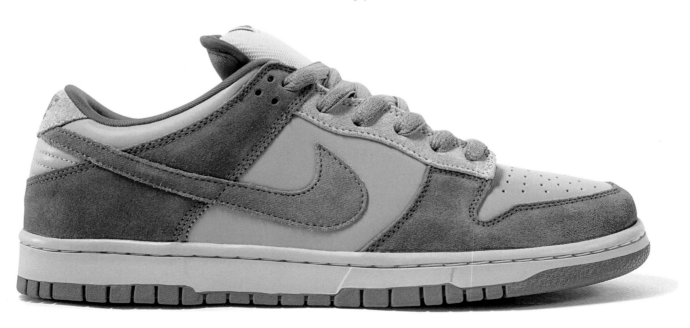

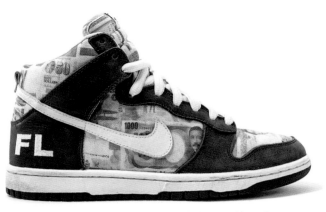

2004: FUTURA x Nike SB Dunk High 'For Love or Money' (Friends & Family)

2006: Stones Throw x Nike SB Dunk High 'Quasimoto' (Friends & Family)

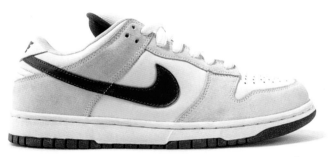

2006: Nike SB Low 'White Purple Pigeon' (Unreleased Sample)

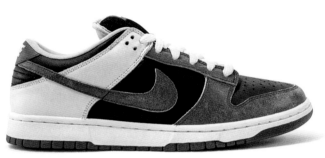

2006: Nike SB Low 'Jason Voorhees' (Unreleased Sample)

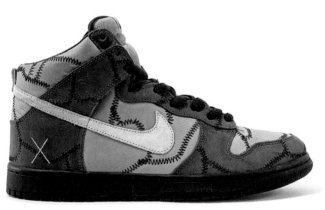

2006: Nike SB High 'Don Quixote' (Unreleased Sample)

2006: Nike SB Mid 'Peacock' (Unreleased Sample)

2008: Made for Skate x Nike SB Blazer (1-of-24)

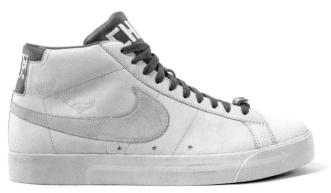

2008: Michael Lau x Nike SB Blazer 'White BMX' (Friends & Family)

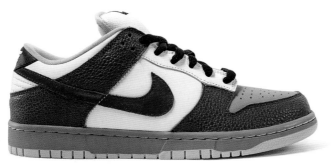

2009: NJ Skate Shop x Nike SB Dunk Low 'Toxic Avenger' (Unreleased Sample)

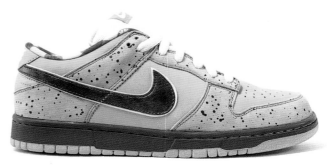

2009: Concepts x Nike SB Dunk Low 'Yellow Lobster' (Friends & Family)

2009: Nike SB High 'Purple Haze' (Unreleased Sample)

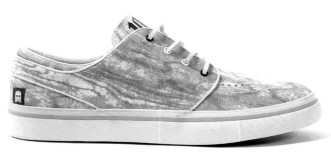

2009: Michael Lau x Nike SB Zoom Stefan Janoski 'White Gardener' (Friends & Family)

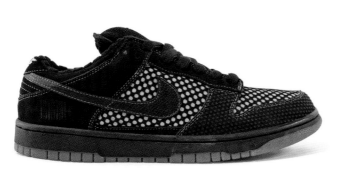

2010: Nike SB Low 'Black/3M' (Unreleased Sample)

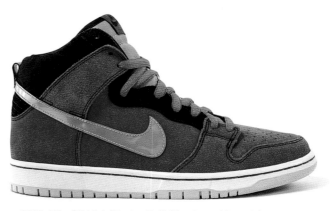

2012: Nike SB High 'Raging Bull' (Unreleased Sample)

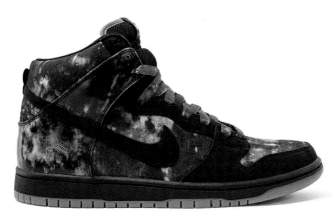

2012: Nike SB Dunk High 'Pushead 2' (Unreleased Sample)

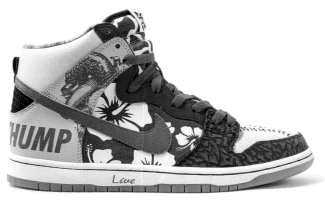

2015: Nike SB High 'What The Doernbecher' (1-of-11)

SNEAKER FREAKER ISSUE 48 — RARE AIR! 1984 – AIR JORDAN 1 'BLACK TOE' — THE GREATEST JORDAN COLLECTION EVER

SNEAKER FREAKER ISSUE 47 — Alley Cats — SNEAKER FREAKER x ATMOS

SNEAKER FREAKER ISSUE 46 — Patta AIR MAX!

SNEAKER FREAKER ISSUE 45 — FRESH GOODS! — JOE FRESHGOODS OUTSIDE CLOTHES

SNEAKER FREAKER ISSUE 44 — INTER VIEW VIRGIL

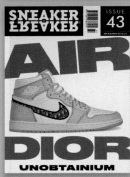

SNEAKER FREAKER ISSUE 43 — AIR DIOR — UNOBTAINIUM

SNEAKER FREAKER ISSUE 42 — 1-800-AIR-ZOOM-SPIRIDON

SNEAKER FREAKER ISSUE 41 — LOONEY TUNED!

SNEAKER FREAKER ISSUE 40 — new balance Classic 574

SNEAKER FREAKER ISSUE 39 — VANS — CHECKERBOARD

SNEAKER FREAKER ISSUE 38 — OVER 200 PAGES! — RIDUNKULOUS NIKE SB RETROSPECTIVE!

SNEAKER FREAKER ISSUE 37 — E.A.R.L. — GENIUS OR GIMMICK? HYPERADAPT

SNEAKER FREAKER ISSUE 36 — OG COLLECTOR FEATURE — CRACKED & ROTTEN VINTAGE JORDANS! — HIP HOP KICKS • SUPREME • NIKE COLAB HISTORY • ADIDAS NMD RETROSPECTIVE

SNEAKER FREAKER Reebok ISSUE 35 — ALIEN STOMPER — BACK ON THE BIG SCREEN

SNEAKER FREAKER ISSUE 34 — OVER 200 PAGES — PUMA DISC BLAZE BAPE

SNEAKER FREAKER ISSUE 33 — FUTTOSUKEPU — DARE TO BE DIFFERENT

SNEAKER FREAKER ISSUE 32 — ADIDAS ORIGINALS SUPERSTAR — LOVE LETTER TO A MASTERPIECE

SNEAKER FREAKER ISSUE 31 — asics GEL — SNEAKERFREAKER MELVIN SON OF ALVIN

SNEAKER FREAKER ISSUE 30 — MEGA 184 PAGE ISSUE — BLACK & GOLD JORDANS — $20k TREASURE FOUND FOR $10

SNEAKER FREAKER ISSUE 29 — MEGA 180 PAGE ISSUE — 20 YEAR ANNIVERSARY SPECIAL — PUMP FURY!

SNEAKER FREAKER ISSUE 28 — AIR MAX — OUT NOW! — THE COMPLETE* RETROSPECTIVE

SNEAKER FREAKER 27 ISSUE — GLOBAL SNEAKER GUIDE — AIR MAX ATTACKS!

SNEAKER FREAKER 26 ISSUE — GLOBAL SNEAKER GUIDE — VINTAGE NB572 DAPPER DAN — HARLEM'S ORIGINAL HIP HOP TAILOR IS BACK! — READ OUR EXCLUSIVE INTERVIEW DAPPER DAN

SNEAKER FREAKER 25 ISSUE — GLOBAL SNEAKER GUIDE — THE ADMIRAL RETURNS — THE 90s REVIVAL — USE THE FORCE! — DAVID ROBINSON'S AIR FORCE 180 IS BACK WE COMPARE THE RETRO TO THE ORIGINAL

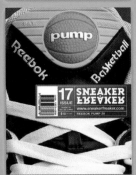

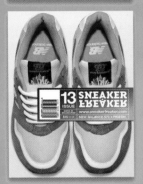

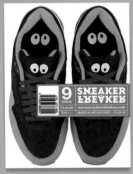

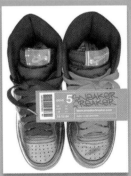

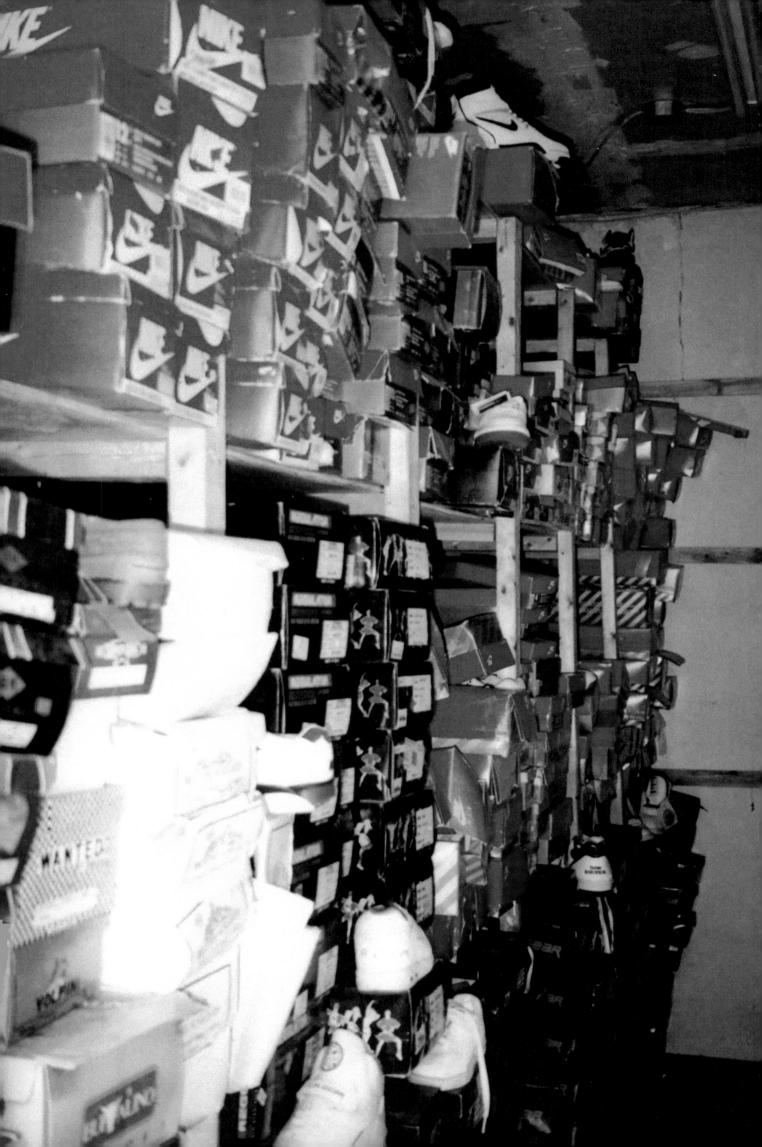